D0207652

A Comprehensive Guide to Outdoor Sculpture in Texas

Carol Morris Little

A Comprehensive Guide to

OUTDOOR SCULPTURE IN TEXAS

University of Texas Press

Austin

HOUSTON PUBLIC LIBRARY

R01082 09899

txr

Publication of this book was made possible in part by a gift from Trammell Crow as "an investment in Texas and a salute to its citizens."

Publication was also assisted by generous contributions from the following:

Texas Commission on the Arts

Mr. and Mrs. Frank McBee

Anonymous

Mr. and Mrs. H. David Herndon

Mrs. Walter W. McAllister, Jr.

Mr. Frank Ribelin

Dr. W. H. "Deacon" Crain

Mr. Gale L. Galloway

Professor and Mrs. Charles Alan Wright

Copyright © 1996
by the University of Texas Press
All rights reserved
Printed in the United States of America

First edition, 1996

Requests for permission to reproduce material from this work should be sent to Permissions, University of Texas Press, Box 7819, Austin, TX 78713-7819.

(∞) The paper used in this publication meets the minimum requirements of American National Standard for Information Sciences—Permanence of Paper for Printed Library Materials, ANSI Z39.48-1984.

Library of Congress Cataloging-in-Publication Data

Little, Carol Morris.
 A comprehensive guide to outdoor sculpture in Texas / by Carol Morris Little. — 1st ed.
 p. cm.
 Includes bibliographical references and index.
 ISBN 0-292-76034-5. — ISBN 0-292-76036-1 (pbk.)
 1. Outdoor sculpture—Texas—Guidebooks. 2. Sculpture gardens—Texas—Guidebooks. I. Title.
NB230.T4L58 1996
730'.74'764—dc20 95-41828

Contents

How to Use This Book

Research for this book began in 1985. During that year, before the observance of the Texas Sesquicentennial, every community under the Lone Star planned projects and events to dramatize its unique role in the development of the state's colorful past. Some of the activities were full of hype, as gregarious and grandiose as the state's reputation warrants; others were as uncomplicated as a family gathering at a tiny cemetery to clean the grounds and place flowers at the resting place of forebears whose lives helped mold the past that was being celebrated. With wagon trains, chili cook-offs, and fireworks displays, Texans observed the passing of 150 years of independence. Yet, like most birthdays and anniversaries, the 1986 Sesquicentennial also provided a time for reflection, and it inspired this study of the state's cultural heritage as portrayed in outdoor sculpture.

Although this survey is designed as a reference tool and guide, its primary purpose is to record the first inventory of the state's publicly sited sculpture. The finished product, however, is not so much a book about art as it is a book about Texas history and culture. It is also a book about Texans—their patriotism, their religious beliefs, their shared values, their sense of humor, and their changing attitudes about public art as a part of their everyday environment.

Within the context of this study, "publicly sited" or "outdoor sculpture" refers to works that are easily accessible for public viewing and are not confined in a building. The survey includes the gamut of outdoor sculpture, from Confederate soldier statues to modern abstractions; however, it generally does not include bas-relief plaques, text panels, or decorative sculpture on buildings. Cemetery monuments are not included unless the memorial represents the work of a well-known artist, marks the grave site of a

famous person, or provides a unique contribution to the study of outdoor sculpture in Texas. Aesthetic quality was not a criterion in the survey, because a work that lacks artistic merit may have other redeeming features, such as historic or social significance.

Parenthetically, Texas has a rich cultural heritage from the Spanish colonial period. The ancient Spanish missions of Texas represent the oldest and some of the most beautiful architecture and ornamentation in the state. Unfortunately, no freestanding outdoor sculpture survives from that era. Readers interested in Spanish colonial art and architecture can contact the San Antonio Missions National Historical Park or consult a number of books on the subject, such as *The WPA Guide to Texas* by Don Graham, *San Antonio's Mission San José* by Fr. Marion A. Habig, O.F.M., and *Missions of Old Texas* by James Wakefield Burke.

Outdoor Sculpture in Texas presents an alphabetical list of cities, with works listed under the city where they are located. Special collections and sculpture gardens are presented separately at the end of the listing for the relevant city. (In some instances, a special collection or sculpture garden may be the only listing under a city.) Individual works are listed under the artist's last name. The artist's life dates and nationality are given in parentheses. The term "American" refers to a citizen of the United States of America. The artists' nationalities refer to the countries in which they spent most of their adult lives or in which they hold citizenship; the native country appears after the adopted homeland. Native Texans are identified, and an asterisk indicates that the artist is, or was during most of his or her lifetime, a resident of the state. For each sculpture or monument that is not part of a special collection or sculpture garden, the following information is given under the artist's name:

Title and date: The title refers to the name of the work. If the sculpture has no specific name, the work is identified by its subject. For example, some Confederate soldier statues are identified simply as *Confederate Soldier Statue.* If a sculpture is a facsimile or working model, that is noted in the title. The ancient Greek statue of Nike is listed as *Nike of Samothrace Facsimile,* and Felix de Weldon's Marine memorial is listed as the *Iwo Jima War Memorial Original Working Model.* If a work is deliberately untitled by the artist, it is recorded as an untitled piece. Unless otherwise indicated, the date refers to the year in which the work was created.

Type, size, and material: Because artistic terms can be ambiguous and open to broad interpretation, the terms used to classify a sculpture are intended to help the reader identify a work, but they are not

intended to be definitive. Unless otherwise specified, dimensions are given in the following order: height, width, and depth. The materials are the primary media used by the artist to produce the finished work.

Location: If no street address exists for the site where the sculpture is located, directions usually are provided to guide the reader.

Funding: In most cases the entity responsible for commissioning or purchasing the sculpture is identified.

Comments: The comments section provides additional information for selected works.

To compile a comprehensive inventory, the author surveyed all 254 Texas counties. Interviews, questionnaires, published material, and direct observation were the primary methods used to accumulate data. Texas artists, foundries, museums, libraries, universities, state agencies, private businesses, chambers of commerce, municipal arts councils, and county historical commissions all provided helpful information. Undoubtedly, some works were overlooked, and other researchers are invited to enlarge and improve this first effort.

A Comprehensive Guide to Outdoor Sculpture in Texas

Introduction

Throughout Texas, images of stone, bronze, and steel fill the state's open spaces. Gleaming stainless steel objects punctuate city plazas; immobile mustangs, frozen in time, stampede down craggy slopes; and lifelike figures, perpetually young, stand as silent sentinels on lofty summits surveying parks, battlefields, and public buildings. Outdoor sculpture in Texas excites the senses and commemorates the people, events, and ideals that deserve remembrance. As the most accessible form of art and history, the state's outdoor sculptures and monuments comprise a unique cultural heritage that gives form and focus to shared values and experiences.

The history of outdoor sculpture in Texas is brief compared with the development of American sculpture in general. By the middle of the nineteenth century, American sculptors and fine arts foundries had produced bronze portrait statues and equestrian monuments for public settings in Boston, New York, Washington, D.C., and other major cities. But these early American artists were not inclined to nail "GTT" (Gone to Texas) signs on their fence posts and trek westward to a wilderness where survival alone required all the creativity one could muster. As noted by art historian Edwin Rayner, "Sculpture is no occupation for pioneers" (Rayner 1936, 60). The tumultuous period between Anglo-American colonization and Civil War Reconstruction afforded little time for Texans to acquire the artistic training or technical skill necessary for the creation of public monuments.

The first large commemorative sculpture erected in Texas was the original Alamo monument dedicated to the martyred heroes of the Battle of the Alamo. After Texian forces defeated Mexican general Antonio López de Santa Anna at San Jacinto on April 21, 1836, new citizens of the Republic of Texas commissioned a

1

monument built with stones gathered from the ruins of Mission San Antonio de Valero (the Alamo). A simple pyramid set on a square base, the Alamo monument stood in the vestibule of the State Capitol until the building burned in 1881. The monument was almost destroyed in the fire, but a surviving remnant is stored with the holdings of the Texas State Archives in Austin.

After the fire of 1881, Texans began the arduous task of building the current Texas State Capitol, a project that extended from 1883 to 1888. On February 26, 1888, the *Austin Daily Statesman* reported that workers had raised the *Goddess of Liberty* to the summit of the new capitol dome. Other giant allegorical figures perched on roof-tops of public buildings throughout Texas are not included in this study of freestanding sculpture; however, the State Capitol's *Goddess of Liberty* deserves special consideration. Interestingly, proof of her origin eluded researchers for almost a century until Margo Gayle, founder and president of Friends of Cast-Iron Architecture, discovered in the Library of Congress an 1897 catalogue published by the Friedley-Voshardt Foundry in Chicago, Illinois. The caption under catalogue item number 453 reads, "Statue. Height 14 feet to top of head. Cast Zinc. Prices according to size. Furnished for the Texas State Capitol in Austin, Texas." Although created in Illinois, the Goddess is in a sense a native Texan because, after arriving in Austin as a dismembered plaster mold, she was cast in zinc and assembled on Texas soil.* In 1985, weakened by time and the elements, the original *Goddess of Liberty* was removed from her summit and replaced with an exact replica cast in forty-eight alumi-num pieces at Dell-Ray Bronze, Inc., of Houston.

The oldest monument on the grounds of the Texas State Capitol and the oldest bronze commemorative sculpture in the state is *Battle of the Alamo*, commissioned by the Texas State Legislature in 1891 as a replacement for the original Alamo monument. Granite for *Battle of the Alamo* was quarried and dressed at Marble Falls, then shipped to Austin, where it was installed at the capitol under the supervision of Vincent V. Hornung, foreman for the crew of J. S. Clark and Company Monumental Works of Louisville, Kentucky. The bronze figure on top of the granite monument is the work of sculptor Carl Rohl Smith, a native of Copenhagen, Denmark, who lived in Louisville between 1890 and 1893 (*Directory of the City of Louisville* 1891, 990). The figure depicts a citizen soldier armed with

*J. C. McFarland's itemized receipt from the Missouri Pacific Railroad Company, dated January 18, 1888, includes $31.90 for a plaster statue, which arrived in seven pieces and weighed a total of 2,200 pounds.

a long-barreled muzzle loader. Beneath the statue is the famous declaration by William Barret Travis, "I shall never surrender or retreat." On April 26, 1891, with typical Texas reserve, the *Austin Statesman* described the soldier statue on the new monument as "a hardy, stalwart son of Texas who stepped from between the handles of the plow to pick up his long rifle and set his face against the swarming hosts who came from Mexico to sweep freedom forever from his fireside." The reporter concluded, "It is safe to say that there now exists no handsomer or more appropriate monument than this." By the turn of the century, Texans had erected a number of stone shafts inscribed with names and events associated with the Texas Revolution as well as three life-size soldier statues dedicated to the state's Confederate veterans. One other nineteenth-century war memorial, a modest stone obelisk erected in 1868, commemorated the men of Comfort who died during the Civil War. Ironically, this oldest Civil War monument in the state honors Texans who were true to the Union.

Before 1900, outdoor sculpture in Texas was either ordered from catalogues through monument dealers, such as the Friedley-Voshardt Foundry and the J. S. Clark and Company Monumental Works, or carved by local stonecutters. Two noteworthy monuments carved by early Texas stonecutters are the *Willet Babcock Memorial* and the *Sheriff H. B. Dickson Memorial*. The *Willet Babcock Memorial* is of particular interest because of its unique design. Babcock, a furniture dealer who ran the Paris Opera House above his furniture showroom, moved from Ithaca, New York, to Texas during the 1850s. He became a community leader in Paris, serving as one of the city's first aldermen and the first fire chief. He also served as a director of the Paris Street Railroad Company and the Paris Gas Light Company. For reasons known only to him, in 1880 (a year before his death on August 27, 1881), Babcock commissioned Paris Marble Works to create a monument for his grave site. The monument is believed to be the work of Gustav Klein, a German immigrant stonecutter who worked for Paris Marble Works and designed many of the memorials in Paris' 120-year-old Evergreen Cemetery. The *Willet Babcock Memorial* features a nearly life-size statue set on an ornately carved pedestal between two inverted torches. The statue, a somber male figure leaning against a large cross, wears a biblical robe—and cowboy boots.

The *Sheriff H. B. Dickson Memorial* is interesting because of the events that precipitated its commission and because of the attention it received in 1894 as one of the most impressive outdoor monuments in Texas. Hamilton Bass Dickson served as sheriff of Wharton

County during an era when desperadoes attacked passenger trains and robbed ranchers in the sparsely settled country along the Colorado River. On February 7, 1894, Sheriff Dickson and Colorado County's Sheriff J. L. Townsend tracked a murderer who had escaped from the Colorado County jail into a dense thicket. As the lawmen approached what appeared to be the culprit lying next to a log, the criminal ambushed them. A rifle shot pierced the air, and Sheriff Dickson fell to the ground, saying to his companion, "Townsend, he has killed me." The figure beside the log was only a dummy placed there by the fugitive to trap the officers in the ambush. People in Wharton and surrounding communities were grief-stricken over the loss of a man who had been described as Wharton's most loved, respected, and distinguished citizen. Adding to the tragedy was the fact that less than one month earlier the county's residents had celebrated the marriage of the sheriff to Belle Faires, who lived in the neighboring community of Edna. Contemporary news accounts describe Sheriff Dickson's funeral as the largest gathering ever assembled in Wharton, and in June 1894, the county commissioners' court authorized a committee to erect a monument on the courthouse lawn in memory of the young sheriff who died in the line of duty. When the Brenham firm of Jaeggli and Martin Stonecutters installed the memorial, area newspapers touted the marble monolith and portrait bust as "the handsomest and largest monument in Southern Texas."

The first professional sculptors to call themselves Texans were European immigrants who used academic training and technical skills obtained overseas to portray the people, events, and ideals Texans revered. These Old World artists created their first Texas works around the turn of the century, when many Texans still remembered Goliad, San Jacinto, and the bitter struggle of the Civil War. It is therefore understandable that most of their commissions were for war memorials and portrait statues of Texas heroes. As pioneers on a cultural frontier, these European newcomers influenced the growth of fine arts in Texas by promoting public art and art education. They also demonstrated through their work the enduring beauty and relevance of outdoor sculpture, and their visual legacy to the cultural heritage of Texas is evident at museums, courthouses, and historic sites in dozens of communities across the state. Most prominent among these early Texas sculptors and monument makers were Elisabet Ney, Frank Teich, and Pompeo Coppini.

Elisabet Ney was famous as a portrait artist in her native Germany before she immigrated to the United States and settled at

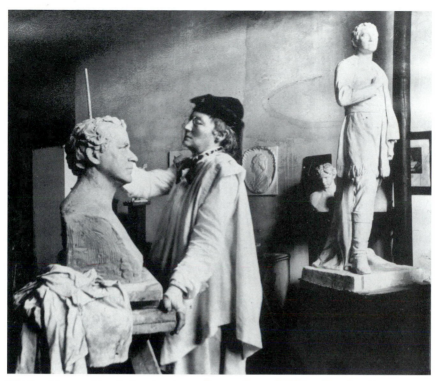

Elisabet Ney working in her Austin studio on a bust of William Jennings Bryan.
Courtesy Elisabet Ney Museum, Austin.

Liendo Plantation near Hempstead, Texas. Ney's clients included
the most notable European personalities of her time, such as Jacob
Grimm, Arthur Schopenhauer, King Ludwig II of Bavaria, King
George V of Hanover, German chancellor Otto von Bismarck, and
others. Yet her reputation as an artist often was overshadowed by
her eccentric behavior. Ney practiced a stubborn individualism that
defied traditional values and, perhaps, later delayed her success as an
artist in America. The indomitable "Miss Ney" shocked pioneer
Texas by bobbing her hair, wearing unconventional clothes, and
pursuing a career. Although she married Dr. Edmund Montgomery
in 1863 in Madeira, she insisted on retaining her maiden name and
refused to acknowledge the Scottish medical doctor and scientist as
her legal husband even to their son and her own parents. Texas
proved to be a hostile environment for Ney's ambitions and life-
style, as well as for the couple's naive notions concerning the
management of a large plantation. Adding to their troubles, in 1873
their older son, Arthur, died of diphtheria in his mother's arms

5

shortly before his second birthday. Later, Ney's younger son, Lorne, rebelled against her; the two never reconciled. Meanwhile, Liendo Plantation generally operated at a loss.

Disillusioned and heartbroken, Ney had not produced a major work of art for more than twenty years when, through the efforts of her friend Texas governor Oran Roberts, she accepted a commission to provide portraits of Sam Houston and Stephen F. Austin for exhibition in the Texas Building at the World's Columbian Exposition of 1893 in Chicago. Ney was fifty-nine years old when she agreed to model the Texas heroes for a group of Texas women who could not raise money for an artist's fee and paid her only for the costs of her materials. Nevertheless, the statues of Houston and Austin brought her instant notoriety and a renewed career. Her most ardent supporters were prominent women's groups who sought to advance cultural interests in Texas. Through the efforts of the Daughters of the Republic of Texas, the State Legislature commissioned from Ney the *Albert Sidney Johnston Memorial* in 1903. This work, considered one of her finest creations, is the artist's only large, publicly sited sculpture in Texas. Two other outdoor works are a small cherub in Fredericksburg and a bust in Austin, both private commissions.

Arriving at Hempstead in 1873, Elisabet Ney was the first professional sculptor to choose Texas as a permanent home. In addition, she was the first artist in the state to promote art education in public schools and to speak out for the establishment of an art department at the University of Texas. She even volunteered to teach art classes without pay if the city of Austin would underwrite the cost of space and materials. Unfortunately, the city refused her offer. Formosa, Ney's Austin studio and residence, was a gathering place for her loyal admirers, as well as for artists and dignitaries who visited the capital. After her death in 1907, Dr. Montgomery sold the studio to Ella Dancy Dibrell, who, with a group of Ney's friends, organized the Texas Fine Arts Association for the primary purpose of preserving the artist's work and memory. The studio, now known as the Elisabet Ney Museum and operated by the Austin Parks and Recreation Department, was the first Texas home of an internationally famous artist as well as the first Texas building designed primarily for the purpose of art. It is listed on the National Register of Historic Places.

Although he lacked the flamboyance of Elisabet Ney, Frank Teich is legendary in Texas for his reputation as a stone carver and granite dealer. Before emigrating from Germany in 1878, he studied design, drawing, and stone carving—skills he later used in Texas to help

build some of the state's most outstanding examples of nineteenth-century architecture. Arriving in San Antonio in 1883, he worked for Gustav Wilke, who hired him to supervise the cutting and placing of granite for the new State Capitol in Austin. Teich's work on the capitol led to contracts for the granite portions and decorative sculpture on several buildings, including the old San Antonio City Hall, the Tarrant County Courthouse, and the original San Antonio National Bank Building, for which he is said to have polished the first columns of Texas granite used in building construction.

Shortly before the turn of the century, Teich discovered vast deposits of superior gray granite in the Texas Hill Country. As a result of this discovery and his subsequent promotion of Texas granite in construction and monument making, Frank Teich is known as the father of the granite industry in Texas. The monument company established by Teich in 1901 on the outskirts of Llano became one of the South's largest suppliers of commemorative sculpture. In fact, at the time of his retirement in the mid-1930s, Teich Monument Works had provided at least one-third of all Confederate monuments located in Texas. In addition, Teich designed innumerable granite bases for bronze sculptures, such as the *Sam Houston* memorial in Houston and the *Austin Confederate Monument* at the capitol, and he created some of the state's most poignant and beautiful cemetery monuments, such as *Grief*, an angelic figure carved from a twenty-ton block of white Carrara marble for a cemetery in Scottsville. He also made numerous portrait statues, thirteen of which are located outdoors in Texas. A catalogue for Teich's Studio of Memorial Art, published in 1926, advertised commissions in Kansas, Missouri, Illinois, Pennsylvania, and Mexico; still, without question, his most popular design was the Confederate soldier statue, variations of which he and other marble companies erected throughout the southern states.

In 1901, Frank Teich advertised for a sculptor to design and model the bronze portion of a Confederate memorial for the capitol grounds. This advertisement prompted a young Italian immigrant, Pompeo Coppini, to come to Texas. A friend warned Coppini about coming West: "Texas is a wild state . . . and San Antonio is an open gambling town near the Rio Grande, where cowboys come to get drunk and run on their horses in the main streets" (Coppini 1949, 70). Ready for adventure, the impetuous young artist did not even take time to notify Teich of his departure from Arlington, New Jersey. Instead, he left home on the day before Thanksgiving and arrived unannounced four days later in the Alamo City, which he found to be a peaceful community reminiscent of the small historic

villages of Sicily. On his first day in the city, Coppini signed an agreement with Teich; however, the two men were not compatible, and their association ended with the completion of the *Austin Confederate Monument.* At the monument's unveiling, Coppini's bronze statues received such lavish praise that he decided to settle permanently in the "wild state," where he felt his talent would fill an artistic void as well as attract lucrative commissions. He later recalled, "My whole life and artistic career became linked, if not dedicated, to San Antonio and the State of Texas!" (81).

Pompeo Coppini remained committed to the development of fine arts in Texas. Like Elisabet Ney, he lobbied for art classes in public schools and for an art department at the University of Texas. He often complained, however, that his efforts to promote art education were unappreciated—and unrewarded. While compiling his autobiography in the late 1940s, he wrote, "No one who is connected with the University of Texas even today has proven any appreciation of my work, nor has ever thought of me in the organization of the Art School there, a project which I had so strongly fostered" (265). While Coppini and the University of Texas experienced a number of serious misunderstandings, he developed a congenial relationship with Baylor University, which awarded him an honorary doctor of fine arts degree in 1910, and with Trinity University, where he served as head of the fine arts department from 1943 to 1945. Before accepting the position at Trinity, Coppini expressed concern that his adamant views on modern trends in art could make the university unpopular: "I asked him [Dr. Paul Schwab] if he had been told by anyone of my strong objections to the tendency of primitivism in Fine Arts, and of my constant fight against it, especially in high schools, colleges, and universities" (386). While teaching at Trinity, he founded the Classic Arts Fraternity, now known as the Coppini Academy of Fine Arts, chartered in 1951 as a nonprofit organization dedicated to the promotion of classic fine art.

Pompeo Coppini was a recognized artist before he immigrated to the United States in 1896, and he worked with the well-known American sculptors Alexander Doyle, Karl Bitter, Attilio Piccirilli, and Roland Hinton Perry before leaving the Northeast for Texas. Examples of his sculpture are located in Kentucky, Michigan, Nebraska, Oregon, Tennessee, Colorado, Illinois, Pennsylvania, New York, New Jersey, and Washington, D.C., as well as in Italy and Mexico. No other immigrant sculptor was as significant in the development of art in Texas as Coppini; since his death in 1957, only one other sculptor, Charles Umlauf, has contributed as many publicly sited outdoor works. Although the subject matter of

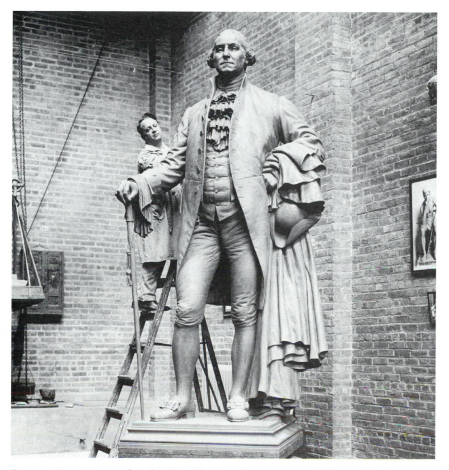

Pompeo Coppini at work in his New York studio on a statue of George Washington, later installed in Portland, Oregon. Careful examination shows pictures of the Lost Cause detail on the *John H. Reagan Memorial* in Palestine, Texas, and the massive bronze doors designed for the Scottish Rite Cathedral in San Antonio.
Courtesy Coppini Academy of Fine Arts, San Antonio.

Coppini's figurative sculpture reflects the interests and values of his contemporaries, many of his creations express emotions and experiences that transcend the subject of the statue. Thus, in assimilating Texas history and idealism in his monuments, he created timeless works of art. Exemplary works of this nature include *Firing Line* in Victoria, *Come and Take It* in Gonzales, the *Littlefield Memorial Fountain* in Austin, *Spirit of Sacrifice* in San Antonio, and the allegorical figure symbolizing the Lost Cause on the *John H. Reagan Memorial* in Palestine, all of which are commemorative war memo-

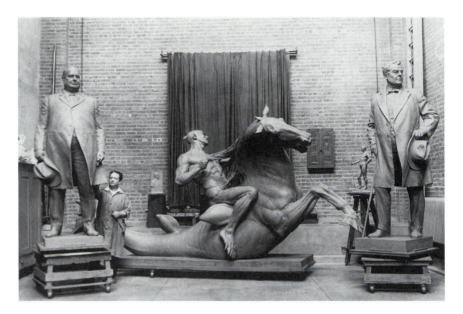

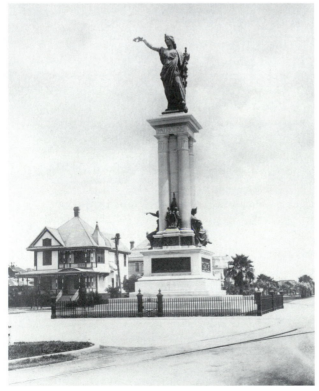

Pompeo Coppini in his New York studio surrounded by figures of James Stephen Hogg, sea nymphs, and John H. Reagan, all elements of the *Littlefield Memorial Fountain* installed at the University of Texas in Austin. Courtesy Coppini Academy of Fine Arts, San Antonio.

A 1918 photograph of the *Texas Heroes Monument* by Louis Amateis. Courtesy Rosenberg Library, Galveston.

rials. Because of his unique ability to express the sentiments of the South, many refer to Pompeo Coppini as the "Sculptor of the Southern Cause."

Commemorative sculpture in the form of war memorials and portrait statues of heroes provides a visual record of the people and events that influenced Texas history. Throughout the state, inscriptions on images of bronze and stone repeat familiar and haunting tributes: "To Our Honored Dead," "Lest We Forget," "To Our Fallen Comrades." The state of Texas has approximately 175 large war memorials dedicated to the veterans of the Texas Revolution, Civil War, Spanish-American War, World Wars I and II, Korea, and Vietnam. Because many honor all Texas veterans, assigning an exact number of monuments to each cause proves difficult—a problem compounded by the tendency of communities to rededicate the monuments of one era to include the heroes of a later conflict. This survey, however, makes possible some general observations.

At least forty-five heroic outdoor sculptures memorialize the state's first veterans, the citizen soldiers of the Texas Revolution. The most spectacular work dedicated to these men and women is the *Texas Heroes Monument,* erected in Galveston in 1900 and funded through a $50,000 bequest in the will of Henry Rosenberg, one of the state's first philanthropists. The famous Italian immigrant Louis Amateis of Washington, D.C., sculpted the memorial, which depicts in relief panels the fall of the Alamo, the massacre at Goliad, the Battle of San Jacinto, and the defeated General Santa Anna standing before General Sam Houston. Life-size allegorical figures and busts of Stephen F. Austin and Sam Houston surround a tall pedestal that supports a twenty-two-foot-high bronze female figure representing Victory. This figure was proclaimed in 1900 as the second-largest bronze statue in America, the largest having been the statue of William Penn atop Philadelphia City Hall. Approximately ten thousand people, including the sculptor, the governor, and descendants of the honored heroes, gathered for the unveiling on San Jacinto Day, April 21, 1900. For more than fifty years, the *Texas Heroes Monument* remained the only large memorial to the founders of the Republic of Texas erected without any state funding. In the early 1960s, the Masonic Lodges of Texas donated heroic statues of Anson Jones and Sam Houston for the entrance to the Lorenzo de Zavala State Archives and Library. Most of the state's monuments to the heroes of the Republic of Texas are products of the cultural boom associated with the 1936 Texas Centennial.

More than fifty war memorials in Texas honor the veterans of the Civil War. The United Confederate Veterans and the United

Daughters of the Confederacy usually sponsored Civil War monuments, the most popular design being the traditional statue of a Confederate soldier who stands at parade rest on summits overlooking parks, cemeteries, and courthouse lawns throughout Texas. If modern critics complain that they are chalky, lifeless apparitions mounted on pedestals, these silent sentinels are nonetheless important as enduring reminders of the state's southern heritage. Many communities struggled for years to raise funds for a monument to their veterans, and for half a century after the collapse of the Confederacy each new memorial attracted statewide attention and extensive press coverage. The following excerpt from a news article in the July 22, 1909, issue of the *Gonzales Inquirer* indicates the importance of these monuments to the people who erected them:

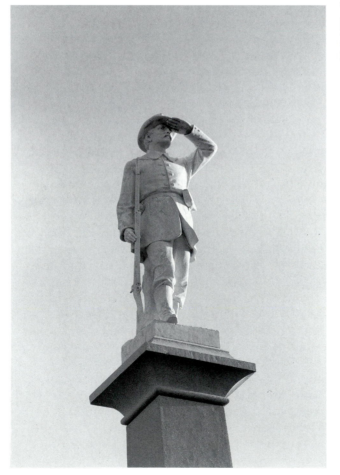

The Confederate monument by Frank Teich in Gonzales. Photo by Robert Little.

At an early hour Wednesday morning, the highways and thoroughfares were lined with people coming into town in buggies, carriages, wagons and on horseback. All the countryside came in to pay their meet of homage. In-coming excursion trains were loaded to the guards. . . . There never was before gathered such a crowd within the city limits. . . . At 11:00 the line of march was made around the principal streets in the following order: Marshal of the Day and Escorts, Mr. W. W. Johnson and his Men, bands, Confederate Veterans, Daughters of the Confederacy, Visiting Firemen, Gonzales Fire Department, Decorated Vehicles; and Citizens in Carriages. The local and visiting firemen made a fine appearance and two bands of music, one from Hallettsville and one from Shiner, rendered inspiring music throughout the day and night. At 3:00 the exercises called for the formal laying of the cornerstone. . . . Mr. J. D. Gates was then introduced, he having been the first Confederate soldier in the State to answer to roll call in 1861. Mr. Gates made a short but appropriate speech for the occasion. . . . He was escorted to the monument and assisted by Sculptor Teich and his men in laying the cornerstone. . . . After the conclusion of these impressive ceremonies the band broke into "Dixie." Hats were wildly waved, veterans gave the Rebel yell, and the long hoped for dream of the Gonzales Chapter, UDC, was realized.

Texas has two castings of the famous Spanish-American War memorial, *The Hiker.* Designed by Theodora Alice Ruggles Kitson and cast by the Gorham Manufacturing Company in Providence, Rhode Island, *The Hiker* was erected in Wichita Falls in 1921 and in Austin in 1951. The United Spanish-American War Veterans dedicated both of these monuments to their fallen comrades. The American Legion and the American Legion Auxiliary, Department of Texas, funded more than half of the state's World War I memorials, ten of which are castings of *Spirit of the American Doughboy,* created by the well-known American sculptor of World War I soldier statues, E. M. Viquesney. Frank Teich placed the first World War I memorial in Llano in 1918; Barvo Walker sculpted the most recent, a heroic bronze of two doughboys in battle dedicated in Fort Worth in 1987. Groups or individuals in the private sector sponsored all of the monuments erected specifically to the state's modern soldiers, the veterans of World War II, Korea, and Vietnam.

With the establishment of the Commission of Control for Texas Centennial Celebrations in 1935, a change occurred in the funding and subject matter of commemorative sculpture: for the first time, the founders of the Republic of Texas became the primary focus of

attention and government became the primary commissioning agent. The Forty-fourth Texas Legislature, in regular session on May 8, 1935, charged the Commission of Control with placing suitable monuments to early patriots of Texas and planning an exposition in recognition of the basic industries and their historical significance in the progress and growth of Texas (Schoen 1938). The Legislature allotted the nine-member, governor-appointed commission $3 million from the general revenue fund of the state. The commission also received a matching $3 million appropriation from the federal government and a large number of grants from public and private corporations and various state and federal agencies. When Dallas became the host city for the exposition, the Texas Centennial Exposition Corporation raised an additional $25 million to transform Fair Park into a showplace of distinctively southwestern art and architecture (Riddle 1983).

The 1936 Texas Centennial celebration added to the state's treasury of public art more than any other event in Texas history. The nation's most talented sculptors, eager for work in the aftermath of the Great Depression, competed for the opportunity to preserve in bronze and stone one hundred years of Texas progress and independence. The well-known French immigrant sculptor Raoul Josset received the largest number of Centennial commissions. In February 1936, he moved from Chicago to Dallas at the invitation of George Dahl, supervising architect for the Dallas Centennial project. Working for the Texas Centennial Exposition Corporation in a large building at Fair Park, Josset carved four colossal allegorical figures representing France, Mexico, the United States, and the Spirit of the Centennial. After completing these works, he set up a studio on Main Street in Dallas, where he created five large outdoor monuments and approximately sixteen bronze plaques for the Commission of Control for Texas Centennial Celebrations. Other renowned artists whose outdoor sculpture commemorates the people and events honored by the Centennial include John Angel, Agop Agopoff, Bryant Baker, Pierre Bourdelle, Enrico Filberto Cerracchio, Herring Coe, Pompeo Coppini, Gaetano Cecere, Leo Friedlander, Charles Keck, Bonnie McLeary, William M. McVey, Julian Muench, Attilio Piccirilli, Laurence Tenney Stevens, Waldine Amanda Tauch, Allie Victoria Tennant, Charlotte Tremper, Hugo Villa, and Sidney Waugh. Waldine Amanda Tauch, the first native Texan to create large outdoor monuments, received three commissions for centennial projects: *Moses Austin* in San Antonio, *Isaac and Frances Lipscomb Van Zandt* in Canton, and *First Shot Fired for Texas Independence* in Cost.

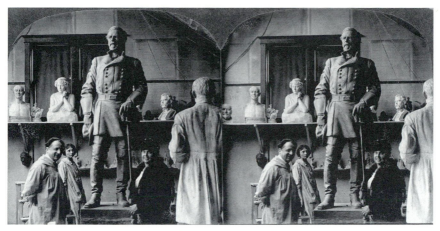

Stereograph of Pompeo Coppini, Waldine Tauch, and Elizabeth Coppini in the San Antonio studio, now headquarters for the Coppini Academy of Fine Arts. Courtesy Coppini Academy of Fine Arts, San Antonio.

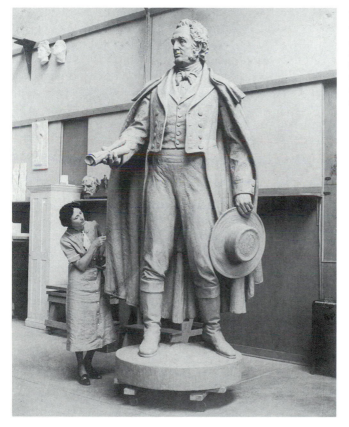

Waldine Tauch with *Moses Austin* in the San Antonio studio. Photo courtesy Coppini Academy of Fine Arts, San Antonio.

Born in Schulenburg on January 28, 1892, Waldine Tauch was the daughter of first-generation Americans whose parents emigrated from Germany. While growing up in Brady, she won her first competition with a figure carved in butter for a dairy exhibition at the county fair. Recognizing Tauch's talent, people in Brady determined that their petite hometown schoolgirl should have the opportunity to study art. Under the leadership of the Brady Tuesday Study Club, the entire community supported fund-raising activities to underwrite the cost of an education for Tauch. Meanwhile, Maggie Miller Henderson, president of the Tuesday Study Club, wrote to the man who she knew could guide Tauch's development as a professional artist—the eminent San Antonio sculptor, Pompeo Coppini. His reply was blunt: "No! Girls are not good pupils. They get married. I lose all my labor" (Hutson 1978, 21). Maggie Miller Henderson persevered, and on June 10, 1910, a large group of friends and well-wishers escorted Waldine Tauch to the depot, where she boarded a train for San Antonio. According to Tauch's biographer, as her train left Brady, "she knew if she were a success, she might never see those beautiful, loving people again; if she failed, she could never face them" (26).

Waldine Tauch did not fail. She became a devoted foster daughter to the childless couple Elizabeth and Pompeo Coppini, with whom she shared most of her life. Coppini accepted her as his protégée and eventually as his professional colleague. Tauch first realized her dream to create heroic sculpture in 1914 with a commission for the *First Inhabitant,* located at the Commerce Street Bridge in San Antonio, and she placed her last outdoor monuments, *Over the Top* in Austin and *Ernst Altgelt* in Comfort, in 1970. No other female artist has as many publicly sited placements in Texas. While the genre of her work reflects the classical training and philosophy of her mentor, Tauch's portrait statues, allegorical figures, and commemorative sculpture express an insight and sensitivity that were hers alone. Because of her meticulously thorough research and a genuine interest in her subjects, many consider Tauch's portraits among her best creations. In 1969, she sculpted *General Douglas MacArthur* for the Academy of Freedom on the campus of Howard Payne University, where she held an honorary doctor of fine arts degree. Tauch often expressed the opinion that this heroic statue of MacArthur striding ashore at Leyte on his return to the Philippines was her masterpiece.

Throughout a career spanning almost six decades, Waldine Tauch promoted classical fine arts in Texas. From 1943 to 1945, she served as an associate professor at Trinity University, where she cofounded

Waldine Tauch between allegorical figures of Fame and History, created by the artist for *First Shot Fired for Texas Independence,* installed in the community of Cost near Gonzales. Photo by De Witt Ward. Courtesy Coppini Academy of Fine Arts, San Antonio.

the Classic Arts Fraternity. As a member of the art committee at the Panhandle-Plains Historical Museum, in Canyon, she used her influence to steer exhibits and accessions away from abstract work and toward representational art (Hutson 1978, xviii). She also worked tirelessly to train and promote talented Texas artists through her position as associate professor and sponsor of the Coppini Academy of Fine Arts in San Antonio, and in 1966 that city

17

appointed her to its first Fine Arts Commission. In the spring of 1969, the Texas Senate passed a resolution expressing the state's appreciation for her sculptures of famous Texans and recognizing her as an eminent American artist and patriot. In addition to innumerable citations and honors as a Texas artist, Tauch was a fellow in the National Sculpture Society and in the American Academy of Arts and Letters. Her work can be seen in Kentucky, Virginia, Indiana, Massachusetts, Oklahoma, New York, and New Jersey. When she won the commission for the *Indiana War Memorial* in 1926, she attained distinction as the first American woman to design and create a monumental war memorial (59).

During the first three decades following the turn of the century, Texas produced several native sons and daughters who became nationally recognized professional sculptors. Writing in 1928, Frances Battaile Fisk noted, "The number of native sculptors with virile and imaginative minds are increasing, practicing their art in the studios of Texas and large art centers, and they will certainly produce something of value that will be a distinct addition to the country's sum total of artistic wealth." Fisk's prediction proved accurate; however, with regard to the creation of figurative outdoor sculpture and a commitment to fine arts in Texas, no artist in the first generation of native Texas sculptors surpassed the career of Waldine Tauch. Unlike most of her colleagues, Tauch remained a permanent resident of Texas, except for brief periods when she moved with Pompeo and Elizabeth Coppini to Chicago and New York. Her determined pursuit of artistic excellence and professional recognition is an inspiring legacy to future Texas artists. During an interview in 1963, she reflected on her career: "I have had a wonderful life. I would not change anything. It is not the privilege of many people to have fulfilled an ambition such as I have. I hope that my works will be an inspiration to those who see them as they have been for me in creating them" (Doyle 1963). Waldine Tauch died in San Antonio in 1986.

As the work of the Commission of Control drew to a close with the erection of the last Texas Centennial monuments in 1939, ominous clouds of war darkened the Texas horizon. In the ensuing storm, 750,000 Texans served in the United States Armed Forces and auxiliary services (Kingston 1985). With all the nation's resources directed toward survival, almost no interest in public art existed during World War II. One of the first important postwar placements is *Riding into the Sunset,* a portrait of Will Rogers on his favorite horse, Soapsuds, created by native Texan Electra Waggoner Biggs and installed at Will Rogers Memorial Coliseum in

1947. Though Biggs is best known in Texas for this equestrian statue, her commissions include portraits of Bob Hope, Harry S. Truman, Dwight D. Eisenhower, Jacqueline Onassis, Mary Martin, Knute Rockne, and many others. In 1948, the famed equine sculptor Alexander Phimister Proctor erected one of his two Texas works, *The Mustangs,* at the entrance to Texas Memorial Museum. This monument to the spirited mustangs of Texas had remained in the Gorham Manufacturing Company's foundry for almost ten years because metals critical to the casting process were unavailable during and immediately after the war.

The most prolific sculptor of outdoor works in Texas moved to Austin from Chicago in 1941 to join the faculty at the University of Texas. At the time, the newly established College of Fine Arts had only nine members (Barac 1987). When Charles Umlauf retired as professor emeritus forty years later, the number of his colleagues had multiplied, and the departments of art, drama, and music had expanded into a fine arts complex equivalent to a small campus, with the hub of operations located in a $44 million performing arts center. Charles Umlauf brought a new dimension to outdoor sculpture in Texas. Instead of creating monuments to the heroes, events, and legends associated with the Southwest, he employed a variety of subjects, techniques, and media to express an idea or conviction. The classical goddesses of arts and sciences are personified in his bronze figures of the Grecian Muses installed at Centennial Park in Austin. *Hope for the Future* at Abilene Christian University and *Hope of Humanity* in Houston's Hermann Park portray the family unit as a basic component of society. *Symbol of Education* in the courtyard of the Texas State Teachers Association office in Austin represents the bud of knowledge nurtured into bloom through education, and *Torchbearers* on the University of Texas campus in Austin inspires the notion that knowledge, symbolized by the torch of enlightenment, is developed and sustained through the exchange of ideas. Umlauf also is well known for his ability to translate spiritual beliefs into physical form. Examples of his religious sculpture are located in Waco, Austin, Houston, Lubbock, Helotes, Hillsboro, and San Antonio.

In addition to his personal legacy of sculpture and drawings, Umlauf influenced the development of art in Texas through his career as a teacher. While training young artists in the areas of technique and craftsmanship, he also shared his philosophy concerning authentic artistic expression. His students are heirs to his conviction that all great art springs from sincere belief rather than from commercialism. By age ten Umlauf was committed to

becoming a professional artist, an ambition that required many sacrifices, both personal and monetary. Reminiscent of the experience of Waldine Tauch, early in his career he traveled to state fairs where he displayed small figures carved from lard, a by-product of the meat sold by his employer, the National Livestock and Meat Board. Today, his work appears in prestigious public and private collections, and his exhibitions include showings throughout the United States and in Spain, Belgium, England, Italy, Canada, Germany, Austria, Australia, and South America. In 1985, Charles and Angeline Umlauf donated their home, studio, and more than 250 pieces of sculpture to the city of Austin as a public park and museum. Although the couple retained a life estate on their private residence, the nearby Umlauf Sculpture Garden and Museum is open to the public. Charles Umlauf died in 1994.

At the midpoint of the twentieth century, figurative sculpture remained the predominant style of outdoor art in Texas. Most works placed during the 1950s were animal figures or naturalistic representations of the human form created by resident artists, such as Waldine Tauch, Lincoln Borglum, Ira Correll, Louis Rodriguez, Pompeo Coppini, and Electra Waggoner Biggs. Texans David Cargill and Pat Foley placed their first outdoor commissions during the 1950s, and like their predecessors, they created representational works in the traditional medium of cast bronze. However, Cargill and Foley have expanded their genre to include stylized interpretations of their subjects. David Cargill works in a variety of media, including wood, stone, marble, terra-cotta, and galvanized steel. His *Ring around the Roses* (1956) and *Last Supper* (1958) demonstrate his range of expression from whimsical "little people" to lofty and inspiring religious pieces. Created and cast at his studio foundry in Beaumont, Cargill's bronze figures are well known for their uplifting, optimistic quality. Pat Foley's publicly sited sculptures often involve a thematic relationship between the subject and its surroundings. For example, *Prometheus Unbound* stands near the entrance to Houston's Institute for Rehabilitation and Research; broken chains on the wrists and feet of the body of the statue serve as an inspiration to handicapped citizens who struggle to free themselves of their disability through medical rehabilitation. His bronze statues on the campus of the Kinkaid School, where he serves as artist-in-residence, capture the delight and spontaneity of schoolchildren at play. By the close of the 1950s, a number of Texas artists were experimenting with the new tools, materials, and nonobjective forms associated with modern sculpture, as Carroll Simms designed his first bronze abstracts, Jim Love experimented

with found objects, and Charles Truett Williams began incorporating abstract metal sculptures into his popular fountain designs. An important note, however, is that only after 1960 did Simms, Love, and Williams place their abstract works in public spaces.

The 1960s mark the beginning of phenomenal growth and diversity in public art—particularly outdoor sculpture—in Texas. At the fifth biennial Texas Sculpture Symposium, held in Dallas in 1985, a representative with the federal government's Art in Public Places Program observed, "We are all enjoying a resurgence of public art that began in the 1960s. Our options are now unlimited—it's everything from manhole covers to environments to objects" (*Dallas Morning News,* March 25, 1985). To study the placement of outdoor sculpture after 1960 is to discover that while several factors brought about the current state of the art of sculpture in Texas, three trends were particularly significant: a dramatic increase in the number of placements, the advent of corporate art, and the emergence of modern sculpture.

Between 1960 and 1980, objects of bronze and steel seemed to spread like kudzu over the state's wide-open spaces as new placements of outdoor sculpture surpassed the total number of publicly sited works previously erected in Texas. The primary factor influencing this period of phenomenal growth in public art was a corresponding period of sustained economic growth. A prosperous economy enabled cities, museums, universities, and private businesses to spend more money on the cultural arts. The number of Texas museums increased from approximately 200, as estimated in 1976 by the *Handbook of Texas,* to more than 600 in 1980, according to the *Texas Museum Directory* compiled by the Texas Historical Commission. While the number of new museums continued to grow, the increase slowed with the economy after the mid-1980s; as of May 1994, 791 Texas museums appeared on the official computer listing maintained by the Local History Programs office at the Texas Historical Commission.

A number of Texas cities responded to the growing interest in art and culture by developing civic art programs with official guidelines, policies, and procedures relating to the acquisition and placement of public art. For example, as early as 1964, the city of Houston organized the Houston Municipal Art Commission, an eighteen-member body appointed by the mayor "to insure the citizens of Houston that publicly-owned works of art meet high standards of artistic excellence and represent a range of tastes, styles, and forms consistent with the diversity of our people and their interests" (Office of the Mayor 1984). This type of grassroots involvement in the arts was

one of the most beneficial legacies of the renewed interest in outdoor sculpture that began around 1960. Yet, most Texas cities were slow to react to the changing landscape, and therefore, too many placements were installed in public spaces without community involvement and without provisions for ongoing care and maintenance. Furthermore, as new placements multiplied, aging statues and monuments suffered the effects of neglect, pollution, and vandalism.

Preservation of publicly sited sculpture is seldom addressed in municipal budgets; nevertheless, local taxpayers often by necessity unwittingly become the custodians of artwork. An abandoned sculpture placed in public view is either adopted by the public or doomed to unsightly gradual decay. One innovative effort to intervene in this process is Adopt-A-Monument, launched in Dallas in 1988 through a partnership between community volunteers and the Office of Cultural Affairs. The city provided a comprehensive survey and condition assessment of city-owned works of art, and a professional conservator hired by the city recommended appropriate conservation strategies and a cost analysis for the repair and maintenance of each work. Based on the city's study, Adopt-A-Monument enlists sponsors from the private sector to adopt a sculpture and underwrite the cost of its conservation. This approach to preservation has spread to other Texas cities, along with new municipal policies that require donors of public art to commit a sum equal to 10 percent of the work's value toward a permanent conservation trust fund. In addition to these local initiatives, the most extensive program designed to preserve the state's sculptures and monuments is Save Outdoor Sculpture! (SOS!), a nationwide project sponsored by the National Museum of American Art (Smithsonian Institution) and the National Institute for the Conservation of Cultural Property. This ambitious program began in Texas in 1993 with the goal of surveying every county to identify sculptures at risk. More than 750 volunteers participated in Texas SOS!, which not only assessed the condition of endangered monuments across the state but also helped local communities become better stewards of their public art. The second phase of SOS! began in 1994 with SOS! Incentive Awards, which provide grants to help qualifying communities pay for professional condition assessments and public awareness projects.

For modern Texas cities, the obligatory Henry Moore or Alexander Calder sculpture in front of City Hall has become a measure of civic pride, much like the Confederate soldier statue on the courthouse lawn in an earlier generation. Yet, along with the

increased popularity of outdoor sculpture, increased concern exists over the maintenance, acquisition, and appropriateness of public art. To ignore or bypass these concerns is to invite trouble. A case in point is the fate of the twenty-foot-tall metal abstract *Night Winds,* formerly located at a busy intersection adjacent to the Longview campus of Kilgore College. Erected in 1981 without community involvement, the sculpture was not welcomed by the viewing public, and in fact was the object of numerous letters to the local newspaper editor in which Longview residents vented their disapproval. Taxpayers complained that their hard-earned tax dollars were wasted, and one former member of the city council suggested that the sculpture represented "a perfect example of communist policy to erect ugly and meaningless objects instead of artworks of beauty and inspiration" (*Dallas Morning News,* March 8, 1986). In 1986, a group of Kilgore College workers under the authority of the college administration cut the sculpture off at ground level, loaded *Night Winds* onto a dump truck, and hauled it away. The furor over this act sparked protest marches, statewide media coverage—and more letters to the editor. The *Night Winds* story typifies the frustration felt by citizens who feel bypassed in decisions regarding publicly sited art, particularly outdoor sculpture, and this frustration extends to Texas artists themselves. Although traditionally preferring to work independently, some Texas artists united during the 1980s to form professional organizations, such as the Texas Sculpture Association (TSA) and Dallas Artists Research and Exhibition (DARE). These types of groups not only address issues of importance to Texas artists but also offer valuable professional insight regarding media selection, site preparation, and construction techniques appropriate for a particular environment.

The economic conditions that led to the boom in outdoor sculpture in Texas during the 1960s, 1970s, and early 1980s also precipitated the advent of corporate art. Before 1960, patriotic organizations and local monument committees sponsored most publicly sited sculpture in Texas, Centennial commissions excepted. Since 1960, corporations and real estate developers have purchased most of the state's outdoor sculpture through art consultants or professional agents. This change in the source and manner of funding occurred because many successful Texas companies used a portion of their profits to purchase art. These corporate art collectors discovered that outdoor sculpture not only energized the working environment but also crystallized their corporate image and attracted people to their banks, shopping malls, housing developments, and multiuse facilities. One of the earliest examples of corporate art in Texas is *The*

Texas Sculpture by Isamu Noguchi at NationsBank in Fort Worth. Installed in 1961 at what was then the First National Bank building, *The Texas Sculpture* epitomizes corporate art by promoting the desired image of the company. A brochure introducing the work to the community noted, "Noguchi hopes that his sculpture, by its great solidity, is symbolic of the solidity of The First National Bank, and that the strength and durability of the granite will also make people think of the bank. The sculpture is 'on the square and in balance'" (Interfirst Bank 1961).

Dallas-based developer Trammell Crow began purchasing art for public spaces in the 1950s, and today his company is the single largest provider of publicly sited outdoor sculpture in Texas. The Crow family and the Trammell Crow Company have placed an impressive number of works in cities throughout Texas. One of the most spectacular examples of corporate art in the nation is the Trammell Crow Center Sculpture Collection installed in the plazas and walkways surrounding the international headquarters of the Trammell Crow Company. Harlan Crow and Michael Le Marchant, of the Bruton Gallery in England, assembled the collection, which includes monumental figurative works by Auguste Rodin, Emile Bourdelle, Aristide Maillol, and other world-renowned twentieth-century French figurative artists. Located in the heart of the Dallas Arts District, the Trammell Crow Center Sculpture Collection demonstrates the company's longtime commitment to the placement of public art in an urban environment.

A relatively new trend in corporate art is the placement of outdoor sculpture in a planned-community development. When Jane Mathes Kelton, chairman of the board of Kelton-Mathes Development Corporation, planned The Highlands of Arlington business community, she envisioned a mixture of commercial architecture and public art. Sculptor Norman Patrick Hines participated in the design process from the beginning, and his 5.5-acre environmental sculpture *Caelum Moor* is the signature and centerpiece of The Highlands of Arlington commercial development, which opened in 1986. According to Kelton, "We are making a strong statement that art should be integrated into the inception of a development as part of the planning process—not added later, as a tacked-on amenity" (Kelton-Mathes 1986).

An understanding of the close association among art, architecture, and landscape design also influenced Ben H. Carpenter, chairman of the board of the Southland Financial Corporation, when he proposed guidelines for Las Colinas, a planned community in Irving, between Dallas and Fort Worth. Carpenter chose Robert Glen, an

internationally recognized sculptor of wildlife, to design a sculptural group that would serve as a focal point of the new urban center; then, realizing the installation required site planning and open-space design, he contacted the SWA Group, specialists in landscape architecture. The result was a prearchitectural master plan by project designer Jim Reeves and project architect Dan Mock. Their design philosophy was to create an appropriate environment for Glen's sculpture, at the same time responding to the parklike quality of a nearby lake and the urban quality of the multistoried towers that eventually would surround the sculpture. After seven and a half years of cooperation between client, sculptor, landscape architects, and contractors, *The Mustangs of Las Colinas* was unveiled in 1984 in Williams Square. *The Mustangs* depicts nine larger-than-life wild horses galloping across a man-made stream that zigzags through the terraced walkways and fountains of Williams Square, a 200-by-300-foot granite abstraction of a prairie. Glen's *Mustangs* is one of the most popular sculptural attractions in the nation and one of the largest equine sculptures in the world. The artist modeled the figures in Nairobi, Kenya, then shipped them to England for casting. A native of South Africa, Glen has spent much of his time in the African wilderness studying the animals he portrays. Seventeen of his works are on permanent display in the Royal Museum of Toronto, Canada, and many others appear in private collections. At other locations in Las Colinas, visitors can see outdoor placements by numerous artists, including Texans Sandi Stein, Harold Clayton, Ben Woitena, Jerry Dane Sanders, John Brough Miller, and Jesús Bautista Moroles.

One of the largest corporate outdoor collections in Texas is the Texas Walk, installed in 1988 at Sea World of Texas in San Antonio. The Texas Walk includes life-size portraits of fifteen outstanding Texans who represent a cross-section of men and women from different historical periods and fields of endeavor. Five nationally recognized figurative sculptors provided statues for the Texas Walk; all are native Texans or longtime residents of the state. Lawrence M. "Larry" Ludtke of Houston modeled six of the portraits. As one of the state's best-known portrait and figurative sculptors, Ludtke has work installed at Rice University, Texas A&M University, Johns Hopkins Medical School, the United States Air Force Academy, the Lyndon Baines Johnson Library in Austin, the Freedoms Foundation of Valley Forge, and the Portrait Gallery of the National Cowboy Hall of Fame. His most recent monumental installation is the Maryland Civil War Memorial erected in 1994 at Gettysburg National Battlefield Park. The two eight-foot figures honor the men

from Maryland who fought at the Battle of Gettysburg for the Union and the Confederacy. Ludtke is a fellow in the National Sculpture Society, a member of the Coppini Academy of Fine Arts, and a corresponding member of the Royal Academy of British Sculptors.

Glenna Goodacre has five works installed in the Texas Walk at Sea World. A native of Lubbock, she now lives and works in Santa Fe, New Mexico. Goodacre describes herself as a figurative artist who is a portrayer of people. The accuracy of her self-description is demonstrated in her works at Sea World and in her most recent Texas placement, *Philosophers' Rock*, installed in 1994 at Zilker Park in Austin. *Philosophers' Rock* depicts three famous Texas scholars, J. Frank Dobie, Walter Prescott Webb, and Roy Bedichek, engaged in an animated conversation near the shores of Barton Springs Pool. Goodacre's bronze sculptures are installed throughout the United States and in Brazil, England, Italy, Canada, and Mexico. Her most famous commission is her *Vietnam Women's Memorial*, placed in 1993 on the National Mall in Washington, D.C. A fellow of the National Sculpture Society, Goodacre has received many awards, including the Gold Medal for Sculpture from the National Academy of Design and numerous honors with the National Sculpture Society, Allied Artists of America, and the National Academy of Western Art. In 1993, she received the Knickerbocker Artists' Gold Medal for Distinguished Achievement in American Art.

The Texas Walk also includes works by Texans Juan Dell, Elizabeth Hart, and Armando Hinojosa. Operating from her studio near Santa Fe, Juan Dell is recognized as an artist of the Southwest through her oil paintings and portrait sculptures. Dallas artist Elizabeth Hart, nationally recognized for her portrait sculpture, created her first outdoor placement for the Texas Walk. Hart's bronze of Senator Margaret Chase Smith is in the collection of the National Portrait Gallery of the Smithsonian Institution. Armando Hinojosa lives in his hometown of Laredo, where he preserves the wildlife and beauty of Texas in his bronze sculptures and watercolor paintings. His work has been privately collected by President Richard Nixon and Texas governors William P. Clements, Dolph Briscoe, and Allan Shivers. In recognition of his contribution to Texas art, the Texas State Legislature named Hinojosa the Official State Artist of Texas for 1982–1983.

While corporate art greatly enriches the cultural climate of Texas, it is by no means the sole provider of publicly sited sculpture. City arts councils, chambers of commerce, county historical societies, and other local organizations sponsor public sculpture, often through fund-raising projects and grants from state and federal

agencies, such as the Texas Commission on the Arts and the National Endowment for the Arts. Moreover, individual donors and private foundations are the primary contributors to the state's most prestigious outdoor sculpture collections, including the Dallas Museum of Art Sculpture Garden, the Marion Koogler McNay Art Museum Sculpture Garden in San Antonio, the Elizabeth Meadows Sculpture Garden in Dallas, the Old Jail Art Center Sculpture Garden in Albany, and the Lillie and Hugh Roy Cullen Sculpture Garden at the Museum of Fine Arts, Houston. One of the most generous providers of outdoor sculpture in Texas is the Meadows Foundation, which has placed works at museums and art centers in Waco, Dallas, Denton, Beeville, Albany, McAllen, Odessa, and San Angelo. One other source of funds for outdoor sculpture is a growing trend to set aside a percentage of new construction costs for the acquisition of art. The University of Houston adopted this policy in 1966, and the results are evident in that institution's outstanding sculpture collection. Another pioneer in this area is The Woodlands, a planned-community development in Montgomery County. Using an art fund that derives its revenues from a small percentage fee (0.0025%) applied to the estimated cost of improvements and developments on commercial land, The Woodlands Corporation has acquired what is believed to be the largest collection of outdoor sculpture of any comparably sized community in the nation.

Before 1960, outdoor sculpture in Texas generally was comprehensible to most Texans. Monuments and sculptures set in public spaces pertained to people, events, and ideas that Texans recognized; avant-garde art remained the province of museums, private collectors, and university studies. In his definitive anthology, *Sculpture in America,* Professor Wayne Craven notes that after World War II American sculpture seemed to move irresistibly toward abstract and nonobjective forms. This trend became evident in Texas during the 1960s when, in addition to portrait, allegorical, and equestrian statues made of stone and bronze, Texans became aware of nonrepresentational designs fashioned from plastic, sheet metal, I beams, and automobile parts. On the development of American sculpture, Craven writes, "Traditional means, like traditional styles, were no longer useful to the sculptors seeking an art that was truly of the 20th century. . . . Men turned to materials . . . [that] seemed to possess an affinity with modern life" (Craven 1984, 616). So it was in Texas. Monumental contemporary sculpture seemed compatible with the energy, industry, and modern architecture of an increasingly urban state.

The term "modern art" generally refers to the revolutionary

styles of artistic expression that originated among young European artists during the first decade of the twentieth century. The new concepts associated with the modern-art movement began to influence American sculpture after World War II, as many talented European artists immigrated to the United States and large numbers of young American artists traveled and studied abroad. The postwar years also initiated an era of rapid growth in the number of new American museums and university-level art departments. Gradually, through the exchange of ideas, Americans became increasingly involved with the new forms, techniques, and materials of modern art. For the first time, sculptors shifted their attention away from representations of the human figure and concentrated instead on abstractions and geometric shapes. Likewise, the laborious and time-consuming processes of carving, modeling, and casting gave way to new techniques related to modern machinery and materials. Electric drills, blowtorches, power saws, giant cranes, and even bulldozers replaced the hammer and chisel, while glass, plastic, aluminum, welded steel, and salvaged machine parts replaced clay, stone, and bronze. When modern outdoor sculpture appeared in Texas during the early 1960s, it permanently altered the visual environment. For Texans in the 1990s, Pop Art, Junk Art, found objects, organic forms, kinetic sculptures, abstractions, and environmentals—all made in every conceivable size and medium— are part of the everyday experience. The international character of modern sculpture is reflected in Texas placements by Henry Moore, Tony Smith, Joan Miró, Alexander Calder, Barbara Hepworth, Alberto Giacometti, Claus Oldenburg, and other of the world's most respected artists. Furthermore, the excitement and diversity of modern art is represented in outdoor placements by talented Texas artists.

The late Charles Truett Williams in many ways exemplifies the first group of Texans who placed contemporary designs in public places. As with most modern sculptors, Williams studied fine arts in a university setting, earning both bachelor's and master's degrees from Texas Christian University. *Mother Earth,* on the campus of the University of North Texas in Denton, is typical of his large abstracts that suggest organic or natural forms. His use of the found object is evident in smaller works, such as *Picnic,* installed in the sculpture garden at the Old Jail Art Center in Albany. Working in wood, stone, cast bronze, cast iron, welded copper, steel, and other media, Williams observed, "Almost any material can be converted to the sculptor's purpose" (Coates 1964).

Another early convert to the tenets of modern art is Houston

sculptor Carroll Simms. Since joining the faculty at Texas Southern University in 1950, he has received a master of fine arts degree from Cranbrook Academy of Art in Michigan and a Fulbright fellowship to study sculpture and ceramics in London. An authority on the primitive sculpture of West Africa, he holds an associate life membership with the International Institute of African Studies at the University of Ibadan in Nigeria. His large symbolic abstracts are located primarily in the Houston area.

Also at the forefront of the modern-art movement in Texas is native Texan Jim Love, who experimented with new art forms and techniques before graduating from Baylor University in 1952. Love's found-object assemblages are made from old machine parts, plumbing fixtures, and junkyard scrap metal. For example, *Paul Bunyan Bouquet No. 2,* created in 1968 and installed on the Rice University campus in Houston, is assembled from discarded railroad equipment. The individual objects forming the sculpture are still recognizable, yet they combine to take on a new identity—a giant's bouquet of flowers. *Jack,* located on the campus of the University of Texas at Dallas in Richardson, is reminiscent of the Pop Art era, in which familiar objects were inflated to gigantic proportions.

One other important artist whose abstract creations first appeared in Texas during the 1960s is Bob Fowler. A native of Houston, Fowler graduated with a degree in fine arts from the University of Notre Dame in 1954 and became a full-time sculptor in 1963. Four years later, the *London Financial Times* named his five-piece installation at a factory in Scotland the best business-architecture project in the world. One of his most popular Texas placements is *African Elephant,* located at the entrance to the Houston Zoological Gardens. This giant pachyderm is formed by a network of welded-steel muscles and tendons, a technique used in several of the artist's more realistic sculptures, including his compelling untitled piece in the C. Frank Webber Plaza at the Texas Medical Center in Houston. Primarily an architectural sculptor, Fowler designs mostly welded-steel abstracts for a particular space related to a building.

During the 1970s, Texans David Deming and Ben Woitena began placing monumental welded-steel abstracts in urban settings surrounded by towering office buildings and sprawling commercial developments. As are many modern sculptors, both Deming and Woitena are directly involved in the fabrication of their work. Deming's roots in the industrial city of Cleveland, Ohio, and his early experience working in a manufacturing company helped to mold his concept of the builder-sculptor. He notes, "Metal became a material that I could move around like clay. I'm positive that this

industrial influence is a very strong part of my work" (Smith 1983). *Mystic Raven,* a twenty-two-foot-high painted steel abstract on the grounds of the Austin Museum of Art at Laguna Gloria, involves Deming's tripod motif, a recurring theme in his outdoor placements. A graduate of the Cleveland Institute of Art and Cranbrook Academy of Art, Deming chairs the Department of Art and Art History at the University of Texas at Austin. Whereas the sculpture of David Deming has a technical or mechanical physicality, Ben Woitena's monumental abstracts have a delicate quality reminiscent of Victorian brackets and zigzagged latticework. A graduate of the University of Texas at Austin, Woitena earned a master of fine arts degree at the University of California at Los Angeles before returning to Texas to make his home in Houston. His popular sculptures convey a fascinating incongruity, with huge I beams and steel bars welded into lacy filigree and sometimes painted in subtle hues.

Color is important in the work of Midlothian resident Mac Whitney, who also began placing large geometric abstracts during the 1970s. Instead of polychromy, Whitney chooses bright red for most of his outdoor placements. Frequently named for Texas towns, his metal-plate sculptures involve wavy or sawtooth edges reminiscent of cutouts made with the pinking shears of a seamstress.

John Brough Miller moved from Michigan to Texas during the 1960s to teach art at Texas Woman's University, where he later served as chairman of the Department of Art. In the 1980s, Miller began placing his monochromatic welded-steel fabrications in group and solo exhibitions, and by the end of the decade he had provided more than a dozen placements in cities across Texas. With the circle as his central motif, Miller often creates an illusion of motion. It has been said that his sculptures cut through space like guns on a battleship. In contrast to the power and massiveness of Miller's sculpture are the delicate, lyrical compositions of Texan Jerry Dane Sanders, who also began placing monumental abstracts during the 1980s. Using the reflective quality of stainless steel, Sanders creates towering, angular forms that glisten above busy intersections and serve as signposts marking banks, office buildings, and corporate headquarters.

At the outset of the modern-art movement in Europe, direct carving in wood and stone gained popularity among sculptors who preferred to carve, chisel, and finish their own works without the assistance of artisans or foundry technicians. This involvement in the total creative process inspired two native Texans who developed successful careers during the 1980s. James Surls and Jesús Bautista Moroles are among the state's most popular contemporary artists,

and their work reflects their appreciation for the unique qualities of their chosen media.

Surls' attachment to the Piney Woods section of the state is evident in his use of pine, oak, and other natural products gathered from the forests and farmland near his home in East Texas. Most of his creations involve spiny appendages (or, according to Surls, "stickers") that protrude from an inner core of steel. *Pine Flower,* on the grounds of Buford Television, Inc., in Tyler, and *Brazos Flower,* at the Brazos Center in Bryan, are examples of this design. *Pine Flower* is a commissioned, site-specific work; although it often is compared to a giant sea urchin, East Texans see it as a fallen pine-cone at home in the natural landscape that surrounds the television complex. *Brazos Flower* connotes the beautiful wildflowers and timberlands that border the banks of the state's third-largest river. Its pinwheel-like petals also are reminiscent of the old windmills scattered throughout the five physiographic regions traversed by the Brazos River's 840-mile course. *Pine Flower* and *Brazos Flower* are typical of Surls' carved objects in that they are reflections of nature, altered in form but not in essence. While Surls' work is closely linked to a rural upbringing and life-style, his sculptures are pur-chased and exhibited by metropolitan museums in New York, Florida, Michigan, Louisiana, Illinois, Colorado, California, Pennsyl-vania, Washington, D.C., and throughout Texas.

Jesús Bautista Moroles has received international recognition for his carved granite columns and stelae. After graduating with a degree in fine arts from the University of North Texas in Denton, Moroles spent a year in the famous Italian town of Pietrasanta, where he became intrigued by the idea of adapting modern tools to the ancient art of stone carving. Although the logistics of carving large blocks of granite require assistants, Moroles is involved in every step of the creative process at his studio in Rockport. His columnar designs are installed in public settings throughout Texas and in other states, including Iowa, Florida, Colorado, Alabama, California, New York, and New Mexico. His largest placement to date is the *Houston Police Officers Memorial* dedicated in November 1992. Moroles works primarily in pink Texas granite and gray Georgia granite, often combining the natural roughness of broken stone with highly pol-ished surfaces to suggest a relationship between the natural environ-ment and human technology. By eliminating the pedestal or making the base part of the sculpture, his massive granite forms are reminis-cent of ancient monuments. Digital-looking carvings, or modern hieroglyphics, etched on his stelae imbue Moroles' sculptures with a sense of permanence and antiquity.

31

During the late 1970s and early 1980s, another form of modern art with roots in the ancient past began to appear in Texas with the installation of earthworks, or environmental sculptures. Always created with a particular site in mind, these sculptures incorporate the natural environment as an intrinsic part of the design. Examples of these types of works are *Wind Wedge* by Larry Bell in Abilene, *Time Span* by Nancy Holt in Austin, and *Interior Exterior Place* by Clyde Connell, also in Austin. Located near Amarillo are *Cadillac Ranch* by the Ant Farm, *Floating Mesa* by Andrew Leicester, and *Amarillo Ramp* by Nancy Holt and her late husband Robert Smithson, who died in an airplane crash while making an aerial survey of the installation site. *Cadillac Ranch* and *Floating Mesa* are easily viewed by passing motorists, but *Amarillo Ramp* is on private property and not accessible to the public. In the 1990s, site-specific installations by young Texas artists began to blend local history, architecture, and archeology with the arts of stone carving and landscape design. In 1994, Brad Goldberg incorporated a Dallas landmark, the Magnolia Building's *Flying Red Horse,* into his design for Pegasus Plaza, an open space between several downtown Dallas skyscrapers. A series of limestone water sculptures and granite boulders carry out the mythological theme. Bald cypress, willow trees, and other plantings soften the plaza, while the sound of water flows from the water sculptures, which are connected to a natural mineral spring 1,600 feet below the site. A blending of art, nature, and architecture also is an important component of Sandi Stein's 1990 installation at the Bexar County Justice Center in San Antonio. In a sunken courtyard that approximates the depth of the city in the 1850s, Sandi Stein used carved limestone stelae and horizontal bands of carved green slate moldings to underscore a connection between modern architecture, archeology, and the city's historical underground aqueducts.

The modern-art movement changed the cultural landscape in Texas after 1960, but it did not replace representational art or render it obsolete. In fact, this survey indicates that since 1980, more than 60 percent of the major placements have been figurative works; the comparable figure in the 1970s was only 40 percent. Opinions often differ with regard to the merits of modern-art forms versus traditional figurative sculpture, and since the appreciation of art is ultimately an individual response, it is inevitable that public art will get mixed reviews. For example, when Dallas launched a master plan for public artworks in 1986, the project's director encouraged conservative Dallasites to broaden their concept of public art, expressing the hope that "we will come to a more expansive concept

so we are not limited to the notion that public art is an equestrian statue with a hero on its back" (*Dallas Morning News,* August 18, 1986). Nevertheless, one year later, an informal poll sponsored by the *Dallas Morning News* revealed that the most popular publicly sited sculpture in the metroplex was Robert Glen's *Mustangs of Las Colinas,* followed by Alexander Phimister Proctor's double equestrian statue of General Robert E. Lee and his aide-de-camp at Lee Park. Bill Marvel, staff writer for the *News,* noted that even after abstraction, Pop Art, and minimalism, many Texans still prefer the statue of a horse.

Texas celebrates the mythic vision of the Old West with monuments to lawmen, cowboys, Indians, pioneers, and trail drivers, along with statues of mustangs, buffalo, and longhorn cattle. These monumental images capture the frontier experience and symbolize for modern Texans their Western heritage. Since 1960, a number of nationally recognized Western artists, including Jim Reno, Juan Dell, Grant Speed, Tom Warren, Robert Summers, Glenna Goodacre, and Veryl Goodnight, have placed outdoor sculpture in Texas. The Cowboy Artists of America Museum, which opened in Kerrville in 1983, features outdoor sculpture by Fritz White and William Moyers and paintings by the nation's premier artists of Western American Realism. Two native Texans who portray Texas myths from their own perspectives are Luis Jimenez and Bob Wade. Characterizing his style, Jimenez says, "I feel I am a traditional artist working with images and materials that are of 'my' time" (Carlozzi 1986, 53). Generally considered the nation's leading Hispanic sculptor, Jimenez creates large, colorful fiberglass figures. *Vaquero,* located in Houston's Moody Park, calls attention to the Mexican origins of the state's first cowboys, as opposed to the Anglo-American heroes of Hollywood films. *Plaza de los Lagartos* in Jimenez' hometown of El Paso recreates a scene from the artist's boyhood, when he watched live alligators at San Jacinto Plaza while on shopping trips with his mother and grandmother. Bob Wade, on the other hand, takes a more humorous, tongue-in-cheek look at Texas mythology. Often described as neo-Western, his monumental sculptures emphasize the perverse side of Texas humor by commemorating cowboy boots, truck stops, giant armadillos, and roadside snake farms. In addition to Wade and his *Biggest Cowboy Boots in the World,* other artists have provided Texas with the world's largest pecan, peanut, watermelon, strawberry, jackrabbit, roadrunner, and rattlesnake.

Traditionally, Texas artists have found inspiration in the state's untamed natural environment, particularly its wildlife. During the

1980s, wildlife sculptors Bob Guelich of San Antonio and Kent Ullberg of Corpus Christi gained recognition for their bronze animal figures. Bob Guelich is best known for his accurate portrayal of waterfowl in flight, and Kent Ullberg is famous for capturing the graceful beauty of fish and fowl native to the Texas coast. In 1981, Ullberg's *Eagle Rock Monument* received a gold medal from the National Academy of Western Art, and in 1983, his *Wind in the Sails* received a gold medal from the National Sculpture Society. In 1990, he became one of the few wildlife artists elected to the status of full academician in the National Academy of Design in New York City. Ullberg's sculptures are installed throughout the United States and in other countries, including France, China, Sweden, Africa, Mexico, Luxembourg, and Venezuela.

Finally, a comprehensive study of outdoor sculpture in Texas is incomplete without special attention to the state's publicly sited liturgical art. Outdoor sculpture in Texas began with the first inhabitants, Native Americans whose carved objects in wood and stone gave tangible form to their religious rites and rituals. With the arrival of the Franciscan missionaries and the development of the mission system in Texas, liturgical paintings and carvings became the predominant form of artistic expression encouraged and supported by the Catholic church and the Spanish crown. Unfortunately, outdoor sculpture from the Spanish colonial period survives only in the form of architectural embellishments and decorative carvings. Today, much of the religious statuary in Texas represents facsimiles and popular molds ordered from monument dealers; however, several contemporary Texas sculptors express the tenets and ideals of the Christian faith through their work. Among the most prominent are Charles Umlauf, Max Greiner, Jr., David Cargill, Terrell O'Brien, Sherman T. Coleman, and Sister Mary Peter Tremonte of the Dominican sisters, Congregation of the Sacred Heart. Of those, only Sister Mary Peter is exclusively a liturgical artist and sculptor. A native of Port Arthur, Sister Mary Peter served as a teacher of art and the founder of Holy Rosary Studio in San Bernardino, California, before returning to Texas in 1965 to chair the art department at Dominican College in Houston. During the early 1970s, she moved to Florence, Italy, to found and direct the Dominican Institute of Fine Arts, which provides gifted students an opportunity to study art under Florentine teachers. Since 1974, she has worked from her private studio in San Antonio under the auspices of her congregation. Her liturgical art appears in more than sixty churches and religious institutions in fifteen dioceses. Sister Mary Peter describes her Dominican mission as an artist: "to spread

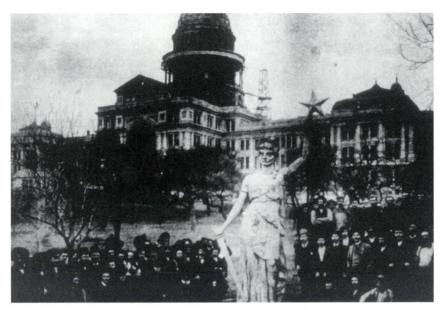

Goddess of Liberty on Capitol grounds before installation.
Austin History Center, Austin Public Library, Photo C00558.

the Word of God through religious and liturgical art, using art as an
expression of God's truth and beauty" (personal correspondence).
Her outdoor placements are located in eight Texas cities.

Outdoor sculpture in Texas presents a panorama of diverse styles
and subjects, from stately marble soldiers guarding courthouse
lawns to bronze mustangs thundering across a concrete prairie to
granite monoliths and steel abstractions towering over sunbaked
city plazas. These visual symbols set in public spaces represent the
collective values and shared experiences of Texas residents over the
past 150 years. They comprise an artistic legacy that can help future
generations understand the continuity of Texas history and culture.
As the state's most accessible art form, outdoor sculpture in Texas
is available for everyone to enjoy. It is a great cultural resource that
enlivens the visual environment, commemorates the past, and
enriches the quality of life.

*Survey of
Outdoor
Sculpture
in Texas*

Abilene

Acton

Addison

Albany

Alpine

Alvin

Amarillo

Anson

Arlington

Aspermont

Athens

Austin

Abilene

Amerine, Wayne
(b. 1928 American)*

THE HERD *1987*

Figurative; life-size; $1/2$" painted sheet aluminum
Location: Winters Freeway at South 14th Street
Funding: Public fund-raising campaign, $6,400
Comments: This sculpture is a replacement for a similar work placed on temporary loan to the city of Abilene in 1986. When vandals attacked the first herd, Abilene residents responded by launching the Save Our Cows Moovement to commission a new, permanently sited herd for their city. An editorial in the July 3, 1986, issue of the *Abilene Reporter-News* encouraged citizen support by noting that the original sculpture was more than a cultural attraction: "It has been a community symbol, a showpiece, a point of pride. Every West Texas town should have a herd of cows grazing on the side of the road."

Pink Flamingo. Photo by Robert Little.

The Herd. Photo courtesy *Abilene Reporter-News.*

Barrington, Joe
(b. 1956 Native Texan)*

PINK FLAMINGO *1987–1988*

Figurative; 12' H; hand-formed painted welded steel
Location: Abilene Zoological Gardens and Discovery Center, Loop 322 and Texas 36
Funding: Patron 200 Organization grant

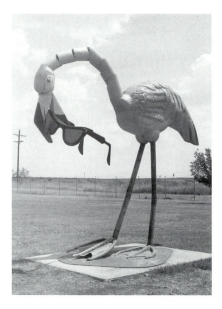

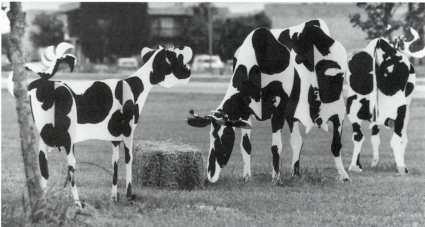

Comments: Barrington also has a white, welded-steel cow skull installed on the median in the 1400 block of South 1st Street and a white, welded-steel deer skull with giant antlers installed in Grover Nelson Park at Loop 322 and Texas 36. A graduate of Midwestern State University in Wichita Falls, Barrington maintains his studio in Throckmorton.

Bell, Larry

(b. 1939 American)

WIND WEDGE *1982*

Environmental; seven panels, tallest reaching 6' H; sheets of glass mounted on concrete bases
Location: Grover Nelson Park, Loop 322 and Texas 36
Funding: Matching grants from Art in Public Places Program and local funding
Comments: When Bell received this commission in conjunction with Abilene's 1981 centennial, he chose a theme based on one of the city's most prominent natural features, the wind. Since the 1960s, many of Bell's sculptures have involved transparency and reflection through the use of glass or mirrors.

Wind Wedge. Photo courtesy Abilene Cultural Affairs Council.

Deming, David

(b. 1943 American)*

SEPTEMBER TRI-POD *1980*

Abstract; 9' × 20' × 16'; painted steel
Location: Chestnut at South 2nd Street
Funding: Donated to the city in 1984 by the Patron 200 Organization

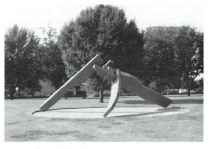

September Tri-Pod. Photo by Robert Little.

Faulkner, Avery

(b. 1940 Native Texan)

OMEGA POINT *early 1970s*

Abstract; 9' H; Cor-ten steel
Location: Abilene Christian University campus mall
Funding: Abilene Christian University and a private grant
Comments: After graduating in 1963, Faulkner remained at Abilene Christian University as an art instructor until the early 1970s, when he accepted a position at Pepperdine University in California.

Omega Point. Photo by Robert Little.

Gilbreth, Terry

(b. 1946 Native Texan)*

SACRED WIND *1992*

Figurative; 6'6" H; bronze
Location: McMurray University
campus mall, 1600 block Sayles
Boulevard
Funding: McMurray University
Alumni Association through the sale
of small versions of the sculpture

McDonnell, Joseph Anthony

(b. 1936 American)

UNTITLED *1984*

Abstract; 10' H; Bear Mountain
red Texas granite
Location: First National Bank Center,
400 Pine at 5th Street
Funding: Commissioned by the First
National Bank of Abilene
Comments: This upright, single
massive block has a hollow back and
a rough-cut front with exposed saw
marks. The highly polished sides,

which represent modern technology,
contrast with the overall primitive,
totemic effect of the sculpture. After
graduate work at the University of
Notre Dame, McDonnell studied
stone carving for two years at the
Academia di Belli in Florence, Italy.
His work has appeared in solo
exhibits in Texas, Michigan, Con-
necticut, Pennsylvania, New York,
Rome, Florence, and Milan. He is a
native of Detroit, Michigan, living in
Cold Spring, New York.

Miller, John Brough

(b. 1933 American)*

BIOMORPHIC FORM *1985*

Abstract; 8'6" × 8'6" × 5'; oxidized
welded steel
Location: Grape at North 1st Street
Funding: Purchased by a private
donor in 1986 during the Sixth
Annual Abilene Outdoor Sculpture
Exhibit

Untitled. Photo by Robert Little.

Biomorphic Form. Photo by Robert Little.

Holy Family. Photo by Robert Little.

Hope for the Future. Photo by Ken Ellsworth, courtesy *Abilene Reporter-News*.

Tremonte, Sister Mary Peter

(b. 1930 Native Texan)*

HOLY FAMILY *1985*

Figurative; 4'6" H; bronze
Location: Holy Family Catholic
Church, 5410 Buffalo Gap Road
Funding: Commissioned by the
church

Umlauf, Charles

(1911–1994 American)*

HOPE FOR THE FUTURE
1985–1986

Figurative; 12' H; bronze
Location: Abilene Christian Univer-
sity campus
Funding: Donated by a group of
private citizens to Abilene Christian
University
Comments: Gayle Potter and other
friends of Abilene Christian Univer-
sity purchased this work from First
State Bank of Abilene in 1989 when
the bank closed. The sculpture
symbolizes a vision for the future as
inspired by the family unit.

Woitena, Ben

(b. 1942 Native Texan)*

RAINMAKER *1984*

Abstract; 9' × 8' × 11'; welded and
stainless steel
Location: Civic Center grounds,
1000 North 6th between Cedar and
Pine streets
Funding: City of Abilene
Comments: *Rainmaker* calls to mind
the fact that Abilene's rainfall
averages only 23.59 inches per year.

Rainmaker. Photo by Robert Little.

43

Acton

Unknown Artist

ELIZABETH CROCKETT *1913*

Portraiture; larger than life-size; Italian marble
Location: Farm Road 167 at Acton State Historic Site, the smallest state park in Texas (0.006 acre), and the grave site of David Crockett's second wife, Elizabeth Patton Crockett
Funding: $2,000 appropriated in a bill sponsored by Senator Pierce Ward and passed by the 32nd Texas Legislature in 1911
Comments: Senator Ward ordered this statue from Italy. It portrays Elizabeth Crockett looking toward the western horizon with her left hand shading her eyes, as she must have watched for her husband to return to Tennessee before he was killed at the Alamo. The widow Crockett and her son Robert came to what is now Hood County in 1854; she died there in 1860. Her statue is dedicated to all pioneer wives and mothers. A specially built wagon transported the monument over pastureland from the Cleburne train depot to Acton.

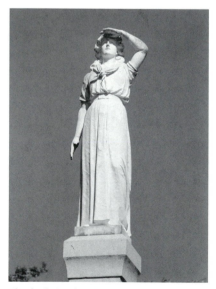

Elizabeth Crockett. Photo by Robert Little.

Addison

Benton, Fletcher

(b. 1931 American)

"D" *1983*

Abstract; 10' × 10' × 4'; steel
Location: One Spectrum Center East, 5080 Spectrum Drive at Dallas Parkway
Funding: Criswell Development Company
Comments: Criswell Development Company installed three abstract sculptures at the Spectrum Center in 1983: *"D,"* a signed and dated piece by Benton; *Loop-de-Loop,* a 3' × 15' × 3' painted aluminum work by Katie Casida; and *Form Anonyme,* a 9' × 9' × 6' painted stainless-steel design by Jan Peter Steen. In addition to these permanent installations, other works are occasionally on temporary exhibit.

Byers, Christopher

(American)

LIGHT AND ENERGY *n.d.*

Abstract; 3 elements, each 40' × 2' × 2'; plate steel

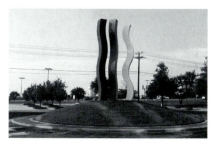

Light and Energy. Photo by Robert Little.

Location: 5055 Keller Springs Road
Funding: Crescent Real Estate Equities Limited Partnership
Comments: These hollow columns are painted in subtle hues that coordinate with the adjacent office building.

House, John V.

(American)

SUN UP AT QUORUM *1981*

Environmental; 19' × 40' × 3'; oxidized steel
Location: Quorum Place, Quorum Drive at North Dallas Parkway
Funding: Quorum Development
Comments: This large arch stretching over a small globe is aligned with the sun in such a manner that its shadow accurately marks the solar calendar. Near midday on the two equinoxes, the sun's rays pass through the aperture in the sculpture and strike the sphere on the ground below. *Sun Up at Quorum* was fabricated in Dallas at Baldwin Metals.

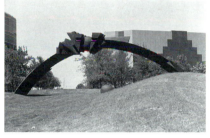

Sun Up at Quorum. Photo by Robert Little.

Meadmore, Clement

(b. 1929 American/Australian)

UPBEAT *1985*

Abstract; 30' × 15' × 15'; painted aluminum
Location: The Colonnade, 15301–15303 Dallas Parkway
Funding: Commissioned by MEPC American Properties, Inc., through Architectural Arts Company
Comments: This colossal piece, with its black matte finish, is typical of Meadmore's hollow aluminum abstracts.

Nauman, Bruce

(b. 1941 American)

NINE-BY-NINE *1980*

Abstract; 9' × 9' × 9'; Cor-ten steel
Location: 16803 Dallas Parkway
Funding: Triangle Pacific Corporation

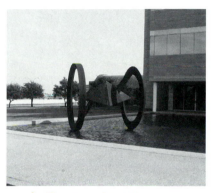

Nine-by-Nine. Photo by Robert Little.

Sanders, Jerry Dane

(b. 1949 American)*

HYPERBOLIC PARABOLOID II *1984*

Abstract; 7' × 10' × 5'; stainless steel
Location: 14180 Dallas Parkway
Funding: Hunt Properties
Comments: As the geometrical title suggests, this work contains sections that are both hyperbolas and parabolas to the main element. Sanders uses mathematical equations and highly polished stainless steel to create abstract designs that are installed throughout the Metroplex area.

Albany

Special Collections and Sculpture Gardens in Albany

The Old Jail Art Center on Texas 6 South is housed in the 1877 Shackelford County jail. Listed on the National Register of Historic Places, the structure is the design of civic architect John Thomas of Thomas and Woerner Builders in Fort Worth. Thomas designed the jail and supervised its construction at a cost of $9,000, an amount considered excessive by local taxpayers. Still evident on the facade are the signatures of the building's stonemasons, who carved their initials in the large limestone blocks to ensure payment for their work. Today, the Old Jail Art Center houses an extensive permanent collection, the major portion of which came from four private collections donated to the center in 1980. The museum's holdings include some of the world's best-known

artists, such as Pablo Picasso, Henry Moore, Aristide Maillol, and Louise Nevelson. The Old Jail Foundation is a nonprofit corporation that maintains the art center for research by scholars, students, and historians as well as for the enjoyment of the public.

Outdoor sculpture at the Old Jail Art Center is located on the surrounding grounds and in the Marshall R. Young Courtyard. The centerpiece of the courtyard is Jesús Bautista Moroles' 18-foot-high **GRANITE SUN** *1984*. Other works in the courtyard include:

FIGURA *1956*, a 5'2"-high bronze by Luigi Broggini
BLUE VECTOR *1985*, an appliqué of mixed media mounted on steel plate by Ken Drew
EVE WITH THE APPLE *n.d.*, a 4'-high bronze by Alfeo Faggi
CONVERSATION *1954*, a two-piece life-size bronze by Pericle Fazzini
LOT'S WIFE *1968*, a figurative bronze by Nathanael Neujean

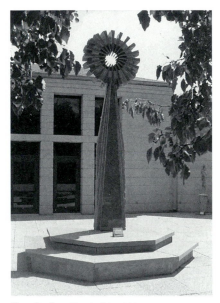

Granite Sun. Photo by Robert Little.

Figura. The stonemasons' initials are apparent on the limestone blocks behind the sculpture. Photo by Robert Little.

GRANDE REGINA *1959–1960*, a 6'3"-high bronze by Augusto Pérez

NEW AGE TOTEM *1978*, a cast-aluminum abstract by Frank Talbert, Jr.

PICNIC *circa 1960*, a hammered metal piece by Charles Truett Williams

The following works are installed on the grounds surrounding the Old Jail Art Center:

THREE CRESCENTS *n.d.*, a painted steel abstract by Carlos Carullo

BUFFALO *1988*, a steel-plate figure

by Dallas artist Stuart Kraft, who restored *Figura, Conversation,* and *Grande Regina* for the center

PRIMAL TRIAD *1982* and **INFINITY ON END** *n.d.*, two Carrara marble abstracts by Marcy MacKinnon

MOON RING *1982* and **VANISHING EDGE** *1983*, two black Texas granite abstracts by Jesús Bautista Moroles

FLIGHT *1987*, a 6'7"-high welded-steel abstract by Daniel Sellers

BALLET OF THE WEST WIND *1983*, a bronze female figure by Evaline Clarke Sellors

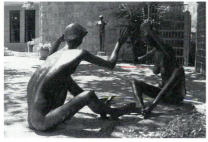

Conversation (foreground) and *Figura* (background). Photo by Robert Little.

Buffalo. Photo by Robert Little.

Grande Regina. Photo by Robert Little.

Moon Ring. Photo by Robert Little.

47

Ballet of the West Wind. Photo by Robert Little.

Range Spirit. Photo by Clay Bush, courtesy Sul Ross State University News and Publications Service.

CURLING STEMS WITH POME-GRANATES *1988,* a 12'-high bronze and wood group by Kathy Webster

AGE OF IRON *1965,* a found-objects assemblage by Charles Truett Williams

Alpine

Barrick, Rex

(American)*

RANGE SPIRIT *1981*

Figurative; 18' H; $^1/_2$" hot-rolled round steel
Location: Sul Ross State University campus entrance
Funding: Donated by the artist
Comments: Barrick was an art instructor at Sul Ross State University when he designed this work and *Three Faces of the Lobo.* Installed by the artist in the campus plaza in 1982, *Three Faces of the Lobo* measures 10 feet high. Barrick

Three Faces of the Lobo. Photo by Clay Bush, courtesy Sul Ross State University News and Publications Service.

describes his work as a three-dimensional form of sketching.

Hext, Charles R. "Bob"

(b. 1948 Native Texan)*

TRES AMIGOS *1990*

Figurative; 8' × 10' × 4'; steel
Location: 106 North 3rd

48

Funding: Alpine Chamber of Commerce
Comments: Hext is a member of the art department at Sul Ross State University.

Tres Amigos. Photo courtesy Bob Hext.

Old Maverick. Photo by Rick Tate, courtesy Museum of the Big Bend, Sul Ross State University.

Nichols, Harold

(b. 1924 Native Texan)*

OLD MAVERICK *1991*

Figurative; 8'4" H; $^1/_4$" plate steel
Location: Sul Ross State University campus, entrance to the Museum of the Big Bend on U.S. 90
Funding: The museum and the artist

Comments: Nichols is a painter and sculptor in Victoria, where *Old Maverick* was created over a period of about five years. Nichols grew up on a ranch near Fort Stockton, and after receiving a masters degree from Sul Ross State University in 1953, he joined the staff of Victoria College, retiring from the position of business manager in 1980.

Unknown Artist

STAGE TO ALPINE *1991–1992*

Figurative; life-size; painted plywood
Location: East of Alpine on Farm Road 1703 near the intersection of U.S. 67 and U.S. 90
Funding: Placed by the artist on land provided by Rick Sohl
Comments: Installed high on a hilltop, this stagecoach with a driver and four horses appears to be rumbling toward Alpine. The plywood material makes this work especially vulnerable to the environment, but until it succumbs to the West Texas sun and wind, the *Stage to Alpine* is a delightful surprise to modern travelers who speed by in air-conditioned automobiles.

Alvin

Bryant, Jack

(b. 1929 Native Texan)*

NOLAN RYAN *1992*

Portrait; life-size; bronze cast at Bryant Art Foundry in Azle
Location: City Hall grounds, 200 block West Sealy
Funding: City of Alvin
Comments: Nolan Ryan is a native of Alvin and a resident of Brazoria County. The hometown sports hero wears a Texas Ranger baseball uniform with his famous number 34.

Nolan Ryan. Photo by Robert Little.

Amarillo

Ant Farm
Chip Lord,

(b. 1944 American)

Hudson Marquez, and

(b. 1947 American)

Doug Michels

(b. 1943 American)

CADILLAC RANCH *1974*

Earthwork; 120' L; ten Cadillac automobiles

Location: 3 miles west of Amarillo on Interstate 40
Funding: Stanley Marsh 3
Comments: Ten half-buried, graffiti-covered Cadillacs (vintage 1949, 1952, 1954, 1956–1960, 1962, and 1964) comprise this roadside monument to the nation's passion for the automobile. The progression of tail fins across the barren landscape calls attention to the automobile design industry of the 1950s and the popularity of its appeal to the American public.

The Acrobats. Photo by Robert Little.

Cadillac Ranch. Photo by Robert Little.

Klessen, Harry

(b. 1933 American)

THE ACROBATS *1979*

Abstract; 30' H; chrome automobile bumpers
Location: 6600 Canyon Drive
Funding: Dulaney Auto and Truck Parts
Comments: Cushioned with old car seats, this work traveled in a two-car tow truck to Amarillo from the artist's home in Sioux Falls, South Dakota.

Leicester, Andrew

(b. 1948 American/English)

FLOATING MESA *1980*

Site specific; 8' H, 384' L; painted steel panels, I beams, and concrete
Location: 11 miles northwest of Amarillo on Ranch Road 1061
Funding: Stanley Marsh 3
Comments: A steel wall stretching around the east side of Goat Mountain near the top of the mesa causes approaching motorists to experience an optical illusion. The top of the mesa appears to be separated from and hovering above the base.

Floating Mesa. Photo by Robert Little.

Doughboy Ready. Photo by Robert Little.

Paulding, John

(1883–1935 American)

DOUGHBOY READY *1920*

Figurative; 7' H; bronze cast at the American Bronze Foundry of Chicago
Location: Ellwood Park, West 11th and Washington
Funding: Llano Estacado Chapter, Daughters of the American Revolution, "In memory of the Panhandle Boys of the World War"
Comments: Dedicated on Armistice Day (now Veterans Day) 1928, this World War I doughboy statue stood undisturbed at the old city auditorium for 38 years, until city officials moved him in 1966 to Ellwood Park. After only a few days at his new home, pranksters or would-be thieves toppled the statue off its pedestal. Then, in 1971, the figure's Springfield rifle was stolen. Thanks to the perseverance of the Amarillo Police Department and concerned citizens, the statue has been reinstalled on its base and rearmed.

Phippen, George

(American)

WIMPY P-1 *1961*

Figurative; one-half life-size; bronze
Location: American Quarter Horse Association international headquarters, 2701 Interstate 40 East off Nelson Street Exit
Funding: King Ranch, Kingsville, Texas
Comments: Wimpy P-1 was the first horse registered in the American Quarter Horse Association. The founding fathers of the AQHA agreed that the winner of the Grand Champion Stallion award in the quarter horse show at the 1941 Southwestern Exposition and Fat Stock Show would be designated Number 1 in the new quarter horse registry. Wimpy, the King Ranch entry, won the coveted award. Next door to the AQHA headquarters is the American Quarter Horse Heritage Center and Museum. The large bas-reliefs installed on the building are the work of Santa Fe artist Kim Crowley.

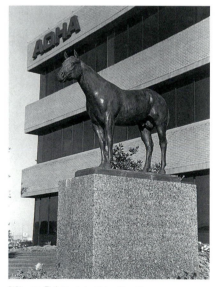

Wimpy P-1. Photo by Helena Biasatti, courtesy American Quarter Horse Association.

Helium Monument. Photo courtesy U.S. Department of the Interior Bureau of Mines.

United States Steel Corporation, American Bridge Division

HELIUM MONUMENT *1968*

Abstract; 13'9" H tripod topped by a 41' H spire; stainless steel and Cor-ten steel
Location: Don Harrington Discovery Center, 1200 Streit Drive
Funding: City of Amarillo, Potter County, and private corporations throughout America as part of the Helium Centennial in 1967 under the direction of the Helium Centennial Committee from Government and Industry
Comments: According to designers Peter Muller–Munk Associates, Inc., of Pittsburgh, Pennsylvania, this structure was designed to remain comprehensible to civilizations 1,000 years into the future. The design forms a tripod, with four spheres surrounded by two elliptical rods suspended from its center. The spheres represent the molecular structure of helium—two neutrons and two protons surrounded by two electrons. Four time capsules, to be opened at intervals of 25, 50, 100, and 1,000 years, include material and artifacts relative to humanity's discovery and wise use of the world's natural resources. In 1982, a U.S. Army Chinook helicopter from Fort Hood airlifted the 8-ton monument 15 miles to its present location to make way for the construction of the new American Quarter Horse Association's international headquarters.

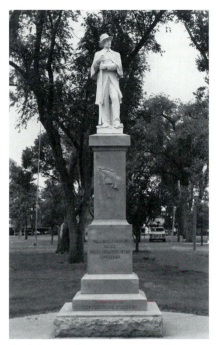

Confederate Soldier Statue. Photo by Robert Little.

Whitacre, H. A., Marble Company

(American)

CONFEDERATE SOLDIER STATUE
1931

Figurative; life-size; Carrara marble
Location: Ellwood Park, West 11th
and Washington
Funding: Will A. Miller Chapter 1372,
United Daughters of the Confederacy
Comments: The Will A. Miller
Chapter ordered this statue from
Carrara, Italy, through H. A.
Whitacre, a monument maker and
resident of New York City. The
Vermont-granite shaft and the soldier
were set in place by Osgood Monu-
ment Company, which has been in
business in Amarillo since 1906.
Only four Confederate veterans were
still living in the Amarillo area and
able to attend the unveiling ceremo-
nies in 1931.

Special Collections and Sculpture Gardens in Amarillo

**The Amarillo Museum of Art
Sculpture Collection** is installed in
the courtyards surrounding the
museum building at 2200 South Van
Buren on the campus of Amarillo
College. The museum building is the
last cultural institution designed by
the late American architect Edward
Durell Stone, whose projects include
the American Pavilion at the Brussels
World Fair, the United States
Embassy in New Delhi, India, and the
John F. Kennedy Center for the
Performing Arts in Washington, D.C.
The museum's sculpture courtyards
include three permanent installa-
tions:

TALON SWEEP *1984*, a welded-steel
abstract by John Brough Miller,
donated to the museum by
Charlene and Tom Marsh in
memory of their son, Tom
Marsh, Jr.

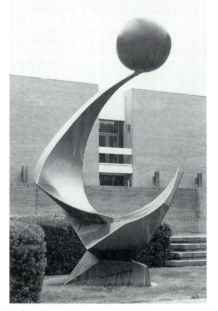

Talon Sweep. Photo courtesy Jackie R. Smith,
Amarillo Museum of Art.

53

CONTINUOUS LINE *1982,* a limestone abstract by David Rogers, donated to the museum by George Lokey

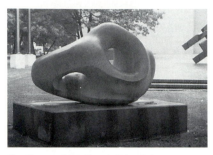

Continuous Line. Photo by Robert Little.

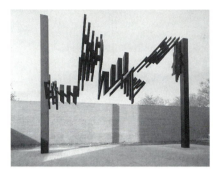

Archway. Photo courtesy Jackie R. Smith, Amarillo Museum of Art.

ARCHWAY *1983,* a painted steel abstract by Ben Woitena, donated to the museum by Claire Childers Burney and T. Jay Reeves in memory of Betty Bivins Childers and Courtney Claire Reeves

Anson

Cerracchio, Enrico Filberto

(1880–1956 American/Italian)*

ANSON JONES *1936*

Portraiture; larger than life-size; bronze
Location: Jones County Courthouse grounds

Funding: $7,500 allocated by the 1936 Commission of Control for Texas Centennial Celebrations
Comments: The artist and Donald Nelson, the architect, signed this statue of Dr. Jones, who fought at the Battle of San Jacinto and served as the last president of the Republic of Texas. Cerracchio immigrated to America in 1900 and became a naturalized citizen in 1905. He maintained a studio and residence in Houston and New York City.

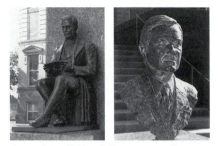

Anson Jones (left) and *Congressman Omar Burleson* (right). Photos by Robert Little.

Dell, Juan

(Native Texan)

CONGRESSMAN OMAR BURLESON *1974*

Portrait bust; life-size, bronze cast at House Bronze, Inc., in Lubbock
Location: Jones County Courthouse grounds
Funding: Public donations through a monument committee
Comments: Juan Dell, a native of Hockley County, resides in Chimayo, New Mexico.

Arlington

Espinos, Carlos

(Mexican)

INDOMITABLE STRENGTH *1986*

Equestrian; life-size; bronze

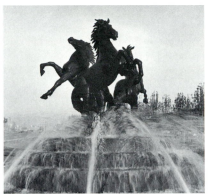

Indomitable Strength.
Photo courtesy Lincoln Property Company.

Location: Lincoln Square, southwest corner of Interstate 30 and Farm Road 157 (Collins Street)
Funding: Lincoln Property Company
Comments: These three horses, ordered from Mexico City through Art and Sculptures, Inc., in Houston, form a beautiful, 4-ton fountain centerpiece.

Guarducci, Othello

(American/Italian)

THE SEA *1980*

Abstract; 7' × 12' × 8'6"; painted steel
Location: Chester W. Ditto Golf Course, 801 Brown Boulevard
Funding: Donated in 1986 to the city of Arlington by Jean Claude Perard
Comments: This abstract impression emulates the lines, movement, and color of the sea.

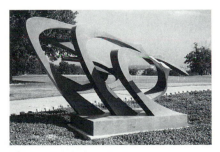

The Sea. Photo by Gerald Urbantke, courtesy Arlington Parks and Recreation Department.

Hines, Norman Patrick

(American)

CAELUM MOOR *1986*

Environmental sculpture; 5.5-acre park containing 22 pieces ranging from 15' H to 34'; pink Texas granite from Marble Falls
Location: The Highlands of Arlington. Take the Matlock Road exit north of Interstate 20. Continue west on the frontage road. The sculpture park is on the right.
Funding: Jane Mathes Kelton and Kelton-Mathes Development Corporation
Comments: As the centerpiece of The Highlands of Arlington, this park is a fusion of earthworks, water, free-standing stone sculptures, and a computerized and recessed lighting system. The 22 granite megaliths,

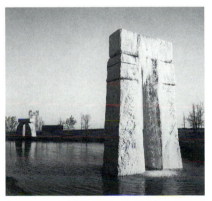

Caelum Moor (Morna Linn detail). Photo by Clay Kelton, courtesy Kelton-Mathes Development Company.

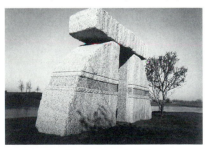

Caelum Moor (Sarsen Caer detail). Photo by Clay Kelton, courtesy Kelton-Mathes Development Company.

55

weighing 540 tons, are arranged in five groups. The work captures some of the mystery of Stonehenge (visited by the artist for inspiration), but the contrast between its highly polished surfaces and the natural, rough texture of the rock is intended to suggest the unification of nature and technology, both integral parts of modern society.

Johnson, J. Seward, Jr.

(b. 1930 American)

CREATING *1981*

Figurative; life-size; bronze cast at the artist's foundry near Trenton, New Jersey, and sited by Sculpture Placement, Ltd., Washington, D.C.
Location: Lincoln Square Shopping Center, southwest corner of Interstate 30 and Farm Road 157 (Collins Street)
Funding: Lincoln Property

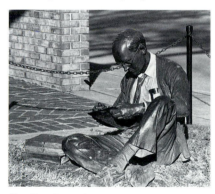

Creating. Photo by Robert Little.

Miller, John Brough

(b. 1933 American)*

EARTHBOUND DISC *1982*

Abstract; 9'6" H; steel
Location: Peyco Properties, 1703 North Peyco Drive off Cooper Drive
Funding: Paul E. Yarborough

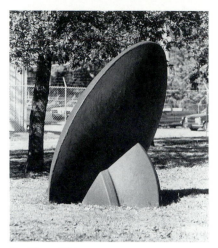

Earthbound Disc. Photo by Robert Little.

Moroles, Jesús Bautista

(b. 1950 Native Texan)*

LAPSTRAKE *1983*

Abstract; 9' × 7' × 2'; Georgia granite
Location: Texas Commerce Bank, 500 East Border Street
Funding: Harlan Crow, placed by Dixie Christian

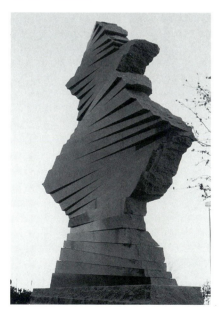

Lapstrake. Photo by Jesús Bautista Moroles.

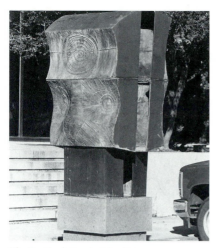

The Sentinel. Photo by Robert Little.

Owens, Gene

(b. 1931 American)*

THE SENTINEL *1963*

Abstract; 9' H; bronze
Location: First City Bank,
201 East Abram
Funding: First National Bank, now
First City Bank
Comments: Reminiscent of large
etched stones placed at tombs during
the Han Dynasty in China, *The
Sentinel* symbolizes the guardianship
of a bank over its patrons' resources.
Unlike the ancient guard stones,
Owens' work is hollow.

Aspermont

Unknown Artist

GODDESS OF JUSTICE *1911*

Figurative; larger than life-size;
metal alloy
Location: Stonewall County Court-
house grounds
Funding: Originally funded by the
county commissioners' court for
placement on the dome of the old
county courthouse

Comments: The Goddess figure was
removed from the old courthouse
dome in 1954. In 1987, it was repaired
and placed on a new pedestal on the
current courthouse grounds.

Athens

Herrmann, Nancy

(American)

SAINT FRANCIS OF ASSISI *1980s*

Abstract; larger than life-size; cast
stone
Location: Saint Edward's Catholic
Church, East Tyler Street
Funding: Private purchase

Salmones, Victor

(American/Mexican)

HELPING HANDS *acquired in
the 1980s*

Figurative; 7'6" H; bronze
Location: The Cain Center,
915 South Palestine
Funding: Donated by Effie Marie Cain

Stewart, Albert

(b. 1947 Native Texan)

**ATHENS FIDDLERS ASSOCIATION
STATUE** *1989*

Figurative; 4' H; bronze
Location: Henderson County Court-
house grounds
Funding: Commissioned by the
Henderson County Texas Sesquicen-
tennial Committee
Comments: For more than 75 years,
a fiddlers' contest has been held in
Athens on the last Friday in May.
This statue commemorates that
event. On the opposite side of the
courthouse grounds, a 14-inch-high
bronze eagle set on a granite shaft
honors Henderson County veterans.

Austin

Baker, Bryant

(b. 1881 American/English)

ANSON JONES *1962*

Portraiture; life-size; bronze
Location: Lorenzo de Zavala State
Archives and Library adjacent to the
grounds of the Texas State Capitol
Funding: Donated to the state by
Texas Masonic Lodges
Comments: Dr. Jones was the last
president of the Republic of Texas
and the first grand master of the
Republic of Texas Masonic Lodge.

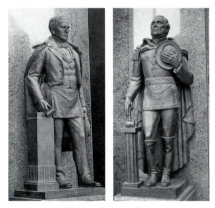

Anson Jones (left) and *General Sam Houston*
[see p. 70] (right) flanking the entrance to the
Lorenzo de Zavala State Archives and Library.
Photos by Robert Little.

Outdoor Studio. Framed by the doorway is
T. Paul Hernandez's *Snake Culvert,* a
concrete sculpture and water retention
device. Photo courtesy Rita Starpattern.

Butler, Laurel, and

(b. 1947 American)*

Rita Starpattern

(1946–1996 Native Texan)*

OUTDOOR STUDIO *1991*

Environmental; 13' × 36' × 7';
painted stucco
Location: Austin Community
Television Access studio, 1143
Northwestern Avenue
Funding: Commissioned by the city
of Austin through Art in Public
Places
Comments: *Outdoor Studio* provides
a mutable backdrop and set for
outdoor video training and video
productions.

Capilano, Chief Joe Mathias

(Canadian)

THUNDERBIRD TOTEM POLE
1936

Totem pole; 35' H; hand-carved wood
Location: Camp Mabry,
West 35th Street
Funding: First given to the city of
Vancouver by the North American
Indian Brotherhood, donated in 1949
to the state of Texas by the Canadian
government in honor of Texans who
served with the Royal Canadian Air
Force in World War II
Comments: Chief Capilano was the
hereditary chief of the Capilano band
of the Squamish Indians of British
Columbia. This totem pole records
the legends and mythology of the
Thunderbird. Four sections depict the
artist's conception of the son,
daughter, mother, and father of the
Thunderbird; the fifth section depicts
a dragon. The legend of the Thunder-
bird is narrated in a text marker
beside the pole.

Thunderbird Totem Pole. Photo by Robert Little.

Cerracchio, Enrico Filberto

(1880–1956 American/Italian)*

JOHN A. WHARTON *installed 1963*

Portrait bust; larger than life-size;
bronze
Location: Texas State Cemetery,
3001 Comal
Funding: Erected by the state of Texas
Comments: Wharton served as
Brazoria County's delegate to the
Secession Convention. At the onset
of the Civil War, he joined Terry's
Texas Rangers and fought at Wood-
sonville, Shiloh, Murfreesboro, and
Bardstown. After the Chickamauga
campaign, he became a major general
in the Confederate army.

Clark, James Senille

(1846–1919 American)

BATTLE OF THE ALAMO *1891*

Figurative; 35'6" H; bronze and granite
Location: Texas State Capitol grounds
Funding: Texas State Legislature

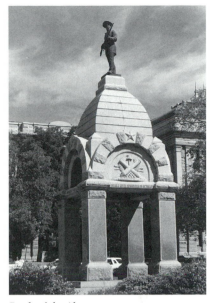

Battle of the Alamo. Photo by Robert Little.

Comments: The oldest war memorial
on the capitol grounds and the oldest
bronze statue in Texas honors the
heroes of the Alamo. James Senille
Clark established a monument
business in Louisville, Kentucky, in
1868 after graduating from Cooper
Art Institute in New York City. He
continued operations in that city
until 1919, the year of his death. He
placed granite and marble monu-
ments throughout the eastern portion
of the nation, and he edited and
published several books on monu-
ment structure. Many of his designs
became stock items for hundreds of
dealers. Clark engaged sculptor Carl
Rohl Smith (1848–1900) for the
bronze soldier figure that crowns
Battle of the Alamo. Smith, whose
name is etched on the base of the
statue, immigrated to America from
Denmark around 1886. He was a
resident of Louisville from 1891 to
1893, when he "removed to Chicago"
(*Directory of the City of Louisville,*
1893, 1023). Before returning to his
native country, Smith lived in a

59

number of American cities, including Washington, D.C., where he designed the famous *General William Tecumseh Sherman Monument,* located at the intersection of 15th Street, Pennsylvania Avenue, and Treasury Place NW.

Clayton, Harold
(b. 1954 Native Texan)*

THE ARBORETUM COWS *1985*

Figurative; 5 figures, 4'6" to 5' H; Italian marble and Italian stone
Location: The Arboretum, 10000 Research Boulevard
Funding: Trammell Crow
Comments: This small herd includes two cows of Italian stone and three cows of Italian marble—one black, one red, and one white. Each cow weighs 4 tons.

The Arboretum Cows. Photo by Ali Hossaini.

Coppini, Pompeo
(1870–1957 American/Italian)*

AUSTIN CONFEDERATE MONUMENT *1901*

Figurative; 5 larger-than-life statues mounted on a 15' H base; bronze and granite
Location: Texas State Capitol grounds
Funding: State of Texas and Camp Hood Confederate Veterans, "Erected A.D. 1901 by Surviving Comrades"
Comments: Frank Teich designed the massive granite base that supports

this memorial's five bronze figures: Jefferson Davis flanked by four soldiers representing the four branches of the Confederate armies. Coppini came to Texas to work on the monument through an offer made by Teich for a sculptor who would come to Texas to work for 75 cents per hour, transportation paid. When the monument committee saw Coppini's 9-foot bronze portrait of President Davis, they were so pleased with his work that they rejected the four granite soldiers already made by Teich's firm and hired Coppini to make the soldier statues in bronze.

GEORGE WASHINGTON *1955*

Portraiture; 9' H; bronze cast by the Roman Bronze Works in New York
Location: University of Texas campus, South Mall
Funding: Texas Society Daughters of the American Revolution
Comments: Washington is portrayed as commander in chief of the American Army of the Revolution on July 3, 1775. Coppini was 85 years old when he executed this, his last work. The DAR raised funds from 1930 to 1955 to pay for the materials and casting, and Coppini donated his time to help the women realize their 25-year effort. It is Coppini's third likeness of the president; one is in Portland, Oregon, and one is in Mexico City.

HOOD'S TEXAS BRIGADE MONUMENT *1910*

Figurative; 9' H figure mounted on a 44' H base; bronze and granite
Location: Texas State Capitol grounds
Funding: Survivors of Hood's Texas Brigade
Comments: This tribute to the Confederate soldiers of Hood's Texas Brigade created a stir among artists, foundries, and marble companies in four states. On December 20, 1907, the *Houston Post* reported that the

renowned sculptor of the Union, Louis Amateis of Washington, D.C., would submit three models to the monument committee representing the survivors of Hood's Texas Brigade and that the model chosen by the committee would be placed on the capitol grounds in Austin. The following day, Pompeo Coppini vehemently criticized the selection of Amateis to the monument committee's chair, Captain F. B. Chilton. Chilton did not appreciate the artist's complaints and, on December 25, replied, "Visit your spleen on Mr. Amateis if you like, but do not so approach me again" (Texas Collection). Two years later, the monument committee had not collected sufficient funds to hire Amateis, and eventually, Chilton contacted the McNeel Marble Company of Marietta, Georgia, whose fees were more in line with the committee's resources. (For information on the McNeel Marble Company, see the Georgetown listing.)

McNeel built the shaft portion of the monument but subcontracted the soldier statue to the American Bronze Foundry in Chicago for $2,000. When the statue arrived in Austin, the monument committee refused it, citing defects in the bronze. A three-way controversy developed between the foundry, the committee, and the marble company. On May 5, 1910, with everyone's patience running out and time for the unveiling fast approaching, M. L. McNeel, secretary and treasurer of McNeel Marble Company, pointed out in a letter to Chilton that the company's granite work was superior to other stone monuments already erected at the capitol: "We do say with pride that a comparison with the other granite monuments on the Capitol Grounds will show that we have furnished in this piece of work a quality material and finish that is by many times superior to the others" (Texas Collection). Understandably, Frank Teich took exception. Since the committee agreed that McNeel's granite shaft was acceptable, Major George W. Littlefield on behalf of the committee persuaded Coppini to make hurriedly a suitable soldier figure for placement on the McNeel pedestal (Coppini 1949, 188–190). Coppini, who had expected the original commission, fashioned this heroic-sized Confederate private in a relaxed stance with his head slightly forward to survey the capitol grounds from his lofty summit. The American Bronze Foundry and McNeel Marble Company placed their controversy in the hands of attorneys, but the

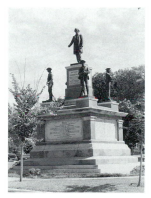

Austin Confederate Monu-ment. Photo by Robert Little.

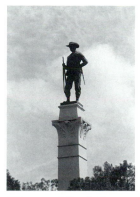

Silhouette of *Hood's Texas Brigade Monument*, over-looking the capitol grounds. Photo by Robert Little.

George Washington. Photo by Larry Murphy, courtesy University of Texas at Austin Office of Public Affairs.

61

marble company and the monument committee completed the project on a congenial note, and in fact, Captain Chilton recommended the company for other work in Texas (Texas Collection, McNeel Marble Company to Chilton, December 30, 1911).

John Bell Hood, a graduate of the United States Military Academy, resigned from the United States Army in 1861 to command the 4th Texas Infantry of the Confederate army. He succeeded Albert Sidney Johnston in command of the Confederate Army of Tennessee on July 18, 1864. Hood's Texas Brigade served throughout the Civil War, participating in more than two dozen battles.

Johanna Troutman (detail).
Photo courtesy *Texas Highways Magazine*.

JOHANNA TROUTMAN *circa 1915*

Portraiture; life-size; bronze cast at the American Bronze Foundry in Chicago
Location: Texas State Cemetery, 3001 Comal
Funding: Commissioned by Governor O. B. Colquitt through an appropriation approved by the Texas Legislature
Comments: In response to the appeal from Texians in 1835 for volunteers

to fight for Texas independence, Johanna Troutman helped raise the Georgia Battalion, a group of citizen soldiers under the command of Colonel William Ward. When the volunteers left Georgia for Texas, Troutman gave them a white silk flag appliquéd with a single blue star and the inscription "Liberty or Death." Known as the Flag of the Lone Star, the banner was unfurled at Velasco on January 8, 1836, and later, James W. Fannin carried it to Goliad, where it was declared the unofficial national flag of Texas. During the Goliad Campaign of 1836, it was torn to shreds, but a replica hangs on the wall inside Presidio la Bahía. The story of Troutman's flag and the names of the martyrs of the Goliad Massacre are inscribed on the base of this monument.

LITTLEFIELD MEMORIAL FOUNTAIN *1933*

Figurative; 12 larger-than-life figures; bronze

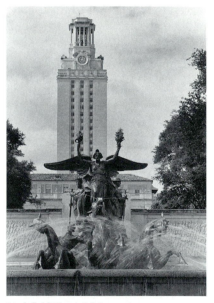

Littlefield Memorial Fountain. Photos by Larry Murphy and Marsha Miller. Courtesy University of Texas at Austin Office of Public Affairs. (1) *Littlefield Memorial Fountain* and the Main Building Tower,

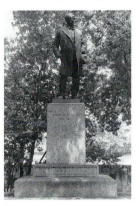

(2) *Robert E. Lee,* (3) *Jefferson Davis,* (4) *James Stephen Hogg,*

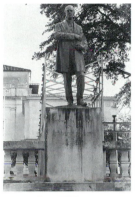

(5) *Albert Sidney Johnston,* (6) *Woodrow Wilson,* (7) *John H. Reagan.*

Location: University of Texas campus, South Mall

Funding: Major George W. Littlefield

Comments: Major George W. Littlefield commissioned Coppini to design a Civil War monument for the University of Texas campus, but after much discussion, the artist persuaded the former Confederate officer to expand the memorial's significance: "Why not dedicate your memorial to the boys of the University of Texas who died so that American democracy might spread all over the world, while honoring the leaders you most admire as America's great men?" (Coppini 1949, 255). With this concept in mind, Coppini designed an allegorical fountain featuring Columbia, a female figure guarded by two male figures at the prow of the Ship of State. The ship is guided through the water by nymphs astride three giant sea horses. The original sketch also included six portrait statues of American heroes, three standing on each side of the fountain centerpiece. Littlefield approved Coppini's drawing shortly before he died, but after his death, university regents and architect Paul Cret changed the original design by placing the portrait statues along the South Mall, leading to the Main Building and Tower. The result gives the impression of seven separate works rather than a single installation. Coppini believed that the finished product presented "a dismembered conception" of his creation (264). J. Frank Dobie also was dissatisfied

63

with the fountain and with Coppini's work in general. He wrote, "As for Coppini, he has littered up Texas with his monstrosities in the name of sculpture" (355). Nevertheless, more than fifty years after its creation, the fountain portion of the Littlefield Memorial remains, next to the Main Building and Tower, the most significant landmark on campus. The six portrait statues along the South Mall include only one person of the twentieth century, President Woodrow Wilson. The statue of Albert Sidney Johnston is the oldest portion of the monument, having been created in Coppini's Chicago studio in 1921. John H. Reagan's portrait was created and cast in New York in 1924 and later placed on the campus as part of the memorial. Coppini believed that *Robert E. Lee* was one of his best works, and years after he completed the fountain, he wrote, "I consider the Robert E. Lee the very best portrait statue I ever made of one of my idolized heroes and a great American soldier" (267). Statues of Jefferson Davis, president of the Confederacy, and James Stephen Hogg, the first native Texan to serve as governor, complete the roster of heroes chosen by Major Littlefield.

STEPHEN F. AUSTIN *1912*

Portraiture; larger than life-size; bronze cast at the Florentine Brothers Foundry in Chicago
Location: Texas State Cemetery, 3001 Comal
Funding: Commissioned by Governor O. B. Colquitt through an appropriation of $10,000 from the Texas Legislature
Comments: Coppini went to Chicago to supervise the casting of this statue, which the artist's autobiography describes as the first large work cast by the lost-wax process at the Florentine Brothers Foundry.

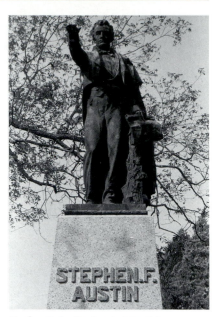

Stephen F. Austin. Photo by Robert Little.

TERRY'S TEXAS RANGERS MEMORIAL *1907*

Equestrian; 14' H; bronze cast at the John Williams Foundry in New York City
Location: Texas State Capitol grounds
Funding: Terry's Texas Rangers Equestrian Monument Committee, chaired by Major George W. Littlefield and composed of five Terry's Texas Rangers Confederate veterans
Comments: Coppini won this commission over several other artists, including Elisabet Ney. Honoring the 8th Texas Cavalry under the command of Colonel Benjamin Terry, this work so challenged the artist that he described it as his toughest undertaking. After almost two years riddled with casting difficulties and several accidents, Coppini completed the bronze portion of the monument only to discover that the county would not allow the 22,000-pound granite die to cross the Colorado River bridge en route to the capitol. Finally, work-

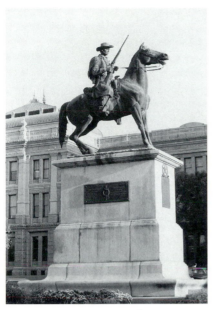

Terry's Texas Rangers Memorial. Photo by Robert Little.

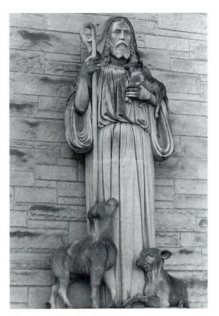

The Good Shepherd. Photo by Robert Little.

men wrapped the granite slab with logs and chains and rolled it across the riverbed. Terry's Texas Rangers were volunteers mustered at Houston on September 9, 1861, and they served for the duration of the war, surrendering to William Tecumseh Sherman at Greensboro, North Carolina, on April 28, 1865.

Correll, Ira A.

(1873–1964 American)*

THE GOOD SHEPHERD *1952*

Figurative; 10' H; Leander limestone
Location: Episcopal Church of the Good Shepherd, Windsor Road and Exposition Boulevard
Funding: Donated to the church by the Hatchett family, who were members of the congregation
Comments: Correll was born in Odon, Indiana, the son of a stonecutter. His ideas about art were decided: "An artist's job is to tell the truth in a beautiful way. It [modern art] is distortion and mutilation" (*Austin*

American-Statesman, March 25, 1955). An avid worker all of his life, Correll was 78 when he carved *The Good Shepherd* statue at the Leander Limestone Corporation Mill, where his son and two grandsons also worked.

Deming, David

(b. 1943 American)*

EAGLE II *1978*

Abstract; 4' × 12' × 10'; rusted steel
Location: Austin Public Library, 7th and Guadalupe

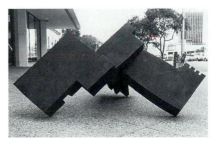

Eagle II. Photo courtesy David Deming.

65

Funding: Donated to the city of Austin in 1980 by a group of business people

Comments: Deming also has bas-relief portrait busts on permanent display at Disch-Falk Field and Memorial Stadium in Austin. The University of Texas Athletic Council commissioned the busts of athletic greats Bibb Falk, Edwin Olle, Dana Bible, and Clyde Littlefield.

Ellis, David

(American)

UNTITLED *1980*

Abstract; 14' × 12' × 2'; wood and stone
Location: Dougherty Art Center, 1110 Barton Springs Road
Funding: Owned by the city of Austin

Ferraro, A.

(Unknown)

DOMINGO FAUSTINO SARMIENTO *1972*

Portrait bust; larger than life-size; bronze
Location: University of Texas campus, Benson Latin American Collection at Sid Richardson Hall
Funding: Donated to the University of Texas by the Republic of Argentina
Comments: Sarmiento is identified on the sculpture's plaque as a writer, statesman, father of public education in Argentina, and friend to the American people.

Fowler, Ken

(American)*

BICENTENNIAL FOUNTAIN *1976*

Abstract; 3'6" H × 5' L; Cor-ten steel
Location: 300 1st Street at Riverside Drive
Funding: Donated to the city of Austin by the Austin Board of Realtors

Bicentennial Fountain. Photo by Robert Little.

Comments: Atkinson Steel Company in Austin fabricated this sculpture, and Fowler, who at the time worked with the Austin Parks and Recreation Department, created the design. Fowler named the sculptural portion of the fountain *Heritage-Festivals-Horizons.* The significance of the title is explained in the inscription: "Heritage is recalled by a granite boulder which forms a base for the Cor-ten steel portion. The granite connotes stability and dependability. The water from the surrounding fountain signifies Festivals. . . . The sweeping arc of steel, while recalling the flag, symbolizes Horizons—our expectations for the future. The deep red-brown color echoes the sacrifice of Americans in defense of our ideals."

Friedley-Voshardt Foundry

(American)

STATUE OF LIBERTY REPLICA *1951*

Figurative; 8'4" H; stamped sheet copper
Location: Texas State Capitol grounds
Funding: Boy Scouts of America
Comments: The Boy Scouts erected many of these statues throughout the United States during the fortieth anniversary of the scouting program. (See the Big Spring listing for more information on this project.) Al Friedley and Herman Voshardt advertised their architectural sheet-

metal ornaments and statuary as early as 1888, when they provided the *Goddess of Liberty* for the dome of the Texas State Capitol. The firm's 1894 catalogue claimed to be "the largest catalogue of sheet metal architectural ornaments, statuary, etc. ever published in this country" (McKinstry 1984, 24). Later expanding their product line to include spun work and artistic metal ceilings, Friedley-Voshardt offered items in lead, zinc, bronze, and copper—all manufactured at their Chicago foundry, located on blocks 733 to 737 South Halsted Street.

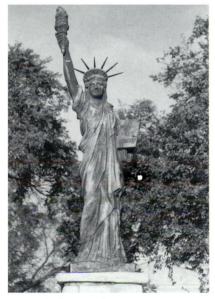

Statue of Liberty Replica. Photo by Robert Little.

Monumental Holistic XV. Photo by Robert Little.

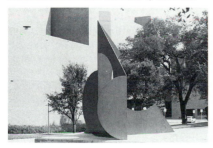

Gold, Betty

(Native Texan)

MONUMENTAL HOLISTIC XV
1981

Abstract; $11' \times 6'5'' \times 7'$; painted steel
Location: University of Texas campus, College of Fine Arts Performing Arts Center
Funding: Donated by Mr. and Mrs. Sidney Feldman
Comments: Gold's work appears in public settings and in private collections throughout the world. Although she works with tapestry, silk-screening, jewelry design, and other media, her primary focus is sculpture. Her large outdoor creations are nonobjective geometric patterns constructed from welded steel and often painted in brilliant colors with glossy enamel. In addition to her Texas placements at the University of Texas at Austin and the Art Museum of South Texas in Corpus Christi, other outdoor works by Betty Gold are installed at the Delaware Art Museum in Wilmington, Purdue University in West Lafayette, Indiana, the Ronald Reagan California State Building in Los Angeles, Florida Atlantic University in Boca Raton, and the National Museum of Contemporary Art in Seoul, Korea.

Goodacre, Glenna

(b. 1939 Native Texan)

PHILOSOPHERS' ROCK 1994

Figurative; 3 larger-than-life figures; bronze cast at Shidoni Art Foundry in Tesuque, New Mexico
Location: Zilker Park, near the entrance to Barton Springs Pool
Funding: Capital Area Statues, Inc. (CAST)
Comments: Capital Area Statues, Inc., is a loosely organized nonprofit group of citizens dedicated to the placement of publicly sited sculpture

in the Austin area. Supported entirely by donations, CAST raised $200,000 for its first project, *Philosophers' Rock,* which features three famous Texans engaged in a lively conversation near the banks of Barton Springs Pool. The men portrayed in the sculpture are J. Frank Dobie (1888–1964), an author, newspaper columnist, and University of Texas English professor; Roy Bedichek (1878–1959), an author, naturalist, and longtime director of the University Interscholastic League; and Walter Prescott Webb (1888–1963), an author, eminent historian, University of Texas history professor, and fellow of the Texas State Historical Association. Glenna Goodacre studied dozens of photographs before modeling her clay sketch, choosing as her inspiration a photograph of Dobie and Bedichek beside a rock at Barton Springs. Webb was not in the picture, and since the historian was known to dislike swimming, Goodacre added him to the group with his jacket and tie removed and his trouser legs rolled up, as if he were wading.

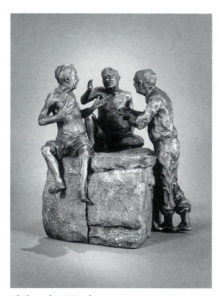

Philosophers' Rock. Photo by Ken W. Hall, courtesy Glenna Goodacre, Ltd.

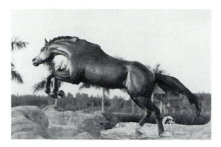

Freedom Mare Jumping Up. Photo courtesy Veryl Goodnight.

Goodnight, Veryl

(b. 1947 American)

FREEDOM MARE JUMPING UP
1992

Figurative; $1^1/_4$ life-size; bronze cast at Valley Bronze of Oregon in Joseph, Oregon
Location: University of Texas campus, north of the Lila B. Etter Alumni House
Funding: Private donation
Comments: This figure is from *The Day the Wall Came Down,* a monumental work consisting of five larger-than-life horses scaling a segment of the collapsed Berlin Wall. The first casting of the larger sculpture is to be installed in Berlin, Germany, and the second casting will be placed at the Bush Presidential Library at Texas A&M University in College Station. Other Austin placements by Veryl Goodnight are *Passing Times* and *No Turning Back,* both installed in the courtyard of the Hirshfeld-Moore House at the corner of West 9th and Lavaca streets. Joe and Betty Moore donated the Hirshfeld-Moore House and the courtyard sculptures to Texas A&M University. The restored Victorian home provides executive office space and hosts public events related to the mission and functions of the Texas A&M University System. The house is not open for tours, but visitors are welcome to view the courtyard, which is visible from the street.

Graeber, Larry

(b. 1949 American)*

MORNING STRETCH *1982*

Abstract; 7' H; painted steel
Location: Echelon Office Complex,
9400 block Research Boulevard
Funding: Walter Vackar

Hamilton, Jim

(b. 1919 American)

TEXAS LONGHORN *1992*

Figurative; 6' H at the withers; bronze
Location: University of Texas
campus, Texas Exes Plaza adjacent to
the Lila B. Etter Alumni House
Funding: Commissioned by the Ex-
Students' Association and donated by
Pete and Lynn Martin Coneway
Comments: Jim Hamilton is an
Oklahoma rancher who began
sculpting at age 48 and developed an
international following among
collectors of Western bronze sculp-
ture. Cast at Castleberry Art Foundry,
Texas Longhorn reflects Hamilton's
memory of the spirited longhorns
that he observed as a young man
working on the Oklahoma range.

Helmick, Ralph

(b. 1952 American)

STEVIE RAY VAUGHAN *1993*

Portraiture; 8' H; bronze
Location: 901 West Riverside Drive
on the shore of Town Lake
Funding: Stevie Ray Vaughan
Memorial Fund
Comments: Austinite and blues
guitarist Stevie Ray Vaughan is
legendary for his musical improvisa-
tions. This statue is placed near the
Auditorium Shores stage where
Vaughan played his last Austin
concert. He died in a helicopter crash
in 1990. Artist Ralph Helmick
designed the bronze shadow below

Stevie Ray Vaughan. Photo by Robert Little.

the standing figure as a metaphor for
the performer's musical legacy.
Helmick lives in Newton, Massachu-
setts, and teaches sculpture at the
School of the Museum of Fine Arts in
Boston.

Hernandez, T. Paul

(b. 1953 American)*

SNAKE CULVERT *1991*

Environmental; 14' × 4' × 4'; concrete
Location: Austin Community
Television Access studio,
1143 Northwestern Avenue
Funding: Commissioned by the city
of Austin through the Art in Public
Places program

Huntington, Anna Hyatt

(1876–1973 American)

DIANA THE HUNTRESS *1922*

Figurative; 8' H; bronze
Location: University of Texas
campus, courtyard bordered by

69

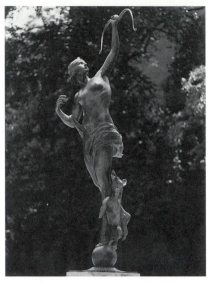

Diana the Huntress. Photo by Larry Murphy, courtesy University of Texas at Austin Office of Public Affairs.

Andrews, Blanton, Carothers, and Littlefield dormitories
Funding: Anna H. and Archer M. Huntington Endowment
Comments: The original casting of Huntington's *Diana* received the J. S. Saltus Medal at the National Academy of Design in 1922. The statue is signed "Anna V. Hyatt."

Josset, Raoul

(1898–1957 American/French)*

GENERAL SAM HOUSTON *1956*

Portraiture; life-size; bronze
(photo on p. 58)
Location: Lorenzo de Zavala State Archives and Library
Funding: Donated to the state in 1961 by the Masonic Lodges of Texas
Comments: Josset died during the completion of this statue, and his guild finished the work in his name. It was cast in pewter and covered with bronze in Italy. An identical statue is installed inside the Masonic Grand Lodge Library and Museum of Texas in Waco.

King, William

(b. 1925 American)

BUS STOP *1986*

Abstract; 10' H; aluminum sheeting
Location: 200 West 4th Street at Colorado Street
Funding: Commissioned by Schlotzsky's, Inc.
Comments: Nine stylized figures resemble a group of giant cookie cutters waiting at a bus stop in front of Schlotzsky's corporate office. King's famous elongated figures often have a humorous or comic quality.

Kitson, Theodora Alice Ruggles

(b. 1871 American)

THE HIKER *cast 1951*

Figurative; 8'5"; bronze cast at the Gorham Manufacturing Company, Providence, Rhode Island
Location: Texas State Capitol grounds
Funding: Spanish-American War Veterans and Auxiliaries, dedicated to Texans who died in the war

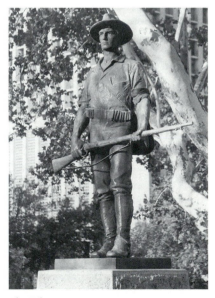

The Hiker. Photo by Robert Little.

70

Comments: In 1906, the first statue of *The Hiker* was cast at the Roman Bronze Works in New York and installed on the campus of the University of Minnesota. The Gorham Manufacturing Company of Providence, Rhode Island, acquired the rights to the statue from Kitson in the early 1920s, and between 1921 and 1965 the company cast at least fifty *Hiker* statues and placed them in towns and cities across the United States. *The Hiker* is one of the few large bronze monuments in Texas cast with sand molds rather than the lost-wax method. The popularity of *The Hiker* is due primarily to the accuracy of the rendition, which is usually considered essential to soldier statues, and to the pleasing appearance of the figure. Kitson's soldier carries a regulation rifle, and his uniform and accoutrements are realistic and historically accurate. The rugged and alert demeanor also is pleasing. Like Pompeo Coppini's Confederate soldier statue in Victoria and Neil Logan's modern soldier statue in Longview, *The Hiker* depicts a hero stripped of his parade uniform and shown as a soldier reacting to the challenges of the battlefield. Texas has two *Hiker* statues, one in Austin and one in Wichita Falls. The Austin *Hiker* was the last war-memorial statue placed on the capitol grounds.

Leftwich, Bill

(b. 1923 Native Texan)*

AUDIE L. MURPHY *1985*

Portraiture; 6' H; bronze cast at the Big Bend Art Foundry in Alpine
Location: Camp Mabry, West 35th
Funding: Sponsored by individual donors through the Texas National Guard
Comments: Audie Murphy (1924–1971) was a native Texan and the

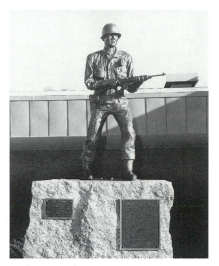

Audie L. Murphy. Photo by Ernie Cromeans, Staff Photographer, courtesy Adjutant General's Department, Texas National Guard.

most decorated soldier in World War II. He received every medal for valor the United States confers. France and Belgium also decorated him. Bill Leftwich lives in Fort Davis.

Michael, Simon G.

(American)

SALUTE *1943*

Portrait bust; larger than life-size; painted metal
Location: Camp Mabry, West 35th
Funding: Donated by Technical Sergeant Michael to the Infantry Replacement Training Center at Camp Wolters in recognition of the selfless devotion of American youth in their preparation for service through wartime training
Comments: Signed by the artist and Bateman Foundry, this bust of a soldier saluting was moved to Camp Mabry when Camp Wolters in Mineral Wells closed.

71

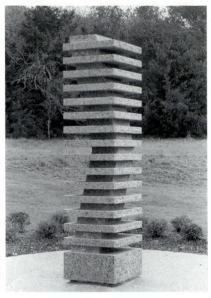

Las Mesas Inner Column. Photo by Robert Little.

Moroles, Jesús Bautista

(b. 1950 Native Texan)*

LAS MESAS INNER COLUMN *1986*

Abstract; 8' × 2' × 2'; Texas granite
Location: Century Park, a multipur-
pose development at 13521–13523
Burnet Road. The sculpture is
installed at the corner of Ida Ridge
Drive and Century Park Boulevard.
Funding: Century Park Development
Group

Mygdal, Eugenie Kamrath

(b. 1939 Native Texan)*

CRISS COLE *1995*

Portraiture; larger than life-size;
bronze cast at Schaefer Art Bronze in
Arlington
Location: Criss Cole Rehabilitation
Center for the Blind, 4800 North
Lamar
Funding: Gift of Joanne Cole in honor
of her husband

Comments: Cole served as a state
representative (1955–1962) and state
senator (1963–1970). From 1970 until
his death in 1985, he was Judge of
Juvenile Court 3 (now the 315th
District Court). A Japanese hand
grenade destroyed Cole's sight while
he was serving in the United States
Marine Corps during World War II.
After the war, he earned a bachelor of
science degree and a law degree from
the University of Houston. As an
attorney, a public servant, and a
judge, Cole was a champion and role
model for the physically challenged.
Mygdal graduated from the Univer-
sity of Texas with a bachelor of fine
arts degree in 1961. After studying in
Italy and at the University of Iowa,
she returned to Texas, where she has
continued her work in sculpture,
choosing the traditional media of
terra-cotta and bronze in her repre-
sentation of natural forms. Since
1972, she has been a member of the
professional staff at The Art Center,
Waco. In 1993, she opened EKM
Studio and Gallery in Houston.

Criss Cole. Photo courtesy Eugenie Kamrath Mygdal and
Sherlock-Garrett & Company.

DR. DANIEL A. PENICK *1986*

Portrait bust; life-size; bronze cast at
Castleberry Art Foundry in
Weatherford
Location: University of Texas
campus, Penick-Allison Tennis
Center
Funding: Private donation
Comments: As president of the Texas

Tennis Association for 50 years, Penick is considered by many to be the father of Texas tennis. A professor of Greek at the University of Texas, he also coached tennis at the university for more than half a century, retiring as coach in 1957.

Generations. Photo by Robert Little.

GENERATIONS *1990*

Figurative; 5 life-size figures; bronze cast at Castleberry Art Foundry in Weatherford
Location: University of Texas campus, Lila B. Etter Alumni House
Funding: Private donations
Comments: The artist writes about this work, "The center of the sculpture group is the longhorn calf, held by the cowboy. The rugged longhorn steer, mascot of the university, is depicted here as a new and curious calf. The old cowboy, representing wisdom and knowledge, is the link between the past, present and future. He is the facilitator to the new generations—calf and girl—who greet each other with excitement and wonder. The innocence and vulnerability of the youthful figures remind us of the care and attention which we need to give to members of generations to come. The longhorn calf suggests that the university is a place of yearly and continuing renewal, and that knowledge is passed on from generation to generation. The horse and pony form part of the composition in order to suggest that the university is a microcosm of, and is connected to, the wide variety of life

found in the world. The horse figures also connect the piece to Texas' Southwestern heritage. The entire sculpture group symbolizes the continuing efforts of ex-students and fellow citizens to sustain a university of the highest quality" (Mygdal 1989).

Non Nobis Solum. Photo by Robert Little.

NON NOBIS SOLUM *1988*

Figurative; 3 life-size figures; bronze cast at Castleberry Art Foundry in Weatherford
Location: Austin State School, 2203 West 35th
Funding: Commissioned by Mr. and Mrs. John McKetta
Comments: Asked to design a sculpture that would portray the school's spirit, the artist chose to emphasize the attributes of caring, sharing, and hope through two children with an Arabian yearling. Volunteers from ten local businesses, including secretaries, construction workers, and company officers, united to contribute more than $20,000 in goods and services toward preparation of the site for the sculpture. The artist was presented a Design Excellence Award from the City of Austin Design Commission for her work on this project. Translated "Not for Us Alone," this sculptural group is intended to convey the idea that the living, no matter in what form or circumstance, are made in God's mold. According to Mygdal, sharing one's self with a fellow creature, whether human or

animal, is a great opportunity and privilege that helps create a more civilized and humane culture.

WILMER LAWSON ALLISON *1987*

Portrait bust; life-size; bronze cast at Castleberry Art Foundry in Weatherford
Location: University of Texas campus, Penick-Allison Tennis Center
Funding: Private donation
Comments: Wilmer Allison coached the University of Texas tennis teams from 1957 to 1972. He won the Wimbledon doubles with John Van Ryn in 1929 and 1930, and he was a member of the U.S. Davis Cup teams in 1929–1933, 1935, and 1936. In 1930, the United States Lawn Tennis Association ranked Allison number three; in 1932 and 1933, the association ranked him number two; in 1934 and 1935, he ranked number one. Winning numerous titles throughout his career, Allison was inducted into the Texas Sports Hall of Fame in 1957 and into the International Tennis Hall of Fame in 1963.

Ney, Elisabet

(1833–1907 American/German)*

ALBERT SIDNEY JOHNSTON *1903*

Sarcophagus; life-size; white Italian marble
Location: Texas State Cemetery, 3001 Comal
Funding: Commissioned by the United Daughters of the Confederacy with funds allocated by the Texas State Legislature
Comments: The carved figure of General Johnston rests atop his crypt, which is surrounded by a wrought-iron fence and a Plexiglas dome. Johnston, leader of the Confederate troops at Shiloh, was wounded on the first day of the battle and bled to death while his staff physician treated the federal wounded. Ney shows the general in death attired in formal military dress. She completed the plaster cast in 1900, and the finished marble carving was shipped in 1904 from Seravezza, Italy, to Saint Louis, where it won a bronze medal at the Saint Louis World's Fair. It is signed "Elisabet Ney, 1903, Austin, Texas."

Albert Sidney Johnston (detail).
Photo courtesy *Texas Highways Magazine.*

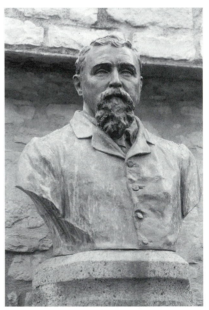

Dr. David Thomas Iglehart. Photo by Robert Little.

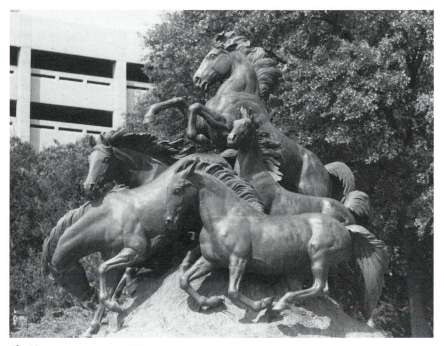

The Mustangs. Photo by Robert Little.

DR. DAVID THOMAS IGLEHART
1903

Portrait bust; life-size; bronze
Location: Austin Symphony Society office, Symphony Square, Red River and 11th
Funding: On permanent loan to the Austin Symphony Society by the Elisabet Ney Museum
Comments: Shortly after the death of Major Iglehart, his widow commissioned Ney to make this bust, which was mounted on a granite watering trough and donated to the city of Austin by Fanny Iglehart and the major's cousin Basil Clarke. The trough was installed at the terminus of Speedway Street. When Speedway was lengthened, the trough was placed on the Ney Museum property, where it remained until Travis County workmen moved it in the early 1960s to Symphony Square. The bust is signed and dated.

Proctor, Alexander Phimister

(1862–1950 American/Canadian)

THE MUSTANGS *1941*

Figurative; 15' H, 10 tons; bronze cast in a single unit at the Gorham Manufacturing Company in Providence, Rhode Island
Location: Texas Memorial Museum at San Jacinto and 24th
Funding: Donated by Ralph R. and Ethel Johnson Ogden
Comments: Shortly after J. Frank Dobie contacted Proctor about creating a monument to the wild horses of Texas, the artist submitted a 15-inch maquette of a small herd of adult mustangs. Dobie and Ralph Ogden suggested the addition of a young colt, and the deal was made with a handshake. During 1938 and 1939, the Proctor family moved onto the King Ranch in South Texas, where the artist could be close to his

subjects. He completed *The Mustangs* in 1941, but it could not be cast because metals critical to the casting process were unavailable during and immediately after World War II. In 1947, the Gorham bronze foundry pointed up the massive sculpture from a $3^1/_2$-foot working model. The finished work portrays seven spirited mustangs—a stallion, five mares, and a colt—as they scramble down a mountainside. Dobie wrote the narrative text and the inscription, "Mustangs. They carried the men who made Texas."

Santos, David

(b. 1958 Native Texan)*

BIG ROCK *1989*

Abstract; 15' H; Texas limestone
Location: Waterloo Park at Red River and 12th
Funding: Donated to the city by the artists
Comments: Two other Texas artists, Alex Iles and Joe Perez, assisted Santos with this work.

BIG ARCH *1992*

Abstract; 16' H; Texas limestone
Location: East Town Lake Park near 2401 Holly Street
Funding: City of Austin and the artists
Comments: Austin artist Joe Perez collaborated with Santos to create this giant arch spanning a popular hike-and-bike trail along the shores of Town Lake.

Shalom, Itzik Ben

(Israeli)

PRELUDE *1980s*

Abstract; 20' H; bronze cast at A.P. Casting in Israel

Location: Republic Square Park at 5th Street and Guadalupe
Funding: On long-term loan to the city of Austin

Steinheimer, Dana John

(b. 1951 American)*

FATHER MICHAEL J. MCGIVNEY *1986*

Portraiture; 2 life-size figures; bronze
Location: 2500 Columbus Drive, adjacent to Zilker Park
Funding: Knights of Columbus, Texas State Council
Comments: Father McGivney is depicted in this work with a small child walking beside him. Father McGivney established the Knights of Columbus in New Haven, Connecticut, in 1882. The K of C has grown into an international organization composed of Roman Catholic men who sponsor benevolent and educational projects.

Stolz, L. W.

(Native Texan)*

WORLD WAR II SOLDIER *1949–1950*

Figurative; life-size; bronze cast at Sheidow Bronze Company in Brooklyn
Location: Colorado and 11th
Funding: American Gold Star Mothers, Inc., Austin Chapter

World War II Soldier. Photo by Robert Little.

Comments: Stolz is a second-generation Texan whose grandfather Otto Emil Stolz immigrated from Germany in the 1870s and established Stolz Marble Works at La Grange in 1895, as well as the Premier Granite Quarries Company in Llano in the 1920s. After Otto Stolz's death in 1935, his sons Lorenz and Clinton continued the family business. L. W. Stolz owns and operates L. W. Stolz, Jr., Memorials in La Grange. He designed this statue while he was a student at the University of Texas at Austin.

Sundt, Duke

(b. 1948 American)

THE TEXAS LONGHORN *1983*

Figurative; 9' H × 10'6" L; bronze cast at the Santa Fe Bronze Foundry
Location: University of Texas Visitor Center, near the Arno Nowotny Building
Funding: Given in recognition of the university's centennial by the Texas

Wranglers and the Silver Spurs with funds raised through donations and sales of copies of the original maquette
Comments: Text panels mounted on a low, circular granite base include a quote by Berta Hart Nance: "Other states were carved or born. Texas grew from hide and horn." Also engraved on the base is a quote from L. Tuffly Ellis, who describes longhorn cattle as "tall, long-legged, flat-sided, thin-flanked, thick-skinned, powerful animals of remarkable hardiness and canniness."

Tauch, Waldine

(1892–1986 Native Texan)*

OVER THE TOP *1970*

Figurative; life-size; bronze
Location: American Legion Headquarters, 700 East 10th
Funding: The American Legion and Auxiliary in memory of the World War I veterans who founded the American Legion

The Texas Longhorn. Photo by Larry Murphy, courtesy University of Texas at Austin Office of Public Affairs.

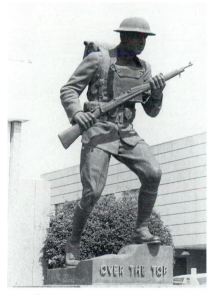

Over the Top. Photo by Robert Little.

Comments: Signed and dated, Tauch's World War I doughboy stands on a pink Texas granite base.

Teich, Frank

(1856–1939 German)*

FIREMAN, SAVE MY CHILD *1896*

Figurative; 9' H; bronze
Location: Texas State Capitol grounds
Funding: State Fireman's Association of Texas in memory of Eugene T. Deats, who died in the Blind Institute fire of November 9, 1877, and to all volunteer firemen who die performing heroic acts
Comments: Frank Teich is credited with providing the granite portion of this monument and the original stone statue, which was replaced by the current bronze figure in 1905. According to the statue's base, W. H. Mullins of Salem, Ohio, manufactured the bronze fireman figure, and J. Segesman, who probably worked under contract for Mullins, served as sculptor. An inscription on the original granite pedestal identifies the Brenham firm of Jaeggli and Martin as contractor and F. Teich of San Antonio as builder.

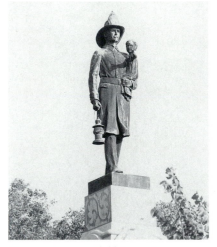

Fireman, Save My Child. Photo by Robert Little.

Umlauf, Charles

(1911–1994 American)*

THE ALLAN SHIVERS MONUMENT *circa 1985*

Figurative; 2 smaller-than-life figures; bronze
Location: Texas State Cemetery, 3001 Comal
Funding: Private commission
Comments: On a pedestal bearing the Texas state seal is a small casting of Umlauf's *Spirit of Flight*, first erected at Dallas Love Field Airport in 1961. On another pedestal at the base of the monument is a figure of a young woman with outstretched arms. Allan Shivers (1907–1985) was the governor of Texas from 1949 to 1957. He also served as a state senator, a lieutenant governor, a member of the Board of Regents of the University of Texas, and the president and chairman of the Chamber of Commerce of the United States.

THE AMERICAN EAGLE *1968*

Figurative; 6' H; bronze
Location: First Federal Savings of Austin, 10th and San Jacinto
Funding: John T. Mahone, president of First Federal Savings of Austin

FAMILY *1960–1961*

Figurative; 15'6" H; bronze
Location: University of Texas campus, near the entrance to the Graduate School of Business Building
Funding: University of Texas and Charles Umlauf
Comments: This figural group depicts a family, the basic unit of society. The artist supervised the casting in Italy and the installation on-site in 1962. Another casting of *Family* is installed at Waterwood National Resort and Country Club on Lake Livingston between Huntsville and Livingston. Umlauf also has several large relief sculptures attached to

Family. Photo by Larry Murphy, courtesy University of Texas at Austin Office of Public Affairs.

Kneeling Christ. Photo by Robert Little.

buildings in Austin. One of the most notable is *Ascension,* above the entrance to Saint Martin's Evangelical Lutheran Church.

KNEELING CHRIST *1985*

Figurative; 3'9" H; bronze
Location: Seton Medical Center, 1201 West 38th
Funding: Donated by Mr. and Mrs. Miguel Gonzalez-Gerth in memory of Betty Brumbalow Gonzalez-Gerth

MADONNA AND CHILD *1989*

Figurative; larger than life-size; bronze cast at the M. Del Chiaro Art Foundry in Pietrasanta, Italy
Location: Saint David's Hospital, 919 East 32nd Street, in the courtyard by the hospital cafeteria
Funding: Donated by Saint David's Hospital Auxiliary

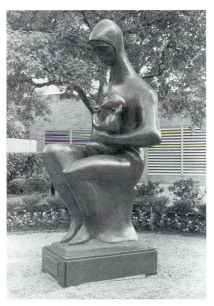

Madonna and Child. Photo by Robert Little.

MOTHER AND CHILD *1990*

Figurative; 6' H; bronze
Location: University of Texas

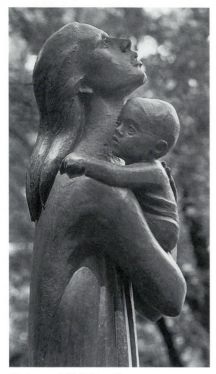

Mother and Child (detail). Photo by Janice Jacob/ *Texas Alcalde.*

campus, Jane and Roland Blumberg Amphitheater on Waller Creek
Funding: Donated to the Ex-Students' Association by Jack and Laura Lee Blanton

PROMETHEUS *1987–1989*

Figurative; 6' H; bronze
Location: Austin Community College Northridge campus, 11928 Stonehollow Drive
Funding: NCNB Texas

SPIRIT OF LEARNING *1989*

Abstract; 10' H; bronze cast at M. Del Chiaro Art Foundry in Pietrasanta, Italy
Location: Teacher Retirement System of Texas office, 1000 Red River
Funding: Teacher Retirement System of Texas purchase
Comments: The artist expresses in this work his hope that learning and understanding will enable humanity to overcome hunger, sickness, poverty, and the many other difficulties that plague the peoples of the world.

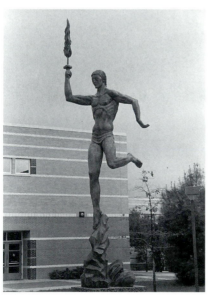

Prometheus. Photo by Robert Little.

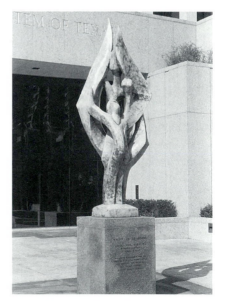

Spirit of Learning. Photo by Robert Little.

SYMBOL OF EDUCATION
1969–1970

Abstract; 6' H; bronze
Location: Texas State Teachers
Association office, 316 West 12th
Funding: Texas State Teachers
Association in memory of Charles H.
Tennyson, former president of the
TSTA
Comments: This work symbolizes
the bud of knowledge, which can be
nurtured into full bloom through
education.

THE THREE MUSES *1963*

Figurative; 3 companion pieces 4'2"
H, 5'2" H, and 2'9" H; bronze

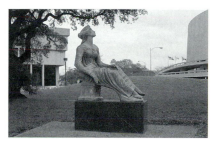

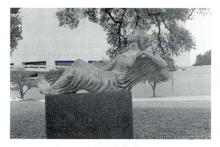

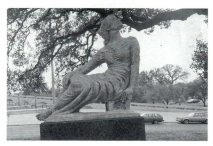

The Three Muses. Photos by Larry Murphy, courtesy
University of Texas at Austin Office of Public Affairs.

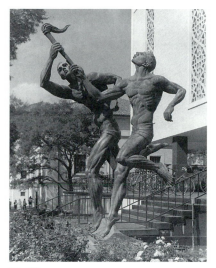

Torchbearers. Photo courtesy Mears Photography and
Charles Umlauf.

Location: University of Texas
campus, Centennial Park,
1500 block Red River
Funding: University of Texas and
Charles Umlauf
Comments: Originally placed in the
roof garden of the Academic Center,
the three figures were moved to
Centennial Park in 1984.

TORCHBEARERS *1962*

Figurative; 12'6" H; bronze
Location: University of Texas campus,
Peter T. Flawn Academic Center
Funding: University of Texas and
Charles Umlauf
Comments: Completed in 1962 and
installed in March 1963, this sculp-
ture portrays two relay runners
passing the symbolic torch of
enlightenment.

Unknown Artist

THE JOHN B. CONNALLY
MONUMENT *n.d.*

Portraiture; life-size; stone
Location: Texas State Cemetery,
3001 Comal

Funding: John and Idanell Brill
Connally
Comments: This statue of Saint
Andrew marks the grave site of John
Connally, who served as secretary of
the Navy in the Kennedy administra-
tion, secretary of the Treasury during
the Nixon administration, and
governor of Texas from 1963 to 1969.
During World War II, Connally won
the Bronze Star for valor. The statue
of Saint Andrew was installed
originally at Westminster Abbey, the
world-famous Gothic church in
Westminster, London. During a visit
to England, the Connallys admired
and later purchased the figure, which
was being sold at auction.

Unknown Artist

SAINT FRANCIS OF ASSISI *1977*

Portraiture; 2' H; bronze cast at
Kasson's Castings in Austin
Location: Zilker Botanical Gardens,
2220 Barton Springs Road
Funding: Donated by the Catholic
Women's Study Club of Austin

Unknown Artist

SAINT PETER HOLDING THE KEYS TO THE KINGDOM REPLICA
circa 1959

Portraiture; life-size; bronze
Location: In front of the Diocese
of Austin Chancery building,
1600 Congress Avenue
Funding: Chancery, Diocese of Austin
Comments: The church ordered this
statue for the new chancery from
Hans C. Hansen in New Orleans,
Louisiana. The original work is in the
basilica of Saint John Lateran in
Rome.

Unknown Artist

TOLTEC WARRIOR REPLICA
A.D. *900–1150*

Figurative; 15' H; acrylic
Location: University of Texas
campus, Sid Richardson Hall, south
end
Funding: University of Texas and the
National Museum of Anthropology

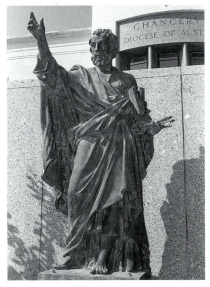

*Saint Peter Holding the Keys to the Kingdom
Replica.* Photo by Robert Little, courtesy Catholic Archives
of Texas.

Toltec Warrior Replica. Photo by Robert Little.

and Natural History in Mexico City
Comments: This work was cast from an original figure that served as one of the supporting columns for the roof of a Toltec temple in Tula in the Mexican state of Hidalgo.

Venet, Bernar

(b. 1941 French)

WESTECH SCULPTURE *1986*

Abstract; 80' H; painted steel
Location: Westech 360, 8911 Capital of Texas Highway
Funding: Commissioned by the Linpro Company of Dallas
Comments: Shaped as a broken line, this sculpture rises from ground level and forms an acute angle that extends to the adjacent building. *Westech Sculpture* was designed as a dynamic entrance piece that complements the natural landscape and the adjoining structures in this office park.

Villa, Hugo

(1881–1952 American)

TEXAS MEMORIAL TO HONORED DEAD *1931*

Figurative; larger-than-life figure and 10' × 30' text panel; bronze
Location: University of Texas campus, north end of Memorial Stadium above the bleachers
Funding: Provided by an act of the 40th Texas Legislature and originally dedicated to the memory of the men and women from Texas who lost their lives in the service of their country during World War I
Comments: The allegorical figure Columbia is three-dimensional above the waist, but the lower body and legs are in relief. She holds an upraised olive branch, the symbol of peace. The huge bronze tablet gives the name, rank, unit, and date and place of death for each person listed. In

1977, Memorial Stadium and this sculpture were rededicated to the memory of all American veterans of all wars. Hugo Villa worked for the Southwell Company in San Antonio during the 1930s, when he sculpted the patterns for the bronze historical markers commissioned for the Texas Centennial. He later left the company to work for Gutzon Borglum.

THE EVOLUTION OF A GREAT STATE *1938*

Figurative; 5' H × 3' W; bronze
Location: Colorado and 12th
Funding: The inscription on the monument reads, *"Texas Historical and Biographical Record* through donations given in honor of the builders of Texas."
Comments: This freestanding bas-relief scene represents stages in the development of Texas, from frontier days to the present. The only record at the Austin History Center or the Barker Texas History Center of a publication titled *Texas Historical and Biographical Record* is a privately published book by Austinite Ernest Emory Bailey. The undated copy is believed to have been published in the late 1930s or early 1940s. It is a genealogical study of historic Texas families. Proceeds from the sale of this book may have funded Villa's bas-relief monument to the builders of Texas.

Visser, Mary

(b. 1946 Native Texan)*

COLOR AT PLAY *1989*

Abstract; 12' × 5' × 2'; ceramic shell over cast concrete
Location: University Hills Library, 4721 Loyola Lane
Funding: Commissioned by Raye and Walter Carrington in memory of Cathy Carrington and Adriana Visser
Comments: This sculpture received

Best in Show for the 1990 Design Excellence Award from the City of Austin Design Commission.

Color at Play. Photo courtesy Mary Visser.

Wade, Bob

(b. 1943 Native Texan)*

BIG MOUTH *1992*

Figurative; 14' L; steel and fiberglass
Location: Chuy's Hula Hut,
3825 Lake Austin Boulevard
Funding: Chuy's
Comments: Originally installed as a rooftop sculpture in Dallas, *Big Mouth* migrated to the pond at Chuy's restaurant in 1995. A coin-operated machine allows patrons of the restaurant to activate the big-mouth bass's motorized head.

Big Mouth. Courtesy Bob Wade.

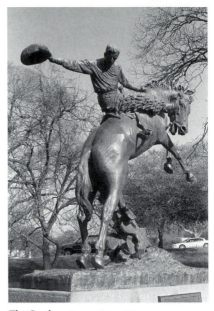

The Cowboy. Photo by Robert Little.

Warren, Constance Whitney

(1888–1948 American)

THE COWBOY *1925*

Equestrian; life-size; bronze
Location: Texas State Capitol grounds
Funding: Donated by Constance Warren through the efforts of Charles Carson of Houston and Governor Pat Neff
Comments: A native of New York, Warren lived most of her adult life in France, where she modeled this equestrian statue in her Paris salon. Warren's idealized conception of life in the American West was influenced by her father, who told her stories of his experiences working as a mining engineer in Texas and other western states. She dedicated *The Cowboy* to the rough and romantic riders of the range.

Special Collections and Sculpture Gardens in Austin

The Austin Museum of Art at Laguna Gloria is located along the Colorado River at 3809 West 35th Street in an Italianate villa built in 1916 by H. H. and Clara Driscoll Sevier. In 1943, the Seviers donated their home and the surrounding 29 acres to the Texas Fine Arts Association; Laguna Gloria Art Museum assumed its operation in 1961 and in 1994 changed its name to Austin Museum of Art at Laguna Gloria. Three site-specific installations have been created as part of the museum's outdoor sculpture program, which provides for sculptors from different aesthetic perspectives to create works specifically for the museum grounds:

INTERIOR EXTERIOR PLACE *1982*, a wood, papier-mâché, and stone sculpture consisting of three freestanding panels that enclose a small area while creating openings through it, by Clyde Connell (b. 1901, American)

TIME SPAN *1981*, a wrought-iron, concrete, and stucco installation that tracks the annual movement of the sun as it casts varying shadows on the natural landscape, by Nancy Holt (b. 1938, American)

DAYTON *1977–1978*, a granite and steel abstract by Jim Huntington (American)

Time Span. Photo by Peter Mears, courtesy Austin Museum of Art at Laguna Gloria and John Weber Gallery, New York.

Mystic Raven. Photo by Jimmy Jalapeeno, courtesy Austin Museum of Art at Laguna Gloria.

In addition to the site-specific sculptures, other works in the museum's outdoor collection include:

MYSTIC RAVEN *1983*, a 22'-tall polychromed-steel abstract by David Deming. When this combination of man, bird, and machine imagery was originally installed in front of First City Centre, at Congress Avenue and 9th, it was the first monumental sculpture placed in Austin's central business district. The art museum acquired the sculpture in the early 1990s, when First City Centre underwent extensive renovation.

SWEET KISS OF FORGIVENESS *1993*, a cast-concrete figurative installation by T. Paul Hernandez, combining yard-art statuary with human and animal symbology

BLUE FLOAT *1978*, a milled-steel construction by Peter Reginato, donated to the museum by Ralph and Maconda O'Connor in honor of Mr. and Mrs. John M. Schiltz

85

Blue Float. Photo by Peter Mears, courtesy Austin Museum of Art at Laguna Gloria.

Seated Figure (1965). Photo by Alan J. Herbert, courtesy Umlauf Sculpture Garden & Museum.

POETESS *1956,* a cast-stone reclining female figure by Charles Umlauf, donated to the museum in 1979 by Mr. and Mrs. H. E. Jessen

The Umlauf Sculpture Garden and Museum is located at 605 Robert E. Lee Road. In 1985, Charles and Angeline Umlauf donated their home, studio, and more than 250 of the artist's sculptures to the city of Austin. The city acquired additional adjoining land from the state of Texas for a museum and garden to display most of the collection. A generous matching challenge grant from the Meadows Foundation and private contributions raised under the leadership of Austin arts patron Roberta Crenshaw funded construction costs on the museum building. Friends of the Umlauf Sculpture Garden manage the museum, which is supported by grants, donations, visitor admissions, rental of the facility for private functions, and interest from the Umlauf Sculpture Garden Endowment Fund. Austin's Parks and Recreation Department maintains the Xeriscape garden and grounds.

B

Ballinger

Bandera

Bay City

Beaumont

Bedford

Beeville

Belton

Big Sandy

Big Spring

Blessing

Boerne

Bonham

Brady

Brazoria

Breckenridge

Brownwood

Bryan

Burnet

Ballinger

Coppini, Pompeo

(1870–1957 American/Italian)*

CHARLES NOYES MEMORIAL
1919

Equestrian; life-size; bronze cast by
the Florentine Brotherhood Foundry
at the Stockyard in Chicago
Location: Runnels County Court-
house grounds
Funding: Gus Noyes in memory of
his son Charles and honoring all
Texas cowboys
Comments: Pompeo and Elizabeth
Coppini were living in Chicago when
Gus Noyes contacted the artist
through Waldine Tauch, who had
known the Noyes family since she
was a young girl. The wealthy
rancher wanted a statue of his son
with his favorite horse erected on the
open range at the spot where the boy
had died. Charles Noyes had been
working cattle when a calf that was
cut from the herd frightened his horse
and caused both horse and rider to
fall. When Coppini came from
Chicago to talk with Noyes about the
commission, he stayed in Charles'
room: "In one corner was the saddle
on which he took the last ride, and
lots of other belongings. I was told
that he was hardly twenty years old,
but was six feet four inches tall in his
stocking feet. I tried to see him in my
imagination and could not sleep all
night" (Coppini 1949, 223). Using
Charles' horse, saddle, tack, clothes,
and a few photographs, Coppini
worked on the two figures until Gus
Noyes said, "Please do not touch it
any more, as it is my Charlie now"
(241). The monument is installed on
the courthouse lawn instead of the
open range because Noyes, unable to
adjust to the surroundings that
reminded him of his son's death, sold
the ranch. He did not even attend the

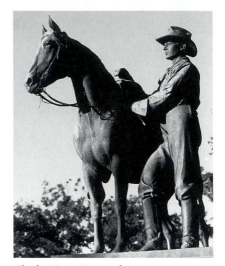

Charles Noyes Memorial.
Photo courtesy *Texas Highways Magazine.*

unveiling on October 25, 1919.
Charles is portrayed standing beside
his horse in his working clothes
wearing gloves and a cowboy hat—as
he was on the day he died.

Bandera

Anderwald, Norma Jean

(Native Texan)*

**BANDERA COWBOY CHAMPION
MONUMENT** *1982*

Figurative; 2'6" H × 4'4" L on an 8' H
base; bronze and native fieldstone
Location: Bandera County Court-
house grounds
Funding: Bandera County Chamber of
Commerce
Comments: Anderwald's sculpture
honors seven national and world
champion cowboys whose roots are in
Bandera County, the Cowboy Capital
of the World. The bas-relief plaque on
the monument features a replica of
the belt buckle awarded to the seven
champions. Thomas O. Smith built
the monument with stone donated

from the ranch of Toots Mansfield, seven times world-champion calf roper. The bronze portion of the monument was cast at OMC Industries in Bryan. Also located on the courthouse grounds is a small bas-relief plaque designed by Charles Simmang in 1936 for the Commission of Control for Texas Centennial Celebrations. It honors Amasa Clark, a member of the U.S. Infantry under Winfield S. Scott. One other interesting sculpture in Bandera is a totem pole placed at the entrance to the Frontier Times Museum at 506 13th Street. No one in Bandera can verify the origin of the 12-foot carved-wood totem. It has marked the entrance to the museum since 1944, except for a seven-year period while it awaited repairs after being broken by a storm. A few years ago, the museum president discovered the damaged totem pole rotting in tall grass a few blocks from the museum. She retrieved the old treasure, which was repaired and reinstalled at the museum's front door.

Bay City

McNeel Marble Company

(American)

CONFEDERATE SOLDIER STATUE
1913

Figurative; larger than life-size; white Georgia marble
Location: The town square in the center of the city
Funding: Captain E. S. Rugeley Chapter 542, United Daughters of the Confederacy
Comments: A general assumption has been that Teich Monument Works provided this statue. Teich was well known to the residents of Matagorda County because he erected the highly publicized Shanghai Pierce statue at Blessing in 1895. News articles announcing the unveiling of the soldier statue at Bay City do not refer to the artist; however, correspondence between the McNeel Marble Company in Marietta, Georgia, and Captain F. B. Chilton, monument

Bandera Cowboy Champion Monument.
Photo by Robert Little.

Confederate Soldier Statue. Photo by Robert Little.

89

committee chairman for the Hood's
Texas Brigade Monument in Austin,
includes references to a new contract
between the company and the United
Daughters of the Confederacy in Bay
City (Texas Collection, February 16,
1911). The unveiling ceremonies on
January 17, 1913, began with a parade
headed by the National Rice Growers
Band.

Beaumont

Cargill, David

(b. 1929 Native Texan)*

BAPTISM OF CHRIST *1965*

Figurative; 10' H; bronze cast by the
artist
Location: Trinity United Methodist
Church, 3430 Harrison
Funding: The Friendship Women's
Sunday School Class
Comments: The sculpture of Beau-
mont artist David Cargill is placed in
public and private collections
throughout the United States.
Creating inspiring and sometimes
whimsical figures, Cargill enhances
the positive areas of life by exalting
beauty, spiritual faith, and familial
love. His stylized sculptures of
animals and children at play are
among his most popular works.

**THE IMPORTANCE OF
BEING MARY** *1977*

Abstract; 5' H; nickel-plated bronze
cast by the artist
Location: Art Museum of Southeast
Texas, 500 Main Street
Funding: Commissioned by the
Beaumont Art Museum, now the
Art Museum of Southeast Texas

LAST SUPPER *1958*

Figurative; 6' H; marble and brick
Location: Forest Lawn Memorial

The Importance of Being Mary.
Photo by Keith Carter, courtesy David Cargill.

Last Supper. Photo by Mamie Bogue.

Love of Family. Photo by Mamie Bogue.

Park, 4955 Pine Street
Funding: Forest Lawn Memorial Park
Cemetery Association

LOVE OF FAMILY *1963*

Figurative; 4 life-size figures; bronze
Location: Forest Lawn Memorial
Park, 4955 Pine Street
Funding: Forest Lawn Memorial Park
Cemetery Association

MEN OF VISION *1995*

Portraiture; 6'6" × 7'5" × 4'6"; bronze
cast by David Cargill at his studio
foundry in Beaumont
Location: Art Museum of Southeast
Texas, 500 Main Street
Funding: Friends of the Rogers
Brothers Committee, through the Art
Museum of Southeast Texas
Comments: Cargill's statues depict
four brothers, Victor J. Rogers, Dr. Sol
J. Rogers, Ben J. Rogers, and Dr.
Nathan J. Rogers. The brothers were
born in Chicago to immigrant parents
who fled Eastern Europe after World
War I. In 1936, Ben Rogers joined his
optometrist brother, Sol, in Texas,
where they founded Texas State
Optical. The four brothers amassed a
fortune, which they used to help
others. Before his death, Ben Rogers
founded and supported dozens of
causes, including the "I Have a
Dream" scholarship program, Boys'
Haven, the Art Museum of Southeast
Texas, the Julie Rogers Theater, the
Babe Zaharias Museum, and the Julie
and Ben Rogers Cancer Institute at
Baptist Hospital of Southeast Texas.

MIRABEAU B. LAMAR *1965*

Portrait bust; larger than life-size;
bronze cast by the artist
Location: Lamar University campus,
4400 Martin Luther King Parkway
Funding: Donated by Ethel (Mrs.
O. B.) Sawyer and the students,
faculty, and staff of Lamar University
Comments: Lamar served as the third

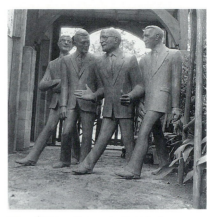

Men of Vision. Photo courtesy David Cargill.

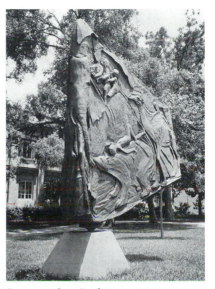

Passengers from Earth. Photo by Keith Carter,
courtesy David Cargill.

president of the Republic of Texas,
and he is known as the father of
public education in Texas.

PASSENGERS FROM EARTH *1974*

Figurative; 8' H; bronze cast by the
artist
Location: Beaumont Public Library,
801 Pearl
Funding: Gift of Carol Tyrrell
(Mrs. W. W.) Kyle

91

WINNING *1982*

Abstract; 17' H; stainless steel
fabricated by the artist
Location: Civic Center Plaza between
the Civic Center and City Hall
Funding: Gift to the city from Irving
M. Eisen and Harold M. Eisen,
owners of Sampson Steel Corporation

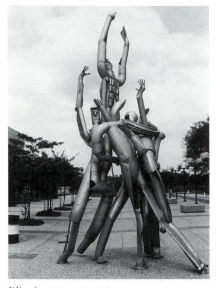

Winning. Photo by Mamie Bogue.

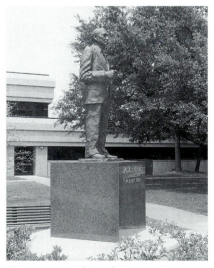

Congressman Jack Brooks. Photo by Mamie Bogue.

Clark, Doug

(b. 1949 Native Texan)*

CONGRESSMAN JACK BROOKS
1989

Portraiture; life-size; bronze cast at
the Fundición Artística in Mexico
City
Location: Lamar University campus,
4400 Martin Luther King Parkway
Funding: Private donations
Comments: Doug Clark received a
bachelor of fine arts degree at the
University of Texas at Austin. In
1990, he was commissioned to design
and sculpt the first Mildred "Babe"
Zaharias American Female Athlete of
the Year trophy, awarded annually in
Beaumont. His studio and foundry are
in Port Arthur.

Coppini, Pompeo

(1870–1957 American/Italian)*

GEORGE O'BRIEN MILLARD *1912*

Portraiture; 7' H; bronze
Location: Pipkin Park, Riverside
Drive and Park Street
Funding: Public donations, including
$300 raised by local schoolchildren,
to a monument committee
Comments: Millard was a member of
the school board and a benefactor of
Beaumont public schools. His statue
originally stood in front of the high
school.

Kitson, Theodora Alice Ruggles

(b. 1871 American)

THOMAS ALVA EDISON *1983,
original mold made 1932*

Portrait bust; 2'6" H; bronze
Location: Edison Plaza Museum,
350 Pine Street
Funding: Donated by Morris Aubry
Architects of Houston

Comments: The first casting of this work is placed at the Edison National Historic Site in West Orange, New Jersey. The Charles Edison Fund gave special permission for this casting from the original mold. The Edison Plaza Museum is located in the historic Travis Street Substation, the first building to distribute electric power in East Texas. The museum houses the largest collection of Thomas Alva Edison inventions west of the Mississippi River.

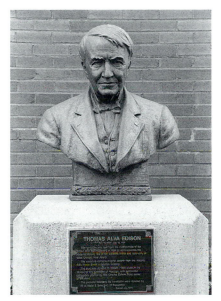

Thomas Alva Edison. Photo by Mamie Bogue.

Kraft, Stuart, and students

(b. 1953 American)*

PHOENIX 1 *1980*

Abstract; 17' × 4' × 9'; painted steel
Location: Westbrook High School Ninth Grade Center, 3443 Fannett Road
Funding: National Endowment for the Arts and the Texas Commission on the Arts

Phoenix 1. Photo by Mamie Bogue.

McArthur, John

(American)

JOE LOUIS *1983*

Portrait bust; 1' 9" H; bronze
Location: 701 Main
Funding: "Contributed with love and fond memories of Joe Louis by Julie, Ben, and Regina Rogers," according to the inscription on the base
Comments: Ben Rogers, a lifelong friend of Joe Louis, was the founder and president of the Joe Louis International Sports Foundation, which has contributed $200,000 to youth organizations throughout the country. John McArthur lives in New York City.

Joe Louis. Photo by Mamie Bogue.

93

McNeel Marble Company
(American)

OUR CONFEDERATE SOLDIERS
1912

Figurative; 6'6" H; molded copper
Location: Weiss Park at Laurel and
Magnolia streets
Funding: Albert Sidney Johnston
Camp, United Confederate Veterans,
and the citizens of Beaumont
Comments: Originally erected in
Keith Park, this statue was moved to
its present location in 1926. In
October 1986, the soldier toppled
from his summit during a storm.
Weeren Enterprises, Inc., in
Nederland repaired the figure and
replaced him on his pedestal. Jack
Weeren observed no foundry marks
on the soldier statue, but he noted
that the figure was copper instead of
bronze as previously thought. Adolph
Geywitz, a representative of the
McNeel Marble Company, arrived in
Beaumont on October 13, 1912, to
oversee the erection of the monu-
ment, which was dedicated on
Confederate Day, November 27,
1912, during the Southeast Texas Fair
(*Beaumont Enterprise*, October 14,
1912).

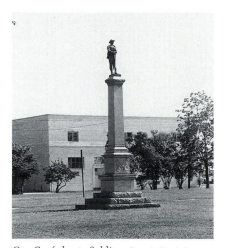

Our Confederate Soldiers. Photo by Mamie Bogue.

Bedford

Harper, John
(Native Texan)*

PARDNERS *1986*

Figurative; life-size; bronze
Location: First American Savings,
1903 Central Drive
Funding: Commissioned by Bedford
Savings and Loan
Comments: The artist drew on his
firsthand experience as a gold miner,
fur buyer, cowboy, and horse trainer
to create historical relevance and
accuracy in his sculptures. At the
time of his death, Harper was a
resident of Tyler.

Pardners. Photo by Robert Little.

Beeville

Borglum, Lincoln
(1912–1986 American)*

CHRIST *1958–1959*

Figurative; life-size; stone
Location: Memorial Park Cemetery,
east of Beeville on U.S. 59
Funding: Private commission
Comments: Lincoln Borglum was the
son of Gutzon Borglum and an
accomplished artist in his own right.
Lincoln Borglum moved to San
Antonio with his family in the 1920s,
and after graduating from high school,
he joined his father in South Dakota
to help the senior Borglum carve his

famous presidential busts into the side of Mount Rushmore. Lincoln completed the busts after Gutzon's death in 1941 and became the first superintendent of the Mount Rushmore National Monument. He was living in Beeville at the time he created this statue of Christ for Memorial Park Cemetery. Other figures of Christ by unidentified artists are located in the cemetery and in the city of Beeville on the grounds of Saint James Catholic Church at 605 Alta Vista Street.

Christ. Photo by Robert Little.

Watson, Colin Webster

(American)

CRETAN BULL DANCERS
acquired 1984

Figurative; 5' H × 6'8" L; bronze
Location: Beeville Art Gallery and Museum grounds, 401 East Fannin
Funding: Meadows Foundation
Comments: This figure is reminiscent of the ancient Cretan dancers who performed on the backs of bulls.

Cretan Bull Dancers. Photo by Grady Harrison, courtesy Beeville Art Gallery and Museum.

Zimmerman, Blaine, and Joe Ennis

(Americans)*

THE IRON MAN *1966*

Abstract; larger than life-size; automobile parts
Location: Meyers Auto Parts, 500 East Houston Street
Funding: Private funding

Special Collections and Sculpture Gardens in Beeville

The permanent sculpture exhibit on the campus of **Bee County College** includes four abstract installations:

TOWER OF REPOSE *n.d.,* by Barrett
 Conrad DeBusk
ZEN GARDEN *1992,* by Jayne
 Duryea and the college glass-
 blowing class of 1992
DINOSAUR *1990,* by Andy North
 and Colin Short
ARTIST AT WORK *1992,* by Roland
 Reyna and Jayne Duryea

Belton

Agopoff, Agop M.

(American)

GOVERNOR PETER HANSBROUGH BELL *1936*

Portraiture; 8'6" H; bronze

95

Location: Bell County Courthouse grounds, East Ave. A and South Main
Funding: $7,500 allocated by the 1936 Commission of Control for Texas Centennial Celebrations
Comments: Bell was a Texas governor, a U.S. senator, a captain in the Texas Rangers, and a veteran of San Jacinto and the Mexican War of 1845. The statue's pedestal is pink Marble Falls granite.

Georgia, by 1891. In 1917, the company merged with the Kennesaw Marble Company and continued operations in Marietta as the Georgia Marble Company, with Colonel Sam Tate as president. When the demand for commemorative marble sculpture decreased after World War II, the Marietta plant began finishing marble for interior and exterior building work.

Governor Peter Hansbrough Bell.
Photo by Robert Little.

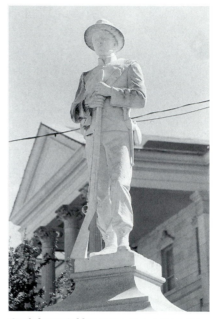

Confederate Soldier Statue. Photo by Robert Little.

Georgia Marble Company

(American)

CONFEDERATE SOLDIER STATUE
1916

Figurative; 7' H; marble
Location: Bell County Courthouse grounds, East Central Avenue and South Main
Funding: Bell County Chapter 101, United Daughters of the Confederacy
Comments: The Georgia Marble Company was in operation in Tate,

Big Sandy

Wynne, Sir David

(British)

SWAN IN FLIGHT *1969*

Figurative; larger than life-size; bronze
Location: Ambassador University campus, Administration Building, U.S. 80
Comments: This work depicts a swan in the five stages of flight.

Swan in Flight. Photo courtesy Office of Institutional Development, Ambassador College.

Big Spring

Friedley-Voshardt Foundry

(American)

STATUE OF LIBERTY REPLICA
1950

Figurative; 8'4" H; stamped sheet copper
Location: Southwest corner of 3rd Street and Nolan
Funding: Boy Scouts of America and Mr. and Mrs. Tom Good in memory of their son, Jake
Comments: Early in 1949, Jack P. Whitaker, Scout commissioner of the Kansas City Area Council, conceived the idea to make a replica of the Statue of Liberty available to individual communities throughout America as part of the Boy Scouts Fortieth Anniversary Crusade. The Boy Scouts enthusiastically adopted Whitaker's idea, and the money for each statue was raised locally through community involvement that included every segment of the citizenry. Six thousand people attended the dedication for the first Statue of Liberty replica on November 20, 1949, in Kansas City, Missouri. The official plaque attached to the base of this statue reads: "With the faith and courage of their forefathers who made possible the freedom of these United States, the Boy Scouts of America dedicate this copy of the Statue of Liberty as a pledge of everlasting fidelity and loyalty. 40th anniversary crusade to strengthen the arm of liberty, 1950."

Sandifer, Rosie

(b. 1946 American)

ADAPTABLE PREDATOR *1995*

Figurative; larger than life-size; bronze
Location: Howard College campus
Funding: Commissioned by the college
Comments: Sandifer's sculpture depicts the school's mascot, the Harris hawk, named for the close friend of John James Audubon, Edward Harris.

Blessing

Teich, Frank

(1856–1939 German)*

SHANGHAI PIERCE *1895*

Portraiture; life-size; marble
Location: 2.7 miles east of Blessing turn north off Texas 35 onto Hawley Cemetery Road
Funding: Colonel Abel Head Pierce
Comments: Dozens of stories have circulated about this monument, perhaps because of the eccentric, flamboyant character of its subject, Able Head "Shanghai" Pierce. The wealthy, boastful rancher claimed to own half the beef in Christendom and described himself as "Webster on cattle." Pierce met Frank Teich while the monument maker was in Blessing visiting the cattleman's brother, Jonathan, who planned to purchase markers for the graves in the Pierce family cemetery. Teich spent the night at the Pierce ranch, and before he returned to San Antonio, he accepted a commission to produce a

97

Shanghai Pierce. Photo by Robert Little.

portrait statue for Shanghai Pierce's grave site. Pierce stipulated that his monument should be as high as any Confederate general and a "fair likeness" of himself. A few months later, a Southern Pacific train brought the marble statue and granite pedestal to El Campo; six oxen hauled the heavy load to the cemetery at Blessing. During a cold and windy rainstorm in December 1900, Shanghai Pierce was laid to rest in a waterlogged grave at the foot of the monument he commissioned from Teich.

Funding: City of Boerne and private donations

Comments: The limestone base of this monument was dedicated on March 6, 1923, in honor of Kendall County's World War I veterans. Almost seventy years later, local citizens gathered to dedicate four bronze busts placed on top of the original monument. The new memorial honors all Kendall County veterans. Jay Hester's studio is in Boerne.

Veterans Park War Memorial. Photo courtesy Jay Hester.

Boerne

Hester, Jay

(b. 1940 American)*

VETERANS PARK WAR MEMORIAL *1992*

Figurative; larger than life-size; bronze
Location: Veterans Park, Main Street (U.S. 87)

Bonham

Anderson, E.

(American)*

CONFEDERATE SOLDIER STATUE *1905*

Figurative; larger than life-size; granite
Location: Fannin County Courthouse grounds

98

Funding: Fannin Chapter 244 and Nathan Bedford Forrest Chapter 256, United Daughters of the Confederacy, and the Sul Ross Camp, United Confederate Veterans, through a monument committee chaired by Dr. John Cunningham

Comments: E. Anderson, proprietor of Bonham Marble Works, designed and built the base and ordered the soldier figure from Italy. The monument is dedicated to the memory of Companies E and F of the 11th Texas Cavalry. Reporting on the dedication ceremony of July 26, 1905, the local newspaper noted that soon the old veterans who watched the unveiling with expectant upturned faces would be gone, "but another generation will come and admire it . . . and [their] hearts will swell with gratitude for such a noble, country-loving, self-sacrificing ancestry" (*Bonham Daily Favorite*, July 27, 1905). Eighty-eight years later, on April 17, 1993, this prediction was realized when members of the Sons of Confederate Veterans from Fannin, Sherman, and Dallas, along with other descendants of Confederate soldiers and guests, rededicated this monument.

Easley, William

(b. 1944 Native Texan)*

CHILDREN/LAW ENFORCEMENT MONUMENT *1994*

Figurative; 3'6" H × 5' W; black granite

Children/Law Enforcement Monument.
Photo courtesy *Bonham Daily Favorite.*

Location: Bonham Public Library, 305 East 5th

Funding: Private donations from the community through the Chamber of Commerce

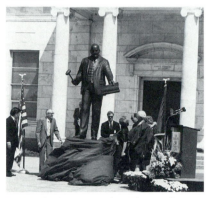

Lady Bird Johnson unveiling Blaine Gibson's statue of Sam Rayburn on September 14, 1990.
Photo courtesy *Sam Rayburn Library.*

Gibson, Blaine

(American)

SAM RAYBURN *1990*

Portraiture; 8' H; bronze

Location: Sam Rayburn Library, 800 West Sam Rayburn Drive

Funding: Donations

Comments: Sam Rayburn served as speaker of the United States House of Representatives from 1940 until his death in 1961, with the exception of four years when he was the minority leader. His unique leadership role in American politics is documented in the books, papers, and historical mementos available for study and research at the Sam Rayburn Library. The Sam Rayburn Sculpture Plaza at the entrance to the library is a combined effort of Blaine Gibson and architect Jack Schutts. The two men worked to develop a site that provides design harmony between the new sculpture and the existing Greek Revival–style library. The Sid Richardson Foundation and the Anne Burnett and Charles Tandy Founda-

99

tion provided grants for the $550,000 landscape project that surrounds the plaza. Lady Bird Johnson unveiled the Sam Rayburn Sculpture Plaza on September 14, 1990. Gibson maintains a studio in West Sedona, Arizona. In 1983, he retired from Walt Disney Productions, where as chief sculptor he designed many of the animal, human, and bird figures at Disneyland, Walt Disney World, and Epcot Center.

Tennant, Allie Victoria

(1898–1971 American)*

JAMES BUTLER BONHAM 1936

Portraiture; 8' H; bronze and pink Marble Falls granite
Location: Fannin County Courthouse grounds
Funding: $7,500 allocated by the 1936 Commission of Control for Texas Centennial Celebrations
Comments: When William B. Travis invited childhood friend James Bonham to come to Texas in 1835, Bonham closed his law office in Montgomery, Alabama, enlisted in the Mobile Greys, and joined Travis at San Felipe. During the siege of the Alamo, Bonham made it through enemy lines twice to seek aid. With no reinforcements promised, he returned to the Alamo to fight with the other defenders. He died there on March 6, 1836. Allie Tennant and architect Donald Nelson attended the monument's dedication on December 18, 1938, and Congressman Sam Rayburn delivered the dedication address. Suffering from a cold, Rayburn wore his overcoat throughout the activities. The *Bonham Daily Favorite* noted, "Sam's friends over the district listen to him with his overcoat on, with a coat on, or in his shirt sleeves—and he never disappoints" (December 19, 1938).

Brady

Finlay, Earl V.

(Native Texan)*

HEART OF TEXAS MONUMENT
1958

Figurative; 7'6" H; granite from Winsboro, South Carolina
Location: McCulloch County Courthouse grounds near the heart, or geographical center, of Texas
Funding: Brady Chamber of Commerce and McCulloch County Commissioners' Court
Comments: Earl Finlay is a descendant of J. K. Finlay, who was a pioneer in the Texas granite industry. The elder Finlay and his two sons owned a cutting and finishing plant in Llano around the turn of the century. Earl Finlay has made numerous stone markers designating historical points of interest throughout the state. Gary Bryson, a native of Brady, carved the red heart and the inscription on the front of the monument.

Heart of Texas Monument. Photo by Carolyn DuVall, courtesy Brady Chamber of Commerce.

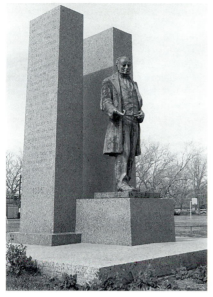

Henry Smith. Photo by Robert Little.

Courthouse Archway. Photo by Robert Little.

Brazoria

Villa, Hugo

(1881–1952 American)*

HENRY SMITH *1936*

Portraiture; 8'4" H; bronze cast at the Mario Scoma Foundry in Brooklyn, New York
Location: 200 block North Brooks (Texas 36)
Funding: $7,500 allocated by the 1936 Commission of Control for Texas Centennial Celebrations
Comments: Smith was active in the struggle for Texas independence, and he served as governor of the Provisional Government of Texas in 1835. His service to the state is recorded on monolithic shafts behind the statue.

Breckenridge

Flanders, C. L.

(American)*

COURTHOUSE ARCHWAY *1883*

Figurative; 10' H; red sandstone
Location: Stephens County Courthouse grounds
Funding: Stephens County Commissioners
Comments: Not originally a freestanding piece, this unique sculptural work once formed the front portal of the old Stephens County Courthouse built in 1883 according to the design of Flanders' brother, architect James E. Flanders. When the building was razed in 1927, local officials preserved this archway as a memento of the county's early heritage. Both C. L. Flanders and James E. Flanders lived in Dallas.

101

Brownwood

Tauch, Waldine

(1892–1986 Native Texan)*

GENERAL DOUGLAS MACARTHUR *1969*

Portraiture; 8' H; bronze cast in plaster by Cesare Contini in San Antonio and shipped to Italy for bronze casting
Location: Howard Payne University campus, Douglas MacArthur Academy of Freedom
Funding: Public donations raised statewide
Comments: When Dr. Guy Newman, president of Howard Payne College, asked whether Tauch would accept this commission, she replied, "Why, of course I'll do it. And I promise you this one will be my masterpiece, for I have long been an admirer of the general" (Hutson 1978, 145). Using MacArthur's Army medical reports, his uniform furnished by Mrs. MacArthur, and his cap furnished by the MacArthur Memorial Foundation in Norfolk, Virginia, Tauch submitted several sketches to the seven-

General Douglas MacArthur. Photo courtesy University News Service, Howard Payne University.

member monument committee. Her finished work depicts the general as he strode ashore at Leyte on his return to the Philippines on October 20, 1944. At the statue's unveiling, Mrs. MacArthur said that it was the best likeness she had ever seen of her husband, even better than the one at West Point.

Bryan

Sandifer, Rosie

(b. 1946 American)

WALKING THE KIDS *1994*

Figurative; 6 life-size figures; bronze
Location: Intersection of Copperfield Drive and Courtlandt Drive
Funding: PAC Realty

Surls, James

(b. 1943 Native Texan)*

BRAZOS FLOWER *1986*

Abstract; 19' H × 19' W; oak and steel
Location: The Brazos Center, 3232 Briarcrest Drive
Funding: Brazos County, private donors, and the Texas Commission on the Arts
Comments: Surls created *Brazos Flower* in his studio at Splendora. He carved the 6-foot petals by hand and inserted a steel rod into each piece of wood with a machine process that he developed specifically for his work. After the wooden petals with rods cured for several months, they were sealed with a weather-protective coating and "cooked" under pressure. A flatbed truck delivered the partially assembled sculpture to the Brazos Center, where a double-line crane placed it on a 6-foot-deep concrete-and-steel pier foundation. Surls completed the work on-site. *Brazos Flower* has 27 petals and weighs

Brazos Flower. Photo by Robert Little.

approximately 10,000 pounds. James Surls served as an instructor in sculpture at Southern Methodist University from 1970 to 1977, when he took a position in the art department at the University of Houston and moved to Splendora.

Burnet

Tauch, Waldine

(1892–1986 Native Texan)*

HAL F. BUCKNER AND BOY *1952*

Portraiture; 8' H; bronze cast at Roman Bronze Works in New York
Location: Buckner Baptist Boys Ranch, Ranch Road 2342
Funding: Donations from numerous individuals, businesses, and churches
Comments: Established in 1948, Buckner Baptist Boys Ranch was the last labor of love for this Baptist pastor, author, evangelist, translator, foreign missionary, and seminary

Hal F. Buckner and Boy. Photo by Carol Little.

103

professor and administrator. Hal Buckner helped establish and develop Buckner Baptist Children's Home in Dallas, Bethesda Home in San Antonio, Baptist Haven in Houston, Mary E. Trew Home for the Aged in Dallas, and Buckner Baptist Boys Ranch. One of his favorite quotations is inscribed on the statue's base: "I do not ask to stand among the great. I only ask a child and I may enter heaven's gate."

Umlauf, Charles

(1911–1994 American)*

WALLACE W. RIDDELL *1980*

Portraiture; life-size; bronze
Location: Burnet County Courthouse grounds
Funding: Numerous donors, including Sheriff Riddell's family, are listed on the base.
Comments: Sheriff Riddell (1899–1978) was at the time of his death Texas' longest-serving sheriff, with a term of 39 years, one month, and eleven days. His statue stands near a small bronze relief plaque executed in 1936 by Raoul Josset in honor of the county's settlers.

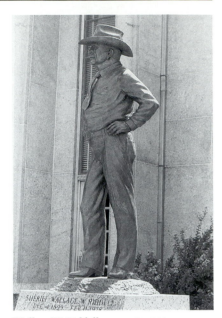

Wallace W. Riddell. Photo by Carol Little.

Caldwell

Cameron

Canadian

Canton

Canyon

Carl's Corner

Carthage

Clarksville

Cleveland

College Station

Colorado City

Comfort

Commerce

Comstock

Copperas Cove

Corpus Christi

Corsicana

Cost

Crowell

Crystal City

Caldwell

Special Collections and Sculpture Gardens in Caldwell

The sculptures of Dr. Joe C. Smith are installed for public viewing on the grounds surrounding his residence at 501 North Stone Street. Using varied media and styles, Smith began sculpting before retiring from his medical practice and continues a very active postretirement career as an artist. In 1964, he was the national champion of the Minox Monochrome Pleasure Division Photography Competition. His sculptures and paintings are placed in the Joe H. Reynolds Medical Building on the campus of Texas A&M University and in several private collections. Although Smith does not enter sculpture shows or sell to the public, his work is exhibited outside his home in Caldwell, where viewers are welcome.

Pieces demonstrating the variety of styles and media employed by Joe C. Smith. The artist's sculpture garden includes more than twenty of his works. Photos courtesy Dr. Joe C. Smith.

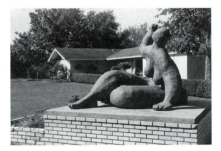

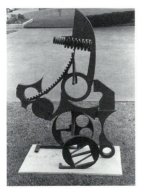
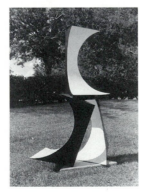
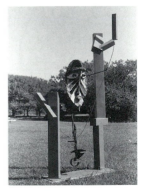

Cameron

Baker, Bryant

(1881–1970 American/English)

BEN MILAM *1938*

Portraiture; larger than life-size; bronze and pink Marble Falls granite
Location: Milam County Courthouse grounds
Funding: $14,000 allocated by the 1936 Commission of Control for Texas Centennial Celebrations
Comments: Mary Frances White, grandniece of Ben Milam, unveiled this statue on July 17, 1938. After fighting in the battle to capture Goliad in October 1835, Milam led a special force of Texians in the assault on San Antonio. The military expedition was successful, but Milam lost his life in the battle. Reputedly, he inspired his men with the challenge "Who will follow old Ben Milam into San Antonio?" This is the moment Bryant Baker immortalizes: Milam calling out to his troops and entreating them to follow.

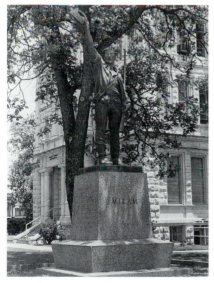

Ben Milam. Photo courtesy *Cameron Herald.*

Coppini, Pompeo

(1870–1957 American/Italian)*

MR. AND MRS. C. H. YOE *1922*

Portrait busts; life-size; bronze
Location: C. H. Yoe High School campus, 400 East 10th Street
Funding: Private donations raised from the community
Comments: These signed busts portraying the school's benefactors are mounted on pedestals that flank the entrance to the school's campus.

Canadian

Cockrell, Bobby Gene

(b. 1927 Native Texan)

AUD *1992*

Figurative; 25' H; steel, concrete, and wire mesh
Location: U.S. 60-83, 3.5 miles south of Canadian
Funding: Private funding
Comments: *Aud,* named for Audrey Cockrell, wife of the sculptor, is installed on a windswept mesa high above the highway on private property. The site is posted against trespassers and no road leads to the figure, but *Aud* is easily viewed by passing motorists at distances up to three miles to the north and south. A menagerie of sculptured animals is installed in the artist's front yard in Canadian.

Pochciol, William A.

(American)*

THE COMING OF WINTER: THE FORERUNNER *1990*

Figurative; 13' H; bronze
Location: The Citadel
Funding: Dr. Malouf Abraham, Jr.
Comments: Located in downtown

107

Canadian, The Citadel is the home of Malouf and Therese Abraham. The building was constructed in 1910 as the First Baptist Church of Canadian. The Abrahams purchased it in 1977 and converted it into a private residence and a showplace for their collection of art and antiques. *The Coming of Winter* is installed on the grounds. The statue portrays the messenger who delivers a warning: the ecological balance of earth and human relationships is worsening to a point of no return. Dallas artist Pochciol hopes that the work also implies a subtle hope that humanity will change its ways.

Price, Gary

(American)

B. M. BAKER SCHOOL MEMORIAL
1994

Figurative; 3 life-size figures; bronze
Location: Baker Elementary School campus, 800 Hillside

Funding: Dr. Malouf Abraham, Jr., and school alumni
Comments: The *Baker School Memorial* consists of three statues and two architectural elements. Abraham dedicated the bronze figures to the inquisitiveness and exuberance of childhood. The sculptures portray children playing and studying beside two preserved sections of the old B. M. Baker School building, which was built in 1921 and razed in 1993. The salvaged portions of the school were preserved with funds donated by former Baker School students.

Canton

Tauch, Waldine

(1892–1986 Native Texan)*

ISAAC AND FRANCES LIPSCOMB VAN ZANDT *1938*

Portraiture; 14' H; bronze and pink Marble Falls granite

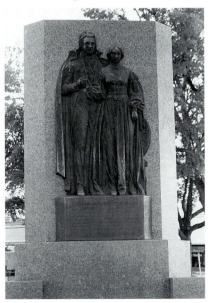

B. M. Baker School Memorial.
Photos courtesy Dr. Malouf Abraham, Jr.

Isaac and Frances Lipscomb Van Zandt.
Photo by Robert Little.

Location: Van Zandt County Court-house grounds
Funding: $7,500 allocated by the 1936 Commission of Control for Texas Centennial Celebrations
Comments: Tauch's portrait of the Van Zandts is the only centennial commission to include a wife and husband. Frances is described on the base as a Christian pioneer wife and mother. Isaac served in the Congress of the Republic of Texas and as charge d'affaires to the United States from 1842 to 1844. He was 28 years old when he died of yellow fever in 1847 during his campaign for the office of governor of Texas. The Van Zandts traveled the Red River in 1839 to Natchitoches, Louisiana, then overland to Camp Sabine in Texas, where they occupied a deserted house until they could raise enough money to reach their final destination in Harrison County. Frances sold her two best dresses and all of the furniture they brought with them from Tennessee to purchase transportation to Marshall. After Isaac's death, Frances continued to live in Marshall until after the Civil War, when she moved to Fort Worth to live near her children.

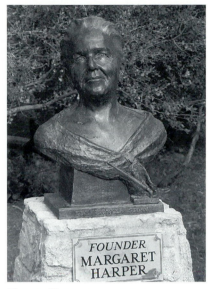

Margaret Harper. Photo by Robert Little.

Canyon

Hill, Jack King

(b. 1923 Native Texan)*

MARGARET HARPER *1980*

Portrait bust; life-size; bronze
Location: Pioneer Amphitheatre, Palo Duro Canyon State Park, 12 miles east of Canyon on Texas 217
Funding: Texas Heritage Foundation and private donations
Comments: Margaret Harper was the guiding force behind the idea to produce a musical in Palo Duro Canyon State Park. *Texas,* the

musical drama by playwright Paul Green, is a pageant that celebrates the courage and tenacity of the pioneers who settled the Texas Panhandle. Performed nightly except Sundays during the summer months, *Texas* has attracted visitors from every state and from more than one hundred foreign countries.

QUANAH PARKER, COMANCHE CHIEF *1970*

Portrait bust; life-size; welded metal
Location: Pioneer Amphitheatre, Palo Duro Canyon State Park, 12 miles east of Canyon on Texas 217
Funding: Mr. and Mrs. Marvin Standefer
Comments: Quanah Parker, the last great chief of the Comanche Indians, was the son of Chief Peta Nocona and Naduah (Cynthia Ann Parker). Quanah Parker's bust looks out onto the vast Palo Duro Canyon, where his braves and their Kiowa allies lost a decisive battle in 1875 with U.S. Army troops led by General Ranald Slidell Mackenzie. After 1875, Palo Duro Canyon was open to permanent

Quanah Parker, Comanche Chief.
Photo courtesy Jack King Hill.

Anglo-American settlement; in 1876, Charles Goodnight in partnership with John G. Adair moved 1,000 head of cattle into the canyon and founded the JA Ranch. Jack King Hill maintains his studio in Amarillo. Another life-size bust of Chief Quanah Parker was commissioned from Hill by the state of Oklahoma for placement at the Hall of Fame for Famous American Indians in Anadarko, Oklahoma.

WHITE BUFFALO *1968*

Figurative; 9' H; fiberglass applied by the artist and Canyon Plastics, Inc., over a plaster model
Location: Kimbrough Memorial Stadium on Buffalo Stadium Road off U.S. 87, 2.1 miles north of Texas 217
Funding: Fund-raising campaign led by Lambda Chi Alpha Fraternity at West Texas State University

Unknown Artist

COWBOY TEX RANDALL *1959*

Figurative; 47' H; concrete and stucco applied to steel frame
Location: U.S. 60 at 15th Street

Funding: Harry Wheeler
Comments: This 7-ton cowboy welcomed shoppers to Harry Wheeler's trading post until the Texas Highway Department excavated an underpass in front of the store, and Wheeler's business failed. Suffering from the West Texas sun and wind, the orphaned cowboy looked a little bedraggled until a group of civic-minded citizens collected enough money to give him a fresh coat of paint. The benefactors' names are painted on the red sign beneath the figure's right stirrup.

Viquesney, E. M.

(1876–1946 American)

SPIRIT OF THE AMERICAN DOUGHBOY *1928*

Figurative; life-size; bronze
Location: Randall County Courthouse grounds
Funding: Palo Duro American Legion Post 97 and the American Legion Auxiliary
Comments: The best source of information on this statue is T. Perry Wesley, former editor of the *Spencer Evening World* in Spencer, Indiana. For many years, Wesley collected information on Viquesney, who lived in Spencer and operated out of several different studios, one being the American Doughboy Studio. According to an unpublished manuscript by Wesley, Viquesney began collecting items worn or carried by World War I doughboys in 1918, and his first statues were cast in various sizes and materials as early as 1920. All of Viquesney's doughboy statues are identified with a plaque that gives the name of the work, the sculptor, and the location of the artist's studio in Spencer.

Cowboy Tex Randall. Photo by Robert Little.

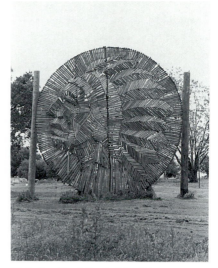

Big Indian Head. Photo by Robert Little.

Carl's Corner

Wade, Bob

(b. 1943 Native Texan)*

BIG INDIAN HEAD *1985*

Figurative; 20' diameter; wood and steel
Location: 6.5 miles north of Hillsboro on Interstate 35 East near Exit 374
Funding: On long-term loan by the artist to the city of Carl's Corner
Comments: This facsimile of an Indian-head penny was originally part of the 1985 Texas Sculpture Symposium held in Dallas. It was moved from Las Colinas to Carl's Corner in 1991.

Eighteen-Wheeler Cattle Truck.
Photo by Robert Little.

EIGHTEEN-WHEELER CATTLE TRUCK *1985*

Figurative; 40' H × 150' L; aluminum, wood, and rubber tires
Location: 1/2 mile north of Carl's Corner Truck Stop on Interstate 35 East
Funding: Carl's Corner Truck Stop
Comments: This two-dimensional eighteen-wheeler is adjacent to the highway and across from one of the sites for Willie Nelson's famous Fourth of July picnics. A composite of familiar objects seen by modern interstate travelers on Texas highways, the cattle truck is attached to aluminum farm gates supported by nine telephone poles. Serving as a giant billboard, it advertises Carl's Corner Truck Stop.

FROGS *1983*

Figurative; 8' H; urethane and steel
Location: Carl's Corner Truck Stop, 7 miles north of Hillsboro on Interstate 35 East
Funding: Carl's Corner Truck Stop
Comments: Originally commissioned for the rooftop of the Tango Club in

111

Bob Wade's *Frogs* before they were moved
from the rooftop of the Tango Club.
Photo courtesy Bob Wade.

Dallas, this amphibian band violated
a local ordinance concerning the size
and placement of signs in that area of
the city. Not welcome in Dallas, the
frogs moved to the small community
of Carl's Corner and lived in relative
harmony with their neighbors until
1991, when Chuy's restaurants
purchased half of the sextet. After
traveling the state on a goodwill tour,
the purchased frogs, renamed the
Bongo Frogs, became permanent
residents at Chuy's in Houston,
leaving only a trio on the rooftop in
Carl's Corner.

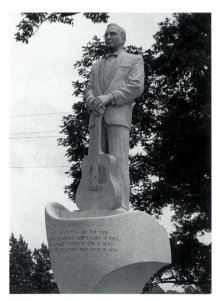

Jim Reeves Memorial. Photo by Robert Little.

Carthage

Zaffardi, Umberto
(American)

JIM REEVES MEMORIAL 1965

Portraiture; 6' H; granite
Location: 3.4 miles east of downtown
Carthage on U.S. 79
Funding: Mary Reeves Davis
Comments: A small memorial park
and this statue of James Travis
"Gentleman Jim" Reeves commemo-
rates the life and music of the famous
country-and-western singer and
Panola County native. After attend-
ing the University of Texas and
playing baseball for a Saint Louis
farm club, Reeves returned to East
Texas. He was performing at the
legendary Rio Palm Isle in Longview
when he was asked to be the regular
host on the Louisiana Hay Ride. His
contract did not allow him to sing,
but when a scheduled performer
failed to appear, Reeves sang in his
place and took six encores. Since his
death in a plane crash on July 31,
1964, his recordings have continued
to attract an international audience.

Clarksville

Muench, Julian Rhodes
(b. 1905 Native Texan)*

DAVID GOUVERNEUR BURNET
1936

Portraiture; 8' H; bronze cast at
E. Gargani and Sons Foundry in
New York
Location: 1011 West Main at Donoho
Funding: $7,500 allocated by the 1936
Commission of Control for Texas
Centennial Celebrations
Comments: Burnet served as the ad
interim president, vice president, and
secretary of state for the Republic of

Texas. His likeness is portrayed in a full standing figure with a long overcoat draped around the shoulders. As a point of interest, Burnet had no particular connection to Red River County. Local historians were surprised when the 1936 Commission of Control chose Clarksville for the monument.

Unknown Artist

CONFEDERATE SOLDIER STATUE
1912

Figurative; life-size; granite
Location: City Square, 100 block Broadway
Funding: Clarksville Chapter 1159, United Daughters of the Confederacy in honor of the Joseph C. Burke Camp 656, United Confederate Veterans
Comments: The members of the Clarksville Chapter of the UDC have preserved their chapter records for more than 75 years. The annual report for 1912 shows an expenditure of $1,500 for this monument but makes no mention of the sculptor. Depicting a soldier standing at parade rest with the butt of his rifle beside his shoe and the barrel in his right hand, the statue is typical of those supplied by monument makers of that era. Also located in Clarksville, on the grounds of Saint Joseph's Church at 800 East Broadway, are *Saint Joseph* and *Our Lady of Victory*. Both are Carrara marble figures ordered from Italy in 1953.

Cleveland

Sweeten, Ronald
(b. 1948 Native Texan)*

HIGH COUNTRY ESCAPE *1987*

Figurative; 3'4" H; bronze
Location: Ronald Sweeten Art Gallery

and Foundry, 1 mile north of Cleveland on U.S. 59
Funding: Owned by the artist
Comments: Exhibits in front of the gallery change as the artist sells his sculptures.

College Station

Bartscht, Heri Bert
(b. 1919 American/German)*

THE GRADUATE *1971*

Abstract; 4'6" H; copper sheeting
Location: Texas A&M University campus, Sterling C. Evans Library
Funding: Class of 1966
Comments: According to the plaque, this sculpture represents the stylized head of a young man emerging from a form known in mathematics as a Möbius strip, a symbol of the continuity of the Aggie spirit. Bartscht lives in Dallas.

The Graduate. Photo by Derrick Grubbs, courtesy Texas A&M University, Office of Public Information.

113

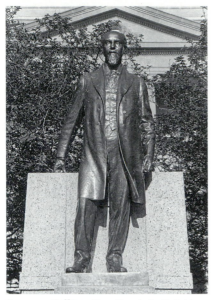

Lawrence Sullivan Ross. Photo by Derrick Grubbs, courtesy Texas A&M University, Office of Public Information.

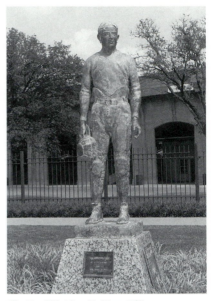

The Twelfth Man (E. King Gill). Photo courtesy Texas A&M University, Office of Public Information.

Coppini, Pompeo

(1870–1957 American/Italian)*

LAWRENCE SULLIVAN ROSS *1919*

Portraiture; larger than life-size; bronze
Location: Texas A&M University campus, entrance to the Academic Building
Funding: 35th Texas Legislature
Comments: Ross served as a Texas Ranger, Confederate brigadier general, governor of Texas, and president of Texas A&M University. Traditionally, his statue gets an annual cleaning by the freshman class.

Foley, Pat

(b. 1922 American)*

THE TWELFTH MAN
(E. KING GILL) *1980*

Portraiture; 7' H; bronze
Location: Texas A&M University, north entrance to Kyle Field
Funding: Class of 1980

Comments: In Dallas on New Year's Day 1922, Texas A&M played against Centre College in the Dixie Classic football game. A&M had so many injuries that Coach Dana X. Bible feared he would not have enough men to finish the game. In desperation, he called in E. King Gill, a reserve who left the football team after regular season to play basketball. The Aggies won the game, but it took every regular player. The only man left on the bench at the end of the game was Gill, depicted in this statue as the team's twelfth man.

UNIVERSITY CENTENNIAL EAGLE
1976

Figurative; 10' H; bronze cast at the Al Shakis Art Foundry
Location: Texas A&M University campus, near the Corps of Cadets dormitory area
Funding: Class of 1976
Comments: The artist designed this massive eagle as the official logo for the university's centennial.

114

The Crystal Tree. Photo by Derrick Grubbs, courtesy Texas A&M University, Office of Public Information.

Kebrle, John, and

(b. 1927 Native Texan),*

Hilliard M. Stone

(b. 1927 Native Texan)*

THE CRYSTAL TREE *1972*

Abstract; 36' H; glass and steel
Location: Texas A&M University campus, Earl Rudder Continuing Education Tower
Funding: Texas A&M University
Comments: This installation, commissioned specifically for the Earl Rudder Continuing Education Tower, contains 2,500 pieces of glass. Hilliard Stone designed the sculpture, built the scale model, and fabricated the giant, tree-shaped frame that secures each piece of glass. The "crystals" are the creation of Dallas artist John Kebrle, whose stained-glass creations adorn churches, schools, homes, and public buildings throughout Texas and in 49 other states. Two chandeliers inside the tower coordinate with this work.

Ludtke, Lawrence M. "Larry"

(b. 1929 Native Texan)*

JAMES EARL RUDDER *1994*

Portraiture; life-size; bronze
Location: Texas A&M University campus, north of the Memorial Student Center
Funding: Private donation
Comments: James Earl Rudder is depicted as president of Texas A&M University.

Ludtke, Lawrence M. "Larry,"

(b. 1929 Native Texan)*

and Veryl Goodnight

(b. 1947 American)

ARCH 406 *1993*

Figurative; 2 life-size figures; bronze
Location: Texas A&M University campus, courtyard behind Langford Architecture Center
Funding: Donated to the university by Betty and Joe Hiram Moore in memory of their son, Stephen
Comments: "Arch 406" refers to a senior design course, Architectural Design 5, the last course in a sequence of design studies that span the

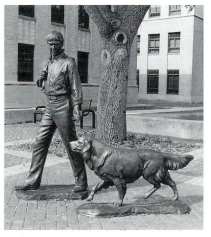

Arch 406. Photo courtesy Texas A&M University Photographic Services.

115

undergraduate curriculum. Stephen Moore was a 1973 graduate of Texas A&M with a degree in environmental design. This sculpture is the cooperative work of Larry Ludtke, who created the male figure, and Veryl Goodnight, who modeled the golden retriever.

Pedulla, Albert T.

(b. 1962 American)*

RICHARD CARTER PARK SCULPTURE *1986*

Figurative; life-size; bronze
Location: Richard Carter Park, Brazoswood Drive between the University Drive and Harvey Road exits off the East Bypass
Funding: City of College Station
Comments: Richard Carter came to the area that is now Brazos County in 1831 as part of Stephen F. Austin's colony. This sculpture symbolizes the staking of Carter's claim to his land grant, which encompassed much of what is College Station today. Albert Pedulla attended public school in College Station and received a fine arts degree from Carnegie-Mellon University in Pittsburgh, Pennsylvania.

Reno, Jim

(b. 1929 American)*

ROBERT JUSTUS KLEBERG, JR. *1979*

Equestrian; smaller than life-size; bronze
Location: Texas A&M University campus, Kleberg Food and Animal Science Center
Funding: Helen Kleberg Groves
Comments: Kleberg, a Texas cattleman, horse breeder, conservationist, businessman, and Texas A&M benefactor, is depicted astride his favorite horse. The Kleberg family

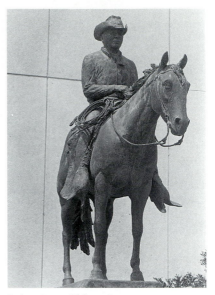

Robert Justus Kleberg, Jr. Photo by Derrick Grubbs, courtesy Texas A&M University, Office of Pubic Information.

and King Ranch are synonymous with the history and heritage of Texas. Artist Jim Reno is described by many as "the horseman's sculptor." In 1973, Penny Tweedy selected Reno to create the official bronze portrait of Secretariat, one of which is in the permanent collection of the National Museum of Racing in Saratoga; he also provided a life-size image of Secretariat for installation at the Kentucky Horse Park Foundation headquarters near Lexington, Kentucky.

Reynolds Metals Company

(American)

EXPLORATION IN SPACE *1968*

Figurative; 8' H; aluminum
Location: Texas A&M University campus, Olin E. Teague Research Center
Funding: Donated by Ford D. Albritton, Jr., and the Reynolds Metals Company of Richmond, Virginia

116

Comments: A spacecraft in orbit around a sculptured sphere of aluminum tubing depicts space flight and symbolizes the university's growing interest in the space program during the late 1960s. The sculpture is appropriately installed in front of the research center named for Texas Congressman Olin E. Teague, who served as chairman of the congressional committee on science and astronautics.

Sandifer, Rosie

(b. 1946 American)

THE ROUGHNECK *1990*

Figurative; 20' H; bronze
Location: Texas A&M University campus, entrance to the Joe C. Richardson Petroleum Engineering Building
Funding: Donated to the university by Susan Dixon Richardson in honor of Joe C. Richardson
Comments: Actual drilling tools are incorporated into this sculpture, which features a 7-foot-tall figure of an oil field worker.

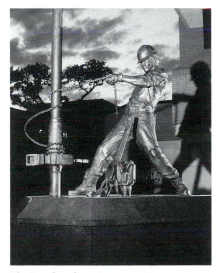

The Roughneck. Photo courtesy Texas A&M Photographic Services.

Smith, Joe C.

(b. 1921 American)

RAPPORT *1993*

Abstract; 12' H; mild steel armature covered with $1/8$" silicon bronze
Location: Texas A&M University campus, College of Medicine Health Science Center
Funding: Private donation
Comments: Ben Woitena of Houston fabricated this work, which is signed with Dr. Smith's pseudonym, J. Lyle.

Ullberg, Kent

(b. 1945 American/Swedish)*

VICTORY EAGLE *1993*

Figurative; 9' H; bronze
Location: Texas A&M University campus, Cain Park adjacent to Cain Hall
Funding: Donated to the university by the Class of 1991
Comments: Cain Park, at the intersection of Joe Routt Boulevard and Clark Street, is a joint project between the Wofford and Effie Cain Foundation and the university.

Colorado City

Dell, Juan

(Native Texan)

CONGRESSMAN GEORGE H. MAHON *1986*

Portrait bust; life-size; bronze
Location: Mitchell County Courthouse grounds
Funding: Public donations

117

Comfort

Tauch, Waldine

(1892–1986 Native Texan)*

ERNST ALTGELT *1970*

Portrait bust; life-size; bronze
Location: Comfort Park, Main Street
and Texas 27
Funding: Comfort Historical Society

Unknown Artist

**TRUE TO THE UNION
MONUMENT** *1866*

Obelisk; 18' H; Texas limestone
Location: High Street, two blocks off
Texas 27
Funding: Local residents and relatives
of the victims
Comments: Although this obelisk has
no outstanding sculptural embellish-
ment, it is significant as one of the
few Civil War memorials erected in

the South to Union sympathizers. It
also is the oldest Civil War monu-
ment identified in this book. When
Texas seceded from the United
States, some German immigrants
remained loyal to the Union and
refused to support the Confederacy.
In 1862, approximately 65 German
dissidents decided to flee to Mexico,
where they hoped eventually to join
the Union forces or wait out the war.
Confederate troops overtook the
German Texans on the banks of the
Nueces River, where 36 immigrants
died in the Battle of the Nueces. After
the war, 17 men from the Comfort
area journeyed to the battle site and
brought back in two sacks the bones
of their friends. These remains are
buried at the monument, which bears
the inscription "Treue Der Union."
In 1994, the Comfort Heritage
Foundation spearheaded a preserva-
tion project to restore the aging
landmark under the supervision of
master stonemason Karl H. Kuhn of
Boerne. The monument is listed on
the National Register of Historic
Places.

Commerce

Lamb, William W.

(American)*

UNTITLED *circa 1971*

Abstract; 9' H; steel
Location: East Texas State University
campus on the east side of the
department of art building
Funding: The university and the
artist, a graduate of Ohio State
University who served as an art
instructor at ETSU at the time the
work was placed

True to the Union Monument, before the
1994 restoration. Photo courtesy Texas Historical
Commission.

Wilbern, Barry

(American)*

THE ARCH *1974*

Abstract; 14' H; wood, plaster, concrete, and steel
Location: East Texas State University campus on the southwest side of the science building
Funding: The university and the artist, a resident of Commerce who was a graduate student at ETSU at the time the work was placed

Comstock

Worrell, Bill

(b. 1935 Native Texan)*

THE MAKER OF PEACE *1994*

Figurative; 16' H; bronze
Location: Seminole Canyon State Historical Park, 45 miles west of Del Rio on U.S. 90

The Maker of Peace. Photo courtesy Bill Worrell.

Funding: Donated to the park by the Rock Art Foundation
Comments: Worrell has a special reverence for the ancient artists whose pictographs are painted on the walls and cliffs of Seminole Canyon State Historical Park. This sculpture is imbued with symbols that reflect the pictographic imagery of prehistoric Texas. The main figure personifies the white-tailed deer because of the close link between that animal and the human culture of the Lower Pecos. The deerskin cape signifies the shaman's spiritual leadership, while the antlers represent wisdom, maturity, and regeneration. The bird on the figure's shoulder is a portrayal of the human soul, and the circle encompassing the opposite shoulder is a symbol of eternity, completeness, and the cyclical nature of the universe. These and other symbols incorporated into the sculpture give modern people a glimpse into the mysterious secrets of the Lower Pecos iconology.

Copperas Cove

Stout, S. J.

(American)*

COPPERAS COVE HISTORICAL MONUMENT *1979*

Figurative; 6' × 4' × 3'6"; bronze and granite
Location: Santa Fe Railroad parking lot, Avenue D
Funding: Copperas Cove Chamber of Commerce
Comments: In recognition of the town's frontier past, this monument includes a bronze bas-relief of a pioneer settler riding a heavily loaded mount down the side of a hill. The relief is mounted on a colossal granite profile of an Indian's head.

Corpus Christi

Coleman, Sherman T.

(b. 1920 Native Texan)*

ALONSO ALVAREZ DE PIÑEDA
1984

Portraiture; 8' H; bronze
Location: Triangle at the 2400 block
Agnes Street
Funding: Westside Businessmen's
Association and the city of Corpus
Christi
Comments: The artist's daughter,
Kathleen Coleman Edwards, assisted
her father in sculpting this portrait of
the great Spanish explorer Alonso
Alvarez de Piñeda, who mapped the
coast of Texas in 1519. Coleman is a
physician specializing in general and
vascular surgery; his sculptures are
placed in private collections and
museums throughout the nation. He
is particularly well known for his
equine sculptures, which are placed
in a number of museums, including
the National Museum of Racing in
Saratoga and the Cowboy Hall of
Fame in Oklahoma City. Coleman
lives in Corpus Christi.

Alonso Alvarez de Piñeda. Photo by Robert Little.

Christ the Healer. Photo by Robert Little.

CHRIST THE HEALER *1983*

Portraiture; 8' H; bronze
Location: Entrance to Spohn Hospital,
600 Elizabeth Street
Funding: Gift from the employees of
Spohn Hospital
Comments: Kathleen Coleman
Edwards assisted with this statue of
Christ. According to the inscription
on the base, it is dedicated to "All
who are suffering and seek His
release."

FRIENDSHIP MONUMENT *1992*

Equestrian; life-size; bronze cast at
Castleberry Art Foundry in
Weatherford
Location: 300 North Shoreline
Boulevard at Lawrence
Funding: A project of the Westside
Business Association and the Devary
Durrill Foundation with individual
and corporate donors
Comments: This equestrian statue is
a portraiture of Captain Blas María de
la Garza Falcón, who in 1764 received
the first private land grant issued by
the province's Spanish governor. The

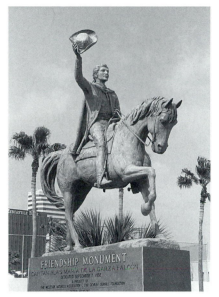

Friendship Monument. Photo by Robert Little.

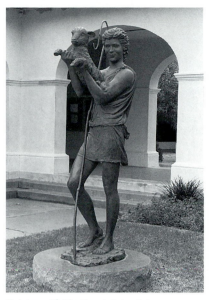

Rejoice with Me. Photo by Robert Little.

captain founded Santa Petronila in the Nueces River area, where he introduced corrals, branding, and cattle drives, thus establishing the famous South Texas ranching

industry. He also established missions, while offering his colony as a haven for travelers and settlers who pioneered and populated South Texas.

THE LORD IS MY SHEPHERD *1985*

Figurative; 3' H; bronze
Location: Saint James Episcopal School campus, 602 South Carancahua
Funding: Commissioned by the school

REJOICE WITH ME *1977*

Figurative; 8' H; bronze
Location: Church of the Good Shepherd Episcopal Church, 700 block South Upper Broadway at Park Avenue
Funding: Church of the Good Shepherd Congregation
Comments: The parable of the lost sheep inspired this work, particularly Luke 15:6, which reads, "Rejoice with me for I have found my lost sheep."

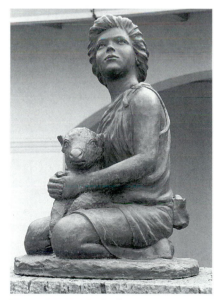

The Lord Is My Shepherd. Photo by Robert Little.

121

Coppini, Pompeo

(1870–1957 American/Italian)*

QUEEN OF THE SEA *1914*

Figurative; 8' H × 12' W; stone
Location: Bluff Balustrade at Peoples and Broadway
Funding: Corpus Christi Chapter, United Daughters of the Confederacy
Comments: This neoclassical relief is a memorial to Confederate soldiers. The principal figure is an allegorical female representation of Corpus Christi holding the keys of success in her hand. She is receiving a blessing from Father Neptune on one side and Mother Earth on the other. To help the United Daughters of the Confederacy meet their goal, the *Corpus Christi Caller* and the *Daily Herald* donated the proceeds from advertising and sales for the December 7, 1914, issue. *Queen of the Sea* was part of the Broadway Bluff Improvement, a campaign started in 1913 to improve and beautify the 40-foot-high bluff area that divided uptown from downtown. The project reflected the City Beautiful Movement then popular nationwide. In 1990, the Rotary Club of Corpus Christi sponsored a restoration of *Queen of the Sea* by Ron Sullivan.

Christopher Columbus. Photo by Robert Little.

Garcia, Roberto, Jr.

(b. 1954 Native Texan)*

CHRISTOPHER COLUMBUS *1992*

Portraiture; larger than life-size; bronze cast at the artist's foundry in Kingsville

Queen of the Sea. Photo by Robert Little.

Location: James C. Storm Pavilion, under Harbor Bridge at the terminus of Chaparral Street
Funding: Private donations
Comments: This statue commemorates the five-hundredth anniversary of Christopher Columbus' voyage to the New World.

Gibbs, Craig

(b. 1948 American)

AZTEC WHEEL *1978*

Figurative; 4' diameter, Cor-ten steel
Location: Triangle at 100 North Mesquite Street and Cooper's Alley
Funding: City of Corpus Christi

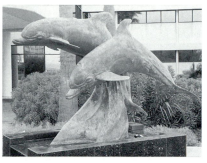

Twin Dolphins. Photo by Robert Little.

Aztec Wheel. Photo by Robert Little.

Hinojosa, Armando

(b. 1944 Native Texan)*

TWIN DOLPHINS *1984*

Figurative; life-size; bronze cast at Stevens Art Foundry in Bulverde
Location: 4350 Ocean Drive
Funding: Twin Dolphins Condominium Developers

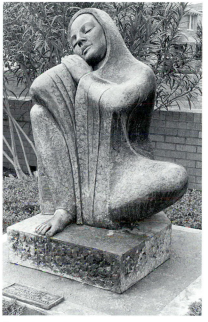

Peace. Photo by Robert Little.

Nassan, Gobran

(Egyptian)

PEACE *1983*

Figurative; 4' H; bronze
Location: Spohn Hospital grounds, 500 Ayers Street at Ocean Drive
Funding: Private donations

123

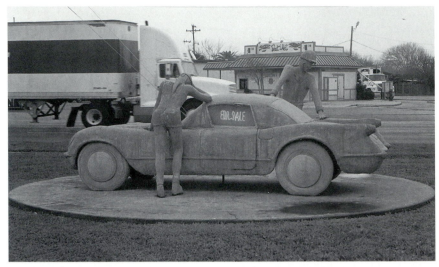

For Sale. Photo by Robert Little.

O'Dowdy, Danny

(American)*

FOR SALE *1984*

Figurative; life-size; ferroconcrete
Location: Hamlin Shopping Center at
the corner of Weber and Staples
Funding: Loeb Organization
Comments: Leon Loeb commissioned
these figures of a wife and husband
shopping for a car after a number of
people requested permission to
display their used cars on the
shopping center's parking lot.

THE SUNSEEKER *1989*

Abstract; 15' H; cement and
multicolored mosaic tiles
Location: Corpus Christi Public
Library, 805 Comanche
Funding: City of Corpus Christi and
donations from supporters of the
library
Comments: *The Sunseeker* is a giant
abstraction of an agave cactus. The
Municipal Arts Council and the
Corpus Christi City Council commis-
sioned this work from O'Dowdy, who
lives in the Corpus area. The

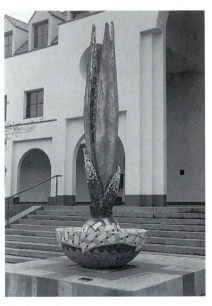

The Sunseeker. Photo by Robert Little.

sculpture's concrete base provides a
small seating area for visitors to the
library. A similar work by O'Dowdy,
The Bromeliad, forms a 7-foot-high
fountain centerpiece at the intersec-
tion of 1600 Alameda and Staples.

124

Rogers, Richard Harrell

(b. 1941 Native Texan)*

ARCHITECTONIC PSALM *1967*

Abstract; 30' × 38' × 22'; concrete,
stone, and stainless steel
Location: Parkway Presbyterian
Church, 3707 Santa Fe
Funding: Parkway Presbyterian
Church congregation
Comments: In designing this work,
the artist combined the contrasting
monolithic forms of a prehistoric era
with the use of stainless steel—a
manifestation of the twentieth
century. He also incorporated the
cross motif as an enduring symbol of
the Christian faith. In 1965, Rogers
visited Stonehenge on Salisbury Plain
in England. The trip inspired ques-
tions about the meaning of the
megaliths and how they were created
without the help of the wheel and
with only flint and bone tools. This
experience later helped him formu-
late his feelings about art: "I began to
understand that to create a work of
art is to create a question. . . . If a
work of art becomes an answer, its
value is lost and one might just as
well destroy the art and put up the
answer in its place" (Rogers 1967).
Also located at Parkway Presbyterian
Church is a small cast-stone fountain
designed in 1957 by Lincoln Borglum.

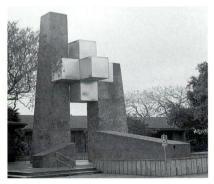

Architectonic Psalm. Photo by Robert Little.

Tatum, H. W. "Buddy"

(b. 1958 Native Texan)*

EL CIRCO DEL MAR *1985*

Figurative; 14' H; bronze
Location: 800 Shoreline Boulevard at
Twigg Street
Funding: Sue and Warren Rees
Comments: Translated as "the circus
of the sea," the sculpture features two
brown pelicans representing a high-
wire artist and a clown.

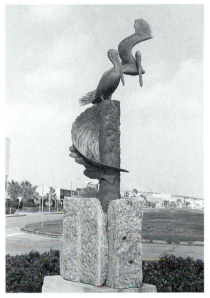

El Circo del Mar. Photo by Robert Little.

Tischler, Tom

(b. 1947 American)*

KEMP'S RIDLEY SEA TURTLES
1990

Figurative; life-size; bronze cast at
Kasson's Castings in Austin
Location: Texas State Aquarium,
2710 North Shoreline Boulevard
Funding: A gift of the Daniel A.
Pedrotti family
Comments: This work is accessible
only to those who pay admission to
the aquarium.

125

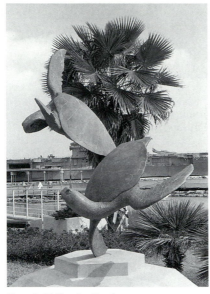

Kemp's Ridley Sea Turtles. Photo by Robert Little.

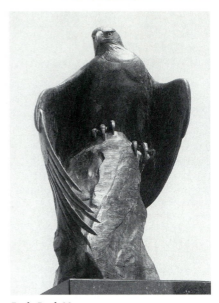

Eagle Rock Monument. Photo courtesy Kent Ullberg.

Turegano, Fernando

(American)

SEA-BIRD *1983*

Abstract; 18' H × 10' W; bronze and epoxy resin
Location: 1700 North Chaparral at Brewster Street behind the Bayfront Plaza Convention Center
Funding: City of Corpus Christi

Ullberg, Kent

(b. 1945 American/Swedish)*

EAGLE ROCK MONUMENT *1985*

Figurative; 6'3" H; bronze
Location: Whataburger National Headquarters, 4600 Parkdale Drive; viewed from 4100 Staples Street
Funding: Whataburger, Inc.
Comments: *Eagle Rock* received national recognition in 1981 through an award presented by the National Sculpture Society in New York City, and it received the 1981 gold medal at the National Academy of Western Art.

IT IS I *1995*

Figurative; 15' H; bronze
Location: First United Methodist Church, 900 South Shoreline Boulevard
Funding: Private donations and the sale of 100 maquettes of the statue

LEAPING MARLIN *1989*

Figurative; larger than life-size; bronze cast at Art Castings of Loveland, Colorado
Location: Park Road 22 entering Padre Island at the Gulf Intracoastal Waterway Bridge
Funding: Private purchase

Leaping Marlin. Photo by Robert Little.

126

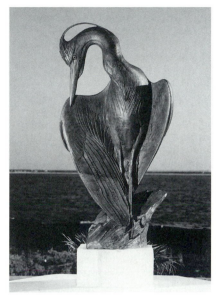

Spring Plumage. Photo by Bryan Tumlinson.

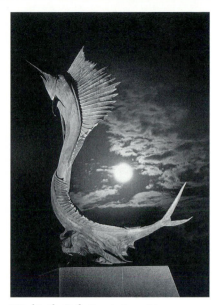

Wind in the Sails. Photo by George Tuley, courtesy *Corpus Christi Caller-Times.*

SPRING PLUMAGE *1990*

Figurative; 5' H; bronze cast at Art Castings of Loveland, Colorado
Location: Texas State Aquarium, 2710 North Shoreline Boulevard
Funding: T. S. and Virgie C. Scibienski Foundation
Comments: Each year, the artist watches from his studio on Padre Island as the native great blue herons preen their spring plumage. This scene inspired his blue heron sculpture, which is placed in the Texas State Aquarium's landscaping near the outdoor marsh-dune exhibit next to the Gulf of Mexico Exhibit Building. This work is accessible only to those who pay admission to the aquarium.

WIND IN THE SAILS *1983*

Figurative; 23' H; bronze and red granite
Location: 400 North Shoreline Boulevard at Schatzel
Funding: *Corpus Christi Caller-Times* in celebration of the paper's one-hundredth anniversary

Comments: In 1983, the National Sculpture Society in New York awarded a gold medal to this graceful pose of two sailfish in motion. The sculpture is designed to be viewed by motorists in the moving traffic along the bayfront. In creating *Wind in the Sails,* the artist incorporated two ideas: the constancy of the bay wind against the shore and an old Swedish blessing that bestows success and happiness. Thus, the sculpture expresses goodwill toward the people of Corpus Christi—that they might have wind in their sails.

Watson, Bill H.

(American)*

WORLD OF KNOWLEDGE *1964*

Figurative; 5' H; chip marble
Location: Parkdale Branch Public Library, 4400 Gollihar Road at Carmel Parkway
Funding: Friends of the Library and the Southwest Sculpture Society

Comments: Twenty-three active members of the Southwest Sculpture Society competed for this commission. The panel of judges included Waldine Tauch, Philip John Evett, and Lincoln Borglum. The Friends of the Library asked the artists to interpret the theme "Open New Worlds through Reading." Watson sculpted a young nude male figure, seated with a drape across his middle and a book resting in his lap. He looks away from the book as if to ponder the ideas he has just discovered through reading.

White, Charles

(b. 1947 American)*

BLOOMING CRANES *1986*

Figurative; 7' H; silicon bronze
Location: Waterstreet Market Phase II, 309 North Water Street
Funding: Charles DeCou, DeCou Management Company, Inc.
Comments: Forming the centerpiece in a circular pool, four graceful birds join their open wings to form the petals of a flower. The cranes' necks emerge from the flower's center and water pours from the beaks.

Special Collections and Sculpture Gardens in Corpus Christi

The Art Museum of South Texas is located at 1902 North Shoreline Boulevard. The museum began operations in 1944 as the Corpus Christi Art Museum housed in a small city-owned community center. In 1967, the museum began a major fund-raising campaign, and in 1972, it changed its name and moved into a modern, bayfront facility designed by the internationally famous American architect Philip Johnson. The Art Museum of South Texas features the work of local and regional artists. The museum's permanent collection of outdoor sculpture represents the work of three artists who have close ties to Texas.

ALAS, IX *1994*, a 7'6" painted steel abstract by Betty Gold, a native Texan now living in California; given to the museum in 1995 by Mr. and Mrs. David Chatkin

MOUNTAIN CORE *1984*, by Rockport sculptor Jesús Bautista Moroles, a 5'-high granite work donated to the museum by Marvin and Sue Overton

Sculptor Kent Ullberg working on the clay models of *Evolution*, later installed at the Art Museum of South Texas. Photo courtesy Kent Ullberg.

128

An untitled installation by Charmaine Locke and James Surls in Mariposa Sculpture Park. Photo by Robert Little.

EVOLUTION *1992,* by Corpus Christi artist Kent Ullberg; involves 3 relief panels, each 5' high and 3' wide. The Corpus Christi Foundation of Sciences and Arts donated *Evolution* to the Art Museum of South Texas on the occasion of the museum's twentieth anniversary.

Mariposa Sculpture Park is located in the 300 block of Chaparral. In 1989, Corpus Christi sculptor Michael Manjarris spearheaded a movement to transform an unkempt, vacant plot of land in downtown Corpus Christi into a place of interest and beauty. The property owner, Houston Savings Association, agreed to lease the land to Manjarris for $1 a year, and local businesses, individual citizens, and the city of Corpus Christi donated money, services, and materials to clean up the area and develop the sculpture park. At its dedication on July 7, 1990, Mariposa Park included sculptures donated by Texas artists

James Surls, Charmaine Locke, Joe Vogel, Kate Petley, Bub Vickers, Anne Wallace, Michael Tracy, Thomas Glassford, Harold Clayton, Damian Priour, and Michael Manjarris. The centerpiece of the park and its largest installation is an untitled work by husband and wife James Surls and Charmaine Locke, their only collaborative outdoor work in Texas.

Corsicana

Amateis, Louis

(1855–1913 American/Italian)

CALL TO ARMS *1907*

Figurative; 9' H; bronze cast at Bureau Brothers Bronze Founders in Philadelphia
Location: Navarro County Courthouse grounds
Funding: Navarro Chapter 108, United Daughters of the Confederacy, with assistance from the C. M. Winkler Camp 147 and the Roger Q. Mills Camp 106, United Confederate Veterans

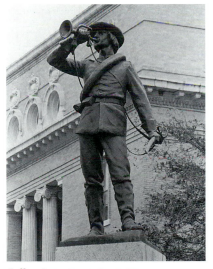

Call to Arms. Photo by Robert Little.

129

Comments: The Navarro Chapter of the UDC organized in 1897 and immediately began fund-raising projects to erect a Confederate monument. On January 20, 1908, more than one thousand people gathered on the courthouse lawn to witness the unveiling of this statue of a Confederate bugler calling his comrades to arms. In 1989, *Call to Arms* was the object of an extensive conservation project under the direction of artist-conservator Stuart Kraft. As a Texas Commission on the Arts artist-in-residence, Kraft and students at Corsicana High School participated in a pilot program to conserve outdoor sculpture in Texas. The local sponsor was the Navarro Council for the Arts. Kraft and his students photographed the monument, assessed its condition, and documented the damage caused by age and exposure to the environment. After using approved procedures for cleaning and rinsing the surface, they applied two hot-wax treatments for protection and then buffed the statue. Finally, they documented their work in a written report now available for other groups interested in promoting a program of community involvement for the conservation of outdoor sculpture.

McDonald, Doug, and Sandra McDonald

(Americans)*

LEFTY FRIZZELL *1992*

Portraiture; larger than life-size; bronze cast at Hoka Hey Fine Arts Foundry in Dublin
Location: Beauford Jester Park, 700 block West Park Avenue
Funding: Lefty Frizzell Memorial Committee
Comments: William Orville "Lefty" Frizzell attained country-music stardom with number-one country

Lefty Frizzell. Photo courtesy Sandra McDonald.

singles such as "If You've Got the Money, Honey, I've Got the Time," "Always Late with Your Kisses," and "Long Black Veil." Although reared in Arkansas, Frizzell was born in Corsicana on March 31, 1928. Doug and Sandra McDonald's studio is in Mabank.

Tennant, Allie Victoria

(1898–1971 American)*

JOSE ANTONIO NAVARRO *1936*

Portraiture; larger than life-size; bronze
Location: Navarro County Courthouse grounds
Funding: $7,500 allocated by the 1936 Commission of Control for Texas Centennial Celebrations
Comments: José Antonio Navarro was a member of the legislature of Coahuila and Texas in 1821 and a land commissioner for the district of Bexar in 1834–1835. He signed the Texas Declaration of Independence

José Antonio Navarro. Photo by Robert Little.

and served as one of the 21 delegates who drafted the new republic's constitution. While on a trade expedition to Santa Fe for President Mirabeau B. Lamar in 1841, Navarro was captured by Mexican soldiers and taken to Mexico City, where he was sentenced to death for his involvement in the Texas Revolution. His sentence was commuted to life in prison, but he escaped in 1845 and returned to Texas to become a delegate to the convention that voted for Texas' annexation to the United States. Born in San Antonio de Bexar in 1795, Navarro was the only native Mexican to sign the Texas Constitution of 1845. He later supported secession from the Union, and all four of his sons fought in the Confederate army. Corsicana is named for the birthplace of Navarro's father, the island of Corsica.

Unknown Artist

FIREMAN'S MEMORIAL *1918*

Figurative; 7' H; marble
Location: Navarro County Courthouse grounds
Funding: Donations raised through a monument committee composed of local citizens
Comments: Dedicated to the Corsicana Fire Department and Chief Ruby Freedman (1859–1917), this figure appears to be a mold typically ordered from a monument firm's catalogue.

Fireman's Memorial. Photo by Robert Little.

Cost

Tauch, Waldine

(1892–1986 Native Texan)*

FIRST SHOT FIRED FOR TEXAS INDEPENDENCE *1936*

Figurative; 13'6" × 16'2" × 3'10$^1/_2$";
bronze and gray Texas granite
Location: Texas 97, 5.5 miles west off U.S. 183 (the highways intersect 2 miles south of Gonzales)
Funding: $10,000 allocated by the 1936 Commission of Control for Texas Centennial Celebrations
Comments: This monument stands near the site of the first shot fired in the Texas Revolution. In early fall of 1835, residents in the tiny hamlet of Gonzales learned that Mexican soldiers were en route to confiscate the town's small cannon, which the Americans presumably kept for protection against Indian attack. The men of Gonzales hurriedly buried the small weapon in a nearby peach orchard and sent out a request for aid from other communities. Among those who responded were Colonel James W. Fannin and his Brazos Guards and William B. Travis, who would later give his life at the Alamo. When the Mexican soldiers arrived, Mayor Andrew Ponton, reinforced by the group of volunteers, sent the following message to the Mexican commander: "I cannot, nor do I desire, to give up the cannon, and only through force will we yield" (Maguire 1985). The ensuing fight required only a single shot from the resurrected cannon to rout the Mexicans, but it signaled the start of the revolution that created a new and independent nation—the Republic of Texas. Ironically, the "Come and Take It" cannon was lost for 100 years. In 1936, the year of the Texas Centennial, a flood in Central Texas uncovered the long-buried relic.

First Shot Fired for Texas Independence.
Photo by Robert Little.

Crowell

Viquesney, E. M.

(1876–1946 American)

SPIRIT OF THE AMERICAN DOUGHBOY and **SPIRIT OF THE AMERICAN NAVY** *1932*

Figurative; 2 life-size figures; bronze and granite
Location: Foard County Courthouse grounds
Funding: Gordon J. Ford American Legion Post 130 and the Legion Auxiliary
Comments: After three years of fundraising, these two figures were unveiled on Armistice Day (now Veterans Day) 1932. Castings of Viquesney's doughboy statue are placed throughout Texas, but this granite sailor is the state's only example of its companion piece. Between the two statues is a German

Spirit of the American Doughboy and *Spirit of the American Navy.* Photo by Robert Little.

77-millimeter field gun captured by American forces during the final drives of 1918. In 1942, a deadly tornado hit Foard County and damaged both figures; they have never been repaired.

Crystal City

Unknown Artist

POPEYE STATUE *1937*

Figurative; 8' H; cast stone
Location: City Hall grounds, 101 East Demmit
Funding: E. C. Segar
Comments: The identity of the person who created this popular statue has not been verified; however, the artist is thought to be San Antonio stonemason Julian Sandoval, who also created the cast-stone elephant statues at the Hertzberg Circus Collection museum in San Antonio. E. C. Segar's cartoon

133

Popeye Statue. Photo courtesy *Texas Highways Magazine.*

creation *Popeye* was the first comic strip series that blended adventure and humor. Since the nautical hero derived his superpower from a can of spinach, the cartoon's writer designed and financed this heroic image of Popeye for Crystal City, the "Spinach Capital of the World."

Unknown Artist

BENITO JUAREZ *1970s*

Portrait bust; larger than life-size; bronze
Location: Zavala City Hall at Dimmit and Zavala
Funding: Government of Mexico
Comments: Benito Juárez was a Mexican political leader who advocated constitutional government, the separation of church and state, and the reduction of the power of the clergy and the military. During the French occupation of Mexico, Juárez helped direct the war for freedom, and after Emperor Maximilian was dethroned, he became president of Mexico in 1867. He was reelected by the Mexican congress in a runoff in 1871.

Dalhart

Dallas

Del Rio

Denison

Denton

Diboll

Dalhart

Dycke, Bobby

(American/Czechoslovakian)*

EMPTY SADDLE MONUMENT
1940s

Figurative; life-size; concrete and
native fieldstone
Location: Intersection at U.S. 87
and U.S. 385
Funding: Commissioned by the
General XIT Committee
Comments: Each year, the General
XIT Committee sponsors the XIT
reunion and parade in Dalhart. In the
early 1940s, shortly before Flossie and
John Marsh were to leave Montana to
attend the XIT reunion, John Marsh
died. His bereaved widow asked the
General XIT Committee to place a
horse with an empty saddle in the
reunion's parade in memory of her
husband, who had been a cowpoke on
the 3-million-acre XIT Ranch. Every
year since, a riderless horse with a
floral wreath around its saddle horn

Empty Saddle Monument. Photo by Bob Wilcoxson,
courtesy Mr. Wilcoxson, Dalhart, Texas.

has been part of the XIT parade as a
tribute to all deceased XIT cowboys.
This tradition inspired the committee
to commission the *Empty Saddle
Monument,* which bears an official
Texas historical marker.

Dallas

Albrecht, Mary Dickson

(b. 1930 American)*

WITH THE WIND *1972*

Abstract; 7' H; welded steel painted
orange
Location: Martin Weiss Park,
1111 Martindale
Funding: Gift to the city of Dallas by
Ebby Halliday
Comments: Forty-nine steel rods are
welded together to form this abstract
design.

Antonakos, Stephen

(b. 1926 American/Greek)

NEON FOR SOUTHWESTERN BELL
1984

Abstract; 34' × 75' × 7'; neon
Location: Southwestern Bell
Texas headquarters, One Bell Plaza,
208 South Akard
Funding: Southwestern Bell
Telephone
Comments: Multicolored neon tubing
forms this glass-enclosed design
installed at street level above
Southwestern Bell's headquarters.
Outside, this work is the focal point
of a landscaped courtyard, where a
man-made pool of water flows down a
terraced slope away from the sculp-
ture; inside, the neon abstract
functions as a skylight. This site-
specific work was ordered through
Architectural Arts Company in
Dallas.

Neon for Southwestern Bell.
Photo courtesy Stephen Antonakos.

Location: Maxus Energy Building,
Harwood and San Jacinto
Funding: Harlan Crow
Comments: Bateman, a New York
City native, chose Texas granite for
this site-specific sculpture, which
represents a merger of the human
character with organic abstraction.
The massive piece was carved from a
$12^{1}/_{2}$-ton block of granite quarried at
Fredericksburg, blocked out at the
artist's studio in Fort Worth, and
completed on-site.

Baudoin, Ali

(American)

PRAIRIE TWIST *1983*

Abstract; 23' H; polished stainless
steel fabricated at Shidoni Art
Foundry in Tesuque, New Mexico
Location: 7920 Beltline
Funding: Liberty Exchange, Ltd.

Bear Mountain Red: A Texas Landscape.
Photo by Robert Little.

Bateman, Alice Maynadier

(b. 1944 American)*

**BEAR MOUNTAIN RED:
A TEXAS LANDSCAPE** *1982*

Abstract; 13' H; sunset-red Texas
granite

Bayer, Herbert

(b. 1900 American/Austrian)

FOUR CHROMATIC GATES *1984*

Abstract; 12' × 11' × 16'6"; ¹/₄" painted aluminum plate
Location: Bullington Plaza, 1500 block Bryan between Akard and Ervay
Funding: Owned by the city of Dallas

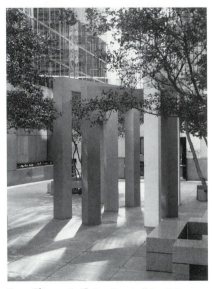

Four Chromatic Gates. Photo by Robert Little.

Berchem, A. J.

(American)

DR. ROBERT C. BUCKNER *1936*

Portraiture; life-size; bronze cast at American Bronze Foundry in Chicago
Location: Buckner Children's Home campus, 5200 South Buckner
Funding: Buckner Children's Home alumni
Comments: Berchem, a resident of Chicago, used an old picture from the files of the *Baptist Standard* to form this likeness of the man who founded Buckner Children's Home in 1879. Buckner came to Texas in 1859 and died in Dallas in 1919. The dedication

of Buckner's orphanage took place in the old John Neely Bryan log cabin, which the Buckner family donated to the city of Dallas in the 1930s. Now located downtown in a plaza bounded by Elm, Commerce, Market, and Record streets, the cabin is considered the first permanent residence in Dallas.

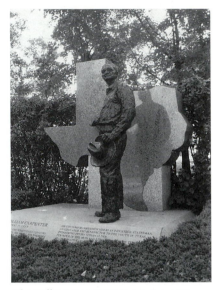

John William Carpenter. Photo by Robert Little.

Berks, Robert

(b. 1922 American)

JOHN WILLIAM CARPENTER *1980*

Portraiture; larger than life-size; bronze
Location: Carpenter Plaza, 400 North Pearl at Crockett Street
Funding: Southland Life Insurance Company
Comments: Carpenter (1881–1959) was a Dallas industrialist, businessman, agriculturalist, civic leader, philanthropist, and Presbyterian elder. Robert Berks is famous for creating biographies in bronze through his portrait sculptures. The

138

trademark of his work is the use of heavily textured surfaces. Carpenter Plaza, a project of the SWA Group in Houston, is part of the parks system of the city of Dallas.

Bourdelle, Pierre

(died 1966 American/French)*

WINGED HORSE AND SIREN *1936*

Figurative; 27' H; raised cement frescoes
Location: Fair Park, entrance to the Esplanade of State
Funding: 1936 Texas Centennial Exposition Corporation
Comments: Large nautilus shells extend from the bases of two pylons. Each pylon features the mythological winged horse on one side and a siren on the other side.

Siren and Winged Horse pylons.
Photos by Robert Little.

Bridges, Jack

(American)*

BIG TEX *1952*

Figurative; 52' H; fiberglass
Location: Fair Park, entrance to the fairgrounds
Funding: Purchased by R. L. Thornton, president of the State Fair of Texas Association, from the city of Kerens
Comments: *Big Tex* originally was constructed in 1949 as a giant Santa Claus placed in Kerens by the

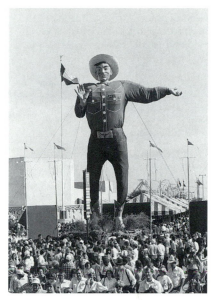

Big Tex. Photo courtesy the State Fair of Texas.

Chamber of Commerce to boost Christmas shopping. After Thornton purchased "The World's Largest Santa Claus," Dallas artist Jack Bridges transformed Saint Nick into the official greeter at the State Fair of Texas. *Big Tex* made his debut in 1952, and the following year, his jaws were motorized to enable him to welcome folks to the fair. For decades, the booming voice of Jim Lowe of Dallas has provided the now familiar "Howdee, folks!" *Big Tex* wears size 70 cowboy boots, a 75-gallon hat, and Lee jeans with a 23-foot waist and a 23-foot inseam.

Brown, David Lee

(American)

UNTITLED *1985*

Abstract; 9'6" × 12'6" × 5'; stainless steel
Location: Lincoln Centre, LBJ Freeway at North Dallas Tollway
Funding: Lincoln Centre Development

139

Comments: All of the outdoor sculpture at Lincoln Centre was placed through Adelle M Gallery in Dallas.

Busiek, Miley

(Native Texan)*

ASTROLOBE *1985*

Figurative; 12' diameter; bronze
Location: 3811 Turtle Creek Boulevard
Funding: Commissioned by Lincoln Property Company

THE DREAM IS PASSED ON *1989*

Figurative; 5 life-size figures; bronze
Location: Hotel Crescent Court, intersection of McKinney and Pearl
Funding: Commissioned by Rosewood Corporation and dedicated to the founding families of the city of Dallas.

The Dream Is Passed On. Photo by Robert Little.

Calder, Alexander

(1898–1976 American)

MAN (INTERMEDIATE MODEL) *1967*

Abstract; 16'4^1/$_2$" × 13'1^1/$_2$" × 10'9"; painted steel
Location: Lincoln Plaza, 500 North Akard
Funding: Purchased in 1985 by Lincoln Property Company
Comments: In the 1930s, Calder's

works inspired the term "stabile," which describes his stationary abstract sculptures. This type of work evolved from the artist's earlier inventions of motorized and hand-powered mobile sculptures and his later models that moved naturally by air and wind. During the 1940s, Calder began transposing his small mobiles and stabiles into monumental pieces. These larger creations serve as popular centerpieces for various architectural projects and urban plazas throughout the world.

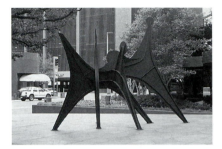

Man (Intermediate Model). Photo by Robert Little, courtesy Lincoln Property Company, Dallas.

Cargill, David

(b. 1929 Native Texan)*

RING AROUND THE ROSES *1956*

Figurative; 4 figures, each 2' H; bronze
Location: Children's Medical Center, 1935 Amelia
Funding: Donated by Betty Blake

Chandler, Clyde Giltner

(1879–1930? American)*

CAPTAIN SYDNEY SMITH MEMORIAL FOUNTAIN *1916*

Figurative; 13' H × 10' W; bronze and granite
Location: Fair Park, main entrance
Funding: State Fair of Texas Association
Comments: Also known as *Gulf Cloud,* this work was commissioned

to honor Captain Sydney Smith, who served as the first secretary of the State Fair of Texas from 1886 to 1912. It was the artist's first large commission and her only publicly sited work in Texas. After studying under Dallas painter Robert Onderdonk, Chandler attended the Massachusetts Normal Arts School and the Art Institute of Chicago. She designed this work in her Chicago studio, which was located next door to her longtime teacher, Lorado Taft. The allegorical female figures symbolize the four geographic areas in Texas. In 1928, Frances Fisk aptly described the fountain as follows: "The Gulf lolls against the feet of the Coastal Plains who rests in the lap of the Table Lands, while the figure with wings, representing the Gulf Breeze, brings the rain which showers down nurturing the state" (219). The base on which the group rests is encircled in a granite bas-relief garland that depicts the state's native vegetation.

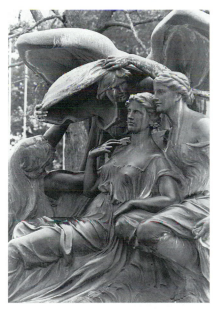

Captain Sydney Smith Memorial Fountain (detail). Photo by Mollie Shelton Hussing. From the Collections of the Dallas Historical Society.

In an opinion survey conducted in 1987 by the *Dallas Morning News*, Dallas residents chose this work as one of the most popular outdoor sculptures in the city.

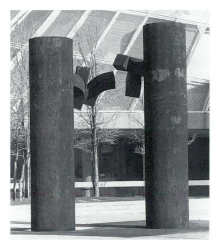

De Música. Photo by Robert Little.

Chillida, Eduardo

(b. 1924 Spanish)

DE MUSICA *1989*

Abstract; 2 elements, each 15' H; Cor-ten steel
Location: Morton H. Meyerson Symphony Center, Betty B. Marcus Garden, 2301 Flora
Funding: Commissioned and donated to the city of Dallas by Frank Ribelin with the involvement of the symphony center's Art Acquisition Committee
Comments: Chillida designed this work specifically for the site. He made several trips to Dallas while developing his proposal, and he worked with the center's architect, I. M. Pei, to determine the sculpture's placement. The branchlike shapes stemming from near the top of the vertical columns represent music, sculpture, and architecture. They appear to reach out to each other without actually touching.

141

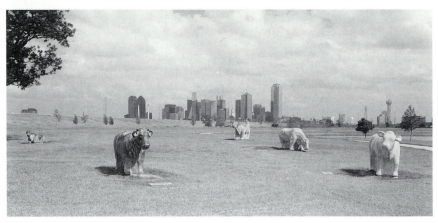

A Long Way Home. Photo by Scott Metcalfe Photography, courtesy Trammell Crow.

Clayton, Harold

(b. 1954 Native Texan)*

A LONG WAY HOME *1985*

Figurative; 5 figures, 4'6" H to 5' H; Italian marble and stone carved at the Sem Ghelardini Studio in Pietrasanta, Italy
Location: Trinity Lake Park at Sylvan Drive at the Trinity River
Funding: Donated to the city of Dallas by Trammell Crow
Comments: The herd includes two cows in black Spanish marble, one cow in red Italian marble, one cow in gray Italian marble, and one cow in Italian stone. These stylized bovines weigh 4 tons each. Their weight, size, and the durability of the marble make them ideal for placement outdoors because they are practically inde-structible, and they are too heavy for thieves to move.

FALL LEAF, SPRING RETURN *1990*

Abstract; 5' H; red Persian travertine
Location: 3300 block Turtle Creek Boulevard
Funding: On long-term loan to the city of Dallas from the Trammell Crow Family Administration

FATHER, MOTHER, AND CHILD *1984*

Abstract; 7'7" × 3' × 2'3"; Arkansas limestone carved on-site
Location: Lovers Lane United Methodist Church, Inwood Road and Northwest Highway
Funding: Private donation

Collie, Alberto

(b. 1939 Venezuelan)

UNTITLED *1985*

Abstract; 35' H; chrome and aluminum
Location: 2501 Oak Lawn
Funding: Originally placed by Crosland Investment Properties, Inc.
Comments: Vertical chrome-plated tubes erupt from the center of an aluminum base.

Coppini, Pompeo

(1870–1957 American/Italian)*

PROSPERO BERNARDI *1936*

Portrait bust; larger than life-size; bronze
Location: Fair Park, near the Hall of State Building
Funding: *La Tribuna Italiana*, an

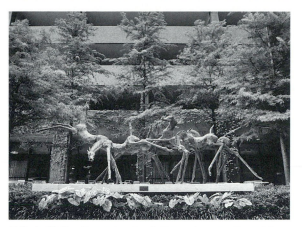

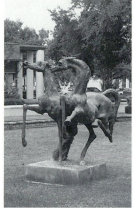

Colts in Motion. Photo by Scott Metcalfe Photography, courtesy Trammell Crow.

Fighting Stallions.
Photo by Robert Little.

Italian American newspaper published in Dallas
Comments: The Italian hero of the Battle of San Jacinto is portrayed in pioneer attire. Coppini created this work in his New York studio.

Dahl, George

(American)*

BUFFALO HUNT *1936*

Pylon with sculptural frieze; 85' H; stone
Location: Fair Park, Parry Avenue entrance
Funding: 1936 Texas Centennial Exposition Corporation
Comments: George Dahl designed the star-crested pylon, and Texas artist James Buchanan "Buck" Winn, Jr., designed the sculptural frieze of a buffalo hunt and wagon train that surrounds the pylon's base. Dahl, a Dallas architect, supervised the $25 million project that created Fair Park much as it exists today. He and his colleague Donald Nelson brought several well-known artists to Texas to create artwork for the park. According to Jose Martin, "At the start of 1936, Raoul [Josset] was invited by Mr. Donald Nelson to

participate in the Centennial Exposition of Dallas, Texas. Mr. Nelson had become the collaborator of the architect, George Dahl. So in the middle of February, Raoul and some sculptor helpers (I was one of them) arrived in Dallas" (Martin 1959).

Davis, Richard

(b. 1942 American)*

IN AND OUT *1976*

Abstract; 25' H; stainless steel
Location: Red Bird Mall, 3662 West Camp Wisdom Road
Funding: Newhouse and Taylor Architects

Debska, Anna

(Polish)

COLTS IN MOTION *1980*

Figurative; 10' × 20' × 6'; steel
Location: 717 North Harwood
Funding: Trammell Crow

FIGHTING STALLIONS *1980*

Figurative; 9' H; bronze
Location: Dallas Decorative Center, 1617 Hi Line Drive
Funding: Trammell Crow

143

De Weldon, Felix

(b. 1907 American/Austrian)

GEORGE B. DEALEY *1948*

Portraiture; larger than life-size;
bronze
Location: Dealey Plaza,
Main and Houston
Funding: George B. Dealey Memorial
Association
Comments: Behind the statue are five
large bas-relief plaques mounted on a
granite wall depicting Dealey's many
contributions to Dallas. The statue
was signed and dated by the artist in
Washington, D.C.

DuPen, Everett

(b. 1912 American)

EXUBERANCE *1982–1983*

Figurative; 10'9" H; cast bronze
Location: Paragon/Great West
Property, 7557 Rambler Road
Funding: Paragon Group

Mule Deer. Photo by Robert Little.

Durenne, A.

(French)

MULE DEER *nineteenth century*

Figurative; life-size; cast iron
Location: Turtle Creek Park at
Gilbert and Turtle Creek Boulevard
Funding: Donated to the city of Dallas
by John and Ruth Stemmons and
Trammell and Margaret Crow in 1977
Comments: In 1990, Trammell Crow

Partners restored this figure through
the Dallas Adopt-A-Monument
program.

Dusenbery, Walter

(b. 1939 American)

RED TWIST *1986–1987*

Abstract; 25' H; red Turkish marble
Location: Bryan at Harwood
Funding: Commissioned by Olympia
and York, Dallas, through Fendrick
Gallery, Washington, D.C., and
International Arts Services,
New York City
Comments: Dusenbery, a California
artist, designed this sculpture
specifically for its location in
downtown Dallas. Measuring 3' by 4'
at its base, the marble tower flares to
4' by 6' at its widest point before
tapering to its summit.

Easley, William

(b. 1944 Native Texan)*

RAMSES COMMEMORATIVE *1990*

Figurative; 6' H; Texas limestone
Location: Fair Park, Dallas Museum
of Natural History
Funding: Private donations
Comments: This work commemo-
rates the Ramses the Great exhibition
held in 1989 at Fair Park and spon-
sored by the Dallas Museum of
Natural History in cooperation with
the Egyptian Antiquities Organiza-
tion and the city of Dallas.

Edstrom, David

(1873–1938 American/Swedish)

SAMUEL P. COCHRAN *1919–1920*

Portraiture; larger than life-size;
bronze cast at the Roman Bronze
Works, New York
Location: 500 South Harwood
Funding: Scottish Rite Class,
1919–1920

Etrog, Sorel

(b. 1933 Canadian/Romanian)

THE LARGE PULCINELLA
1965–1967

Abstract; 9' H; bronze
Location: Lake Cliff Park,
300 East Colorado
Funding: Trammell and Margaret
Crow

Friedley-Voshardt Foundry

(American)

STATUE OF LIBERTY REPLICA
1950

Figurative; 8'4" H; stamped sheet
copper
Location: Fair Park, east of the
Hall of State
Funding: Boy Scouts of America

Ginnever, Charles

(b. 1931 American)*

PISA *1984*

Abstract; 15' H; steel plate painted
red and black
Location: Spring Valley Center,
5220 Spring Valley Road
Funding: Hurd Development
Comments: Geometric shapes form
this abstract sculpture that leans to
one side much like the Tower of Pisa.

Goldberg, Brad

(b. 1954 American)*

PEGASUS PLAZA *1994*

Environmental; 350' × 100'; water,
limestone, and Texas granite
Location: Pegasus Plaza, downtown
Dallas at Akard and Main streets
Funding: Dallas Institute of Humani-
ties and Culture and the city of
Dallas. The private sector, including a
$500,000 donation from actress Greer
Garson Fogelson, funded this $2.25

million project, except for a $750,000
bond election held in 1982.
Comments: The plaza's theme of
rebirth is based on the mythological
winged horse, Pegasus, whose image
has crowned the adjacent Magnolia
Building since 1934, when the famous
revolving *Flying Red Horse* was
installed as the trademark for
Magnolia Oil products. The myth is
made visual through a series of stone
water sculptures and landforms that
tap into a mineral spring 1,600 feet
below the site. Medusa Fountain is
named for the serpent-haired monster
who gave birth to Pegasus as she was
being slain by the hero Perseus.
Pegasus Fountain, a limestone

Pegasus Plaza. Photo courtesy Brad Goldberg.

landform that emits mist from a long, man-made fissure, suggests the location where Pegasus struck the ground on Mount Helicon shortly after his birth. Later, that same spot became sacred to the Muses because they believed it to be a source of poetic inspiration. The Muses' role in the legend is represented by a series of strategically placed granite boulders covered with carved symbols of the nine Muses. Pegasus Plaza, created from a parking lot, is intended as a place set aside for art, beauty, and contemplation in the downtown core of the city.

UNTITLED *1981*

Abstract; 10' × 17' × 6'; Texas granite
Location: The Warrington Condominium, 3831 Turtle Creek Boulevard
Funding: Privately funded by the developer
Comments: Goldberg is a Dallas resident who specializes in site-specific installations.

Goodacre, Glenna
(b. 1939 Native Texan)

PLEDGE ALLEGIANCE *1994*

Figurative; 7 larger-than-life figures; bronze
Location: Texas Scottish Rite Hospital for Children, 2222 Welborn Street
Funding: Purchased through Altermann and Morris Art Galleries and donated to the hospital by Sarah M. and Charles E. Seay
Comments: Gathered around the American flag, seven children say the Pledge of Allegiance on the hospital's front lawn. One tries to remember the words, one has the wrong hand over her heart, another is distracted by the moment—as children often are. Glenna Goodacre captures in bronze the motion and emotion of a shared national ritual.

PUDDLE JUMPERS *1989*

Figurative; 6 life-size figures; bronze
Location: Tom Landry Sports Medicine and Research Center on the Baylor Health Care System campus, 411 North Washington
Funding: Private donation
Comments: Two life-size busts by Goodacre, *Expectations* and *The Athlete,* are installed inside the center. Other outdoor placements in Dallas include four life-size busts on the grounds of the headquarters of Texas Instruments.

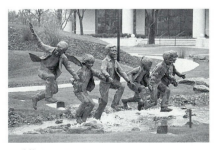

Puddle Jumpers. Photo by Robert Little.

Pledge Allegiance. Photo courtesy Texas Scottish Rite Hospital for Children.

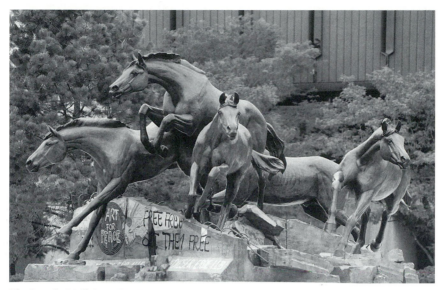

The Day the Wall Came Down, incorporating the Dallas *Freedom Horses* (right) and *Freedom Mare Jumping Up* (center) installed at the University of Texas in Austin. Photo courtesy Veryl Goodnight.

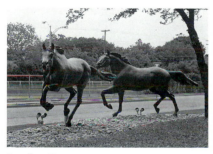

Freedom Horses. Photo by Robert Little.

Goodnight, Veryl

(b. 1947 American)

FREEDOM HORSES *1992*

Figurative; 2 figures, each 1^1/$_4$ life-size; bronze cast at Valley Bronze of Oregon in Joseph, Oregon
Location: The Shelton, 5900 Luther Lane at Lomo Alto
Funding: Purchased through Altermann and Morris Art Gallery and donated to the public by Japanese businessman Takeharu Miyama

Comments: Goodnight created these two galloping bronze horses as part of a larger work. Inspired by the collapse of the Berlin Wall, Goodnight designed a monumental sculpture consisting of five larger-than-life horses traversing the rubble of the Berlin Wall to freedom. The first casting of the larger work, titled *The Day the Wall Came Down,* is to be installed in Berlin, Germany; the second casting will be exhibited at Stone Mountain, Georgia, during the 1996 Olympics and later installed at Texas A&M University in front of the George W. Bush Presidential Library. A third figure from the larger work is installed on the campus of the University of Texas at Austin near the Ex-Students' Association Lila B. Etter Alumni House.

Greiner, Max, Jr.

(b. 1951 Native Texan)*

DIVINE SERVANT *1987*

Figurative; life-size; bronze cast at Eagle Bronze in Lander, Wyoming
Location: Dallas Baptist University

147

campus, 3000 Mountain Creek
Parkway
Funding: Ira and Betty Craft
Comments: Another casting of this
work is installed on the campus of
Dallas Theological Seminary, 3909
Swiss Avenue. It was placed at the
seminary in 1987 by an anonymous
donor.

Hadzi, Dimitri

(b. 1921 American)

BISHOPS TRIAD 1980

Abstract; 24' H; granite
Location: One Dallas Centre,
350 North Saint Paul Street
Funding: Originally placed by Vincent
A. Carrozza and currently owned by
the Trammell Crow Company

Hauser, Erich

(German)

33/69 1969

Abstract; 9' H; brushed stainless steel
Location: Turtle Creek Boulevard at

33/69. Photo by Robert Little.

Stonebridge Drive
Funding: Donated to the city by the
Edward and Betty Marcus Foundation
in July 1986

Irwin, Robert

(b. 1928 American)

PORTAL PARK DALLAS 1980

Environmental; 12' H × 700' L;
Cor-ten steel
Location: Carpenter Plaza, Pearl and
Pacific at Central Expressway
Funding: National Endowment for
the Arts and Southland Life Insurance
Company; owned by the city of
Dallas
Comments: A thin metal strip cuts
through grassy mounds and intersects
passing streets as it winds its way
through Carpenter Plaza, the intro-
ductory portal park to the downtown
area.

Johanson, Patricia

(b. 1940 American)

SAGGITARIA PLATYPHYLLA and PTERIS MULTIFIDA 1986

Environmental; 2 segments of varying
widths, *Saggittaria Platyphylla*
measures 235' × 157' and *Pteris
Multifida* measures 178' × 88';
painted concrete
Location: Fair Park, Leonhardt
Lagoon
Funding: Meadows Foundation,
Communities Foundation of Texas,
Texas Commission on the Arts,
Dallas Park and Recreation Depart-
ment, and donations from other
organizations
Comments: This work was commis-
sioned as a part of the Sesquicenten-
nial renovation of the State Fair-
grounds at Fair Park. The controver-
sial water-garden piece that snakes
along the shores and then arches and
curves like a roller coaster across the

lagoon has been compared to a bloated python. However, this narrow ribbon of concrete protects the shores from erosion, creates a friendly environment for aquatic organisms and plants, and provides little islands and paths for water creatures, wildlife, and human observers.

Saggitaria Platyphylla (top) and *Pteris Multifida* (bottom). Photos by Robert Little.

Johnson, J. Seward, Jr.

(b. 1930 American)

AFTERMATH 1983

Figurative; life-size; bronze
Location: Bryan Tower, 2001 Bryan
Funding: Trammell Crow
Comments: After many years as a painter, Johnson began working as a sculptor in 1968. His hyperrealistic sculptures portray people involved in the activities of daily life: business-men greet each other with a hand-shake on a crowded street; children share an ice-cream cone on the school grounds; workers take a lunch break at a construction site. The artist

makes the following statement about the philosophy that motivates him and influences his work: "We are overwhelmed in the twentieth century with what technology has brought us. We need to be reminded of the warmth of the human spirit, and so examples should be present in our environments. We have to understand that our age can be a humanitarian one, and not one which relegates the human being to an alienated condition" (Sculpture Placement, Ltd., n.d.). Johnson's works are cast at the Johnson Atelier, a $2.5 million state-of-the-art facility near Trenton, New Jersey, where Johnson developed his unique coloration process. To achieve the hues that are a hallmark of his work, an artisan heats the bronze surface of the sculpture with the flame of a hand-held acetylene torch. Simulta-neously, various traditional patina chemicals are applied with a brush; the flame bonds the chemical color onto the bronze surface. *Aftermath* and other Johnson works are occa-sionally rotated to different locations

Aftermath. Photo by Robert Little.

149

in the downtown area. All exhibitions and sales of J. Seward Johnson sculptures are coordinated through Sculpture Placement, Ltd., of Washington, D.C.

GETTING INVOLVED *1984*

Figurative; life-size; bronze
Location: Concorde Bank,
Olive Street side
Funding: Trammell Crow

THE RIGHT LIGHT *1984*

Figurative; life-size; bronze
Location: Corner of Flora and Olive
Funding: Trammell Crow

TIME'S UP *1984*

Figurative; life-size; bronze
Location: Maxus Energy Building,
Harwood and San Jacinto
Funding: Harlan Crow

The Right Light.
Photo by Robert Little.

Time's Up.
Photo by Robert Little.

Johnson, Philip

(b. 1906 American)

JOHN F. KENNEDY MEMORIAL *1970*

Cenotaph; 4 walls, each 32' H, forming a 50' square; concrete, steel, and marble
Location: John F. Kennedy Memorial Plaza, Main and Commerce
Funding: The citizens of Dallas

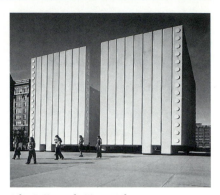

John F. Kennedy Memorial.
Photo courtesy *Texas Highways Magazine.*

Comments: Placed near the site of President Kennedy's assassination, the cenotaph incorporates 72 elements joined by steel tendons and supported by only eight members. In the center of the four-sided, partially enclosed area is a slab of black marble with the president's name inscribed in gold. A few blocks away is another Philip Johnson design, Thanks-Giving Chapel, located in Thanks-Giving Square at the intersections of Bryan, Pacific, and Ervay. The small white-Italian-marble chapel was erected in 1977 to commemorate the two-hundredth anniversary of the American Thanksgiving tradition.

Josset, Raoul

(1898–1957 American/French)*

FRANCE, MEXICO, and UNITED STATES *1936*

Figurative; 3 figures, each 20' H, on a 12' H base; concrete
Location: Fair Park, Automobile Building
Funding: 1936 Texas Centennial Exposition Corporation
Comments: The Esplanade of State at Fair Park is flanked by six female allegorical figures representing countries whose flags have flown over Texas. Three of the figures are by

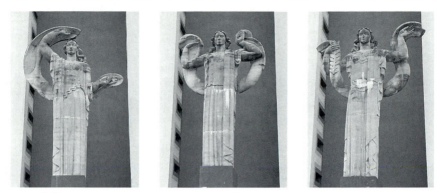

France (left), *Mexico* (center), and *United States* (right). Photos by Robert Little.

Josset, and three are by Laurence Tenney Stevens. Josset's *United States* has the emblem of a shield on her chest and carries a laurel sprig, *France* has a fleur-de-lis on her chest and carries a cluster of grapes, and *Mexico* features an eagle and a snake. Jose Martin wrote about creating these statues, "The work was made in a big building at Fair Park. It was a memorable period of hard work, but of tremendous interest and pleasure. Raoul created four models for big statues, representing the United States, Mexico, and France, and the spirit of the Centennial and other decorative sculptures. I was working on the enlargement of his models" (Martin 1959).

NURSE AND CHILD *1938*

Figurative; larger than life-size; Alabama marble purchased from the Georgia Marble Company of Marietta, Georgia
Location: Texas Scottish Rite Hospital for Children, 2222 Welborn Street
Funding: Texas Scottish Rite Hospital Board of Trustees
Comments: There is no record of an official title for this statue, but hospital files record that one of the sculptor's friends said that the artist had hoped to convey a nurse lifting

up a child, perhaps out of illness. In his biographical sketch of Josset, Jose Martin records that he and Pierre Bourdelle shared Josset's studio on Main Street at the time this work was created. The statue serves as the focal point of a cenotaph honoring those who have remembered the hospital in their estates.

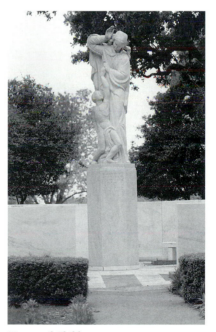

Nurse and Child. Photo courtesy Texas Scottish Rite Hospital for Children.

151

Spirit of the Centennial. Photo from the Collections of the Dallas Historical Society.

SPIRIT OF THE CENTENNIAL *1936*

Figurative; 20' H; concrete, plaster, and metallic silver coating
Location: Fair Park, Maintenance Building
Funding: 1936 Texas Centennial Exposition Corporation
Comments: Texas actress, model, and singer Georgia Carroll modeled for this tribute to the builders of the 1936 exposition. As a singer with the Kay Kyser Band, she was introduced to audiences by the band's leader as "Gorgeous Georgia Carroll." (She later married Kyser.) Josset designed this figure of a beautiful woman standing between the prickly prongs of a West Texas cactus, and Jose Martin did the carving. Josset and Martin also provided the reflection pool and fountain figure in front of the statue.

Kearney, John

(b. 1924 American)

THE QUORUM *1985*

Figurative; larger than life-size; chromium-plated automobile bumpers
Location: NCNB Plaza, 901 Main Street
Funding: Dallas Main Center, J.V. 1
Comments: Kearney, a native of Omaha, Nebraska, uses 25 to 50 tons of automobile bumpers each year in creating his sculptures, which are mostly figures of animals. *The Quorum* is composed of four stylized figures of giant frogs.

Kliem

BERLIN BEAR STATUE *circa 1970*

Figurative; 2'6" H; bronze
Location: Fair Park, Tower Building Plaza
Funding: Given to Dallas by the city of Berlin

Kraft, Stuart

(b. 1953 American)*

GABRIEL *1985*

Figurative; 14' H; steel
Location: Regency Plaza,
3710 Rawlins
Funding: Originally placed by Triland
Corporation

Pegasus. Photo by Robert Little.

PEGASUS *1984*

Figurative; 24' H; steel
Location: Booker T. Washington
High School for the Performing Arts
and Visual Arts at the corner of
2400 Flora and 1800 Fairmount
Funding: Cadillac Fairview Urban
Development, Inc.
Comments: Fifteen students worked
with Kraft while he served as artist-
in-residence to construct this
portrayal of the mythological winged
horse.

PHOENIX I *1980*

Figurative; 10' H; steel
Location: Stoneleigh P Restaurant,
2926 Maple Avenue
Funding: Stoneleigh P Restaurant

Les Ondines (top) and *Sacrifice* (bottom), installed
in the Betty B. Marcus Garden at the Morton H.
Meyerson Symphony Center. Photos by Robert Little.

Laurens, Henri

(1885–1954 French)

LES ONDINES *1934*

Abstract; 2'6" H × 5'3" L; bronze
Location: Morton H. Meyerson
Symphony Center, Betty B. Marcus
Garden, 2301 Flora
Funding: On long-term loan from
Gwendolyn Weiner to the city of
Dallas through the Art Committee of
the Dallas Symphony Association

Liberman, Alexander

(b. 1912 American/Russian)

VENTURE *1985*

Abstract; 38' H; Cor-ten steel
Location: NCNB Plaza,
901 Main Street
Funding: Dallas Main Center, J.V. 1

Comments: Liberman became a U.S. citizen in 1946. He lives in New York City and constructs his sculptures in Warren, Connecticut.

Lipchitz, Jacques

(1891–1973 American/French)

SACRIFICE *1948–1958*

Abstract; 4'1" H × 3' W; bronze
Location: Morton H. Meyerson Symphony Center, Betty B. Marcus Garden, 2301 Flora
Funding: On long-term loan from Gwendolyn Weiner to the city of Dallas through the Art Committee of the Dallas Symphony Association

Macken, Mark

(Belgian)

LOT'S WIFE *1967*

Figurative; life-size; bronze
Location: Stone Place, 2403 Millmar, on garden walkway between Elm and Main streets

Lot's Wife. Photo by Scott Metcalfe Photography, courtesy Trammell Crow.

Funding: Donated to the city of Dallas by Trammell Crow, Storey Stemmons, and John Stemmons

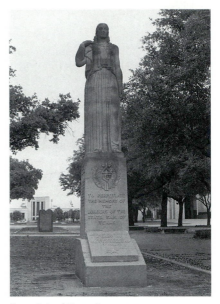

State Fair of Texas Statue. Photo by Robert Little.

Martin, Jose

(1891–1984 American/French)*

STATE FAIR OF TEXAS STATUE *1938*

Figurative; larger than life-size; stone
Location: Fair Park, Parry Avenue entrance
Funding: 1936 Texas Centennial Exposition Corporation to perpetuate the memory of the builders of the State Fair of Texas
Comments: Martin was born in Arbois, France, and moved to America in 1928. Much of the work that he did while living in Dallas is in the form of decorative sculpture on buildings.

Martin, Louis

(American)

JUSTICIA *1973*

Figurative; 4' H; bronze, metal,
and marble
Location: Dallas County Courthouse,
600 Commerce
Funding: Presented to the citizens of
Dallas County by the Dallas Bar
Association
Comments: A symbolic female figure
of Justice is mounted above six
bronze plaques on a hexagonal base.

Awakening of Spring. Photo courtesy of the
Public Information Office of Richland College.

Mascherini, Marcello

(b. 1906 Italian)

AWAKENING OF SPRING
circa 1973

Figurative; life-size; bronze
Location: Richland College campus,
12800 Abrams Road, near Fannin Hall
Funding: Commissioned by Mr. and
Mrs. Stephan Kahn, who donated the
work to the college in 1973
Comments: During the annual
epidemic of spring fever, the students
at Richland occasionally outfit this
reclining nude female figure in a
bikini and sunglasses. Three abstract
works by former students of the
college are installed near *Awakening
of Spring.*

McMath, J. B.

(American)*

THE FLYING RED HORSE *1934*

Figurative; 30' H figure on a 50' H
steel tower; neon tubing
Location: Magnolia Building,
Main and Akard
Funding: Magnolia Oil Company
Comments: After the Magnolia
Building was constructed in 1921–
1922 to house the offices of the
Magnolia Petroleum Company (later
Mobil Oil), it remained the tallest
building in Dallas for almost twenty
years. In 1934, the revolving "flying
red horse," trademark for Magnolia
products, was erected on the rooftop.
Designed by McMath and built under
his direction by the Texlite Sign
Company, the bright-red neon sign
quickly became the city's most
visible landmark. Pilots reported
seeing the horse from Hillsboro; a few
claimed to see it from as far away as
Waco. The sign's 1,162 feet of neon
tubing was first lit on November 8,
1934, for the annual convention of

The Flying Red Horse. Photo by James Wright Steeley.

155

the National Petroleum Institute. It is listed on the National Register of Historic Places.

Medellín, Octavio

(b. 1907 American/Mexican)*

SAINT BERNARD OF CLAIRVAUX SHRINE *1959*

Figurative; life-size; carved stone
Location: Saint Bernard of Clairvaux Catholic Church, 1404 Old Gate
Funding: Given by Jan Bunson in memory of her godmother
Comments: Medellín was born in Mexico, but he moved to Texas as a young man with his parents. While living in San Antonio during the 1930s, he and other local artists founded La Villita Art Gallery. Medellín taught art classes there and at the Witte Museum before moving to Denton to join the faculty of North Texas State Teacher's College (now North Texas State University). Later, while on staff at the Dallas Museum of Fine Arts, he taught sculpture at the museum, at Southern Methodist University, and at Cooke County Junior College. In 1960, he became a fellow of the International Institute of Arts and Letters, and in 1966, he founded the Medellín School of Sculpture, which was closely associated with the Creative Art Center of Dallas located in El Sibil, the Dallas home of Texas artist Frank Reaugh. Medellín's work has been exhibited nationally and was featured in a national tour organized by the Bronx Museum of the Arts. He is best known for his figurative work and his direct carving in wood and stone.

Huipago. Photo by Scott Metcalfe Photography, courtesy Trammell Crow.

Miller, Carol

(Mexican)

HUIPAGO *1983*

Figurative; 2'6" H; stone
Location: Byrd Park, Vassar at Turtle Creek
Funding: Trammell Crow

Saint Bernard of Clairvaux Shrine.
Photo by Carol Little.

Miller, John Brough

(b. 1933 American)*

COLD STRESS STEEL *1978*

Abstract; 13' H; Cor-ten steel
Location: Richland Community
College, 12800 Abrams Road, visitor
parking area on East Circle Drive
behind Fannin Hall

**AN OCULAR CAPRICIOUS
THOUGHT ABOUT DNA** *1983*

Abstract; 19'9" H; steel
Location: 1645 Stemmons Freeway
Funding: Trammell S. Crow

DESCENDING SPHERES and
MALTHUSIAN CONCEPTION
1979–1980

Abstract; 10' H and 6'6" H,
respectively; steel
Location: Lakewood Library,
6121 Worth Street
Funding: Donated to the city of
Dallas by Trammell Crow
Comments: These two works were
designed as companion pieces.

STELE II *1977*

Abstract; 10' H; steel
Location: Texas Woman's University,
Parkland Campus
Funding: Donated by artist
Comments: Miller created this work
while serving as chairman of the
Department of Art at Texas Woman's
University.

Descending Spheres and *Malthusian
Conception.* Photo courtesy Trammell Crow.

Man and Pegasus. Photo by Scott Metcalfe
Photography, courtesy Trammell Crow.

Milles, Carl

(1875–1955 American/Swedish)

MAN AND PEGASUS *1949*

Figurative; 11' H; bronze
Location: Bryan Tower,
2001 Bryan Street
Funding: Trammell Crow
Comments: A nude male figure with
hands and feet extended flies above,
not astride, the allegorical winged
figure of Pegasus. The sculpture
symbolizes the stimulant agent of
poetic inspiration. This casting was
shipped to Dallas from Stockholm,
Sweden, for placement at Bryan
Tower in 1972.

157

The Dallas Piece. Photo by Lee Clockman, courtesy Division of Cultural Affairs, Dallas Park and Recreation Department.

Moore, Henry

(1898–1986 British)

THE DALLAS PIECE 1978

Abstract; 3 elements, 16' H, weighing a total of 27 tons; bronze cast at Morris Singer Foundry in Basingstoke, England
Location: Dallas City Hall Plaza at Akard and Young
Funding: Donated to Dallas by W. R. Hawn and other donors in memory of his wife, Mildred
Comments: Moore designed *The Dallas Piece* specifically for its site in front of Dallas City Hall, and architect I. M. Pei joined the artist in Dallas to help in positioning the work. At the time of Moore's death in 1986, his works—which derive from the human form—stood, sat, and more often reclined in public view in cities from London to Chicago, from Melbourne to New York. Moore is believed to have more public commissions than any other artist, even Auguste Rodin.

Moroles, Jesús Bautista

(b. 1950 Native Texan)*

CONCAVE STELE 1987

Abstract; 6'8" × 4' × 1'3"; black Belgian granite
Location: Triton Building, 6688 North Central Expressway
Funding: Sullivan Corporation

WINDOW 1981

Abstract; 9' × 14' × 1'4"; Texas granite
Location: 12345 Inwood Road
Funding: Frank Ribelin

Window. Photo courtesy Jesús Bautista Moroles.

Orlando, Joe

(b. 1949 American)*

ALLEN'S PIECE and A PIECE FOR MR. PETE 1986

Abstract; 33'4" H and 42' H, respectively; painted steel
Location: Park Central Development, 12750 Merit Street
Funding: On long-term loan to Huffines Steel
Comments: These two hyperbolic paraboloids spiraling above LBJ Freeway are highly visible to passing motorists.

Ostermiller, Dan

(American)

MOUNTAIN COMRADES *1991*

Figurative; 9' H; bronze
Location: Tom Landry Sports
Medicine and Research Center on the
Baylor Health Care System campus,
411 North Washington
Funding: Private donation
Comments: In the atrium of the
center is *American Gold,* a colossal
bronze eagle created by Ostermiller
and donated to the center by Boone
and Peggy Powell.

Owen, Michael G., Jr.

(1915–1976 American)*

PERUNA *1937*

Figurative; 2' H; granite
Location: Southern Methodist
University campus, near the athletic
building
Funding: Private donations
Comments: Peruna is the mustang
mascot of Southern Methodist
University. Owen's stylized recum-
bent figure marks the grave of the
first Peruna. The artist moved to
Dallas during the 1930s to work on
the Centennial project at Fair Park.

Padovano, Anthony

(b. 1933 American)

ARC SEGMENTS *1972*

Abstract; 7'6" H × 9' W; steel coated
with epoxy
Location: Ridgewood Park,
6818 Fisher Road
Funding: Donated to the city of
Dallas by Mr. and Mrs. Trammell
Crow and Mr. and Mrs. John
Stemmons

Spheres. Photo courtesy City of Dallas
Office of Cultural Affairs.

Pan, Marta

(b. 1923 French)

SPHERES *1973*

Abstract; 3 spheres ranging from
3' to 6' in diameter; red polyester
Location: Fair Park, Leonhardt
Lagoon
Funding: Donated to the city of
Dallas in memory of Billie Marcus
Comments: Originally floating in
Central Park in New York City, these
spheres were brought to Dallas by
Stanley Marcus in 1974 and placed at
City Hall in 1978. After spending
several years in storage because of
problems with vandals and mainte-
nance, the work was installed in the
Leonhardt Lagoon in 1991.

Parker, Sam

(American)

TROUBADOUR *1970*

Figurative; 2'6" H; steel
Location: Red Bird Park,
5150 Mark Trail Way
Funding: Donated to the city of
Dallas by Trammell Crow
Comments: This contemporary
troubadour with sombrero and guitar
resembles a charming stick figure.

159

Equinox. Photo courtesy Charles O. Perry.

Perry, Charles O.

(b. 1929 American)

EQUINOX *1982*

Abstract; 45' H; tubular anodized aluminum and polished stainless steel
Location: Lincoln Centre, 5420 LBJ Freeway
Funding: Commissioned by Lincoln Centre Development
Comments: After receiving a master's degree in architecture at Yale University and practicing in San Francisco, Perry moved in 1964 to Rome, Italy, where he continued his career in architecture and sculpture. In 1977, he returned to America to live in Norwalk, Connecticut. Monumental geometrical forms by Charles Perry are placed in public spaces in more than a dozen states, from Maine to California. The universal appeal of his work is reflected by the placement of his sculpture in locations as diverse as Australia, Singapore, and Saudi Arabia. Among his many awards is

the Prix de Rome in architecture in 1964 and the National Academy of Design Award in 1987. Perry created *Equinox* in his studio in Norwalk and shipped it to Dallas in 1,200 pieces, which he and a crew of eight assembled on-site in 30 days. All of the outdoor sculpture installed at Lincoln Centre was placed through the Adelle M Gallery in Dallas.

Priour, Damian

(b. 1949 Native Texan)*

CUTTING EDGE OF THE OBELISK
1988

Obelisk; 14' H; Texas fossilized limestone and glass
Location: 1400 Turtle Creek
Funding: Lucy Crow Billingsley
Comments: Shimmering industrial glass gives the illusion of a waterfall flowing through an ancient limestone monolith. A native of Corpus Christi now living in Austin, Priour often incorporates highly fused plate glass reminiscent of the ocean with fossilized limestone indented with the forms of prehistoric sea life.

Cutting Edge of the Obelisk.
Photo courtesy Damian Priour.

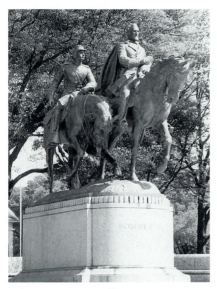

Robert E. Lee on Traveller. Photo by Robert Little.

Proctor, Alexander Phimister

(1862–1950 American/Canadian)

ROBERT E. LEE ON TRAVELLER
1935–1936

Double equestrian; larger than
life-size; bronze
Location: Lee Park,
3400 Turtle Creek Boulevard
Funding: The Dallas Southern
Memorial Association
Comments: Representatives of the
association did not accept the artist's
first model, because it portrayed the
general and his aide in a torrential
rainstorm with their heads and the
heads of their mounts lowered. In
time, Proctor accepted the Southern
concept that Lee himself never was
personally defeated. Both the monu-
ment committee and Lee's grandson
Dr. Bowling Lee enthusiastically
approved the working model for this
monument, which shows the men
and mounts marching forward, heads
erect. General Lee's features were
acquired from old photographs, and

Traveller's likeness also was achieved
from old pictures, in addition to the
general's own writings and a live
model borrowed from a neighbor's
stable. Proctor took two years to
make the working model and almost
two more to complete the sculpture.
When President Franklin D.
Roosevelt unveiled the work on June
12, 1936, the artist heard him say,
"Magnificent!" General Lee mounted
on Traveller is riding ahead of a
young companion, who represents,
according to the base, "the entire
youth of the South to whom Lee
became a great inspiration." In 1991,
the Dallas Southern Memorial
Association sponsored a $50,000
restoration of *Robert E. Lee on
Traveller* through the Dallas Adopt-
A-Monument program. Upon
completion of the restoration project,
the statue received an official Texas
historical marker awarded by the
Texas Historical Commission.

Rickey, George

(b. 1907 American)

TWO OPEN RECTANGLES
HORIZONTAL *1985*

Abstract; 20' H; stainless steel
Location: Southwestern Bell Texas
headquarters, One Bell Plaza,
208 South Akard
Funding: Southwestern Bell
Telephone Company

Romo, Miguel

(Mexican)

IGNACIO ZARAGOZA *1987*

Portraiture; 9' H; bronze
Location: Jaycee/Zaragoza Park,
3114 Clymer Avenue
Funding: Donated by the government
of Mexico
Comments: Texas-born General
Ignacio Seguín Zaragoza led the

161

Mexican troops at the Battle of Puebla, in which Mexico defeated the French on May 5, 1862. The statue's base and 8-foot pedestal were provided by local businesses.

Rosati, James

(b. 1912 American)

UNTITLED *1983*

Abstract; 16' H; aluminum fabricated at Lippincott, Inc., in North Haven, Connecticut
Location: 3333 Lee Parkway
Funding: Originally placed by the Bank of Dallas
Comments: This bright red abstract was chosen from a small model in the artist's studio. Rosati liked the idea of a painted work for this site because he felt a stainless-steel sculpture would blend into the building. While visiting Dallas for the installation, the artist noted, "All I was trying to do was to make something visually exciting. . . . There is nothing I intended about the sculpture other than what you see. There is no great message" (*Dallas Morning News*, November 24, 1983).

Russin, Robert I.

(b. 1914 American)

HELIOS DALLAS *1982–1983*

Abstract; 12' H; red travertine marble on a polished bronze base cast at Fedde Bronze Works in Denver, Colorado
Location: Lincoln Centre, North Dallas Tollway and LBJ Freeway
Funding: Lincoln Centre Development
Comments: Outdoor sculpture at Lincoln Centre was placed through the Adelle M Gallery in Dallas.

Salmones, Victor

(American/Mexican)

CHICO Y CHICA DE LA PLAYA *n.d.*

Figurative; smaller than life-size; bronze
Location: Dallas Arboretum, 8617 Garland Road
Funding: Meadows Foundation

Sánchez, José Luís

(Spanish)

ASTRO-FLOWER *1968*

Abstract; 12' H; bronze
Location: Pacific Plaza at the intersection of Pacific, Olive, and Harwood
Funding: Great American Reserve Insurance Company

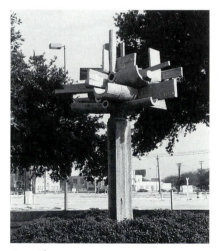

Astro-Flower. Photo by Robert Little.

Saylor, Jo

(American)

RED BALLOON *1990*

Figurative; 3'6" H; bronze
Location: Children's Medical Center of Dallas, 5000 Medical Center Drive
Funding: Private donation

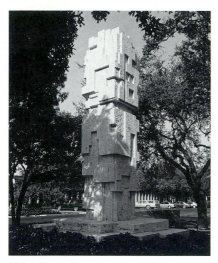

Maiandros. Photo by Scott Metcalfe Photography, courtesy Trammell Crow.

Stahly, François

(b. 1911 French)

MAIANDROS 1966

Abstract; 21' H; travertine marble
Location: 1617 Hi Line Drive
Funding: Trammell Crow

Stein, Sandi, and students

(b. 1946 Native Texan)*

SPIRIT OF 1989 1989

Figurative; 18' H; carved limestone

Location: Booker T. Washington High School for the Performing and Visual Arts at the corner of 2400 Flora and 1800 Fairmount
Funding: Private donations
Comments: Texas artist Sandi Stein worked with the students of the arts magnet school to create this carved collage, using the ancient form of a totem pole to record the student's everyday experiences. *Spirit of 1989* was featured at the Ramses the Great exhibit in Dallas in 1989.

Stevens, Laurence Tenney

(1896–1972 American)*

SPAIN, THE CONFEDERACY, and TEXAS 1936

Figurative; 3 figures, each 20' H on a 12' H base; concrete
Location: Fair Park, Centennial Building
Funding: 1936 Texas Centennial Exposition Corporation
Comments: These allegorical female figures are located directly across from three companion works made by Raoul Josset. *Spain* carries a castle and castanets; *The Confederacy* wears a band of seven stars around her head, symbolic of Texas being among the first seven states to secede; and *Texas* wears a Lone Star crown.

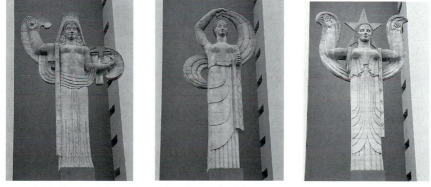

Spain (left), *The Confederacy* (center), and *Texas* (right). Photos by Robert Little.

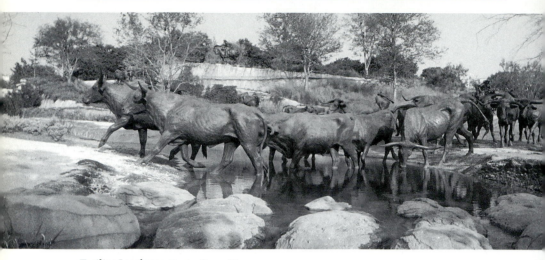

Trailing Longhorns. Courtesy Trammel Crow.

Summers, Robert

(b. 1940 Native Texan)*

TRAILING LONGHORNS
1992–1995

Figurative; more than 50 larger-than-life figures; bronze cast at Eagle Bronze in Lander, Wyoming
Location: Corner of Young and Griffin streets
Funding: Dallas Parks Foundation
Comments: Trammell Crow started Pioneer Plaza in 1992 with the goal of creating a focal point of historical significance for downtown Dallas and the expanded Dallas Convention Center. The Dallas Parks Foundation, a nonprofit corporation, exists to fulfill Crow's vision through corporate and individual contributions. The 4.2-acre plaza features 50 bronze longhorn steers being driven by three cowboys on horses through a landscaped area that includes native plant material and a flowing river. The plaza is across the street from the former site of the Doggett Grain building, where Trammell Crow started his real estate activities in 1948.

Surls, James

(b. 1943 Native Texan)*

TURNING FLOWER *1990*

Abstract; 12' H; wood and steel
Location: Turtle Creek Park
Funding: On extended loan to the city of Dallas by the Dallas Parks Foundation

Turning Flower. Photo by Robert Little.

Tauch, Waldine

(1892–1986 Native Texan)*

ROBERT LEE THORNTON STATUE
1968

Portraiture; larger than life-size; bronze cast at Roman Bronze Works in New York

Location: Fair Park, Hall of State Plaza
Funding: State Fair of Texas Association
Comments: R. L. Thornton was a Dallas businessman and civic leader. He served as president of the State Fair of Texas Association from 1945 to 1963 and as the mayor of Dallas from 1953 to 1961.

Teich, Frank

(1856–1939 American/German)*

CONFEDERATE MEMORIAL 1896

Portraiture; life-size; Italian marble and Texas granite
Location: Pioneer Park Cemetery, near Dallas City Hall and the Dallas Memorial Convention Center at Griffin and Marilla
Funding: Dallas Chapter 6, United Daughters of the Confederacy
Comments: According to the *Confederate Veteran,* Dallas Chapter 6 was the first UDC chapter formed in Texas. The members began meeting in 1894 under the leadership of Kate Cabell Currie, who later served as president of the national organization. The Dallas *Confederate Memorial* was unveiled on April 29, 1897, in a dedication ceremony so extravagant that the Texas Legislature closed to allow its members to attend. Also present was Governor C. A. Culberson, who delivered a welcome "as broad as the prairies of the Lone Star state and as beautiful as the flowers that deck them" (*Confederate Veteran,* July 1898, 301). Among the assembled dignitaries were Mary Anna Morrison Jackson, widow of General Stonewall Jackson; Margaret Davis Hayes, daughter of Confederate president Jefferson Davis; John H. Reagan, by then the last surviving member of the Confederate cabinet; and representatives from every state in the Trans-Mississippi Department

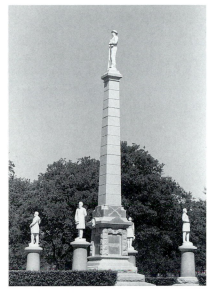

Confederate Memorial. Photo by Robert Little.

of the former Confederate States of America. The monument includes life-size figures of Robert E. Lee, Albert Sidney Johnston, Stonewall Jackson, Jefferson Davis, and a Confederate private. Originally placed in City Park, it is the oldest public sculpture in Dallas and one of three large Confederate memorials erected in Texas before the turn of the century.

CONFEDERATE SOLDIER STATUE 1929

Figurative; 7' H; marble
Location: Greenwood Cemetery, 3020 Oak Grove
Funding: Dallas Chapter 6, United Daughters of the Confederacy
Comments: This monument marks the grave site of Captain S. P. Emerson and honors all Confederate soldiers.

Tejas Warrior. Photo by Mollie Shelton Hussing. From the Collections of the Dallas Historical Society.

Tennant, Allie Victoria

(1898–1971 American)*

TEJAS WARRIOR *1936*

Figurative; 11' H figure on a 20' H dais; bronze and gold leaf
Location: Fair Park, Hall of State Building
Funding: 1936 Texas Centennial Exposition Corporation
Comments: *Tejas Warrior* underwent extensive restoration in 1990 through the Dallas Adopt-A-Monument program. Tennant also designed the relief work on the Aquarium Building at Fair Park as part of the Centennial project.

The Dallas Mammoth. Photo by Robert Little.

Tischler, Tom

(b. 1947 American)*

THE DALLAS MAMMOTH *1989*

Figurative; 13' H; bronze cast at Kasson's Castings in Austin
Location: Fair Park, Dallas Museum of Natural History
Funding: Commissioned by Dallas Museum of Natural History
Comments: Tischler has worked as an exhibit designer for the Zoological Museum in Zurich, Switzerland, and as an architect and technical adviser with the Ethiopian Conservation Organization, helping to establish Ethiopia's national parks and reserves system. *The Dallas Mammoth* (also called *Jumbo*), is based on the skeletal remains of a creature that was excavated from the banks of the Trinity River near downtown Dallas and reassembled for display in the museum's Earth Science Hall.

Todd, Michael

(b. 1935 American)

SUNAMI *1985*

Abstract; 17' L; steel
Location: NCNB Plaza, 901 Main Street
Funding: Dallas Main Center, J.V. 1

Ullberg, Kent

(b. 1945 American/Swedish)*

LINCOLN CENTRE EAGLE *1981*

Figurative; 25' H; cast stainless steel and black granite
Location: Lincoln Centre, 5410 LBJ Freeway at Dallas Parkway
Funding: Lincoln Centre Development
Comments: Outdoor sculpture at Lincoln Centre was placed through the Adelle M Gallery in Dallas.

Lincoln Centre Eagle. Photo by Robert Little.

Umlauf, Charles

(1911–1994 American)*

ICARUS *1965*

Figurative; 5' H; bronze
Location: 1617 Hi Line Drive
Funding: Trammell Crow

PIETA *n.d.*

Figurative; 4' H; bronze cast in
Pietrasanta, Italy
Location: Holy Trinity Catholic
Church, 3815 Oak Lawn Avenue
Funding: Given in memory of
Jane Keliher Northrup
Comments: Umlauf's pietà is unusual
in that the front of the sculpture
depicts Christ removed from the
cross and held in his mother's arms,
and the opposite side depicts a seated
female figure looking heavenward
with raised hands, as if in supplica-
tion. The female figure and the two
biblical figures are one piece and yet
entirely distinct. The hands and feet
of all three figures are disproportion-
ately large, a familiar characteristic of
the artist's style.

RECLINING MUSE *1982*

Figurative; 7' H; bronze cast in
Pietrasanta, Italy
Location: Doubletree Hotel at
Lincoln Centre, 5410 LBJ Freeway
Funding: Commissioned by Lincoln
Centre Development
Comments: This work was placed
through the Adelle M Gallery in
Dallas.

SPIRIT OF FLIGHT *1961*

Figurative; 18' H figure on a 30' H
plinth; bronze cast by Vignali and
Tommasi Fonderia d'Arte in
Pietrasanta, Italy
Location: Dallas Love Field Airport
Funding: City of Dallas
Comments: Near the main entrance
to Love Field, this allegorical male
figure symbolizing flight forms the
centerpiece of a fountain from which
eighteen birds spiral up in flight.
Spirit of Flight was the winning entry
in a contest sponsored by the city in
1959 through the Love Field Monu-
ment Competition. Umlauf con-
tracted with the Vignali and
Tommasi foundry because bids from

Spirit of Flight. Photo by Photoscope Corporation,
Dallas, courtesy Charles Umlauf.

167

American foundries were too expensive. The contract marked the beginning of a relationship between the sculptor and the foundry that continued throughout the artist's career. In 1989, Houston artist Ben Woitena restored *Spirit of Flight* as part of an extensive renovation project at Love Field conducted by the Public Works and Aviation Department.

Unknown Artist

GUARD LION *nineteenth century*

Figurative; life-size; stone
Location: 2020 Ross Avenue
Funding: Trammell Crow

Unknown Artist

FIREMAN'S MONUMENT *1902*

Portraiture; life-size; granite
Location: Fair Park, City Communications Building
Funding: John Clark Monument Fund Association in memory of Clark, a fireman who died to save others in a Dallas fire
Comments: According to contemporary papers on file at the Dallas Firefighters Museum, the monument committee ordered this statue from a firm in Connecticut. Unfortunately, there is no record of the firm's name.

Unknown Artist

FOUNTAIN AT FIVE POINTS *1907*

Figurative; 7' H; granite
Location: 2100 Commerce Street at Central Expressway
Funding: Donated to Dallas by the National Humane Alliance of New York
Comments: In the center of the bowl is a four-sided shaft decorated with three lions' heads. Originally, water

flowed from the lions' mouths into the large basin, where horses drank. A lower basin serviced smaller animals. The fountain and the accompanying plaques were moved from Pershing Square to the present location in 1951.

Unknown Artist

GOLD STAR MOTHERS WAR MEMORIAL *1956–1957*

Abstract; 20' H; steel, marble, and concrete
Location: 700 block Akard at Canton
Funding: Public donations
Comments: Five pointed arches symbolizing a star are encircled at ground level with a marble rim inscribed with the following: "The mother to him who gave his life— The Soldier—To her who bore life and gave a son."

Unknown Artist

(Chinese)

INFOMART HAN HORSES
Western Han Dynasty 206 B.C.–A.D. *25*

Figurative; 2 figures, each 5'4$^{1}/_{2}$" H; stone
Location: Entrance to the Infomart, 1950 Stemmons Freeway
Funding: Trammell Crow

Infomart Han Horses. Photo by Scott Metcalfe Photography, courtesy Trammell Crow.

Unknown Artist

NIKE OF SAMOTHRACE
FACSIMILE *original 300–190 B.C.*

Figurative; larger than life-size;
Italian marble
Location: Children's Medical Center,
1935 Amelia Court
Funding: Donated to the Children's
Medical Center by Mrs. Ruby Kiest
in 1967
Comments: This statue, commonly
known as Winged Victory, is a
faithful recreation of the original
work unearthed in 1863 on the island
of Samothrace. When the statue of
the Greek goddess was discovered,
the arms and the head were missing,
as replicated in this copy. The
original is on display at the Louvre
Museum in Paris.

Whitney, Mac

(b. 1936 American)*

TARKIO *1978*

Abstract; 22' H; rolled steel painted red
Location: Murray Financial Center,
5580 LBJ Freeway
Funding: Originally placed by Murray
Savings and Loan

Wiinblad, Bjorn

(Danish)

THE MUSES *1993*

Figurative; 3 works, each 5'7" H;
bronze
Location: Crow Design Center,
1400 Turtle Creek Boulevard
Funding: Trammell Crow

Williams, Arthur

(b. 1942 American)

BIRTH II *1983*

Abstract; 7' × 15' × 7'8"; welded and
pressed steel

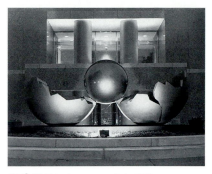

Birth II. Night photo courtesy Arthur Williams.

Location: 6688 North Central
Expressway
Funding: Sullivan Corporation
Comments: Sculpture by Arthur
Williams appears in public and
private collections throughout the
United States. In addition to large
steel and cast-bronze sculptures,
Williams carves alabaster, marble,
and wood. This work and his monu-
mental installation in Galveston are
from his *Birth* series.

Williams, Charles Truett

(1918–1966 Native Texan)*

UNTITLED FOUNTAIN PIECE
circa 1966

Abstract; 8' H; bronze
Location: Temple Emanu-El, Dorothy
and Rabbi Gerald K. Klein Garden,
8500 Hillcrest Road
Funding: Private donation

Winn, Walter

(b. 1930 Native Texan)*

KEEP THE DREAM ALIVE *1976*

Portraiture; larger than life-size;
bronze
Location: Martin Luther King, Jr.,
Community Center, 2922 Martin
Luther King Boulevard
Funding: City of Dallas Bicentennial
project funded by individual donations

169

Comments: This 8-foot-tall statue of Dr. Martin Luther King, Jr., was designed by Winn and completed by Oscar Graves, a sculptor from Detroit. "Keep the Dream Alive" has become a slogan to encourage the continuance of Martin Luther King's message.

Witkin, Isaac

(b. 1936 South African)

SABRAS *1973*

Abstract; 6'6" H; bronze
Location: University of Texas Southwestern Medical Center at Dallas
Funding: Donated to the University of Texas Southwestern Medical Center by the Patsy R. and Raymond D. Nasher Collection in memory of Patsy Nasher and in honor of Drs. Rhoda and Eugene Frenkel

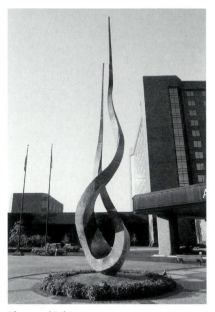

Flames of Life. Photo by Scott Metcalfe Photography, courtesy Trammell Crow.

Special Collections and Sculpture Gardens in Dallas

The Anatole Hotel at 2201 Stemmons Freeway has an outstanding collection of outdoor sculpture placed by Trammell Crow on the hotel's exterior grounds and in the hotel's Verandah Park. The main entrance is marked by **FLAMES OF LIFE** *1979,* a 47'-high bronze abstract by Prince Monyo Mihailscu-Nasturel. Also placed at entrances into the hotel are two monumental bronze figures, **BUDDHISTIC GUARDIAN LIONS** *Ching Dynasty, circa 1730–1782,* and two stone figures, **RECUMBENT STONE CAMELS** *circa 1400.* One other installation outside the hotel is Electra Waggoner Biggs' **RIDING INTO THE SUNSET** *original circa 1947.* Made in 1989, this sculpture is the most recent casting of the famous equestrian statue of Will Rogers (1879–1935) on his horse Soapsuds. Earlier castings are placed in Fort

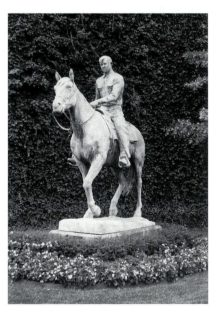

Riding into the Sunset. Photo by Robert Little.

170

Playtime. Photo by Robert Little.

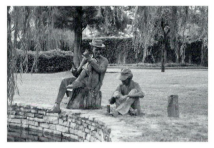

Sharing. Photo by Robert Little.

Worth, Lubbock, and Claremore, Oklahoma. Three sculptures are installed in Verandah Park: **PLAYTIME** *1984* by David Cargill, **SHARING** *1984* by J. Seward Johnson, Jr., and **BERLIN WALL SEGMENT WITH GRAFFITI** *1990* by German artist Jurden Grope, who added to and enhanced the graffiti drawn by anonymous persons and then signed the sections of the

notorious wall with his name and "Berlin, 1990." Appearing to float in the Verandah Park lake is **THREE IN A BOAT,** a stylized figural group by Danish artist Ernst Eberlein.

Dallas Alley, at the 800 block of Munger in the West End Historic District, is the site of ten sculptures by native Texan William Easley. The Pepsi-Cola Company of North Texas commissioned Easley to design and install modern monuments to ten Texans who are legendary in the field of popular music: Blind Lemon Jefferson, Buddy Holly, Bob Wills, Lightin' Hopkins, Lefty Frizzell, Roy Orbison, The Big Bopper, Scott Joplin, T-Bone Walker, and Tex Ritter. Easley created the sculptures for Dallas Alley over a period of four years, beginning in 1992 with tributes to Blind Lemon Jefferson, Buddy Holly, and Bob Wills. **BACK IN A BIT** commemorates the music of Blind Lemon Jefferson, who was born in 1897 on a farm near Wortham, Texas. His career as a blues guitarist and songwriter developed on the streets of Dallas and in dozens of other cities throughout the South, where he performed as a street singer. Easley's creation depicts Jefferson's guitar, travelbag, and tin can, all placed under a street sign at the intersection of Elm and Central.

Back in a Bit.
Photo by Robert Little.

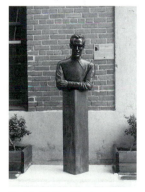

Buddy Holly: The Boy Next Door. Photo by Robert Little.

"San Antonio Rose" Monument. Photo by Robert Little.

171

BUDDY HOLLY: THE BOY NEXT DOOR honors Lubbock native Buddy Holly, who influenced the development of American music with his band, The Crickets, and their recordings of rock-and-roll classics, such as "Peggy Sue" and "That'll Be the Day." Holly's rockabilly band is said to have combined old hillbilly music with rock, blues, and country to create a new musical sound. Holly was born in 1936; he died in an airplane crash at the age of 23. The **"SAN ANTONIO ROSE" MONUMENT** is dedicated to Bob Wills, the king of western swing, who is remembered most for his recording of "San Antonio Rose," and his band, the Texas Playboys. Inspired by the lyrics of "San Antonio Rose," Easley modeled a column reminiscent of the architecture of the Alamo. The column supports a likeness of Wills' hat, fiddle, and bow. Bob Wills was born in Turkey, Texas, in 1906. He wrote more than 500 songs and sold millions of records.

The Dallas Market Center Sculpture Collection is located at the Dallas Market Center, a 6.9 million-square-foot complex comprising the world's largest wholesale mart. The center's outdoor sculpture includes sixteen works installed between 2050 and 2300 Stemmons Freeway on the grounds surrounding Market Hall, the Dallas Trade Mart, the World Trade Center, the International Menswear Mart, and the International Apparel Mart. The entire collection was placed by Trammell Crow. Representing the work of contemporary artists from around the world, as well as several pieces from antiquity, the collection includes the following sculptures at the designated locations:

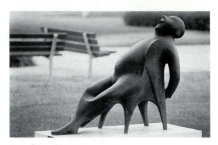

Laughing Man. Photo by Scott Metcalfe Photography, courtesy Trammell Crow.

Figure IV. Photo by Robert Little.

Market Hall, 2200 Stemmons

LAUGHING MAN *n.d.,* a life-size bronze by Harry Marinsky (British)

Dallas Trade Mart, 2100 Stemmons Freeway

FIGURE IV *1957,* a 6'-tall carved lava rock abstract by Hans Aeschbacher (b. 1906, Swiss)
ENDANGERED SPECIES *1979,* a whimsical 7'-tall bronze figure by Texan David Cargill
THE EAGLE *1964,* a figurative bronze memorial to President John F. Kennedy by Elisabeth Frink (b. 1930, British)
THE POTS CARRIER *1963,* a stylized bronze figure by Samuel Henri Honein (b. 1929, Egyptian)
CERA PERDIDA VERTICAL *1969* and **WORLD TRADE** *1969,* two bronze and stone designs by José María Subirachs (b. 1927, Spanish)

172

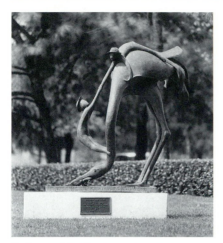

Endangered Species. Photo by Scott Metcalfe Photography, courtesy Trammell Crow.

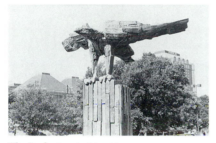

The Eagle. Photo by Robert Little.

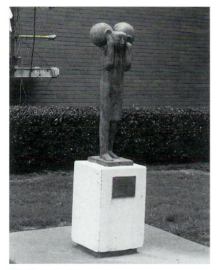

The Pots Carrier. Photo by Robert Little.

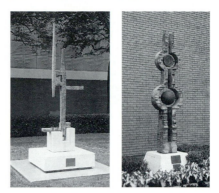

Cera Perdida Vertical (left) and *World Trade* (right). Photos by Robert Little.

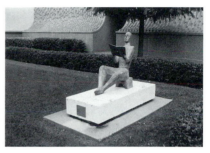

Singing Man. Photo by Robert Little.

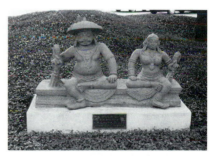

Indian Prince with Royal Consort.
Photo by Robert Little.

SINGING MAN *1963*, a figurative bronze by Elizabeth Turolt (b. 1902, Austrian)

INDIAN PRINCE WITH ROYAL CONSORT, a nineteenth-century stone carving formerly installed in the royal palace in the Kerala region of southern India

173

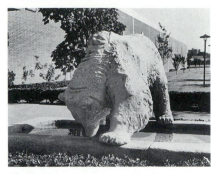

The Bear. Photo courtesy Trammell Crow.

Cortens. Photo by Robert Little.

Grand Double. Photo by Scott Metcalfe Photography, courtesy Trammell Crow.

**World Trade Center,
2050 Stemmons Freeway**

THE BEAR *1961,* a life-size cast-stone animal figure by Mogens Boggild (Danish)
CORTENS *1977,* a metal sectional sphere by Dusan Dzamonja (b. 1928, Yugoslavian)
GRAND DOUBLE *1964,* a 9' bronze abstract by Alicia Penalba (b. 1918, Argentine)
ANTIQUE PAIR OF STONE ELEPHANTS, two nineteenth-century hand-carved stone elephants from China

Antique Pair of Stone Elephants.
Photo by Robert Little.

**International Menswear Mart,
2300 Stemmons Freeway**

LONGHORN RIDER *1979,* a whimsical creation by David Cargill
HAN DYNASTY FOO LION *206 B.C.–A.D. 2200,* a monumental carved granite figure from China

Longhorn Rider. Photo by Robert Little.

Han Dynasty Foo Lion. Photo by Robert Little.

**International Apparel Mart,
2300 Stemmons Freeway**

HONG BIRD *circa* A.D. *1650*

Hong Bird. Photo by Robert Little.

The Dallas Museum of Art Sculpture Garden is located at the corner of Saint Paul Street and Woodall Rodgers Freeway. Architect Edward Larrabee Barnes designed the museum building and the 1.2-acre sculpture garden, which opened to the public in 1983. Two works in the collection were commissioned especially for the garden: an untitled monumental stainless-steel abstract created in 1983 by Ellsworth Kelly (b. 1923, American) and **GRANITE SETTEE,** a granite abstract created in 1982–1983 by Scott Burton (1939–1989, American). Kelly's work was acquired with a donation from Michael J. Collins and matching grants from The 500, Inc., and the 1982 Tiffany and Company benefit opening. It is installed at one end of the reflecting pool. *Granite Settee* was acquired through the National Endowment for the Arts with matching funds from Robert K. Hoffman, the Roblee Corporation, Laura Carpenter, Nancy O'Boyle, and an anonymous donor. It is installed to face one of the garden's four limestone water walls and the city's skyline. In addition to those two special commissions, the museum's permanent collection includes:

AVE *1973,* a painted steel abstract by Mark Di Suvero (b. 1933, American), donated by the Irvin L. and Meryl P. Levy Endowment Fund

CLARENCETOWN LIGHT II *1971,* a welded-aluminum abstract by John Henry (b. 1943, American), Foundation for the Arts Collection, given by Robert and Meryl Meltzer

FIGURE FOR LANDSCAPE *1960,* given by the Meadows Foundation, and **SEA FORM (ATLANTIC)** *1964,* donated by Mr. and Mrs. James H. Clark; both bronze abstract pieces by Barbara Hepworth (1903–1975, British)

175

Ave. Photo courtesy Dallas Museum of Art,
Irvin L. and Meryl P. Levy Endowment Fund.

DOUBLE NICHE *1979,* a bronze and
limestone abstract 6'7" tall, by
Bryan Hunt (b. 1947, American),
Foundation for the Arts Collec-
tion, given by Robert and Meryl
Meltzer in memory of Edward
Marcus
FLORA *1911,* a life-size bronze by
Aristide Maillol (1861–1944,
French), given by Mr. and Mrs.
Eugene McDermott
TWO-PIECE RECLINING FIGURE
1961, a bronze abstract by Henry
Moore (1898–1986, British),
purchased by the Dallas Art
Association
UNTITLED *circa 1972,* by Beverly
Pepper (b. 1924, American), given
by Michael J. and Wynnell Collins
UNTITLED *1971,* a Cor-ten steel
abstract by Richard Serra (b. 1939,
American), acquired with match-
ing grants from National Endow-
ment for the Arts and The 500,
Inc., in honor of Mr. and Mrs. Leon
Rabin
WILLY *1962, fabricated 1978,* a steel
abstract by Tony Smith (1912–
1980, American), acquired with

funds provided by the Irvin L. and
Meryl P. Levy Endowment Fund
and the General Acquisitions Fund
FLOWER *1982,* an oak and welded-
steel abstract by James Surls (b.
1943, native Texan)*, donated by
Vincent A. Carrozza and
Trammell Crow Company
DALLAS MUSEUM PIECE *1976,* a
welded-steel abstract by Mac
Whitney (b. 1936, American)*,
donated by Dr. and Mrs. Harold J.
Joseph

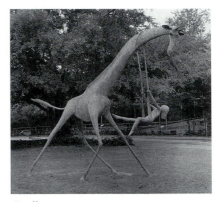

Giraffe. Photo by Keith Carter.

Kudu. Photo by Scott Metcalfe, courtesy Trammell Crow.

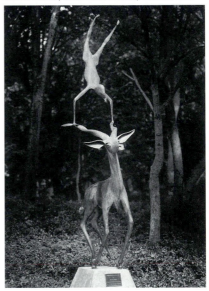

The Dallas Zoo at 621 East Clarendon has a collection of outdoor sculpture that ranges from whimsical, stylized designs to beautiful, authentic wildlife figures. When the zoo's new entrance at Interstate 35 and Marsalis is completed, visitors will be greeted by sculptured giraffes ranging from 60 feet to 80 feet in height. Other works installed on the grounds of the zoo include:

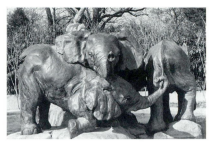

African Elephant Calves. Photo by S. L. York, courtesy Dallas Zoo.

TURTLE and **ALLIGATOR,** by Dallasite Wayne Amerine, brightly colored painted-concrete figures. The turtle was purchased for the zoo by the Dallas Zoology Society, and the alligator was given by Ann Smith.

GIRAFFE and **KUDU,** created in 1971 by native Texan David Cargill. Both life-size bronze figures were donated by Trammell Crow.

RHINOCEROS, created in 1970–1971 by David Cargill. This whimsical bronze rhino with five of Cargill's gleeful "little people" on its back was donated by Trammell Crow and John and Storey Stemmons.

AFRICAN ELEPHANT CALVES, a five-piece fountain by American artist Lorenzo Ghiglieri. The life-size bronze group was donated in 1990 by Jeannie W. and David H. Monnich and Sarah M. and Charles E. Seay.

MICHAEL'S LAMB, a life-size bronze lamb by Dallasite Mary Jean Jaynes; donated in 1988 by Joe and Barbara Farnell and David and Ann DeVoss

PORCELLINO REPLICA, a 4'3" bronze and granite replica of a portion of the fountain created in 1639 by Pietro Tacca (1577–1640) for the New Market of Florence, Italy, where the original remains today; donated by Mr. and Mrs. Curtis Calder

Rhinoceros. Photo by Scott Metcalfe, courtesy Trammell Crow.

Porcellino Replica. Photo by S. L. York, courtesy Dallas Zoo.

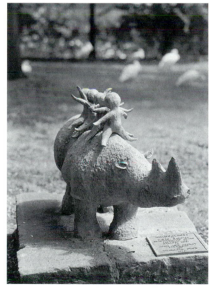

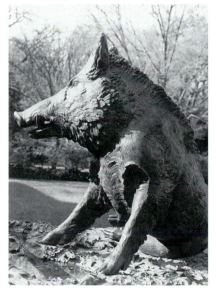

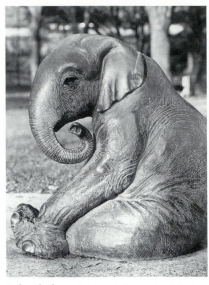

Baby Elephant. Photo by S. L. York, courtesy Dallas Zoo.

BABY ELEPHANT, a life-size bronze created in 1988 by Tom Tischler; donated by Myron Martin

GALAPAGOS TORTOISE, a life-size bronze by Tom Tischler; donated by Jane Heldt

The Elizabeth Meadows Sculpture Garden at the Meadows Museum on the campus of Southern Methodist University opened in 1969 with a collection of outdoor sculpture given to the university by Algur H. Meadows. International in scope, the sculpture garden has one of the finest collections of sculpture to be found on any university campus in America. The museum's permanent collection of outdoor works includes:

LA JOIE DE VIVRE *1927,* by Jacques Lipchitz (1891–1973, American/French). Lipchitz created this 11'8" bronze abstract for the Viscount Charles de Noailles' garden in Hyères after a very difficult period in the artist's life. Students of the artist's work feel that the lyrical, uplifting aspect of this piece was a statement by the artist, indicating a renewed optimism in the face of pain and adversity. Lipchitz was born in Lithuania, but he lived most of his life in France before 1941. In response to the Nazi

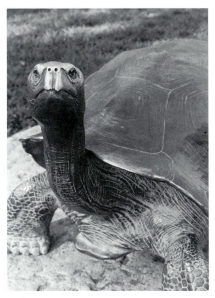

Galápagos Tortoise. Photo by S. L. York, courtesy Dallas Zoo.

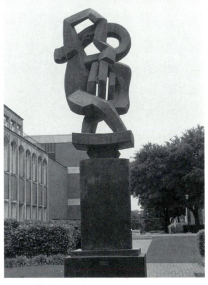

La Joie de Vivre. Courtesy Elizabeth Meadows Sculpture Garden, Meadows Museum, Southern Methodist University, Dallas.

threat in France, he immigrated to America, where he lived until his death.

THE THREE GRACES *1937–1939,* by Aristide Maillol (1861–1944, French). Maillol chose lead for these classical female figures because he felt the bronze medium would be too dark. This particular casting was made for Maillol's private garden, where it remained for some years after his death.

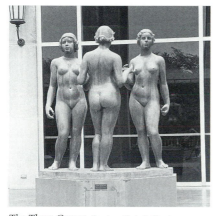

The Three Graces. Courtesy Elizabeth Meadows Sculpture Garden, Meadows Museum, Southern Methodist University, Dallas.

CROUCHING WOMAN *1934* and **HORSE AND RIDER** *1951,* by Marino Marini (b. 1901, Italian). *Crouching Woman* typifies the artist's ability to present the viewer with a block of material that appears to be in the process of taking shape. *Horse and Rider* depicts a troubled rider not in control of the horse. This work personifies Marini's belief that people of the twentieth century are out of harmony with the natural order.

THREE-PIECE RECLINING FIGURE *1961–1962,* by Henry Moore (1898–1986, British). Biomorphic in nature, this bronze abstract is composed in three parts but perceived as one unit.

Three-Piece Reclining Figure (left) and *Figure with Raised Arms* (right). Courtesy Elizabeth Meadows Sculpture Garden, Meadows Museum, Southern Methodist University, Dallas.

SPIRIT'S FLIGHT *1979,* by Isamu Noguchi (1904–1988, American). Black Japanese basalt and stainless steel form this work, dedicated in memory of Algur H. Meadows. Composed of a helix or square column that rotates around its axis, *Spirit's Flight* symbolizes the Algur H. Meadows Award for Excellence in the Arts. A miniature version is presented to recipients of the award.

GEOMETRIC MOUSE II *1969–1970,* by Claes Oldenburg (b. 1929, American/Swedish). Oldenburg's flashy works include giant vinyl and plastic replicas of commonplace objects, such as hamburgers, typewriters, and candy bars. These colossal figures, representing the banalities of everyday life, have been labeled Pop Art because the subjects are taken from items popular among the broadest base

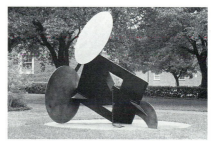

Geometric Mouse II. Courtesy Elizabeth Meadows Sculpture Garden, Meadows Museum, Southern Methodist University, Dallas.

179

of the population. Oldenburg's outdoor works in Texas include two examples of his mouse theme, this one in Dallas and one in Houston. This work, specially made for the Meadows Sculpture Garden, was Oldenburg's first all-metal sculpture and therefore represents a turning point in his career.

CUBI VIII *1962*, by David Smith (1906–1965, American). Smith's *Cubi* series consisted of nearly thirty pieces of glistening metallic geometric designs. This work, made up of rectangular shapes, is composed in the round, unlike many in the series that are flat and planar. Smith began his revolutionary experiments with welded-metal sculpture around the end of the 1930s, and by 1960 he was a major influence in the international movement in modern art. His work is considered by many to represent the most important body of sculpture in that genre produced by an American artist. Creations from his *Cubi* series formed from stacked stainless-steel boxes are on permanent display at the Dallas Museum of Art, the Fort Worth Art Museum, and the Museum of Fine Arts, Houston.

FIGURE WITH RAISED ARMS *1956–1957*, by Fritz Wotruba (1907–1975, Austrian). The 5'11" piece is typical of the semiabstract stone carvings that made Wotruba one of Europe's leading modern sculptors during the 1950s and 1960s.

The Lomas Financial Corporation Sculpture Collection is installed on the grounds of the Lomas corporate office complex at 1600–1750 Viceroy. Two works, **THE FAMILY** *1985* and **GENERATION BRIDGE** *1983*, are located near the entrance to the main office, which is easily accessible to the public. *The Family* is a 20'-tall

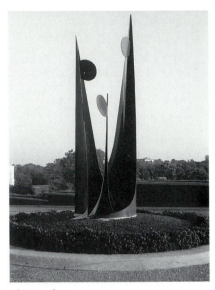
The Family. Photo by Robert Little.

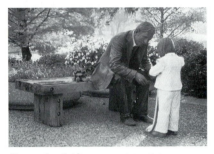
Generation Bridge. Photo by Robert Little.

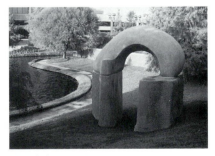
Untitled. Photo by Robert Little.

180

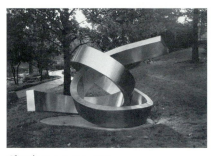

Chnofs. Photo by Robert Little.

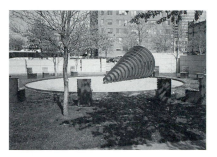

Harrow. Photo by Judith M. Garrett, courtesy A. H. Belo Corporation.

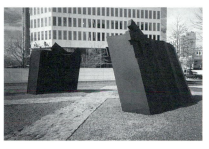

Journey to Sirius. Photo by Judith M. Garrett, courtesy A. H. Belo Corporation.

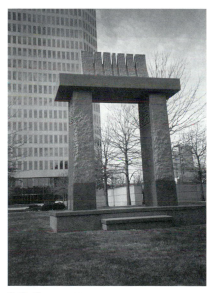

Stele Gateway. Photo by Judith M. Garrett, courtesy A. H. Belo Corporation.

abstract of mild steel plate commissioned for the site from Dallas artist D. Wallace Dean. Nearby, the office building's courtyard provides the setting for *Generation Bridge,* a life-size figurative bronze group by J. Seward Johnson, Jr. Other pieces in the collection are placed on the company's grounds adjacent to the office complex. On a grassy hillside in the park is **SPRING** *1983,* by J. Seward Johnson, Jr. Both *Generation Bridge* and *Spring* were placed through Barbara Guggenheimer Associates, Inc., and are registered with Sculpture Placement, Ltd., Washington, D.C. Next to the man-made lake is a commissioned untitled architectural work carved in 1986 from Indiana limestone by Denton artist Mike Cunningham. **GIRL ON A SWING** *1984,* a figurative bronze by Harplee, and **CHNOFS** *1985,* a stainless-steel abstract by Josef Staub, are installed along the terraced walkways surrounding the creek and the lake.

Lubben Plaza at 400 South Market Street in downtown Dallas is an urban park developed by the A. H. Belo Corporation and deeded to the city in 1985 in recognition of the centennial of the *Dallas Morning News.* The Dallas Morning News–WFAA Foundation has commissioned three monumental sculptures for Lubben Plaza: **HARROW** *1992* by Dallas artist Linnea Glatt, **JOURNEY TO SIRIUS** *1992* by Houston artist

181

Dallas Land Canal. Photo courtesy Patsy R. and Raymond D. Nasher Collection.

George Smith, and **STELE GATE-WAY** *1994,* by Jesús Bautista Moroles. *Harrow* involves a motorized cone of Cor-ten steel that turns on a circular track, completing one revolution each 24 hours. The rotation of the cone symbolizes the cyclical nature of life and the balancing of life's events. *Journey to Sirius* involves two monumental welded-steel structures. The geometric surfaces suggest the natural geometry of the Bandiagara Cliffs in the West African republic of Mali, and the cantilevered sculptural forms represent the spirit as inspired by the ancient pictographs of that region. *Stele Gateway* recalls a post-and-lintel architectural element engraved with hieroglyphic writing. The messages are visual symbols used by the artist to represent the idea of all civilizations coming together.

The Patsy R. and Raymond D. Nasher Collection provides a rotating exhibition at various sites at NorthPark, including the NorthPark Center and NorthPark East, both

Hammering Man. Photo courtesy Patsy R. and Raymond D. Nasher Collection.

182

located at Northwest Highway and Central Expressway. Before Patsy Nasher's death in 1988, she and her husband had assembled one of the finest private collections of modern sculpture in the world. The rotating sculpture exhibit at the NorthPark complex fulfills Patsy Nasher's commitment to make great works of art easily accessible to the general public. In 1987, "A Century of Modern Sculpture: The Patsy and Raymond Nasher Collection" was exhibited throughout the world, including at the Dallas Museum of Art; the National Gallery of Art, Washington, D.C.; the Centre de Art Reina Sofía, Madrid, Spain; Forte di Belvedere, Florence, Italy; and the Tel Aviv Museum of Art, Tel Aviv, Israel. The only permanently sited sculpture in the NorthPark exhibit is **DALLAS LAND CANAL** *1971*, a 236'-long earthwork by Beverly Pepper (b. 1924, American). One of the most popular pieces frequently on exhibit at NorthPark is **HAMMERING MAN** *1982*, by Jonathan Borofsky (b. 1943, American). This 16' steel sculpture is painted matte black, giving it a silhouette appearance. A motorized right arm allows the figure to hammer a piece of metal held in the left hand. The rotating exhibition occasionally includes works by other artists, such as Jim Dine, Frank Stella, Tony Smith, and Mark Di Suvero.

Samuell-Grand Park, located at 6200 East Grand, has a permanent sculpture exhibit. Placement of these works was a collaborative effort on the part of the Texas Sculpture Society, the Samuell region of the Dallas Park and Recreation Department, and the department's Division of Cultural Affairs. The exhibit includes three works: an untitled 16' welded-steel abstract created in 1985 by Jess Daniel (American); **MIRROR IMAGE** *1986*, a 7' steel abstract

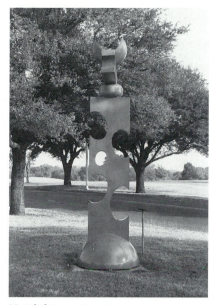

Untitled. Photo by Robert Little.

April. Photo by Jean de Maeyer, courtesy Trammell Crow.

183

created by Barrett Conrad DeBusk (b. 1955, native Texan)* and donated to the city of Dallas by John M. Weaver of Lynchburg, Virginia; and **APRIL** *1971*, a life-size figurative bronze by Mark Macken (Belgian), donated to the city by Preston Royal Realty, Trammell Crow, Henry S. Miller, Henri Bromberg, Robert Cullum, and Eddie Kahn. *April* is placed in the Samuell-Grand Park Perennial Garden.

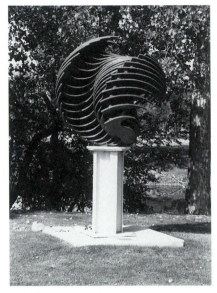

The Wave. Photo by Robert Little.

Signature Place Outdoor Sculpture Collection is installed on the grounds surrounding the property at 14725 Preston Road. Originally placed by Rostland Texas, Inc., in the early 1980s, the sculpture at Signature Place reflects the work of several artists with ties to Northeast Texas. Installations include **THE CHILD** by John Thomas Campbell of Denton, **THE WAVE** and **STANDING STEEL** by Dallasite D. Wallace Dean, **HELICAL VOLUTION #13** by Dallas artist Morton Rachofsky, and **CONVERGENCE** and **CADENCE,** both by Bill Shanhouse, formerly of

Dallas. The sculptures are installed on the grounds surrounding a large office complex, a private health-athletic club, and a landscaped park. The small lake and the surrounding property visible from Preston Road are owned by Telesis Management Corporation and are accessible to the public for fishing and picnics. In addition to the permanently sited works, Telesis Management Corporation also sponsors temporary exhibitions of outdoor sculptures by Texas artists.

The Stemmons Towers International Sculpture Garden is located at the Stemmons Towers office complex at 2730 Stemmons Freeway. Trammell Crow placed the four installations that comprise the collection. The centerpiece of the garden is **THE FAMILY** *1964*, by Harry Bertoia (b. 1915, American/Italian). Installed on concrete bases in the Stemmons Towers garden pool, the work consists of four bronze abstracts representing a family group. Three smaller works placed on the landscaped grounds between the office buildings and the freeway include two maquette-sized figurative bronzes, **HAND OF GOD** *acquired 1965* and **MAN AND PEGASUS** *1949*, by Carl Milles (1875–1955, American/Swedish), and a 3' bronze abstract, **FETE** *1965*, by François Stahly (b. 1911, French).

The Family. Photo by Scott Metcalfe Photography, courtesy Trammell Crow.

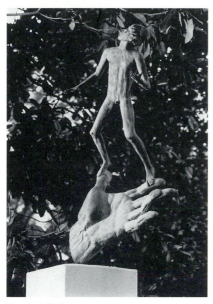

Hand of God. Photo by Scott Metcalfe Photography, courtesy Trammell Crow.

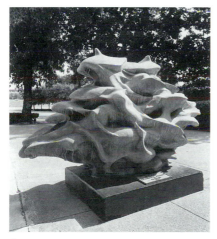

Fete. Photo by Scott Metcalfe Photography, courtesy Trammell Crow.

The Trammell Crow Center Sculpture Collection was assembled under the personal direction of Harlan Crow with Michael Le Marchant of the Bruton Gallery in England. In the heart of the Dallas Arts District, the collection is installed in the public spaces surrounding the 50-story

Trammell Crow Center bordered by Ross, Harwood, Flora, and Olive streets. The center's landscaped gardens and courtyards provide a setting for more than twenty monumental bronzes created by several of the most influential French figurative sculptors of the past century. The collection includes seven major works by Auguste Rodin, considered the father of modern sculpture; as a group the collection traces an artistic evolution that celebrates the spirit of humanity and the beauty of the human form. The Trammell Crow Center Sculpture Collection elevates the urban environment to a level rarely experienced in American cities while it contributes to the philosophy of making the arts accessible to as many people as possible. The collection includes:

MOTHER AND CHILD *1925* and **YOUNG GIRL CARRYING WATER** *1910,* by Joseph Bernard (1866–1931, French). *Mother and Child* captures a moment in time as two life-size figures—a mother and baby dancing together—pause in a graceful and tender pose. Bernard's most famous work, *Young Girl Carrying Water* transforms the ordinary chore of carrying water into a moment of charm and beauty.

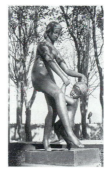 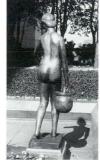

Mother and Child.
Photo by Robert Little.

Young Girl Carrying Water.
Photo by Robert Little.

185

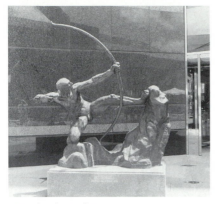

Hercules the Archer. Courtesy Trammell Crow.

The Crouching Bather. Photo by Robert Little.

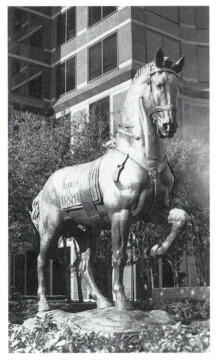

Horse for "Alvear" Monument. Photo by Robert Little.

Penelope. Photo by Robert Little.

HERCULES THE ARCHER *1909,* by Emile Antoine Bourdelle, (1861–1929, French). Bourdelle was a student of Auguste Rodin. This piece is considered his most famous work. The collection also includes his largest and most ambitious bronze, **HORSE FOR "ALVEAR" MONUMENT** *1913–1915.* Other works on exhibit by Bourdelle are **THE CROUCHING BATHER** *1906–1907,* **MONUMENT TO DEBUSSY** *1907,* **TORSO OF**

186

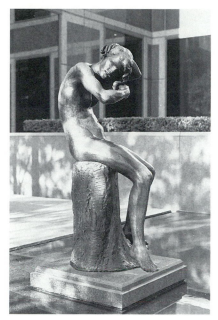

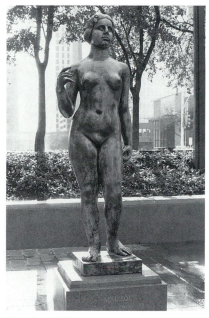

Lucile. Photo by Robert Little.

Nymph with Flowers. Photo by Robert Little.

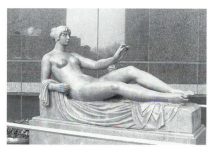

Monument to Cézanne. Photo by Robert Little.

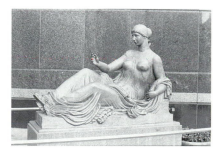

Port-Vendres. Photo by Robert Little.

"FRUIT" *1911,* and **PENELOPE** *1912,* an outstanding example of Bourdelle's ability to merge lyricism and monumentality.

LUCILE *1983,* by Stephan Buxin (b. 1909, French). This life-size seated figure exemplifies the artist's belief in truth to nature as a guiding principle.

MONUMENT TO CEZANNE *1921–1925* and **PORT-VENDRES** *1921,* by Aristide Maillol (1861–1944, French). These two companion pieces appear together in only one other location, the gardens of the Louvre Museum in Paris. Both are cast in lead. One other Maillol piece at the center is **NYMPH WITH FLOWERS** *1931,* a young female figure whose serene pose and smooth surface give her the aura of a goddess.

187

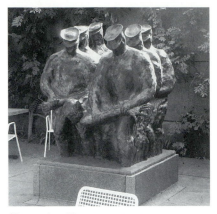

Men against Man. Photo by Robert Little.

MEN AGAINST MAN *1986*, by Kaare K. Nygaard, (American/ Norwegian). This figurative group is in a patio below street-level near the corner of Flora and Harwood streets. It is the only outdoor sculpture at the Trammell Crow Center that is not by a French figurative sculptor. Dr. Nygaard is a surgeon practicing at the Mayo Clinic in Rochester, New York, and at White Plains Hospital in White Plains, New York.

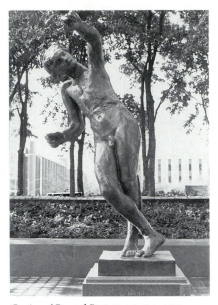

Genius of Eternal Rest. Photo by Robert Little.

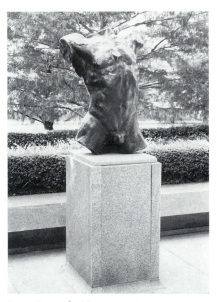

Large Torso of a Man. Photo by Robert Little.

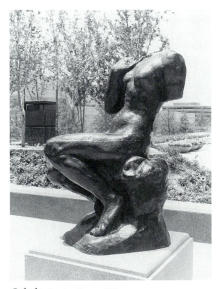

Cybele. Courtesy Trammell Crow.

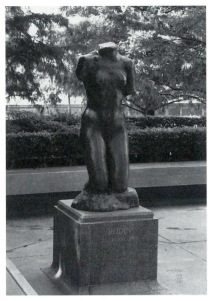

The Prayer. Photo by Robert Little.

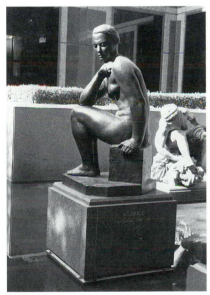

Meditation. Photo by Robert Little.

CYBELE *1889,* by Auguste Rodin (1840–1917, French). Three other works by Rodin are installed outdoors at the center: **GENIUS OF ETERNAL REST** *1898,* **LARGE TORSO OF A MAN** *1882,* and **THE PRAYER** *1909.* Three works by Rodin are installed in the center's foyer: **PIERRE DE WIESSANT** *1885* and **JEAN DE FIENNES** *1885,* from Rodin's monumental group *The Burgers of Calais,* and **MEDITATION** *1885,* a female figure created as part of a monument to the poet Victor Hugo.

MEDITATION *1930–1931,* by Robert Wlérick (1882–1944, French). Both Stephan Buxin and Jean Carton were students of Wlérick. This figure connotes a classical naturalism along with quietude and contemplation.

Del Rio

Covarrubias, Manuel Alcala

(Mexican)

AMISTAD DAM EAGLES *1969*

Figurative; 2 figures, each 7' H; bronze cast by Vladimir Alvarado in Ciudad Juárez, Chihuahua
Location: Amistad Dam at the United States–Mexico border
Funding: Governments of the United States and Mexico
Comments: The sculptor created this monument according to a design provided by artist William Kolliker, a native of Switzerland and a naturalized American citizen living in El Paso. The monument unites the bald eagle of the United States and the eagle and serpent of Mexico without sacrificing the strongly individual characters of the two emblematic birds. President Richard Nixon and President Gustavo Díaz Ordaz

189

Amistad Dam Eagles. Photo courtesy Del Rio News-Herald.

dedicated the Amistad Dam and eagles on September 8, 1969, in recognition of the enduring friendship between Mexico and the United States.

Wade, Bob

(b. 1943 Native Texan)

TEXAS SIXSHOOTER *1981*

Figurative; 20' L; steel and stucco
Location: 124 East Garfield
Funding: Del Rio Council on the Arts, Humphrey's Gun Shop, and Bob Wade

Comments: Always a popular tourist attraction, this giant replica of a Colt single-action revolver gained national attention with the passage of the Violent Crime Control and Law Enforcement Act of 1994 and the subsequent lawsuit filed against the federal government by local sheriffs, including the sheriff of Val Verde County, Texas. According to Gary Humphrey, owner of Humphrey's Gun Shop, during the national news coverage of what was popularly known as the Brady Bill, images of *Texas Sixshooter* appeared on all three major television networks' nightly news programs. *USA Today*, the *New York Times*, the *Washington Post*, and the *San Antonio Express-News* also ran coverage.

Texas Sixshooter. Courtesy Bob Wade.

Denison

Chamberlain, A. P.

(American)*

UNION SOLDIER STATUE *1906*

Figurative; life-size; granite
Location: Fairview Cemetery,
U.S. 75-A, north of Denison
Funding: Nathaniel Lyon Post 5,
Grand Army of the Republic,
Department of Texas, and the post's
auxiliary, the Woman's Relief Corps
Chapter 2
Comments: The Union soldier statue
in Denison is unique among Civil
War monuments in Texas. The entire
state has only two other memorials to
Union sympathizers, *True to the
Union Monument* in Comfort and the
dismembered remains of a Union
soldier statue in a private cemetery in
Milam County. The Denison statue's
base is signed by A. P. Chamberlain,
owner of Denison Marble Works.
Chamberlain advertised stone coping,
curbing, and "all kinds of cut stone
work," but he is not known to have
created life-size human figures
(*Denison City Directory* 1907, 67). A
likely explanation is that Chamber-
lain made the base in Denison and
ordered the statue from a catalogue
published by one of the numerous
commercial firms that mass-produced
generic soldier statues following the
Civil War. Dedicated "in memory of
the loyal soldiers and sailors," this
monument marks the final resting
place of six Union soldiers who
settled in Grayson County after the
war. Local records show that 40
Union veterans organized a Grand
Army of the Republic (GAR) post in
Denison in July 1884 and named the
organization in honor of General
Nathaniel Lyon, a graduate of West
Point, who devoted his life and his
fortune to the preservation of the
Union. General Lyon died in the

battle at Wilson's Creek, Missouri, on
August 10, 1861, and left approxi-
mately $30,000 to the federal
government for the prosecution of the
war. Interestingly, on February 23,
1861, Grayson County voted 901 in
opposition to secession and 463 in
favor.

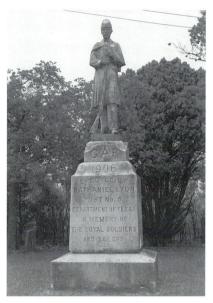

Union Soldier Statue. Photo by Carol Little.

MUNSON MEMORIAL *1913*

Figurative; 6' H; granite
Location: Fairview Cemetery,
U.S. 75-A, north of Denison
Funding: Family of Dr. Thomas V.
Munson
Comments: This monument marks
the grave site of Thomas Volney
Munson, the viticulturist who is
credited with saving the vineyards of
France when they were stricken with
a root disease before the turn of the
century. In appreciation, France
conferred on him the French Legion
of Honor. Reputedly, Munson
requested that a grapevine be planted
on his grave. This monument forms a
column artistically encircled with a

vine and clusters of grapes. Another outstanding monument in Fairview Cemetery is a maquette-sized bronze of *Spirit of Flight* by Charles Umlauf. This figure is a small version of the monumental fountain centerpiece placed at the entrance to Love Field airport in Dallas. Another casting of this work is installed at the grave site of former Texas governor Allan Shivers in Austin.

Dean, Robert Lee, Jr.

(b. 1929 American)

GENERAL DWIGHT DAVID EISENHOWER *1972*

Portraiture; larger than life-size; bronze
Location: Eisenhower Birthplace State Park, 108 East Day Street
Funding: Denison Historical Society and private donations
Comments: Julie Nixon Eisenhower unveiled this statue on July 9, 1973. The inscription reads, "This memorial is dedicated to young people

everywhere that they may be inspired to greatness by the example of our most distinguished son, Dwight David Eisenhower." The small frame house in Denison where President Eisenhower was born on October 14, 1890, is now Eisenhower Birthplace State Park. Dean's statue portrays Eisenhower as he often appeared during World War II, wearing the short jacket that was named after him and loose-fitting wool trousers. The artist borrowed both garments from Texas A&M University to help him design his clay model. Robert Dean is a 1953 graduate of the United States Military Academy; as a West Point cadet, he marched in Eisenhower's inaugural parade.

McVey, William M.

(b. 1905 American)*

ICARUS *1989–1990*

Figurative; larger than life-size; Vermont gray granite
Location: Grayson County Airport,

General Dwight David Eisenhower.
Photo courtesy Denison Chamber of Commerce.

Icarus. Photo by Quin, Sherman, Texas.
Photo courtesy Grayson County Airport.

9000 Grayson Drive
Funding: Commissioned and donated by Harold Thomas Hastings
Comments: This figure of a pilot of the 1930s and 1940s is dedicated to the airmen of Texas whose vision and dedication advanced the science of flight and to the veterans of Grayson County who served in the United States military and gave their lives in defense of their country. McVey designed the statue and the base, which was built by Kotecki Monuments, Inc., in Cleveland. He moved to Texas from his native Ohio in 1923 to study architecture and play football for the Owls at Rice Institute (now Rice University) in Houston. After earning his degree and returning to Ohio for a brief period, he came back to Houston to work for Pyramid Stone Company, where he developed a strong interest in stone-carved sculpture. In 1930, he obtained a scholarship to study in Paris, where two of his carvings were accepted by the Paris Grand Salon. Primarily an architectural sculptor, McVey designed the relief work and sculptural embellishments on the interior and exterior of the Texas Memorial Museum in Austin; he installed 32 terra-cotta panels and a large relief carving on the campus of Rice University; and he created the decorative relief work and massive bronze entrance doors for the San Jacinto Monument. McVey retired as head of the Department of Sculpture at the Cleveland Institute of Art in 1968. In 1983, he visited Houston to receive a distinguished alumnus award from Rice University. His work enhances buildings, public spaces, and private collections throughout the nation.

In High Places. Photo by Mark Caswell, courtesy Public Affairs and Information Services, University of North Texas.

Denton

Austed, Arnold

(American)*

UNTITLED *1981*

Abstract; 8' H; painted metal
Location: Denton Public Library grounds, 502 Oakland
Funding: City of Denton and private donations
Comments: Austed created this tiered fountain design before he moved from Denton to Middletown, Connecticut.

Balciar, Gerald

(American)

IN HIGH PLACES *1990*

Figurative; 15' H; bronze
Location: University of North Texas campus, west entrance to the University Union
Funding: Contributions from alumni
Comments: Gerald Balciar is a Colorado artist. In addition to his

193

popular sculptures, Balciar is known for a process that he developed in the 1980s for "pointing up" maquette-sized works to life-size or larger proportions. Texan Edd Hayes used Balciar's method to enlarge *Wild and Free,* a one-and-one-half times life-size installation in the Astrodome Complex in Houston. Balciar's process involves making plaster casts from the models. The casts are cut apart and the pieces are numbered and laid on an overhead projector, which enlarges them to the desired size. Paper patterns of the projected images are used to create plywood sections that are reassembled on an armature and covered with cheese-cloth and clay. A plaster cast is made from the clay figures and sent to the foundry in sections for casting.

For the Mayor: The Three Graces.
Photo by Robert Little.

Campbell, John Thomas

(b. 1946 American)*

**FOR THE MAYOR:
THE THREE GRACES** *1976*

Abstract; 4'6" H; Georgia granite
Location: Denton City Offices courtyard, 215 East McKinney
Funding: Donated to the city through Heritage Gallery
Comments: Campbell is a resident of Denton and a teacher of sculpture and design at Collin County Community College. He holds a master of fine arts degree from the University of North Texas. His work appeared in "Excellence '90," sponsored by the Texas Sculpture Association in Dallas, and he received the 1990 Greater Denton Arts Council Award in the Twenty-second Annual Juried Fine Arts Awards Exhibit sponsored by the North Texas Art League.

Cargill, David

(b. 1929 Native Texan)*

SALLY *1972*

Figurative; 2' H; bronze
Location: The Selwyn School, Bachman Amphitheater, 3333 University Drive, West
Funding: The Bachman family in memory of Sally Bachman
Comments: The inscription reads, "We are learning to work together as one."

Sally. Photo by Robert Little.

Davis, Richard

(b. 1942 American)*

SILVER SECRETS *1981*

Abstract; 8'6" H; stainless steel
Location: Voertman's Bookstore,
1313 West Oak Street
Funding: Paul Voertman
Comments: Davis is a member of the
University of North Texas art
department.

DeBusk, Barrett Conrad

(b. 1955 Native Texan)*

CAGED AND CONFUSED *1980*

Abstract; 16' H; steel
Location: University of North Texas
Art Building
Funding: University of North Texas
art department through Voertman's
Student Competition Purchase Award

Friedlander, Leo

(b. 1890 American)

THE PIONEER WOMAN *1938*

Figurative; 15' H; white Georgia
marble, axe-finished
Location: Texas Woman's University
campus, intersection of Sawyer and
Oakland
Funding: $25,000 allocated by the
1936 Commission of Control for
Texas Centennial Celebrations
Comments: Friedlander designed this
monument and Piccirilli Brothers
carved it in their New York studio.
The Commission of Control origi-
nally accepted a nude sketch by a
different artist, but in response to
criticism from the press, the public,
and Texas artists, the acceptance was
withdrawn. Among those who
objected was Waldine Tauch, who
considered nudity appropriate for
classical figures but not appropriate
for an American pioneer woman.
After the public outcry died down,

The Pioneer Woman. Photo courtesy Texas Woman's
University, Office of Public Information.

the commission quietly gave the job
to Friedlander, who had not submit-
ted a sketch for the original competi-
tion. The seven Piccirilli brothers
were Italian marble cutters, who
worked under the leadership of their
father in a studio on 142nd Street.
Attilio Piccirilli gave Pompeo
Coppini his first job in America.

Laing, Richard, with Mount-Miller Architects

**BETTY JANE BLAZIER MEMORIAL
PLAY WALL** *1970*

Abstract; 4'6" to 6' H; metal core
covered with Portland cement
Location: Civic Center Park,
500 block Bell Avenue
Funding: Unitarian Fellowship
through donations in memory of
Betty Jane Blazier, who worked with
children at the Texas Woman's
Nursery School for eighteen years
before her death in 1964
Comments: Laing designed the wall,
in consultation with Mount-Miller
Architects, and Denton resident

195

Betty Jane Blazier Memorial Play Wall.
Photo by Robert Little.

Alvin Ellis built it on a foundation provided by the Denton Parks and Recreation Department. Although playground sculpture is not generally within the context of this survey, this particular work is unique in that it is specifically designed to help children develop a sense of mass and form. In a special parks department program, Denton youngsters explore the wall while wearing blindfolds and cotton balls in their ears. The experience allows them to discover the wall's mass, shape, and texture through the sense of touch.

Miller, John Brough

(b. 1933 American)*

COMPOSITION IN STEEL
circa 1971

Abstract; 7' H; steel
Location: Texas Woman's University, behind the Student Center off Bell Avenue
Funding: Private donation

Roper, Jo

(American)

SAINT FRANCIS AND THE BIRDS
1952

Figurative; 3'6" H; limestone
Location: Texas Woman's University campus, Hubbard Memorial Chapel Gardens
Funding: Contributions through the Ex-Students' Association in honor of

Dr. and Mrs. L. H. Hubbard
Comments: Jo Roper was a resident of Montezuma, New Mexico, at the time she sculpted this figure. She spent six weeks at Texas Woman's University while completing the commission.

Unknown Artist

NIKE OF SAMOTHRACE FACSIMILE *original 300–190 B.C.*

Figurative; larger than life-size; plaster cast made in 1982
Location: Texas Woman's University campus, portico of Old Main Building
Funding: Individual donations through a fund drive initiated by Annette Skinner Williams
Comments: This replica, also called *Winged Victory,* replaced another Nike facsimile placed on the campus in 1929. After several decades of exposure and vandalism, the first statue became badly worn and damaged. This figure was made from a mold cast from the original statue at the Louvre Museum in Paris.

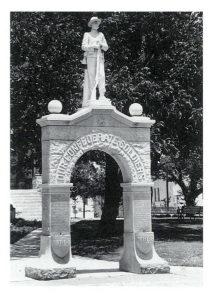

Our Confederate Soldiers. Photo by Robert Little.

Unknown Artist

OUR CONFEDERATE SOLDIERS
1918

Figurative; life-size; marble
Location: Denton County Courthouse grounds
Funding: Katie Daffan Chapter 193, United Daughters of the Confederacy

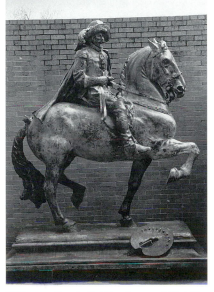

Velázquez. Photo by Mark Caswell, courtesy Public Affairs and Information Services, University of North Texas.

Warren, Constance Whitney

(1888–1948 American)

VELAZQUEZ *1924*

Portraiture; larger than life-size; bronze
Location: University of North Texas campus, east side of the General Academic Building
Funding: Donated to the university by Harlan Crow
Comments: Warren's equestrian portrays the painter Diego Velázquez.

Whitney, Mac

(b. 1936 American)*

CARRIZO *1992*

Abstract; 13'2" H; painted stainless steel
Location: University of North Texas campus
Funding: Private purchase

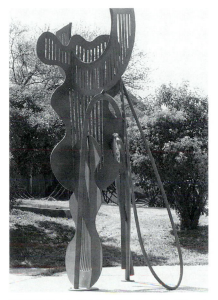

Carrizo. Photo by Mark Caswell, courtesy Public Affairs and Information Services, University of North Texas.

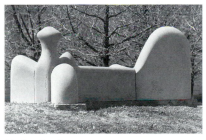

Mother Earth. Photo by Mark Caswell, courtesy Public Affairs and Information Services, University of North Texas.

Williams, Charles Truett

(1918–1966 Native Texan)*

MOTHER EARTH *1958–1959*

Abstract; 4'7" H × 12' L; marble
Location: University of North Texas
campus, intersection of Mulberry and
Avenue A
Funding: Donated by Regent and
Mrs. Hugh Wolfe in 1973
Comments: *Mother Earth* was a part
of the Ted Weiner sculpture collec-
tion in Fort Worth before Dr. and
Mrs. Wolfe acquired it and gave it to
the university.

Diboll

Wells, Ronnie

(b. 1944 American)*

WOODSMAN *1986*

Figurative; 7' H; bronze
Location: Temple-Eastex, Inc.,
headquarters on U.S. 59
Funding: Temple-Eastex, Inc.

Comments: This figure of a woods-
man carrying the old-fashioned
implements of a logger is dedicated
to the men who fostered the logging
industry in East Texas almost a
century ago. The artist's model was
83-year-old Albert Mitchell, who
worked in the logging industry for
more than 50 years. Wells based his
likeness of Mitchell as a younger man
on personal interviews and a 1954
photograph. Wells served as the
official Texas state sculptor for 1990–
1991. His wildlife paintings and
sculptures have received numerous
awards, and he was named 1993
sculptor of the year at the World
Wildlife Exposition in Gatlinburg,
Tennessee, and 1994 artist of the year
at the North Carolina Wildlife and
Sportsman's Show. Wells Studio and
Gallery is in Salado. Another woods-
man figure is located on the campus
of Diboll High School at 1000 East
Harris. This welded-steel cartoon-
style lumberjack was created by I. W.
"Buckshot" Ferguson of Pineland and
donated to the school in 1984 by Mr.
and Mrs. Joe C. Denman, Jr.

Edinburg

El Paso

Edinburg

Zamudio, Cuauhtémoc

(Mexican)

**PADRE MIGUEL HIDALGO
Y COSTILLA** *1976*

Portrait bust; larger than life-size;
bronze
Location: Hidalgo County
Courthouse grounds
Funding: Private donations as part of
the county's Bicentennial project
Comments: Hidalgo County is named
for Miguel Hidalgo y Costilla (1753–
1811), a Mexican priest and patriot
who advocated liberating Mexico
from Spanish rule. In 1811, he was
captured, degraded from the priest-
hood, and executed for treason. As a
martyr, he inspired a movement that
ten years later culminated in freeing
Mexico from European domination.
Father Hidalgo is considered the
father of Mexican independence, and
since Texas was at that time a
province of Mexico, he is an impor-
tant figure in Texas history as well.

El Paso

Ayala, Raúl

(Mexican)

OLD BOWIE MONUMENT *1991*

Figurative; life-size; bronze
Location: 801 South San Marcial
Funding: Former students of Bowie
High School commissioned this
realistic figure of a bear, the school's
mascot.

Federal-Seaboard
Terra Cotta Company

(American)

SCOTTISH RITE TEMPLE SPHINXES
1966

Figurative; 2 figures, each 10' L;
terra-cotta cast at the Federal-Seaboard
Terra Cotta Company in Perth Amboy,
New Jersey
Location: Scottish Rite Temple,
300 West Missouri
Funding: El Paso Scottish Rite bodies
Comments: At the time of their
dedication, each of these figures was
described as the largest single piece of
terra-cotta ever made. They were
fashioned after the sphinxes at the
Scottish Rite Temple in Washington,
D.C., except each Washington sphinx
was cast in four pieces, instead of one.
The El Paso sphinxes were the first to
be placed in Texas; the same mold later
was used for the pair placed at the Lee
Lockwood Library in Waco.

Goodacre, Glenna

(b. 1939 Native Texan)

PUDDLE JUMPERS *1989*

Figurative; 6 life-size figures; bronze
cast at Shidoni Art Foundry in
Tesuque, New Mexico
Location: Site to be determined,
currently located at 908 Blanchard
Funding: Frank Davis, J. O. Stewart,
and other contributors

Harrison, Wiltz A.

(b. 1916 American)*

MOSES' ROCK *1964*

Abstract; 16' H; bronze
Location: Temple Mount Sinai
courtyard, 4408 North Stanton
Funding: Donated to the temple by the
Blaugrund family
Comments: Harrison resides in El Paso.

Houser, John

(b. 1935 American)*

**FRAY GARCIA DE
SAN FRANCISCO Y ZUNIGA** 1995

Portraiture; larger than life-size;
bronze
Location: Pioneer Plaza downtown
Funding: City of El Paso
Comments: In 1993, the El Paso City
Council approved $1 million for the
creation of *The Travelers,* twelve
monumental sculptures that will
recognize outstanding people in the
history of the Southwest. This 14-
foot-tall portrait of Fray García de San
Francisco y Zúñiga, founder of the
seventeenth-century Paso del Norte
Mission in Juárez, is the first figure to
be completed by local sculptor John
Houser. No time frame has been
established for the completion of all
twelve statues, which will be sited in
various downtown locations. The
second statue will depict explorer
Juan de Oñate.

Jimenez, Luis

(b. 1940 Native Texan)

PLAZA DE LOS LAGARTOS 1995

Figurative; life-size; painted fiberglass
Location: San Jacinto Plaza
Funding: City of El Paso and the
National Endowment for the Arts
Comments: Jimenez chose to create a
group of fiberglass alligators for San
Jacinto Plaza because of his childhood
memories of live alligators that once
lived in a pool at the plaza. Jimenez
remembers going to the plaza with
his mother and grandmother and
being fascinated by the reptiles that
languished motionless in the hot sun.

Madero, Rogelio

(b. 1936 American/Mexican)*

THE FOUNTAIN 1989

Abstract; 12' H; welded brass
Location: Thomason General
Hospital, 4815 Alameda

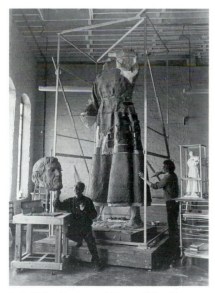

Artist John Houser and his son Ethan Houser
at work on the clay model of *Fray Garcia de
San Francisco y Zuniga.* Photo by Jody Schwartz.

Plaza de los Lagartos. Photo courtesy Luis Jimenez
and City of El Paso Art Resources Department.

201

Funding: J. O. and Marlene Stewart
Comments: Rogelio Madero is a former El Paso resident now living in Monterrey, Mexico. In 1983, he placed a smaller water sculpture, *El Ala,* inside the Colony Cove Shopping Center in El Paso.

McBeth, James R.

(American)

THE TEXAS WEDGE *1986*

Environmental; 4' to 20' H; aluminum
Location: University of Texas at El Paso campus, entrance to the library
Funding: University of Texas at El Paso, through 1 percent of the new library's construction costs designated for artworks
Comments: McBeth, an art instructor at Weber State College in Ogden, Utah, won this commission over 70 other artists who submitted sketches. *The Texas Wedge* consists of 196 anodized aluminum tubes positioned to reflect the brilliant hues of the West Texas sunset.

Mosley, Aaron Royal

(b. 1935 American)

HOPE *1993*

Figurative; larger than life-size; bronze
Location: Southwest Acquired Immune Deficiency Syndrome Committee, 1505 Mescalero
Funding: City of El Paso Art Resources
Comments: This piece is the first of *The Hope Trilogy,* a three-piece installation dedicated to friends and family with the courage to support a loved one who has been diagnosed with acquired immune deficiency syndrome. The completed work will portray hope, despair, and compassion.

Rivera, Reynaldo

(American)

THE SURVIVOR *1994*

Figurative; 7' H; bronze

The Texas Wedge. Photo courtesy University of Texas at El Paso, News and Publications Office.

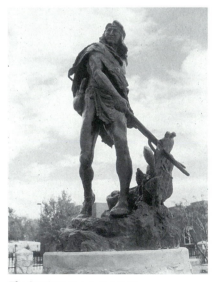

The Survivor. Photo by Stella Gutiérrez, courtesy City of El Paso Art Resources Department.

Location: Ysleta Pedestrian Plaza, 9107 Alameda Avenue
Funding: City of El Paso
Comments: This figurative bronze by New Mexico artist Reynaldo Rivera celebrates the Tigua heritage and the contributions of the Ysleta del Sur Pueblo to the culture and history of El Paso. Forebears of the Tigua residents of Ysleta del Sur Pueblo came to the area in the 1680s, establishing one of the earliest Native American settlements associated with a Spanish mission in Texas. According to a 1989–1990 historical documentation and excavation of Ysleta, archeologists have determined that the original inhabitants of the Ysleta del Sur Pueblo migrated to the area from the Isleta Pueblo near Albuquerque, New Mexico. Those early Ysletans carried on the life-style and traditions of their ancestors, growing crops in irrigated fields and caring for a number of domesticated animals, including pigs, sheep, goats, and chickens. Rivera's statue depicts a seventeenth-century Tigua pausing from his work to hear the chiming of bells in a nearby mission.

Ruiz de Rivera, José

(b. 1904 American)

THE CAVALRYMAN *1938*

Figurative; 8'3" H; black granite
Location: Intersection of Missouri, Prospect, and Santa Fe
Funding: Given to the city by Percival Henderson in memory of William Crawford Harvie
Comments: This work is the oldest freestanding sculpture in El Paso. Henderson dedicated the figure to the pioneer Southwest cavalryman and his friend William Harvie, who was active in the El Paso Scottish Rite. The statue was erected in 1939 and formally unveiled in March 1940 during a reunion of El Paso Scottish

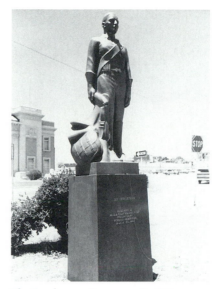

The Cavalryman. Photo courtesy City of El Paso Art Resources Department.

Rite bodies. José Ruiz de Rivera employed a full-time blacksmith to sharpen his tools as the artist carved the cavalryman from a 10-ton block of granite quarried at Coopersburg, Pennsylvania. In 1995, local artist Ron Clark did an intensive study of *The Cavalryman,* including an X-ray and a geological evaluation of the granite. Clark then proceeded to restore the sculpture, which had been identified by the Save Outdoor Sculpture! program as one of the ten historic Texas sculptures most in need of conservation.

Soler, Urbici

(1890–1953 American/Spanish)*

SIERRA DE CRISTO REY SHRINE *1938–1940*

Figurative; 33'6" H figure on 9' H base; Cordova cream limestone from Travis County
Location: Cristo Rey Mountain, from Paisano Drive take Anapra Road; the statue is technically located in New Mexico, but it is visible from El Paso,

203

Sierra de Cristo Rey Shrine.
Photo courtesy *Texas Highways Magazine.*

and its existence is due primarily to residents of El Paso
Funding: Catholic Diocese of El Paso and public donations
Comments: Located at the summit of Sierra de Cristo Rey 949 feet above the Rio Grande and 1,300 feet from the Mexican border, this statue of Christ appears as eternal as the mountain. Urbici Soler arrived in El Paso on October 4, 1937, in response to a telegram from Father Lourdes Costa, whose dream it was to erect a monument on the mountaintop visible from his humble mission in the Smelter District of northwest El Paso. The telegram's message was a single word, "Come." Urbici envisioned his commission to carve a colossal statue on the summit of Cristo Rey as an opportunity to create a work that would rival the *Christ of the Andes*. Working from a scaffold, he used an air chisel to carve a 30-ton block of Cordova cream limestone that was fixed to a cross of reinforced concrete set 30 feet into the mountain. After three years filled with

delays and controversy, the monument was dedicated on October 17, 1940, in a ceremony that attracted approximately 50,000 people and religious leaders from throughout the United States and Mexico. In 1994, the Diocese of Las Cruces, New Mexico, hired El Paso artist Steve Beck to restore this famous shrine. Other works in El Paso by Urbici Soler include *Cristo Moreno* in the sanctuary of Our Lady of the Assumption Church, a red sandstone bust of Diego Rivera in the Special Collections at the University of Texas at El Paso, and several works in the university's main library.

Aztec Calendar Replica.
Photo courtesy *Texas Highways Magazine.*

Unknown Artist

AZTEC CALENDAR REPLICA *1952*

Figurative; 11' diameter; plaster
Location: Calendar Park at the intersection of East San Antonio Street, South El Paso Street, and Texas Avenue
Funding: Donated to the city of El Paso by Pemex
Comments: At the time of its casting in 1952, this calendar was one of only three such replicas cast from the original in Mexico City.

F

Farmers Branch

Farmersville

Flatonia

Forney

Fort Bliss

Fort Clark Springs

Fort Stockton

Fort Worth

Fredericksburg

Freer

Farmers Branch

Whitney, Mac
(b. 1936 American)*

CONCHO and **CROCKETT** *1986*

Abstract; 2 companion pieces;
Concho 13' H, *Crockett* 12'8" H;
stainless steel
Location: 1601 LBJ Freeway
Funding: Park West Associates and
IBM

Farmersville

Unknown Artist

CONFEDERATE SOLDIER STATUE
1917

Figurative; 7' H; gray granite
Location: Farmersville City Park,
corner of Main and Hall streets
Funding: Farmersville Chapter 1208,
United Daughters of the Confederacy

Flatonia

Mikulik, Gene A.
(American)*

THE AMERICAN DOUGHBOY
1985

Figurative; larger than life-size;
bronze
Location: American Legion Hall,
$^1/_2$ mile east of Flatonia on U.S. 90
Funding: Jerome Michal American
Legion Post 94 and local citizens
Comments: In nearby Schulenburg,
Mikulik has a small statue of Saint
Isadore, the patron saint of farmers,
installed at the Saint Rose of Lima
Catholic Church, 1010 Lyons
Avenue.

Concho (top) and *Crockett* (bottom) before
their installation in Farmers Branch.
Photos courtesy Mac Whitney.

206

Forney

Craftsmen at
Little Red's Antiques

STATUE OF LIBERTY REPLICA
1986

Figurative; 8' H; cast aluminum
Location: Interstate 20 at Forney
Funding: Richard Whaley
Comments: These replicas have been
placed in several Texas cities,
including Hurst, Houston, Dallas,
Salado, and North Richland Hills.
Richard Whaley, owner of Little Red's
Antiques, orders the statues accord-
ing to his specifications from a
foundry in Mexico. The finishing
work is done in Forney under his
direction by workers employed for
the job at Little Red's Antiques.
Although not individually recorded in
this survey, these statues are easily
identified because they do not include
a flame in the torch. Various improvi-
sations—from globes to Christmas
lights to bronze flames—have been
installed in Liberty's lamp.

First to Fire. Official U.S. Army photo by Tony Cuciniello.
Used with permission.

Fort Bliss

Streadbeck, Steve

(American)

FIRST TO FIRE *1989*

Figurative; 2 figures, 15' H; bronze
cast at Adonis Bronze in Orem, Utah
Location: Memorial Circle, Fort Bliss
Funding: Installation Morale, Welfare,
and Recreation Fund
Comments: When he was command-
ing general of Fort Bliss, Major
General Donald Infante commis-
sioned this monument depicting two
United States air defenders in battle.
Fort Bliss is home to the U.S. Army
Air Defense Artillery Center.

Statue of Liberty Replica. Photo by Robert Little.

Fort Clark Springs

Beard, Ralph

(American)*

EMPTY SADDLE *1982*

Figurative; life-size; fiberglass
Location: Off U.S. 90 on Farm Road 693
Funding: Fort Clark Springs Association and Ralph Beard
Comments: Beard ordered this fiberglass horse from California and transformed it into a monument to the horse soldiers who served at Fort Clark, an army post established in 1852 to protect settlers and travelers. The saddle, bridle, and saddlebags are treated leather; the stirrups and reins are metal. The riderless horse, unaware that the cavalry is gone, looks expectantly toward the old fort's open gate. Beard also purchased the two concrete eagles that flank the monument.

Fort Stockton

Creative Display Company

(American)

PAISANO PETE *1979*

Figurative; 11' H; plastic foam and fiberglass
Location: U.S. 290 and Main Street

Funding: Tourist Development Board of Fort Stockton
Comments: *Paisano Pete* is reputedly the world's largest roadrunner. Creative Display Company is located in Sparta, Wisconsin.

Fort Worth

Aarnos, Seppo

(b. 1937 American/Finnish)*

HORNED FROG *1984*

Figurative; 2' H; Cor-ten steel
Location: Texas Christian University campus, between Reed Hall and Sadler Hall in the 2800 block University Drive
Funding: House of Student Representatives of Texas Christian University
Comments: Aarnos moved from Georgetown to Fort Worth in the late 1980s. In addition to this figure of TCU's mascot, Aarnos has placed an 18-foot Cor-ten–steel abstract at the entrance to Ridglea Country Club at 3700 Bernie Anderson Avenue.

Bedford, Jon G.

(American)

GALAPAGOS TORTOISE *1984*

Figurative; 7' × 9' × 6'; chrome-plated automobile bumpers and steel

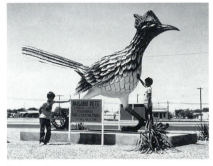

Paisano Pete. Photo courtesy *Texas Highways Magazine*.

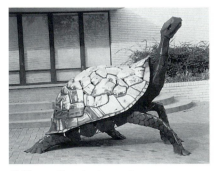

Galápagos Tortoise. Photo by Robert Little.

fabricated at Shidoni Art Foundry in
Tesuque, New Mexico
Location: Fort Worth Museum
of Science and History,
1501 Montgomery Street
Funding: Fort Worth Museum of
Science and History

Biggs, Electra Waggoner

(b. 1912 Native Texan)*

RIDING INTO THE SUNSET
circa 1947

Equestrian; 9'11" H, 3,200 lbs.; bronze
Location: Will Rogers Memorial
Coliseum, 3400 West Lancaster
Funding: Gift of Amon G. Carter; part
of Fort Worth's park system
Comments: The artist accepted a
commission from Amon G. Carter in
1937 to create an equestrian statue of
the famous American philosopher-
humorist Will Rogers (1879–1935)
and his horse Soapsuds. She was
dissatisfied with the enlargement of
the first model, however, and after
five years of work she started over.
Living in New York at the time, she
borrowed a New York Police Depart-
ment horse that resembled Soapsuds
and hired a model similar in physique
to Rogers to pose on a barrel in her
studio. This piece, installed in 1947
at Will Rogers Memorial Coliseum, is
the first casting; others are placed in
Dallas, Lubbock, and Claremore,
Oklahoma.

Bryant, Jack

(b. 1929 Native Texan)*

HORSE THIEF *1989*

Equestrian; life-size; bronze cast at
Bryant Art Foundry in Azle
Location: 3340 Camp Bowie
Boulevard
Funding: Privately owned

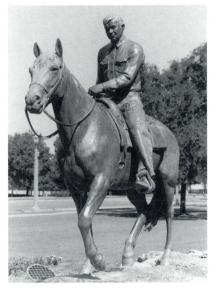

Riding into the Sunset. Photo by Robert Little.

MIDNIGHT *1984*

Equestrian; life-size; bronze cast at
Bryant Art Foundry in Azle
Location: Amon G. Carter Exhibits
Hall in the Will Rogers Memorial
Center, 3401 West Lancaster
Funding: Presented to the city of Fort
Worth by numerous private donors,
whose names are listed on the base;
part of Fort Worth's park system
Comments: Midnight (1910–1936)
was called the "world's greatest
bucking horse." He worked on the
American Rodeo Circuit from 1923 to
1933; only nine cowboys managed to

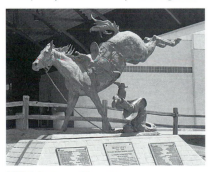

Midnight. Photo by Robert Little.

stay in the saddle. This monument depicts Midnight in a familiar pose—bucking a rider to the ground.

Bryant, Jack, and

(b. 1929 Native Texan)*

Cynthia Bryant

(Native Texan)*

SAVE THE FUTURE *1993*

Figurative; life-size; bronze cast at Bryant Art Foundry in Azle
Location: Fort Worth Fire Station 2, 1000 Cherry Street
Funding: Sponsored by the Friends for Fort Worth Fire Fighters through donations and the sale of limited edition prints and small versions of the life-size work; part of Fort Worth's park system

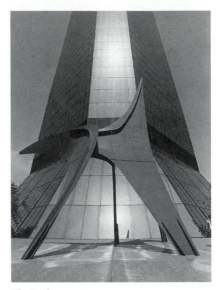

The Eagle. Photo courtesy Texas American Bank Fort Worth.

Calder, Alexander

(1898–1976 American)

THE EAGLE *1974*

Abstract; 40' H, 16 tons; painted steel plate fabricated at the Segre Iron Works in Waterbury, Connecticut
Location: TeamBank, 5th Street and Throckmorton
Funding: Originally purchased for the site by Fort Worth National Bank and Texas American Bancshares, Inc.
Comments: This monumental work is one of Calder's major stabiles (a nonmoving sculpture, as opposed to his popular mobiles). Inside the bank building are several works by Texas artists whose outdoor commissions are included in this survey: Charles Truett Williams, Richard Davis, David Deming, Mac Whitney, and Gene Owens.

Duffie, Robert

(Native Texan)*

THE EAGLE'S NEST *1988*

Figurative; 12'6" H; bronze cast in 160 pieces at Bryant Art Foundry in Azle
Location: 7001 Will Rogers Boulevard
Funding: Commissioned by Robert and Howard Hallam, chairman of the board and president of the Ben E. Keith Company
Comments: *The Eagle's Nest* was unveiled at the opening of the Ben E. Keith Beers distribution center in 1988. The inscription on the base reads, "This symbol of courage, vision, and strength is affectionately presented to our father, Gaston Hallam, for his leadership of the Ben E. Keith Company." Robert Duffie is best known for his Western paintings and bronzes, which are in public and private collections throughout the United States. In 1986, he served as the official Texas Sesquicentennial Wagon Train Commemorative Artist.

Goldberg, Brad

(b. 1954 American)*

CONTINUUM *1992*

Site specific; 5 elements, the largest measuring 11' × 5' × 5'; sunset-red Marble Falls granite
Location: Tarrant County Plaza in Heritage Park, north of the Tarrant County Courthouse overlooking the Trinity River
Funding: Tarrant County, with generous assistance from Josephine Hudson, a descendant of John Peter Smith, who founded Fort Worth's first school on the site of Heritage Park; part of Fort Worth's park system
Comments: After winning a competition administered by Urban Strategies for Tarrant County in 1991, Goldberg created *Continuum*, a sculptural installation composed of a grouping of granite monoliths inscribed with linguistic symbols taken from the evolution of human communication.

Continuum. Photos courtesy Brad Goldberg.

James L. West. Photo by Robert Little.

Johnson, J. Seward, Jr.

(b. 1930 American)

JAMES L. WEST *1994*

Portraiture; life-size; bronze
Location: James L. West Presbyterian Special Care Center, 1111 Summit Avenue
Funding: James L. and Eunice West Charitable Trust
Comments: James L. West (1900–1983) was a businessman and philanthropist whose generosity made the Special Care Center possible. All exhibitions and sales of J. Seward Johnson sculptures are coordinated through Sculpture Placement, Ltd., of Washington, D.C.

Johnson, Philip

(b. 1906 American)

FORT WORTH WATER GARDENS *1974*

Environmental; 4.3 acres; water and stone
Location: Interstate 30 and Main Street
Funding: Donated to the city of Fort Worth by the Amon G. Carter Foundation; part of Fort Worth's park system
Comments: This urban waterland is one of the state's most outstanding examples of beautiful and innovative projects designed to provide a respite from city noise and traffic. Working

211

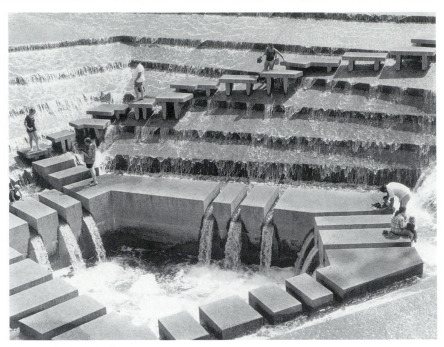

Fort Worth Water Gardens. Photo courtesy *Texas Highways Magazine.*

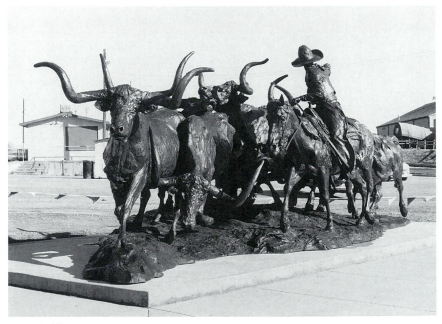

Texas Gold. Photo by Daniel Burgess, courtesy Texas Longhorn Breeders Foundation of America.

with John Burgee of New York, Johnson designed a terraced walkway that allows visitors to stand 38 feet below ground level and watch 1,050 gallons of water per minute rush down 710 feet of wall. While water gardens are not within the context of this study, this example is included to make the interested reader aware of an urban art form that is relatively new to Texas. Similar projects include the golden fountains in Tranquility Park in downtown Houston, the water wall at Transco Tower near Westheimer Road and South Post Oak Road in Houston, the water garden at the Bayfront Arts and Science Park in Corpus Christi, and the large cascading water sculpture near the Tower of the Americas in San Antonio's beautiful Hemisfair Park.

Johnston, Randolph

(1908–1992 American)

YEARNING TO KNOW *1990*

Figurative; life-size; bronze cast at Bronzart Foundry, Inc., in Sarasota, Florida

Yearning to Know. Photo courtesy Texas Christian University, Office of University Relations.

Location: Texas Christian University Starpoint School, 2829 Stadium Drive
Funding: Commissioned and donated to the school by M. J. Neeley in memory of his wife, Alice Snead Neeley
Comments: This is one of the last major works by Johnston, who moved to the Bahamas in 1951. The sculptural group is based on a photograph of Alice Neeley's mother, Mary Brazelton Snead, and the two Neeley daughters, Marian and Kathleen.

Kelsey, T. D.

(American)

TEXAS GOLD *1984*

Figurative; 11' × 29' × 13'8"; bronze cast in 900 sections at Art Castings Company in Loveland, Colorado
Location: Texas Longhorn Breeders Association of America headquarters at North Main and Stockyards Boulevard
Funding: Given to the association by artist-rancher T. D. Kelsey and his wife, Sidni
Comments: At the time it was placed, this sculpture depicting seven longhorn steers herded by a lone rider was recognized as the largest piece of cast bronze in the nation. *Texas Gold* is a tribute to the hardy survivors that developed from a herd of approximately two hundred cattle brought by the Spanish in the late 1600s to what is now Texas. It is also a tribute to the city of Fort Worth, whose Old West heritage and famous stockyards earned it the nickname "Cowtown." T. D. and Sidni Kelsey came to Fort Worth from their home in Kiowa, Colorado, to unveil *Texas Gold* on December 8, 1984.

213

Larson Company of Tucson, Arizona

ACROCANTHOSAURUS and **TENONTOSAURUS** *1993*

Figurative; life-size; steel, rebar, and cement
Location: Dino Dig at the Fort Worth Museum of Science and History, 1501 Montgomery Street
Funding: Fort Worth Museum of Science and History
Comments: The first exhibit of its size and scope in the world, Dino Dig combines life-size representations of dinosaurs with a large, outdoor discovery area where visitors can

Acrocanthosaurus, a bipedal meat eater that lived in the Fort Worth area 113 million years ago. Courtesy Fort Worth Museum of Science and History.

Tenontosaurus drinking from a pool in Dino Dig, a permanent exhibit at the Fort Worth Museum of Science and History. Courtesy Fort Worth Museum of Science and History.

become amateur paleontologists and dig for dinosaur bones. Inside the museum, visitors can see the actual *Tenontosaurus* skeleton unearthed at Weatherford in 1988; in Dino Dig, they see what the creature looked like when it was alive. One of the dig sites contains casts of the tail, vertebrae, and skull of the actual dinosaur. The 6-foot-tall *Tenontosaurus* and the 14-foot-tall *Acrocanthosaurus* lived in the Fort Worth area 113 million years ago. These anatomically accurate representations of the two dinosaurs were based on fossil evidence. Museum personnel and Dr. Louis Jacobs, director of the Shuler Museum of Paleontology at Southern Methodist University, worked closely with the Larson Company of Tuscon, Arizona, to insure scientific accuracy.

Lore, J. M.

(American)

CAMP WORTH PLAQUE *1921*

Figurative; 2' H × 3' W; bronze and limestone
Location: Corner of Houston and West Belknap
Funding: Erected by the Mary Isham Keith Chapter, Daughters of the American Revolution
Comments: This plaque marks the site of Camp Worth, a United States military post named in honor of General William J. Worth and commanded by Major Ripley A. Arnold from 1849 to 1853. The camp, which became the city of Fort Worth, protected frontier settlers against Indian attacks. Lore's relief depicts pioneers in ox-drawn wagons as they leave the protection of the fort surrounded by cowboys and Indian guides.

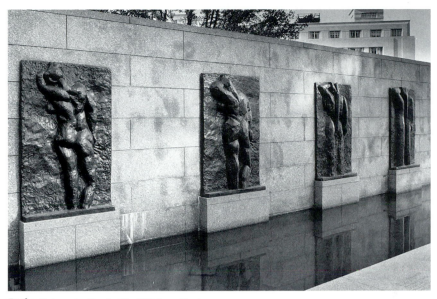

Backs. Photo courtesy Tom Fox, The SWA Group, Houston.

Matisse, Henri

(1869–1954 French)

BACK I *1909,* **BACK II** *1913,* **BACK III** *1916–1917,* and **BACK IV** *1930*

Figurative; 4 figures, *Back I* and *Back II* 6'2⅝" H, *Back III* 6'1⅞" H, *Back IV* 6'2½" H; bronze
Location: Burnett Park, bounded by West 7th, Lamar, and West 10th streets
Funding: Purchased in 1982 by the Anne Burnett and Charles Tandy Foundation; part of Fort Worth's park system
Comments: The *Backs* sequence consists of four life-size studies of a female back, and the series of sculptures demonstrates the evolution of Matisse's style as he moved away from naturalistic designs toward expressive and more abstract forms. The clay models, found in the artist's studio after his death, were cast in bronze between 1955 and 1960. The Tandy Foundation purchased *Backs* in 1982 as part of a $5 million renovation of Burnett Park.

The SWA Group in Houston provided full design services for the redevelopment project, which includes fiber optics, granite pathways, soaring jets of water, and a reflection pool. The Houston firm received the 1985 Award of Excellence from the Boston Society of Landscape Architects for their work on the redesigned park. *Backs* is dedicated to the memory of Anne Tandy, whose grandfather, Samuel Burk Burnett, donated land for Burnett Park in 1919.

McKenzie, R. Tait

(1867–1938 American/Canadian)

BOY SCOUT STATUE *1937*

Figurative; life-size; bronze
Location: Longhorn Council Service Center, 4917 Briarhaven
Funding: Donated by Mrs. A. L. Shuman in 1957 in memory of her son Leroy Shuman
Comments: Leroy Shuman was a member of the first local Boy Scout troop, and his father, A. L. Shuman, served as the first president of the Longhorn Council.

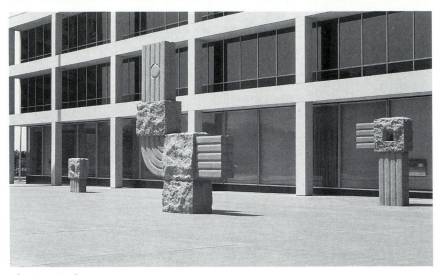

The Texas Sculpture. Photo by Robert Little.

Moore, Henry

(1898–1986 British)

UPRIGHT MOTIVE #1, #2, #7
1955–1956

Abstract; 3 elements: #1 10'10" H,
#2 10'6³/₄" H, #7 10'11³/₈" H; bronze
Location: Amon Carter Museum,
3501 Camp Bowie Boulevard
Funding: Museum purchase
Comments: Amon G. Carter, founder
and publisher of the *Fort Worth Star-
Telegram*, was a collector of painting
and sculpture by American Western
artists, including Frederic Remington
and Charles Russell. Before his death,
Carter chose a site for a museum to
house his collection, and a bequest in
his will funded the project. Philip
Johnson designed the building, which
is faced with Texas fossil limestone.

Noguchi, Isamu

(1904–1989 American)

THE TEXAS SCULPTURE *1961*

Abstract; 3 pieces, the tallest reaching
20' H; carved Japanese granite

Location: NationsBank entrance
plaza, 500 West 7th Street at
Lamar Street
Funding: First National Bank, now
NationsBank
Comments: Noguchi designed the
entire entrance plaza, which origi-
nally included fifteen large Japanese
stones and landscaping. They were
removed when the plaza was paved.
According to the artist, "Only in
Texas could there have been this
space and carved pieces of this size to
put in it. The individual pieces are
symbols of energy, of man, of the
bank—but they have no names. The
whole thing is *The Texas Sculpture*"
(Interfirst Bank 1961).

Nunnally, Fannie Becton

(American)*

CONFEDERATE SOLDIER STATUE
1939

Figurative; 5'8" H; white Carrara
marble
Location: Oakwood Cemetery, Grand
Avenue at Gould Street
Funding: Julia Jackson Chapter 141,

216

United Daughters of the Confederacy
Comments: The Confederate private, dressed in an unofficial uniform, was sculpted in Milan, Italy, according to a design sketched by Fannie Becton (Mrs. Jesse J.) Nunnally, who served as registrar of the Julia Jackson chapter and as chairperson of the monument committee. The statue was restored in 1991 by Anderle's Art Factory, Inc., in Glen Rose, Texas. It was rededicated on October 13, 1991, in recognition of the chapter's ninety-fourth anniversary.

Perry, Lisa

(b. 1950 American)*

BILL PICKETT, BULLDOGGER
1986

Portraiture; 9'10" H, 1,400 pounds; bronze cast at Bryant Art Foundry in Azle
Location: Corner of Rodeo and Exchange Avenue
Funding: North Fort Worth Historical Society
Comments: Unveiled in May 1987, this statue features the legendary cowboy Bill Pickett (1870–1932), who is solely responsible for inventing bulldogging as a rodeo event. Pickett is the only black man named to the Cowboy Hall of Fame. The artist is a Montana native now living in Springtown, Texas.

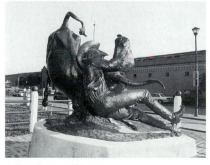

Bill Pickett, Bulldogger. Photo by Lee Angle, Fort Worth, courtesy Lisa Perry.

Along the River. Photo courtesy Chris Powell.

To Stand. Photo courtesy Chris Powell.

Powell, Chris

(b. 1957 American)

ALONG THE RIVER *1994*

Environmental; 8 pieces, covering approximately 30' × 40'; Texas granite
Location: Heritage Park, north of the Tarrant County Courthouse, overlooking the Trinity River
Funding: Coordinated by Urban Strategies with private donations; part of Fort Worth's park system
Comments: Powell's installation involves an 8-foot-high monolith and seven granite blocks measuring 2 feet square.

TO STAND *1994*

Environmental; 3 units, covering an area of 22' × 13'; Leudars limestone
Location: Broadway Baptist Church, 305 West Broadway
Funding: Commissioned by the church with funds provided by individual donors

The Brand Inspector. Photo courtesy Jim Reno.

Reno, Jim

(b. 1929 American)*

THE BRAND INSPECTOR *1983*

Equestrian; life-size; bronze cast
at Castleberry Art Foundry in
Weatherford
Location: Texas and Southwestern
Cattle Raisers Foundation,
1301 West 7th Street
Funding: Given by Anne Sowell of
the Tandy Foundation
Comments: Reno depicts a brand
inspector of the 1880s looking
through his brand book to identify
the markings on the longhorn steer in
front of him. This bronze succinctly
tells the story of the Texas longhorn
and the men who were trained to
identify a cattleman's brand. Most
inspectors could identify a stolen calf
merely by the gloss of its hide or the
development of its muscle. Through
his cunning and courage, along with
his book of registered markings, the
brand inspector was a powerful and
essential figure in the establishment
of the Texas cattle industry.

CHARLES DAVID TANDY *1980*

Portraiture; larger than life-size;
bronze cast at Castleberry Art
Foundry in Weatherford
Location: Pipkin Park, adjacent to the
Tarrant County Courthouse
Funding: Donated in loving memory
of Charles Tandy by the Tandy
Corporation; his many friends; his
wife, Anne Burnett Tandy; and his
stepdaughter, Anne W. Phillips
Comments: Charles Tandy was an
outstanding Texas businessman, civic
leader, and philanthropist.

Sellors, Evaline Clarke

(b. 1908 Native Texan)*

A SONG *1968*

Figurative; $^3/_4$ life-size; bronze cast
at the Roman Bronze Works in
New York
Location: Child Study Center,
1300 West Lancaster
Funding: Donated by the
Carl John Aldenhoven family
Comments: Sellors describes her
motivation for this work as follows:

218

"My idea was to create something giving vision to the blind through touch. For those who could not walk, I wanted to convey a sensation of joy and comfort. This is why the figure is seated. To the retarded, I wanted to bring an awareness of well-being. The animals and birds were left small to create friendliness and to eliminate any feeling of fear or intimidation. And last, if I could, I wanted to use illusion or imagination to create the spirit of a song which would, hopefully, fill and lift the hearts of all those who see or feel her" (Child Study Center n.d.). In 1986, a limited edition of small bronze copies of the original model was commissioned by Mr. and Mrs. Larry D. Eason and cast at Hoka Hey Fine Arts Foundry in Dublin, Texas, for presentation to outstanding supporters of the Child Study Center's work.

AL HAYNE MONUMENT *1937*

Portrait bust; larger than life-size; bronze
Location: Intersection of Main and Lancaster streets
Funding: Commissioned by the city of Fort Worth; part of Fort Worth's park system
Comments: The Spring Palace was an elaborate structure measuring 225 feet by 375 feet and costing $100,000. Designed to house a trade fair promoting the produce of Texas, the building included space for counties to display the bounty of Texas farms, orchards, and forests. The first exhibition, on May 10, 1889, attracted people to Fort Worth from all over the United States, with special trains bringing visitors from Boston and Chicago. The exhibition of 1890 was even more successful until a fire broke out on May 30 during a formal ball attended by more than 7,000 people. Within a few minutes, the entire structure was in flames. Al Hayne died from injuries sustained

Al Hayne Monument. Photo by Robert Little.

while rescuing an unconscious woman from the burning building. The site of the fire is identified by this monument and an official Texas historical marker.

Thorvaldsen, Bartholomew "Bertel"

(1770–1844 Danish)

THE SERMON ON THE MOUNT REPLICA *replica 1969*

Figurative; life-size; marble
Location: First United Methodist Church, 800 West 5th
Funding: The congregation of First United Methodist Church
Comments: Italian sculptor Gamba Quirino carved this replica of the original work, which is located in Copenhagen, Denmark. Another statue by Thorvaldsen, *The Christ,* is placed in the church's courtyard, along with life-sized marble busts of Francis Asbury and John Wesley by Bruno Filie of the Apollini and Tosi Studio in Pietrasanta, Italy.

219

Unknown Artist

**HORSE FOUNTAIN
WATER TROUGH** *1892*

Figurative; 4' H, 4' square;
Texas limestone
Location: Tarrant County Courthouse
grounds
Funding: Fort Worth Women's
Humane Association
Comments: This is actually one
section of a large fountain that was
torn down in 1940.

Unknown Artist

JOHN PETER SMITH *circa 1901*

Portrait bust; life-size; marble
Location: 1100 Throckmorton at
Jennings Avenue
Funding: Private donations
Comments: John Peter Smith (1831–
1901) was a local businessman, phil-
anthropist, and Confederate hero. This
bust was made from a death mask.

Unknown Artist

RAIN SPRITES REPLICA
installed 1965

Figurative; 4' H; lead
Location: Fort Worth Public Health
Center, 1800 University Drive
Funding: Purchased by the employees
of the health center
Comments: Health center employees
purchased this reproduction of an old
Italian statue from the Florentine
Craftsman Company in New York.

Walker, Barvo

(Native Texan)*

DUTY *1987*

Figurative; larger than life-size;
bronze cast at the American Art
Foundry in Rhome, Texas

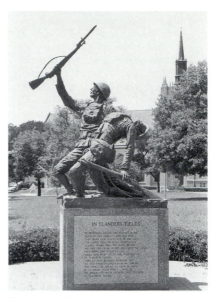

Duty. Photo by Robert Little.

Location: Veterans Memorial Park,
4100 Camp Bowie Boulevard at
Crestline Road
Funding: Commissioned by E. L.
"Pappy" Sprague with $10,000 as seed
money from the World War I Veter-
ans Association and additional funds
from the sale of small versions of the
statue and from individual contribu-
tors; part of Fort Worth's park system
Comments: Walker used a World War
I uniform and two high school
students as models to design this
memorial depicting two doughboys in
battle. Veterans Memorial Park is
near the original headquarters of
Camp Bowie, where the 36th Army
Division trained during World War I.
Duty depicts a World War I foot
soldier holding his rifle above his
head with one hand and supporting a
wounded buddy with the other hand.

Fountain Sculpture. Photo by Robert Little.

Spirit of Woman. Photo by Robert Little.

Williams, Charles Truett

(1918–1966 Native Texan)*

FOUNTAIN SCULPTURE
1962–1963

Abstract; 14'6" H; hammered sheet copper and bronze
Location: Caravan Motor Hotel, 2601 Jacksboro Highway
Funding: Purchased by Lon C. Richardson, hotel owner
Comments: This work is an outstanding example of the artist's organic fountain sculptures. Two smaller works by Williams are installed in Fort Worth at 2601 Ridgmar Plaza.

Special Collections and Sculpture Gardens in Fort Worth

The Fort Worth Botanic Garden is located at 3220 Botanic Garden Boulevard. The garden is owned and operated by the City of Fort Worth Parks and Community Services Department and supported primarily by public funds. Visitors to the garden number more than 600,000 annually. Installed in locations throughout the gardens is an impressive collection of outdoor sculpture by well-known Texas artists.

SPIRIT OF WOMAN *1990,* by Jack Bryant, is installed on the north vista of the gardens. This life-size bronze figure cast at Bryant Art Foundry in Azle depicts a pioneer woman calling her family in from the fields at dusk. Donated to the gardens by the Altrusa Club of Fort Worth, the statue is a tribute to all women who achieve whatever tasks they set out to do with courage, devotion, good humor, and a sense of self-fulfillment.

NAIADS *1992–1993,* by Glenna Goodacre, is the largest and most recently acquired work at the gardens. Only fifteen bronze castings will be made of the two larger-than-life female figures, which were purchased for the entrance to the Botanic Garden Center and Conservatory through Altermann and Morris Gallery in

221

Naiads. Photo by Robert Little.

Dallas. Texas artist Gene Owens designed and made the tiles for the two fountains that flank the front doors to the conservatory.

ALONG BESIDE ME *1989,* by Fort Worth artist Chris Powell, involves four glazed stoneware abstractions based on plant and geologic forms. The group of totemic designs is placed in the enclosed garden adjacent to the Dorothea Leonhardt Lecture Hall. Deborah Moncrief donated the installation to the gardens.

SAINT FRANCIS OF ASSISI *n.d.,* a 4'5" bronze figure by Frances Rich, is installed near the Botanic Garden Center and Conservatory. Deborah Moncrief donated the work in 1990.

FROG and **NATURE FINIALS,** by Evaline Clarke Sellors, are placed in the Fragrance Garden. *Frog* is a larger-than-life amphibian sitting on a bronze lily pad in the Fragrance Garden pool. It was acquired through the Evelyn Siegal Gallery in Fort Worth. *Nature Finials* is composed of four bronze reliefs set on brick pillars. The relief work on each finial depicts naturalistic vines, leaves, small animals, and birds.

The Greenwood-Mount Olivet Cemetery Company Outdoor Sculpture Collection includes several outstanding figurative and liturgical pieces that are available for public viewing at Greenwood Cemetery and

Along beside Me. Photo courtesy Chris Powell.

Nature Finials. Photo by Robert Little.

Mount Olivet Cemetery. The most unusual work in the collection is Ivo Stagetti's **FOUR HORSES OF THE BASILICA OF SAN MARCO REPRODUCTION** *1985–1986,* installed at the entrance to Greenwood Cemetery at 3100 White Settlement Road. Stagetti's copy of the original was made in ten sections and cast at Fonderia Mariani e Belfiore in Pietrasanta, Italy. Rollie Barthelemy, with the Cold Spring Granite Company in Cold Spring, Minnesota, constructed the massive base and entrance setting for the bronze, larger-than-life quadriga. The creator of the original quadriga of Saint Mark's Square in Venice, Italy, is thought by some to have been Lysippus, a Greek sculptor in the fourth century B.C. While scholars continue to debate its Greek or Roman origin, the sculpture's history is well documented after A.D. 1204, when the gilded bronze stallions were brought to Venice from Constantinople as spoils of war. The work is the only quadriga known to have survived intact from antiquity. In 1982, it was removed from the facade of Saint Mark's Cathedral and installed indoors away from the environmental pollutants that were destroying it. Like the original, the Greenwood horses are in classic

quadriga formation. They are unbridled and their bits have been broken to unleash their strength and speed. Another outstanding work at Greenwood Cemetery is **I AM THE RESURRECTION** *1952,* by American artist Bernhard Zuckerman. Zuckerman based his marble carving of Christ's ascension on a bronze door relief located in Florence and created by the Italian sculptor Lorenzo Ghiberti. At Mount Olivet Cemetery, located at 2301 North Sylvania Avenue, the cemetery company has installed **AMERICAN G.I.** *1980* by Giordano Grassi (Italian) and **SPIRIT OF THE AMERICAN DOUGHBOY** by E. M. Viquesney (1876–1946, American). Grassi's soldier figure is dedicated to the county's modern soldiers, and the Viquesney sculpture, acquired in 1929 from the Friedley-Voshardt Foundry, is dedicated to the veterans of Tarrant County who died in World War I and to the Bothwell Kane Post 21 American Legion and its auxiliary. Also at Mount Olivet is **THE LAST SUPPER** *1959,* by Italian stonecarver Guiseppe Solari. The artist's high-relief carving in white Carrara marble is based on Leonardo da Vinci's famous painting. A red granite mounting supports the work and records the biblical account of Christ's last supper with his apostles.

223

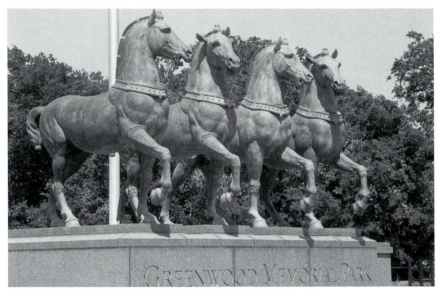

Four Horses of the Basilica of San Marco Reproduction. Photo by Robert Little.

The Kimbell Art Museum is located at 3333 Camp Bowie Boulevard. Museum founder Kay Kimbell established the Kimbell Art Foundation in the 1930s, and upon his death in 1964, he left his art collection and personal fortune to the foundation for the establishment of a public art museum. A few months after his death, his wife, Velma Fuller Kimbell, contributed her share of their property to facilitate the immediate and full implementation of her husband's desire to provide the finest possible museum in Fort Worth. Louis I. Kahn (1901–1974) designed the Kimbell Art Museum with vaulted ceilings and narrow skylights to enhance the display and viewing of great works of art. Three works are installed on the grounds surrounding the museum:

RUNNING FLOWER (LA FLEUR QUI MARCHE) *1952*, by Fernand Léger (1881–1955, French), is a monumental ceramic polychrome sculpture on loan from the Anne Burnett and Charles Tandy Foundation.

FIGURE IN A SHELTER *1983*, by Henry Moore (1898–1986, British), is a large bronze sculpture on loan from the Anne Burnett and Charles Tandy Foundation.

CONSTELLATION (FOR LOUIS KAHN) *1980*, by Isamu Noguchi (1904–1989, American), is an installation consisting of four carved basalt stones donated by the Isamu Noguchi Foundation in honor of Louis I. Kahn and the Kimbell Art Museum.

The Collection of the Modern Art Museum of Fort Worth includes five outdoor works located on the museum grounds at 1309 Montgomery Street. Chartered in 1892 and established in 1901, the Modern Art Museum of Fort Worth was the state's first art museum. Herbert Bayer designed the building, which opened in 1954, and O'Neil Ford and Associates expanded the facility in 1974. The museum is internationally recognized for its collections and exhibitions. Outdoor works include:

HINA *1990–1991*, by Deborah Butterfield (American), a life-size bronze abstraction of a horse purchased by the museum in 1992 with a grant from the Web Maddox Trust

BALL CONTACT *1990*, by Tony Cragg (British), an abstract composed of eight steel elements representing the seven continents and the globe of the earth. This was among 37 works acquired by the museum in 1992.

SCULPTURE FOR DERRY WALLS *1987*, by Antony Gormley (b. 1950, British), a life-size figure created with ductile iron and stainless steel. Gormley used a cast of his own body to form this work, which is one of three hollow cruciform figures originally installed along the city walls of Londonderry in Northern Ireland in May 1987. Strongly influenced by his study of meditation in India during the 1970s, Gormley emphasizes the human form as a place of being rather than an object of desire or power.

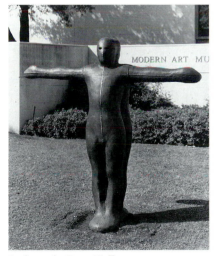

Sculpture for Derry Walls. Collection of the Modern Art Museum of Fort Worth, Gift of Anne Burnett Tandy in memory of Ollie Lake Burnett, by Exchange. Photo by Steve Watson.

TEXAS SHIELD *1986*, by Jesús Bautista Moroles (b. 1950, native Texan), a Texas pink granite abstract donated by Marvin Overton

CHANCE MEETING *1989*, by George Segal (b. 1924, American), a bronze figurative group. The museum purchased the three life-size pieces in 1992 with funds provided by the Sid W. Richardson Foundation Endowment Fund.

Fredericksburg

Cook, Richard

(b. 1951 American)*

JACOB BRODBECK *1985*

Figurative; life-size; bronze cast at Stevens Art Foundry in Bulverde
Location: Pioneer Plaza and Main Street
Funding: Private commission
Comments: Brodbeck immigrated to Texas from Germany in 1846. He taught at Vereins Kirche in Fredericksburg before moving to San Antonio, where he became district school inspector. Because of his advanced theories in aviation, Brodbeck is considered the father of Texas aviation.

Greiner, Max, Jr.

(b. 1951 Native Texan)*

DIVINE SERVANT *1990*

Figurative; life-size; bronze cast at Eagle Bronze in Lander, Wyoming
Location: Living Water Christian Retreat and Lodge, Fiedler Road, in the community of Harper, between Fredericksburg and Kerrville
Funding: Clyde and Peggy Smith

225

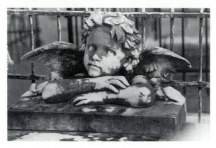

Cherub. Photo by Carol Little.

Ney, Elisabet

(1833–1907 American/German)*

CHERUB *circa 1905*

Figurative; 1'3" H; marble
Location: Fredericksburg City
Cemetery
Funding: Friedrich W. Schnerr
Comments: This little angel with her
chin resting on her arms was Ney's
last creation and the only tombstone
that she consented to do for a
nonpublic figure. The cherub is based
on one of the angelic figures in
Raphael's painting *Sistine Madonna*.
It marks the burial site of Elizabeth
Emma Schneider Schnerr (1827–
1903), wife of Friedrick W. Schnerr.

Tremper, Charlotte Augusta

(American)

JOHN O. MEUSEBACH *1936*

Portrait bust; larger than life-size;
bronze
Location: Vereins Kirche, Market
Square

Funding: $2,500 allocated by the 1936
Commission of Control for Texas
Centennial Celebrations
Comments: New York City artist
Charlotte Tremper attended the
dedication of Meusebach's bust on
May 9, 1937. John Meusebach
immigrated from Germany to become
a citizen of the Republic of Texas in
1845. He served as commissioner
general in charge of settling German
immigrants in Texas, and he founded
the cities of Fredericksburg and Loyal
Valley, where he died in 1897. In
1847, he negotiated the Meusebach-
Comanche Treaty with twenty
Comanche chiefs. The treaty pro-
tected German frontier settlers from
Indian raids and opened the land in
the San Saba area for surveying and
colonization.

Freer

Stacy, Peggy

(American)*

FREER RATTLESNAKE *1976*

Figurative; 7' H × 14' L; concrete and
steel
Location: East of Freer city limits on
the north side of U.S. 59
Funding: Freer Chamber of Commerce
Comments: This coiled diamondback
rattlesnake is painted in realistic
colors and markings. It was designed
by Stacy and built by Pete Hunter,
both of Freer. The annual Rattlesnake
Round-Up in Freer attracts 30,000
people every April.

Gainesville

Galveston

Georgetown

Glen Rose

Goldthwaite

Goliad

Gonzales

Granbury

Grand Prairie

Greenville

Groesbeck

Groom

Gainesville

Correll, Ira A.

(1873–1964 American)*

COOKE COUNTY CENTENNIAL MONUMENT *1948*

Figurative; 2 panels, each
12' H × 27' L; Texas limestone
Location: Intersection of South
Weaver and Fair Park Boulevard
Funding: Sponsored by the Maggie
House Garden Club
Comments: In an interview printed in
the *Austin American-Statesman* on
June 20, 1948, Ira Correll talked about
one of the statues on his recently
completed Gainesville monument:
"They call it just a pioneer, but I
carved Davy Crockett. Can't think of
a greater Texan, and I thought he
belonged there."

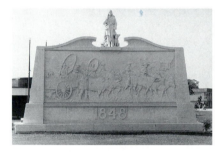

Cooke County Centennial Monument.
Photos by Eric Williams, courtesy *Gainesville Daily Register.*

McNeel Marble Company

(American)

CONFEDERATE SOLDIER STATUE
1911

Figurative; life-size; granite
Location: Cooke County Courthouse
grounds
Funding: Donations collected through
the efforts of Captain A. J.
Merriwether in tribute to Confederate
soldiers and sailors and the women of
the Confederacy
Comments: Research on this monu-
ment proved fruitless until August
1986, when Margaret Hays, chairman
of the Cooke County Sesquicenten-
nial Committee, stumbled on
information about the Gainesville
soldier while searching through the
Gainesville Public Library's vertical
files for information on C. P. Rodgers'
transcontinental flight of 1911. On a
newspaper clipping dated October 17,
1911, next to a report about Rodgers'
landing in Gainesville, was part of an
article on the unveiling of the
Confederate soldier "on the public
square last Sunday afternoon." The
unidentified article appeared in either
the *Hesperian* or the *Signal,* the two
newspapers published in Gainesville
during 1911. The best indication that
McNeel Marble Company provided
this statue is a letter dated February
16, 1911, from the company to F. B.
Chilton stating that the company had
signed a contract with the UDC
chapter in Gainesville, Texas (Texas
Collection).

Teich, Frank

(1856–1939 American/German)*

CONFEDERATE SOLDIER STATUE
1908

Figurative; larger than life-size;
marble
Location: Leonard Park,
1000 West California

Funding: Lou Dougherty Chapter, United Daughters of the Confederacy, $2,000

Comments: Mrs. J. M. Wright, president of the Lou Dougherty Chapter, noted at the statue's unveiling that the courageous service of Texans in the Confederate army made "the Lone Star the brightest in the galaxy of stars on the bonny blue flag" (*Confederate Veteran*, August 1908, 377).

Galveston

Adickes, David

(b. 1927 Native Texan)*

CORNET *1986*

Figurative; 20' H × 26' L; white concrete over steel frame
Location: The Strand and 23rd Street
Funding: Purchased by J. R. McConnell
Comments: The artist created this giant cornet as a stage prop for the New Orleans World's Fair. His model was a turn-of-the-century–style cornet purchased in a New Orleans antique shop. In 1986, Adickes converted the cornet into a freestanding outdoor sculpture for placement in Galveston.

Cornet. Photo by Robert Little.

Dignified Resignation. Photo by Robert Little.

Amateis, Louis

(1855–1913 American/Italian)

DIGNIFIED RESIGNATION *1911*

Figurative; larger than life-size; bronze
Location: Galveston County Court-house grounds, Moody Avenue and 21st Street
Funding: Veuve Jefferson Davis Chapter 17, United Daughters of the Confederacy
Comments: This is the only memorial in Texas that features a statue of a Confederate sailor. Dedicated to those who served in the army and navy of the Confederate States of America, the figure has a Confederate flag draped over his left shoulder and a broken cutlass in his right hand. Amateis received gold and silver medals for his sculpture from the Royal Academy of Turin before he immigrated to America in 1883. While serving as a professor of fine arts at Columbian University (now George Washington University) from

1892 to 1898, he modeled portraits of America's most famous citizens.

HENRY ROSENBERG STATUE
1906

Portraiture; larger than life-size; bronze cast at Bureau Brothers Bronze Founders of Philadelphia
Location: Rosenberg Library, 2310 Sealy at the 23rd Street entrance
Funding: Sidney Sherman Chapter, Daughters of the Republic of Texas, and local citizens
Comments: Galveston's beloved philanthropist is seated in a bronze chair fashioned after one from the Rosenberg home. Rosenberg's gifts to the people of Galveston include publicly sited art, a library, the YMCA building, an orphanage, a public school building, and many other benefactions.

Henry Rosenberg Statue. Photo by Robert Little.

TEXAS HEROES MONUMENT *1900*

Figurative; 72' H, 34' square at the base; bronze and granite
Location: 25th Street and Broadway
Funding: Donated to the city by Henry Rosenberg through a $50,000 bequest in his will
Comments: This spectacular monument to the heroes of the Texas Revolution was dedicated on April 21, 1900, the sixty-fourth anniversary of the Battle of San Jacinto. The light-gray granite pedestal consists of four columns attached to a central shaft, surmounted by a colossal bronze allegorical figure depicting Victory. The statue wears a Lone Star crown and carries a laurel wreath in her right hand and a rose-entwined sword in her left. The figure of Victory stands above two heroic female figures representing Defiance and Peace. Also featured are busts of Sam Houston and Stephen F. Austin. Mounted on the plinth are four bas-relief scenes depicting the Battle of the Alamo, the Goliad Massacre, the Battle of San Jacinto, and the surren-

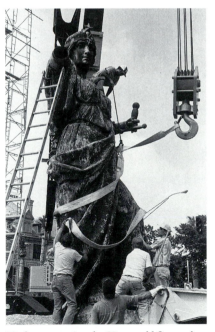

Workers removing the 90-year-old figure of Victory from her 50-foot summit on top of the *Texas Heroes Monument.* Photo courtesy Texas Historical Commission.

230

der of General Santa Anna to General Houston at San Jacinto. Amateis designed the monument in his Washington, D.C., studio and completed it at his studio in Rome. J. F. Manning and Company of Washington, D.C., made the granite base from stone quarried near Concord, New Hampshire. Four months after its dedication, the monument survived the horrible Galveston hurricane of 1900, which claimed the lives of 6,000 residents. In 1987, the State Legislature established the Texas Heroes Monument Commission to raise funds for the restoration of the aging monument. When Victory was removed from her pedestal in 1990, workers discovered several cracks in the monument and only one of four original bolts still intact to secure her to her 50-foot-high perch. The restored monument was rededicated on Sunday, April 21, 1991.

Sidney Sherman. Photo by Robert Little.

Cecere, Gaetano

(b. 1894 American)

SIDNEY SHERMAN *1936*

Portraiture; larger than life-size; bronze
Location: 7th Street and Broadway
Funding: $14,000 allocated by the 1936 Commission of Control for Texas Centennial Celebrations
Comments: Behind the statue, a 17-ton monolithic die is decorated with an intaglio design of General Sherman mounted on his horse with his saber raised—as he entered the Battle of San Jacinto. This intaglio and another on the opposite side were designed and executed by Pierre Bourdelle. Sidney Sherman was a successful businessman in Newport, Kentucky, when colonists in the province of Texas began their struggle for independence. Sherman was among the first to respond to the call

for volunteers to fight for Texas, and in 1835, he sold his business and used the money to equip a company of 52 volunteers for the Texas Revolution. Before he boarded a steamer in Cincinnati to sail south, the women of Newport, Kentucky, presented him with a blue and gold banner with the motto "Liberty or Death." Sherman and his men carried this flag at San Jacinto; today it hangs in the House of Representatives Chamber at the Texas State Capitol.

Coppini, Pompeo

(1870–1957 American/Italian)*

WOODMEN OF THE WORLD *1904*

Portraiture; 8' H; bronze
Location: Lakeview Cemetery, 3015 57th Street
Funding: Order of Woodmen of the World and public donations in memory of the Woodmen who died in the great hurricane of 1900
Comments: General Joseph Cullen

231

Root, founder of the Order of
Woodmen of the World, posed for this
statue, which also was erected in
Memphis, Tennessee.

Moore, David

(b. 1921 Native Texan)*

THE DOLPHINS *1975*

Figurative; 6' H; bronze cast at
Al Shakis Art Foundry in Houston
Location: Fort Crockett Seawall Park,
between 46th and 47th streets
Funding: Donated to the city by a
private donor and by Galveston
Foundation, Inc.

THE FLOWER *1980*

Figurative; 3'2" H; bronze
Location: Trinity Episcopal Church,
2216 Ball Avenue, facing 21st Street
Funding: Commissioned by the vestry
in memory of the Reverend Edmund
H. Gibson, longtime rector of the
church and a strong supporter of the
Trinity Episcopal School
Comments: The artist chose this
design because the Reverend Mr.
Gibson avidly engaged in cultivating
and hybridizing hibiscus.

HERON *1979*

Figurative; 3'7" × 5$^1/_2$" × 1'; bronze
cast at Al Shakis Art Foundry in
Houston
Location: Ashton Villa,
2328 Broadway
Funding: Commissioned by the
Galveston Historical Foundation
Comments: Ashton Villa is a restored
historical home and museum owned
by the Galveston Historical Founda-
tion. During restoration of the home,
the original cast-iron fish pond,
which had been missing for many
years, was located at a church rectory
in New Orleans and returned to
Galveston. Mr. and Mrs. John W.
Harris provided funds for the restora-

The Flower. Photo by Robert Little.

Heron. Photo courtesy David Moore.

tion of the fish pond, and the histori-
cal foundation commissioned Moore
to make this sculpture based on
descriptions of the pond's original
centerpiece.

Muhich, Mark

(b. 1950 American)*

ANGEL OF IMAGINATION 1985

Abstract; 9' H; sheet steel painted in brilliant colors
Location: Rosenberg Library at Sealy Street and 23rd Street
Funding: Rosenberg Library through contributions specifically designated for this acquisition
Comments: This colorful, mythical creature symbolizes the whimsy and brilliance of the imagination.

Angel of Imagination. Photo by Robert Little.

Parks, Charles Cropper

(b. 1922 American)

HIGH TIDE 1985

Figurative; 16'6"; bronze cast at Laran Bronze Foundry in Chester, Pennsylvania
Location: Pier 21 at Strand Harborside
Funding: Owned by GPM, Inc.
Comments: The sculpture of Charles Parks spans the globe from Stockholm to San Francisco. His creations reflect the artist's interest in the inherent beauty of growing things, which he emphasizes in his portraitures, liturgical figures, and animal sculptures created in his studio in his hometown of Wilmington, Delaware. Parks is an academician at the National Academy of Design in New York City and a past president of the National

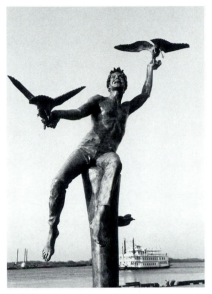

High Tide. Photo courtesy The Woodlands Corporation.

Sculpture Society. He also serves as a trustee of South Carolina's Brookgreen Gardens, where five of his major works have been placed in the permanent collection.

Rhind, John Massey

(1860–1936 American/Scot)

GALVESTON DRINKING FOUNTAINS 1898

Figurative; 4 fountains ranging from 7' H to 13' H; gray granite
Location: 12th Street at Ball Avenue, 15th Street at Ball Avenue, 31st Street at Seawall, and 722 Moody Avenue
Funding: Henry Rosenberg
Comments: As a young man in Scotland, Rhind studied under his father, who was a sculptor and stonecutter. Rhind became an architect, and after coming to America in 1889, he maintained an office in New York and New Jersey. In 1898, Rhind designed seventeen drinking fountains for the city of Galveston. Henry Rosenberg's will

233

Galveston Drinking Fountains, located at 12th Street and Ball Avenue (top) and at 722 Moody Avenue (bottom). Photos by Mary Faye Barnes, courtesy Galveston County Historical Commission.

specified that his executors should provide no fewer than ten drinking fountains for man and beast. In all, Rosenberg's executors commissioned from Rhind five small and twelve large fountains, ranging from modest stone troughs to very large, ornately embellished bronze and granite designs. Until the 1980s, almost all were lost, but in recent years seven have been rediscovered. Four of the large fountains have been restored, except for the bronze ornamentation, which was donated by the city to the U.S. Army during World War II to be melted down for ordnance.

Williams, Arthur

(b. 1942 American)

BIRTH IV *1987*

Abstract; 8'6" × 19' × 9'2"; welded steel and pressed steel
Location: University of Texas Medical Branch at Galveston, 10th Street at Market
Funding: University of Texas Medical Branch at Galveston
Comments: Williams is the author of *Sculpture: Technique, Form, Content,* a 304-page sculpture textbook published by Davis Publications of Worcester, Massachusetts, in 1989. One other sculpture at the university is a bust by an unknown artist of Ashbel Smith, founder of the University of Texas Medical Branch at Galveston.

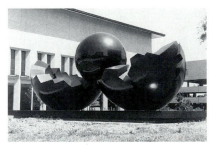

Birth IV. Photo by Arthur Williams, courtesy the University of Texas Medical Branch at Galveston.

234

Georgetown

Aarnos, Seppo

(b. 1937 American/Finnish)*

BONDED HELIX *1986*

Abstract; 10' H; Cor-ten steel
Location: 4915 Interstate 35 South
Funding: Rogers Construction
Company
Comments: After immigrating to the
United States at the age of sixteen,
Seppo Aarnos lived in Illinois before
moving to Texas in 1982. Working as
an art teacher since 1962, he fre-
quently has contributed his talent to
assist projects and organizations that
benefit young people. Aarnos lives in
Fort Worth.

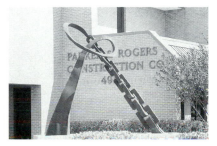

Bonded Helix. Photo by Robert Little.

Dahlberg, H. Clay

(American)*

HENRY C. MATYSEK *1975*

Portrait bust; larger than life-size;
bronze
Location: Williamson County
Courthouse grounds
Funding: Kiwanis Club of
Georgetown
Comments: Matysek served as sheriff
of Williamson County.

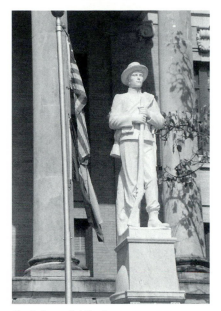

Confederate Soldier Statue. Photo by Robert Little.

McNeel Marble Company

(American)

CONFEDERATE SOLDIER STATUE
1916

Figurative; larger than life-size;
marble
Location: Williamson County
Courthouse grounds
Funding: Williamson County
Chapter, United Daughters of the
Confederacy
Comments: The McNeel (often
misspelled McNeil) Marble Company
of Marietta, Georgia, placed monu-
ments and cemetery memorials
throughout the South for almost 75
years. Brothers Morgan and R. M.
McNeel of Marietta organized the
company in 1891; by 1912, they
advertised as "the largest monumen-
tal plant in the South" (*Confederate
Veteran*, December 1912, 592). The
same advertisement exhorted
patriotic Southerners, "Don't delay
starting the movement, because the

heroes of the sixties are fast leaving us, and every year's delay denies many of them seeing the memorial." The McNeels expanded their services through branch offices in several other cities and continued operations until 1965, when the company was liquidated by Morgan McNeel, Jr.

Umlauf, Charles

(1911–1994 American)*

MOTHER AND CHILD *1952*

Figurative; 6' H; cast stone
Location: Southwestern University campus, Lois Perkins Chapel grounds
Funding: Donated by Mr. and Mrs. Herman Brown of Houston

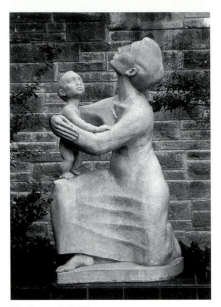

Mother and Child. Photo by Robert Little.

Glen Rose

Jonas, Louis Paul

(b. 1894 American)

TYRANNOSAURUS REX and APATOSAURUS *1964*

Figurative; 2 figures, each 60' L × 20' W; fiberglass on a steel frame
Location: Dinosaur Valley State Park, Farm Road 205, 4 miles west of Glen Rose
Funding: Donated to the park by Sinclair Oil Corporation in 1970 after

Tyrannosaurus Rex and *Apatosaurus.*
Photo courtesy *Texas Highways Magazine.*

its merger with Atlantic Richfield
Comments: From 1930 to 1969, the dinosaur was the trademark for Sinclair Oil products. When Sinclair merged with Atlantic Richfield, the logo was discontinued. These two specimens were made for the 1964 New York World's Fair by the well-known wildlife sculptor Louis Paul Jonas, with assistance from Yale University and the American Museum of Natural History. For his models, the artist created small versions of the extinct creatures. Then he made a transparency of the small models and projected the image to life-size proportion on wallboard. The dinosaurs are formed with clay, wire, burlap, and plaster under the fiberglass coating.

Goldthwaite

Unknown Artist

CONFEDERATE MEMORIAL MONUMENT *1915*

Figurative; life-size; marble
Location: Mills County Courthouse grounds
Funding: Public donations, the Self Culture Club, and Jeff Davis Camp 117, United Confederate Veterans
Comments: The Self Culture Club was a civic club for women.

Goliad

Guerra, Don Joaquín Gutiérrez, and Agustín Guerra

(Mexican)

GENERAL IGNACIO SEGUIN ZARAGOZA *1980*

Portraiture; 10' H; bronze

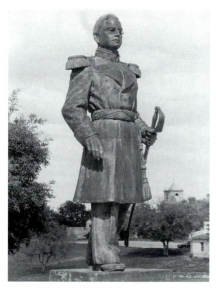

General Ignacio Seguín Zaragoza.
Photo by Robert Little.

Location: Adjacent to Presidio la Bahía, 1.5 miles south of Goliad on U.S. 183
Funding: Presented to the state of Texas by Governor Toxqui Fernández de Lara on behalf of the people of the state of Puebla, Mexico
Comments: General Ignacio Seguín Zaragoza was born at Presidio la Bahía in the state of Coahuila and Texas on March 24, 1829, while his father served as a Mexican officer at the presidio. After the Texas Revolution, Zaragoza moved with his parents to Matamoros and later to Monterrey, where he became involved in the effort to create a democratic government in Mexico. After the Spanish and English withdrew from Mexico in early 1862, Zaragoza and his Mexican troops defeated the French army of intervention at Puebla, Mexico, on May 5, 1862. The Mexican victory is celebrated annually as Cinco de Mayo. Memorial masses are held on May 5 each year in the amphitheater adjacent to the general's statue. The openwork, painted steel sculpture installed on the stage of the amphitheater is the work of Joe de Los Santos.

Josset, Raoul

(1898–1957 American/French)*

JAMES WALKER FANNIN'S MEN *1939*

Figurative; 45' H; pink Marble Falls granite
Location: Adjacent to Presidio la Bahía, 1.5 miles south of Goliad on U.S. 183
Funding: $25,000 allocated by the 1936 Commission of Control for Texas Centennial Celebrations
Comments: A few yards outside the walls of Presidio la Bahía is the cenotaph memorial for James Walker Fannin and 352 men under his

command who were murdered while prisoners of the Mexican army. The Goliad Massacre represents the largest single loss of life in the cause of Texas independence, and it inspired the battle cry "Remember Goliad" at the Battle of San Jacinto. On Palm Sunday, March 27, 1836, the prisoners who were able to walk were divided into groups and marched in three directions out from the presidio. At a prearranged signal, Mexican guards simultaneously opened fire on the groups at close range. Fannin and other wounded soldiers were shot inside the presidio courtyard. Approximately 20 people escaped the massacre. The victims' bodies were burned and their remains left unattended until June 3, 1836, when General Thomas Jefferson Rusk and troops of the Texas army gathered and buried them in a common grave. The names of those who died are carved on sixteen grave slabs divided by two monolithic shafts, which rise to a height of 30 feet. A portion of the inscription reads, "Beneath this monument repose their charred remains. Remember Goliad." The Lady of Loreto statue installed in an alcove above the entrance to Presidio la Bahía is the work of Texas artist Lincoln Borglum.

James Walker Fannin's Men. Photo by Robert Little.

Stolz, Gustave

(American/German)*

FANNIN MEMORIAL *1885*

Obelisk; 30' H; marble
Location: Fannin Square at the corner of Market and Franklin
Funding: "Erected in memory of J. W. Fannin and his comrades in Arms" by local citizens
Comments: This is one of the few public monuments erected by early Texas stonecutters before the turn of the century. Gustave Stolz immigrated to Texas from Germany in the

Fannin Memorial. Photo by Robert Little.

1870s and settled in Victoria, where he established Victoria Marble Works, the company name engraved on the *Fannin Memorial.* Although the company is no longer in existence, several descendants of the Stolz family still live in the area. Otto Emil Stolz, Gustave's cousin, established Stolz Marble Works at La Grange in 1895 and Premier Granite Quarries Company in Llano in the 1920s. His grandson currently owns L. W. Stolz, Jr., Memorials in La Grange.

Gonzales

Coppini, Pompeo

(1870–1957 American/Italian)*

COME AND TAKE IT *1910*

Figurative; larger than life-size; bronze
Location: Texas Heroes Park, 400 Saint Joseph Street
Funding: State of Texas
Comments: Often referred to as "The Texas Minuteman," this statue depicts a strong young Texian defiantly marching toward the Mexican army on October 2, 1835, the date enshrined in history as "the Lexington of Texas." When the tiny hamlet of Gonzales learned that Mexican forces were approaching to confiscate a small cannon, the townspeople called out to their neighbors for help. The ragtag army that assembled was composed of citizen soldiers dressed in homespun work clothes and buckskins. Their banner was made by the ladies of Gonzales—a flag that pictured the cannon, a lone star, and the words "Come and Take It." The plaque reads, "In grateful memory of those heroes who made this spot historic as the birthplace of Texas Independence." A few blocks from downtown Gonzales, at the entrance to the

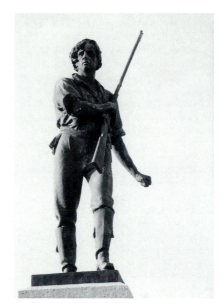

Come and Take It. Photo by Robert Little.

Gonzales Museum in the 1100 block of Memorial Street, is the *Defenders of the Alamo Memorial.* The 1936 Commission of Control for Texas Centennial Celebrations commissioned this bronze relief mounted on a pink Texas granite shaft from Raoul Josset. The inscription lists the 36 Gonzales men who died at the Alamo and the 2 survivors, Suzanna A. Wilkinson Dickenson (Mrs. Almaron) and her baby.

Teich, Frank

(1856–1939 American/German)*

CONFEDERATE SOLDIER STATUE *1909*

Figurative; 8' H; life-size; Carrara marble
Location: Confederate Heroes Square, downtown
Funding: Gonzales Chapter 545, United Daughters of the Confederacy
Comments: Teich contracted to provide this statue and granite shaft for $3,200, which was raised over a

239

period of three years. Major George W. Littlefield of Austin contributed $100 toward the cause. According to the local newspaper, 4,000 to 5,000 people gathered for the unveiling: "At an early hour Wednesday morning, the highways and thoroughfares were lined with people coming into town in buggies, carriages, wagons, and on horseback. Incoming excursion trains were loaded to the guards. . . . There was a ball game between Yoakum and Lockhart after the program, and that night the Firemen had a big ball at the Gonzales Opera House, which made a grand finale to the day's program. The Shiner band furnished the music to a large crowd. There was a storm that night and the lights went out, but they improvised crude lights and the dance went merrily on until an early hour next morning, and the day went out in a blaze of glory with our hearts full of love for country, home, and patriotism" (*Gonzales Inquirer*, July 22, 1909).

Granbury

Youngblood Monument Company

(American)*

GENERAL HIRAM B. GRANBERRY
1913

Portraiture; life-size; granite
Location: Hood County Courthouse grounds
Funding: 33rd Texas Legislature, United Daughters of the Confederacy General Granberry Chapter 683, and local donations
Comments: General Granberry, a native of Georgia, served during the Civil War under the command of John Bell Hood and died in the Battle of Franklin in 1864. In 1893, his body was brought from its burial site in Tennessee and reinterred in the

Granbury Cemetery on a mesa overlooking the Hood County seat. Though spelled differently, the town of Granbury was named in honor of General Granberry. Jim Youngblood, owner of Youngblood Monument Company in Waxahachie, built the pedestal and ordered the statue from Italy.

Grand Prairie

Moroles, Jesús Bautista

(b. 1950 Native Texan)*

INTERLOCKING *1986*

Abstract; 10' × 5' × 5'; Dakota granite
Location: 1901 Texas 360
Funding: National Health Insurance Company

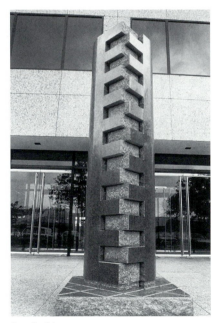

Interlocking. Photo by Dixie Christian, courtesy Jesús Bautista Moroles.

Greenville

Morgan, Barbara Harris

(Native Texan)*

TWO PART INVENTION *1979*

Abstract; 12' H; unfinished steel
Location: 4500 Wesley
Funding: Originally placed on-site by
First Federal Savings and Loan
Comments: Composed of two pieces
of $^5/_{16}$-inch steel, this work is
intended as a visual representation of
the artist's musical and sculpting
background.

North Texas Marble and Granite Works

CONFEDERATE SOLDIER STATUE
1926

Figurative; 6' H; granite
Location: Greenville Intermediate
School, 3201 Stanford
Funding: Greenville Chapter 1236,
United Daughters of the Confederacy
Comments: North Texas Marble and
Granite Works was a local monument
company located at 1904 Lee Street.
The Article of Agreement, signed by
the chapter officers, says the monu-
ment was built according to a
drawing submitted by the women of
the UDC. The monument is made of
blue granite from Winnsboro, South
Carolina; the statue, which likely was
ordered through a catalogue, is white
Victor granite. The monument was
dedicated on January 5, 1926.

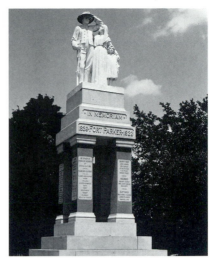

Fort Parker Memorial. Photo courtesy
Texas Highways Magazine.

Groesbeck

Viquesney, E. M.

(1876–1946 American)

**SPIRIT OF THE AMERICAN
DOUGHBOY** *1929*

Figurative; life-size; bronze
Location: Limestone County
Courthouse grounds
Funding: Sim B. Ashburn American
Legion Post 88

Weldert, Roy, and W. H. Dietz

(Americans)*

FORT PARKER MEMORIAL *1932*

Figurative; 3 life-size figures and
20' H monument; Italian marble and
gray Texas granite
Location: Fort Parker Memorial Park
Cemetery, Farm Road 1245, 1.9 miles
west of Texas 14
Funding: Local citizens and matching
funds appropriated by the 37th and
42nd Texas Legislatures

241

Comments: Weldert and Dietz operated a monument company in Waco. Competing with monument contractors from as far away as Maryland and New York, the Waco firm won the commission and began construction on the base portion of the monument on June 1, 1922. The monument's inscription reads in part, "Fort Parker, established by Illinois colonists in 1833—Three years later, at 8 o-clock a.m., as the dew drops glistened in the sun rays, it fell by the hand of the Comanches." In 1932, local citizens hired Weldert and Dietz to order three life-size figures for placement on the ten-year-old base. Senator William R. Poage reported to the Texas Senate in August 1932, "The statue represents pioneer, [Benjamin] Parker, as he was leaving the Fort to treat with the Indians, and also his wife and daughter, as they tried to persuade him not to expose himself by going outside the Fort. The statue is wrought of the finest marble, and executed in Italy by the best sculptors in that land of artists" (Texas Senate 1932). The *Fort Parker Memorial* commemorates the May 19, 1836, attack by Comanche Indians on Fort Parker in Limestone County. Among the settlers taken captive was nine-year-old Cynthia Ann Parker, who was born in Illinois in 1827 and brought to Texas by her parents at the age of six. After her capture by the Indians, Cynthia Ann became part of the Pahuka band of Comanches, whose customs, manners, and language she gradually adopted. Twenty-four years after her capture, Captain Sul Ross and a group of Texas Rangers rescued Cynthia Ann, but by that time she had become Naduah, wife of Chief Peta Nocona and the mother of his three children. Unable to readjust to Anglo society, Cynthia Ann died in 1864 at the age of 37, six months after the death of her small daughter, Prairie Flower, who came with her mother into the white man's culture. Cynthia Ann's son was the famous Comanche chief Quanah Parker.

Groom

Thomas, Steve

(American)*

CROSS OF THE PLAINS *1995*

Figurative; 190' H; steel
Location: Interstate 40, east of Amarillo
Funding: Steve Thomas and private donations
Comments: Steve Thomas, a structural engineer, provided the design and most of the financing for this, the tallest cross in the Western Hemisphere. Fourteen tractor-trailer rigs hauled the huge steel skeleton to the ten-acre site, which was donated by Chris Britten of Amarillo. After workers covered the armature with thin sheets of steel, large cranes tacked the three sections of the cross into place and secured them with twelve steel pins that weigh 300 pounds each. Thomas hopes that the site soon will included a chapel and twenty-eight life-size bronze statues depicting the Twelve Stations of the Cross. Supporters of this project wanted to provide a different type of roadside attraction along Interstate 40, which tracks the famous Route 66 and carries approximately 10 million travelers into and out of Amarillo each year.

Harlingen

Haynesville

Heath

Helotes

Henderson

Hico

Hidalgo

Hillsboro

Houston

Hunt

Huntsville

Hutto

Harlingen

De Weldon, Felix W.

(b. 1907 American/Austrian)

**IWO JIMA WAR MEMORIAL
ORIGINAL WORKING MODEL**
1954

Figurative; larger than life-size;
plaster, concrete, and black Brazilian
granite
Location: Marine Military Academy,
320 Iwo Jima Boulevard
Funding: Donated to the Marine
Military Academy in 1981 by Dr.
Felix de Weldon. Costs for developing
the memorial site were provided
entirely by donations.
Comments: While serving in the
Navy during World War II, Dr. de
Weldon was deeply touched by Joe
Rosenthal's Pulitzer prizewinning
photograph of U.S. Marines and a
Navy hospital corpsman raising the
American flag at Mount Suribachi.
De Weldon modeled the scene into a
small sculpture that became the
symbol for the seventh and final war-
bond drive. Nine years after the war,

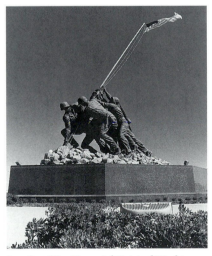

*Iwo Jima War Memorial Original Working
Model.* P.A.O. photo courtesy Marine Military Academy,
Harlingen.

he completed this working model
based on the earlier work. Only three
men in the original scene survived
the war. Each posed for this model,
and de Weldon used pictures and
physical statistics to design the
figures of the two men who died in
later phases of the Battle of Iwo Jima.
Texans played a prominent role in
this famous event. The man placing
the flagpole into the ground was
Harlon H. Block of Weslaco. He was
killed in action. Texan C. B. Gath-
wright, a Seabee from the Lower Rio
Grande Valley, fabricated the actual
flagpole used by the soldiers out of
confiscated Japanese water pipe.
Words from Fredericksburg native
Admiral Chester Nimitz inspired the
inscription on the base of the
monument. Referring to the bravery
of the American soldiers at Iwo Jima,
Admiral Nimitz said, "Uncommon
valor was a common virtue." The
model is maintained by contributions
to the perpetual-care fund through
the Marine Military Academy and is
dedicated to all Marines who have
given their lives in the defense of the
United States since 1775.

Haynesville

Flusche, Eugene

(Native Texan)*

MOUNT CARMEL CROSS *1984*

Figurative; 40' H; metal and acrylic
Location: Intersection of Texas 25
and Texas 240
Funding: Eugene Flusche
Comments: Towering above the
farmland near the Oklahoma border
is this illuminated cross marking the
site of the old Mount Carmel church
and cemetery. In 1907 a small group
of German immigrants founded the
Mount Carmel parish and built a
small church that was finally razed in

1964. Flusche, with the help of some friends, built this 40-foot monument in the isolated area approximately 30 miles northwest of Wichita Falls to commemorate the founders of the parish, some of whom are buried in the shadow of the cross. An automatic timer turns off the lighting system at midnight.

Heath

Clayton, Harold

(b. 1954 Native Texan)*

BUFFALO *1989*

Figurative; 9' H; Texas limestone
Location: Entrance to Buffalo Creek Country Club and Estates on Country Club Drive off Farm Road 740
Funding: Whittele Development

Helotes

Umlauf, Charles

(1911–1994 American)*

CRUCIFIXION *1965*

Figurative; larger than life-size; bronze cast in Pietrasanta, Italy
Location: Generalate of the Sisters of Divine Providence, entrance to the grounds
Funding: Donated by Mr. and Mrs. Victor Motl

Henderson

Keck, Charles

(1875–1951 American)

THOMAS JEFFERSON RUSK *1936*

Portraiture; 10' H; bronze

Crucifixion. Photo courtesy Sisters of Divine Providence.

Location: Rusk County Courthouse grounds
Funding: $14,000 allocated by the 1936 Commission of Control for Texas Centennial Celebrations
Comments: Rusk served as secretary of war and chief justice of the Republic of Texas. He signed the Texas Declaration of Independence, presided over the Constitutional Convention of 1845, and served as a United States senator.

Hico

Rice, James

(American)*

BILLY THE KID *1993*

Figurative; larger than life-size; fiberglass
Location: 2nd and Pecan Street
Funding: Private funding

Hidalgo

La Torre, Salvadore de

(Mexican)

MIGUEL HIDALGO Y COSTILLA
1976

Figurative; life-size; bronze
Location: 5th Street at Esperanza
Funding: Private donations, owned by
the city
Comments: See the Edinburg listing
for a biographical sketch of Father
Hidalgo.

Vettrus, Jerome

(American)*

WORLD'S LARGEST KILLER BEE
1992

Figurative; 8' × 8' × 8'; fiberglass over
steel, fabricated at Fabricators of
Animal Sculptures and Trademark
Corporation (FAST) of Sparta,
Wisconsin
Location: Hidalgo Municipal Build-
ing, 300 East Esperanza
Funding: Commissioned by Hidalgo
Economic Development Department
Comments: The city's mascot is
installed on a portable base that allows
it to be present at special events.

Hillsboro

Park, Alex

(American)*

A CONFEDERATE SOLDIER *1925*

Figurative; 6'6" H; Georgia granite
Location: Hill County Courthouse
grounds
Funding: Hill County Camp 966,
Sons of Confederate Veterans, and
public donations in memory of the
soldiers of the Southern Confederacy
Comments: Alex Park was manager

A Confederate Soldier in front of the Hill
County Courthouse after a fire on New Year's
Day 1993 almost destroyed the building.
Photo by Robert Little.

of Hillsboro Monument Works when
he won the contract to build this
memorial for $5,000, although several
larger firms competed for the job.
According to the *Hillsboro Mirror* of
July 8, 1925, the Confederate private
and the pedestal are both "made of
Stone Mountain, Georgia, granite
selected for patriotic reasons from the
opposite side of the mountain on
which the great southern memorial is
now being carved."

Umlauf, Charles

(1911–1994 American)*

KNEELING CHRIST *1971*

Figurative; 3'9" × 3'2" × 2'2"; bronze
Location: First Presbyterian Church,
Old Brandon Highway off Interstate
35, between the Education Building
and the sanctuary
Funding: Donated in honor of Christ
and to the glory of God by a family
whose members have belonged to the
congregation for many years
Comments: See pp. 79 and 436 for
photographs of other castings of this
work.

Houston

Adickes, David

(b. 1927 Native Texan)*

VIRTUOSO *1983*

Figurative; 36' H, 21 tons; steel and
concrete
Location: Lyric Centre,
440 Louisiana Street
Funding: Owned and restored by
Lyric Centre Enterprises, Inc., part of
the Enav Group of Companies
Comments: Adickes' stylized string
trio is equipped with an integrated
sound system. The giant cellist and
his accompanists continuously
serenade downtown Houston.

Amateis, Louis

(1855–1913 American/Italian)

SPIRIT OF THE CONFEDERACY
1908

Figurative; 12' H; bronze cast at
Roman Bronze Works in New York

Virtuoso. Photo by Robert Little.

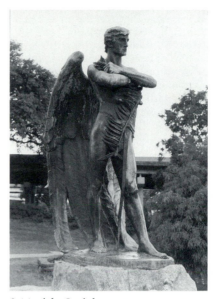

Spirit of the Confederacy. Photo by Robert Little.

Location: Sam Houston Park,
1100 Bagby
Funding: Robert E. Lee Chapter 186,
United Daughters of the Confederacy,
and public donations; owned by the
city of Houston
Comments: The UDC commissioned
Amateis to create a monument that
would commemorate the spirit of the
Confederacy and honor all Confeder-
ate soldiers. Instead of portraying a
defeated or defiant warrior, the
Yankee sculptor, working in his
Washington, D.C., studio, created
this angelic symbol of courage and
resignation; it represents the spirit of
the Old South. Nearly 5,000 people
assembled for the dedication cer-
emony on a sunny afternoon in
January 1908. The unveiling was
typical of patriotic gatherings, except
for a spontaneous event observed and
recorded by a local news reporter:
"An interesting feature of the
occasion was the singing of 'America'
by a chorus of school children, under
the direction of Miss Bessie Hughes.
The children were assembled around
the monument and as the childish

247

voices rang out upon the air, the great throng joined in the singing, and the park was made to resound with the strains of America's greatest hymn in fitting attestation that the spirit of national patriotic fervor has been deeply implanted in the hearts of Americans everywhere" (*Houston Chronicle*, January 20, 1908).

Angel, John

(1881–1960 British)

FOUNDER'S MEMORIAL *1930*

Portraiture; larger than life-size; bronze
Location: Rice University campus Quadrangle
Funding: Rice University Board of Trustees
Comments: The seated figure of William Marsh Rice, founder of Rice University, is mounted on a pink Texas granite monument in which his ashes are entombed. Drawings

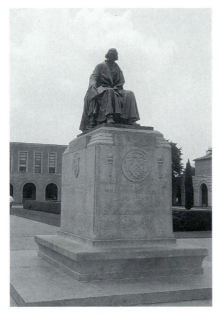

Founder's Memorial. Photo by Thomas LaVergne, courtesy Rice University.

and specifications for the pedestal were prepared by the architectural firm of Cram and Ferguson of New York City. For the portrait statue, Ralph Adams Cram recommended John Angel, who opened a studio in New York City during the 1920s to work on decorative sculpture for the Cathedral of Saint John the Divine. As a consulting architect on the cathedral, Cram was familiar with Angel's work. The memorial depicts Rice holding an open book and a bronze scroll bearing a reproduction of the original master plan for the campus.

Baker, Jay

(American)

LIGHT SPIKES *1990*

Figurative; 8 pieces, each 24' H × 4' square; aluminum, clear acrylic, translucent vinyl, and fluorescent lighting
Location: Houston Intercontinental Airport, between the roads that access Terminal C, near the Mickey Leland International Airlines Building
Funding: Donations from Houston's construction industry and a grant from the Economic Summit Committee; owned by the city of Houston
Comments: Baker designed *Light Spikes* for the 1990 Economic Summit of Industrialized Nations. Originally placed across the street from the site of the summit at the George R. Brown Convention Center, the installation later was permanently installed at the airport. Each spike is clad with the flag design of the member nations: France, Japan, Italy, Canada, Germany, the United Kingdom, and the United States; the eighth spike represents the European community.

Light Spikes. Photo courtesy Kristina Ceppi, Department of Aviation, City of Houston.

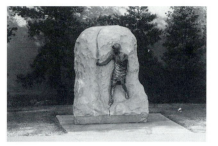

Peggy MacGregor Fountain. Photo by Robert Little.

Borglum, Gutzon

(1867–1941 American)*

PEGGY MACGREGOR FOUNTAIN
1927

Figurative; life-size; granite and bronze cast at the American Art Foundry in New York
Location: Peggy's Point, corner of Main and Richmond
Funding: Owned by the city of Houston
Comments: The fountain and pool portion of this work no longer exist; indeed, even the park it graced is now a busy thoroughfare. Only the inscription on the back records the work's original motivation and setting: "It was his wish and here in stone and bronze is builded a memorial. May it grace, perpetuate, and fulfill the conception of Henry Frederick MacGregor that in this park given and dedicated by him to the people of Houston and named for his wife, Elizabeth Stevens MacGregor, who he affectionately called Peggy, should be erected a fountain as a tribute to the inspiration of a devoted wife." The work is signed by Gutzon Borglum, who is remembered most for his presidential busts at Mount Rushmore.

Byrnes, Thomas H.

(American)*

THE FIREMAN'S MONUMENT
1889

Portraiture; life-size; white Carrara marble
Location: Glenwood Cemetery, 2525 Washington Street
Funding: Houston Fire Department and public donations; owned by the city of Houston
Comments: This standing figure in a fireman's uniform is the likeness of Robert Brewster, the oldest living fireman in Houston in 1888. The memorial was unveiled in Glenwood Cemetery on April 6, 1900, and relocated to Fire Station 1 at 410 Bagby in 1975. In 1993, local firemen and city officials returned the statue to its original site at Glenwood. The Houston Fire Department added the bronze plaque on the base of the monument in 1947 to commemorate the volunteer firemen who died when the French ship *Grand Camp* exploded at the Texas City docks. Thomas Byrnes designed the monument and ordered the statue according to his specifications from Italy. Byrnes is listed in the 1887–1888 *General Directory of the City of Houston* as a marble-works dealer and the proprietor of Houston Marble Works, providers of headstones, tombstones, and monuments, with offices at Texas and Travis streets.

249

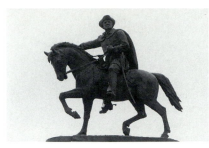

Sam Houston. Photo by Robert Little.

Cerracchio, Enrico Filberto

(1880–1956 American/Italian)*

SAM HOUSTON *1924*

Equestrian; larger than life-size;
bronze cast at Roman Bronze Works
in New York
Location: Hermann Park, Fannin and
Montrose
Funding: The Women's City Club
with state funding and public
donations; owned by the city of
Houston
Comments: This magnificent
equestrian statue is mounted on a
20-foot-high Texas limestone arch
made by Teich Monument Works in
Llano. Houston is depicted as he rode
toward San Jacinto, where he led
Texas troops in a successful surprise
attack on the Mexican army and won
independence for Texas. Cerracchio
became an American citizen in 1905
and made his home in Houston,
where he lived for 40 years, main-
taining a studio in Texas and in
New York.

Chin, Mel

(b. 1952 American)*

MANILA PALM: AN OASIS SECRET
1978

Figurative; 50' H; steel, rope,
and fiberglass
Location: Contemporary Arts
Museum, 5216 Montrose

Funding: Funds provided by Ann
Robinson of Robinson Galleries for
the 1978 Main Street Festival; placed
on loan to the museum in June 1978
Comments: A telescopic pole and
removable fronds form this playful
creation of a palm tree erupting from
a pyramid. According to the artist, "A
tree doesn't stand alone, so the idea of
the pyramid was born. We think of a
pyramid as a tomb, something dead,
and for a palm to burst forth from it,
well, it's kind of entertaining"
(*Houston Chronicle,* June 12, 1978).

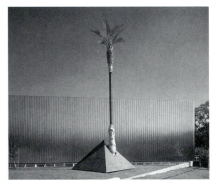

Manila Palm: An Oasis Secret. Photo by Rick
Gardner Photography, courtesy Contemporary Arts Museum.

Coe, Herring

(b. 1907 Native Texan)*

TWILIGHT WATCH *circa 1970*

Figurative; larger than life-size;
cast stone
Location: Villa de Matel Convent,
6510 Lawndale Avenue
Funding: Villa de Matel Home for
Retired Sisters
Comments: A native of Beaumont,
Coe studied electrical engineering at
South Park College (now Lamar
University). After working as an
engineer, he decided to make his
hobby of sculpture a full-time
occupation. As did William McVey,
Coe developed his skill in creating
architectural ornamentation at the
Pyramid Stone Company in Houston.

250

His career was put on hold while he served with the Seabees of the United States Navy during World War II. After the war, he returned to Beaumont, where he has continued to work as an artist for half a century. His architectural carvings include the 27 fossilized Texas limestone reliefs on Houston's old city hall, completed in 1939 with funds provided by the Federal Emergency Administration of Public Works. Among his many public monuments is a colossal memorial placed in 1960 at the Vicksburg National Cemetery to honor Texans who fought with valor in the Civil War.

Crovello, William

(American)

HAGOROMO *1974*

Abstract; 5'10" H; polished stainless steel
Location: Courtyard between 9 and 11 Greenway Plaza near the southwest corner of Edlow and Richmond Avenue
Funding: Commissioned by Century Development Corporation
Comments: The fluid, curving image of this open form represents the Japanese hagoromo, a magical garment worn by an angel in flight. According to legend, without the hagoromo, an angel cannot fly. Crovello is a native of New York now living in Spain and Belgium.

Di Suvero, Mark

(b. 1933 American)

PRANATH YAMA *1978*

Abstract; 15'6" × 18' × 6'4"; Cor-ten steel and stainless steel
Location: Texas Medical Center, McCollum Plaza at the Michael E. DeBakey Center for Biomedical Education and Research

Funding: Given to Baylor College of Medicine in May 1982 by the board of trustees in honor of Leonard F. McCollum
Comments: The title for this kinetic sculpture is taken from a Hindu expression, "pranath yama," which refers to the cycle of life and death.

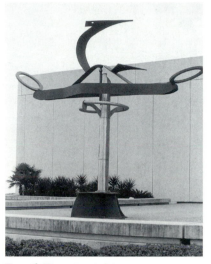

Pranath Yama. Photo by Robert Little.

Dubuffet, Jean

(1901–1985 French)

MONUMENT AU FANTOME *1969–1971*

Abstract; 7 figures, 33' H at the tallest point; fiberglass over stainless-steel armature
Location: 1100 Louisiana at Lamar
Funding: Purchased by the owners of 1100 Louisiana
Comments: Commissioned for 1100 Louisiana in 1983, these figures were fabricated in France at the atelier of Robert Haligon. Because of health problems, the 82-year-old artist, whose signature appears on the inner edge of the work, could not attend the dedication on Halloween, October 31, 1983. The abstracted shapes are

251

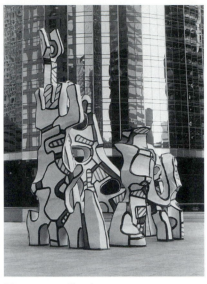

Monument au Fantôme. Photo by Robert Little.

painted bright red and blue with a stark white background and black outlining. *Monument au Fantôme* consists of seven entities: *L'Eglise* (Church), *L'Arbre* (Tree), *Le Mat* (Mast), *Le Fantôme* (Phantom), *Le Chien* (Dog), *Le Buisson* (Hedge), and *La Cheminée* (Chimney). Together they form an eerie, dreamlike village that is also fanciful and playful. *Monument au Fantôme* is part of the artist's *Hourloupe* series.

Edwards, Lonnie

(American)

GEORGE H. HERMANN MEMORIAL *1981*

Portraiture; larger than life-size; bronze
Location: Hermann Park, Fannin and Outer Belt
Funding: Hermann Hospital Estate; owned by the city of Houston
Comments: Tributes to George Hermann are engraved on each side of the large, granite base. The texts describe the man, his gift, his

concern, and his legacy. Hermann was a Houston businessman, humanitarian, and philanthropist.

Foley, Pat

(b. 1922 American)*

GIRL AND HOOP *1976–1977*

Figurative; 5' H; epoxy and bronze
Location: Kinkaid School campus, 201 Kinkaid Drive
Funding: Privately funded
Comments: As an artist-in-residence at the Kinkaid School, Pat Foley has placed several life-size works on the school grounds. His sculptures depict teachers and children learning and playing together.

PROMETHEUS UNBOUND *1972*

Figurative; 7' H; epoxy and bronze
Location: Texas Medical Center, TIRR (The Institute for Rehabilitation and Research), at Moursund and Lamar Fleming Avenue
Funding: Donated in honor of Dr. William A. Spencer, founder of TIRR,

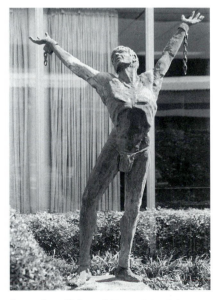

Prometheus Unbound. Photo by Robert Little.

by the hospital's volunteer auxiliary
Comments: This work inspires and
encourages thousands of physically
disabled citizens as they struggle to
free themselves from their disabilities
through medical rehabilitation at
TIRR.

SHRINER WITH CHILD *1986*

Figurative; 7' H; bronze
Location: Texas Medical Center,
Shriners Hospital for Crippled
Children
Funding: Donated by Richard L.
Bischoff, Andrew A. Schatle, and
W. D. "Bill" Pardue
Comments: Beneath this figure of a
Shriner holding a small girl and
carrying her crutches is the inscrip-
tion, "No man stands so tall as when
he stoops to help a crippled child."
When the new Shriners Hospital
for Crippled Children is complete,
this work will be reinstalled at
7000 Main Street.

WOMAN WITH BIRDS *1958*

Figurative; 12' H; epoxy and bronze
Location: Smith International
Drilling Systems, 16740 Hardy Street
Funding: Drilco Division of Smith
International

Fowler, Bob

(b. 1931 Native Texan)*

SHALOM *1988*

Abstract; 6'6" H; welded steel
Location: La Colombe d'Or Hotel,
3410 Montrose
Funding: Steven N. Zimmerman
Comments: Located in the small
sculpture garden at the entrance to
the hotel, *Shalom* is dedicated to
Sylvia and Herman Zimmerman on
the occasion of their fiftieth wedding
anniversary. A golden heart is placed
inside the figure.

UNTITLED PAIR OF HORSES *1963*

Figurative; smaller than life-size;
welded steel
Location: Jesse Jones Hall for the
Performing Arts, lower level,
700 Capitol Street at Louisiana
Funding: Cleburn Interests
Comments: Originally commissioned
by Luby's, Inc., these horses were
later donated to the city and rein-
stalled at Jones Hall.

UNTITLED *1970*

Abstract; 11' H; Cor-ten steel
Location: Gregory-Lincoln High
School campus, 1101 Taft Street
Funding: Given to the Houston
Independent School District by
Nina Cullinan

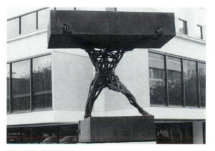

Untitled (1984). Photo by Robert Little.

UNTITLED *1984*

Abstract; 12' H; Cor-ten steel and
plate steel
Location: Texas Medical Center,
C. Frank Webber Plaza, 1100 M. D.
Anderson Boulevard at West Cullen
Funding: Donated to the Texas
Medical Center by Dr. and Mrs.
Richard S. Ruiz in memory of Dr.
Juan Jose Ruiz

Galea Brothers Marble Company

(Italian)

SAINT THOMAS *1956*

Figurative; life-size; white Italian
marble

253

Location: Saint Thomas High School, 4500 Memorial Drive
Funding: Donated to Saint Thomas High School by the Paul A. Mattingly family

Garbel, Camille

(French)

LA COLOMBE D'OR *1983*

Figurative; 6' wingspread; bronze
Location: La Colombe d'Or Hotel, 3410 Montrose
Funding: Steven N. Zimmerman
Comments: The artist's impression of a bird in flight is mounted on a 5-foot-high pole in front of the hotel.

La Colombe d'Or. Photo by Robert Little.

Ginnever, Charles

(b. 1931 American)*

PUEBLO BONITO *1977*

Abstract; 12' × 30' × 23'; Cor-ten steel
Location: Knox Triangle, Waugh Drive and Feagan Street
Funding: Donated to the city of Houston by the Robert W. Knox, Sr., and Pearl Wallis Knox Foundation
Comments: This large Cor-ten steel abstract provides an unexpected and graceful respite on a grassy knoll surrounded by city traffic and large office buildings.

Goodacre, Glenna

(b. 1939 Native Texan)

THE BLUEBIRDS *1988*

Figurative; life-size; bronze
Location: Methodist Hospital, 6565 Fannin, courtyard between Dunn Tower and the Fondren-Brown Building
Funding: Donated to the hospital by the Blue Bird Circle
Comments: The Blue Bird Circle is a charitable group supporting the study of childhood neurological disorders and patient care. *The Bluebirds* was placed by Altermann and Morris Galleries.

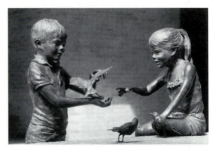

The Bluebirds (detail). Photo courtesy Methodist Hospital, Houston.

Goodnight, Veryl

(b. 1947 American)

TEAM ROPERS *1988*

Figurative; larger than life-size; bronze
Location: Astrodome Complex, north entrance to Astrohall
Funding: On long-term loan to the Houston Livestock Show and Rodeo
Comments: This work is a companion piece to *Yes* by Larry Ludtke. The two artists worked together on another Texas placement, *Arch 406* installed on the campus of Texas A&M University in College Station.

254

Artist Veryl Goodnight and *Team Ropers*.
Photo by R. Brooks, courtesy Veryl Goodnight.

Guelich, Bob

(b. 1945 American)*

FIRST LOOK *1984*

Figurative; 13' H × 18' L; bronze cast at Dell-Ray Bronze, Inc., in Houston
Location: Tower Park North, Interstate 45 and West Road
Funding: Commissioned by Finger Corporation, Houston, and owned by Aldine Independent School District
Comments: Nine Canadian geese, each weighing 250 to 300 pounds, are frozen in flight as they swoop down toward a small pond. Guelich is nationally recognized for his wildlife figures, particularly birds in flight; however, *First Look* was his first large-scale outdoor commission.

Guthrie, Trace

(b. 1950 Native Texan)*

MIGRATION *1981*

Figurative; 5 life-size figures; bronze
Location: 5599 San Felipe

First Look. Photo by Robert Little.

Funding: Owned by 5599 San Felipe, Ltd., and managed by Tanglewood Property Management Company
Comments: Five geese in flight add a sense of movement and freedom to this urban setting.

OLIVER TWIST *1974*

Figurative; 4'4" H; bronze cast at Al Shakis Art Foundry in Houston
Location: Hermann Park, entrance to Miller Outdoor Theatre
Funding: Owned by the city of Houston
Comments: This portrait, based on the writings of Charles Dickens, was Guthrie's first public commission.

Oliver Twist. Photo by Robert Little.

255

Artists Trace Guthrie (left) and Richard Fielden working on their clay model of *Prickly Pair of Texas Walkin' Boots*. Photo courtesy Trace Guthrie and Richard Fielden.

Guthrie, Trace, and

(b. 1950 Native Texan)*

Richard Fielden

(b.1940 Native Texan)*

PRICKLY PAIR OF TEXAS WALKIN' BOOTS *1995*

Figurative; 4'6" H × 4'8" W; bronze cast at Bob Wilson Art Foundry
Location: 1500 Post Oak Avenue
Funding: Harris County Improvement District 1

Hayes, Edd

(b. 1945 Native Texan)*

WILD AND FREE *1991*

Figurative; 6 larger-than-life figures; bronze cast at Land's End Sculpture Center in Paonia, Colorado

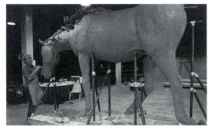

Edd Hayes working on clay model of one of the mares in *Wild and Free*. Photo by Carolyn Hayes.

Location: Astrodome Complex, Astroarena
Funding: Private donations through the Houston Livestock Show and Rodeo Association
Comments: In the fall of 1991, sculptor Edd Hayes set up a studio in the Astrodome Complex, where he converted an 18-by-56-inch maquette of *Wild and Free* into a monumental sculpture using a pointing-up process developed by Colorado artist Gerald Balciar. The sculpture depicts a stallion, three mares, and two colts traversing a natural rock foundation landscaped with native plants and grasses. Installed in two sections on the Fannin Street side of the Astroarena, the small herd is visible from Loop 610. Since Hayes began sculpting in 1981, his works have been placed in private, corporate, and museum collections around the world. His West Texas roots and his love of horses influence his work; however, his sculptures range from mermaid figures to portrait statues. His larger-than-life bronze of legendary cowboy Casey Tibbs is installed at the entrance to the Pro Rodeo Hall of Fame in Colorado Springs, Colorado.

Heizer, Michael

(b. 1944 American)

45 DEGREES, 90 DEGREES, 180 DEGREES *1984*

Abstract; 3 elements:
45 Degrees 21'6" × 18'x 22';
90 Degrees 23'6" × 12' × 18';
180 Degrees 8'6" × 18' × 20';
granite and concrete
Location: Rice University campus, Abercrombie Engineering Laboratory
Funding: Donated to Rice University in tribute to George and Alice Brown by their family

45 Degrees, 90 Degrees, 180 Degrees. Photo by Ivan Dalla Tana.

The Family of Man and a detail. Photos by Robert Little.

Hepworth, Barbara

(1903–1975 British)

THE FAMILY OF MAN 1970

Abstract; 9 figures, from 5'7" H to 9'10" H; bronze
Location: First City Tower, South Plaza, Fannin and Lamar
Funding: First City Bancorporation of Texas

Comments: The artist sculpted this series five years before her death. It has only two castings, this one and one other at the Hepworth Museum in Cornwall, England. Dame Hepworth named these simple images, representing the spiritual nature of human beings, Ancestor I and II, Parent I and II, Youth, Young Girl, Bridegroom, Bride, and Ultimate Form.

257

Huntington, Anna Hyatt

(1876–1973 American)

RED DEER *1929* and
RED DOE WITH FAWN *1934*

Figurative; 3 pieces, each life-size;
bronze
Location: Hermann Park,
1 Hermann Circle Drive
Funding: Donated by the artist in
1934 (*Red Deer*) and in 1937 (*Red Doe
with Fawn*) to the Museum of Fine
Arts, Houston; currently on loan from
the museum to the Houston Museum
of Natural Science
Comments: Huntington was one of
America's most popular and prolific
animal sculptors. She became
familiar with all forms of animal life
through her father, who was a
Harvard professor of paleontology,
and she studied art with at least two
famous American sculptors who have
works on public display in Texas,
Henry Kitson and Gutzon Borglum.

Janes, Kirtland, and Company

(American)

THE PILLOT DOGS *1860s*

Figurative; 2 figures, each 4'6" H;
cast iron
Location: Sam Houston Park,
1100 Bagby
Funding: Owned by the Harris
County Heritage Society
Comments: In the early 1870s, Mr.
and Mrs. Eugene Pillot purchased
these dogs for their 1868 Queen
Anne–style cottage at 1803
McKinney. Pillot was a Houston
entrepreneur who owned the
Tremont Opera House in Galveston
and served on the board of the
Houston Gas Company. Many years
later, Pillot descendants donated the
dogs to the River Oaks Garden Club,
which in turn gave them to the Harris
County Heritage Society for place-
ment at the restored Pillot House,
now located in Sam Houston Park.
Listed as No. 84 in the Janes,
Kirtland, and Company's 1870
Illustrated Catalogue, the dogs were
cast in Morrisania, New York, from
an original model made by a New
York sculptor identified in the
catalogue simply as "Richardson."
Janes, Kirtland, and Company was
located at Reade, Centre, and Elm
streets in New York City. In 1990,
after having been outdoors for more
than a century, the original dogs were
moved inside the Pillot House
because of damage caused by vandals.
New bronze dogs made from casts of
the original figures at Dell-Ray
Bronze, Inc., replaced the old
cast-iron canines.

Jimenez, Luis

(b. 1940 Native Texan)

VAQUERO *1977*

Equestrian; 16'6" × 24'9" × 5'6" plus
5' H base; molded fiberglass

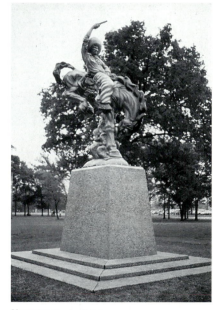

Vaquero. Courtesy Luis Jimenez.

Location: Moody Park, 3725 Fulton
Funding: National Endowment for
the Arts and the City of Houston
Comments: *Vaquero* is intended to
commemorate Mexican cattlemen
and horsemen, who were the first
Texas cowboys. The statue was
installed in Moody Park in 1981 as
part of an urban redevelopment
program that targeted the park and
the surrounding Hispanic neighbor-
hood. For several years after the
statue's installation, *Vaquero* was the
object of a bitter dispute among
Houston's Hispanic citizens. Many
accepted the sculpture as a proud
symbol of Hispanic heritage; others
saw it as a stereotypical image of a
gun-toting bandit. The latter group
finally was assuaged after meeting
with the artist, who came to Houston
to attend a community meeting and
answer questions about his work.
Also, the City of Houston agreed to
surround the sculpture with a small,
landscaped plaza instead of an open
field, thereby providing a more
appropriate setting for a major work
of art by one of the nation's leading
sculptors. Luis Jimenez is a native of
El Paso and a graduate of the Univer-
sity of Texas.

Kaposta, Eric Charles

(b. 1951 American)*

HARRIS COUNTY
WAR MEMORIAL *1985*

Figurative; larger than life-size;
bronze
Location: Bear Creek Park,
War Memorial Drive at Addicks-
Fairbanks Road
Funding: Herbert D. Dunlany
Veterans of Foreign Wars Post 581 in
cooperation with the American
Legion and Gold Star Mothers
Comments: The powerful American
eagle is perched beside a folded
bronze flag. On red granite walls to

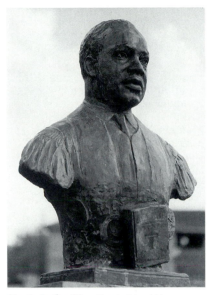

Martin Luther King. Photo by Robert Little.

the left and right of the sculpture are
the names of the county's veterans
and a plaque with the following
inscription by Bob Eckels: "This
monument dedicated May 27, 1985,
to honor those who lie silent that we
may enjoy in abundance the privi-
leges and responsibilities of freedom."

MARTIN LUTHER KING *1981*

Portrait bust; life-size; bronze
Location: Bricker Park, 4500 Brisco
Funding: Community development
funds through Art in Public Places
Program; owned by the city of
Houston

Lomax, Dan

(American)

HEART OF STEEL *1980*

Abstract; 18' H; Cor-ten steel
Location: 7500 San Felipe
Funding: The Russo Properties, Inc.

Love, Jim

(b. 1927 Native Texan)*

CALL ERNIE *1985*

Figurative; 10' × 19' × 29'; painted steel
Location: William P. Hobby Airport
Funding: Funded by Southwest
Airlines through the Houston
Municipal Art Commission and
donated to the city
Comments: Love constructed this
representation of an airplane from a
pump jack. It was designed
specifically for an airport setting.

PAUL BUNYAN BOUQUET NO. 2
1968

Figurative; 9'3" H; cast iron and
red brass pipe
Location: Rice University campus,
Lovett College Courtyard
Funding: Gift of the Brown
Foundation, Inc.
Comments: Discarded railroad
equipment is incorporated into a
bouquet of unusual flowers that
tower over the natural landscaping in
the courtyard garden.

PORTABLE TROJAN BEAR *1974*

Figurative; 7'6" × 11' × 5';
steel and wood
Location: Hermann Park
Funding: Cameron Iron Works,
Houston Chamber of Commerce, and
Houston Cultural Arts Committee;
owned by the city of Houston
Comments: A recurring figure in
Love's sculpture since the early 1970s
is the abstracted bear motif. Instead
of Greek warriors, this giant animal is
usually filled with laughing children.
The *Portable Trojan Bear* has a
humorous, touchable quality, unlike
some of Love's smaller bear figures,
which have a more poignant aspect.
In *A Century of Sculpture in Texas,
1889–1989,* Patricia D. Hendricks and
Becky Duval Reese observe, "When
we look at the sculpture of Jim Love,

Paul Bunyan Bouquet No. 2.
Photo by Thomas LaVergne, courtesy Rice University.

Portable Trojan Bear. Photo by Robert Little.

Yes. Photo by John McCaine Photography, Houston.

we see an artist coming to terms with the art of his time in the creation of distinct objects, which speak to us in a wry, soft-edged existentialist vocabulary" (Hendricks and Reese 1989, 95).

Ludtke, Lawrence M. "Larry"

(b. 1929 Native Texan)*

PIETA *1966*

Figurative; 3' × 4' × 2'6"; bronze
Location: Saint Mary's Seminary, 9845 Memorial Drive
Funding: Donated in memory of Monsignor Gilbert F. Pekar in 1974 by Howard Sampley
Comments: Ludtke's pietà is a mournful and touching portrayal of Mary and the crucified Christ. While well known for his poignant liturgical art, Ludtke is most famous for his portrait sculptures. His commissions include portraits of presidents Ronald Reagan and Lyndon Johnson, General Robinson Risner, Congressman Maury Maverick, former attorney general Robert Kennedy, Texas hero General Sam Houston, Martha Mitchell, and John Wayne. Ludtke pursued an early career in professional baseball, and he served in the United States Army during the Korean conflict. He maintains his studio and home in Houston.

YES *1994*

Figurative; larger than life-size; bronze
Location: Astrodome Complex, north entrance to Astrohall
Funding: Commissioned by the Houston Livestock Show and Rodeo Western Art Committee

Mascherini, Marcello

(b. 1906 Italian)

DANCER *1950*

Figurative; 8'6" H × 4'8" W; bronze

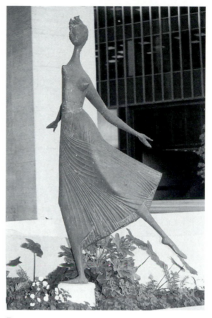

Dancer. Photo by Robert Little.

Location: Jesse Jones Hall for the Performing Arts entrance, 700 Capitol Street at Louisiana
Funding: Donated by Mr. and Mrs. Robert Straus to the city of Houston in 1955

McDonnell, Joseph Anthony

(b. 1936 American)

HORIZONTAL CUBES *1984*

Abstract; 5' × 9' × 4'; bronze
Location: 1800 West Loop South
Funding: Harlan Crow

McGuire, Frank

(American)

AXIS *1978*

Abstract; 15' × 50' × 20'; painted Cor-ten steel
Location: West End Multi-Service Center, 170 Heights Boulevard
Funding: Community development funds

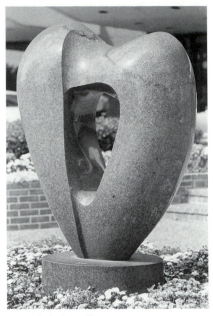

A Symbol of Excellence. Photo by Robert Little, courtesy the Texas Heart Institute.

McKinney, Theodore H.

(American)

A SYMBOL OF EXCELLENCE *1977*

Abstract; 5' × 4' × 2'; red Minnesota granite and black California granite
Location: Texas Heart Institute, 1101 Bates Avenue
Funding: Commissioned by the Denton A. Cooley Foundation
Comments: McKinney created this work in appreciation for heart surgery on his daughter and himself.

McKissack, Jeff

(1902–1980 American)*

THE ORANGE SHOW *1960*

Folk-art sculpture; varied sizes; mixed media
Location: 2401 Munger
Funding: Purchased and developed by Jeff McKissack

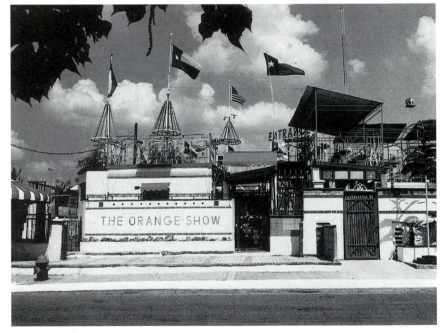

The Orange Show. Photo by Hickey and Robertson, Houston, courtesy The Orange Show Foundation.

Comments: This folk-art park displays diverse artistic endeavors contributed by numerous people and coordinated by McKissack for more than 25 years. Each exhibit celebrates the orange and good health. Since McKissack's death, his project has been continued through The Orange Show Foundation, a group of 21 citizens dedicated to preserving his work and establishing *The Orange Show* as an integral part of Houston's cultural landscape.

Mihailscu-Nasturel, Prince Monyo

(Rumanian)

WOMAN WITH A DOVE *1986*

Figurative; life-size; bronze
Location: Texas Medical Center, C. Frank Webber Plaza, 1100 M. D. Anderson Boulevard at West Cullen
Funding: Donated to the Texas Medical Center by Dr. Richard S. Ruiz, in honor of Luz Stranahan Ruiz

Milles, Carl

(1875–1955 Swedish)

THE SISTERS *n.d.*

Figurative; 2 figures, each 6' H; bronze
Location: Rice University campus, Mary Ellen Hale Lovett Memorial Garden
Funding: Gift of Joseph and Ida Kirkland Mullen and the Lovett children
Comments: Milles is known for his beautiful fountain figures. These two young girls almost disappear when the fountain's spray is at its full height.

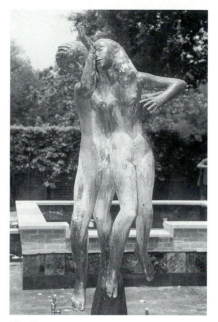

The Sisters. Photo by Thomas LaVergne, courtesy Rice University.

Miralda, Enrique

(Mexican)

FIGURAS *1982*

Abstract; 21' H; steel core with iron, concrete, and cement coating
Location: 602 Sawyer
Funding: Sawyer II Investors

Miró, Joan

(1893–1974 Spanish)

PERSONAGE AND BIRDS *1982*

Abstract; 55' H; bronze and stainless steel
Location: Texas Commerce Tower, Milam and Capitol
Funding: Gerald D. Hines Interests, Texas Commerce Bancshares, Inc., and United Energy Resources, Inc.
Comments: Brilliant hues of blue, yellow, red, and green are displayed on this abstract figure of a woman with three shapes above her head.

263

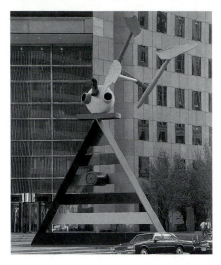

Personage and Birds. Photo by Robert Little.

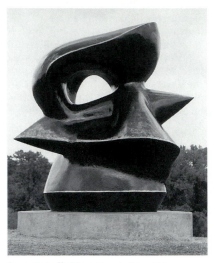

Large Spindle Piece. Photo by Robert Little.

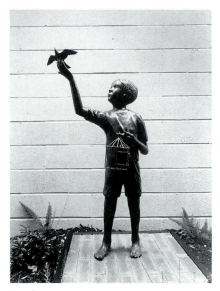

Freedom. Photo courtesy David Moore.

The triangular base is stainless steel; the figures are bronze. This work was enlarged from a maquette and fabricated over a period of six months at two foundries, the Modern Art Foundry in New York and Lippincott Foundry in Connecticut. I. M. Pei, architect for the Texas Commerce Tower, suggested a work by Miró for his new building. He chose *Personage* because of its humorous, colorful qualities.

Moore, David

(b. 1921 Native Texan)*

FREEDOM *1975*

Figurative; 3'6" H; bronze
Location: Saint Paul Presbyterian Church atrium, 7200 Bellaire Boulevard
Funding: Private donor

Moore, Henry

(1898–1986 British)

LARGE SPINDLE PIECE *1969*

Abstract; 11' H × 10'6" W; bronze cast at H. Noack Foundry in Berlin

Location: Allen Parkway, near Jeff Davis Hospital
Funding: Donated to the city of Houston by the Robert W. Knox, Sr., and Pearl Wallis Knox Foundation
Comments: One of six casts made, this work was intended for Tranquility Park downtown, but Moore objected to the location, so the site was changed to the open, natural setting in the parkway. According to Moore, "Sculpture needs daylight, sunlight. Nature seems to be its best setting. I would rather have my work on show in a landscape (immaterial which) than in any beautiful building I know" (Koepf 1966, 45).

Moroles, Jesús Bautista

(b. 1950 Native Texan)*

A MEETING PLAZA *1987*

Environmental; 3' × 16' × 16'; Texas granite
Location: Saint Thomas Presbyterian Church, 14100 Memorial Drive
Funding: Private donation to the church

HOUSTON POLICE OFFICERS MEMORIAL *1992*

Environmental sculpture; 22' × 120' × 120'; granite
Location: On Buffalo Bayou near the 1500 block Memorial Drive across from Glenwood Cemetery
Funding: A community effort funded

Houston Police Officers Memorial.
Photo courtesy Robert McClain & Co., Houston.

by local citizens and placed through Davis-McClain Gallery
Comments: This monument is dedicated to all officers of the Houston Police Department since its inception in 1841. Composed of terraced pyramid-shaped elements, landscaped areas, a fountain, and a waterfall, the memorial invites visitors to rest and reflect.

INNER COLUMN TOWERS *1984*

Abstract; 20' H; pink Texas granite
Location: 15600 JFK Boulevard at World Towers One
Funding: Commissioned by Riata Development Corporation and placed by Dixie Christian
Comments: The uncomplicated design of this granite column fits the requirements of the developer, who wanted a sculpture that could be comprehended by passing motorists and enjoyed by the general public.

VANISHING EDGE *1983*

Abstract; 7'4" × 1'6" × 10"; Texas granite
Location: Decorative Center of Houston, 5120 Woodway
Funding: Harlan Crow

Mott, J. L., Iron Works

(American)

SCANLAN FOUNTAIN *1880–1885*

Figurative; 10' H; stone
Location: Sam Houston Park, 1100 Bagby
Funding: Purchased by Timothy Thomas J. Scanlan for his home; donated to the city by Scanlan descendants for placement at Sam Houston Park, where it was dedicated in 1972
Comments: J. L. Mott Iron Works was established in 1828 by Jordan Lawrence Mott, a prolific inventor in whose name more than fifty patents

Scanlan Fountain. Photo by Robert Little.

are recorded. Originally operating out of Morrisania, which became a borough of New York City in 1898, the Mott foundry was one of the largest of its kind in the nation. Manufacturing metal goods ranging from decorative staircases to plumbing fixtures and stove castings for his unique coal-burning stoves, Mott copyrighted his first catalogue of drinking fountains in 1875. In 1906, Mott Iron Works moved to Trenton, New Jersey, where it remained at Hancock and Lalor streets until it discontinued operations sometime during the 1930s. Mott's beautiful fountains are located in several Texas cities, including Houston, Jefferson, New Braunfels, and San Antonio.

Muguet, George

(French)

MICHAEL E. DEBAKEY, M.D. *1978*

Portrait bust; life-size; bronze
Location: Texas Medical Center, entrance to Alkek Tower and Fondren-Brown Building of the Methodist Hospital

Funding: Donated by King Leopold and Princess Lilian of Belgium
Comments: Muguet created this signed and dated bust in his Paris studio. The inscription reads, "In grateful acknowledgment of his devoted service that the people of all nations may live more abundantly."

Murray, Robert

(b. 1936 Canadian)

TIKCHICK *1974*

Abstract; 7'2" × 8'5" × 4'3"; aluminum plate
Location: 4200 Montrose
Funding: John Hansen Investment Builders

Mygdal, Eugenie Kamrath

(b. 1939 Native Texan)*

ASCENDING DOVE *1968*

Figurative; larger than life-size; stainless steel
Location: Saint John the Divine Episcopal Church, 2450 River Oaks Boulevard
Funding: Commissioned by the church
Comments: This sculpture commemorates the souls of the deceased in the release of the spirit to Heaven. It is located in the center of the Burial Urn Garden.

Nevelson, Louise

(1899–1988 American/Russian)

FROZEN LACES—ONE *1979–1980*

Abstract; 28' H; Cor-ten steel fabricated at Lippincott Foundry in New Haven, Connecticut
Location: The Enron Building, 1400 Smith Street
Funding: Property owner of Enron Building
Comments: Placed in 1983, this is the first of four works from Nevelson's

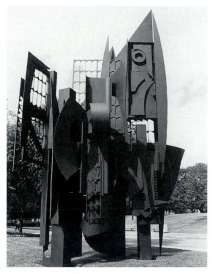

Frozen Laces—One. Photo courtesy Enron Property Company.

Essence series, on the theme of lace. The artist came to Houston for the dedication.

Newman, Barnett

(1905–1970 American)

BROKEN OBELISK *1963–1967*

Abstract; 26' × 10'6" × 10'6"; Cor-ten steel fabricated at Lippincott Foundry in New Haven, Connecticut
Location: Rothko Chapel, 3900 Yupon
Funding: Donated in 1968 by the Menil Foundation in memory of Martin Luther King, Jr.
Comments: Two other castings of Newman's obelisk are displayed at the Museum of Modern Art in New York and at the University of Washington in Seattle.

Oldenburg, Claes

(b. 1929 American/Swedish)

GEOMETRIC MOUSE X
1969–1970, installed 1975

Abstract; 18' × 22' × 11'; aluminum

and Cor-ten steel fabricated at Lippincott Foundry in New Haven, Connecticut
Location: Houston Central Library Plaza, 500 McKinney Avenue
Funding: Donated anonymously to the city of Houston
Comments: When Crating, Delivery and Installation Art Services restored this work in 1984, it was painted its current shade of red instead of its original orange. The color change was in keeping with Oldenburg's switch from orange to OSHA (Occupational Safety and Health Administration) red. Before beginning the restoration process, Crating, Delivery and Installation contacted the artist's New York agent, who informed the company that all of Oldenburg's older works will be painted OSHA red whenever they are restored. The "Library Mouse" is almost 8 feet taller than its counterpart at the Meadows Museum in Dallas.

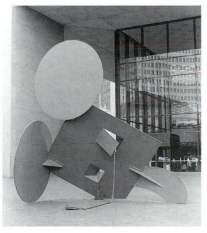

Geometric Mouse X. Photo by Robert Little.

Pepper, Beverly

(b. 1924 American)

POLYGENESIS *1982*

Abstract; 60' H including 10' H base, cast ductile iron

267

Location: Four Leaf Towers,
5100 San Felipe
Funding: Private funding; dedicated to
city of Houston in 1982 by Interfin
Corporation
Comments: In 1982, this was
described as the world's largest
sculpture created from ductile. Two
50-foot-tall rust-red elements are
illuminated from within with
concealed neon tubing.

Reginato, Peter

(b. 1945 Native Texan)

ANOTHER VIEW *1972*

Abstract; 4'4" H; welded steel
Location: Lanier Middle School,
2600 Woodhead
Funding: Donated to the school by
John Hansen

HIGH PLAINS DRIFTER *1973*

Abstract; 16' H; Cor-ten steel
Location: Entrance to Two Allen
Center, 1200 Smith at Clay
Funding: Century Development
Corporation
Comments: Visitors to the Allen
Center can walk under a large, cutout
space in this angular work, which
was placed at the center in February
1974. Other outdoor sculptures by
Texas artists such as Kent Ullberg
and David Cargill provide rotating
exhibits throughout the Allen Center
complex.

Dreams and Memories. Photo by Robert Little.

Reno, Jim

(b. 1929 American)*

DREAMS AND MEMORIES *1986*

Equestrian; life-size; bronze cast at
Shidoni Art Foundry in Tesuque,
New Mexico
Location: Astrodome Complex,
Houston Livestock Show and Rodeo
Association offices
Funding: Donated to Harris County
by the Houston Livestock Show and
Rodeo
Comments: The younger figure is
filled with dreams of the future, the
older with recollections from the
past.

Rogers, Richard Harrell

(b. 1941 Native Texan)*

FOUNTAINHEAD *1986*

Abstract; 43' H × 15' W; precast green
concrete
Location: Bridgewater Development,
Mason Road 1 mile north of
Interstate 10
Funding: Dunn-Rogers Company

STAR-GATE VECTOR *1969*

Abstract; 16' × 22' × 20'; painted steel
Location: Lamar Fleming Junior High
School, 4910 Collingsworth
Funding: McAshan Foundation

Salmones, Victor

(American/Mexican)

BLOCH GARDEN FOR
CANCER SURVIVORS *1993*

Figurative; 7 life-size figures; bronze
Location: Hermann Park, on a
triangle between Fannin Street,
Hermann Drive, and Montrose
Boulevard
Funding: Annette and Richard Bloch
Comments: The figures depict

ordinary persons of all ages entering the maze of cancer and emerging healthy. The colonnade and other elements previously on the site are intended to create a quiet and serene atmosphere for contemplation.

Sayre, Tom

(American)

BOUNDARY *1976*

Abstract; 7' × 7'6" × 17'; steel
Location: Texas Pipe and Supply, 2330 Holmes Road
Funding: Purchased by Jerry Rubenstein of Texas Pipe and Supply Company

RED SHIFT *1981*

Abstract; 26' × 25' × 19'; steel painted black
Location: Loop 610 and Northwest Freeway
Funding: PIC Realty Corporation

Simms, Carroll Harris

(b. 1924 American)*

A TRADITION OF MUSIC *1986*

Abstract; 10' × 4' × 2'; bronze cast at Al Shaklis Art Foundry in Houston
Location: Texas Southern University campus
Funding: Texas Southern University
Comments: Other bronze abstracts by Simms installed on the TSU campus include *Man and the Universe* (1961), *African Queen Mother* (1968), and *Jonah and the Whale* (1973). In 1971, the Houston Municipal Art Commission presented an award for distinguished achievement to Texas Southern University for the placement of *African Queen Mother,* which creates unification and harmony in a large campus area. It symbolically depicts sacred and traditional life in Africa and aspects

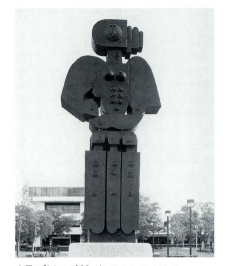

A Tradition of Music. Photo by Frank Martin Photographs, courtesy Carroll Simms.

of Afro-religious tradition in the New World. In 1977, the city of Houston placed another casting of *Jonah and the Whale* at the Fifth Ward Multi-Service Center at 4014 Market.

Smith, George

(b. 1941 American)*

AMMA OF THE UNIVERSE *1980s*

Abstract; 6'9" H; welded steel
Location: Lanier Middle School, 2600 Woodhead
Funding: Donated by John Hansen

Stewart, Hanna

(American)*

ATROPOS' KEY *1972*

Abstract; 10'6" H; bronze
Location: Hermann Park, Miller Outdoor Theatre grounds
Funding: Donated to the city by Patricia S. Woodward
Comments: This abstraction represents one of the three Fates, daughters of Zeus in Greek mythology.

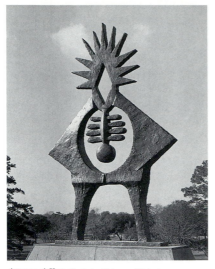

Atropos' Key. Photo by Hickey and Robertson, Houston, courtesy Hanna Stewart.

PASSAGE *1979*

Abstract; 13' × 34' × 10'; steel and concrete
Location: Corner of West Main and Mount Vernon
Funding: Donated by the artist
Comments: This work invites the viewer to walk through the sculpture's passageway and arches. Stewart, a professor at the University of Saint Thomas, also has a crescent-shaped fountain piece at the World Trade Center Courtyard, 1520 Texas Street.

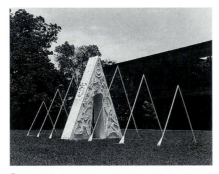

Passage. Photo by Hickey and Robertson, Houston, courtesy Hanna Stewart.

Summers, Robert

(b. 1940 Native Texan)*

TEXAS LEGACY *1987*

Equestrian; $^3/_4$ life-size; bronze cast at Shidoni Art Foundry in Tesuque, New Mexico
Location: Astrodome, Houston Sports Center
Funding: Given to the people of Houston and Harris County by Mr. and Mrs. Paul N. Howell
Comments: Prior to the Texas Sesquicentennial in 1986, the Texas Legislature voted to accept from a group of private investors a monumental sculpture for placement on the capitol grounds. Summers received the commission and created *Texas Legacy*—two cowboys herding six longhorns across a railroad track—to commemorate the state's cattle and railroad industries. After a downturn in the Texas economy, the capitol placement was postponed indefinitely, but this smaller version of *Texas Legacy* was installed in Houston. The sculpture reminds Texans of the state's early economic base.

Surls, James

(b. 1943 Native Texan)*

POINTS OF VIEW *1990–1992*

Abstract; 30' H; wood and steel
Location: Houston Market Square Park, bounded by Congress, Milam, Preston, and Travis
Funding: Private individuals and corporate sponsors, plus grants from the Brown Foundation, the Texas Commission on the Arts, the Cultural Arts Council of Houston, and the National Endowment for the Arts
Comments: The Houston Market Square Park Project began as a collaboration between the city's Parks Department, Diverse Works, Downtown Houston Association, and

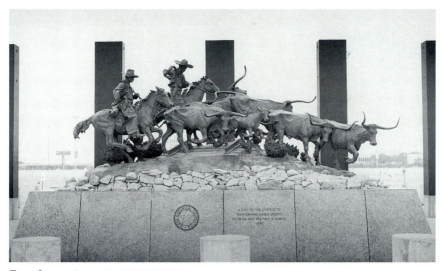

Texas Legacy. Photo by John McCaine Photography, Houston.

five artists. It developed into a community-based endeavor established as a nonprofit group with membership from more than twenty civic and cultural organizations and a separate fund-raising council of community leaders. Its goal is to enhance Houston's central business district as a cultural, retail, and visitor center. Houston Market Square Park is considered one entity. Sculptor-musician Doug Hollis and sculptor-writer Richard Turner designed and created the walkways, which are constructed from a collage of salvaged fragments from historically significant Houston structures. Malou Flato's hand-painted tiles portraying vivid market scenes cover the park's large, double-sided benches. Photographer Paul Hester provided 80 enamel tiles permanently etched with historic and original photographs depicting the old Market Square's role in Houston's development. At the center of the park's design is Surls' abstract tree form, *Points of View,* which directs the eyes of visitors toward the surrounding modern skyscrapers.

Wortham Center Spheres. Photo by Tom Fox, courtesy The SWA Group, Houston.

SWA Group

(American)*

WORTHAM CENTER SPHERES
1987

Abstract; 6 spheres, each 5'4" in diameter; spun steel fabricated at Berger Iron Works, Inc., in Houston **Location:** Gus S. Wortham Theater Center, bounded by Texas, Smith, and Preston streets and Buffalo Bayou **Funding:** The Wortham Theater Foundation and monies raised entirely from the private sector **Comments:** The SWA Group designed these gleaming spheres as part of the environmental and landscaping development for the Wortham Theater Center site.

271

Desire and Fate. Photo courtesy Trudy Sween.

Sween, Trudy

(American)*

DESIRE AND FATE 1985

Abstract; 2 pieces, 15' H and 23' H; carbon steel painted flat black
Location: 1300 Hercules Drive, in the Clear Lake area
Funding: Commissioned by Christopher Development Company
Comments: This lyrical abstraction, designed to harmonize with the surrounding architecture, is the artist's first monumental sculpture. A native of Pittsburgh, Pennsylvania, Sween works in a variety of media, including sculpture, painting, drawing, theater-set design, and photography. A solo exhibit of her renditions of the Texas state flag appeared in the capitol rotunda in 1981. Sween is one of the founding members of the Cultural Arts Council of Houston; in 1984 Governor Mark White nominated her to be inducted into the Texas Women's Hall of Fame. Her work has been exhibited in Spain, England, Norway, South America, and the United States.

FAST FORWARD 1980

Abstract; 5' H × 11'6" L; stainless steel
Location: 3355 West Alabama
Funding: S. I. Morris of Morris and Associates, Architects
Comments: A long, graceful ribbon of half-inch-thick stainless steel forms loops.

Teich, Frank

(1856–1939 American/German)*

DICK DOWLING 1905

Portraiture; 7' H; Italian marble
Location: Hermann Park, Outer Belt Drive at Brailsfort
Funding: Dick Dowling Camp 197, United Confederate Veterans, and public contributions; owned by the city of Houston
Comments: Moved from the city hall in 1958, the statue of Richard Dowling commemorates the Battle of Sabine Pass, in which Southerners thwarted a Northern invasion of

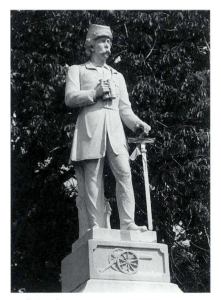

Dick Dowling. Photo by Robert Little.

272

Texas. Under the leadership of Ireland native Dick Dowling, 43 Confederate soldiers held a 1,500-man Union force. The Confederates sank two Union gunboats and put the other invasion ships in retreat. Dowling's statue was designed by Teich Monument Works of Llano, Texas, and carved in Italy either by Teich or by Italian artisans under contract to the Llano firm.

Hermann Park Lions (detail). Photo by Robert Little.

HERMANN PARK LIONS
early 1900s

Figurative; 2 life-size figures; gray Texas granite
Location: Hermann Park
Funding: Owned by the city of Houston
Comments: For many years, these figures were located behind the Museum of Natural Science in Hermann Park. In 1993, they were placed in temporary storage. The lions are neither signed nor listed in Teich's surviving records; however, his daughter, Frankie (Mrs. Linden Foster), identified them as her father's work. Foster remembered that the lions were mounted on pedestals at the entranceway to the park when she and her father attended their dedication. Frankie and Linden Foster lived in Llano, where he worked with his father-in-law at Teich Monument Works.

Thorvaldsen, Bartholomew "Bertel"

(1770–1844 Danish)

THE CHRIST REPLICA *original nineteenth century, replica late 1950s*

Figurative; life-size; white marble
Location: Saint Paul's United Methodist Church, 5501 South Main
Funding: Given in memory of Edna and Robert W. Henderson by Mrs. Fred Couper, Mrs. R. W. Henderson, and Mrs. Joe Wessendorff
Comments: Former pastor Alfred H. Freeman saw Thorvaldsen's original work in Copenhagen, Denmark. Later, when asked about an appropriate memorial for placement in the churchyard, he suggested this replica. Thorvaldsen carved *The Christ* as part of a larger work that included twelve companion statues of the apostles.

Tremonte, Sister Mary Peter

(b. 1930 Native Texan)*

SAINT DOMINIC GUZMAN *1982*

Figurative; 7' H; bronze
Location: Sacred Heart Convent

Saint Dominic Guzman.
Photo by Sister JoAnn Niehaus.

273

(Dominican Sisters),
6501 Almeda Road
Funding: Privately funded to commemorate the centennial of the Dominican Sisters of Houston
Comments: Sister Mary Peter Tremonte is a Dominican Sister of the Houston congregation. Saint Dominic Guzmán was the founder of the Order of Preachers.

Umlauf, Charles

(1911–1994 American)*

ENTRANCE INTO JERUSALEM
1953

Figurative; 3'6" H; bronze
Location: Memorial Lutheran Church
Funding: Donated to the church in 1970 by Andrew K. Schwartz
Comments: The figure of Christ on a donkey commemorates his arrival in Jerusalem for Passover.

HOPE OF HUMANITY *1971–1972*

Figurative; 12'6" H including 6' H granite base, bronze
Location: Hermann Park,
1 Hermann Circle Drive
Funding: Commissioned by Mr. and Mrs. Frank W. Michaux

TEACH ALL NATIONS *1966*

Figurative; 9'6" H on a 2'6" H base; bronze
Location: Saint Luke's Methodist Church, Sanctuary Garden
Funding: Private donation

Unknown Artist

BERLIN WALL SEGMENT
1990–1991

Figurative; 12' H; reinforced concrete
Location: Rice University campus
Funding: Donated to the university by Browning-Ferris Industries

Berlin Wall Segment. Photo by Thomas LaVergne, courtesy Rice University.

Comments: This graffiti-covered section of the infamous wall was one of the first large segments to be dismantled.

Unknown Artist

EURYDICE *early nineteenth century*

Figurative; 7'2" H; white marble
Location: Warwick Hotel, 5701 Main
Funding: The Mecom Collection
Comments: This figure of Eurydice, the wife of Orpheus in Greek mythology, and an untitled companion piece of the same size and period flank the entrance to the hotel. Both pieces came from a Viennese palace. The beautiful bronze fountain sculpture at the Ewing Street entrance to the hotel is also part of the Mecom Collection. John W. Mecom, Jr., acquired the fountain figures in Paris through Jacques Le Jeune. They became the centerpiece for the Warwick Hotel fountain in 1964.

Unknown Artist

FIGURE OF CHRIST *1939*

Figurative; life-size; bronze
Location: Sacred Heart Catholic
Co-Cathedral, 1111 Pierce Street
Funding: Mrs. Carter Raia in memory
of her husband
Comments: Jesus is standing with
outstretched arms. A bell-shaped
insignia inscribed on the back of the
statue appears to be the only record of
the work's possible origin.

Unknown Artist

LOMBARD LAMP *1869*

Figurative; 12' H plus a 4'6" H base;
stone and metal
Location: Esplanade at Heights
Boulevard and 11th Street
Funding: The plaque reads, "Pre-
sented to the people of the City of
Houston by the people of the Free and
Hanseatic City of Hamburg so that it
may forever brighten a bridge of
friendship and human relations,
trade, and commerce. March 1979."
Comments: These beautiful lamps
have been a familiar sight in Ham-
burg, Germany, since 1869, when
they were placed on the famous
Lombard Bridge.

Unknown Artist

SAINT ANTHONY *1974*

Figurative; 6' H; marble
Location: Texas Medical Center,
Saint Anthony Center,
6301 Almeda Road
Funding: Donated by Mrs. Nell
Rayborn in honor of Sister
Presentation Flynn
Comments: This traditional standing
figure of Saint Anthony holding a
young child was ordered from a
catalogue and shipped from Italy.

Unknown Artist

TWINS FOUNTAIN *n.d.*

Figurative; 5' H; bronze
Location: Texas Medical Center,
Shriners Hospital for Crippled
Children
Funding: Presented to Arabia Temple
Crippled Children's Clinic by Mr. and
Mrs. S. P. Martel
Comments: Two children stand on
tiptoe at each side of the fountain's
bowl. The twins have been in this
location for as long as anyone
associated with the center can
remember. When the new Shriners
Hospital for Crippled Children is
complete, this work will be moved to
7000 Main Street.

Van Vranken, Rose

(American)*

FLAME *1991*

Abstract; 11' × 6'6" × 4'3"; bronze
Location: M. D. Anderson Cancer
Center, 1515 Holcombe Boulevard

Flame. Photo courtesy Rose Van Vranken.

275

Funding: Commissioned by the University of Texas M. D. Anderson Cancer Center

Comments: Van Vranken's fundamental technique is direct carving in wood or stone. *Flame* and other bronze castings of her biomorphic forms are made from the carvings. Van Vranken's sculpture and graphics have been exhibited throughout the United States and in Europe, and her work has been chosen for such prestigious collections as the Coventry Cathedral in Coventry, England. Her most recent awards include the 1990 Gold Medal and Best of Show at the International Platform Association Annual Exhibition in Washington, D.C.; the 1985 Medal of Honor from the Academic Artists Association Exhibition for Contemporary Realism in Art in Springfield, Massachusetts; and sixteen awards for sculpture from the Salmagundi Club in New York City since being elected to membership in 1980. The Houston artist created *Flame* to commemorate the fiftieth anniversary of the cancer center in 1991. The semiabstract burning flame symbolizes the center's educational mission to pass on knowledge in the areas of research, treatment, and prevention. The sculpture also symbolizes eternity, remembrance, and hope for the future, all important concepts to the patients, families, and friends of M. D. Anderson.

THE THEOTOKOS *1981*

Figurative; 5' H; bronze
Location: Saint Cyril of Alexandria Church, 10503 Westheimer
Funding: Commissioned by Saint Cyril Church

Saxophone. Courtesy Bob Wade.

Wade, Bob

(b. 1943 Native Texan)*

SAXOPHONE *1993*

Figurative; 70' H; mixed media
Location: Billy Blues Bar and Grill, 6025 Richmond
Funding: WaterMarc Food Management Co.
Comments: Wade's gigantic saxophone is a found-objects assemblage. An upside-down Volkswagen car forms the bottom curve of the instrument. A surfboard and a beer keg form the mouthpiece, and stainless steel room-service trays form the stops.

Wang, Wei Li "Willy"

(b. 1938 American/Chinese)*

GEORGE R. BROWN *1988*

Portraiture; slightly larger than life-size; bronze cast at Dell-Ray Bronze, Inc., in Houston
Location: George R. Brown Convention Center, 1001 Convention Center

Boulevard; just west of the center in a park at Crawford and Lamar
Funding: Texas Eastern Corporation
Comments: Wang graduated with honors from the Peking Central Institute of Fine Arts in 1962 with a degree in sculpture. He is a member of the Chinese Artists Association of Beijing, China, and the National Sculpture Society in New York City. In addition to numerous private commissions, Wang has public commissions installed in China, Tibet, Syria, the Republic of Guinea, Washington, D.C., and California.

Weidl, Seff

(b. 1912 German)

SANCTITY OF CONTRACT *1967*

Figurative; 16'6" H; bronze
Location: 1980 Post Oak Boulevard
Funding: Commissioned by Stewart Title Guaranty Company
Comments: Stewart Title Guaranty placed this work at the Dallas office in 1967 and moved it to Houston in 1974. Another casting is placed at the firm's San Antonio office.

Westphal, Rolf

(American)[*]

EAST OF THE PECOS *1979*

Abstract; 75' L; steel and wood
Location: La Colombe d'Or Hotel, 3410 Montrose Boulevard
Funding: Steven N. Zimmerman

WEST OF THE PECOS *1975*

Abstract; 27' × 20' × 17'; painted steel
Location: Houston Intercontinental Airport, Will Clayton Parkway
Funding: Donated to the Contemporary Arts Museum by Armco Steel Corporation and placed by the museum on long-term loan to the city of Houston

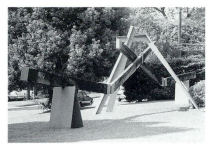

East of the Pecos. Photo by Robert Little.

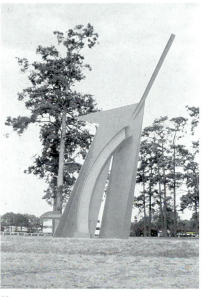

Houston. Photo courtesy Mac Whitney.

Whitney, Mac

(b. 1936 American)[*]

HOUSTON *1979*

Abstract; 50'x 24' × 36'; painted steel
Location: Stude Park, 1031 Stude
Funding: City of Houston

UNTITLED *1983*

Abstract; 12' H; painted steel
Location: 3555 Timmons Lane
Funding: Sutter Companies, Inc.

Williams, Wheeler

(1897–1972 American)

WAVE OF LIFE *1953*

Figurative; 8' × 18' × 7'; Indiana limestone
Location: Texas Medical Center, University of Texas at Houston, Main Building, 1100 Holcombe Boulevard
Funding: Commissioned by Prudential Insurance Company
Comments: Williams carved this interpretation of the American family from a single block of stone over a period of almost two years. The Prudential Insurance Company placed it at the Prudential Building in 1953; the University of Texas acquired the work as part of the purchase of the Prudential Building in 1974.

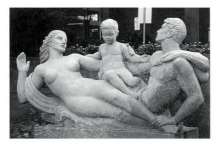

Wave of Life. Photo by Robert Little.

Wilson, Bob

(b. 1943 Native Texan)*

LOVE *1987*

Figurative; larger than life-size; bronze
Location: Saint Joseph's Hospital, Mary Gibbs Jones Building, 1819 Crawford
Funding: Gift of Houston Endowment, Inc.
Comments: At the artist's request, the sisters who work at Saint Joseph's named this sculpture. Wilson is the owner of Bob Wilson Art Foundry, formerly Al Shakis Art Foundry in Houston.

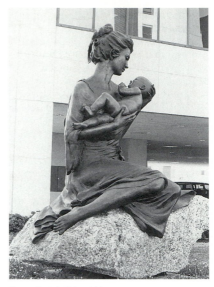

Love. Photo by Robert Little.

Woitena, Ben

(b. 1942 Native Texan)*

CIBOLO *1977*

Abstract; 12'6" × 15' × 4'10"; steel, painted dark red, cream, and gray
Location: 4203 Montrose Boulevard
Funding: Commissioned by John Hansen Investment Builders

THREE-QUARTER TIME *1975*

Abstract; 16' × 27' × 15'; painted steel
Location: Memorial Park Esplanade at Woodway and Memorial
Funding: Owned by the city of Houston

Woodham, Jean

(American)

ORBIT *1974*

Abstract; 8' H; welded bronze
Location: 2 Houston Center
Funding: Texas Eastern Corporation
Comments: Open steel spheres resemble an orbital path around a planet.

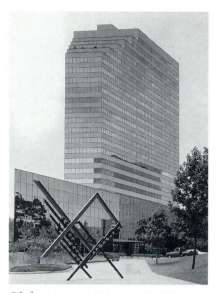

Cibolo. Photo by Frank Martin, courtesy Ben Woitena.

Special Collections and Sculpture Gardens in Houston

The Bayou Bend Collection of the Museum of Fine Arts, Houston, is located at 1 Wescott Street off Memorial Drive. Several garden sculptures are installed in the fourteen acres of formal and woodland gardens that surround Bayou Bend, the former home of Governor Stephen Hogg's children, Will, Mike, and Ima Hogg. The gardens include beautiful marble replicas purchased by Ima Hogg in the 1930s from the Antonio Frilli Studio in Florence, Italy. The replicas carved by Frilli and installed in the gardens include **DIANA OF VERSAILLES,** depicting the goddess of the chase; **CLIO,** depicting the muse of history; and **EUTERPE,** depicting the muse of music. The *Clio* and *Euterpe* originals were in the Vatican museum, and Frilli's reproduction of *Euterpe* was the first cast made from the original statue.

Houston Zoological Gardens is located in Hermann Park. From humble beginnings with an inventory of 40 animals, the Houston Zoo has grown to rank fifth in attendance among zoos in the United States. With expanding exhibits and facilities, it is involved in survival plans for 22 species and participates in fish and wildlife management programs. Six sculptural installations, most by Texas artists, are placed in the gardens:

DOLLY'S RIDE *1995,* by Houston artist Ann Armstrong, is a gift to the children of Houston from the First Houston Doll Club. Cast at United Metal Smiths of Houston, Inc., it depicts a toddler holding a rag doll and sitting on the back of a Galápagos tortoise. This work is distinguished as one of the few publicly sited sculptures that incorporates a doll into the design. Armstrong's sensitive bronze sculptures typically portray human emotions; *Dolly's Ride* suggests the happy bond between children, animals, and favorite toys. In addition to sculpting, Armstrong travels extensively as an instructor in sculpture.

HOODED COBRA *1960,* a life-size bronze by native Texan Herring Coe, is installed at the entrance to the Reptile Building.

AFRICAN ELEPHANT *1982,* a 21' welded-steel sculpture by native Texan Bob Fowler, was donated to the Houston Zoological Gardens by Mr. and Mrs. Max Herzstein "for our children, grandchildren, and all the young at heart." Fowler studied the African elephant intermittently for eight years before sculpting this figure. Two other works by Fowler are placed in the zoo. In 1975, Houston Endowment, Inc., installed his 8' welded-steel **GORILLA** at the entrance to the Gorilla Habitat

279

African Elephant. Photo courtesy
Houston Zoological Gardens.

Spoonbill. Photo by Michael Bowerman,
courtesy Houston Zoological Gardens.

Building. In 1967, his **SPOONBILL**
was placed at the entry to the
Tropical Bird House.

ROLLING BEAR CUBS *1937*, a
carved Indiana limestone sculpture
by William M. McVey (b. 1905,
American)*, was donated to the
zoo in 1989 by Lisa, Toni, and
Cindi Lazzari. McVey came to
Texas in 1923 to study architec-
ture and play football for the Owls
at Rice Institute (now Rice
University); 60 years later, in 1983,
he returned to Houston to receive
a distinguished alumnus award. A
resident of Cleveland, Ohio,
McVey served as head of the
Department of Sculpture at
Cleveland Institute of Art before
retiring in 1968. In addition to 32
terra-cotta panels and a large relief
carving on the campus of Rice
University, he also created the
decorative relief work and massive
bronze entrance doors for the San
Jacinto Monument. *Rolling Bear
Cubs* was a special commission for
the grounds of the J. R. Parten
residence in Houston. The Lazzari
family subsequently owned the
home—and the bears—until recent
years, when they decided to make
the cubs available for the public's
enjoyment.

LEAPFROG, a life-size bronze by
Victor Salmones, was donated to
the city in 1976 by Mrs. Jules Ross
Frankel in memory of her husband

BROWNIE *1907*, by an unknown
artist, is a 4' bronze gnome. The
Houston Civic Club purchased the
statue for the city with private
donations, a large portion of which
were collected by Houston
schoolchildren. Originally

Gorilla. Photo courtesy Houston Zoological Gardens.

280

Rolling Bear Cubs. Photo by Michael Bowerman, courtesy Houston Zoological Gardens.

Leapfrog. Photo by Michael Bowerman, courtesy Houston Zoological Gardens.

installed in the old City Park (now Sam Houston Park), *Brownie* was stolen in 1935 and sold by the thieves as scrap for $2.87. Following his rescue from the scrap yard, repeated attempts to kidnap *Brownie* caused city officials to place him in storage in 1937. Thirty years later, the Houston Parks Department asked sculptor David Parsons to renovate *Brownie*, who by this time had one arm missing, and in 1968, the statue found a permanent home in the Children's Zoo.

Brownie. Photo by Michael Bowerman, courtesy Houston Zoological Gardens.

The International Sculpture Garden at the Houston Garden Center in Hermann Park includes five larger-than-life portrait busts. Nearby, the **LILLIAN SCHNITZER FOUNTAIN** *1875*, by J. Worrington Wood, was dedicated in the Hermann Park Rose Garden in 1964. Portrait busts in the International Sculpture Garden include:

JOSE DE SAN MARTIN *1983*, by P. Buiguez, donated by the Argentine Consulate and the people of Argentina to the city of Houston
ALVAR NUÑEZ CABEZA DE VACA *1987*, by Pilar Cortella de Rubín (American/Spanish), donated to

the city of Houston by King Juan Carlos of Spain
JOSE MARTI *1981*, by Tony López (Cuban), donated to the city of Houston in 1984 by the José Martí Masonic Lodge and the Houston Cuban community. The bust is signed by the artist and inscribed, "In recognition for the generosity and opportunities received by our community during these years of exile."
BENITO JUAREZ *1985*, by Julian Martínez-Sotos (b. 1921, Mexican), donated to the city of Houston by Pemex on behalf of the Mexican people

281

SIMON BOLIVAR *1977,* by
C. Talacca, donated by the
governor and people of Venezuela
to the city of Houston in 1978

**The Lillie and Hugh Roy Cullen
Sculpture Garden** is located on the
grounds of the Museum of Fine Arts,
Houston, at 1001 Bissonnet. The
museum's outdoor sculpture collec-
tion is installed in plazas surrounding
the museum and in the sculpture
garden, which opened on April 5,
1986. Designed by American sculptor
Isamu Noguchi, the sculpture garden
measures 43,560 square feet and
provides a setting for works by major
nineteenth- and twentieth-century
artists. Works on permanent exhibit
in the garden include:

ADAM *1889,* a larger-than-life
figurative bronze by Emile
Antoine Bourdelle (1861–1929,
French), purchased by the museum
with funds provided by Mr. and
Mrs. Isaac Arnold, Jr.
QUARANTANIA I *1947–1953,* a
bronze abstract by Louise Bour-
geoise (b. 1911, American/French),
purchased by the museum
ARGENTINE *1968,* a painted steel
abstract by Anthony Caro (b. 1924,
British), purchased by the museum
with funds provided by the Brown
Foundation Accessions Endow-
ment Fund
COLLOQUIO COL VENTO *1962,* a
large, painted-steel kinetic abstract
by Pietro Consagra (b. 1920,
Italian), purchased by the museum
SPACE, CONCEPT, NATURE I and
SPACE, CONCEPT, NATURE II
1965, two companion bronze
abstracts by Lucio Fontana (1899–
1968, Italian), the gift of John and
Dominique de Menil
LARGE STANDING WOMAN I
1960, an 8' figurative bronze by
Alberto Giacometti (1901–1966,
Swiss), purchased by the museum

with funds provided by the
Brown Foundation Accessions
Endowment Fund
UNTITLED *1989,* a welded-steel
abstract by DeWitt Godfrey (native
Texan)*, purchased by the
museum with funds provided by
Panhandle Eastern
**FOUNTAIN FIGURE #1,
FOUNTAIN FIGURE #2,** and
FOUNTAIN FIGURE #3 *1983,*
three figurative bronze companion
pieces by Robert Graham (b. 1938,
American/Mexican), purchased by
the museum with funds provided
by the Charles Engelhard Founda-
tion, Mr. and Mrs. Theodore N.
Law, and Mr. and Mrs. Meredith J.
Long
ARCH FALLS *1981,* a bronze
abstract by Bryan Hunt (b. 1947,
American), purchased by the
museum with funds provided by
the Charles Engelhard Foundation
HOUSTON TRIPTYCH *1986,* a
three-piece bronze abstract
installation by Ellsworth Kelly
(b. 1923, American), purchased by
the museum with funds provided
by the Brown Foundation Acces-
sions Endowment Fund and Mr.
and Mrs. M. S. Stude in honor of
Mr. and Mrs. George R. Brown
**CAN JOHNNY COME OUT AND
PLAY?** *1991,* a 7' bronze by Jim
Love (b. 1927, native Texan)*, the
gift of Caroline Wiess Law in
memory of Theodore N. Law
FLORE NUE *1910,* a life-size
figurative bronze by Aristide
Maillol (1861–1944, French),
purchased by the museum with
funds provided by Isaac Arnold, Jr.,
in honor of his wife, Antonette
Tilly Arnold
THE PILGRIM *1939,* a figurative
bronze by Marino Marini (b. 1901,
Italian), gift of the Hobby Founda-
tion
BACK I *1909,* **BACK II** *1913,* **BACK
III** *1916–1917,* and **BACK IV**
1930s, a series of bronze reliefs by

Left: *The Walking Man* by Auguste Rodin.
The Museum of Fine Arts, Houston; Gift of Margaret Root Brown in honor of Louisa Stude Sarofim.
Right: *Two Circle Sentinel* by David Smith.
The Museum of Fine Arts, Houston; Museum purchase with funds provided by the Brown Foundation Accessions Endowment Fund in memory of Alice Pratt Brown.

Henri Matisse (1869–1954, French), purchased for the museum by Mr. and Mrs. Theodore N. Law, Mr. and Mrs. Gus Wortham, the Cullen Foundation, and the Brown Foundation. A photograph of another casting of Matisse's *Backs* is included in the Fort Worth listings.

THE WALKING MAN *1905*, a figurative bronze by Auguste Rodin (1840–1917, French), a bequest of Margaret Root (Mrs. Herman) Brown given in memory of Louisa Stude Sarofim. Rodin authorized this posthumous casting in his will.

UNTITLED *1990*, a figurative bronze, edition 4/4, by Joel Shapiro (b. 1941, American), purchased by the museum with funds provided by Isabell and Max Herzstein in memory of Benjamin K. Smith

TWO CIRCLE SENTINEL *1961*, a welded stainless-steel abstract by David Smith (1906–1965, American), purchased by the museum with funds provided by the Brown Foundation Accessions Endowment Fund in memory of Alice Pratt Brown

DECANTER *1987*, a bronze and steel abstract by Frank Stella (b. 1936, American), purchased with funds provided by the Alice Pratt Brown Museum Fund. *Decanter* is one of the first of Stella's works created specifically for an outdoor setting.

Works installed on the museum grounds outside the sculpture garden include:

THE CRAB *1962*, a painted steel abstract by Alexander Calder (1898–1976, American), purchased by the museum. *The Crab* is smaller than many of the works placed by the artist in the 1960s, when his sculptures were often enlarged to colossal proportions. Calder's humor, his interest in motion, his experience sketching animals, and his fondness for color—all are evident in this piece.

ABESTI GOGORA V *1966*, a pink-granite abstract by Eduardo Chillida (b. 1924, Spanish), gift from the Houston Endowment, Inc., in memory of Mr. and Mrs. Jesse H. Jones. This work is the artist's expression of the essence of

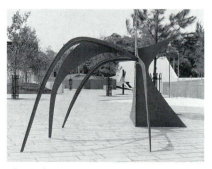

The Crab. The Museum of Fine Arts, Houston; Museum purchase.

283

a "great song or wondrous melody," as the title is translated from Basque. It was made in Spain but designed specifically for this location. Chillida consulted astronomers to help determine the exact spot on the museum's grounds where the sun's light would show the work to best advantage during the changing seasons. The artist and eight assistants spent nine months sculpting it in an abandoned quarry in northwest Spain.

MAGARI *1977,* a welded-steel abstract by Mark Di Suvero (b. 1933, American), donated to the museum by Mr. and Mrs. George R. Brown

LE CHEVAL MAJEUR *1914,* a 5' bronze abstract by Raymond Duchamp-Villon (1878–1918, French), gift of the museum's board of trustees

HERCULES UPHOLDING THE HEAVENS *1918,* a figurative bronze by Paul Manship (1885–1966, American), given to the museum in 1939 by Mellie Esperson. While studying in Italy, Manship was inspired by Roman culture and antiquity in general. One of his most famous sculptures based on ancient mythology is *Prometheus* at Rockefeller Plaza in New York City.

PAINTING, SCULPTURE, MUSIC, and **FLOWER ARRANGEMENT** *1935,* four relief panels in carved Indiana limestone by William M. McVey (b. 1905, American)*, donated to the museum by the Garden Clubs of Houston

TEXAS SHIELD *1986,* a granite abstract by Jesús Bautista Moroles (b. 1950, native Texan)*, donated to the museum by Frank Ribelin

PIETA *1944–1945,* a life-size figurative bronze by Charles Umlauf (1911–1994, American)*, purchased by the museum

The Menil Collection at 1511 Branard features works of art assembled by John and Dominique de Menil and the Menil Foundation. The collection includes antiquities, Byzantine art, medieval art, artifacts of tribal cultures, and twentieth-century painting and sculpture. Three works are installed near the museum:

BYGONES *1976,* by Mark Di Suvero (b. 1933, American), an abstract 25'11" × 31'6" × 14'2" of Cor-ten beams and mild steel plate installed at the corner of Sul Ross and Mulberry

CHARMSTONE *1991,* by Michael Heizer (b. 1944, American), a 15' abstract of modified concrete with flakes of obsidian, quartzite, and black granite and pieces of granite, commissioned by the collection and installed at the museum

ISOLATED MASS/CIRCUMFLEX (#2) *1968,* also by Michael Heizer, an abstract 1' × 8'6" × 80' of Mayari-R steel, installed at 1515 Sul Ross

Other works in The Menil Collection are placed by the Menil Foundation on the campus of the University of Saint Thomas at 3812 Montrose Boulevard. Three sculptures are by Tony Smith (1912–1980, American). In 1960, at age 48, Smith began creating sculpture that became a new type of outdoor public monument. He used his experience as a designer, painter, teacher, and sculptor to fabricate massive pieces that often are painted with a black matte finish to reduce the effect of sunlight on the surface. Having worked as an architectural apprentice to Frank Lloyd Wright, he based his work on formal architectural premises of geometric solids. Using industrial tools and materials, minimalists like Tony Smith created works large enough and strong enough to withstand the rigors of outdoor art in

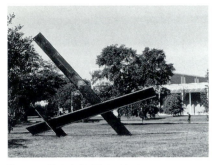

Bygones. Photo by Paul Hester, Houston,
© The Menil Collection, Houston.

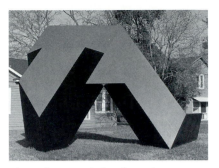

The Snake Is Out, before the work was
moved to its present location. Photo by David
Crossley, Houston, © The Menil Collection, Houston.

crowded urban settings. Works by
Smith installed at the University of
Saint Thomas include **NEW PIECE**
1966, fabricated 1973, measuring 8' ×
8' × 8'; **THE ELEVENS ARE UP** *1963,
fabricated 1973,* 8' × 2' × 8'; and **THE
SNAKE IS OUT** *1962, fabricated
1973,* 15' × 24' × 18'. One other work
on loan from the collection to the
University of Saint Thomas is an
untitled steel enamelac abstract
created in 1974 by Clark Murray
(b. 1937, American). Installed at the
Jerabeck Activity and Athletic
Center, this white tubular network of
angles was handmade by the artist.

**The University of Houston Public Art
Collection** includes a diverse array of
outdoor sculpture selected by the Art
Acquisition Committee, which is
appointed by the chancellor. Funding
is provided through a stipulation
passed in 1966 by the board of regents
that 1 percent of the contract for
major new construction be set aside
for the purchase of works of art. The
collection is installed on the cam-
puses at the University of Houston,
the University of Houston–Clear
Lake, and the University of Houston–
Downtown:

University of Houston Campus

BENCHES *1985,* a granite abstract by
Scott Burton (1939–1989, Ameri-

can), installed at the entrance to the
College of Architecture building
UNTITLED *1985,* a ceramic work in
two parts by Malou Flato (b. 1953,
native Texan), fabricated at
Prefabrications Plastering and
Fiberglass Company in Dallas and
installed at Cougar Place dormi-
tory courtyard
TOWER OF THE CHEYENNE *1972,*
a Cor-ten steel abstract by Peter
Forakis (b. 1927, American),
installed in the Anne Garrett
Butler Plaza
ABSTRACT FIGURE *1966,* a
welded-steel abstract by Bob
Fowler (b. 1931, native Texan),
installed in the arbor at the
University Center. This was the
first outdoor work purchased by
the university.
TROIKA *1978,* a Cor-ten steel
abstract by Charles Ginnever
(b. 1931, American)*, installed at
Science and Research Building 2
BIG ORANGE *1968,* a polychrome
steel abstract by Willi Gutmann
(b. 1927, Swiss), installed at the
General Services Building
ROUND ABOUT *1978,* a brushed-
aluminum abstract by Linda
Howard (b. 1934, American),
installed at the College of Optom-
etry building. These square
aluminum tubes form a curvilin-
ear design that appears to alter its
form according to the perspective

285

of the viewer and the reflection of the sunlight.

OM *1969*, a Cor-ten steel abstract by Manashe Kadishman (b. 1932, Israeli), installed at Entrance 6

WATERFALL, STELE, AND RIVER *1972*, a stainless-steel abstract by Lee Kelly (b. 1932, American), installed in the Cullen Family Plaza

COLLEGIUM *1984*, a 32' aluminum abstract by William King (b. 1925, American), installed south of the Communications Building. Three tall, angular shapes give the impression of three people walking together and holding hands. Commissioned by the university, the sculpture suggests friendliness and companionship, both important aspects of campus life.

LANDSCAPE WITH BLUE TREES *1982–1983*, a large, painted steel assemblage by Jim Love (b. 1927, native Texan)*, installed in the Cullen College of Engineering Courtyard. Two blue trees and a whimsical bird "critter" form this courtyard sculpture.

ALBERTUS MAGNUS *1955, 1970 casting 3/3*, a figurative bronze by Gerhard Marcks (1889–1981, German), installed in the Bates College of Law entrance plaza. Marcks' conception of Saint Albertus Magnus (1206?–1280) depicts the German theologian, philosopher, and scientist looking up from his study, apparently pondering the contents of the large book lying open on his lap. Marcks is considered by many to have been the leading German sculptor of the twentieth century.

ORPHEUS *1959, 1971 casting 1/4*, a figurative bronze, also by Gerhard Marcks, installed in the Fine Arts Building Courtyard

SPLIT LEVEL *1971*, a Cor-ten steel abstract by Clement Meadmore (b. 1929, American/Australian), fabricated at Lippincott Foundry in

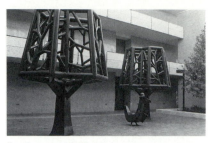

Landscape with Blue Trees. University of Houston Public Art Collection, courtesy Blaffer Gallery.

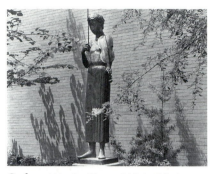

Orpheus. University of Houston Public Art Collection, courtesy Blaffer Gallery.

Split Level. University of Houston Public Art Collection, courtesy Blaffer Gallery.

286

New Haven, Connecticut,
installed at the School of Hotel
and Restaurant Management

SANDY: IN DEFINED SPACE *1967,
1972 casting 3/5,* a figurative
bronze by Richard McDermott
Miller (b. 1922, American),
installed at the Science and
Research Building's east entry
plaza. The framework surrounding
a nude female figure is used as a
prop to define and support the
main subject. The young woman's
pose is tranquil and relaxed, not
confined or imprisoned.

LOTUS *1982,* a 7' granite sculpture
by Jesús Bautista Moroles (b. 1950,
native Texan)*, installed at the
Graduate School of Social Work

UNTITLED *1991,* a three-piece
abstract of etched black granite by
Matt Mullican (b. 1951, Ameri-
can), installed at the Houston
Science Center Building

LEDA AND THE SWAN *1978,
installed 1986,* a figurative bronze
by Reuben Nakain (1897–1986,
American), installed at the College
of Business Administration. These
two stylized figures represent Leda
(mother of the mythological twins
Castor and Pollux) and Zeus (the
swan).

LUNCHEON ON THE GRASS *1979,*
a welded-steel abstract by Peter
Reginato (b. 1945, native Texan),
installed at the University Center
Underground Plaza

CONTEMPLATION *1976,* a Cor-ten
steel abstract by Tom Sayre (b.
1940, American), installed on the
east lawn in front of University
Center

JONAH AND THE WHALE *1973,* a
bronze abstract by Carroll Harris
Simms (b. 1924, American)*,
installed on the Athletic Facility
grounds

ALI *1978,* a painted steel abstract by
Brian Wall (b. 1931, American/
British), installed at the College
of Technology

Contemplation. University of Houston
Public Art Collection, courtesy Blaffer Gallery.

**University of Houston–
Downtown Campus**

VLURU *1991,* a wood and steel
abstract by Robert Bourdon (b.
1947, American), installed at the
entry to Main Building

BANDIAGARA *1990,* a three-piece
welded-steel abstract by George
Smith (b. 1941, American)*,
installed on the south deck of
One Main Building

**University of Houston–
Clear Lake Campus**

FLIGHT *1976,* a 3' bronze and stone
abstract by H. J. Bott, installed
near the bridge over Horse Pen
Bayou. This Bicentennial commis-
sion has a time capsule incorpo-
rated into the base; the capsule is
to be opened in 2076.

THE FIREBIRD *1978,* a bronze
sculpture 8'3" × 2'10" × 4'6" by
Richard Hunt (b. 1935, American),

Spiritus Mundi. University of Houston
Public Art Collection, courtesy Blaffer Gallery.

287

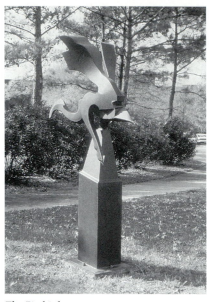

The Firebird. University of Houston Public Art Collection, courtesy Blaffer Gallery.

installed at the rear entrance to the Bayou Building
SUNDIAL *1982*, a 5' bronze sundial by Charles Pebworth (b. 1926, American)*
SPIRITUS MUNDI *1976*, a 12' cast-bronze and welded-bronze sculpture by Pablo Serrano (b. 1910, Spanish), installed at the main entrance to the Bayou Building. The artist, who visited the site before the ground-breaking for the Bayou Building in 1974, said that this work represents the juxtaposition of humanity and nature, technology and the humanities, and the tensions inherent in all human and natural existence. The sculpture rests on a solid concrete base with indirect lighting between the two pieces.

Hunt

Shepperd, Al, and Doug Hill
(Native Texans)*

STONEHENGE II and EASTER ISLAND STATUE REPLICAS
1989–1991

Abstract; 13' at highest point; stone, steel, concrete, and plaster
Location: Farm Road 1340, 2 miles west of Hunt
Funding: Al Shepperd
Comments: The late Al Shepperd designed and funded these sculptures, which are based on the ancient monoliths on Easter Island and the mysterious monument at Stonehenge on the Salisbury Plain in England. Shepperd's friend and neighbor Doug Hill built the hollow facsimiles. The project began when Hill, a masonry contractor, gave Shepperd a large boulder, which Shepperd placed in a mowed area in an open field. Inspired by the site of that boulder and a visit to Salisbury Plain, Shepperd enlisted Hill to construct *Stonehenge II*. Two years later, the men placed two Texas versions of the Easter Island statues about 200 yards from their first creation.

Huntsville

Adickes, David
(b. 1927 Native Texan)*

TRIBUTE TO COURAGE *1994*

Portraiture; 67' H, 30 tons; concrete and steel
Location: Interstate 45, 2 miles south of Huntsville
Funding: Donated to the city of Huntsville by the artist and local businesses, individuals, and institutions

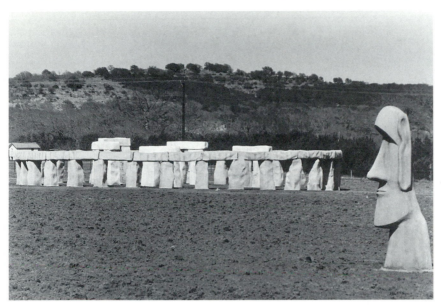

Stonehenge II and *Easter Island Statue Replicas*. Photos by Ken Schmidt, courtesy *Kerrville Daily Times*.

Comments: This statue of General Sam Houston is the world's largest freestanding figure of an American hero. Huntsville was Sam Houston's Texas home. In addition to his burial site, the city is home to the Sam Houston Memorial Museum and Sam Houston State University. Adickes portrays the first president of the Republic of Texas as a 67-year-old man, shortly before he relinquished his position as governor and retired to Huntsville.

Baudoin, Ali

(American)

RAINBOW WALKER *1987*

Abstract; 18' H; brushed and polished stainless steel
Location: Sam Houston State University campus, near Bowers Stadium on Bearkat Boulevard
Funding: Commissioned by Terry Davis and Ed Killiam

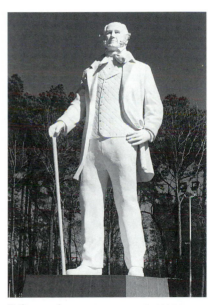

Tribute to Courage. Photo courtesy David Adickes.

289

Boles, Michael F.

(American)

DOUBLE-DOUBLE *1977*

Abstract; 9' H; concrete and fiberglass
Location: Sam Houston State
University campus, University
Theater Center entrance
Funding: SHSU Student Association

Coppini, Pompeo

(1870–1957 American/Italian)*

GENERAL SAM HOUSTON *1911*

Figurative; 12' H × 12' W;
Texas granite
Location: Oakwood Cemetery, Sam
Houston's grave site, Sam Houston
Memorial Drive at 9th Street
Funding: State of Texas
Comments: After Coppini received
this commission, he submitted a
design for a bronze memorial. The
State Legislature rejected the artist's
design because it was not made of
Texas granite. The competition was
reopened, and several stonecutters,
including Frank Teich, submitted
sketches. Coppini quickly converted
his original sketch into a high-relief
sculpture hewn from Texas granite.
When he presented it in Austin, it
was unanimously accepted. Made in
his San Antonio studio, the memorial
is composed of three panels with
General Houston on horseback in the
center, flanked by allegorical figures
of History and Victory. The work is
signed by the artist and the contrac-
tor, the Charles Lucas Company of
San Antonio.

Guthrie, Trace

(b. 1950 Native Texan)*

SAM HOUSTON
CENTENNIAL STATUE *1979*

Portraiture; life-size; bronze
Location: Sam Houston State
University Quadrangle
Funding: Sam Houston State Univer-
sity Centennial Project through
donations

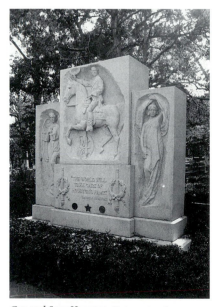

General Sam Houston. Photo courtesy the
Sam Houston Memorial Museum.

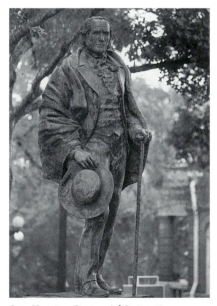

Sam Houston Centennial Statue. Photo courtesy
Sam Houston State University Public Information Office.

Kraft, Stuart, and local students

(b. 1953 American)*

THE ATHLETE *1987*

Abstract; 12' H; welded steel
Location: Kate Barr Ross Park on
U.S. 75 North
Funding: Huntsville Arts
Commission
Comments: Art and welding students
at Huntsville High School assisted
the artist with this work.

BEAUTY AND THE BEAST *1981*

Abstract; 12' × 9' × 6'; welded steel
Location: Huntsville High School,
Farm Road 2821 East
Funding: National Endowment for
the Arts and Texas Commission on
the Arts
Comments: Kraft served as artist-in-
education at Huntsville High School
when he and the high school's art and
welding classes created this work.

Pebworth, Charles

(b. 1926 American)*

TOTEM *1982*

Abstract; 9'4" H; bronze cast at
Shidoni Art Foundry in Tesuque,
New Mexico
Location: Between 12th and
13th streets in Town Creek Park
Funding: City of Huntsville
Comments: A native of Oklahoma,
Pebworth has lived in Huntsville for
many years. In addition to a number
of indoor placements in Texas, he has
large outdoor installations in Hous-
ton and The Woodlands.

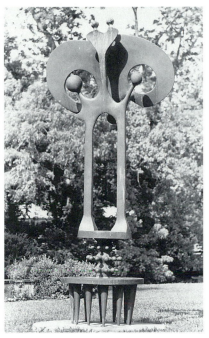

Totem. Photo by Robert Little.

Stewart, John

(American)

RECLINING FIGURE *1989*

Abstract; 7'3" H; fiber cement and
steel
Location: Fire Station 2,
2109 Sam Houston Avenue
Funding: Huntsville Arts
Commission

Thorvaldsen, Bartholomew "Bertel"

(1770–1844 Danish)

THE CHRIST *1934*

Portraiture; life-size; bronze
Location: Oakwood Cemetery,
Houston Memorial Drive at
9th Street
Funding: Judge and Mrs. Ben H.
Powell in memory of their son,
Rawley Rather Powell

291

Hutto

Double D Statuary

(American)*

HIPPO *1992*

Figurative; 10' H; concrete
Location: East Street between U.S. 79 and Farley Street
Funding: Hutto Chamber of Commerce
Comments: The legend of the hippo in Hutto presumably began in 1915, when a hippopotamus escaped from a traveling circus into the Williamson County countryside. The circumstances of the animal's escape and the subsequent rescue and return to the circus inspired stories that have been embellished through the years. One

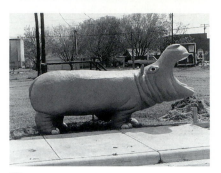

Hippo. Photo by Whitfield Photography, courtesy Hutto Chamber of Commerce.

other explanation for the town's unusual mascot is the claim that a rival football team once observed that the Hutto players were as big as hippopotamuses. Double D Statuary operates out of Odem.

Ingleside

Iraan

Irving

293

Ingleside

Tatum, H. W. "Buddy"

(b. 1958 Native Texan)*

**THE SPIRITS OF
MUSTANG ISLAND** *1986*

Figurative; 12' H; bronze
Location: Ingleside High School,
2800 Mustang Avenue
Funding: Ingleside Sesquicentennial
Committee through donations

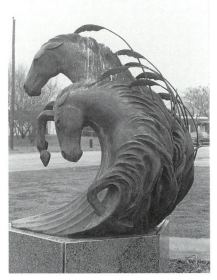

The Spirits of Mustang Island.
Photo by Robert Little.

Iraan

Ayers, Bernie W.

(American)*

DINNY *1965*

Figurative; 15' H × 65' L; steel, wire,
and concrete
Location: Alley Oop City Park,
1000 Park Side Street on the west
edge of town

Funding: Materials and labor donated
Comments: Dinny the Dinosaur is
the favorite pet of the comic-strip
character Alley Oop. *Dinny* was a
community project initiated by
Ayers, who enlisted local construc-
tion workers and high school shop
students to build the figure. V. T.
Hamlin, creator of the comic strip,
came to Iraan for the unveiling. In
1967, Ayers and local citizens built a
bust of Alley Oop for the park.

Irving

Bartscht, Heri Bert

(b. 1919 American/German)*

SOCRATES *1966*

Abstract; 3' H; bronze
Location: Cistercian Preparatory
School, near the front entrance at
One Cistercian Road
Funding: Commissioned by the
Cistercian Preparatory School
Comments: Bartscht is a professor of
art at the University of Dallas,
located in Irving.

Baudoin, Ali

(American)

ELISSA *1985*

Abstract; 8' H; polished stainless steel
Location: Royal Port Centre,
5005 Royal Lane, near the north
entrance to Dallas–Fort Worth
Intercontinental Airport
Funding: Lakeview Properties

Clayton, Harold

(b. 1954 Native Texan)*

BLUEBONNET HILL COWS *1985*

Figurative; 5 figures, 4'6" to 5' H;
Italian marble, Italian stone, and

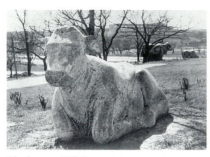

Bluebonnet Hill Cows. Photo by Peter H. Waters, courtesy Harold Clayton.

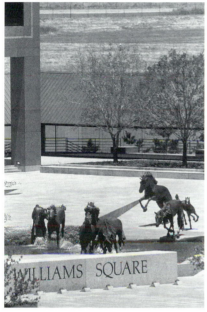

The Mustangs of Las Colinas.
Photo courtesy Tom Fox, The SWA Group, Houston.

The Mustangs of Las Colinas (detail).
Photo courtesy Tom Fox, The SWA Group, Houston.

Spanish marble, carved at the studio of Sem Ghelardini in Pietrasanta, Italy
Location: Las Colinas Urban Center, Rochelle Boulevard off East John Carpenter Freeway
Funding: Commissioned by Trammell Crow
Comments: Three cows of red, black, and white marble and two of stone are located in a hilltop park between Texas Commerce Bank and Waterside Commons office complex. Each weighs 4 to 5 tons.

Fillerup, Peter

(American)

TRAIL TO MANHOOD 1984

Figurative; 6'10" H; bronze
Location: 1329 West Walnut Hill Lane
Funding: Donated to the Boy Scouts of America in 1989 by the Regional Board and staff

Glen, Robert

(East Africa)

THE MUSTANGS OF LAS COLINAS
1984

Figurative; larger than life-size; bronze cast at Morris Singer Foundry in Basingstoke, England
Location: Las Colinas Urban Center, Williams Square, 5215 North O'Connor Boulevard
Funding: Las Colinas Corporation, commissioned by Ben H. Carpenter
Comments: Robert Glen, best known as a sculptor of African wildlife, spent almost seven years creating *The Mustangs.* The entire herd comprises one of the largest equine sculptures in the world. The SWA Group of landscape architects designed the setting—a meandering creek curving across the granite abstraction of a flat,

295

arid Texas prairie. The realistic effect of water splashing around the horses' hooves as they gallop through the creek is achieved by emitting water under high pressure through a narrow opening along the top of a copper pipe shaped around each hoof. The history of the mustang and its significance to the American West is inscribed on a large text panel nearby. In part, the inscription by J. Frank Dobie reads, "Before the eighteenth century was far advanced, bands of mustangs were ranging over Texas and the northern plains, wilder than deer and as free as eagles. . . . These horses bore Spanish explorers across two continents. They brought to the plains Indians the age of horse culture. Texas cowboys rode them to extend the ranching occupation clear to the plains of Alberta. Spanish horse, Texas cow pony, and mustang were all one in those times when, as sayings went, a man was no better than his horse, and a man on foot was no man at all." The *Mustangs*, Williams Square, and the Las Colinas Urban Center development received the 1985 American Society of Landscape Architects Honor Award, the 1985 Urban Land Institute Award for Excellence, and the 1988 National Sculpture Society Distinguished Sculpture Award. Williams Square is dedicated to Dan C. Williams and his wife, Carolyn Carpenter Williams.

Cross River IV. Photo by Robert Little.

Shaping Up. Photo by Robert Little.

Johnson, J. Seward, Jr.

(b. 1930 American)

SHAPING UP 1987

Figurative; life-size; bronze cast at J. Seward Johnson's foundry near Trenton, New Jersey, and sited by Sculpture Placement, Ltd., Washington, D.C.
Location: Four Seasons Resort and Club, 4150 North MacArthur Boulevard, adjacent to outdoor jogging track
Funding: Four Seasons Resort and Club

McDonnell, Joseph Anthony

(b. 1936 American)

CROSS RIVER IV 1983

Abstract; 7'6" H; polished bronze
Location: 125 East John Carpenter Freeway
Funding: Harlan Crow

Stele I. Photo by Robert Little.

Boy Scout Statue. Photo courtesy
Boy Scouts of America National Office, Irving.

STELE I *1982*

Abstract; 20' H; polished bronze
Location: Las Colinas Urban Center,
Waterway Tower, 433 Las Colinas
Boulevard
Funding: Harlan Crow

TRIPLE CUBES *1982*

Abstract; 6' H × 8' W; anodized
bronze
Location: IBM Building,
1212 Corporate Drive
Funding: Harlan Crow

McKenzie, R. Tait

(1867–1938 American/Canadian)

BOY SCOUT STATUE *1937*

Figurative; life-size; bronze cast at the
Modern Art Foundry in Long Island,
New York
Location: National Office of the Boy
Scouts of America, 1325 Walnut Hill
Lane
Funding: Donated in 1955 to the Boy
Scouts national headquarters in
Brunswick, New Jersey, by the
Philadelphia Council of Boy Scouts
Comments: Cast in 1955 and erected
at the Boy Scouts of America head-
quarters in Brunswick, New Jersey,
this statue was moved to Irving in
1979 for placement at the new
national office. Dr. McKenzie created
his first Boy Scout statuette in 1915.
The figure represented the ideal Boy
Scout as a tangible symbol of
Scouting. The first life-size model
was unveiled in 1937 at the headquar-
ters of the Philadelphia Council,
which still holds the copyright.
Recognized worldwide as a pioneer in
the field of physical education,
McKenzie served as a professor of
physical therapy on the medical
faculty at the University of Pennsyl-
vania. One of his most famous
sculptures is the Scottish-American
war memorial in Edinburgh, Scotland.

297

Prometheus. Photo by Robert Little.

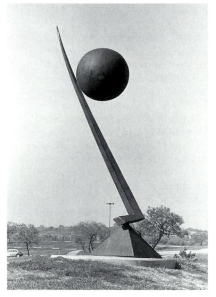

Descending Sphere. Photo by Robert Little.

Medellín, Octavio

(b. 1907 American/Mexican)*

PROMETHEUS *1978–1979, placed 1987*

Abstract; 15' H; welded copper tubing and handmade glass
Location: North Lake College campus, 5001 North MacArthur Boulevard, adjacent to the lake
Funding: Commissioned by Core Lab, which donated it to the college in 1987

Miller, John Brough

(b. 1933 American)*

DESCENDING SPHERE *1983*

Abstract; 14'6" H; steel
Location: North Lake College, 5001 North MacArthur Boulevard
Funding: Competition sponsored by North Lake College

ROBOTISTIC PLAY *1984*

Abstract; 16'5" H; steel
Location: Las Colinas Urban Center, National Museum of Communications, 6305 North O'Connor Road
Funding: Trammell S. Crow

Moroles, Jesús Bautista

(b. 1950 Native Texan)*

INTERLOCKING *1983*

Abstract; 9' × 4' × 3'; Oklahoma granite
Location: Las Colinas Urban Center, Caltex House, 125 East John Carpenter Freeway
Funding: Private funding, placed through Dixie Christian

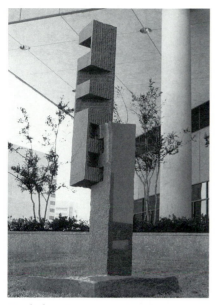

Interlocking. Photo courtesy Jesús Bautista Moroles.

Ong'esa, E. Omweri

(East African)

IN SEARCH OF WATER *1984*

Figurative; 4' H; carved stone
Location: Las Colinas Urban Center, Caltex House, 125 East John Carpenter Freeway
Funding: Gift of Caltex Oil (Kenya) Limited
Comments: When Caltex opened its office in Las Colinas, other branches of the company donated works of art from their respective locations all over the world. This work came from Kenya. The sculpture depicts an East African folklore tale about collective responsibility. The plaque reads in part: "For survival during a severe drought, man and his animal neighbors unsuccessfully dig for underground water. A waiting rabbit, with one kick, finds water, surprising the tired larger animals, and the man carries a flag up the mountain to signal success."

Orlando, Joe

(b. 1949 American)*

A PIECE FOR TRANSFER and SPIRO *1983*

Abstract; 6'3" H and 4'6" H, respectively; bronze
Location: Las Colinas Urban Center, 433 Las Colinas Boulevard
Funding: Harlan Crow
Comments: *A Piece for Transfer* is installed next to the canal, and *Spiro* is installed in the building's courtyard. The unusual patina on these two companion pieces is made from a hepar (liver of sulfur) base with cupric nitrate overlay.

Sanders, Jerry Dane

(b. 1949 American)*

HYPERBOLIC PARABOLOID *1983*

Abstract; 10' × 20' × 12'; stainless steel
Location: Las Colinas Urban Center, behind 122 West John Carpenter Freeway
Funding: Harlan Crow

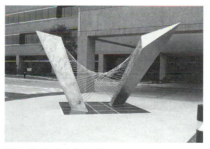

Hyperbolic Paraboloid. Photo by Robert Little.

Seitz, Philip

(American)

SAINT BERNARD *circa 1962*

Portraiture; life-size; welded steel
Location: Cistercian Monastery, One Cistercian Road

299

Funding: Philip Seitz and the monastery
Comments: The artist fabricated this work from welded steel while he was serving as a priest in the Cistercian Order and assigned to Cistercian Monastery.

Stein, Sandi

(b. 1946 Native Texan)*

RISING *1980*

Abstract; 3'6" H; Georgia marble
Location: Texas Commerce Bank, 545 East John Carpenter Freeway
Funding: Harlan Crow
Comments: Stein carved this work on a street corner in downtown Dallas. Visiting with onlookers and occasionally inviting them to use the hammer and chisel on a piece of scrap stone, the artist provided an opportunity for direct community involvement in an ongoing public art project. *Rising* was moved to Las Colinas in 1986.

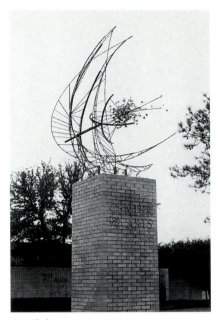

Untitled. Photo courtesy Hilliard Stone.

Stone, Hilliard M.

(b. 1927 Native Texan)*

UNTITLED *1979*

Abstract; 12' H; welded steel and brilliantly colored glass nuggets
Location: Jaycee Park Center for the Arts, 2000 Airport Freeway
Funding: Commissioned by Irving Art Association and donated by the association to the city of Irving

Summers, Robert

(b. 1940 Native Texan)*

BYRON NELSON *1992*

Portraiture; larger than life-size; bronze
Location: Four Seasons Resort and Club, 4150 North MacArthur Boulevard

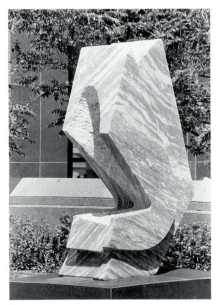

Rising. Photo by Robert Little.

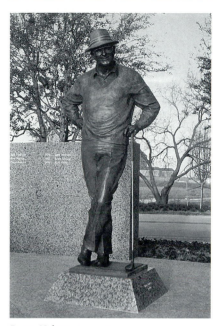

Byron Nelson. Photo by Mark Humphries, courtesy Four Seasons Resort and Club.

Funding: United Services Automobile Association, San Antonio
Comments: A portion of the inscription reads, "Byron Nelson personifies the true champion: valiant in competition, humble in victory. His performance, unchallenged in the history of golf, ranks among the greatest feats in sports." The Four Seasons Resort and Club is host site of the Byron Nelson Classic, a PGA Tour event that benefits the Salesmanship Club of Dallas and its year-round camp, education program, day treatment center, and family counseling service for boys and girls with significant emotional and behavioral problems.

Thursby, Peter

(b. 1930 British)

JUBILEE FOUNTAIN *1979*

Abstract; 15' H; granite and bronze
Location: Las Colinas Towers Plaza behind 201 East John Carpenter Freeway
Funding: Southland Financial Corporation
Comments: This fountain centerpiece, a commemorative sculpture commissioned in 1977 for Queen Elizabeth II's Silver Jubilee, is an enlarged casting of the original design.

Varga

(Hungarian)

OUR LADY OF DALLAS
between 1957 and 1962

Portraiture; life-size; cast stone
Location: Cistercian Monastery, One Cistercian Road
Funding: Donated to the monastery by the Roland Eakin family in memory of Michael M. Le Brun
Comments: Information on this work is difficult to obtain because the monastery's early records are written in Hungarian, and they have not been organized and translated. Records indicate that the statue is the work of a man named Varga, a Hungarian living in Canada at the time of the commission. Adams and Adams Architects, who designed the monastery, ordered the work on behalf of the Eakin family. Heri Bartscht designed the installation site.

Von Ringelheim, Paul

(b. 1934 American/Austrian)

EQUINOX *1980*

Abstract; 40' H; stainless steel
Location: 351 Phelps Court
Funding: Lombard Properties, Inc., and Pow-Tex Corporation

301

Woitena, Ben

(b. 1942 Native Texan)*

MERIDA *1983*

Abstract; 8' × 7' × 12'; welded
aluminum
Location: 8505 Freeport Parkway
Funding: Harlan Crow

Merida. Photo by Robert Little.

Jacksonville

Jefferson

Junction

Jacksonville

Gould Monument Works

(American)*

**CHEROKEE COUNTY
WAR MEMORIAL** *1928 and 1992*

Figurative; life-size; marble and
granite
Location: Jacksonville City Park at
Main and West Larissa
Funding: Jolly Workers Club in 1928
and local citizens in 1992
Comments: The focal point of this
memorial is a life-size doughboy
statue placed in 1928 by the Jolly
Workers Club, a group of business
and professional women in Jackson-
ville. The women ordered the statue
from Carrara, Italy, through Gould
Monument Works, according to
Howard Jowers, who currently leases
the company. Gould Monument
Works was established in 1889; at the
time it was sold by C. R. Thompson
in 1978, it advertised as the largest
monument manufacturer in the state.
In 1990, a storm knocked the
doughboy statue from its base and
broke it into nineteen pieces. Local
residents immediately began a fund
drive to repair the figure and to
expand the monument to include all
Cherokee County war dead. The new
portion of the monument was
designed by Betty Higginbotham and
built by Howard Jowers. The marble
and granite monuments that flank
the repaired doughboy list the
county's casualties in World Wars I
and II, Korea, and Vietnam. The
memorial was dedicated on
May 30, 1992.

Cherokee County War Memorial.
Photo by Robert Little.

Jefferson

Glick, Tommie Wurtsbaugh

(Native Texan)

THOMAS JEFFERSON *1984*

Portrait bust; larger than life-size;
bronze
Location: Thomas Jefferson Memorial
Park, 112 Austin Street
Funding: Commissioned and funded
by the Historical Jefferson Foundation
and private contributions

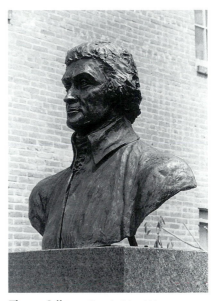

Thomas Jefferson. Photo by Robert Little.

Comments: Glick's bust of the third president of the United States is the centerpiece of Thomas Jefferson Memorial Park, located in Jefferson's Historic Riverfront District. The sculpture and the park are designed to stimulate learning and to make art and history an integral part of the life of the community. Quotations from Jefferson's writings are inscribed on the sculpture's 6-foot, Dakota granite pedestal, built by Allen Monuments, Inc., in Texarkana. The pedestal also lists the achievements for which Jefferson wanted to be remembered: the author of the Declaration of Independence, the creator of the Statute of Virginia for Religious Freedom, and the father of the University of Virginia. The following quote from Jefferson is inscribed on the back of the monument: "Still one thing more, fellow citizens—a wise and frugal government, which shall restrain men from injuring one another, which shall leave them otherwise free to regulate their own pursuits of industry and improve-

ment, and shall not take from the mouth of labor the bread it has earned—this is the sum of good government." Glick, a native of Jefferson, resides in Great Neck, Long Island, New York, and Jefferson, Texas. Robert Coles of Virginia, a fifth-generation great-grandson of Thomas Jefferson, attended the dedication on July 4, 1989, the 163rd anniversary of Jefferson's death.

Mott, J. L., Iron Works

(American)

THE STERNE FOUNTAIN *1913*

Figurative; 12' H; bronze
Location: Intersection of Market and Lafayette
Funding: Given to the city of Jefferson in honor of Ernestine and Jacob Sterne by their children
Comments: Guiseppe Moretti (1859–1935, American) sculpted the fountain centerpiece, a statue of the Greek goddess Hebe. In 1981, Phoebe Dent Weil, of Washington University Technology Associates, Inc., in Saint Louis, Missouri, supervised the fountain's restoration with a low-pressure blasting technique that used tiny glass beads instead of sand. This process revealed the natural color of the bronze, a bright salmon pink. Controlled oxidation with heat and chemicals produced the current dark patina. The fountain has bowls at three levels to accommodate people, horses, and small animals. In 1983, it received an official Texas historical marker.

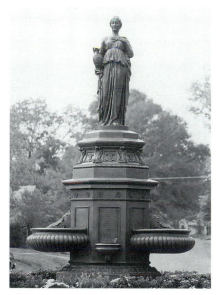

The Sterne Fountain. Photo by Robert Little.

305

Teich, Frank

(1856–1939 American/German)*

CONFEDERATE SOLDIER STATUE
1907

Figurative; life-size; zinc
Location: Marion County Courthouse grounds
Funding: Dick Taylor Camp, United Confederate Veterans, and public donations
Comments: In 1983, Phoebe Dent Weil, of Washington University Technology Associates, Inc., supervised the restoration of this statue. During the restoration process, the Saint Louis firm planned to decipher the pedestal's faded inscription, which had been the object of much speculation over the past three-quarters of a century. But before the firm returned to Jefferson to restore the monument, two determined local historians using white body powder decoded the message, "For Oakwood Cemetery." Research of old newspa-

The Deer Horn Tree. Photo by Fane L. Burt, courtesy Kimble Business and Professional Women's Club.

per accounts revealed that the statue was to be placed in Oakwood Cemetery, where so many Confederate soldiers are buried. At the last moment, the Dick Taylor Camp chose the park site instead, making the dedication inscribed by Teich Monument Works inaccurate but not completely erased.

Junction

Kimble Business and Professional Women's Club

THE DEER HORN TREE *1968*

Figurative; 8' H; deer antlers and wire
Location: Deer Horn Park,
1502 South Main
Funding: Kimble Business and Professional Women's Club
Comments: The members of the women's club designed and built this tree in recognition of the area's abundant deer population.

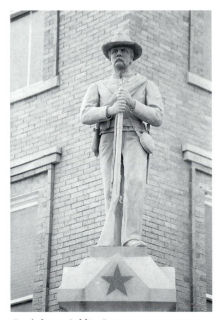

Confederate Soldier Statue. Photo by Robert Little.

Kaufman

Kerrville

Kilgore

Killeen

Kingsville

Kingwood

Kaufman

Unknown Artist

CONFEDERATE SOLDIER STATUE
1911

Figurative; larger than life-size; granite
Location: Kaufman County Courthouse grounds
Funding: Public donations through a campaign drive led by local resident Joseph Huffmaster
Comments: The Kaufman County Confederate soldier statue continues to survive attacks more than 100 years after the conclusion of the American Civil War. The original gun barrel, frequently defaced and finally lost or stolen, has been replaced with an actual gun barrel. The original base, repeatedly toppled by local hoodlums, has been moved by county officials to a remote area, where high grass protects it from would-be vandals.

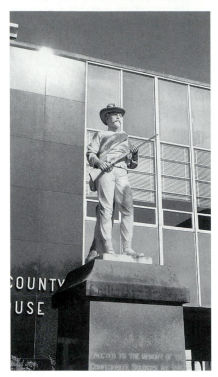

Confederate Soldier Statue. Photo by Carol Little.

Kerrville

Moyers, William

(American)

WIND AND RAIN *1994*

Figurative; life-size; bronze
Location: Cowboy Artists of America Museum, 1550 Bandera Highway
Funding: Donated to the museum by Bill and Neva Moyers

The original base of this Kaufman County Confederate soldier statue, now hidden from would-be vandals. Photo by Carol Little.

White, Fritz

(b. 1930 American)

OUT OF THE MYSTIC PAST
cast 1985

Figurative; 10' H × 13' W; bronze cast at Art Castings of Loveland, Colorado
Location: Cowboy Artists of America Museum, 1550 Bandera Highway
Funding: Donated to the museum by Lamar Savings and Loan in Austin
Comments: Stanley Adams, chairman of the board of Lamar Savings and Loan, commissioned this work from White after seeing the maquette-sized version. He was so impressed with the piece that he wanted to make it available to the general public. It won Best of Show and a gold medal at the 1983 Cowboy Artists of America Exhibition in Phoenix, Arizona.

Out of the Mystic Past. Photo by Robert Little.

Kilgore

Duncan, William G.

(American)

M. T. "LONE WOLF" GONZAULLAS *1986*

Portraiture; life-size; bronze
Location: Lou Della Crim House, 201 North Longview
Funding: Commissioned by John Robert Florence, Jr., great-grandson of Lou Della Crim

Comments: Captain M. T. Gonzaullas of the Texas Rangers helped return law and order to Kilgore and the East Texas area during the turbulent days of the oil boom in the early 1930s. The statue wears the official Ranger uniform and carries a detailed rendering of Gonzaullas' custom-made Smith and Wesson .44/40 revolvers.

Killeen

Lake, Albert L.

(American)*

LYNDON BAINES JOHNSON *1976*

Portraiture; 9' H; bronze
Location: Central Texas College campus
Funding: Donations raised through the Citizens Advisory Committee
Comments: Lake portrays the thirty-sixth president of the United States holding a book in one hand while

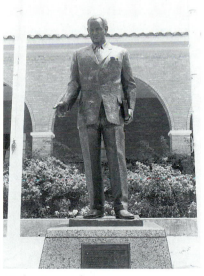

Lyndon Baines Johnson.
Courtesy Central Texas College.

raising the other hand in a beckoning gesture, inviting all people to seek higher learning. The president dedicated Central Texas College in 1967 and returned as a private citizen in 1970 for the dedication of the Lyndon Baines Johnson Plaza and the Lady Bird Johnson Center for the Performing Arts. The statue, which is located in the plaza, is intended to emphasize the importance placed on education by the Johnson administration's Great Society.

Kingsville

Bott, H. J.
(b. 1933 American)*

PLAY *1965*

Abstract; 14' × 22' × 10'; steel and concrete
Location: Dick Kleberg Park, South Escondido Road off Business Highway 77
Funding: Commissioned by the Kingsville Lions Club
Comments: The diversity of Bott's work extends from representational bas-relief to modern abstractions. The head of this stylized, black-and-yellow lion is a climbing gym; the mouth is a slide. Bott also has provided numerous bas-relief plaques placed throughout the state as part of the official Texas Historical Marker Program.

Hinojosa, Armando
(b. 1944 Native Texan)*

LEADERS OF THE PACK *1986*

Figurative; 10' × 10' × 4'; bronze cast at Stevens Art Foundry in Bulverde
Location: Texas A&M–Kingsville
Funding: Texas A&M–Kingsville Alumni Association
Comments: For the university's sixtieth anniversary, the alumni association commissioned a limited edition of 200 signed and numbered desk-size bronze javelinas, the sale of which helped to finance this life-size sculpture. The first students of the school chose the javelina for their mascot in 1925. Hinojosa is an alumnus and a former Texas State Artist.

Kingwood

Young, Ken
(American)*

FOREST WIND *1986*

Abstract; 10' × 7' × 3'; welded bronze
Location: Park adjacent to the Harris County Public Library, Kingwood Branch, 4102 Rustic Wood Drive
Funding: Given by Friendswood Development Company to the city of Kingwood

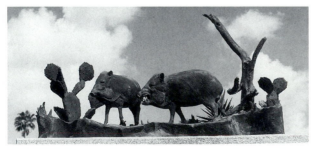

Leaders of the Pack. Photo by Hugh Lieck, courtesy Texas A&M–Kingsville.

L

La Grange

Lampasas

Laredo

Liberty

Liberty Hill

Llano

Lockhart

Longview

Lubbock

Luckenbach

Lufkin

Luling

La Grange

Bourdelle, Pierre, and

(died 1966 American/French)*

Raoul Josset

(1898–1957 American/French)*

MIER EXPEDITION AND DAWSON'S MEN MEMORIAL *1937*

Figurative; 48' × 10' × 7';
bronze and Texas limestone
Location: Monument Hill, 1 mile
south of La Grange and 10 miles
north of Schulenburg, off Texas 77
Funding: Funds allocated by the 1936
Commission of Control for Texas
Centennial Celebrations
Comments: A tall limestone shaft
rises over the entombed remains of
the men who died in the Dawson
Massacre at Salado Creek in 1842 and
the members of the Mier Expedition
who died at Rancho Salado in Mexico
six months later. The Salado incident
involved the notorious Black Bean
Episode, in which the Mexican
government ordered that every tenth
prisoner be executed. The Texians

*Mier Expedition and Dawson's Men
Memorial.* Photo courtesy *Texas Highways Magazine.*

drew beans to determine which men
would be spared; black beans signified
death. Located at one of the most
scenic sites in Texas, the monument
was designed by the Austin architec-
tural firm Page and Southerland.
The contractor was L. W. Stolz of
La Grange. Bourdelle executed the
5-foot-wide plaster mural and Josset
sculpted the 10-foot-high winged
female figure. Bronze plaques on the
shaft list the names of the victims.

Lampasas

Williams, Charles Truett

(1918–1966 Native Texan)*

PLANT FORMS *1962*

Abstract; 7' H; brass, copper, and
other metals
Location: Lampasas Public Library,
201 South Main
Funding: Private donation to the
library
Comments: Originally a fountain
centerpiece, this sculpture was
restored in 1994. The fountain
portion of the work is no longer
operational.

Laredo

Garcia, Roberto, Jr.

(b. 1954 Native Texan)*

GEORGE WASHINGTON *1990*

Portraiture; larger than life-size;
bronze cast at the artist's foundry
in Kingsville
Location: 1110 Houston Street
Funding: Commissioned by Elizabeth
Walker Quiroz, Mr. and Mrs. Evan
Quiroz, Evan Quiroz, Jr., Gene
Walker, and J. O. Walker in memory
of James Oliver Walker, Sr.

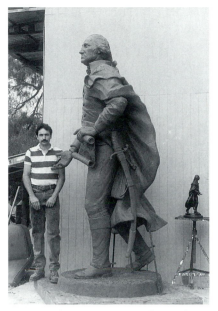

Sculptor Roberto Garcia, Jr., working on his monumental statue of George Washington at the artist's studio foundry in Kingsville.
Photo courtesy Roberto Garcia, Jr.

Comments: The vision to place a statue of Washington in Laredo began during the 1980s with Connie Kazen, wife of the late U.S. congressman Abraham Kazen, Jr., of Laredo. Connie Kazen is a member of the Society of Martha Washington and a supporter of the Washington's Birthday Celebration Association, an organization dedicated to promoting American patriotism and the ideals that Washington embodied. Citizens of Laredo began observing Washington's birthday in 1898; this statue was dedicated in 1992 on the ninety-fifth anniversary of the first celebration. Roberto Garcia, Jr., received a fine arts degree from the University of Texas at Austin, where he became a student assistant to retired professor Charles Umlauf. Garcia later furthered his studies in bronze casting at the New Jersey foundry of J. Seward Johnson, Jr.

Guerra, Don Joaquín Gutiérrez, and Agustín Guerra

(Mexican)

GENERAL IGNACIO SEGUIN ZARAGOZA *1980*

Portraiture; larger than life-size; bronze
Location: San Agustín Plaza, facing Zaragoza Street
Funding: Given to the city of Laredo by Governor Fernández de Lara of Puebla, Mexico, and the Mexican people
Comments: Also located in San Agustín Plaza is a small cast-stone statue of Saint Augustine, patron saint of Laredo, which was sculpted in the 1960s by an unidentified artist in Monterrey, Mexico, and donated to Laredo by the Order of the Alhambra 64 and public contributions in 1969.

Hinojosa, Armando

(b. 1944 Native Texan)*

REACHING FOR A STAR *circa 1988*

Figurative; life-size; bronze
Location: Honoré Ligarde Elementary School, 2805 South Canada
Funding: Laredo School Board of Trustees

Liberty

Whitechapel Bell Foundry, Ltd.

(British)

LIBERTY BELL REPLICA *1960*

Figurative; 3'11" diameter;
77 percent copper and 23 percent tin
Location: Liberty Bell Plaza, 1710 Sam Houston Avenue
Funding: Benefactors of the Liberty Muscular Dystrophy Research Foundation, Inc., under the coordination of television station KTRK-TV in Houston

313

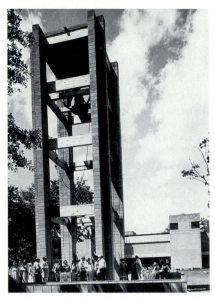

Dedication of *Liberty Bell Replica*, in 1976.
Photo courtesy *Texas Highways Magazine*.

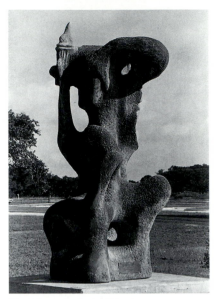

The Libertarian by Mel Fowler.
Photo by Robert Little.

Comments: While searching for a symbol for the fight against muscular dystrophy, William T. Wagner of KTRK-TV in Houston learned that the Whitechapel Bell Foundry in London had the original pattern and molding pit used in casting America's Liberty Bell. Wagner enlisted contributions to commission this first exact replica, which was cast in the same molding pit and shaped by the same strickle as the 1752 Liberty Bell. The bell arrived in Texas in 1960, but it did not have a permanent home until 1976. As an American Bicentennial project, the citizens of Liberty organized a committee to secure the bell for their city and raised funds to build a bell tower. Liberty is a fitting location because Sallie and Nadine Woods, both victims of muscular dystrophy and natives of Liberty, established in 1950 with the assistance of other local residents the first organization in America to support research, patient aid, and education in muscular dystrophy.

Liberty Hill

Special Collections and Sculpture Gardens in Liberty Hill

The International Sculpture Park is located on the campus of Liberty Hill High School at Loop 332 and Texas 29. The sculpture park began as an American Bicentennial project organized by native Texan Walter Melville "Mel" Fowler (1921–1987) and financed through the efforts of individual artists and volunteers in the community without any federal or state monies. The project began in 1976 during the International Sculpture Symposium, which was held in Liberty Hill under Fowler's leadership. The symposium attracted 25 sculptors from six countries, and each artist, including Fowler, created one or more sculptures to donate to the community for the park project. In 1987, the park was moved from its first location in downtown Liberty Hill to the new high school campus,

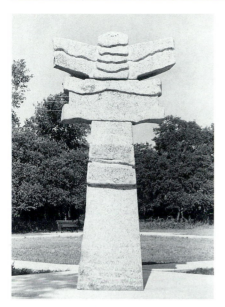

Guardian by Brad Goldberg. Photo by Robert Little.

where winding concrete walkways with tree-shaded benches lead to sculptures by several artists who have ties to Texas: Mel Fowler, Duff Browne, Tom Sayre, Jim Thomas, Brad Goldberg, Tom Piccolo, Dana Smith, Arthur Williams, Mary Paige Huey, Sharon Corgan-Leeber, Nati Escobedo, Dolores Cumley, and David Eugene Everett. Artists from other states and from France, Canada, Japan, Germany, and Italy also are represented. In 1977, the International Sculpture Park project and the city of Liberty Hill won the Texas

John's Knot by Tom Sayre. Photo by Robert Little.

Arts Award for best support of the arts in a community of under 100,000 population. Mel Fowler, an internationally recognized artist, was best known for his experiments with negative space in his delicate, abstract stone carvings. He maintained studios in Liberty Hill and in Pomezzana, Italy, where he died only a few months after realizing his dream of finding a suitable setting for the sculpture park in Liberty Hill.

Llano

Finlay, Jack, and James Finlay

(Native Texans)*

CONFEDERATE SOLDIER STATUE
1915

Figurative; larger than life-size; Texas granite
Location: Llano County Courthouse grounds
Funding: Llano County Chapter 2500, United Daughters of the Confederacy, and public donations
Comments: Jack and James Finlay first learned about stone carving and polishing from their father, J. K. Finlay, a pioneer in the Texas granite industry. J. K. Finlay began working with stone in 1888 at Finlay's Mill, located eight miles from Llano on the Llano River. Using a crude polisher consisting of a rubbing wheel that rubbed sand against the stone, he worked for three weeks to polish one column of granite used in the building of the State Capitol in Austin. After the turn of the century, Finlay and his sons established a cutting and finishing plant in Llano. It was in their Llano plant that James cut this statue while his brother Jack made the base. Reputedly, their father served as the model.

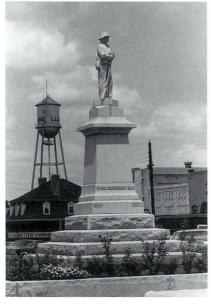

Confederate Soldier Statue. Photo by Carol Little.

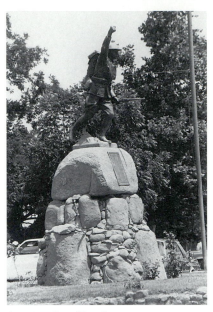

American Doughboy Statue. Photo by Carol Little.

Teich, Frank

(1856–1939 American/German)*

AMERICAN DOUGHBOY STATUE
1918

Figurative; larger than life-size;
bronze cast in 1921 at the American
Bronze Foundry in Chicago
Location: Llano County Courthouse
grounds
Funding: Llano Shakespeare Club and
public donations
Comments: Frank Teich established
Teich Monument Works in 1901; by
1935, he was operating ten quarries
and five finishing plants in Llano.
Teich's World War I soldier appears to
have been influenced by E. M.
Viquesney's *Spirit of the American
Doughboy,* but this work preceded
Viquesney's design.

Lockhart

Pyramid Stone Company

(American)*

COME UNTO ME *1952*

Portraiture; larger than life-size;
cast stone, a marble, silica sand,
and cement mixture
Location: First United Methodist
Church, 313 West San Antonio
Funding: Donated by Mr. and Mrs.
Fred Adams in memory of Mr. and
Mrs. George Adams
Comments: Frank Monaco, Sr., of
Pyramid Stone Company designed
this statue of Jesus.

Longview

Deming, David

(b. 1943 American)*

SLIP-SLIDE *1979*

Abstract; 4' × 7' × 5'; Cor-ten steel
Location: Longview Art Museum,
102 West College Avenue
Funding: Purchase award for the
museum's 1980 Invitational

Slip-Slide. Photo by Robert Little.

Knoblock, Keith

(b. 1941 American)

R. G. LETOURNEAU *1989*

Portraiture; life-size; bronze
Location: LeTourneau University
campus
Funding: Private donors and
LeTourneau University
Comments: R. G. LeTourneau
invented and pioneered the use of
components now standard in many
types of construction equipment.
With plants in Texas, Georgia,
Illinois, Mississippi, and California,
the LeTourneau Company built 70
percent of the earth-moving equip-
ment used by the United States
Armed Forces during World War II.
LeTourneau's statue is accompanied
by an official state historical marker.
Another casting of this work is
installed at Glen Oak Park in Peoria,
Illinois, where LeTourneau first

started his earth-moving industry.
Knoblock is an associate professor in
art at Illinois State University. He has
taught sculpture and drawing at the
university for 22 years, and he has
placed large publicly sited sculptures
in Peoria, Bloomington, Decatur,
Chicago, and Springfield, Illinois.

Logan, Neil

(b. 1949 American)*

SERVED WITH HONOR *1983*

Figurative; life-size; bronze
Location: Gregg County Courthouse
grounds
Funding: Gregg County Veteran's
Memorial Committee through public
donations, with the largest contribu-
tion derived from a benefit concert
underwritten by Longview resident
Billy Arnold and starring country-
and-western singer Mel Tillis
Comments: The artist's sketch for
this memorial was prepared by
Logan's associate Monty Graham.
James Diffenderfer, who served with

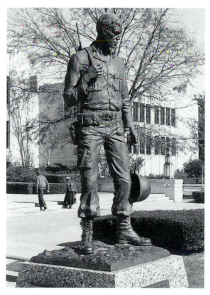

Served with Honor. Photo by Carol Little.

317

Logan in the Navy aboard the USS *Kittyhawk,* worked throughout the project as a special assistant to the sculptor. All three men are Vietnam veterans. The statue depicts a modern soldier outfitted with equipment and clothing used in World War I, World War II, Korea, and Vietnam. The inscription reads, "In honored memory of all Gregg County veterans of all wars, living and dead." *Served with Honor* is unusual among American war memorials in that the soldier's expression is war-weary, and his face is slightly downcast. Yet his countenance is not intended to imply defeat but rather to show the fatigue and exhaustion of a combat soldier, his removed helmet signifying completion of a patrol and his rifle still slung and ready for action.

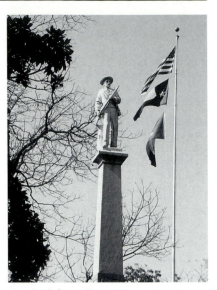

Our Confederate Heroes. Photo by Carol Little.

Teich, Frank

(1856–1939 American/German)*

OUR CONFEDERATE HEROES
1911

Figurative; larger than life-size; white Italian marble and gray Texas granite
Location: Gregg County Courthouse grounds
Funding: Richard B. Levy Chapter 1070, United Daughters of the Confederacy, through public donations of $3,000
Comments: At the base of the shaft, a life-size classical female figure raises her right hand as if to inscribe the names of Gregg County's Confederate heroes. The monument was dedicated in Bodie Park on June 3, 1911, and later moved to the courthouse grounds. In 1911, news reports noted that the monument was the culmination of a six-year labor of love on the part of the ladies of the Richard B. Levy Chapter, United Daughters of the Confederacy.

Wedemeyer, Henry

(1901–1991 Native Texan)*

MADONNA AND CHILD *1985*

Figurative; 4' H; carved limestone
Location: Trinity Episcopal Church, 900 East Padon
Funding: Donated to the church by Mr. and Mrs. D. W. Harris
Comments: Wedemeyer spent his youth in Houston, where he studied under Enrico Filberto Cerracchio; later, while living in San Antonio, he worked for fourteen years with Gutzon Borglum. Wedemeyer's Longview studio displays a bust of Theodore Roosevelt given to him by Borglum, his friend and mentor, upon completion of the Mount Rushmore project. Wedemeyer provided the design used by Borglum to sculpt the first clay model of the *Texas Trail Drivers Monument* in front of Pioneer Hall in San Antonio, and he designed the official Texas coat of arms commissioned by the Daughters of the Republic of Texas. A mosaic of the coat of arms is installed in the

Madonna and Child. Photo by Carol Little.

Saint Francis. Photo by Carol Little.

floor of the Texas State Capitol Extension. Wedemeyer also helped design portions of several historic buildings in San Antonio, including the sculptural work in the lobby and mezzanine of the old Aztec Theatre. His experience with Borglum prepared Wedemeyer for a later career as a draftsman and representative for various architects throughout the Southwest. In addition to *Madonna and Child* and *Saint Francis,* other local works by the Longview artist include bronze relief panels located at Longview Bank and Trust at 1st and Whaley streets. The reliefs, mounted at the base of a flagpole, depict scenes from Gregg County history. A similar work by the artist is located on the Longview campus of Kilgore College at 300 South High Street. At the time of his death in 1991, Wedemeyer was the only surviving honorary founding member of the prestigious San Antonio Conservation Society.

SAINT FRANCIS *1981*

Figurative; 4' H; carved limestone
Location: Trinity Episcopal Church, 900 East Padon
Funding: Given by Mr. and Mrs. Fred G. Monsour and the family, relatives, and friends of Maggie B. Thomas

Whitney, Mac

(b. 1936 American)*

HOUSTON WORKING STUDY *1982*

Abstract; 12'6" H; rolled steel painted bright red
Location: Benchmark Office Complex, 2020 Bill Owens Parkway South
Funding: Benchmark Developers
Comments: This scale model is one-fourth the size of the finished work, which is located in Stude Park in Houston.

319

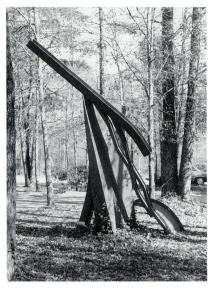

Houston Working Study. Photo by Carol Little.

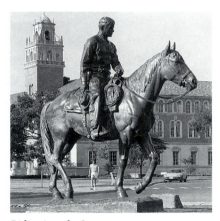

Riding into the Sunset. Photo courtesy
Texas Tech University Photographic Services.

Lubbock

Biggs, Electra Waggoner
(b. 1912 Native Texan)*

RIDING INTO THE SUNSET
circa 1947

Equestrian; 9'11" H, 3,200 lbs.; bronze
Location: Texas Tech campus,
Broadway Street entrance,
Amon G. Carter Plaza
Funding: Donated by Amon G. Carter
Comments: This statue depicts Will
Rogers riding his favorite horse,
Soapsuds. Amon G. Carter worked to
establish Texas Tech and served as
chairman of its first board of trustees.
He also was a close friend of Will
Rogers, who at one time punched
cattle near the site of the university.
Fraternity pledges have polished
Will's boots, washed Soapsuds' tail,
and counted its hairs. Tech students
delight in claiming that the horse's
posterior faces College Station, the
home of Texas A&M University.
Other castings of this work are
located in Fort Worth, Dallas, and
Claremore, Oklahoma. It was
installed in Lubbock on June 7, 1948.

Carter, Granville W.
(1920–1992 American)

WEST TEXAS PIONEER FAMILY
1971

Figurative; 3 figures, each larger than
life-size; bronze
Location: American State Bank Park,
1401 Avenue Q
Funding: Commissioned by American
State Bank, Lubbock
Comments: These figures represent
the hundreds of families who
migrated from Central and East Texas
between 1890 and 1910 to acquire
land and build a new life. The father
carries a hoe, symbolic of his inten-
tion to convert the grassy prairie into

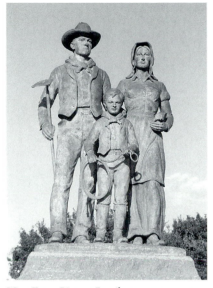

West Texas Pioneer Family. Photo by Robert Little.

farmland; the mother carries a Bible and a wildflower, reflective of faith and beauty; the boy loops a rope in his hands, signifying his hopes and aspirations for the future. A hoe, instead of a gun, in the father's hand emphasizes the establishment of law and order in the ranchlands of the South Plains prior to the establishment of the area's farming communities. This monument is intended to honor the faith, dreams, and determination of West Texas pioneer families. Granville Carter often created sculptures that involved poignant or inspiring themes, such as the heroic limestone figures of the archangels Michael and Gabriel at the National Cathedral in Washington, D.C., and the monumental portrait of George Washington kneeling in prayer, completed in 1990 for the Washington Memorial Park in Paramus, New Jersey. Carter served as a president of the National Sculpture Society, and he taught at the National Academy of Design in Manhattan for nineteen years. He was a national academician, an honor that

had been awarded to only 50 sculptors in the United States at the time of his death in 1992.

Cavness, John

(b. 1958 Native Texan)*

UNTITLED *1984*

Abstract; 9' × 10' × 3'; steel
Location: Texas Tech University campus, northwest corner of the law school building
Funding: Law School Class of 1984

Goodacre, Glenna

(b. 1939 Native Texan)

GOVERNOR PRESTON SMITH
1985

Portraiture; 9' H; bronze
Location: Texas Tech University campus, administration building courtyard
Funding: Private donations through a monument committee chaired by Representative Elmer Tarbox
Comments: This statue honors Governor Smith for his unwavering support of education in Texas during his 22 years in public service. Both Preston Smith and Glenna Goodacre attended Texas Tech University.

House, Jerry

(American)*

LUBBOCK SESQUICENTENNIAL MONUMENT *1986*

Figurative; 4'8" × 3'6" × 2'3"; bronze and red granite
Location: Lubbock County Courthouse grounds
Funding: Donated by J. D. Hufstedler in recognition of the cotton industry in the Texas High Plains region
Comments: Jerry House is the owner of House Bronze, Inc., a fine arts foundry in Lubbock. He fashioned the

mold for this work from an actual old bale of cotton secured with bagging and ties commonly used in the cotton industry in the 1930s.

O'Brien, Terrell

(b. 1947 Native Texan)*

DAYS OF YOUTH *1993*

Figurative; life-size; bronze cast at House Bronze, Inc., in Lubbock
Location: Methodist Children's Hospital, 3610 21st Street
Funding: Private purchase

THE EMPTY TOMB *1993*

Figurative; larger than life-size; bronze cast at House Bronze, Inc., in Lubbock
Location: Resthaven Memorial Park, 1600 block Frankford Avenue
Funding: Resthaven Memorial Park
Comments: Resthaven Memorial Park has many beautiful sculptural installations. In addition to *The Empty Tomb*, O'Brien has placed at the cemetery portrait statues of Old Testament prophets Ezekiel, Hosea, Isaiah, and Jeremiah, all dedicated on Memorial Day in 1985.

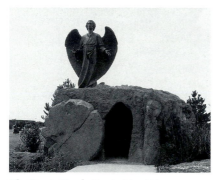

The Empty Tomb. Photo by Robert Little.

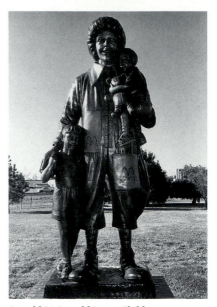

Ronald McDonald Loves Children.
Photo by Artie Limmer, courtesy Texas Tech University Photographic Services.

RONALD MCDONALD LOVES CHILDREN *1992*

Portraiture; 8'4" H; bronze cast at House Bronze, Inc., in Lubbock
Location: Lubbock Ronald McDonald House, 1212 Indiana Avenue
Funding: Commissioned by Richard Ligon, owner of the Plainview McDonald's restaurant, with support from other area McDonald's operators and Ken Fadke, the owner of several McDonald's restaurants in New Mexico
Comments: The Lubbock Ronald McDonald House is a home away from home for families with children receiving treatment in Lubbock hospitals. More than 3,000 families have resided at the Lubbock Ronald McDonald House since its doors opened on March 19, 1988. The true meaning of the phrase "the house that love built" has been captured in bronze by this work, which depicts Ronald McDonald with two young

children. The artist used two of his children as models for the boy and girl who appear with the famous clown.

Sandifer, Rosie

(b. 1946 American)

FREEDOM OF YOUTH *1986*

Figurative; life-size; bronze cast at House Bronze, Inc., in Lubbock
Location: Texas Tech University campus, Holden Hall courtyard
Funding: Private donations

PLAINS WOMAN *1983*

Figurative; 3'3" H; bronze
Location: Saint Mary of the Plains Hospital, 4000 24th Street
Funding: Private donation

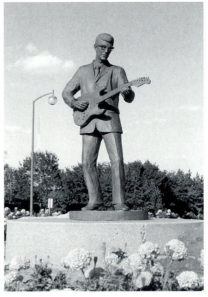

Buddy Holly. Photo by Robert Little.

Speed, Grant

(b. 1930 Native Texan)

BUDDY HOLLY *1980*

Portraiture; 7'5" H; bronze
Location: Lubbock Memorial Center, 800 block Avenue Q
Funding: Commissioned in 1979 by the Chamber of Commerce and the city of Lubbock
Comments: Grant Speed of Lindon, Utah, is an internationally recognized Western artist and gold medal winner at the Cowboy Artists of America Annual Show in Phoenix, Arizona. The artist portrays Buddy Holly (1936–1959) as the public remembers him, singing his songs and playing his electric guitar. Holly, a Lubbock native, was a musician-composer who influenced the course of rock-and-roll music.

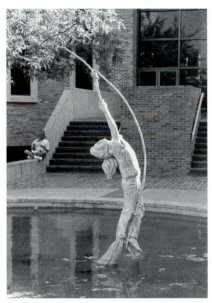

Freedom of Youth. Photo by Robert Little.

323

Taylor, Bruce

(American)

UNTITLED *1992*

Abstract; 18'8" above the water;
aluminum and galvanized steel
Location: Maxey Park, 4300 block
24th Street at Quaker Avenue
Funding: Lubbock Arts Alliance
Comments: Commissioned by the
alliance and later donated to the city,
this kinetic sculpture is installed in a
small lake. It is especially interesting
to view at night when the colorful
elements reflect on the water.

Tremonte, Sister Mary Peter

(b. 1930 Native Texan)*

FLIGHT INTO EGYPT *1986*

Figurative; 7' H; bronze
Location: Saint Mary of the
Plains Hospital, 4000 24th Street,
main entrance
Funding: Commissioned by the
hospital
Comments: The hospital has com-
missioned two other large bronze
sculptures from Sister Mary Peter.
The Good Samaritan (1987) is
installed near the emergency-room
entrance at 4000 24th Street, and
Angel of Mercy (1988) is installed
between 4000 and 4102 24th Street in
a plaza dedicated to the employees of
the hospital.

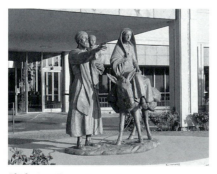

Flight into Egypt. Photo by Robert Little.

Umlauf, Charles

(1911–1994 American)*

ANGEL *1958*

Figurative; 12' H; cast stone
Location: Lubbock City Cemetery,
2011 East 31st Street
Funding: City of Lubbock
Comments: Signed by the artist and
Lubbock Monument Works, this
memorial is dedicated to World War I
veterans. The inscription reads, "To
those who served our country in time
of war, they gave their today for our
tomorrow."

Special Collections and Sculpture Gardens in Lubbock

Lubbock Lake Landmark is located on
the northern outskirts of the city off
Loop 289 on U.S. 84 (Clovis Road). A
joint venture between Texas Tech
University and the Texas Parks and
Wildlife Department, the landmark
contains a complete cultural record
dating from the Clovis Period (12,000
years ago). The Lubbock Lakesite
Foundation commissioned
Springtown artist Lisa Perry to create
life-size anatomically correct
representations of the giant short-
faced bear in 1993 and a bison in
1994. The foundation provided
reference material relative to the size,
shape, and conformation of the
animals based on skeletal remains
unearthed at the landmark. Perry's
models were cast in bronze at the
Bryant Art Foundry in Azle. In all,
replicas of four extinct Late Ice Age
animals are scheduled to be placed in
natural settings at the site.

**The Museum of Texas Tech
University Sculpture Garden** at 4th
Street and Indiana Avenue is located
at the entrance to the main museum
building. Other components of the
Museum of Texas Tech include

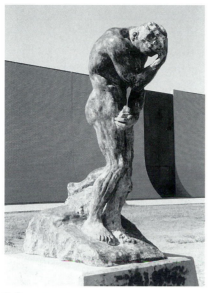

Judas. Photo by Robert Little.

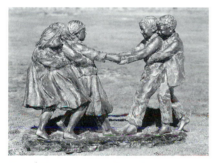

Tug-of-War. Photo courtesy Glenna Goodacre, Ltd.

Moody Planetarium, the Ranching Heritage Center, the research and educational elements of Lubbock Lake Landmark, the Natural Science Research Laboratory, the Val Verde County Research Site, and the Goodman Cotton Gin. The main museum building's entry plaza includes the following works: two large figurative bronze sculptures, **JUDAS** by Eros Pellini and **HOMMAGE A VALLEJO** by Alicia Penalba, both on long-term loan from Gwendolyn Weiner; **LARGE DEPOSI-TION I,** an 8'6" bronze abstract by

Jack Zajac also on long-term loan from Gwendolyn Weiner; **DRY DOCKS,** an oak and aluminum abstract by Novem Mason and Jack Lewis, placed at the museum by the city of Lubbock; and **TUG-OF-WAR** *1988,* a bronze figurative group by Glenna Goodacre, acquired with funds from the Clifford B. Jones Trust and the West Texas Museum Association

The Ranching Heritage Center of the Museum of Texas Tech University is located adjacent to the main museum building. Installed at the entrance to the center is **THE RANCHER: AN AMERICAN HERITAGE** *1987,* a bronze equestrian by Harold Holden of Kremlin, Oklahoma. Garland Weeks of San Angelo assisted the artist in sculpting the clay model, which was cast by House Bronze, Inc., in Lubbock. Holden first received a commission for a small version of this work to be presented annually to the recipient of the National Golden Spur Award. A group of nine organizations presents the award to individuals who have given unselfishly to the livestock industry. This life-size casting, dedicated on September 19, 1987, was funded by the Lubbock Cultural Affairs Council Grants Program and individual contributions.

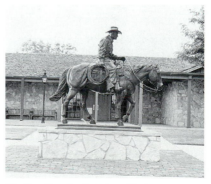

The Rancher: An American Heritage. Photo courtesy Ranching Heritage Association, Inc.

Luckenbach

Cook, Richard

(b. 1951 American)*

HONDO CROUCH *1977*

Portrait bust; smaller than life-size;
bronze
Location: The General Store
Funding: Kathy Morgan
Comments: Hondo Crouch was the
mayor of Luckenbach and a home-
spun poet, humorist, and philosopher
whose philosophical meanderings
gained statewide popularity.

Hondo Crouch. Photo by Carol Little.

Lufkin

Alexander, Malcolm

(American)

**THE TRANS ALASKA PIPELINE
MONUMENT WORKING MODEL**
1981

Figurative; 4' H; bronze
Location: Museum of East Texas,
503 North 2nd Street

Funding: Purchased from Atlantic
Richfield and donated to the museum
by Mr. and Mrs. Simon W.
Henderson, Jr.
Comments: A monumental casting of
this sculpture is located at Prudhoe
Bay near Valdez, Alaska. The
monument was commissioned by a
group of eight pipeline companies in
1977 and formally dedicated in 1980
"to the hardworking, courageous men
and women who toiled against time,
wilderness, and the Arctic environ-
ment to build the Trans Alaska
Pipeline," according to the work's
plaque. The Lufkin piece is one of six
scale models, and it is one-third the
size of the full-scale sculpture. The
five figures represent a surveyor, an
engineer, a welder, a teamster, and a
worker.

Ferguson, I. W. "Buckshot"

(Native Texan)*

ROADRUNNER *1980s*

Figurative; larger than life-size;
painted steel
Location: Angelina College campus,
main entrance on U.S. 59
Funding: Donated to the college by
Mr. and Mrs. Joe C. Denman, Jr.
Comments: Other works by Ferguson
located in Lufkin include welded-
steel figures of a golfer and a tennis
player installed on the grounds of
Colony Cove Country Club. Ferguson
lives in Pineland.

Roadrunner. Photo by Robert Little.

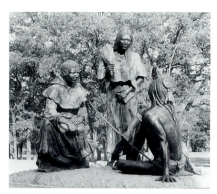

Angelina. Photo by Robert Little.

Knox, Jim

(b. 1922 American)

ANGELINA *1986*

Figurative; 3 figures, larger than life-size; bronze
Location: Lufkin Civic Center, 500 North 2nd at Howe Street
Funding: Angelina County Sesquicentennial Committee and public donations
Comments: Angelina is the only Texas county named for a woman. She was a member of the Tejas tribe and one of the first Christian converts in the province of Texas. She later became a missionary to her people. The eagle feather in her right hand represents the Indian sign of authority; the top row of cowry shells represents the Father, Son, and Holy Spirit; the second row represents the three great forces, Positive, Negative, and Neutral. Jim Knox, a resident of Tucson, Arizona, was among 32 artists who competed for this commission. Knox bases his figures of Native Americans on research gathered through the Bureau of Indian Affairs and the Smithsonian Institution. His works have been shown in Rome, London, Paris, Venice, and throughout the United States.

Roederer, Rick

(b. 1954 American)*

DANCING STARS *1987*

Abstract; 3 pieces; 5' H, 10' H, and 15' H; I beams
Location: Museum of East Texas side yard at North 2nd and Paul streets
Funding: Donated by the artist to the museum in memory of Mary Claire Newman
Comments: Using a heating torch with a 12-inch flame, Roederer bent heavy metal construction material to form these graceful, lyrical forms.

Viquesney, E. M.

(1876–1946 American)

SPIRIT OF THE AMERICAN DOUGHBOY *1922*

Figurative; life-size; bronze
Location: Angelina County Courthouse grounds
Funding: American Legion Post 113 and public donations

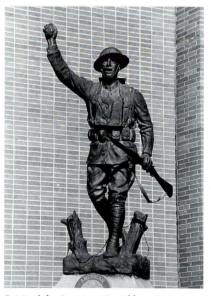

Spirit of the American Doughboy.
Photo by Robert Little.

Comments: E. M. Viquesney described the research he did prior to modeling his first doughboy in 1918, "I began mingling with the returned Doughboys, and found them anxious to give me their help. . . . Every buckle, every snap, every strap was carefully studied, arranged, passed on to other Doughboys for further criticism and re-arrangement. There is a row of stitching on the knapsack of this figure that was one of my last finds and which I believe appears on no other World War Statue" (*Owen Leader*, June 2, 1976).

Luling

Thomas, William "Speedy"

(Native Texan)*

PUMP JACK SCULPTURES 1986

Abstract; 16 pump jacks; steel and wood
Location: Highway 183 and locations throughout the city
Funding: Luling Chamber of Commerce
Comments: Responding to a slump in the Texas oil industry, the Luling Chamber of Commerce mustered its sense of humor and commissioned Thomas to transform idle oil-field equipment into public art that attracts tourist dollars and thus bolsters the local economy. Another interesting example of pump jack sculpture is located on Texas 154 west of Quitman in Northeast Texas. Across from Shell Western's office, a wooden cowboy straddles an active pump jack that resembles a bucking bronco. In December, the cowboy is replaced by a Santa Claus figure, and during football season the rider becomes a Dallas Cowboy. Unlike the Luling equipment, the Quitman well site has been in operation since 1943.

Luling *Pump Jack Sculptures.*
Photos by Robert Little.

Mansfield

Marfa

Markham

Marshall

Mason

McAllen

McKinney

Memphis

Midland

Mission

Moscow

Mount Pleasant

Muleshoe

Mansfield

Miller, John Brough

(b. 1933 American)*

UNTITLED *1982*

Abstract; 14'6" H; welded steel
Location: 102 Sentry Drive North
Funding: Paul E. Yarborough

Marfa

Special Collections and Sculpture Gardens in Marfa

The Chinati Foundation (La
Fundación Chinati), established by
American artist Donald Judd (1928–
1994), is located on Cavalry Row,
west of U.S. 67 at the southern edge
of Marfa. Perhaps the most famous
representative of the minimalist art
movement (a term and movement he
disavowed) of the 1960s, Judd moved
to Marfa from New York City in the
1970s and later began restoring
historic Fort D. A. Russell, a long-
abandoned cavalry post built around
the turn of the century to protect
frontier settlers. In the old fort's
renovated buildings and surrounding
acreage, works by Judd and other
important artists are on permanent
exhibit. Marking the grave site of
Louie, one of the last horses to serve
the 77th Cavalry, is Claes
Oldenburg's **MONUMENT TO THE
LAST HORSE** *1991*, a colossal
horseshoe with a nail protruding from
it. Judd's concern with the articula-
tion of space is exemplified by fifteen
large concrete works, stretching in a
1-kilometer line, placed in a field at
the western edge of the foundation
property. The works consist of two to
six units, each measuring 2.5 × 2.5 × 5
meters. While the outer dimensions
of the units are equal, the structures

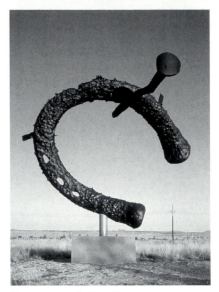

Monument to the Last Horse.
Photo by Todd Eberle, courtesy The Chinati Foundation.

Untitled. Photo by Marianne Stockebrand,
courtesy The Chinati Foundation.

Installation view of concrete works by
Donald Judd. Photo by Marianne Stockebrand,
courtesy The Chinati Foundation.

330

and placements vary, rendering the works open or enclosed. To avoid historical or symbolic associations, Judd used neither titles nor numbers to identify his works. Permanent installations at The Chinati Foundation are complemented by temporary exhibitions and artists' residencies. Tours are available to the public Thursday, Friday, and Saturday afternoons or by appointment.

Markham

Stephens, Danny

(b. 1947 Native Texan)*

THOMAS LETULLE *1986*

Portraiture; life-size; bronze cast at Shidoni Art Foundry in Tesuque, New Mexico
Location: LeTulle Ranch Public Cemetery northeast of Markham: 6 miles west of Bay City, turn north off Texas 35 onto Farm Road 1468; turn right on Farm Road 2175, passing the Marathon Plant; turn left on the unmarked road that leads to the cemetery
Funding: Thomas LeTulle
Comments: Several years before his death, LeTulle commissioned this sculptural group as a centerpiece for a 500-grave public cemetery. He also set up a $50,000 trust to provide maintenance on the property. LeTulle was well known for his unusual method of herding cattle with dogs rather than cowboys. He reputedly preferred canine cowhands because dogs don't drink, cuss, chew tobacco, or smoke. He used a mule instead of a horse because of the animal's sturdiness and low altitude. LeTulle's monument depicts the rancher with two dogs and his mule Kate. The sculpture marks the grave site of

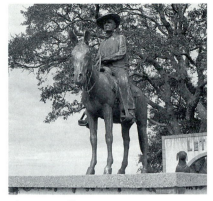

Thomas LeTulle. Photo by Robert Little.

Thomas LeTulle and his wife, Alta Ree Smith LeTulle, who worked alongside her husband for more than 45 years. The couple conducted at least 22 extended cattle drives.

Marshall

Teich, Frank

(1856–1939 American/German)*

CONFEDERATE MONUMENT *1906*

Figurative; 7' H; Carrara marble and Texas granite
Location: Old Harrison County Courthouse Museum, Peter Whetstone Square
Funding: Marshall Chapter 412, United Daughters of the Confederacy, $2,500
Comments: Thirteen Confederate companies were sworn into service in Harrison County near the site of this monument. According to the May 1906 issue of *Confederate Veteran*, Teich accompanied the plaster model of this statue to Italy to oversee the work of the local stonecarvers. The granite base was made at Teich Monument Works in Llano.

331

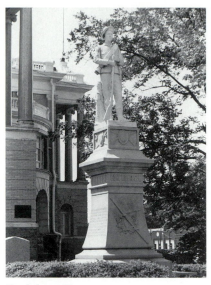

Confederate Monument. Photo by Robert Little.

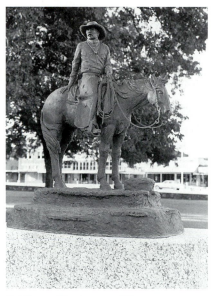

Cattlemen, Cowboys, and Drovers.
Photo by Mitch Mikeska.

Mason

Mikeska, Mitch

(b. 1958 Native Texan)*

CATTLEMEN, COWBOYS, AND DROVERS *1986*

Equestrian; 4'6" H; bronze cast by
The Bronze Center in San Angelo
Location: Mason County Courthouse
grounds
Funding: Mason County Sesquicen-
tennial Committee through public
donations
Comments: A cowboy and his horse
appear to be walking in the West
Texas wind. This Sesquicentennial
commission honors the cattle
industry in Mason County.

McAllen

Special Collections and Sculpture Gardens in McAllen

The McAllen International Museum
at 1900 Nolana has a varied perma-
nent collection that includes Mexican
folk art, masks and textiles, contem-
porary American and regional prints,
and old European oil paintings.
Founded in 1967 by the city of
McAllen and the McAllen Junior
League, the museum moved into its
present facility in 1976. Two works
are located on the museum grounds:
DACTYL *1983, installed 1987,* a
painted steel abstract by Stuart Kraft
(b. 1953, American)*, purchased by
the museum through a Meadows
Foundation grant; and **LA FUERZA**
1978, a 5'4" figurative bronze by
Víctor Salmones (American/Mexi-
can), donated by the Meadows
Foundation.

332

Dactyl. Photo courtesy McAllen International Museum.

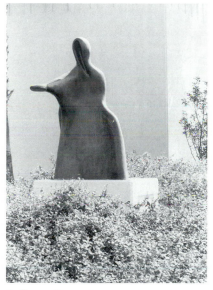

La Fuerza. Photo courtesy McAllen International Museum.

McKinney

Coppini, Pompeo

(1870–1957 American/Italian)*

JAMES W. THROCKMORTON *1911*

Portraiture; 7' H; marble
Location: Old Collin County
Courthouse Square
Funding: McKinney Federation of
Women's Clubs
Comments: Throckmorton, who was
a resident of McKinney, presided at
the Constitutional Convention of
1866 and subsequently served as the
eleventh governor of Texas. In July
1867, General Philip Sheridan
removed him from office, claiming
that the governor was an impediment
to Reconstruction.

Memphis

Backus, G. W.

(American)*

OUR PATRIOTS *1924*

Figurative; life-size; granite
Location: Hall County Courthouse
grounds
Funding: Winnie Davis Chapter 1231,
United Daughters of the Confederacy,
American Legion Post 175, and the
American Legion Auxiliary
Comments: The base identifies the
designer and builder of this monu-
ment as G. W. Backus of Vernon,
Texas. Backus was the owner-
operator of Backus Monument
Company, which, after a succession
of owners, continues to operate under
the name Winters-Howie Monument
Company at the firm's original
location on Wilbarger Street in
Vernon. In 1986, this war memorial
to the soldiers of the Civil War and
World War I was rededicated to honor
all veterans.

333

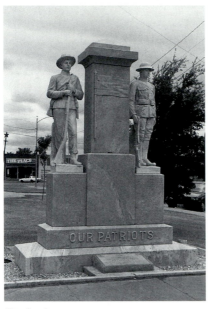

Our Patriots. Photo by Robert Little.

Midland

Dobberfuhl, Donna

(b. 1949 American)*

**CENTENNIAL PLAZA
WALL OF HISTORY** *1985*

Figurative; 4'6" H × 43' L; brick
Location: Centennial Plaza,
105 North Main
Funding: Public donations through
the Midland Centennial Plaza
Association, a group of citizens
organized by the Midland Jaycees
Comments: Dobberfuhl used the age-
old art of bricklaying and brick
sculpture to commemorate the
history of Midland and the south-
western United States. Six bas-relief
panels feature significant events that
occurred from the 1600s to the
present.

Friedley-Voshardt Foundry

(American)

STATUE OF LIBERTY REPLICA
1950

Figurative; 8'4" H; stamped sheet
copper
Location: Midland County
Courthouse grounds
Funding: Boy Scouts of America,
Buffalo Trail Chapter

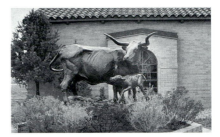

Old Maude. Photo courtesy the
Nita Stewart Haley Memorial Library, Midland.

Goodnight, Veryl

(b. 1947 American)

OLD MAUDE *1983*

Figurative; life-size; bronze
Location: Nita Stewart Haley
Memorial Library, 1805 West Indiana
Avenue
Funding: Trustees of the Nita Stewart
Haley Memorial Library; some funds
from the sale of 40 desk-size models
Comments: In 1980, Veryl Goodnight
visited the J. Evetts Haley Ranch near
Sallisaw, Oklahoma, to observe cattle
during calving season and compile
sketches and notes on which she
would base her conception of the
famous Texas longhorn cow Old
Maude. J. Evetts Haley learned of the
original Old Maude in 1936 while
doing research on his biography of
Charles Goodnight. According to
Haley, Maude was brought into the
Palo Duro Canyon from Colorado in
1876 with the first Goodnight herd—

after she had been driven up the Goodnight Trail from the frontiers of Texas. Reputedly, Old Maude calved 27 times and lived long after she lost all of her teeth from old age. The model used by Goodnight was WR-1859, a 20-year-old longhorn born on the Wichita Wildlife Refuge in Oklahoma and leased by the artist from the Dickinson Ranch in Calhan, Colorado. For two months, WR-1859 and the artist worked together at the artist's barn-loft studio to perfect details that can be obtained only by observing a live model at close range. Veryl Goodnight is a distant relative of the great cowman Charles Goodnight.

Guelich, Bob

(b. 1945 American)*

OUR LADY OF GUADALUPE SHRINE *1993*

Figurative; 13'6" H; painted bronze
Location: Our Lady of Guadalupe Catholic Church
Funding: Private donations

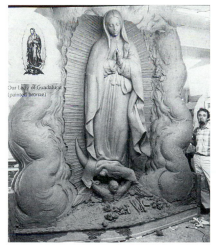

Artist Bob Guelich with clay model of *Our Lady of Guadalupe Shrine.*
Photo courtesy Bob Guelich.

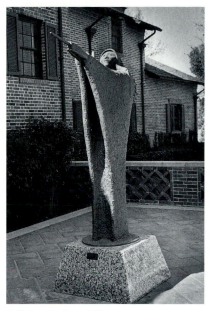

Offering the Sacred Pipe. Photo by Hendershot Photography, courtesy Museum of the Southwest.

Houser, Allan

(b. 1915 American)

OFFERING THE SACRED PIPE *1980*

Figurative; 6'7" × 5'4" × 1'7"; bronze
Location: Museum of the Southwest, 1705 West Missouri
Funding: Gift to the museum from Mr. and Mrs. W. D. Kennedy
Comments: Allan Houser, one of America's outstanding artists, authorized three castings of this work. Two are sited at museums, the Museum of the Southwest in Midland and the Wheelwright Museum in Santa Fe, New Mexico. The third is placed outside the United Nations Building in New York City. The United Nations placement is poignantly in keeping with the symbolism of the sculpture, which portrays the standing figure as an American Indian extending the sacred pipe in a gesture of peace. Houser is a Cherokee Indian.

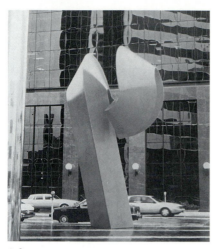

Solo. Photo by Charles O. Perry.

Perry, Charles O.

(b. 1929 American)

SOLO *1985*

Abstract; 24' H × 13' W; painted
aluminum
Location: The Summit Building,
300 North Marienfeld
Funding: Commissioned by Wagner
and Brown, Oil and Gas Producers
Comments: Perry created this work
in his studio in Norwalk, Connecti-
cut, and shipped it to Midland in
pieces to be assembled on-site.

Queen, John

(American)

**TRIBUTE TO THE AMERICAN
SOLDIER** *1975*

Abstract; 10' H; steel fabricated at
Cooper Construction Company in
Odessa
Location: George Mahon Federal
Building and U.S. Courthouse,
100 East Wall
Funding: Federal funds from the
Art in Architecture Program and the
General Service Administration,
$4,588

Sandifer, Rosie

(b. 1946 American)

FREEDOM OF YOUTH *1989*

Figurative; life-size; bronze
Location: Museum of the Southwest,
Children's Courtyard, 1705 West
Missouri
Funding: Donated by James R. Cox
Comments: The first casting of this
work was installed in 1986 on the
campus of Texas Tech University in
Lubbock.

Unknown Artist

(American)

METAL DUCK AND DINOSAUR
acquired 1975

Figurative; 2 figures, 7' H and 8' H;
metal pipe and wire
Location: American Building
Company, Highway 80 West,
2.2 miles west of Loop 250
Funding: Purchased at auction by
H. C. McCullough, owner of
American Building Company
Comments: Huge metal frames bent
into the shape of a duck and a
dinosaur appear as an artist's sketch
enlarged and mounted on the flat
West Texas horizon.

Mission

Warren, Suter C.

(American)*

THE GRAPEFRUIT *1982*

Abstract; 8' sphere; Cor-ten steel
fabricated by R. E. Friedricks
Company (REFCO) in McAllen
Location: La Placita Park,
801 Conway Avenue
Funding: City of Mission
Comments: Hidalgo County in South

Texas produces much of the state's citrus. Grapefruit is the largest-selling fruit crop in the state.

Unknown Artist

THE VIRGIN MARY *1948*

Figurative; larger than life-size; stone
Location: La Lomita Mission Park, south of downtown off Farm Road 1016
Funding: Oblate Fathers of Mary Immaculate
Comments: La Lomita Mission Park commemorates the missionary efforts of the Oblate Fathers of Mary Immaculate, who have served in the Lower Rio Grande Valley of Texas since 1849. La Lomita Mission included a chapel and residence quarters. It also provided a way station for circuit riders as they traveled to the scattered ranches from Brownsville to Roma, administering the sacraments, conducting Mass, and counseling believers.

Moscow

Holster, Burt

(b. 1924 Native Texan)*

MOSCOW DINOSAURS *1980*

Figurative; 11 life-size figures; painted fiberglass on wooden frames
Location: Dinosaur Gardens, U.S. 59 north of Moscow
Funding: Don and Yvonne Bean
Comments: Hundreds of school mascots, company logos, and business signs placed throughout Texas are made by Burt Holster, owner and operator of The Fiberglass Animal in Clarksville. Don and Yvonne Bean ordered these reptilian replicas from Holster for their dinosaur park, which is open to the public for a small fee on weekends.

Mount Pleasant

Unknown Artist

CONFEDERATE SOLDIER STATUE *1911*

Figurative; life-size; granite
Location: Titus County Courthouse square
Funding: Dudley W. Jones Camp 121, United Confederate Veterans, and area chapters of the United Daughters of the Confederacy

Muleshoe

Wolff, Kevin

(American)

NATIONAL MULE MEMORIAL *1965*

Figurative; life-size; fiberglass and Arkansas stone
Location: Intersection of U.S. 70 and U.S. 84, downtown
Funding: Worldwide donations
Comments: Under the leadership of the late Dr. J. B. Barnett of Marlin, Texas, the Mule Memorial Association organized in Muleshoe on August 25, 1961, for the purpose of promoting and erecting a monument

National Mule Memorial.
Photo by Lonnie Adrian, Adrian Photography, courtesy Muleshoe Chamber of Commerce and Agriculture.

to the mule. Hundreds of people responded to the effort by sending contributions that were often accompanied by touching personal sentiments about mules. After sufficient funds were raised, Old Pete, a local mule, modeled for the statue designed by Wolff and fabricated at Fiberglass Menagerie in Alpine, California. The monument now bears an official Texas historical marker, which reads in part, "The mule. Without ancestral pride or hope of offspring, the mule, along with the buffalo, hound, and longhorn, made Texas history." The town of Muleshoe is not named for the monument; it is named for the old Muleshoe Ranch, a part of the great XIT.

Nacogdoches

Navasota

New Boston

New Braunfels

New London

North Richland Hills

Nacogdoches

MacDonald, Richard

(American)

STEPHEN F. AUSTIN *1986*

Portraiture; larger than life-size;
bronze and pink Texas granite
Location: Stephen F. Austin State
University campus, Sesquicentennial
Plaza in front of the Ralph W. Steen
Library
Funding: Private donations
Comments: The idea to erect a statue
of the father of Texas on the Stephen
F. Austin State University campus
during the Texas Sesquicentennial
originated with the student body and
grew to encompass the entire
community. Out of more than 180
portfolios submitted by artists
throughout the United States and
several foreign countries, Californian
Richard MacDonald received the
commission. According to the artist,
symbols within the sculpture
represent the character and life of
Stephen F. Austin. His foot is

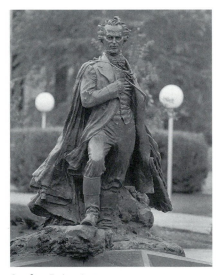

Stephen F. Austin. Photo by Doug Fonville,
courtesy Stephen F. Austin State University.

forward, symbolizing his determina-
tion to go forward in the face of
adversity, which is suggested by a
sweeping wind that blows his cape
and hair. Out of the rocks at his feet
is an emerging Texas star, symbolic
of Austin's struggle to carve a
civilized society from a rough land.
Austin's fashionable traveling suit is
consistent with the historical figure,
in that Austin did not adopt the
buckskin attire of the frontiersman.

Mendoza, Antonio

(Mexican)

**FRAY ANTONIO MARGIL
DE JESUS** *1976*

Portraiture; smaller than life-size;
bronze
Location: Sacred Heart Catholic
Church, 500 North Street
Funding: Donations from the
congregation
Comments: Father Antonio Márgil de
Jesús was a Franciscan priest who
came as a missionary to the Indian
tribes in East Texas.

Navasota

Teich, Frank

(1856–1939 American/German)*

LA SALLE MONUMENT *1930*

Portraiture; 7' H; bronze and pink
Texas granite
Location: Texas 90, downtown
Funding: Texas Society Daughters of
the American Revolution and citizens
of Navasota
Comments: Teich was in his seven-
ties when he received the commis-
sion for this statue of René-Robert
Cavelier, Sieur de La Salle, who was
murdered by his own men near
Navasota in 1687. On the 250th
anniversary of the explorer's death,

La Salle Monument.
Photo courtesy *Texas Highways Magazine.*

Teich, at age 80, greeted a delegation from France who honored the sculptor for creating this portrait of their famous countryman. In 1993, during the emphasis on outdoor sculpture inspired by the nationwide Save Outdoor Sculpture! project, Navasota citizens hired Houston artist Ben Woitena to restore this work.

New Boston

Ghiglieri, Lorenzo

(American)

JAMES BOWIE *1986*

Portraiture; 8' H; bronze
Location: Bowie County Courthouse grounds
Funding: Alumax Corporation grant and individual donations
Comments: This sesquicentennial commission depicts the Alamo defender James Bowie as a citizen soldier prepared to fight for Texas

independence. Bowie County has two statues of the man whose name it bears, this one at the county seat and another in Texarkana. Lorenzo Ghiglieri is a native of California who has lived much of his adult life exploring the Northwest, especially the ice fields of Alaska's Arctic tundra. His many outdoor placements include a life-sized eagle at Pershing Park in Washington, D.C., a heroic-sized portrait of Abraham Lincoln at the entrance to the city hall in Kansas City, Missouri, and a fountain composed of five life-sized elephants at the Dallas zoo.

New Braunfels

Mott, J. L., Iron Works

(American)

FOUNTAIN FIGURE *1896*

Figurative; 20' H; cast iron
Location: Main Plaza, downtown
Funding: Erected through private

Fountain Figure. Photo by Robert Little.

donations and local fund-raising activities in honor of the fiftieth anniversary of the founding of New Braunfels

Comments: The Mott company name is engraved on this beautiful octagonal pool and fountain adorned with the company's popular ram's-head motif. J. L. Mott Iron Works in New York City is responsible for providing some of the state's oldest examples of decorative public fountains.

purchased this statue from a firm in Jacksonville, Texas, in the same year he ordered the accompanying American doughboy statue. Sales records for the 1930s are no longer extant at Gould Monument Works in Jacksonville; however, C. R. Thompson, a former owner, and Howard Jowers, who currently leases the company, both understand that the firm did in fact order this statue from Carrara, Italy.

Confederate Soldier Statue. Photo by Robert Little.

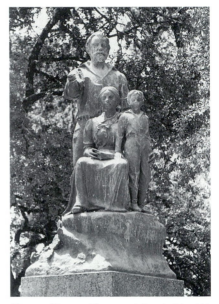

German Pioneers Monument. Photo by Robert Little.

Unknown Artist

CONFEDERATE SOLDIER STATUE
mid-1930s

Figurative; 7' H; marble
Location: Main Plaza, downtown
Funding: Donated by Mr. and Mrs. E. A. Clousnitzer
Comments: The plaque reads, "To the memory of our fallen soldiers 1861–1865." According to the Clousnitzers' daughter, Fern Clousnitzer Frieze, her father

Villa, Hugo

(1881–1952 American)

GERMAN PIONEERS MONUMENT
1938

Figurative; larger than life-size; pink Texas granite and bronze cast at E. Gargani and Sons Foundry in New York
Location: Landa Park, 110 Golf Course Road off Landa Drive
Funding: Monument Association for German Pioneers of Texas

Comments: The plaque reads, "Dedicated to the memory of the German pioneers who helped convert a wilderness into the great State of Texas." The monument is signed and dated by the artist and the foundry. The architect was Leo M. J. Dielmann. A five-cornered star of pink granite forms the base for three figures: a mother holding a Bible, a father extending his right arm as if to survey his new homeland, and a young son representing the new generation who would be heir to the society established by his parents. Bronze text panels and bas-relief scenes on the pedestal depict the progression of German settlement in Texas.

Viquesney, E. M.

(1876–1946 American)

SPIRIT OF THE AMERICAN DOUGHBOY *1937*

Figurative; life-size; bronze
Location: Main Plaza, downtown
Funding: Donated by Mr. and Mrs. E. A. Clousnitzer
Comments: The plaque reads, "Dedicated to the World War veterans of Comal County." This statue was badly damaged by a drunk driver in 1986 and repaired by Washington University Technology Associates, Inc., of Saint Louis, Missouri.

New London

Coe, Herring

(b. 1907 Native Texan)*

NEW LONDON CENOTAPH *1938*

Figurative; 32' H; granite from the Premier Granite Quarry in Llano
Location: Texas 42 in front of West Rusk High School

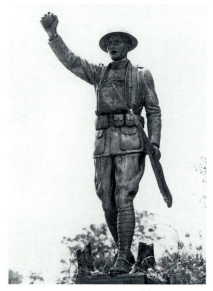

Spirit of the American Doughboy.
Photo by Robert Little.

New London Cenotaph. Photo by Robert Little.

Funding: Worldwide contributions
Comments: This memorial commemorates the lives lost in the horrible New London school explosion, in which 294 children and teachers were killed. The explosion, attributed to leaking raw natural gas, occurred shortly before classes were dismissed on the afternoon of March 18, 1937. In 1979, Gould Monument Works in Jacksonville restored the monument.

North Richland Hills

Sanders, Jerry Dane

(b. 1949 American)*

DIRECTION *1986*

Abstract; 15' × 12' × 10'; Cor-ten steel
Location: Bates Container Corporation, 6433 Davis Boulevard
Funding: Bates Container Corporation

Odessa

O'Donnell

Ozona

Odessa

Hanbury, Una

(died 1989 American)

SOMEWHERE A BIRD IS SINGING
n.d.

Figurative, life-size, bronze
Location: Noel Plaza, 300 block
West 4th Street
Funding: W. D. and Ellen Noel

Wolff, Kevin

(American)

WORLD'S LARGEST JACKRABBIT
1962

Figurative; 8' H; fiberglass fabricated
at the International Fiberglass
Company in Venice, California
Location: 802 North Sam Houston
Funding: Odessa Chamber of
Commerce
Comments: The *World's Largest
Jackrabbit* has inspired hundreds of
puns. At first the idea to erect a

World's Largest Jackrabbit.
Photo courtesy *Texas Highways Magazine.*

monument to the West Texas native
was called "harebrained," and it
generated a "hare-raising" contro-
versy among some of the local
citizenry who felt it was an expensive
passing fancy that would be "hare
today, gone tomorrow." The "har-
ried" Chamber of Commerce also
came under criticism for misnaming
the critter by calling it a rabbit
instead of a hare. Gradually, people
stopped "splitting hares" and decided
to enjoy what has become a landmark
that attracts hundreds of visitors and
delights local children.

Worden, Kay

(American)

LIVELY ENCOUNTER *1991*

Figurative; 3 life-size pieces; bronze
cast at the Paul King Foundry in
Johnston, Rhode Island
Location: Noel Plaza, 300 block
West 4th Street
Funding: Donated to the city of
Odessa in 1991 by W. D. and
Ellen Noel
Comments: This charming figurative
group includes a boy, a rabbit, and a
young girl doing a cartwheel. All are
the second edition in a series of six
castings.

**Special Collections and
Sculpture Gardens in Odessa**

**The Art Institute for the Permian
Basin,** at 4909 East University, hosts
art exhibitions and sponsors lectures,
a summer art camp, an arts loan
program, and family and adult art
classes. Included in its permanent
collection are the following outdoor
sculptures, all donated to the
institute by the Meadows
Foundation:

Grand Striptease. Photo courtesy Art Institute for the Permian Basin.

GRAND STRIPTEASE *1966,* a 9'7" figurative bronze by Giacomo Manzu (b. 1908, Italian). This figure is located at the entrance to the institute; the other outdoor works are placed in the Rhodus Sculpture Garden. The Meadows Foundation donated *Grand Striptease* in honor of the George Lee Rhodus family, who lived in Odessa from 1943 to 1957.

CAPRICCIO LUNARE *1950s,* a 7'3$^{1}/_{2}$" bronze abstract by Carmelo Cappello (Italian)

PATTINATRICE *1959,* a 4'6" figurative bronze by Emilio Greco (b. 1913, Italian)

GERARCHIE *1954,* a 4'10" figurative bronze depicting political hierarchy, by Marino Mazzacurati (Italian)

O'Donnell

Goodacre, Glenna

(b. 1939 Native Texan)

DAN "HOSS CARTWRIGHT" BLOCKER *1973*

Portrait bust; larger than life-size; bronze
Location: Heritage Plaza, 8th and Doak streets
Funding: City Council, 1946 Study Club, and donations
Comments: The sculptor and Dan Blocker's mother attended the dedication of this lifelike portrayal of the Ozona native and beloved star of the television series *Bonanza.* Under his smiling features is the following quotation: "Thanks to film, Hoss Cartwright will live. But all too seldom does the world get to keep a Dan Blocker." This work represents the artist's first bronze portrait. It was cast in Lubbock by Forrest Fenn, who later founded Fenn Galleries in Santa Fe, New Mexico.

Dan "Hoss Cartwright" Blocker. Photo courtesy Glenna Goodacre, Ltd.

347

Ozona

McVey, William M.

(b. 1905 American)*

DAVY CROCKETT *1936*

Portraiture; 9' H; pink Marble Falls
granite carved by E. Leonarduzi
Location: City Park at the city
square, U.S. 290
Funding: $7,500 allocated by the 1936
Commission of Control for Texas
Centennial Celebrations
Comments: Crockett came to Texas
from Tennessee in January 1836, only
to die at the Alamo in March of that
same year. He is credited with the
saying, "Be sure you are right, then go
ahead." This sentiment is engraved
on the front of the monument below
the high-relief carving of the legend-
ary hero—minus his coonskin cap.
Donald Nelson was the architect.

Davy Crockett. Photo by Sandra Childress.
Courtesy Cameras Two Photography, Ozona.

P

Palestine

Pampa

Panna Maria

Paris

Pasadena

Pflugerville

Pittsburg

Plainview

Plano

Pleasanton

Port Arthur

Port Lavaca

Port Neches

Post

Poteet

Prairie View

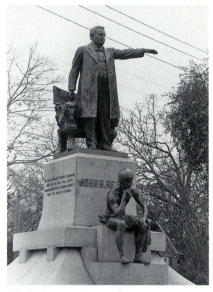

John H. Reagan Memorial. Photo by Robert Little.

Palestine

Coppini, Pompeo

(1870–1957 American/Italian)*

JOHN H. REAGAN MEMORIAL
1911

Figurative; 2 figures, each larger than life-size; bronze cast at the Nelli Foundry in Rome, Italy, during Pompeo and Elizabeth Coppini's only return visit to their homeland
Location: Reagan Park, Reagan Street at Crockett Road
Funding: John H. Reagan Chapter 2292, United Daughters of the Confederacy, and public donations
Comments: Coppini borrowed the $800 entry fee to submit his sketch for this commission. The monument committee unanimously accepted his design, but raising funds for such a large work proved difficult for the Reagan Chapter. In March 1910, the *Confederate Veteran* printed a plea for contributions to help cover a $2,135 deficit. The monument

depicts John H. Reagan, who served as postmaster general and secretary of the treasury of the Confederate States of America. Later, Reagan served in the Congress and Senate of the United States and as the chairman of the Railroad Commission of Texas. The seated allegorical figure beneath Reagan's statue is *The Lost Cause,* representing the cause of the Confederacy. Reminiscent of a Roman soldier, the pensive figure appears to be contemplating his lost cause. The Confederate flag is draped across his lap, and thirteen stars, representing the thirteen Confederate states, are mounted on the front of his helmet.

Pampa

Neef, Russell E. "Rusty"

(b. 1928 American)*

THIS LAND IS YOUR LAND *1992*

Figurative; 12' H × 150' L;
welded steel
Location: 1101 North Hobart
(Texas 70)
Funding: Rusty Neef, the Pampa Area Foundation for Outdoor Art, and several local businesses
Comments: Rusty Neef has lived in Pampa since 1928, and he has been a certified welder for 50 years. This welded-steel sculpture depicts a giant treble clef scored with the entire

This Land Is Your Land. Photo courtesy Rusty Neef.

350

chorus of "This Land Is Your Land," by singer-songwriter Woody Guthrie. Guthrie lived in Pampa from 1929 to 1937. Neef obtained permission to reproduce Guthrie's song from Ludlow Music, Inc., and the Woody Guthrie Foundation. Local music teacher Wanetta Hill arranged the song for the sculpture in four-four time and the key of G. At night the chorus is illuminated by red, white, and blue lighting.

TREE 1 and **TREE 2** *1992*

Abstract; 2 figures, each about 7' H; welded steel
Location: 1100 block Somerville
Funding: Thelma Bray

Sanders, Gerald

(Native Texan)*

WALL OF HISTORY *1986–1994*

Figurative; 10' H; mixed media
Location: 1000 North Sumner
Funding: Sponsored by the Pampa Area Foundation for Outdoor Art
Comments: Sanders created the overall design; Reece Field and James Hinkley with other area artists and local high school students have continued to add to the work. The wall is an ongoing project that depicts the history of the Panhandle area of Texas. Gerald Sanders is a nationally recognized Western artist who began his career as a sculptor after retiring from 35 years with the telephone company. When he entered his first competition at the National Juried Artist Studio Exhibition in Amarillo in 1977, he won three top awards. Since then, Sanders has created dozens of works at his studio in Pampa, working in a variety of media, including wood, bronze, alabaster, elk horn, and even paper pulp.

Smith, Al

(American)

ONION *1977*

Figurative; 5' H; welded steel
Location: 401 North Cuyler
Funding: Pampa Beautification Foundation

Smith, Warren, and Pampa High School students

(American)*

LOCH NESS LIZARD *1992*

Figurative; 5' H × 20' L; recycled metal from charge-tube discards made at Titan Specialties in Pampa
Location: Pampa Park at Somerville and Hobart streets
Funding: Sponsored by the Pampa Area Foundation for Outdoor Art
Comments: Warren Smith and the students in his metal trades class at Pampa High School constructed this giant lizard.

Panna Maria

Rodriguez, Louis

(Native Texan)*

FATHER LEOPOLD MOCZYGEMBA *1976*

Portrait bust; life-size; bronze
Location: Immaculate Conception Catholic Church
Funding: Private donors
Comments: Father Leopold Bonaventura Maria Moczygemba (1824–1891) came to Texas in 1852, and on December 24, 1854, he founded Panna Maria, the first permanent Polish Catholic settlement in America. Father Moczygemba eventually established parishes, founded schools, and served as pastor in ten states and performed

351

his ministry in Latin, Polish, German, Italian, English, Czech, and Spanish. He is known as the patriarch of American Polonia. He died in Detroit, Michigan, in 1891, and was reinterred in Panna Maria in 1976 during the American Bicentennial Celebration.

Paris

Coppini, Pompeo

(1870–1957 American/Italian)*

CONFEDERATE MONUMENT *1903*

Figurative; 15' H; bronze
Location: Lamar County Courthouse
Funding: Lamar Chapter 258, United Daughters of the Confederacy, Mary Connor, and public donations
Comments: When Coppini received a blueprint of the Lamar Chapter's idea for a monument, the sculptor was so offended by the "monstrous design" that he made a trip to Paris to meet with the monument committee before bidding for the commission. He gives the following account in his autobiography: "I begged them never to go through with the erection of another disgrace to the noble Southern cause. I had nothing with me, not even a pencil, so I went to the center of the Plaza, which was the hub of all activities of the town, and at a store where they were selling school books and stationery, I got myself a few sheets of children's drawing paper, a small ruler, and a pencil and retired to my dingy hotel room to make a scale drawing of a figure, a Confederate soldier on top of a pedestal and four busts adorning it representing General Lee, Jefferson Davis, Albert Sidney Johnston, and General T. J. (Stonewall) Jackson" (Coppini 1949, 93). On the next day, Coppini received the commission and signed a

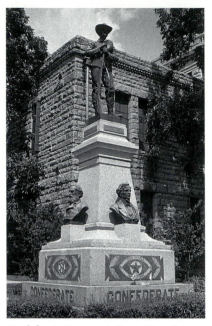

Confederate Monument. Photo by Marvin Gorley.

contract. According to the artist, this commission marked the beginning of his career as a Texas sculptor. Coppini employed Otto Zirkel of San Antonio to build the stone portion of the monument.

Klein, Gustav

(1850–1884 American/German)*

WILLET BABCOCK MEMORIAL *1881*

Figurative; larger than life-size; marble
Location: Evergreen Cemetery, Church Street at Jefferson Road
Funding: Commissioned in 1880 by Willet Babcock for $2,450
Comments: Gustav Klein was a German immigrant who worked for the Paris Marble Works, also known as the North Texas Marble Works. Although Babcock, a local businessman, was not a famous Texan, his

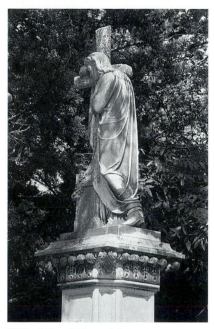

Willet Babcock Memorial. Photo by Marvin Gorley.

gravestone has perpetuated his name. Several unusual features make this monument an oddity. While the sculptured figure leaning on a cross wears a biblical-style robe, the foot protruding from the hem of the garment is clad in cowboy boots. The grave site faces west instead of east, and the torches at each corner of the monument's base are mounted upside down. Although not a portrait of Christ, the figure is often referred to as "Jesus in cowboy boots."

Loving, Mark

(Native Texan)*

AIKIN FOUNTAIN 1983

Abstract; 6' H; stainless steel fabricated by Curtis Adams, head instructor of the Paris Junior College welding department
Location: Paris Junior College, Wilma Aikin Garden

Funding: Paris Junior College, with steel provided by Babcock and Wilcox, a Paris boiler manufacturing plant

Wees, J. L.

(American)*

CULBERTSON FOUNTAIN
1924–1927

Figurative; 18' H; Italian marble and stone
Location: Paris Downtown Plaza
Funding: Donated to the city by J. J. Culbertson
Comments: Culbertson was a pioneer in cotton mills and a local philanthropist. He commissioned Saint Louis architect J. L. Wees to fashion this fountain after the ones seen by the Culbertson family during their European travels. The Triton centerpiece and the basins are made of Italian marble and embellished with stone carvings. The base and carved pillars surrounding the pool are made of Bedford stone; the steps are of Carthage stone. Culbertson gave the fountain to mark the rebuilding of Paris after a terrible fire that almost destroyed the city in 1916. Restored in 1976 as an American Bicentennial project, it serves as the centerpiece for one of the most beautiful plazas in the state.

WORLD WAR I MEMORIAL 1920s

Figurative; 9' H; bronze
Location: 231 Lamar Avenue
Funding: J. J. Culbertson
Comments: After Wees moved to Paris from Saint Louis, he designed several homes and public buildings that are still extant. Culbertson commissioned him to design this monument honoring Lamar County soldiers who died in World War I.

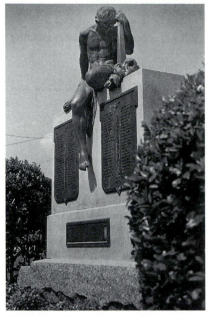

World War I Memorial. Photo by Marvin Gorley.

Aarnos, Seppo

(b. 1937 American/Finnish)*

SAXONY WAVE *1987*

Abstract; 13' H; Cor-ten steel
Location: Saxony Executive Homes
subdivision, County Road 685
Funding: Parker and Rogers
Construction Company

Divine Servant. Photo courtesy Max Greiner Jr. Designs.

Pasadena

Southard, Charles

(American)

LITTLE LEAGUER *1972*

Figurative; 3' H; bronze
Location: Pasadena Public Library,
1201 Minerva
Funding: Privately donated to the
city of Pasadena
Comments: This figure of a young
baseball player was given in recogni-
tion of the city's Little League
baseball program. Also located in
Pasadena inside the Pasadena Town
Square Shopping Mall at Tatar and
East Southmore is Bob Wade's giant
bronze armadillo sculpture, *The
Legendary Daisy Belle.* The work is
Wade's tongue-in-cheek expression of
the conflict between the state's
reverence for its Western tradition
and the reality of a new, urban
environment.

Pittsburg

Greiner, Max, Jr.

(b. 1951 Native Texan)*

DIVINE SERVANT *1990*

Figurative; life-size; bronze cast at
Eagle Bronze in Lander, Wyoming
Location: Jefferson and Lafayette
streets
Funding: Pilgrim Foundation
Comments: According to the artist,
the sculpture, which depicts Jesus
washing the disciple Peter's feet, is
intended to communicate without
words the concepts of servanthood,
humility, and the incredible love of
Christ. Greiner works at his home
studio near Kerrville. Through the
sale of his art, he has helped raise
more than $200,000 to benefit
wildlife conservation and educa-
tional, medical, and religious
nonprofit organizations. Other
castings of *Divine Servant* are placed
in Dallas and Fredericksburg.

354

Texas Windmill, Texas Longhorn, and *Texas Farmer*. Photo by Gordon Zeigler, courtesy Tom Warren.

Plainview

Warren, Tom

(b. 1923 Native Texan)*

TEXAS WINDMILL *1984,*
TEXAS LONGHORN *1984,* and
TEXAS FARMER *1984*

Figurative; 20' H, 3' H, and 4' H, respectively; solid steel
Location: 600 block Austin at West 6th Street
Funding: City National Bank
Comments: Plainview artist Tom Warren used cutting torches and

finishing grinders to carve these three sculptures from solid blocks of steel. An accomplished painter and sculptor of small bronzes, Warren limits his work in solid steel to the spring and summer months, when he can work outdoors. This sculpture recognizes the essential contribution made by the windmills that enabled ranchers and their livestock to survive the harsh environment of West Texas.

Plano

Gussow, Roy

(b. 1918 American)

TWO FORMS *1985*

Abstract; 6' H; stainless steel fabricated by the artist
Location: 2700 West Plano Parkway
Funding: J. C. Penney Financial Services

Johnson, J. Seward, Jr.

(b. 1930 American)

THE WINNER *1986*

Figurative; life-size; bronze

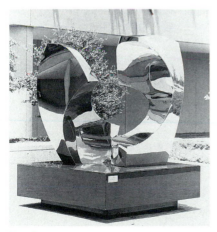

Two Forms. Photo by Robert Little.

The Winner. Photo by Robert Little.

355

Location: Preston Park Village,
1900 Preston Road
Funding: Lincoln Property
Comments: Johnson's works are cast
at the Johnson Atelier near Trenton,
New Jersey. All exhibitions and sales
of J. Seward Johnson sculptures are
coordinated through Sculpture
Placement, Ltd., of Washington, D.C.

Sanders, Jerry Dane

(b. 1949 American)*

MOTION II *1981*

Abstract; 30' × 10' × 10';
stainless steel
Location: Pitman Office Park,
1255 West 15th
Funding: Hunt Properties

Motion II. Photo by Robert Little.

Schultz, Saunders, and Bill Severson

(Americans)

TREPHONIA *1984–1986*

Abstract; 20' H; polished stainless
steel fabricated at Scopia Foundry in
Saint Louis, Missouri
Location: Preston Park South,
between 4965 and 4975 Preston Park
Boulevard, at the center of the motor-
cade area dividing One Preston Park
South and Two Preston Park South
Funding: Homart Development
Company
Comments: *Trephonia,* or "sounds of
trees," is designed to be an artistic
link between the natural environ-
ment of the Texas plains and the
high-tech business center at Preston
Park South. The area's strong winds
move the sculpture's 36 stainless-
steel elements, creating music within
a two-octave scale. Rich O'Donnell
created and tuned the seven musical
components of the sculpture to a
pentatonic scale with major and
minor tones. The seven instruments
are major and minor tubular bells,

Trephonia. Photo by Robert Little.

wind reeds, wind whips, jingles,
bangles, and tuba-phones.

Pleasanton

Taschl, John

(American/Austrian)

THE COWBOY *1969*

Figurative; 8'2" H; bronze cast at the
Modern Art Foundry in Long Island,
New York
Location: City Hall, 108 2nd street
(U.S. 281)
Funding: Gift of Mona and Ben Parker

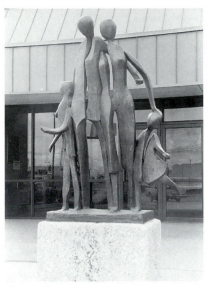

The Cowboy. Photo courtesy Mona Parker and the *Pleasanton Express.*

The Family. Photo by Mamie Bogue.

Comments: Taschl was an art professor at the University of New Mexico when he received this commission. The statue's plaque reads, "In this part of Texas men first used the techniques of handling cattle on horseback. This statue, dedicated to the cowboy, was given to the city of Pleasanton, Texas, by Mona and Ben Parker and placed here to mark this area as 'The Birthplace of the Cowboy.'"

Port Arthur

Cargill, David

(b. 1929 Native Texan)*

THE FAMILY *1981*

Abstract; 5' H; bronze
Location: Port Arthur Public Library, 3601 Cultural Center Drive
Funding: Gift from the Friends of Port Arthur Public Library in honor of library director Lucy Stiefel
Comments: The positioning of these stylized figures and their relation to each other creates a sense of warmth, completeness, and security. *Jesus and the Children,* a sculptural relief by Cargill, is mounted on the outer wall of the Presbyterian Church of the Covenant in Port Arthur.

Friedley-Voshardt Foundry

(American)

REPLICA OF THE STATUE OF LIBERTY *1950*

Figurative; 8'4" H; stamped sheet copper
Location: Proctor at Stilwell
Funding: Donated to the citizens of Port Arthur by the Port Arthur District Sabine Area Council of the Boy Scouts of America

Kitson, Henry Hudson

(1863–1947 American/English)

MUSIC OF THE SEA *1884*

Figurative; 4' H; bronze cast at

357

Bedford Bronze Foundry, Inc., in Massachusetts
Location: Jefferson County Sub-courthouse, 525 Lakeshore Drive
Funding: Given to the city in 1940 by Edith Smith Norton in memory of her father, Mayor Charles E. Smith
Comments: In a letter to Edith Smith Norton written by Kitson in 1941 and reprinted in the local newspaper, the artist said that Auguste Rodin visited his Paris salon while he was creating *Music of the Sea* and that the old master complimented the work. Kitson also wrote, "Queen Elizabeth of Rumania visited the salon and while looking over the section of sculpture saw *Music of the Sea* and became enthusiastic about it. On the strength of her encounter with that figure, I received an invitation to make the portraits of the king and queen" (*Port Arthur News*, March 11, 1941). After Hurricane Carla in 1961, the artist's son, John Kitson, wrote to the Chamber of Commerce to inquire how "the young lad listening to the music of the sea" survived the storm. According to that letter, which also was reprinted in the local newspaper, the first casting of the work was made in Paris and purchased in

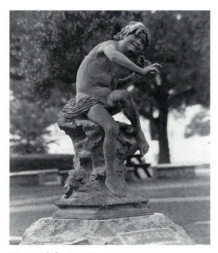

Music of the Sea. Photo by Robert Little.

Boston at Kitson's studio by a prominent art patron who gave it to the Boston Museum of Fine Arts (*Port Arthur News*, December 24, 1961). Port Arthur's statue is obviously a later casting made by the Bedford Bronze Foundry, Inc., after Kitson returned from Paris to Boston.

Pham Thang

(Vietnamese)

OUR LADY OF PEACE 1986

Figurative; 16'6" H; concrete on a metal frame
Location: Peace Park, 900 9th Avenue
Funding: Parishioners of Queen of Vietnam Parish
Comments: This statue of Mary is housed under a lovely pagoda-type structure, which is surrounded by the fourteen stations of the cross.

Stockinger, Max

(American)*

THE DRAGON 1993

Abstract; 17' H; welded plumbing pipe
Location: 719 Proctor Street
Funding: Private donor
Comments: Max Stockinger is a resident of Port Arthur.

Port Lavaca

Josset, Raoul

(1898–1957 American/French)*

RENE ROBERT CAVELIER, SIEUR DE LA SALLE 1936

Portraiture; 22' H;
pink Kingsland granite
Location: Indianola Beach at the terminus of Texas 316, 16 miles south of the city of Port Lavaca
Funding: $10,000 allocated by the

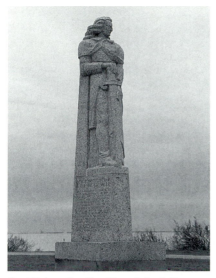

René Robert Cavelier, Sieur de La Salle.
Photo by Robert Little.

1936 Commission of Control for
Texas Centennial Celebrations
Comments: This monument marks
the site where René Robert Cavelier,
Sieur de La Salle, landed in 1685. The
stylized portrayal of the French
explorer was designed by Josset and
carved by Ugo Lavaggi. The statue
looks out over the solitary beach that
was once part of the finest and
busiest harbor in Texas. Fort Saint
Louis, established by La Salle on
Matagorda Bay, gave the United
States its first claim to Texas as a part
of the Louisiana Purchase.

Port Neches

Cargill, David

(b. 1929 Native Texan)*

BEATITUDES *1962*

Figurative; 7' H × 6' W; bronze
Location: Saint Elizabeth's Catholic
Church, 909 Gulf Avenue
Funding: Saint Elizabeth's Catholic
Church

Comments: Nine open reliefs depict
people involved in activities that
demonstrate the principles taught in
Jesus' Sermon on the Mount.

Post

Gelert, J.

(1852–1923 American)

CHARLES WILLIAM POST *1956*

Portraiture; larger than life-size;
bronze cast at the Spampinato
Art Foundry in Chicago
Location: Garza County Courthouse
grounds
Funding: Donated by Marjorie
Merriweather Post
Comments: The citizens of Battle
Creek, Michigan, commissioned the
first casting of this statue for Post
Park in Battle Creek. In 1956,
Marjorie Merriweather Post obtained
permission from Battle Creek to have
a duplicate casting made from
Gelert's original work. The Battle
Creek statue was taken to the
Spampinato Art Foundry, where an
identical copy was made for the little
town in Texas founded by and named
for her father. C. W. Post was a
rancher, agriculturist, real estate
developer, inventor, and the founder
of Postum Cereal Company, which
produced Postum coffee, Post
Toasties, and Elijah's Manna, now
known as Grape Nuts cereal. In 1975,
newspaper columnist Frank Tolbert
expressed concern over the condition
of Post's statue, writing that Post's
metallic likeness had turned greenish
black and suffered much from bird
droppings. Boy Scout Troop 316 in
Post wanted to clean the statue, but
according to Scout Master Jimmy
Mitchell, "the Post family had left
written instructions that the towns-
people aren't supposed to mess with
that statue." Mitchell even contacted

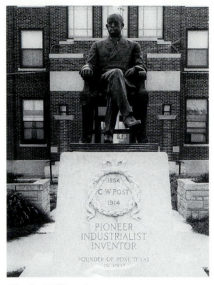

Charles William Post. Photo by Rodney Marshall, courtesy *The Post Dispatch.*

Marjorie Merriweather Post's daughter, actress Dina Merrill, "who replied in a nice way for us not to do a thing to her grandfather's statue" (*Dallas Morning News,* June 10, 1975). Tolbert's last word on the subject, as reported in his column, was that "the statue of the Post Toasties man still sits at the head of Main Street and not even the bird droppings can be erased by the townspeople" (*Dallas Morning News,* April 21, 1977).

Poteet

Hesse, Alfred

(American/Australian)*

WORLD'S LARGEST STRAWBERRY
1965

Figurative; 7' H; painted fiberglass

Location: Avenue H and 6th Street
Funding: Gift of the Central Power and Light Company and C. C. Wines, the company's vice president
Comments: The strawberry capital of the world is an appropriate home for this enormous berry designed by Alfred Hesse, a resident of Corpus Christi. Along with the world's largest strawberry, Texas also claims the world's largest pecan, installed on the grounds of the Guadalupe County Courthouse in Seguin. Monroe J. Engbrock, a plastering contractor in Seguin, built the 5-foot long, 1,000-pound pecan in 1978 for the Guadalupe County Pecan Growers Association. Texans have also erected monuments to the watermelon in Dilly and to the peanut in Pearsall and Floresville. Poteet, Texas, is named for Poteet Canyon, the cartoon character created by cartoonist Milton Caniff. Located near the strawberry monument is the *Poteet Canyon Monument,* a mosaic wall depicting scenes from an episode in the *Steve Canyon* comic strip.

Prairie View

Hunt, Richard

(b. 1935 American)

CENTENNIAL *1978*

Abstract; 20' H; Cor-ten steel
Location: Prairie View A&M University campus
Funding: Commissioned by the university in honor of the school's centennial

R

Refugio

Richardson

Richmond

Rockport

Rockwall

Round Rock

Rusk

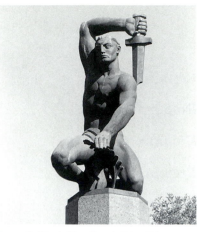

Amon B. King's Men. Photo by Robert Little.

Refugio

Josset, Raoul

(1898–1957 American/French)*

AMON B. KING'S MEN *1937*

Figurative; 20'6" H; bronze and pink
Texas granite
Location: King's Park at Commerce
and Purisima streets
Funding: $7,500 allocated by the 1936
Commission of Control for Texas
Centennial Celebrations
Comments: Bronze plaques mounted
on the shaft tell the story of Captain
Amon Butler King and his men, who
were captured by the Mexican army
on March 15, 1836. On March 16,
Mexican General José Urrea ordered
his soldiers to march the prisoners to
a place about 1 mile north of Nuestra
Señora del Refugio Mission. There, on
the road to Goliad, the Mexicans
executed the Americans and left their
bodies. After the Texas Revolution, a
group of Refugio citizens buried the
remains in a common grave. In 1934,
the bones and relics of King's men
were reinterred at Mount Calvary
Catholic Cemetery with appropriate
military and religious ceremonies.

Richardson

Love, Jim

(b. 1927 Native Texan)*

JACK *1971*

Abstract; 10'3" H; painted steel pipe
Location: University of Texas at
Dallas campus at Armstrong Parkway
off Campbell Road
Funding: Gift of Margaret Milam
(Mrs. Eugene) McDermott
Comments: *Jack* is installed in a
plaza between Green Hall and

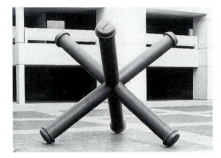

Jack. Photo by Robert Little.

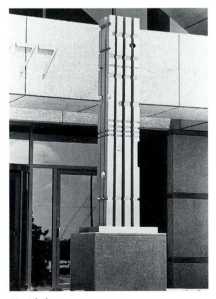

Untitled. Photo by Robert Little.

362

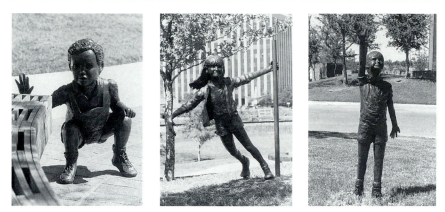

Waiting for Dad. Photos courtesy Adelle M Gallery, Dallas.

Jonsson Hall. Mounted on the front elevation of each hall is a bronze life-size bust of Cecil H. Green and J. Erik Jonsson, the men for whom the buildings are named. The busts are signed by J. Paderevski.

McDonnell, Joseph Anthony

(b. 1936 American)

UNTITLED *1984*

Abstract; 10' H; iodized copper
Location: Texins Credit Union, 777 Campbell Road
Funding: Trammell Crow

O'Halloran, Kathleen J.

(b. 1948 American)*

WAITING FOR DAD *1987*

Figurative; 3 life-size figures; bronze
Location: Greenway Plaza on the northeast corner of Campbell Road and Central Expressway
Funding: Purchased through Adelle M Gallery in Dallas and owned by Elman Richardson, Ltd.
Comments: Located across the street from *Waiting for Dad* is another installation created by O'Halloran, in 1992. *Canned Communication* is a sculptural group of life-size bronze figures designed specifically for the

grounds of the regional headquarters of Northern Telecom. Both works reflect the Dallas artist's interest in sculpting the human form in motion.

Sanders, Jerry Dane

(b. 1949 American)*

TOMORROW'S LEGACY *1982*

Abstract; 40' × 30' × 20';
stainless steel

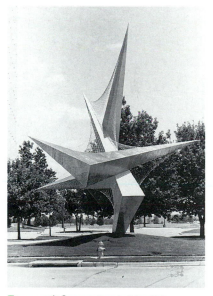

Tomorrow's Legacy. Photo by Robert Little.

363

Location: 2400 North Central Expressway at Palisades Drive
Funding: Originally placed by Hunt Properties

Richmond

Unknown Artist

JAYBIRD MONUMENT *1900*

Figurative; 27' H; granite
Location: 402 Morton Street
Funding: Jaybird Association
Comments: Although the identity of the monument maker is not known, the significance of this jaybird and its granite perch is well documented. The Jaybirds and the Woodpeckers

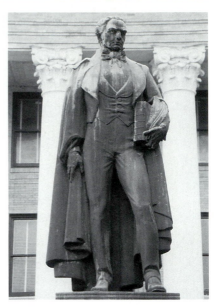

Mirabeau B. Lamar. Photo by Robert Little.

represented two warring factions that developed in Fort Bend County after the Civil War. The conflict reached a crisis in 1889 with the Battle of Richmond, which left five dead and the Union sympathizers out of their Reconstruction government offices— and shortly thereafter out of town. This monument honors the local citizens who fought to restore integrity to county government. The following is engraved around the base of the monument: "Go, stranger, and to the Jaybirds tell that for their country's freedom they fell."

Waugh, Sidney

(1904–1963 American)

MIRABEAU B. LAMAR *1936*

Portraiture; 9'6" H; bronze
Location: Fort Bend County Courthouse grounds
Funding: $14,000 allocated by the 1936 Commission of Control for Texas Centennial Celebrations

Jaybird Monument. Photo by Robert Little.

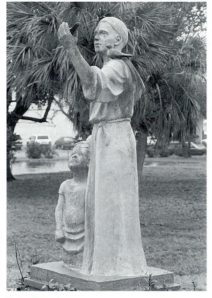

Saint Francis. Photo by Robert Little.

Comments: Mirabeau Lamar is known as the father of public education in Texas. He served in the Battle of San Jacinto, the Mexican War, and as the third president of the Republic of Texas. He died in Richmond on December 19, 1851.

Rockport

Borglum, Lincoln

(1912–1986 American)*

SAINT FRANCIS *1956*

Figurative; life-size; granite
Location: Saint Peter's Episcopal Church, 412 North Live Oak
Funding: Gift of James H. Sorenson, Jr., in memory of his father and grandfather
Comments: The model for the child figure with Saint Francis was the artist's son, James Gutzon Borglum.

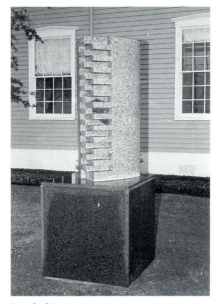

Interlocking. Photo by Robert Little.

Moroles, Jesús Bautista

(b. 1950 Native Texan)*

INTERLOCKING *1985*

Abstract; 6'11$^1/_2$" × 2'8" × 2'8";
Texas granite
Location: Rockport Center for the Arts, 902 Navigation Circle, behind Rockport Harbor adjacent to the Texas Maritime Museum and the Rockport Beach Park
Funding: Private donation
Comments: The artist's studio is located in Rockport.

Rockwall

Houston, Robert

(American)*

JOINT VENTURE *1974*

Abstract; 8' H × 6' W; Cor-ten steel
Location: 1722 Ridge Road
Funding: Cecil Unruh

365

Comments: Unruh purchased this angular, geometric abstract from Stewart Art Gallery in Dallas. At the time, the artist was a Dallas resident.

Round Rock

Gorham Foundry

(American)

BRONZE EAGLE *1985*

Figurative; 2'6" H, 6' wingspan; bronze
Location: Capital Memorial Gardens, 14619 Interstate 35 North
Funding: Capital Parks, Inc.
Comments: This work was cast by the Gorham Foundry in City of Industry, California.

Rusk

Unknown Artist

CONFEDERATE SOLDIER STATUE *1907*

Figurative; life-size; marble
Location: Cherokee County Courthouse grounds

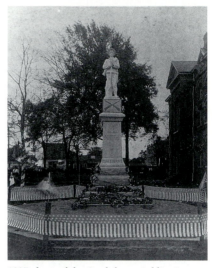

1907 photo of the Confederate Soldier Statue in Rusk. Webb Finley Photo Collection. Courtesy Cherokee County Historical Commission.

Funding: Cherokee County Confederate veterans
Comments: When workers moved the statue to make room for a new courthouse, the soldier's gun was damaged. Local news articles from as far back as 1941 refer to the possibility of returning the statue to Italy for repairs, but this has never been done. The monument's plaque reads, "In memory of the Confederate dead of Cherokee County."

S

Sabine Pass

Salado

San Angelo

San Antonio

San Augustine

San Felipe

San Marcos

Santa Anna

Scottsville

Sherman

Shiner

Sinton

Snyder

South Padre Island

Spearman

Spring

Stephenville

Stonewall

Sweetwater

Sabine Pass

Clark, Doug

(b. 1949 Native Texan)*

MONUMENT TO SAM HOUSTON
1990

Figurative; 14' H, 2 tons; bronze
Location: Lions Park,
5200 block Broadway
Funding: Donations raised through
Dick Dowling Lions Club and
Port Arthur Historical Society
Comments: This massive monument
depicts Houston as a soldier, fron-
tiersman, and public official.

Coe, Herring

(b. 1907 Native Texan)*

RICHARD DOWLING *1936*

Portraiture; larger than life-size; pink
Fredericksburg granite and bronze
cast at Roman Bronze Works in
New York
Location: Sabine Pass Battleground
State Historical Park, south of Sabine
Pass on Farm Road 3322
Funding: $7,500 allocated by the 1936
Commission of Control for Texas
Centennial Celebrations
Comments: This monument marks
the site of Fort Griffin, a compound
consisting of little more than a series
of mud and rock embankments. The
statue portrays Confederate lieuten-
ant Richard "Dick" Dowling, a 24-
year-old Irish immigrant, who was
serving as temporary commander of
Fort Griffin on the day the Union
navy tried to launch an invasion of
Texas. The inscription reads in part,
"At this site on September 8, 1863,
Dick Dowling and forty-seven men
comprising Company F Texas Heavy
Artillery Jefferson Davis Guards
C.S.A., from a mud fort repulsed an
attack made by four warships and
twelve hundred men of the federal

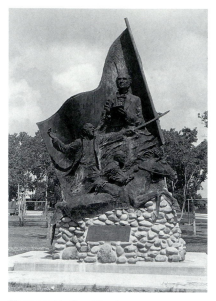

Monument to Sam Houston.
Photo courtesy Doug Clark.

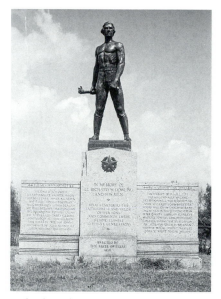

Richard Dowling. Photo by Robert Little.

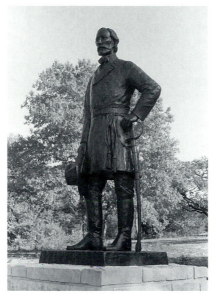

Elijah Sterling Clack Robertson.
Photo by Robert Little.

army, thus saving Texas from invasion by the enemy." Without a single Confederate casualty, Dowling and his men captured approximately 350 Union sailors; almost 200 federals were killed or wounded.

Salado

Dahlberg, H. Clay

(American)*

ELIJAH STERLING CLACK ROBERTSON *1989*

Portraiture; larger than life-size; bronze cast at House Bronze Fine Arts Foundry in Lubbock
Location: Salado College Hill
Funding: Commissioned by the Robertson Colony–Salado College Foundation
Comments: Robertson fought in the Texas Revolution and served in the post office department and the Senate of the Republic of Texas. He attended

the Secession Convention of 1860, later serving as aide-de-camp and purchasing agent for General H. E. McCulloch. After the Civil War, he returned to Salado, where he lived until his death in 1879. His statue is located on the former site of Salado College, a private educational institution that Robertson helped establish. The school received its charter in 1860 and continued until 1885, when the school property was turned over to the Salado public school system.

Kelley, Troy

(b. 1939 Native Texan)*

SIRENA *1986*

Figurative; life-size; bronze
Location: Southeast of Main Street Bridge over Salado Creek
Funding: Private donation
Comments: *Sirena* sits on a small island in the waters of Salado Creek. The sculpture is based on the legend of a magic and malevolent catfish who made a devious bargain with the young Indian maid Sirena. The catfish would cast a love spell on an Indian warrior whom Sirena desired to marry; in return, Sirena would become a mermaid and share her love with the catfish for one night during each full moon for one year. A caveat to the bargain was that if the maiden was seen by human eyes while she

Sirena. Photo courtesy Troy Kelley.

369

was transformed, she would remain a mermaid forever. One night her husband, finding Sirena gone from their bed, sought her by the creek. Sirena had emerged from the water to remove a fish hook from her skin, and the Indian brave beheld his young bride as a mermaid. The maiden's folly resulted in her being transformed forever, and it is said that the waters of the creek are still fed with her tears.

San Angelo

Barrick, Rex

(American)*

LIGHTNING *1984*

Abstract; 15' H including base; rolled steel
Location: Bill Holland Building, 430 West Beauregard
Funding: Bill Holland
Comments: Three pieces of half-inch bar steel form a lightning bolt.

Castleberry, René

(b. 1955 Native Texan)*

SCALED AT REST *1988*

Environmental; 5' H × 8'6" L; silica bronze
Location: 1116 West Avenue N
Funding: Commissioned by Fairmount Cemetery Association
Comments: This work involves five larger-than-life quail perched on a realistic log. The log extends to form a small man-made pond where animals can drink and bathe. At the request of the cemetery association, the artist designed a sculpture that would encourage quail and other wildlife to remain on the cemetery property, which has become surrounded by city traffic. For many years, Castleberry studied under

Remo Joseph Scardigli (1910–1985), a naturalized citizen who lived in San Angelo and became well known for his sculpture and jewelry making. A decorative relief by Scardigli is located on a building at the corner of Irving and Beauregard streets.

Cavness, John

(b. 1958 Native Texan)*

ALACRANERA *1985*

Abstract; 7' × 7' × 3'6"; stainless steel
Location: Chicken Farm Art Center, 2505 North Randolph
Funding: Private purchase
Comments: Cavness serves on the faculty of San Angelo Central High School. In 1958, he placed a bronze bobcat (the school mascot) on the campus at 100 Cottonwood Street.

Greco, Emilio

(b. 1913 Italian)

FIGURA ACCOCCOLATA *1956*

Figurative; 4'2³/₄" H; bronze

Figura Accoccolata. Photo courtesy *San Angelo Standard-Times* and the San Angelo Museum of Fine Arts.

The Ethicon Rams (detail). Photo courtesy Jim Bean Professional Photography, San Angelo.

Location: San Angelo Museum of Fine Arts, 704 Burgess Street
Funding: Meadows Foundation
Comments: The San Angelo Museum of Fine Arts is located on the grounds of Fort Concho, a national historic landmark.

Ludtke, Lawrence M. "Larry"

(b. 1929 Native Texan)*

THE ETHICON RAMS *1966*

Figurative; 2 figures, each 2'11" H and 4' L; bronze cast at Modern Art Foundry in New York City
Location: The Ethicon Plant
Funding: General Robert Johnson for Ethicon, a Johnson and Johnson company
Comments: The Texas Granite Corporation in Marble Falls provided the sunset-red granite bases for the bronze figures. David Drake, president of the Livestock Producers Auction Company, loaned Ludtke a majestic rambouillet that lived in the Houston artist's back yard and served as a live model.

Raimondi, John

(American)

RAN *1979*

Abstract; 21' × 18' × 10'; Cor-ten steel
Location: Civic League Park, West Beauregard and Park Street

Funding: Levi Strauss Company, Mr. and Mrs. W. M. Jones, San Angelo Independent School District, the National Endowment for the Arts, and the Texas Commission on the Arts
Comments: Students from Lake View and Central high schools helped to fabricate this work.

Teich, Frank

(1856–1939 American/German)*

THOMAS MCCLOSKEY *1917*

Portraiture; larger than life-size; granite
Location: Fairmount Cemetery, 1116 West Avenue N
Funding: Laura (Mrs. Tom) McCloskey
Comments: For more than twenty years, Tom McCloskey was the proprietor of the Arc Light Saloon located on the corner of Concho and Chadbourne streets in San Angelo. McCloskey's establishment attracted local businessmen, though it also was the scene of at least one shoot-out. The Arc Light Saloon was known throughout most of West Texas as a dignified and convivial meeting place, but McCloskey himself was best known for his kindness and generosity. The *San Angelo Daily Standard* of December 29, 1914, announced the saloon-keeper's death with the headline, "Tom McCloskey friend of the poor is no more."

Tremonte, Sister Mary Peter

(b. 1930 Native Texan)*

CHRIST THE KING *1983*

Figurative; 6' H; bronze
Location: Christ the King Retreat Center, 802 Ford Street
Funding: Commissioned by the Diocese of San Angelo and donated by Frank and Sheila Thompson

371

Vinklarek, John

(American)*

THE RESCUE *1985*

Figurative; life-size; bronze cast at
Hoka Hey Fine Arts Foundry in
Dublin, Texas
Location: City Hall Plaza,
72 West College Avenue
Funding: San Angelo Fire Department
through public contributions
Comments: This work by Angelo
State University art instructor
Vinklarek is erected in commemora-
tion of the hundredth anniversary of
the San Angelo Fire Department. The
artist designed a fireman rescuing a
small child from a fire.

San Antonio

Aguilar, Alfredo Gracia

(Mexican)

AYER Y HOY *1990*

Abstract; 10'6" H; painted welded
steel
Location: Monterrey Plaza, eastern
edge of Hemisfair Park
Funding: Given to San Antonio in
1992 by its sister city Monterrey,
Mexico

Ayer y Hoy. Photo by Robert Little.

Alden, Bette Jean

(Native Texan)*

SAMUEL GOMPERS STATUE *1982*

Figurative; 25' H; shell and sandstone
mixture
Location: Alamo and East Market
streets, facing the Henry B. Gonzalez
Convention Center
Funding: Texas AFL-CIO, San
Antonio AFL-CIO, and the American
Federation of Government Employees
Comments: Life-size figures repre-
senting the working family encircle
the statue of Samuel Gompers, the
founding president of the American
Federation of Labor.

Bednarek, the Reverend J. G.

(American)*

**REPLICA OF OUR LADY OF
LOURDES GROTTO** *1904*

Figurative; 35' × 40' × 30'; stone,
granite, and marble
Location: Incarnate Word College,
4301 Broadway, on the Motherhouse
grounds by the San Antonio River
Funding: Donations and Sisters of
Charity of Incarnate Word
Comments: The Reverend J. G.
Bednarek, a young priest from the
Chicago archdiocese, designed and
helped construct this replica of the
sacred shrine at Lourdes, France. The
statues of Our Lady of Lourdes,
Bernadette, and Mary are typical of
figures ordered through catalogues
from monument dealers. William C.
Sullivan donated the statue of Mary
in memory of his mother, Mrs.
Daniel Sullivan. Several other works
are installed on the campus and
Motherhouse grounds. *Jubilee
Memorial,* placed on the lawn
fronting the Motherhouse in 1919,
was ordered from Deprato Statuary, a
large marble company that main-
tained offices in Chicago, New York,

Jubilee Memorial (1919). Photo by Robert Little.

Stork Fountain. Photo by Robert Little.

and Pietrasanta, Italy. The second Jubilee Memorial, a marble statue of the Christ Child installed near the Broadway entrance to the campus, was imported from Italy in 1927 as a gift to Mother Columkille Colbert from the student body. A bronze statue of Jesus stands at the entrance to the Motherhouse, and a beautiful fountain sculpture is located on the front lawn of the old George W. Brackenridge home, now located on the campus of Incarnate Word College. The fountain centerpiece depicts a large stork with its wings spread and water flowing from its uplifted beak. Brackenridge purchased *Stork Fountain* for his home around the turn of the century. In 1993, Incarnate Word College purchased the most recent work on the campus, *New Friends,* by Paul Tadlock, an American. It is a life-size bronze figure installed between the Science Building and the Wellness Center.

Bigger, Michael

(b. 1937 American)*

COR-LYNCHE TRIAD 1989

Abstract; 3 pieces, each 7' H;
painted steel
Location: Intersection of Saint Mary's and Josephine streets
Funding: Owned by the city of San Antonio
Comments: Formerly an instructor at the University of Texas at San Antonio, Bigger lives in Minneapolis, Minnesota, where he serves as an associate professor at Minneapolis College of Art and Design. The Cor-ten and stainless-steel cross on top of Saint Luke's Lutheran Hospital at 7930 Floyd Curl Drive and *Storm Clouds,* a fountain sculpture in the hospital's atrium, also are by Michael Bigger.

STEEL SCULPTURE *1981*

Abstract; 4'6" × 2'6" × 2'6"; welded steel
Location: Hemisfair Plaza at the entrance to the University of Mexico Permanent Resident School of San Antonio
Funding: Donated by the artist in 1988

TOP BRIDGE II *1983*

Abstract; 16' × 7' × 11'; painted steel
Location: 1983 Oakwell Farms Parkway
Funding: Donated to Oakwell Farms Homeowners Association by Robert L. B. Tobin

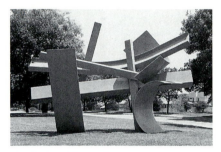

Top Bridge II. Photo by Robert Little.

Briseño, Rolando

(b. 1952 Native Texan)*

PADRE DAMIAN MASSANET'S TABLE *1991*

Abstract; 5'6" H; wrought iron and cast iron
Location: San Antonio River Walk near the Presa Street Bridge
Funding: Commissioned by the Order of Alhambra, Bexar Caravan 56
Comments: The Order of Alhambra presented this commemorative work to the city of San Antonio in recognition of the 300th anniversary of the first mass said on the bank of the San Antonio River. The sculpture is located on a small island in the river.

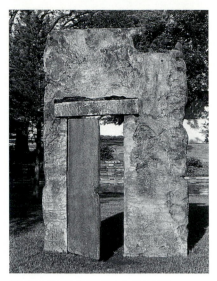

Mi Casa Es Tu Casa. Photo by Robert Little.

Cavillo de Chopa, Diana

(Mexican)

MI CASA ES TU CASA *1990*

Abstract; 10' H; urethane foam
Location: Monterrey Plaza, eastern edge of Hemisfair Park
Funding: Given to San Antonio in 1992 by its sister city Monterrey, Mexico

Coleman, Sherman T.

(b. 1920 Native Texan)*

UNTITLED *1995*

Figurative; larger than life-size; bronze
Location: Cancer Therapy and Research Center, 7979 Wurzbach Road
Funding: Cancer Therapy and Research Center

Contreras, Jesús

(b. 1902 Mexican)

MIGUEL HIDALGO Y COSTILLA
1941

Portraiture; larger than life-size; bronze
Location: Plaza Mexico, Mexican Cultural Institute at 600 Hemisfair Park
Funding: Presented in 1942 to the city of San Antonio by the Mexican government
Comments: A Mexican patriot who is considered the father of Mexican independence, Father Hidalgo led an assault on the prison at Dolores, Mexico, in 1910. He was shot by Spaniards in 1911.

Coppini, Pompeo

(1870–1957 American/Italian)*

COPPINI MEMORIAL *1953*

Figurative; 15' × 24' × 10'; bronze and Italian marble
Location: Sunset Memorial Park, 1701 Austin Highway
Funding: Pompeo Coppini
Comments: Guido Brothers Construction Company brought this 57,000-pound marble monument from the Galveston shipyards, where it arrived from Italy, and installed it at Sunset Memorial Park. The bronze portion of the memorial, depicting Father Time, Minerva, Gloria, the eye of God, Coppini, and his wife, Elizabeth, was cast in America and attached to the marble monument in San Antonio. Work on the *Coppini Memorial* began in 1945, when the artist became concerned that his final resting place might be marked by an ordinary tombstone, which he feared could lack "individuality, originality, or real refined taste" (Coppini 1949, 396). Also, as a healthy and energetic 75-year-old, Coppini was restless when commissions were not forth-

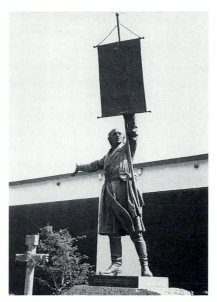

Miguel Hidalgo y Costilla. Photo by Robert Little.

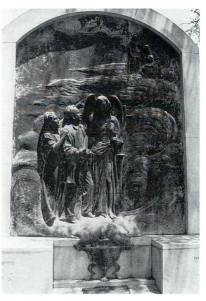

Coppini Memorial. Photo by Robert Little.

coming. He hoped that his memorial might generate new business and inspire future artists to create beautiful cemetery statuary. Coppini died on September 27, 1957, twelve years after he completed his elaborate tombstone. His wife, Elizabeth, was buried beside him a few months later. One other outstanding cemetery monument placed in San Antonio by Coppini is the *Winn Memorial* created in 1905 for the Winn family plot in the San Antonio City Cemetery.

GEORGE STORCH *1951*

Portrait bust; larger than life-size; bronze
Location: Trinity University Campus, Storch Education Center
Funding: Private donation to the university
Comments: In addition to Coppini's bust of George Storch, a life-size bronze bust of Bruce Thomas, former dean and president of the university, was installed in 1975 at Bruce Thomas Residence Hall. The artist was Charles Harris, a student at the university.

GEORGE W. BRACKENRIDGE *1930s*

Portraiture; larger than life-size; bronze
Location: Funston Place at 3501 Broadway
Funding: Private donations

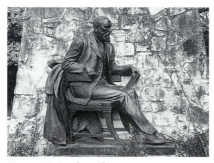

George W. Brackenridge. Photo by Robert Little.

Comments: At the time of his death in 1957, Coppini left the large plaster model for this work in the San Antonio studio that he shared with Waldine Tauch. Coppini created the model during the Depression for Frank Huntress, president of the Express Publishing Company. When it was ready for casting, no funds were available; therefore the monument was never completed. In 1968, Tauch received approval from Mayor Walter W. McAllister and the Fine Arts Commission to have the model cast in Italy for the city of San Antonio, but when the bronze statue arrived in 1969, she discovered that her agreement with city officials had never been signed. A debate ensued over whether the city or Tauch owed $30,000 for the casting and shipment of an unauthorized statue. It took almost one year to secure funds through private donations and to pass an ordinance that the statue be accepted by the city. Finally, on November 14, 1970, the seated likeness of the beloved San Antonio philanthropist was placed at the entrance to the park that bears his name.

LUDWIG MAHNCKE *1906*

Portrait bust; larger than life-size; bronze cast at the Nelli Foundry in Rome
Location: Mahncke Park, on Broadway between Parland and Funston streets
Funding: Citizens of San Antonio
Comments: The citizens of San Antonio commissioned this work to honor Mahncke, who served as the city park commissioner from 1896 to 1906.

SPIRIT OF SACRIFICE *1939*

Figurative; 60' H shaft with base measuring 12' W × 40' L; gray Georgia marble and pink Texas granite
Location: Alamo Plaza at South

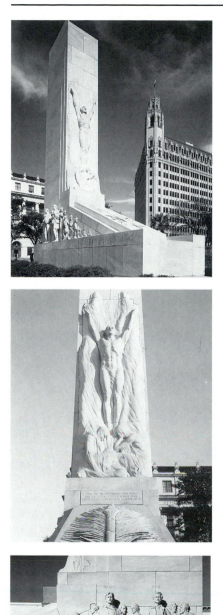

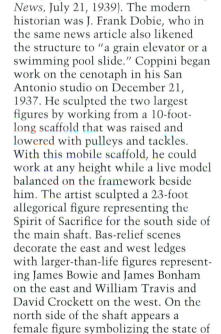

Alamo and East Crockett streets
Funding: Funds allocated by the 1936
Commission of Control for Texas
Centennial Celebrations
Comments: Coppini argued in vain
for this work to be constructed of
Texas granite and bronze, but
architect Carlton Adams chose the
material and the architecture of the
cenotaph before the sculptor was
selected. Although Coppini was
dissatisfied with much about the
commission, he was quick to defend
his work: "I was not allowed to make
a real, actual scene of the Battle of the
Alamo . . . so I had to parade my
beloved heroes to stand there for
centuries to come as if to have their
picture taken, as the modern histo-
rian wrote, by the admirers of their
manly figures" (*San Antonio Evening
News*, July 21, 1939). The modern
historian was J. Frank Dobie, who in
the same news article also likened
the structure to "a grain elevator or a
swimming pool slide." Coppini began
work on the cenotaph in his San
Antonio studio on December 21,
1937. He sculpted the two largest
figures by working from a 10-foot-
long scaffold that was raised and
lowered with pulleys and tackles.
With this mobile scaffold, he could
work at any height while a live model
balanced on the framework beside
him. The artist sculpted a 23-foot
allegorical figure representing the
Spirit of Sacrifice for the south side of
the main shaft. Bas-relief scenes
decorate the east and west ledges
with larger-than-life figures represent-
ing James Bowie and James Bonham
on the east and William Travis and
David Crockett on the west. On the
north side of the shaft appears a
female figure symbolizing the state of

Spirit of Sacrifice (top), and details depicting
the 23-foot-high allegorical figure on the
south side of the main shaft (middle) and the
relief on the west ledge of the main shaft
(bottom). Photos courtesy *Texas Highways Magazine*.

Texas. The names of the Alamo defenders are etched on the monument; however, Coppini did not compile this list, and many historians question its accuracy.

Coppini, Pompeo, and

(1870–1957 American/Italian)*

Waldine Tauch

(1892–1986 Native Texan)*

GENIUS OF MUSIC *circa 1946*

Figurative; life-size; bronze
Location: Brackenridge Park at the Tuesday Music Hall, 3755 North Saint Mary's Street
Funding: Harry Hertzberg in memory of his mother, Anna Hertzberg, who founded the Tuesday Music Club
Comments: When Hertzberg commissioned this seated nude allegorical figure playing a flute, he stipulated that both artists work on the sculpture. The Tuesday Music Club had been supportive of Tauch's career, and Coppini was a close friend of

Harry Hertzberg. Coppini had many close friends among San Antonio's leading citizens, particularly his brothers in the Masonic Order. In 1926, he placed the massive bronze doors at the entrance to the Scottish Rite Temple still located at Avenue E and 4th Street.

Dattelli, Armando

(Italian)

CHRISTOPHER COLUMBUS *1957*

Portraiture; larger than life-size; bronze and granite
Location: Columbus Park, West Martin and Columbus Avenue
Funding: Donated to the city of San Antonio by the Christopher Columbus Italian Society

De Almeida, Leopoldo

(b. 1898 Portuguese)

SAINT ANTHONY *1950*

Figurative; larger than life-size; bronze

Genius of Music. Photo by Robert Little.

Saint Anthony. Photo by Robert Little.

Location: River Walk, 600 block
East Commerce Street
Funding: Donated to the city of
San Antonio by the government of
Portugal

Dean, Robert Lee, Jr.

(b. 1929 American)

GENERAL DOUGLAS MACARTHUR *1969*

Portraiture; life-size; bronze
Location: Texas Military Institute,
20955 Tejas Trail West
Funding: Robert M. Ayres, Jr.
Comments: Both Douglas MacArthur
(class of 1897) and Robert Ayres (class
of 1944) attended this military
academy.

Deuel, Austin

(b. 1940 American)

HILL 881 SOUTH *1986*

Figurative; 2$^1/_2$ times life-size; bronze
cast at Phippen Bear Paw Bronze in
Scottsdale, Arizona
Location: Veterans Memorial Plaza,
100 Auditorium Circle, at the corner
of Saint Mary's and East Martin
streets
Funding: Private contributions to
the Vietnam Veterans Memorial of
San Antonio, Inc.
Comments: John D. Baines of San
Antonio promoted the effort to erect
this memorial to Vietnam veterans.
Baines and the artist served together
in Vietnam, where Deuel was a U.S.
Marine Corps combat artist. The
memorial depicts two soldiers, a
radioman lending aid to a wounded
comrade. The radioman waits on a
hillside and searches the sky for a
medical evacuation helicopter. This
scene was indelibly printed in the
artist's mind as he witnessed a battle
on April 30, 1967, in which U.S.
Marines captured Hill 881 South near

Hill 881 South. Photo by Bud Shannon/Photography, Inc.,
courtesy John Delavan Baines.

Khe Sanh. The battle was one of the
bloodiest in the Vietnam War, and as
the Americans awaited the conflict, a
young Marine hastily wrote the
following poem, which is etched on the
sculpture's base:

> Day is over as danger hastens
> Young Marines at their battle stations.
> Instruments of war outline the sky,
> Means of death are standing by.
> Can it be true on this high hill
> Forces will clash only to kill?
> Silence fills the near moonless night.
> Restless thoughts of a bloody fight—
> Endless memories for those awake
> Meaningful discussion experience
> would make,
> Though the silent world in which we
> live
> Permits only God's comfort to give.
> Somewhere through the darkness
> creeping
> A date with death is in the keeping.
> Alone I sit and question why
> Life itself to be born to merely die.
> David G. Rogers
> 1st Lt. USMC
> April 30, 1967
> Hill 881 South,
> Republic of Vietnam

Austin Deuel lives in Scottsdale,
Arizona. Most of his paintings and
bronzes depict the American West.

379

Dobberfuhl, Donna L.

(b. 1949 American)*

ENGLISH LION *1989*

Figurative; larger-than-life figure on an 8' H wall; brick
Location: Winston Churchill High School, 12049 Blanco Road
Funding: Donated by the Class of 1988
Comments: Dobberfuhl is a native of Crawfordsville, Indiana, now living and working in the community of Converse, northeast of San Antonio. Working with bronze, white bronze, brick, and fabric, Dobberfuhl is particularly interested in preserving and promoting the rare art form of sculpted brick. Two other sculpted-brick animal figures by Dobberfuhl are installed at Motor Imports automobile dealership, 96 Northeast Loop 410. Her work has been featured in numerous regional and national invitational exhibitions.

Easley, William

(b. 1944 Native Texan)*

DAVY CROCKETT *1989*

Portrait bust; life-size; bronze cast at Castleberry Art Foundry in Weatherford
Location: Crockett Park, North Main Avenue and Cypress Street
Funding: Owned by the city of San Antonio

TORIBIO LOSOYA *1986*

Portraiture; life-size; bronze cast at Castleberry Art Foundry in Weatherford
Location: 120 Losoya Street
Funding: Given to the city of San Antonio by the Adolph Coors Company
Comments: Losoya was born in the Alamo compound in 1809, and there he died with the other heroic defenders on March 6, 1836. He was a

Toribio Losoya. Photo by Robert Little.

Mexican soldier with Juan Seguín's Texian Volunteers. Rodriguez Brothers Memorials, the same company that built the base for the Alamo cenotaph in 1939, provided the base for the statue. William Easley was born three blocks from the Alamo, near the present site of the Losoya statue.

Ettl, Katherine Speed

(b. 1911 American)

COMBAT MEDIC MEMORIAL *1979*

Figurative; larger than life-size; bronze cast at the Bedi-Makky Foundry in Brooklyn
Location: U.S. Army Medical Department Museum, Fort Sam Houston, Stanley Road and Harry Wurzbach Road
Funding: Worldwide donations to the Combat Medic Memorial Fund under the leadership of Lieutenant Colonel Richard J. Berchin, Medical Service Corps

Comments: The Combat Medic Memorial Fund Committee organized not only to erect a memorial but also to foster understanding of the role and importance of the medical soldiers who support United States combat forces. The Princeton, New Jersey, artist illustrates this concept in her sculpture of a combat medic leaning over an injured soldier. The uniforms and equipment are from World War II, circa 1944, European Theater. The Bedi-Makky Foundry, where this work was cast, has been in operation for more than 75 years. Eugene Bedi and Joseph Rassy began the Bedi-Rassy Foundry in 1925. After Rassy retired, Istvan Makky bought into the firm, which continued under the name Bedi-Makky Foundry. In 1980, Eugene Bedi retired, and Istvan Makky formed a partnership with Peter Maurar.

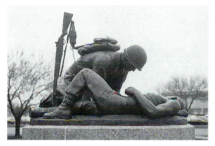

Combat Medic Memorial.
U.S. Army photograph used with permission.

Evett, Philip John

(b. 1923 American/English)*

UNTITLED 1966

Abstract; 35' H; welded aluminum
Location: Trinity University campus, Ruth Taylor Courtyard
Funding: Private donation to the university
Comments: Evett, a professor at Trinity, donated his time to create this decorative piece, which was erected upon the completion of the theater building.

Flores, Jake

(American)*

MONUMENT TO HISPANICS IN TEXAS 1981

Figurative; 2'6" H; bronze and granite
Location: San Antonio City Hall grounds, 100 Military Plaza
Funding: Erected by the Mexican American Business and Professional Association
Comments: The sculpture on this monument depicts two eagles, the national birds of the United States and Mexico.

Fussel, Guss W.

(German)

WEST BERLIN BEAR 1968

Figurative; 3'4" H; bronze
Location: 600 block Hemisfair Way off South Alamo Street
Funding: Given to the city of San Antonio in 1968 by the city of Berlin, West Germany, in commemoration of Hemisfair

Graeber, Larry

(b. 1949 American)*

THREE-PIECE CIRCLE 1984

Abstract; 16' H; painted welded steel
Location: Saint Mary's University campus, 2700 Cincinnati Avenue
Funding: Private donation to the university
Comments: Omni Interests originally placed this work at Omni Plaza. When it was donated to the university, it was the only modern sculpture located on the campus. The oldest sculpture installed at Saint Mary's is the *Immaculate Conception Memorial,* a life-size bronze figure of Mary placed in 1904. The memorial is set on a granite pedestal identical to that of the *Saint Louis College Silver Jubilee Monument,* which was

381

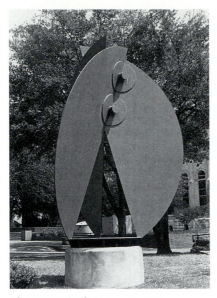

Three-Piece Circle. Photo by Robert Little.

Immaculate Conception Memorial.
Photo by Robert Little.

installed in 1919. Both statues were cast in France and erected in College Park on the campus of Saint Louis College, which became Saint Mary's University. Another liturgical statue, the *Marian Year Statue of Our Blessed Mother,* was ordered from Italy and placed on campus in 1954 by the university and the student council. Carved of Carrara marble, it depicts Mary standing on a sculptured globe with her heel crushing the head of a serpent. Two other carved statues at Saint Mary's are *Saint Joseph and the Child Jesus* and *Sacred Heart of Jesus,* both made of Carrara marble and brought to the campus from Kirkwood, Missouri, in 1968. No further record of their origin exists in Saint Mary's archives.

TRIUMPH *1980*

Abstract; 16' H; steel and Plexiglas
Location: Vista Verde buffer strip off Interstate 10, downtown
Funding: City of San Antonio Arts Council with support from area businesses

Saint Louis College Silver Jubilee Monument.
Photo by Robert Little.

Guelich, Bob

(b. 1945 American)*

FISHING LESSON *1985*

Figurative; life-size; bronze
Location: San Antonio Botanical
Center, Garden for the Blind,
555 Funston Place
Funding: San Antonio Garden
Center, Inc.
Comments: This fountain centerpiece
includes three Texas blue herons
mounted on a large stone. The birds,
the movement and sound of the
water, the texture of the rock base,
and the walkway approaching the
sculpture are all designed for the
convenience and enjoyment of people
who are visually handicapped.

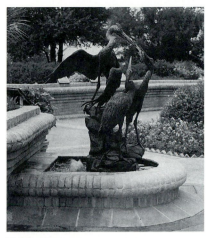

Fishing Lesson. Photo courtesy Bob Guelich.

Hepworth, Barbara

(1903–1975 British)

**CONVERSATION WITH
MAGIC STONES** *1973*

Abstract; 6 pieces, tallest, 5' H;
bronze and stone
Location: Trinity University campus,
Trinity University Library grounds
Funding: Private donation to the
university

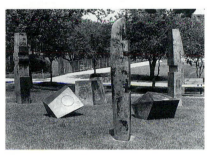

Conversation with Magic Stones.
Photo courtesy Trinity University, San Antonio.

Kim, Deuk-Hoi

(Korean)*

RED BRIDGE *1988*

Abstract; 8' H; painted steel
Location: River Bend Parking Garage,
Presa and Market streets
Funding: City of San Antonio,
purchase prize in the city's 1988
sculpture competition

Ludtke, Lawrence M. "Larry"

(b. 1929 Native Texan)*

MAURY MAVERICK *1987*

Portrait bust; larger than life-size;

Maury Maverick. Photo by Robert Little.

383

bronze cast at the Roman Bronze
Works in New York
Location: Maverick Plaza at the
Convention Center, Alamo and
East Market streets
Funding: Commissioned by the city
of San Antonio
Comments: Maury Maverick, a
descendant of the illustrious Texan
Sam A. Maverick, served as mayor of
San Antonio from 1939 to 1941.

Mason, Jimilu

(American)

AUDIE L. MURPHY STATUE *1975*

Portraiture; 8' H; bronze
Location: Audie L. Murphy Memorial
Veterans Hospital, 7400 Merton
Minter Boulevard
Funding: Audie L. Murphy
Foundation
Comments: Audie Murphy, the most
decorated soldier of World War II and
a native Texan, is portrayed leading
an attack against the enemy. He
carries a gun with the bayonet drawn
in his left hand while his right hand
motions to his comrades to follow
him.

McLeary, Bonnie

(1890–1971 Native Texan)

BEN MILAM *1936*

Portraiture; larger than life-size;
bronze
Location: Milam Park, Santa Rosa
between Houston and Commerce
streets
Funding: Funds allocated by the
1936 Commission of Control for
Texas Centennial Celebrations
Comments: Bonnie McLeary (Mrs.
Ernest Kramer) was a native of San
Antonio. Her father, J. H. McLeary,
served as attorney general of Texas
from 1880 to 1882. She is particularly
well known for her garden sculptures
and her portrayal of children. *Ben*

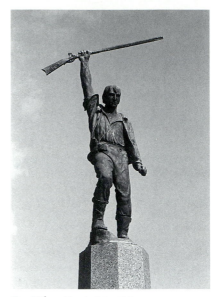

Ben Milam. Photo by Robert Little.

Milam is her only publicly sited
outdoor work in Texas. McLeary
modeled this statue of the Texas
Revolutionary hero in her New York
studio. At the unveiling on Septem-
ber 7, 1936, Senator E. J. Altgelt made
an accurate observation and predic-
tion: "It is fortunate that part of the
Centennial funds was made available
for monuments and historic markers
throughout the State. The Centennial
celebration may pass into history and
fade from recollection, but these
enduring monuments will serve
through all the years as reminders
of the dramatic and heroic chapters
of the history of Texas" (Bivins
Scrapbook).

Monjo, Enrique

(Spanish)

CONQUISTADOR *acquired 1977*

Figurative; 7'7" H; bronze
Location: Spanish Governor's Palace,
105 Plaza de Armas
Funding: Gift to the city of San
Antonio by the government of Spain

384

Large Interior Form. Photo courtesy Trinity University, San Antonio.

Moore, Henry

(1898–1986 British)

LARGE INTERIOR FORM *1981*

Abstract; 15' H; polished bronze
Location: Trinity University campus esplanade near the University Center
Funding: Private donation to the university
Comments: The three interior open spaces in this curved shape represent the artist's use of the hole. Moore often discussed negative space: "A hole as such can possess as much form significance as a piece of mass. The air can become the object of the sculptor: not the stationary stone but the hollowed-out hole becomes the artistic expression" (Koepf 1966, 46).

THREE-WAY PIECE #1: POINTS *1964*

Abstract; 6'4" H, 3 tons; bronze
Location: One Alamo Center, 106 South Saint Mary's Street
Funding: Purchased from a private

collection in 1981 by MBank Alamo and currently owned by Principal Mutual Life Insurance Company

Mott, J. L., Iron Works

(American)

FOUNTAIN FIGURE *1892*

Figurative; 20' H; cast iron
Location: City Water Board Park, Market Street at the River
Funding: Bexar County Commissioners Court
Comments: This beautiful Mott fountain was removed from its original site on the courthouse grounds in 1927. Consigned to a junkyard, where it gradually deteriorated, the old fountain might have been lost forever. In the 1960s, Judge A. W. Seeligson received permission from county commissioners to save the old landmark that she had admired on the courthouse lawn as a young child. The restored fountain was rededicated in 1963.

Fountain Figure. Photo by Robert Little.

385

Perkins, Jonas

(American)

JOSE ANTONIO NAVARRO *1995*

Portraiture; 9' H; bronze
Location: Corner of West Commerce
and Santa Rosa streets
Funding: Project coordinated by
David McDonald, superintendent of
Casa Navarro State Historical Park,
and funded primarily by the San
Antonio Conservation Society with
assistance from private foundations,
corporations, and individual donors

Piedboeuf, Lambert

(b. 1863 French)

**FOURTEEN STATIONS
OF THE CROSS** *n.d.*

Figurative; 14 pieces, each
2'4" H × 1'10" W; bronze and concrete
Location: Our Lady of the Lake
Convent, 411 Southwest 24th Street
Funding: Congregation of the
Sisters of Divine Providence
Comments: An outdoor shrine had
long been a dream of the Sisters of
Divine Providence, who began
collecting funds for such a monument
in 1924. During the Depression,
unemployed workers began work on
the grotto under the direction of
Father Ferdinand Thiry, who designed
the structure after the original shrine
in Lourdes, France. The statues of
Our Lady of Lourdes and Saint
Bernadette are molds such as those
ordered through monument dealers.
Construction of the shrine extended
from 1924 to 1930; the statues were
added in 1930, and in 1930–1931
Lambert Piedboeuf's bronze relief
panels were installed. Piedboeuf's
signature is recorded on each of the
fourteen stations, which are mounted
on concrete pillars and placed at
intervals along the pathway from the
grotto to Providence Cemetery.

Statuary installed on the campus of
Our Lady of the Lake University,
which is adjacent to the convent
grounds, includes a life-size marble
statue of Blessed John Martin Moye.
The Lady of the Lake Sisters of
Divine Providence ordered this statue
of the founder of their order from
Strasbourg, France, in 1954. Other
campus statuary includes concrete
molds of *Our Lady of the Lake*,
placed in 1906, and *Saint Anthony*
and *Saint Joseph*, both placed in 1909.

Powell, J. Ellsworth

(American)

RISEN LORD *1977*

Abstract; 4' H; white polymer
Location: Saint Luke's Methodist
Hospital, entrance, 7930 Floyd Curl
Drive
Funding: Purchased by the hospital
Comments: The features in this
highly stylized standing figure of
Christ are not recognizable, as he was
not at first recognizable on the road
to Emmaus after the Resurrection.
Another casting of this work is
installed on a 50-foot-high steeple at
the Lutheran Church of the Risen
Lord in Odessa.

Pritchett, Mark

(American)*

MISSING MAN MONUMENT *1977*

Figurative; 25' H; anodized aluminum
and steel
Location: Randolph Air Force Base
Funding: Red River Valley Fighter
Pilots Association, San Antonio
Chapter, with funds raised by the
selling of Prisoners of War/Missing in
Action bracelets
Comments: Four stylized jet aircraft
depict the U.S. Air Force
Thunderbirds Aerial Demonstration
Team's version of the missing man

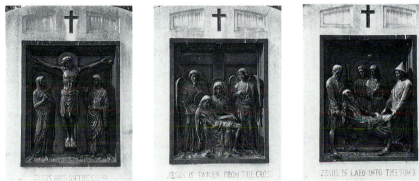

formation. The monument is
dedicated to the American casualties
of the war in Southeast Asia. On the
base is written, "We who came home
must never forget those who could
not." Since the early days of military
aviation, pilots have flown the
missing man formation with the
number-three position vacant to
salute fallen comrades. During the
Southeast Asian conflict, the
Thunderbirds' version, with four
planes, came to symbolize the
sacrifice of all American service
personnel, whether aviators or not.

Grotto designed by Father Ferdinand Thiry
and details from *Fourteen Stations of the
Cross* by Lambert Piedboeuf: "Jesus Dies on
the Cross," "Jesus Is Taken from the Cross,"
and "Jesus Is Laid into the Tomb."

Photos taken with permission of Our Lady of the Lake
University, established in 1895 by the Congregation of
Divine Providence. Photos by Robert Little.

387

Covered Bus Stop. Photo by Robert Little.

Rodriguez, Dionicio

(American/Mexican)*

COVERED BUS STOP *circa 1940*

Figurative; 8'9" H; cement mixture
Location: 4901 Broadway at
Patterson Road
Funding: Donated to the city of
Alamo Heights by Charles
Baumberger, president of San Antonio
Portland Cement Company
Comments: Rodriguez lived in San
Antonio intermittently from the late
1920s to the mid-1940s. While
working for Charles Baumberger at
the San Antonio Portland Cement
Company, now Alamo Cement
Company, he used a formula known
only to himself to create his unique
simulated tree trunks that appear
throughout the city. Rodriguez was a
Mexican national who spoke little
English. He kept his techniques
secret, working inside a tent and
using tools he made himself. He
never shared his process of cement
sculpture or coloring, but his cowork-
ers observed that he used a metal rod

Covered Park Bench. Photo by Robert Little.

Japanese Tea Garden Gate. Photo by Robert Little.

base on which he developed three-dimensional designs with layers of specially prepared cement. In 1933, Arkansas developer Jim Matthews hired Rodriguez to help him build a new neighborhood park, now known as the T. R. Pugh Memorial Park, located at the corner of Lakeshore Drive and Fairway Avenue in North Little Rock. Rodriguez spent four years constructing the faux wooden shingles, benches, and rails; they created such a picturesque setting that the gristmill in the park was used in 1939 as background for the opening credits in the movie *Gone with the Wind*. The park and the artist's painted cement sculptures have been restored and are considered one of North Little Rock's most important tourist attractions.

COVERED PARK BENCH *1930s*

Figurative; 7' H × 8' W; cement mixture
Location: Otto Koehler Park on North Saint Mary's Street, adjacent to the miniature train in Brackenridge Park
Funding: Otto Koehler
Comments: The bench under the pagoda-style roof is formed from an 8-foot-long simulated split log. Two other examples of Rodriguez's tree-trunk sculptures, a bridge and a gazebo, are located nearby in Brackenridge Park.

GAS STATION COLUMNS *1930s*

Figurative; 4 pieces, each 10' H; cement mixture
Location: North Saint Mary's Street and Kings Court
Funding: Unknown
Comments: These four tree columns support a roof that once covered gas pumps.

JAPANESE TEA GARDEN GATE
1940s

Figurative; 12' H; cement mixture
Location: 3800 North Saint Mary's Street, at the northwestern edge of Brackenridge Park
Funding: Owned by the city of San Antonio
Comments: The history of the Japanese Tea Garden and its entry gate is preserved on a bronze marker near the garden. In the early 1900s, San Antonio parks commissioner Ray Lambert conceived the idea of beautifying the abandoned rock quarries formerly used by the San Antonio Portland Cement Company. Lambert asked Kimi Eizo Jingu, a Japanese artist who had recently moved to San Antonio, to help the city design an authentic Japanese tea garden to be erected at the old quarry on Saint Mary's Street. The garden was completed in 1919, and the Jingu family moved into a house on the site to act as overseers. Before his death in 1936, Jingu had become nationally recognized for his knowledge of teas. The Jingu family remained in the garden house until December 7, 1941. After Pearl Harbor, the fear and resentment of the American public against the Japanese resulted in the family's removal from the house and the garden's name change. It was during this period that Rodriguez's garden gate was constructed with the inscription "Chinese Tea Garden." In 1983, the San Antonio City Council ordained that the original name be restored to the garden in consideration of the number of Japanese Americans who had fought honorably for the United States during World War II.

389

Rodriguez, Louis

(Native Texan)*

FRANKLIN DELANO ROOSEVELT
1946

Portrait bust; larger than life-size;
bronze
Location: Military Plaza,
200 block West Commerce Street
Funding: Erected by Comité
Mexicana de Acción Cívica
Comments: Louis and James
Rodriguez were born and reared in
San Antonio, where they established
Rodriguez Brothers Monument Works
in 1921. In 1939, Louis was one of
approximately twenty sculptors who
attended classes held by Waldine
Tauch in her San Antonio studio; he
later designed the base for her *Moses
Austin.* Descendants of Louis and
James continue to operate the firm
under the name "Rodriguez Brothers
Marble and Granite Memorials."

LION *1930s*

Figurative; 4'6" H; stone
Location: Lions Field Park,
2909 Broadway
Funding: Owned by the city of
San Antonio
Comments: The Lions Club estab-
lished this park in 1912 and gave it to
the city in the 1930s.

Lion. Photo by Robert Little.

San Antonio de Padua. Photo by Robert Little.

SAN ANTONIO DE PADUA *1930s*

Figurative; life-size; Carrara marble
Location: Bexar County Courthouse
grounds, Main Plaza at Dwyer and
Market
Funding: Donated in 1955 to the city
of San Antonio by the Order of the
Alhambra
Comments: Rodriguez designed this
traditional figure of Saint Anthony
and traveled to Pietrasanta to choose
the marble and direct the sculpting by
Italian artisans.

SUNKEN GARDEN THEATER
ENTRANCE ARCH *1936*

Figurative; 6' × 20' × 7'; stone
Location: 3755 North Saint Mary's
Street
Funding: Private donations in honor
of the heroes of the Texas Revolution

THEODORE ROOSEVELT *1935*

Figurative; 2'6" H × 3'6" W; bronze
Location: 2300 Roosevelt Avenue
Funding: Alamo Area Council of
Boy Scouts of America

Comments: The plaque reads in part, "In memory of Theodore Roosevelt, Scout Citizen, who organized the Rough Riders in this vicinity in May, 1893." A bas-relief figure of President Roosevelt on his horse is located above the inscription. The Rough Riders were the first U.S. Cavalry Volunteers. They organized as a regiment to fight in the Spanish-American War and trained in the vicinity of this marker under the command of Leonard Woods with assistance from Theodore Roosevelt.

Rogers, Richard Harrell

(b. 1941 Native Texan)*

CENTERED DISC *1978*

Abstract; 12' H; Cor-ten steel and concrete
Location: Canavan Center, 8647 Wurzbach Road
Funding: John and Suzanne Canavan
Comments: A circle within a circle presents an interplay of shapes that can be enjoyed by passing motorists.

COLONNADE *1985*

Abstract; 45' H × 26'3" W; brushed aluminum
Location: The Colonnade, 9834 Colonnade Boulevard, near Interstate 10 and Wurzbach Road
Funding: Trammell Crow Company

DOUBLE HELIX *1981*

Abstract; 24' H × 12' W; aluminum
Location: University of Texas Health Science Center, 7703 Floyd Curl Drive
Funding: San Antonio Medical Foundation

LOTUS *1987*

Abstract; 12' diameter; Cor-ten steel
Location: The Collection, 7959 Broadway
Funding: Commissioned by Claiborn Carrington and Ed Kopplow

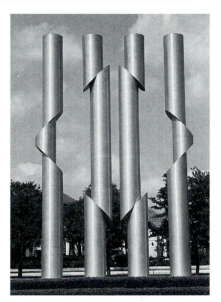

Colonnade. Photo by MarJo Rogers.

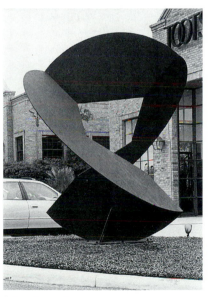

Lotus. Photo by Robert Little.

391

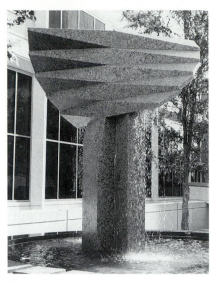

Sunset Spiral. Photo by MarJo Rogers.

SUNSET SPIRAL 1985

Abstract; 14' H × 8' W; sunset-red
Marble Falls granite
Location: NationsBank,
300 Convent Street
Funding: Trammell Crow Company

UNTITLED 1978

Abstract; 30' × 5' × 5'; Cor-ten steel
Location: The Exchange courtyard,
4901 Broadway
Funding: George Geis with Geis and
Geis Contractors
Comments: As with most of Rogers'
abstracts, this work was designed for
a particular setting. The tall, narrow
sculpture fits the small amount of
space available, and the rust-red
finish complements the materials
used in the surrounding building.

VECTOR IV 1986

Abstract; 4' H × 12' W; Marble Falls
sunset-red granite, Swedish blue-pear
granite, and stainless steel
Location: Park Hills Baptist Church,
17747 San Pedro Avenue
Funding: Friends of Ronald Eubank

Samarripa, Oscar

(Mexican)

FRANCISCO I. MADERO 1976

Portrait bust; larger than life-size;
bronze
Location: 102 Concho Street at
Market Square Mall
Funding: Owned by the city of
San Antonio
Comments: After working as a leader
in the Mexican Revolution, Madero
served as president of Mexico until
his government was overthrown in
1913. This portrait is done in high
relief and mounted on a 4-foot
pedestal.

Sandoval, Julian

(American)*

HERTZBERG ELEPHANTS 1930s

Figurative; 2 figures, each 3'5" H;
painted cement
Location: Hertzberg Circus Collection,
210 West Market Street
Funding: Owned by the city of
San Antonio
Comments: The Hertzberg Circus
Collection, housed in the San
Antonio Public Library Annex,
contains more than 20,000 items of
big-top memorabilia. When Hertzberg
died in 1940, his will left the collec-
tion to the city of San Antonio, and
his painted cement elephant became
a mascot guiding visitors to one of
the most popular attractions in the

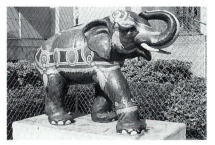

Hertzberg Elephant. Photo by Robert Little.

city. The elephant statue was a gift to Harry Hertzberg from his friend, the San Antonio jeweler Tom Scaperlanda. Scaperlanda hired Julian Sandoval, a San Antonio cast-stone worker, to cast the elephant and place it in the front yard of Hertzberg's home on Euclid Avenue, where it remained until Hertzberg's death. Though not generally known, Julian Sandoval cast five elephants from the Hertzberg mold. One of the five was purchased by Joaquin R. Abrego as a present to his wife. When Abrego died in 1989, his children donated the Abrego elephant to the library, and thus, after more than half a century, two of the quintuplets are united to stand on matching pedestals in front of the library annex.

Simmang, Charles, Jr.

(b. 1874 Native Texan)*

GONZALES HEROES MONUMENT
1936

Figurative; 1'4" H × 2'5" L; bronze
Location: Alamo Plaza
Funding: Daughters of the Republic of Texas, Gonzales Chapter
Comments: The artist's signature is on this relief scene, which pictures the 32 men from Gonzales as they arrived at the Alamo. These heroes came through the Mexican lines to fight for Texas independence in response to the urgent appeal from William B. Travis.

Stein, Sandi

(b. 1946 Native Texan)*

UNTITLED *1990*

Environmental; 10' H;
Texas limestone and green slate
Location: Bexar County Justice Center courtyard, 111 East Nueva
Funding: Bexar County Federation of Governments

Untitled, installation by Sandi Stein in the Bexar County Justice Center sunken courtyard. Photo by R. Greg Hursley.

Comments: The Bexar County Justice Center, completed in 1990, is an annex to the 1892 Bexar County Courthouse designed by J. Riely Gordon and D. E. Lamb. The new center is a joint venture of Ford, Powell and Carson, Joneskell Architects, and Humberto Saldana and Associates. Designers of the new center were challenged to create a contemporary annex that would be compatible with neighboring structures of historical and architectural significance. Sandi Stein worked with the architects from the beginning of the project to create a public art installation that would complement the design of the new Justice Center and enhance the building's open spaces. In the sunken courtyard on the south side of the center adjacent to the jury room and cafeteria, Stein carved four Austin cream limestone columns. Chiseled on-site during the building's construction, the columns call to mind ancient stelae that might have been unearthed by workers excavating the site. On the walls surrounding the courtyard, she

393

designed thin horizontal bands of carved green slate moldings that simulate strata in the earth and further underscore the connection between modern architecture and archeology. Sheltered from traffic and crowds, the sunken courtyard is approximately at the level of the city of San Antonio in the 1850s.

Sugarman, George

(b. 1912 American)

KITES *1986*

Abstract; 40' H; painted aluminum
Location: Mercantile Building,
Loop 410 and McCullough Avenue
Funding: Mercantile Bank, now
Groos Bank

Tauch, Waldine

(1892–1986 Native Texan)*

FIRST INHABITANT *1914*

Figurative; 7' H; imitation stone
Location: Commerce Street Bridge
at Losoya
Funding: San Antonio Express
Publishing Company, $1,000
Comments: Pompeo Coppini
encouraged the publisher of the
San Antonio Express to commission
Tauch to create a drinking fountain
for the bridge on the newly widened
Commerce Street. It was her first
public monument, and after much
consideration, Tauch chose to sculpt
a Native American in high relief. She
used a live model of Indian back-
ground, and she hired Hannibal
Pianta of San Antonio to cast her
design in plaster and then in stone.
With this work, Waldine Tauch
proved to others and to herself that
her dream to sculpt large, public
monuments could be realized.

Kites. Photo by Robert Little.

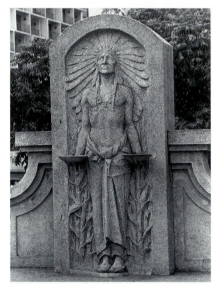

First Inhabitant. Photo by Robert Little.

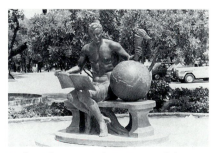

*Higher Education Reflects Responsibility
to the World.* Photo by Robert Little.

394

HIGHER EDUCATION REFLECTS RESPONSIBILITY TO THE WORLD
1965–1968

Figurative; larger than life-size; bronze
Location: Trinity University campus, northwest entrance
Funding: Private donation to the university
Comments: The seated male figure studies the Book of Knowledge and holds the Torch of Enlightenment above a sculptured globe of the world.

MOSES AUSTIN *1937*

Portraiture; larger than life-size; bronze
Location: Military Plaza, 200 block West Commerce Street
Funding: Funds allocated by the 1936 Commission of Control for Texas Centennial Celebrations
Comments: According to the artist's usual procedure, the clay figure of Austin was first modeled in the nude, then clothes were applied. Tauch's biographer records that she had particular difficulty fashioning Austin's cape: "For the cape, she draped a metal lath upon the back of the statue, carefully blending it to shape the folds. The edges of the lath were razor sharp and working with it was an ordeal, for it cut her hands so viciously that every night when she finished her hands were bleeding" (Hutson 1978, 97). A few weeks after shipping the model to New York for casting, Tauch received word that the statue had been badly damaged in shipment. Since she was under pressure to complete her other Centennial commissions, Pompeo Coppini set his own work aside and went to New York to repair the statue while she completed the eight bronze reliefs for the pedestal. The finished work portrays Moses Austin as a confident man, full of hope that his dream to colonize Texas will be a reality. In his right hand he holds the

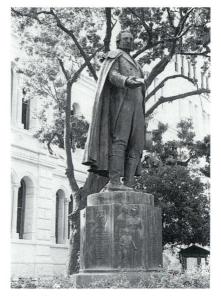

Moses Austin. Photo by Robert Little.

agreement with the Spanish government giving him permission to bring 300 families to settle in Texas. Austin died before his dream came to fruition, but his dutiful eldest son carried out the plan to a degree that far surpassed anything Moses Austin could have envisioned.

Teich, Frank

(1856–1939 American/German)[*]

CONFEDERATE MEMORIAL *1899*

Figurative; larger than life-size; granite
Location: Travis Park, Travis and Navarro streets
Funding: Barnard E. Bee Chapter, United Daughters of the Confederacy
Comments: This traditional Confederate soldier statue mounted on a tall shaft is one of the oldest publicly sited sculptures in the city. The September 1899 issue of *Confederate Veteran* reported that this work was the first historic monument erected in San Antonio. Frank Teich moved to the Alamo City in 1883, and when

395

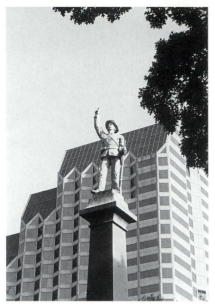

Confederate Memorial. Photo by Robert Little.

Pompeo Coppini came to work for him in 1901, his shop was at the corner of Alamo Street and the Aransas Pass Railroad track. Teich probably made the *Confederate Memorial* in that location.

Thomas, Jim

(b. 1936 American)*

AMERICAN BUFFALO *1990*

Figurative; life-size; fiberglass
Location: Louis W. Fox Academic and Technical High School, 637 North Main
Funding: Louis W. Fox Academic and Technical High School through fund-raising activities
Comments: Western artist Jim Thomas is best known for his small bronze figures created and cast at his studio foundry outside Leander. This special commission is made in fiberglass because the school wanted to transport it to sporting events as the team's mascot. An identical

buffalo is located in Shertz, Texas, at Samuel Clemens High School, 101 Elbel Road.

Torres, José Acosta

(Native Texan)*

MARTIN LUTHER KING, JR. *1981*

Portraiture; 8' H; cast metal
Location: Martin Luther King Plaza at New Braunfels and Houston streets
Funding: Youth Leadership Conference for Community Progress in San Antonio through an eleven-year fund-raising effort

Tremonte, Sister Mary Peter

(b. 1930 Native Texan)*

SAINT HELENA *1985*

Figurative; 8' H; bronze
Location: Saint Helena's Church, 14714 Edgemont
Funding: Commissioned by the church

SAINT JOHN NEUMANN *1983*

Figurative; 3 figures, tallest 6' H; bronze
Location: Saint John Neumann Catholic Church, 6680 Crestway
Funding: Commissioned by the church's Women's Club

Umlauf, Charles

(1911–1994 American)*

CRUCIFIXION *1948*

Figurative; 10' H; aluminum cast at Roman Bronze Works, Inc., in New York
Location: The Shrine of Saint Anthony on West Nottingham, half a block west off the 7700 block Broadway
Funding: Marion Koogler McNay
Comments: This figure of Christ on

Saint John Neumann (detail).
Photo by Sister JoAnn Niehaus.

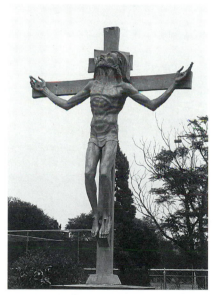

Crucifixion. Photo courtesy Charles Umlauf.

the cross is placed in a small cemetery near the grave of Marion Koogler McNay. In addition to this freestanding sculpture, Umlauf has several exceptional religious relief sculptures in San Antonio. *Annunciation,* a 13-foot-high cast-stone sculptural group, is mounted on the facade of the Annunciation Chapel at Our Lady of the Lake University campus. *Christ of the Open Arms,* a 15-foot-high bronze figure of Christ, is mounted on the facade of the Margarite B. Parker Chapel on the Trinity University campus. *Ascended Christ,* a 12-foot-high bronze group, is located at Christ Episcopal Church.

Unknown Artist

ARCHANGELS BAROQUE REPLICAS *circa 1968, from eighteenth-century originals*

Figurative; 6' H; acrylic
Location: Mexican Cultural Institute, Hemisfair Plaza
Funding: Government of Mexico
Comments: These two facsimiles of eighteenth-century Mexican architectural figures represent the baroque church sculpture of the colonial period. Also located at Hemisfair Plaza are replicas of *Toltec Warriors* (A.D. 900–1150) and *Mayan Panel* (A.D. 600–800). The government of Mexico donated all of these works in 1968 for exhibition at Hemisfair Plaza. The original figures, from which the acrylic molds were made, are housed in the National Museum of Anthropology in Mexico City.

Unknown Artist

BENITO JUAREZ *1968*

Portrait bust; larger than life-size; bronze
Location: Mexican Cultural Institute, 600 Hemisfair Plaza

397

Funding: Government of Mexico
Comments: Marking the entrance to
the institute and flanked by the flags
of the United States and Mexico is
this bust of Benito Juárez, a Mexican
political leader who was elected
president of Mexico in 1861. After the
French were ousted from Mexico and
Emperor Maximilian dethroned,
Juárez again became president in
1867. He was reelected by the
Mexican congress in a runoff in 1871.

Wade, Bob

(b. 1943 Native Texan)

THE BIGGEST COWBOY BOOTS
IN THE WORLD *1979*

Figurative; 2 figures, each
40' H × 30' W; urethane and steel
Location: North Star Mall at
Loop 410
Funding: Originally funded through
the Washington Project for the Arts
in Washington, D.C., the National
Endowment for the Arts, and private
donations; later, purchased for North
Star Mall by the Rouse Company
Comments: The armature for these
giant cowboy boots is covered with
urethane foam painted to resemble
ostrich skin and calf—the ultimate in
Western footwear. Because of their
size and weight, each boot came to
San Antonio from Washington, D.C.,
in a separate truck.

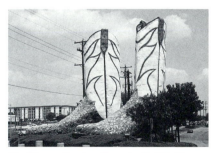

The Biggest Cowboy Boots in the World.
Photo by Robert Little.

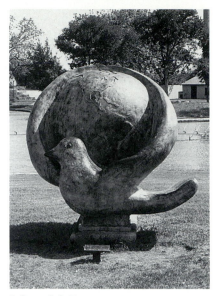

Paloma de la Paz. Photo by Robert Little.

Weidl, Seff

(b. 1912 German)

SANCTITY OF CONTRACT *1968*

Figurative; 16'6" H; bronze
Location: Stewart Title Guaranty
Company, 2961 Mossrock
Funding: Stewart Title Guaranty
Company
Comments: Another casting of this
work is placed at Stewart Title
Guaranty Company in Houston.

Zamudio, Cuauhtémoc

(Mexican)

PALOMA DE LA PAZ *1992*

Abstract; 6'9" H; urethane foam
Location: Monterrey Plaza, eastern
edge of Hemisfair Park
Funding: Gift to the city of
San Antonio from its sister city
Monterrey, Mexico

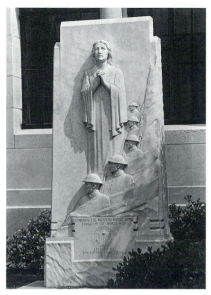

War Mothers Memorial. Photo by Robert Little.

Zirkel, Clifford

(1897–1977 American)*

WAR MOTHERS MEMORIAL *1938*

Figurative; larger than life-size;
Italian marble
Location: Municipal Auditorium,
100 Auditorium Circle
Funding: American War Mothers,
San Antonio Chapter 2, and private
contributions
Comments: Erected in honor of
mothers whose sons fought in the
World War, this World War I memo-
rial was carved in Italy according to
Zirkel's design. Clifford Zirkel and
his brother operated Zirkel Monu-
mental Works in San Antonio.

Special Collections and Sculpture Gardens in San Antonio

Fiesta Texas is a family-entertain-
ment theme park located at Loop
1604 and Interstate 10 West. In
hometown settings, Fiesta Texas
celebrates the history and culture of
Texas through Broadway-quality
entertainment and attractions for the
entire family. Sculptural installations
help carry out the theme in various
sections of the park:

FOLKLORICO DANCER *1992*, a
life-size bronze figure by native
Texan Linda Sue Henley, is
installed in Los Festivales, the
Hispanic-themed area of the park.
Los Festivales reflects the strong
influence that the Mexican culture
has on San Antonio and South
Texas. Henley consulted local
folklórico experts, who helped the
artist capture the dress and
movement of a traditional
folklórico dancer. Roger Holmes,
with House Bronze, Inc., in
Lubbock, met the challenge of
casting the statue of a small figure
dressed in a skirt with a surface
area of almost an acre.

J. P. ROCK *1992*, a life-size bronze
by Texas artist Dori Rordin, is
installed at the Rockville High
School Theater in Rockville, a
section of Fiesta Texas dedicated
to the 1950s.

**The Marion Koogler McNay Art
Museum** at 6000 North New
Braunfels Avenue is located in the
former home of Marion Koogler
McNay. The Spanish Mediterranean–

Folklórico Dancer. Photo by Michael Murphy,
courtesy Fiesta Texas.

inspired house was built in 1927
according to the design of San
Antonio architects Atlee B. Ayres and
Robert M. Ayres. McNay died in
1950, and the museum opened in
1954. In addition to her home,
McNay left the surrounding 23 acres,
her collection of art, and a major
portion of her estate to establish the
museum for the advancement and
enjoyment of modern art, making it
the first privately endowed museum
in Texas. Eight subsequent additions
to the building include an audito-
rium, a research library, support
facilities, and expanded gallery space.
The collection has grown to include
Southwest folk art, the Tobin
collection of theater arts, French and
American works of the nineteenth
and twentieth centuries, the
Oppenheimer collection of medieval
and Renaissance works, and the finest
collection of nineteenth- and twenti-
eth-century prints in the region. The
following sculptures often are on
view on the grounds and in the
Estelle Blackburn Patio.

DON QUIXOTE *1946* and
 **ABRAHAM LINCOLN ON THE
 PRAIRIE** *1961*, by Anna Hyatt
 Huntington (1876–1973, Ameri-
 can), are on loan from the Hispanic
 Society of America, New York.
 The contrasts between *Abraham
 Lincoln* and *Don Quixote* make
 the sculptures interesting compan-
 ion pieces. Huntington portrays a
 young, clean-shaven Lincoln
 reading a book while he rides a
 horse. The horse and rider are
 relaxed; the struggles of life have
 not taken their toll. On the other
 hand, Quixote and his horse
 present a weary and disheveled
 appearance, symbolizing the loss
 of youthful energy and idealism.
 Yet, Quixote's intense expression
 reveals a man who has not
 abdicated his quest.

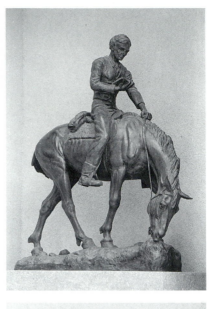

Abraham Lincoln on the Prairie (top) and
Don Quixote (bottom), on loan from the
Hispanic Society of America, New York.
Photo courtesy Marion Koogler McNay Art Museum.

400

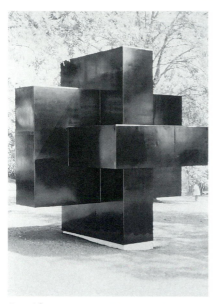

Asteriskos. Photo courtesy Marion Koogler McNay Art Museum.

ASTERISKOS *1968*, a welded-steel abstract by Tony Smith (1912–1980, American), was given to the museum by the Catto Foundation in honor of Mrs. Catto's father, the late Governor William Pettus Hobby. *Asteriskos* originally was exhibited at Hemisfair in 1968. Two years later, the sculpture disappeared from its location on the grounds of the Convention Center. Investigation by city officials revealed that a city work crew had hauled the sculpture to the city work yard for use as scrap metal. According to the artist's specifications, the work was refabricated and given to the McNay Art Museum in 1970.

CRUCIFIX *1947*, an aluminum sculpture by Charles Umlauf (1911–1994, American)*, is a bequest of Marion Koogler McNay.

BIRDS *1959*, a figurative bronze also by Umlauf, is a gift of Mary and Sylvan Lang. Both works are studies for larger sculptures. *Birds* is a model for *Spirit of Flight*,

installed at Love Field Airport in Dallas. *Crucifix* is a model for *Crucifixion*, installed at the grave site of Marion Koogler McNay at Saint Anthony of Padua Church in San Antonio.

Pioneer Hall, at 3805 Broadway in Brackenridge Park, houses the Texas Pioneer, Texas Trail Driver, and Texas Ranger's Museum. Erected in 1936 in conjunction with the Texas Centennial Celebration, Pioneer Hall now serves as a repository for historical collections relating to the state's pioneers, trail drivers, and Texas Rangers. Installed in front of the museum are two one-quarter-life-size equestrian bronze sculptures:

TEXAS TRAIL DRIVERS MONUMENT *1925*, by Gutzon Borglum (1867–1941, American)*, was commissioned by the Texas Trail Drivers Association. Although signed and dated by the artist in 1925, this work was not cast at the Bedi-Makky Foundry in Brooklyn until 1942 because of a number of problems, including inadequate funding. The monument, which includes four longhorns being led up a rocky incline by two mounted cowboys, is actually the model for a much larger work that was never funded. Reputedly, Borglum sculpted the faces of well-known Texas cowmen in the bas-relief panels that surround the rectangular granite base, and students of the Old West enjoy trying to identify the individuals pictured. The lead cowboy is thought by many to be George W. Saunders, the famous Texas trail driver who organized the Trail Drivers Association and later supervised the publication of the documentary book *The Trail Drivers of Texas*. The monument is dedicated to the memory of the trail drivers of Texas, who drove

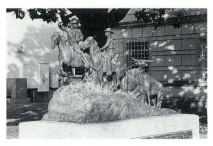

Texas Trail Drivers Monument.
Photo by Robert Little.

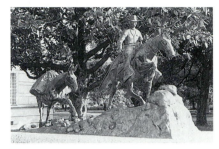

Texas Ranger Monument. Photo by Robert Little.

more than ten million longhorn cattle to northern markets between 1866 and 1895.

TEXAS RANGER MONUMENT *1983*, by Richard Cook (b. 1951, American)*, was designed as a companion piece to Borglum's monument. The Former Texas Rangers Association commissioned this work, which is dedicated to all Texas Rangers from 1923 to the present. Cast at Stevens Art Foundry in Bulverde, Cook's sculpture depicts a Texas Ranger leading a pack mule on a solitary trek across the range.

The San Antonio Museum of Art, at 200 West Jones Avenue, is located on the San Antonio River in a restored historic building formerly used as the Lone Star Brewery. In addition to 66,000 square feet of exhibition space, the museum has a 2.5-acre sculpture garden, which includes the following works:

CEMENT BRAHMA and **CEMENT HORSE** *circa 1980*, two painted cement figures donated by the artist, Eliseo Alvarado (b. 1910, native Texan)*. Alvarado's folk-art figures are nostalgic reminiscences of an earlier, rural life-style.

CHERRY BLOSSOM *1987*, a 5' welded-steel abstract by David Anderson (b. 1946, American), donated in 1987 by Anne and Vincent Carrozza

THROUGH THE LOOKING GLASS *1988*, an 8' welded-steel abstract by Michael Bigger (b. 1937, American)*, given by a private donor

COLORADO TRI-POD *1976*, an 8' Cor-ten steel abstract by David Deming (b. 1943, American)*, given by a private donor in 1978

ROUND LANDSCAPE FOUNTAIN *1990*, a working fountain 1'7" × 5'2" × 5'2" of sunset-red Marble Falls granite, by Jesús Bautista Moroles (b. 1950, native Texan)*, donated by Ann Bowers

NAILS *circa 1981*, an 8' abstract of pipe and welded steel plate, by Burdette Parks (b. 1945, American), donated in 1981 by the artist

INSCAPE *1964–1968*, a bronze abstract 2'6" × 3'4" × 1'11", by James Rosati (b. 1912, American), donated in 1983 by Gilbert M. Denman, Jr.

METAMORPHUS DU CHEVRON *1976*, a welded-steel abstract 8' × 14' × 3', by Ben Woitena (b. 1942, native Texan)*, given by Dr. and Mrs. Peter B. Fisher in 1981

The San Antonio Zoo is located at 3903 North Saint Mary's Street in the Brackenridge Park area at the headwaters of the San Antonio River. In settings that resemble their natural habitats, more than 3,000 animals live in family groups, some of them coexisting with other species as they do in nature. The San Antonio Zoo is well known for its captive breeding

program, which produced the first white rhinoceros born in the United States and the first penguin born in Texas. The $3 million Children's Zoo includes an animal nursery, where baby animals that need delicate care can be observed through a viewing window. Since 1929, the San Antonio Zoological Society has operated the zoo under contract with the city. Four outdoor sculptures are placed at the zoo.

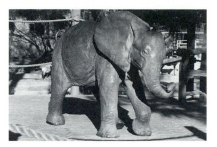
Ganesia. Photo courtesy Donna Dobberfuhl.

GANESIA *1993*, a life-size bronze elephant calf commissioned by the San Antonio Zoological Society, and **STANDING ALERT** *1990*, a life-size bronze eagle given by a private donor, are both the work of Texan Donna Dobberfuhl.

PRIDE OF LIONS *1986*, by Texan Bob Guelich, is a bronze figurative group, cast at Dell-Ray Bronze, Inc., in Houston. Commissioned and placed at the zoo by the Amy Shelton McNutt Charitable Trust, the work includes a male lion with a lioness and five cubs. The artist uses videotape, photographs, and live models to capture realistic detail.

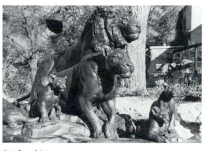
Pride of Lions. Photo courtesy Bob Guelich.

RAMONA'S GIFT *1988*, by American artist Dennis Smith, is a 3' figurative bronze given to the Zoological Society by Lewis J. Moorman, Jr., and Lewis J. Moorman III.

The Texas Walk is a two-acre sculpture garden located within the 250-acre Sea World of Texas in San Antonio. Sea World of Texas commissioned the Texas Walk in February 1986. The sculpture garden includes 15 life-size bronze statues of notable Texans who have played a prominent role in Texas history.

JOSE ANTONIO NAVARRO *1988*, by Juan Dell (native Texan). Navarro signed the Texas Declaration of Independence and helped

Ramona's Gift. Photo by Robert Little.

403

José Antonio Navarro. Photo by Geoff Reed and Clem Spalding, courtesy Sea World of Texas, Inc.

Barbara Charline Jordan. Photo by Geoff Reed and Clem Spalding, courtesy Sea World of Texas, Inc.

draft the Constitution of the Republic of Texas.

BARBARA CHARLINE JORDAN *1988,* by Glenna Goodacre (b. 1939, native Texan). Barbara Jordan was the first black woman to serve as a state senator. After serving three terms as a U.S. congressional representative, she accepted the Lyndon B. Johnson Centennial Chair of National Policy at the School of Public Affairs at the University of Texas at Austin.

DWIGHT DAVID EISENHOWER *1988,* also by Goodacre. As supreme commander of the Allied Expeditionary Force during World War II, Eisenhower possessed the greatest military authority in history. He masterminded the D-day invasion, which led to the defeat of Hitler's German army. After the war he served as commander of the North Atlantic Treaty Organization and as president of Columbia University. A native Texan, Eisenhower served as president of the United States from 1953 to 1961.

Dwight David Eisenhower. Photo by Geoff Reed and Clem Spalding, courtesy Sea World of Texas, Inc.

KATHERINE ANNE PORTER *1988,* also by Goodacre. A world-renowned author, Porter is most remembered for her novels *Pale Horse, Pale Rider,* and *Ship of Fools.* Her *Collected Stories* won both the Pulitzer Prize and the National Book Award.

404

Katherine Anne Porter. Photo by Geoff Reed and Clem Spalding, courtesy Sea World of Texas, Inc.

William Barret Travis. Photo by Geoff Reed and Clem Spalding, courtesy Sea World of Texas, Inc.

Stephen F. Austin. Photo by Geoff Reed and Clem Spalding, courtesy Sea World of Texas, Inc.

STEPHEN F. AUSTIN *1988*, also by Goodacre. As the founder of Anglo-American Texas, Stephen F. Austin brought the first immigrants to settle in the province in 1822. Upon Mexico's separation from Spain, Austin spent more than a year in Mexico to receive approval for expanding his colonization project; in 1825, 1827, and 1828, he was granted permission to work with a land commissioner to award land titles to a growing number of settlers. Austin devoted his life and fortune to assure the successful Anglo-American colonization of Texas.

WILLIAM BARRET TRAVIS *1988*, also by Goodacre. Colonel Travis was commander of the Texas troops at the Alamo, where he died on March 6, 1836. He is remembered for his inspirational challenge, "Victory or death."

ROBERT WOODROW WILSON *1988*, by Elizabeth Hart (native Texan)*. Wilson, a native Texan, received, along with fellow physicist Arno A. Penzias, the Nobel Prize in science in 1978 for research that led to the theory that

405

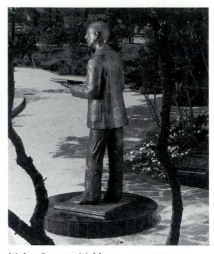

Robert Woodrow Wilson. Photo by Geoff Reed and Clem Spalding, courtesy Sea World of Texas, Inc.

Walter Prescott Webb. Photo by Geoff Reed and Clem Spalding, courtesy Sea World of Texas, Inc.

the universe was created by an enormous explosion, the big-bang theory.

WALTER PRESCOTT WEBB *1988,* also by Hart. Webb was an author, educator, and historian. He taught in the history department of the University of Texas for 45 years.

ADMIRAL CHESTER NIMITZ *1988,* by Armando Hinojosa (b. 1944, native Texan)*. Admiral Nimitz was commander in chief of the Pacific Fleet during World War II. On September 2, 1945, he accepted Japan's surrender on behalf of the United States aboard his flagship *Missouri* in Tokyo Bay. He was a native of Fredericksburg. Another work by Hinojosa is installed at the entrance to Sea World.

DOUBLE EAGLE *1988,* depicting the national bird of the United States, is 8'6" tall with a 14' wingspan. It was cast at Stevens Art Foundry in Bulverde.

EDWARD HIGGINS WHITE II *1988,* by Lawrence M. "Larry" Ludtke (b. 1929, native Texan)*. White was the first American to walk in space. On January 27,

1967, along with astronauts Gus Grissom and Roger Chaffee, he died in a flash fire inside their spacecraft during a ground test at Cape Kennedy. All of Ludtke's Sea World commissions were cast at Roman Bronze Works in New York.

HENRY B. GONZALEZ *1988,* also by Ludtke. In 1956, Henry B. Gonzalez became the first Mexican American in the Texas Senate. Later, he became the first Mexican American in the U.S. House of Representatives, where he continues to serve as a representative from Texas.

HOWARD ROBARD HUGHES *1988,* also by Ludtke. Hughes designed the world-famous Hughes rock bit, which enabled drilling for oil in previously impenetrable rock, and thus revolutionized the oil industry.

LYNDON BAINES JOHNSON *1988,* also by Ludtke. Johnson was the youngest Senate majority leader in U.S. history. He served as vice president under John F. Kennedy and became president in 1963

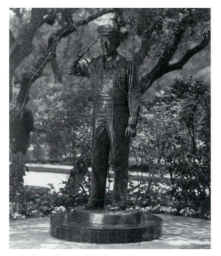

Admiral Chester Nimitz. Photo by Geoff Reed and Clem Spalding, courtesy Sea World of Texas, Inc.

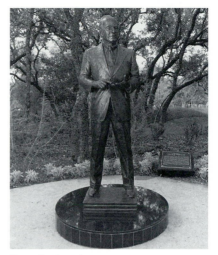

Henry B. Gonzalez. Photo by Geoff Reed and Clem Spalding, courtesy Sea World of Texas, Inc.

Double Eagle. Photo courtesy Armando Hinojosa.

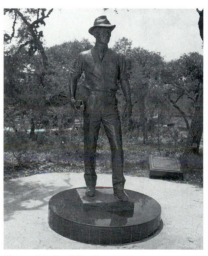

Howard Robard Hughes. Photo by Geoff Reed and Clem Spalding, courtesy Sea World of Texas, Inc.

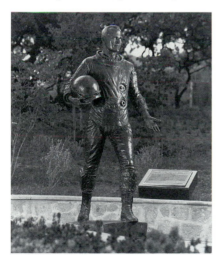

Edward Higgins White II. Photo by Geoff Reed and Clem Spalding, courtesy Sea World of Texas, Inc.

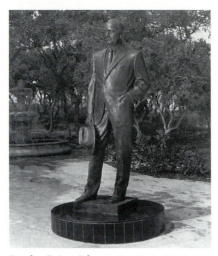

Lyndon Baines Johnson. Photo by Geoff Reed and Clem Spalding, courtesy Sea World of Texas, Inc.

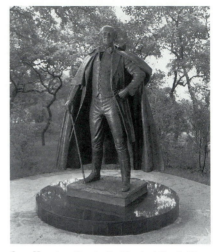

Sam Houston. Photo by Geoff Reed and Clem Spalding, courtesy Sea World of Texas, Inc.

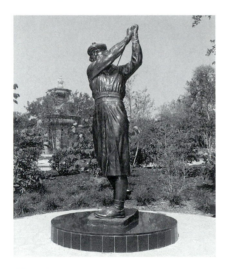

Mildred "Babe" Didrikson Zaharias. Photo by Geoff Reed and Clem Spalding, courtesy Sea World of Texas, Inc.

upon Kennedy's assassination. He was elected to a full term as president in 1964.

MILDRED "BABE" DIDRIKSON ZAHARIAS *1988,* also by Ludtke. The Associated Press named Zaharias the most outstanding female athlete of the first half of the twentieth century. Babe mastered every sport she tried, but her great love was golf, in which she won every major amateur and professional title.

SAM HOUSTON *1988,* also by Ludtke. Houston attended the Convention of 1836, where he signed the Declaration of Independence. He served as commander in chief of the Texas army; after leading the Texas troops at San Jacinto, he became the first president of the Republic of Texas.

The Witte Museum, at 3801 Broadway, is named for Alfred G. Witte, who left a bequest of $65,000 for the establishment of the institution. The Witte has been open to the public since 1926. In addition to its extensive permanent collection, the museum offers family programs and

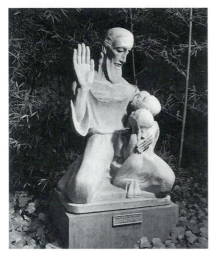

Christic and the Children. Photo by Jim Zintgraff, San Antonio, courtesy the Witte Museum.

changing exhibits, many of which feature the art, history, archeology, and anthropology of the Southwest. The following sculptures are located on the grounds:

ALBERT STEVES *1937,* a life-size bronze bust by Pompeo Coppini, was commissioned by Fanny (Mrs. Albert) Steves while her husband was serving as president of the Witte Museum and donated in 1937.

SEA GULLS *1967,* a 12' bronze figurative group by Charles Umlauf (1911–1994, American)*, was donated by Edith (Mrs. W. W.) McAllister. The four birds in flight are replacements for the original birds, which were stolen.

CHRIST AND THE CHILDREN *1943,* a 4' cast-stone figurative group by Charles Umlauf, was donated by Marion Koogler McNay and Olivia Nolte. It was shown in the Artists for Victory exhibition at the Metropolitan Museum of Art in New York. A second casting is in the permanent collection of the Santa Barbara Museum of Art in California.

FATHER AND CHILD *1962,* a 13'6" cast-stone sculpture by Charles Umlauf, was given by Albert Hirschfeld in honor of his parents, his sister, and his brother.

MOTHER AND CHILD *1962,* a 13'6" cast-stone sculpture by Charles Umlauf, was given by Joan Brown (Mrs. William C.) Winter in memory of her son.

WAR MOTHER *1945,* a 3'6" cast-stone sculpture by Charles Umlauf, was donated by the artist.

San Augustine

Cecere, Gaetano

(b. 1894 American)

JAMES PICKNEY HENDERSON *1936*

Portraiture; larger than life-size; bronze
Location: San Augustine Courthouse grounds
Funding: $14,000 allocated by the 1936 Commission of Control for Texas Centennial Celebrations
Comments: Donald Nelson was the architect for this monument erected in honor of Henderson, attorney general of the Republic of Texas, first governor of the state of Texas, and United States senator. The base is pink Marble Falls granite.

San Felipe

Angel, John

(1881–1960 British)

STEPHEN F. AUSTIN *1938*

Portraiture; larger than life-size; bronze
Location: Stephen F. Austin State Historical Park, Park Road 38 off Farm Road 1458

409

Funding: $14,000 allocated by the 1936 Commission of Control for Texas Centennial Celebrations
Comments: Texas owes its very existence to the sacrifice and commitment of this one man, Stephen Fuller Austin, who led more than a thousand American families to colonize the Mexican province of Texas. From 1823 to 1828, he was the actual ruler of Texas and thereafter its most influential leader. As the father of Texas, Austin wrote the following words, which are inscribed beneath his statue: "The prosperity of Texas has been the object of my labors, the idol of my existence. It has assumed the character of a religion for the guidance of my thoughts and actions."

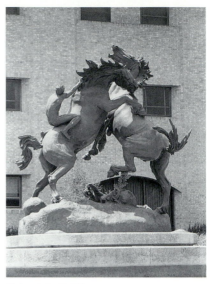

Fight of the Stallions. Photo by Robert Little.

San Marcos

Huntington, Anna Hyatt

(1876–1973 American)

FIGHT OF THE STALLIONS *1950*

Equestrian; 17' H × 12' W; cast aluminum
Location: Southwest Texas State University, Campus Mall off LBJ Drive
Funding: Given by Mr. and Mrs. Archer M. Huntington in 1952
Comments: The artist captures the fierceness and violence of two fighting stallions, and only by closer inspection does the viewer become involved with the fate of the riders. The human figures are life-size; the horses are larger than life-size. With this distortion in proportions, Huntington emphasizes the main subject of the work.

Wallace, Scott M.

(American)

UNTITLED *1985*

Abstract; 12'9" H; stainless steel
Location: Southwest Texas State University campus, Lyndon B. Johnson Memorial Student Center
Funding: Southwest Texas State University through a competitive exhibition commemorating the center's twentieth anniversary

Santa Anna

Perry, Thomas T.

(1853–1943 American)*

CARVED STONE MELON AND CORN *1905*

Figurative; 1' × 3' × 1'; native stone
Location: 401 Bowie Street
Funding: Thomas T. Perry
Comments: Thomas Perry designed and built many of the houses, barns,

410

gravestones, and public buildings in Santa Anna. One of his buildings, made of stone from Santa Anna Mountain, was moved by a real estate developer to Salado, where it has been rebuilt as part of an open mall featuring small specialty shops. This small stone carving was probably part of a larger work, but now it serves as decorative yard sculpture.

Scottsville

Teich, Frank

(1856–1939 American/German)*

GRIEF *1904*

Figurative; 10' H; Carrara marble
Location: Scottsville Cemetery, Farm Road 1998
Funding: Captain Peter Youree and his wife, Elizabeth Scott Youree, in memory of their only son, William Scott Youree
Comments: Often called *Weeping Angel*, Teich's angelic figure in perpetual mourning is considered his most artistic creation. The grief of the parents who placed the monument is expressed in the words inscribed on the front of the statue: "Could love have saved, thou hadst not died." The memorial was so admired that Teich advertised in his catalogue, "Through the recommendation of Mr. Peter

Youree, President of the Commercial National Bank, for whom this contract was executed for his son's grave, Frank Teich received $40,000 worth of orders in Shreveport alone. It pays to do high class work" (Teich 1926, 24). The Teich angel is installed near a 1904 stone chapel with hand-hewn cypress pews and beautiful stained-glass windows, also a memorial to William Scott Youree from his parents. The Scottsville Cemetery has the largest collection of Teich memorials in the state, as well as several outstanding molds apparently ordered from Italy through catalogues. After providing a quiet respite for more than a century, the Scottsville Cemetery was ravaged by vandals in 1987. Repairs were made, but several of the monuments were not restored to their former beauty.

SCOTTSVILLE CONFEDERATE MONUMENT *1915*

Figurative; 7' H; marble
Location: Scottsville Cemetery entrance, Farm Road 1998
Funding: Captain Peter Youree and his wife, Elizabeth Scott Youree, in memory of Scottsville's Confederate soldiers
Comments: From his 18-foot-high summit, this statue of a young Confederate private stands guard over the 145-year-old Scottsville Cemetery.

Sherman

Biggs, Electra Waggoner

(b. 1912 Native Texan)*

REPOSE *1953*

Figurative; smaller than life-size; marble
Location: West Hill Cemetery
Funding: Private funding

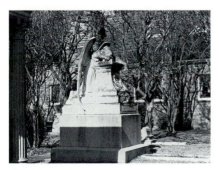

Grief. Photo by Robert Little.

411

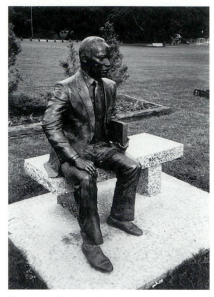

Martin Luther King, Jr. Photo by Carol Little.

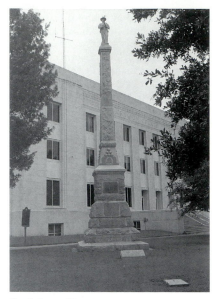

Confederate Monument. Photo by Carol Little.

Easley, William

(b. 1944 Native Texan)*

MARTIN LUTHER KING, JR. *1987*

Portraiture; life-size; Schaefer Art
Bronze Casting, Inc., in Arlington
Location: Martin Luther King Park,
1003 Day Street
Funding: Contributions from
businesses and individuals
Comments: On January 18, 1988,
more than 400 citizens gathered for
the unveiling of this seated figure
depicting civil rights leader Martin
Luther King, Jr. An excerpt from one
of King's most famous speeches is
inscribed on a nearby commemora-
tive plaque, which reads in part, "So I
say . . . to you, my friends, that even
though we may face difficulties of
today and tomorrow, I still have a
dream. It is a dream deeply rooted in
the American dream that one day this
nation will rise up and live out the
true meaning of its creed—we hold
these truths to be self evident, that all
men are created equal."

Reed, Warren

(American)*

CONFEDERATE MONUMENT *1896*

Figurative; larger than life-size;
bronze cast at an unidentified foundry
in Saint Louis, Missouri, and granite
quarried at Stone Mountain, Georgia
Location: Grayson County
Courthouse grounds
Funding: Public donations raised over
a six-year period under the auspices of
the Mildred Lee Camp, United
Confederate Veterans, with special
support from North Texas Female
College, Kidd-Key Conservatory of
Music, Mary Nash College, and the
United Daughters of the Confederacy
Dixie Chapter 35
Comments: This monument is the
oldest Confederate soldier statue in
Texas and one of only three bronze
figures erected in the state before the
turn of the century, the other two
being on the capitol grounds in
Austin. Unveiled on San Jacinto Day,
April 21, 1897, before a throng

estimated at 20,000, the Sherman monument preceded the Dallas Confederate memorial by a week and one day. A newspaper reporter described the day-long unveiling ceremony: "Every window was filled with people; the awnings were crowded; the sidewalks were so jammed that passage through them could not be effected, and the streets were literally packed with a surging mass of humanity" (*Denison Sunday Gazetteer*, April 25, 1897). The celebration featured numerous speeches by state and local dignitaries and a parade that included two bands, a fife and drum corps, five camps of United Confederate Veterans, students from five colleges, 1,000 schoolchildren carrying wreaths, and members of the Odd Fellows and Woodmen of the World. After the sheeting fell to the ground exposing the bronze and granite monument, guns were fired, the Rebel yell pierced the air, and the United Daughters of the Confederacy placed garlands at the base as onlookers sang "In the Sweet Bye and Bye." Ironically, on February 23, 1861, Grayson County had voted almost 2 to 1 in opposition to secession.

Surls, James

(b. 1943 Native Texan)*

FROM THE CENTER *1986*

Abstract; 17' H; wood and steel
Location: Austin College campus
Funding: Given to the college in 1989 by two foundations and an anonymous donor

Takiguchi, Masaru

(b. 1941 American/Japanese)

QUEST *1980*

Abstract; 10' H; stone
Location: Austin College campus

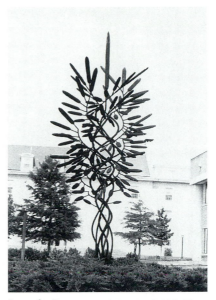

From the Center. Austin College photo by Vickie Kirby.

Funding: Gift of William and Margaret Collins
Comments: Masaru Takiguchi first visited the United States in 1968. In 1969, 1970, and 1973, he served as a visiting instructor in sculpture at the University of Houston.

Unknown Artist

ATHENA-MINERVA STATUE *1898*

Figurative; 5' H; marble
Location: 400 North Rusk Street
Funding: North Texas Female College and Kidd-Key Conservatory of Music, Class of 1898
Comments: The monument committee chose a statue of Athena (Minerva) because Sherman was known as the Athens of Texas, in reference to its many schools and colleges.

413

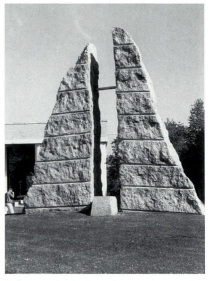

Solstice Calendar. Austin College photo by Vickie Kirby.

Van Alstine, John

(American)

SOLSTICE CALENDAR *1986*

Abstract; 18' H; Texas granite and stainless steel
Location: Austin College campus
Funding: Heywood and Harriet Clemons, the Texas Commission on the Arts, and the National Endowment for the Arts
Comments: Van Alstine, who lives in New Jersey, designed this calendar to mark time between the longest and shortest days of the year.

Shiner

Coppini, Pompeo

(1870–1857 American/Italian)*

JULIUS A. WOLTERS *1919*

Portraiture; life-size; Italian marble
Location: Shiner City Cemetery
Funding: The Julius A. Wolters family

Sinton

Corsini, D. R.

(American)

EAGLE WAR MEMORIAL *1976*

Figurative; 8' H; red granite and bronze cast at the Gorham Foundry at City of Industry, California
Location: San Patricio County Courthouse grounds
Funding: Placed in 1986 by private contributors to honor the county's veterans

Viquesney, E. M.

(1876–1946 American)

SPIRIT OF THE AMERICAN DOUGHBOY *1934*

Figurative; life-size; bronze
Location: San Patricio County Courthouse grounds
Funding: Erected in 1938 by the Sinton Veterans of Foreign Wars Post

Snyder

Fiberglass Menagerie

(American)

WHITE BUFFALO STATUE *1971*

Figurative; life-size; fiberglass
Location: Scurry County Coliseum grounds, U.S. 84
Funding: Scurry County Historical Commission and the Order of the White Buffalo
Comments: This statue is a replacement for the first fiberglass buffalo on the courthouse square, which was purchased in 1967 through member-

Artisans at House Bronze, Inc., in Lubbock working on Robert R. Taylor's *White Buffalo*, later installed on the town square in Snyder. Photo by Robert Little.

ship dues in the Order of the White Buffalo, a group of local citizens who organized to fund the project. When vandals destroyed the first town mascot, Scurry County residents purchased this painted fiberglass bison from Fiberglass Menagerie in Alpine, California. It stood on the courthouse square until 1994, when it was replaced with a bronze version of the legendary animal. Historians estimate that 60 million to 75 million buffalo roamed the American Great Plains before buffalo hunters slaughtered them to near extinction. In 1876, buffalo hunter J. Wright Mooar shot and killed a rare white buffalo cow near present-day Snyder. Although only seven white buffalo killings have been recorded in the United States, this was Mooar's second kill, the first having been several years earlier in Kansas. The Snyder buffalo skin attracted national attention and was exhibited at the Columbian World Exposition in Chicago in 1893. Mooar died in Snyder in 1940 at the age of 88.

Taylor, Robert R.

(American)*

WHITE BUFFALO *1994*

Figurative; 10' H; bronze cast at House Bronze, Inc., in Lubbock
Location: Scurry County Courthouse grounds
Funding: Fund-raising projects
Comments: To finance this monument, Dr. Robert Taylor created small and mid-sized statues of a white buffalo, which sold for $500 and $1,000. The sale of these statues and the sale of inscribed granite pavers installed at the base of the sculpture covered the expense of casting the giant bison. Like its fiberglass predecessors, the bronze buffalo commemorates the rare white buffalo cow killed near Snyder in 1876 by J. Wright Mooar. At the time, the town of Snyder did not exist. Instead, vast herds of buffalo and other wildlife grazed on thousands of acres of unfenced Panhandle prairie. Indians living on the Panhandle plains relied on the buffalo for food,

415

clothing, blankets, tepees, tools, and thread; even the stomach was used as a container for water. Many Native Americans still believe that a white buffalo is sacred. As recently as 1994, when a white calf was born on a farm in southern Wisconsin, representatives from the Sioux, Cheyenne, Oneida, Cherokee, and other tribes came to see the young buffalo. According to the American Bison Association, the last authenticated white buffalo was born in the 1930s and died in 1959.

South Padre Island

Concepción, Tomás

(Mexican)

PADRE JOSE NICOLAS BALLI *1981*

Portraiture; 7' H; bronze
Location: Entrance to Queen Isabella Causeway
Funding: Cameron County Commissioners Court
Comments: Padre José Nicolás Balli was the first American-born Spaniard ordained as a Catholic priest on this continent. In 1765, he received title to a large tract of land that encompassed present-day Padre Island National Seashore and South Padre Island. On this land, he and his nephew, Juan José Balli, established the Santa Cruz Ranch, located approximately 26 miles up from the southern tip of the island. While both men ran the ranch, Padre Balli's primary work was to minister to the spiritual welfare of the small ranch population on the island and nearby coastal land. Tomás Concepción based his portraiture of the early Texas missionary on five pictures of the Balli family—all descendants of the priest's two brothers. The statue represents a composite of family features.

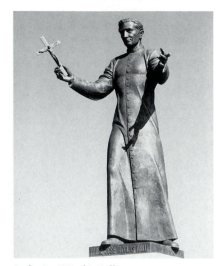

Padre José Nicolás Balli.
Photo courtesy *Texas Highways Magazine.*

Boardwalk Blue Monument.
Photo by Ken Meyer, courtesy Kent Ullberg.

416

Ullberg, Kent

(b. 1945 American/Swedish)*

BOARDWALK BLUE MONUMENT
1983

Figurative; 23' H; bronze and granite
Location: Boardwalk Condominium
Yacht Club entrance
Funding: Commissioned by Board-
walk Condominium Yacht Club
Comments: Ullberg's accurate and
artistic portrayal of Texas wildlife is
evident in this delicate yet powerful
figure of a blue marlin.

Spearman

Bacle, Jerry

(American)

INDIAN CHIEF *1978*

Figurative; 7' H; carved wood
(tree-stump sculpture)
Location: Stationmaster's House
Museum, 30 South Townsend
Funding: Stationmaster's House
Museum and the artist
Comments: Bacle, an artist from
Hooker, Oklahoma, carved this full
figure of a Native American tribal
chief.

Spring

Tremonte, Sister Mary Peter

(b. 1930 Native Texan)*

CHRIST THE GOOD SHEPHERD
1981

Figurative; 4'6" H; bronze
Location: Christ the Good Shepherd
Church, 18511 Klein Church Road
Funding: Commissioned by the
church
Comments: As a sculptor and

liturgical designer, Sister Mary Peter
has provided art and design concepts
for more than 50 churches in Texas.
In addition to the statue at the
entrance of Christ the Good Shepherd
Church, Sister Mary Peter designed
the stained-glass and Leptat-glass
windows, the baptistry, and other
liturgical appointments inside the
church building.

Stephenville

Nasco Dairy Supply Company

(American)

MOO-LA *1972*

Figurative; life-size; fiberglass
Location: Erath County Courthouse
grounds
Funding: Local businesses and
individual contributions
Comments: This holstein cow statue
mounted on a steel pedestal honors
the dairy industry as the number-one
contributor to Erath County's
economy. The Nasco Company is
located in Madison, Wisconsin.

Stonewall

Mason, Jimilu

(American)

LYNDON BAINES JOHNSON *1974*

Portraiture; 8' H; bronze
Location: Lyndon B. Johnson State
Historical Park, off U.S. 290
Funding: State of Texas
Comments: This statue of Lyndon
Baines Johnson, native Texan and
thirty-sixth president of the United
States, stands on the banks of the
Pedernales River directly across from
the LBJ Ranch. Lady Bird Johnson
unveiled the portrait of her husband

on August 4, 1974. Johnson assumed the presidency in 1963 upon the assassination of John F. Kennedy; he retained the office in the national presidential election of 1964. Anti-poverty programs, civil rights legislation, and the Vietnam War era marked his years in the White House. Jimilu Mason lives in Alexandria, Virginia.

Sweetwater

Lewis, Dorothy Swain

(b. 1915 American)

WASP MEMORIAL *1993*

Figurative; life-size; bronze
Location: Avenger Field on the campus of Texas State Technical College, 300 College Drive, west of Sweetwater on Interstate 20
Funding: Sweetwater Chamber of Commerce, WASP Memorial Committee, and Texas State Technical College
Comments: This bronze statue of a woman pilot trainee honors Women Air Force Service Pilots (WASPs) of World War II. WASP was created in 1942, when the commanding general of the Army's air forces, H. H. "Hap" Arnold, asked Jacqueline Cochran, one of the most famous women pilots of the twentieth century, to return to the United States from England, where she had been the head of a group of women volunteer pilots assisting in the war effort overseas. Hard pressed for pilots after Pearl Harbor, General Arnold wanted Cochran to direct a women's pilot trainee program in Texas. First located in Houston, the trainee program moved to Avenger Field on February 21, 1943. During their

WASP Memorial. Photo courtesy Dorothy Swain Lewis.

service, WASPs flew every type of plane used by the United States military. Throughout the United States, they ferried planes, towed targets, flew tracking missions, and did smoke laying. Their duties also included personnel transport, simulated bombing missions, radio-controlled target flying, and flight testing of new aircraft. They flew for the Weather Wing, and they tested airplanes to be certain they were safe for use by instructors and students. Thirty-eight WASPs died in service to their country, but because they operated under civilian rather than military status, they did not receive veterans' benefits except through special legislation decades after World War II. In 1984, each member of WASP received the Victory medal, and those who served on duty for more than a year also received the American Theater medal. Dorothy Swain Lewis served at Avenger Field as a flight instructor and as a WASP test pilot.

T

Tascosa

Temple

Terrell

Texarkana

Texas City

Throckmorton

Tilden

Turkey

Turnertown

Tyler

Tascosa

Doney, Clyde

(b. 1932 Native Texan)

CAL FARLEY *1973*

Portraiture; 2 figures, almost life-size;
bronze
Location: Cal Farley's Boys Ranch,
40 miles northwest of Amarillo off
U.S. 385
Funding: Private contributions
Comments: Cal and Mimi Farley
established Boys Ranch in Oldham
County in 1939 with only six
youngsters and very little money.
Today, it is one of the largest and
most successful child-care facilities
in the United States. Farley is known
as "America's Greatest Foster
Father." The inscription on the base
of the sculpture reads, "It's where
you're going that counts." Clyde
Doney lives in Durango, Colorado.

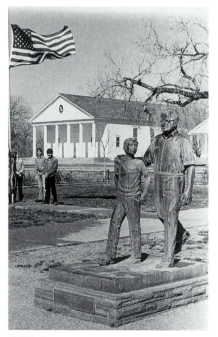

Cal Farley. Photo courtesy Cal Farley's Boys Ranch.

Temple

Special Collections and Sculpture Gardens in Temple

The Cultural Activities Center is
located at 3011 North 3rd Street.
Founded in 1958, the center moved
into a new $1 million building in
1978. The architectural design for the
center provided for a curved, polished
granite wall as a backdrop for a major
piece of outdoor sculpture. The work
chosen for the site was **ORPHEUS**
1979, a 14' bronze abstract by Richard
Hunt (b. 1935, American). Vivian
(Mrs. Irvin) McCreary donated it in
honor of Raye Virginia and H. K.
Allen, with matching funds provided
by the National Endowment for the
Arts. Hunt's conception of the
mythological musician Orpheus is
symbolic of the Cultural Activities

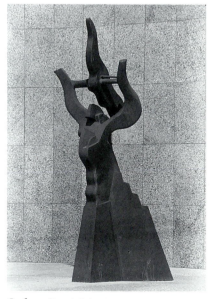

Orpheus. Photo by Robert Little.

Center's continuing leadership role in the arts. In 1988, the center purchased **CREST OF A TURNING TIDE** *1987*, a 6' iron abstract by Texas artist George Gobel. This work is installed in the center's McCreary Courtyard.

Terrell

Teich, Frank

(1856–1939 American/German)*

GENERAL GRIFFITH STATUE
circa 1901

Portraiture; life-size;
marble and granite
Location: Oakland Cemetery,
U.S. 80 West
Funding: The John Summerfield
Griffith family
Comments: Teich's signature is on this statue of John Summerfield Griffith (1829–1901), an early pioneer in Texas, a Civil War soldier, and a state representative.

Texarkana

Correll, Ira A.

(1873–1964 American)*

THE LAST SUPPER *1954*

Figurative; 7' H × 13' L;
Texas limestone
Location: Chapelwood Memorial Gardens, King's Highway between U.S. 82 and U.S. 67
Funding: Tiffin Reed
Comments: Tiffin Reed, owner of Chapelwood Memorial Gardens, arrived at the Leander Limestone Corporation mill two days before this monument was scheduled for completion. To Reed's surprise, the features of the individual figures were only sketched on the large block of limestone, and none of the detail carving was complete. Workers at the mill assured Reed that Correll always met his deadlines, and in fact, when Reed returned the following Monday, Correll had completed the entire monument over the weekend. At the time, the artist was 81 years old. Other outstanding monuments at Chapelwood include *Jesus in the Garden of Gethsemane, Sleeping Disciples,* and a replica of Michelangelo's *Pietà,* all ordered from Italy.

McVey, William M.

(b. 1905 American)*

JIM BOWIE *1936*

Portraiture; larger than life-size;
bronze
Location: 800 State Line Avenue
Funding: $7,500 allocated by the 1936 Commission of Control for Texas Centennial Celebrations

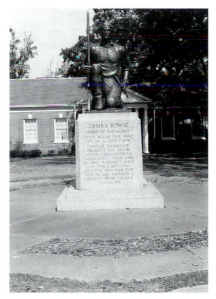

Jim Bowie. Photo by Carol Little.

421

Comments: William Ward Watkins was the architect for the pink Marble Falls granite monument.

Unknown Artist

CONFEDERATE MOTHERS MONUMENT *1918*

Figurative; larger than life-size; Carrara marble
Location: United Daughters of the Confederacy Park at 5th Street and State Line Avenue
Funding: Captain James T. Rosborough and the Captain James T. Rosborough Chapter, United Daughters of the Confederacy, with contributions from local citizens
Comments: Designed to honor the mothers of Confederate soldiers, this monument features the statue of a Confederate private and a seated female figure representing the mothers of Southern soldiers. Carved in Leghorn, Italy, the monument has the following inscription: "O Great Confederate Mothers, we would print your names on monuments, that men may read them as the years go by and tribute pay to you who bore and nurtured hero-sons and gave them solace on that darkest hour, when they came home with broken swords and guns."

Unknown Artist

WORLD WAR I MEMORIAL *1936*

Figurative; 20' H; Italian marble
Location: Adjacent to the United Daughters of the Confederacy Park at 5th Street and State Line Avenue
Funding: Texarkana Memorial Unit
Comments: This memorial is dedicated to World War I veterans of Bowie County, Texas, and Miller County, Arkansas. According to the inscription, the Texarkana Memorial Unit was "an organization of women

banded together to honor [the World War I veterans'] loyalty, their service, and their sacrifice." Another World War I memorial is located in Texarkana at the grave site of Otis Henry in Rose Hill Cemetery, 100 South Lelia Street. Erected in 1931 by his mother with donations from friends, the memorial includes four life-size figures of carved marble. The monument bears several inscriptions, including, "Corporal 359th Inf 90 Div Co H. Gassed One Kilometer Southeast of Vincey. Died October 6, 1918. Born June 22, 1894, in Denison, Texas." The grief that motivated Corporal Henry's mother, a lady of modest means, to erect such a monument to her son inspires a deep sense of appreciation for all World War I veterans and their families.

Texas City

Unknown Artist

TEXAS CITY ANGEL *circa 1950*

Figurative; 4' H; Carrara marble
Location: Texas City Memorial Park, Loop 197 North at 29th Street
Funding: Public donations
Comments: On April 16, 1947, a French freighter exploded at the shipping docks in Texas City. The explosion and subsequent fires devastated the shipping yards and surrounding town. This angelic figure is a memorial to local volunteer firemen who died in the disaster. The angel is placed in a fountain near the graves of 59 unidentified victims whose bodies were burned beyond recognition. City records and local archives do not reveal the provenience of this piece, but most residents believe that Texas City citizens and volunteer firemen purchased the angel from Otto Monument Works of Galveston,

which ordered the statue from Italy. Another historic site in Texas City is Bay Street Park at 1400 Bay Street, where a replica of a 1913 vintage airplane is on view. In 1913, nine of the twelve airplanes assigned to the United States Army were located on an air field immediately south of Bay Street Park. The replica (Type H, Signal Corps SC-9) represents one of the first flying machines used by the Signal Corps before World War I.

Throckmorton

Barrington, Joe

(b. 1956 Native Texan)*

COLD CHISEL *1979*

Figurative; 10' × 5' × 3'; welded steel
Location: Barrington Park, off U.S. Highway 380 downtown
Funding: Donated by the artist in memory of his grandfather R. W. Barrington, who operated a blacksmith shop on the site
Comments: Joe Barrington is a native of Throckmorton, where he continues to reside and maintain his studio foundry.

Tilden

Miles, Larry

(American)*

BOOT HILL MARKER *early 1960s*

Figurative; 3'6" H; concrete
Location: Boot Hill Cemetery, one block north of the McMullen County Courthouse
Funding: Made and donated by Larry Miles, a local rancher
Comments: Amid the scattered wooden crosses in the old Boot Hill Cemetery is this concrete boot

Boot Hill Marker. Photo courtesy Judge Elaine Franklin.

mounted on an old tree stump. Several grave markers in the cemetery record the violent lives—and deaths—of people who died in Tilden when it was a lawless frontier town in the Texas brush country.

Turkey

Willis, Bill

(American)

BOB WILLS MEMORIAL *1971*

Figurative; 30' H; aluminum and granite
Location: State Highway 86
Funding: Private contributions through the Bob Wills Foundation
Comments: A base of red granite supports a 16-foot aluminum shaft topped with the figure of a guitar that on special occasions revolves to the sounds of Wills' tunes. Etched on the 8-foot-high granite base are scenes from the life of Bob Wills, a native of Turkey and the "King of Western Swing." His classic recordings include "San Antonio Rose" and "Faded Love." Bill Willis is from Granite, Oklahoma.

423

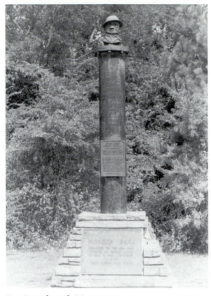

Joe Roughneck Monument. Photo by Robert Little.

Turnertown

Lone Star Steel Foundry

(American)*

JOE ROUGHNECK MONUMENT
1956

Figurative; smaller than life-size;
cast iron
Location: Pioneer Park, 7.3 miles west
of Henderson on State Highway 64
Funding: Lone Star Steel and East
Texas Chamber of Commerce
Comments: This bust is the first of
three Joe Roughneck statues placed in
Texas. Dedicated as a memorial to
workingmen in the oil field, the
monument was unveiled by three
East Texans who worked on the
original drilling crew that brought in
the Daisy Bradford 3. In spite of two
unsuccessful wells, East Texas oil
promoter Columbus Marvin Joiner
was convinced that he could tap vast
oil deposits in Rusk County. His
third well, the Daisy Bradford 3, came

in on October 3, 1930, making Joiner
the father of the East Texas oil fields
and earning him the nickname "Dad
Joiner." When the time capsule inside
the Turnertown *Joe Roughneck
Monument* is opened in 2056, the
articles inside will depict the
discovery and development of the
largest oil field in America. In 1957, a
second Joe Roughneck was placed by
local businessmen at the city hall
(505 West Davis) in Conroe in
recognition of the discovery of oil in
Montgomery County in 1931. A third
and last Joe Roughneck statue was
placed in Kilgore at Sesquicentennial
Plaza (909 North Kilgore) by the
Kilgore Sesquicentennial Monument
Committee. Erected in 1986, that
roughneck commemorates the East
Texas oil field boomers, many of
whom settled in Kilgore near "the
world's richest acre," on which 1,100
oil wells were drilled, including one
that was drilled through the marble
floor of a Kilgore bank. When the
Kilgore monument committee
contacted Lone Star Steel Company
concerning the acquisition of a Joe
Roughneck bust, they learned that
the cast had been destroyed in a fire.
Lone Star allowed its original
copyrighted plastic mold to be used to
make the Kilgore roughneck. The
East Texas Oil Museum at U.S. 259
and Ross Street in Kilgore chronicles
the history of the great East Texas oil
boom.

Tyler

Barrington, Joe

(b. 1956 Native Texan)*

EAST TEXAS WATCH DOG *1991*

Figurative; 3'2" H; mild steel
Location: University of Texas at
Tyler campus, 3900 University
Boulevard, next to the levee between

the library and the administration building
Funding: Purchased from 1991–1992 outdoor sculpture invitational sponsored by University of Texas at Tyler Friends of the Arts

Bishop, DeeAnn, and Rick Bishop

(Americans)*

THE EAGLE HAS LANDED *1981*

Figurative; larger than life-size; bronze and Cor-ten steel
Location: 200 block North Broadway
Funding: First City National Bank of Tyler
Comments: The Bishops own and operate Darbi Sculptors, located at their home in Spicewood, Texas, 35 miles west of Austin. The Bishops limit their designs to winged figures, primarily eagles. Their sculptures are shaped with a hammer and anvil without the use of heat.

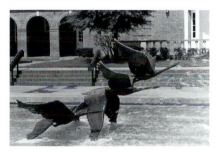

Geese Flying. Photo by Robert Little.

Foley, Pat

(b. 1922 American)*

GEESE FLYING *1983*

Figurative; 5' H × 10' L; bronze cast at Al Shakis Art Foundry in Houston
Location: Tyler Junior College campus, Wise Plaza, 1500 East 5th at Mahon Drive
Funding: Tyler Junior College

Gissen, Linda

(American)

TRIUMPH OVER TRAGEDY *1993*

Figurative; 6' H; bronze and copper
Location: Congregation Beth El, 1010 Charleston Drive
Funding: Commissioned by Philip Hurwitz
Comments: Gissen is nationally recognized for creating sculptures that commemorate and celebrate Judaica. In this work, the artist presents in horrific detail the history of the Holocaust. Using more than one hundred figures of men, women, and children, Gissen unfolds in five concentric circles the landmark events of Nazi Germany's persecution of the Jews. Yet, as the title implies, the sculpture inspires hope out of despair; barbed wire gradually evolves into branches of laurel and olive trees, and at the summit of the spiral, a figure holds aloft a Torah.

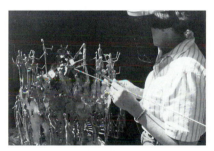

Artist Linda Gissen working on *Triumph over Tragedy.* Photo courtesy Linda Gissen.

Harper, John

(Native Texan)*

DR. H. E. JENKINS *1987*

Portraiture; life-size; bronze cast at Bryant Art Foundry in Azle
Location: Tyler Junior College campus, Wise Plaza, 1500 East 5th at Mahon Drive
Funding: Watson Wise and the college's board of trustees

Comments: Jenkins (1899–1983) served as president of Tyler Junior College from 1946 to 1981. The late John Harper lived in Tyler when he created this portraiture of TJC's professor emeritus. His indoor Western and wildlife sculptures are placed in corporate and private collections in several states and in Canada.

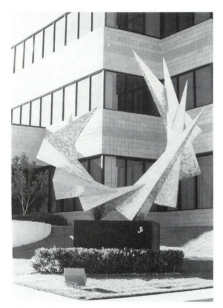

Motion III. Photo by Robert Little.

Sanders, Jerry Dane

(b. 1949 American)*

MOTION III 1985

Abstract; 20' H; Cor-ten and stainless steel fabricated by the artist
Location: 3301 Golden Road off Troop Highway
Funding: Dennis Daryl

Pine Flower. Photo by Robert Little.

Surls, James

(b. 1943 Native Texan)*

PINE FLOWER 1979

Abstract; 7' × 15' × 7'; wood and steel
Location: Buford Television, Inc., 5800 block Paluxy
Funding: Bob Buford

Tremonte, Sister Mary Peter

(b. 1930 Native Texan)*

MOTHER FRANCES SIEDLISKA AND CHILD 1993

Portraiture; larger than life-size; bronze
Location: Mother Frances Hospital, 800 East Dawson Street
Funding: Commissioned by the hospital
Comments: Mother Frances Hospital is named for Mother Frances Siedliska, who is depicted in this work walking with her adopted daughter, Grace. Mother Frances is shown holding out her mantle to shelter Grace from a heavy rain storm.

PRESENTATION IN THE TEMPLE 1988

Figurative; 7' H; bronze
Location: Mother Frances Hospital, 800 East Dawson Street
Funding: Commissioned by the hospital in commemoration of the

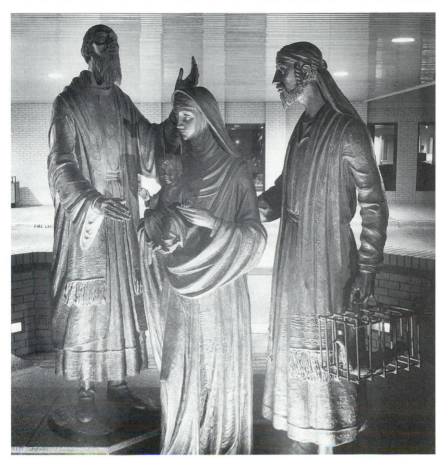

Presentation in the Temple. Photo by Robert Langham III, courtesy Mother Frances Hospital.

fiftieth anniversary of the founding of the hospital

Comments: The accompanying commemorative plaque explains the sculpture: "The Holy Family is depicted ascending the steps of the temple for the ceremony of purification after the birth of Jesus. Mary and Joseph have come to Jerusalem to present their son according to the law. The old prophet Simeon encounters the young couple and through the Holy Spirit recognizes the infant Jesus as the long-awaited Messiah. Today, this beautiful piece of sculpture speaks richly about finding God in the human experience. We can see ourselves in each character. We are the young mother nurturing life; we are the strong but gentle father-husband caring for his loved ones; we are the elderly man of wisdom whose last days are the reward of a life lived in service; and finally, we are the child, dependent on others, full of potential and obedient to the will of God as we know it."

427

Unknown Artist

CONFEDERATE SOLDIER STATUE
1909

Figurative; 6'6" H; Italian and
Georgia marble
Location: Oakwood Cemetery,
700 block Oakwood Street
Funding: Mollie Moore Davis
Chapter 217, United Daughters of the
Confederacy, and public donations
Comments: Morris Brothers Marble
Works in Tyler made the marble base
locally and ordered the soldier figure
from Italy. After the base was set in
1907, Morris Brothers uncrated the
statue to discover a large crack on the
face of the soldier. They returned the
statue to Italy for repair, thereby
delaying the dedication until 1909,
although the base reads 1907.

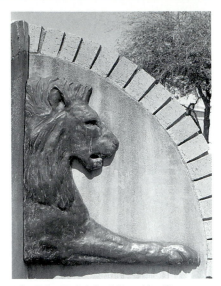

John Tyler High School Lions (detail).
Photo by Robert Little.

Wedemeyer, Henry

(1901–1991 Native Texan)*

**JOHN TYLER HIGH SCHOOL
LIONS** *1982*

Figurative; 6' H; bronze and brick
Location: John Tyler High School,
1120 North NW Loop 323

Funding: Tyler Independent
School District
Comments: To commemorate the
rebuilding of John Tyler High School
after a fire almost destroyed the
school, Wedemeyer used bas-relief
sculptures of a male and female lion,
each surrounded by a border of bricks
salvaged from the burned building.

Vernon

Victoria

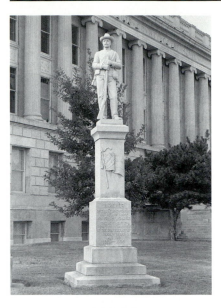

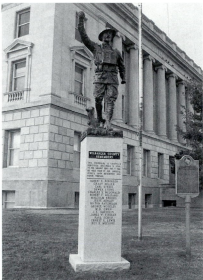

Confederate Soldier Statue (top) and
Spirit of the American Doughboy (bottom).
Photos by Robert Little.

Vernon

Unknown Artist

CONFEDERATE SOLDIER STATUE
1916

Figurative; life-size; gray granite
Location: Wilbarger County
Courthouse grounds
Funding: L. S. Ross Chapter, United
Daughters of the Confederacy

Viquesney, E. M.

(1876–1946 American)

**SPIRIT OF THE AMERICAN
DOUGHBOY** *1926*

Figurative; life-size; bronze
Location: Wilbarger County
Courthouse grounds
Funding: A monument committee
composed of local World War I
veterans
Comments: Originally erected at the
old county courthouse, this statue
was moved in the 1930s to a local
park, where it endured repeated
assaults by vandals. The figure even
suffered a bullet hole in the rim of his
hat. In 1994, in honor of the county's
sons who fought in World War I, the
county historical commission and
private donors raised money to return
the memorial to the courthouse
grounds.

Victoria

Coppini, Pompeo

(1870–1957 American/Italian)*

FIRING LINE *1912*

Figurative; larger than life-size;
bronze
Location: DeLeon Plaza,
100 Main at Constitution

430

Firing Line. Photo by Robert Little.

Funding: William P. Rogers Chapter, United Daughters of the Confederacy
Comments: This work is unique among Confederate soldier statues in Texas. Coppini gratefully acknowledged that the William P. Rogers Chapter allowed him to use his own ideas in creating the work, and he was determined to please them as well as produce something of lasting significance. He wrote to the chapter, "If your heroes deserve a monument, it is not because they make a good showing in dress-parade, but because they were such fighters as to be able to hold an overwhelming army at bay, notwithstanding they were poorly clad and not sufficiently fed. . . . If you will allow me to make that statue according to my views, I am almost sure to give you one of the most forceful types of a true Confederate soldier" (Coppini 1949, 197–198). The sculptor created a young, muscular soldier standing on the edge of a rocky cliff after a hard battle. (For readers interested in 1936 Centennial commissions, a large bas-relief plaque by Raoul Josset is located in the 400 block of Commercial Street.)

Hermes, Leroy, and Jerome Kutach

(Americans)*

THE CHANCERY LIGHTHOUSE
1985

Abstract; 3 stories high; limestone
Location: 1505 East Mesquite
Funding: Contributions from the members of the Diocese of Victoria
Comments: This monument is an abstracted form of the 1852 Matagorda Island lighthouse, which stands at Pass Cavallo, the original access to Indianola and Port Lavaca. The original structure was rebuilt in 1872 after it sustained extensive damage during the Civil War. *The Chancery Lighthouse* represents the immigration experience of early Texas settlers who came by sea. Architects Hermes and Kutach designed the new lighthouse and the chancery to express the story of the development of the Catholic church in South Texas and to create an atmosphere conducive to carrying on the work of the church in that region. Sister Mary Peter Tremonte of San Antonio was the chief designer and sculptor of the magnificent artwork, stained glass, and furnishings inside the chancery.

Galea Brothers Marble Company

(American)

AVE MARIA *1954*

Portraiture; life-size; marble
Location: 208 West River Street
Funding: Private donations

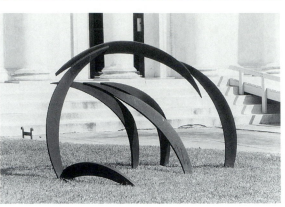

Untitled, companion works by Mac Whitney
installed on the grounds of The Nave Museum.
Photos by Robert Little.

Whitney, Mac

(b. 1936 American)*

UNTITLED *1975*

Abstract; 2 companion pieces,
each 7' H; welded steel
Location: The Nave Museum
grounds, 306 West Commercial
Funding: Gift to the museum by
Ann Robinson

Waco

Washington

Waxahachie

Weatherford

Weslaco

Wharton

White Deer

Wichita Falls

Windthorst

The Woodlands

Waco

Burlwood Industries, Inc.

(American)

BEAR AND CUB and
EAGLES AND CUB *1986*

Figurative; 9' and 12', respectively;
carved wood
Location: Western Sizzlin restaurant,
1835 North Valley Mills Drive
Funding: Western Sizzlin

Coppini, Pompeo

(1870–1957 American/Italian)*

BURLESON MEMORIAL *1905*

Portraiture; larger than life-size;
bronze
Location: Baylor University campus,
the Quadrangle
Funding: Burleson Monument
Association Committee
Comments: The Reverend Rufus C.
Burleson served as president of Baylor
University for 21 years. When the
monument committee came to

inspect the statue, Burleson's wife and
granddaughter were present. The little
girl exclaimed, "Grandma, that is
Grandpa!" Georgianna Jenkins
Burleson was so moved by the statue
that she broke down in tears. This
work was Coppini's first major
commission after his arrival in Texas,
and its success helped establish his
reputation.

R. E. B. BAYLOR *1938*

Portraiture; larger than life-size; bronze
Location: Baylor University campus,
Speight Avenue across from Waco Hall
Funding: $14,000 allocated by the 1936
Commission of Control for Texas
Centennial Celebrations
Comments: Robert Emmett Bledsoe
Baylor wrote the charter by which
Baylor University was founded. The
Congress of the Republic of Texas
granted the charter on February 1,
1845, making Baylor one of the oldest
educational institutions in the state.
R. E. B. Baylor was a lawyer, an
educator, a missionary, and a delegate
from Fayette County to the Conven-
tion of 1845. He served as judge of the

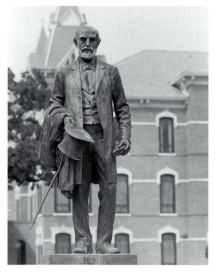

Burleson Memorial. Photo courtesy Baylor University,
Office of Public Relations.

R. E. B. Baylor. Photo courtesy Baylor University,
Office of Public Relations.

third judicial district of the Republic of Texas, and after statehood, he remained in that position until the court ceased to function during the Civil War. It is said that Baylor traveled the Texas frontier on horseback with his law books in one side of his saddlebag and the Bible in the other.

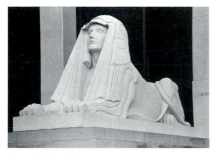

Scottish Rite Sphinx. Photo by Robert Little.

Federal-Seaboard Terra Cotta Company

(American)

SCOTTISH RITE SPHINXES *1969*

Figurative; 2 figures, each 10' L and 4,000 lbs.; terra-cotta
Location: Lee Lockwood Scottish Rite Library, 2801 West Waco Drive
Funding: Donated by the El Paso Scottish Rite bodies
Comments: Cast in a single unit, these allegorical figures are identical to those placed at the Scottish Rite Temple in El Paso. For more information, see Federal-Seaboard Terra Cotta Company under the El Paso listing.

Lightfoot, Jewel P.

(American)

KING SOLOMON'S TEMPLE PILLARS REPLICA *1948*

Figurative; 2 pieces, each 39' H; stone
Location: Temple of the Grand Lodge

of Texas, 715 Columbus Avenue
Funding: Owned by the Masonic Grand Lodge Library and Museum of Texas
Comments: Lightfoot, a past grand master, designed this replica of the two pillars of the porch of King Solomon's Temple. The terrestrial and celestial globes on top of the pillars have an 8-foot diameter. Raoul Josset designed the large sculptured frieze on the front of the building.

Pomodoro, Gio

(b. 1926 Italian)

SQUARE IN BLACK *1963*

Abstract; 3'9" H × 3'9" W; carved slate
Location: The Art Center, Waco, 1300 College Drive
Funding: Donated in 1985 by the Meadows Foundation

Tauch, Waldine

(1892–1986 Native Texan)*

PIPPA PASSES *1957*

Figurative; life-size; bronze

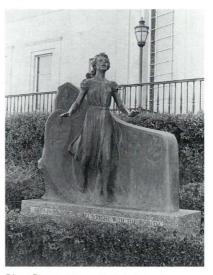

Pippa Passes. Photo courtesy Baylor University, Office of Public Relations.

Location: Baylor University campus, Armstrong-Browning Library entrance
Funding: Brady Tuesday Club and Mr. and Mrs. John L. Jones
Comments: The artist's interpretation of Robert Browning's famous poem-drama depicts the young factory worker Pippa skipping down the street in her northern Italian home in Asolo. The statue of Pippa is surrounded by four bas-relief medallions that reflect the four segments of the poem: Morning, Noon, Evening, and Night.

Teich, Frank

(1856–1939 American/German)*

GOVERNOR RICHARD COKE and DR. DAVID RICHARD WALLACE *1920s*

Portraiture; life-size; marble and granite
Location: Oakwood Cemetery, 2124 South 5th
Funding: The families of Governor Richard Coke and Dr. David Richard Wallace
Comments: Richard Coke came to Waco in the 1850s to practice law. He fought for the Confederacy throughout the Civil War, and after the war he was elected to the Texas Supreme Court. General Philip Sheridan removed him from the bench, claiming that Coke was an impediment to Reconstruction. In 1873, he defeated Reconstruction governor and former Union officer E. J. Davis. Coke's election marked the political end of Reconstruction in Texas. Installed on an identical base and facing the statue of Governor Coke is the statue of his close friend Dr. David Richard Wallace. In 1861, Wallace moved with the faculty of Baylor University from Independence to Waco. During the Civil War he served as a surgeon in the Confeder-ate army, and at the close of the war, he was the surgeon for the Department of Southern Texas. After the war, he dedicated his practice to the treatment of people with mental disorders. Because of his work with mentally ill people, he is considered the father of modern psychiatry in Texas.

Umlauf, Charles

(1911–1994 American)*

THE KNEELING CHRIST *1973*

Figurative; 3'9" H; bronze and Carrara marble
Location: Baylor University campus, Lina Mills Bennett Auditorium courtyard
Funding: Donated in 1977 by Mr. and Mrs. John Koonce

Unknown Artist

VOLUNTEER FIREMEN'S MONUMENT *1883–1893*

Figurative; life-size; marble and granite
Location: Oakwood Cemetery, 2124 South 5th

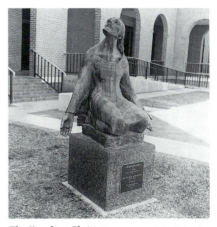

The Kneeling Christ. Photo courtesy Baylor University, Office of Public Relations.

Funding: Waco volunteer firemen and public donations

Comments: In 1978, Frank Tolbert credited Johnny Black with aptly describing Oakwood Cemetery as a giant chessboard, complete with stone and marble kings, queens, knights, castles, and pawns (*Dallas Morning News*, February 25, 1978). Indeed, the cemetery does have a large number of life-sized sculptured human figures with regal carriages, as well as military figures (knights) and ornately carved mausoleums (castles). Even the dozens of individually designed plinths are reminiscent of marble pawns. Most of the monument makers who placed markers at the more than 20,000 grave sites are not identified, but among the notable individuals buried in the cemetery are Neil McLennan and George Bernard Erath, both of whom have Texas counties named in their honor.

Wade, Bob

(b. 1943 Native Texan)

FUNNY FARM FAMILY *1968*

Abstract; 7' H; iron and steel
Location: The Art Center, Waco, 1300 College Drive
Funding: On long-term loan from McLennan Community College
Comments: Created while the artist was teaching at McLennan Community College, this found-object assemblage was Wade's first Texas placement.

Washington

Josset, Raoul

(1898–1957 American/French)*

GEORGE C. CHILDRESS *1936*

Portraiture; larger than life-size; bronze cast at E. Gargani and Sons

Foundry of New York
Location: Star of the Republic Museum off Farm Road 1155, Washington-on-the-Brazos State Historical Park
Funding: $7,500 allocated by the 1936 Commission of Control for Texas Centennial Celebrations
Comments: Donald Nelson designed the hone-finished granite monument, including the tall shaft that forms a background for the statue. Childress was the chairman of the five-member committee that drafted the Texas Declaration of Independence signed in Washington on March 2, 1836. He later served under provisional president David G. Burnet as the agent sent to Washington, D.C., to secure recognition of the new republic by the United States.

Waxahachie

Adickes, David

(b. 1927 Native Texan)*

MARVIN E. SINGLETON *1988*

Portraiture; life-size; bronze
Location: Citizens National Bank Annex, 801 U.S. 77
Funding: Family of Marvin E. Singleton

Piccirilli, Attilio

(1866–1945 American/Italian)

RICHARD ELLIS STATUE *1936*

Portraiture; 7'4" H; bronze
Location: Ellis County Courthouse grounds
Funding: $7,500 allocated by the 1936 Commission of Control for Texas Centennial Celebrations
Comments: The nine Piccirilli sons and their father were sculptors and marble cutters who immigrated from Italy and established a home and

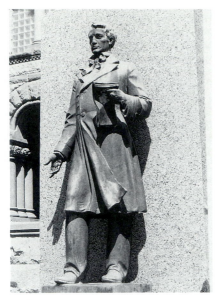

Richard Ellis Statue. Photo by Robert Little.

Mary Martin as Peter Pan. Photo by Robert Little.

studio in New York City on 142nd Street. Attilio was the oldest son. The Piccirilli family gave Pompeo Coppini his first job as a sculptor in America. Richard Ellis served as president of the Convention of 1836 and as a senator in the First, Second, Third, and Fourth Congresses of the Republic of Texas.

Unknown Artist

CONFEDERATE SOLDIER STATUE
1912

Figurative; 7' H; granite
Location: Ellis County Courthouse grounds
Funding: United Daughters of the Confederacy
Comments: The inscription reads, "In honor of the dead and living of Ellis County who wore the gray."

Weatherford

Thomason, Ronald

(b. 1931 American)*

MARY MARTIN AS PETER PAN
1976

Figurative; life-size; bronze cast at Castleberry Art Foundry in Weatherford
Location: Weatherford Public Library, 1214 Charles Street
Funding: Individual contributions through a monument committee
Comments: Weatherford honors its hometown celebrity, the late Mary Martin, with this statue depicting her in her starring role as Peter Pan. The inscription reads, "Peter Pan: a tribute to the genius of Weatherford's Mary Martin who brought a myth to life for millions." Heritage Gallery, located inside the Weatherford Public Library, includes the Mary Martin Collection, which displays costumes, photographs, memorabilia, and hand-stitched needlepoint donated by Mary

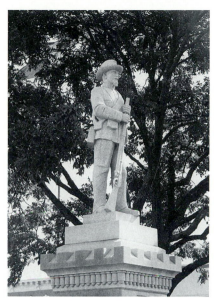

Confederate Monument. Photo by Robert Little.

Martin. After her death, the Broadway star's children, Larry Hagman and Heller Halliday DeMerritt, expanded the original collection donated by their mother.

Waldron Shield and Company

(American)

CONFEDERATE MONUMENT *1915*

Figurative; 7' H plus base; granite
Location: Parker County Courthouse grounds
Funding: Sam Lanham Chapter, United Daughters of the Confederacy
Comments: Alex Rawlins, owner of Rawlins Monuments in Weatherford, installed the base portion of this monument on the courthouse grounds on October 25, 1915. The Sam Lanham Chapter needed thirteen years to reimburse Rawlins for the monument, but after the last payment was made and the dedication held on January 1, 1928, the chapter immediately announced plans to purchase a Confederate soldier statue to be placed on the monument. Rawlins ordered the figure from Waldron Shield and Company, importers and manufacturers of granite and marble monuments, in Barre, Vermont. The statue arrived on November 25, 1929; Rawlins received the last payment on November 5, 1937. According to company records, Alex Rawlins never asked the UDC to make scheduled payments, nor did he charge interest on the unpaid balance. His descendants continue to operate Rawlins Monuments in Weatherford.

Weslaco

Pan American University Department of Art

(American)*

HARLON BLOCK MEMORIAL *1977*

Abstract; 14' H; concrete
Location: Harlon Block Memorial Park
Funding: Donations by local citizens
Comments: Weslaco native Harlon Block and several of his schoolmates took early graduation from Weslaco High School in 1943 to join the United States Marine Corps. Two years later, Corporal Block's wartime service was immortalized in one of World War II's most enduring images. On February 23, 1945, Associated Press photographer Joe Rosenthal photographed five U.S. Marines and one U.S. Navy pharmacist's mate, second class, raising the American flag on Iwo Jima after the Marines captured Mount Suribachi. Rosenthal's Pulitzer prizewinning photograph showed Harlon Block planting the base of the flagpole (his back to the viewer); he died in battle two days later. After the war, the flag-raising on Mount Suribachi was

439

memorialized by Felix de Weldon's monumental sculpture the *Iwo Jima War Memorial*, based on Rosenthal's photograph. In 1976, students at Weslaco's Cuellar Elementary School conceived the idea for a monument to the memory of their hometown World War II hero. The Weslaco City Commission supported the idea and enlisted the aid of Jerry Bailey, head of the art department at Pan American University. Stephanie Jane Harris, a student at the university, designed the monument, and the university sculpture class constructed the work.

Wharton

Jaeggli and Martin Stonecutters

(American)*

SHERIFF H. B. DICKSON MEMORIAL *1894*

Portrait bust; life-size; Italian marble and Texas granite
Location: Wharton County Courthouse grounds
Funding: Public donations raised by a monument committee appointed by the Wharton County Commissioners Court
Comments: Sheriff Hamilton Dickson was a much respected and beloved lawman on the Texas frontier. He died on February 7, 1894, at the age of 39 in an ambush staged by outlaws. The Brenham firm of Jaeggli and Martin Stonecutters competed with several other monument companies for this commission, which was hailed by contemporary news accounts as "the handsomest and largest" monument in southern Texas.

Sheriff H. B. Dickson Memorial. Photo by Robert Little.

Reel, Ron

(American)*

WHARTON COUNTY VETERANS MEMORIAL *1988*

Abstract; 5' H; Texas granite and concrete
Location: Wharton County Courthouse grounds
Funding: Wharton County Veterans Memorial, Inc., a nonprofit group organized to raise funds for the memorial

Wharton County Veterans Memorial.
Photo by Robert Little.

Comments: Ron Reel donated his time as the architect and designer of this memorial, which represents two hands guarding the light of freedom. The idea to build a monument to the county's veterans of World War II, Korea, and Vietnam began with an informal discussion among members of East Bernard American Legion Post 226 and gradually grew to involve the entire county. The inscription reads, "In memory of those who served. Freedom is not free."

Steinheimer, Dana

(b. 1951 American)*

WHARTON BRONTOSAURUS AT RIVERFRONT PARK *1992*

Figurative; 20' H × 77' L; fiberglass and welded steel
Location: Wharton Riverfront Park at the intersection of 400 Colorado Street and 300 South Richmond Road
Funding: City of Wharton Hotel/ Motel Tourism Fund

White Deer

Unknown Artist

WHITE DEER *1968*

Figurative; life-size; cast iron
Location: 3rd and Main streets
Funding: City of White Deer

Wichita Falls

Kitson, Theodora Alice Ruggles

(b. 1871 American)

THE HIKER *1928*

Figurative; 7' H; bronze cast at the Gorham Manufacturing Company in Providence, Rhode Island

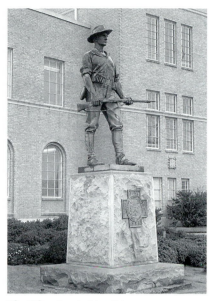

The Hiker. Photo by Robert Little.

Location: Memorial Auditorium, 1300 7th Street
Funding: David D. McCaleb Camp United Spanish-American War Veterans

Sugarman, George

(b. 1912 American)

CRAPE MYRTLE ABSTRACTION *1982*

Abstract; 14' × 31' × 21'; painted metal
Location: Harold Jones Park,

Crape Myrtle Abstraction. Photo by Robert Little.

1400 block 9th Street between Broad and Holliday
Funding: Erected by the city of Wichita Falls
Comments: Sugarman's crape myrtle is painted in shades of pink and green. Wichita Falls adopted the popular blooming tree as a symbol of the city's strength and stamina because, like the crape myrtle, the city flourishes in a hostile climate.

Herb. Photo by Robert Little.

Swanner, Toni

(b. 1967 American)*

HERB *1992*

Figurative; 16' L; stainless steel
Location: Wichita Falls Museum and Art Center
Funding: Commissioned by the museum

Viquesney, E. M.

(1876–1946 American)

SPIRIT OF THE AMERICAN DOUGHBOY *1927*

Figurative; life-size; bronze
Location: Memorial Auditorium, 1300 7th Street
Funding: Pat Carrigan American Legion Post 120

Michelangelo's Moses Replica. Photo by Robert Little.

Vivani, Cesare

(Italian)

MICHELANGELO'S MOSES REPLICA *n.d.*

Figurative; 3'6" H; white Carrara marble
Location: First Presbyterian Church, 3601 Taft Boulevard
Funding: Donated by Mr. and Mrs. Walter M. Priddy
Comments: Mr. and Mrs. Priddy purchased this replica in 1963 from Pietro Bazzanti and Son Art Gallery in Florence, Italy.

Special Collections and Sculpture Gardens in Wichita Falls

The Fain Fine Arts Center Sculpture Exhibit is installed on the campus of Midwestern State University at 3410 Taft Boulevard. In addition to temporary special exhibits, the center's permanent collection includes five welded-steel designs by former students of the university:

442

BROKEN HAMMER *1978* by Joe
Barrington, **PAINT TUBE** *1989* by
Mike Murdock, **SOME REALLY BIG
LIPS** *1994* by Tracey Schultz, **TEXAS
TORNADO** *1989* by the sculpture
class of 1989, and **AWAITING** *1985*
by M. Steigge. Other outdoor works
on the campus include two welded-
steel abstracts by Tom Crossnoe
installed adjacent to the Fowler
Building (School of Business).

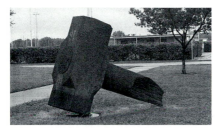

Broken Hammer. Photo by Robert Little.

Windthorst

Citizens of Windthorst

SAINT MARY'S GROTTO
1949–1950

Figurative; 3'6" statue; native stone
and Italian marble
Location: Saint Mary's Church, U.S.
Highway 281
Funding: Donations by local residents
and the community's World War II
military servicemen during their
service overseas
Comments: Almost 20 percent of the
entire population of Windthorst left
home to serve in World War II. With
so many of its citizens fighting
overseas, the town decided to erect a
shrine to Our Lady of Perpetual Help
as a visual symbol of their prayers for
a safe return. Throughout the war,
each of the 64 Windthorst servicemen
sent home a portion of his military

Saint Mary's Grotto. Photo by Robert Little.

paycheck to help finance the building
of a grotto after the war was over.
When the shrine was dedicated on
August 22, 1950, all 64 veterans were
present, although most had served in
some of the most brutal battles of the
war. The statue for the shrine was
imported from Italy, but local
volunteers built the grotto with
native fieldstone and granite from the
Wichita Mountains. The shrine and
the story of its erection attract
hundreds of visitors each year to the
small German community in Archer
County.

The Woodlands

**Special Collections and Sculpture
Gardens in The Woodlands**

The Woodlands Corporation's
collection of outdoor sculpture is
installed in public spaces throughout
this planned community develop-
ment in Montgomery County. From
its inception, The Woodlands has

443

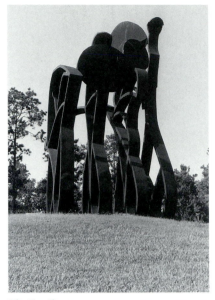

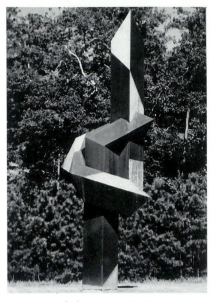

The Family. Photo courtesy The Woodlands Corporation.

Man's Struggle for a Better Environment. Photo courtesy The Woodlands Corporation.

incorporated art into the everyday environment, making outdoor sculpture as much a part of the community as its homes, parks, and businesses. Sixteen large outdoor installations placed by The Woodlands Corporation reflect the community's emphasis on the cultural arts and the importance of the arts to the quality of life:

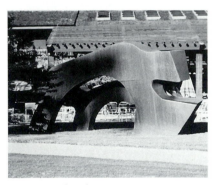

Casten Metal Sculpture. Photo courtesy The Woodlands Corporation.

THE FAMILY, a 40' formed-steel abstract by Huntsville artist Charles Pebworth, identifies the entrance to The Woodlands at Woodlands Parkway and Interstate 45. Installed in 1974, this entrance piece was the first outdoor sculpture purchased for The Woodlands.

MAN'S STRUGGLE FOR A BETTER ENVIRONMENT, by native Texan Bob Fowler, also was installed in 1974, making it the second work chosen for The Woodlands. The 26' Cor-ten and stainless-steel abstract attracts the attention of

Disc II. Photo courtesy The Woodlands Corporation.

Untitled. Photo courtesy The Woodlands Corporation.

Revoluta. Photo courtesy The Woodlands Corporation.

motorists passing Grogan's Mill Road median at Woodlands Parkway.

CASTEN METAL SCULPTURE, a 9'6" metal abstract by Chicago native Richard Hunt, was installed in 1977 at Research Forest Drive.

DISC II, a 17' (including the base) Cor-ten steel abstract by San Antonio artist Richard Harrell Rogers, was installed in the median at Timberloch Place in 1979.

REVOLUTA, a 10'6" aluminum abstract by Corbin Bennett and Dixon Bennett, marks the entrance to the MND Building at 2001 Timberloch Place. It was installed in 1980.

UNTITLED, also installed in 1980, is a 14' abstract of painted steel plate by Horace L. Farlowe. It is placed at the entrance to the Trade Center.

TOMORROW, a cast-metal figurative group by Charles Cropper Parks, measures 8' high, including the base. It was installed at Grogan's Mill Village Center in 1981.

EXCALIBUR, a 6'9" painted steel abstract by David Hayes, is installed in the median on Lake Woodlands Drive. Purchased by The Woodlands Corporation in 1984, this fanciful abstraction from the Arthurian legend is painted in varying shades of blue, yellow, green, red, and orange.

CHILDREN AT PLAY, a 9' bronze figurative work by Clement Renzi, was installed in 1984 at Panther Creek Village Square.

RISE OF THE MIDGARD SERPENT, measuring 6' high and 35' long, is the work of Marc Rosenthal. Given to The Woodlands by Cynthia Mitchell in 1985, this friendly water creature swims in Lake Woodlands along Woodlands Parkway.

FAMILY GROUP is an 8'6" bronze abstract by Houston artist Pat Foley. Placed in 1985, it welcomes patients and visitors to Memorial Hospital–The Woodlands.

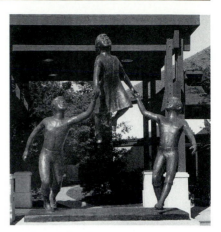

Children at Play. Photo courtesy The Woodlands Corporation.

Rise of the Midgard Serpent, in the late evening mist on Lake Woodlands. Photo courtesy The Woodlands Corporation.

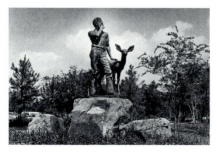

Tomorrow. Photo courtesy The Woodlands Corporation.

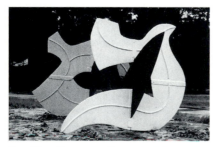

Excalibur. Photo courtesy The Woodlands Corporation.

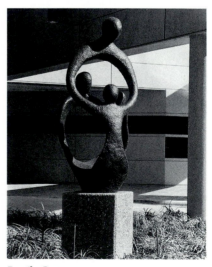

Family Group. Photo courtesy The Woodlands Corporation.

446

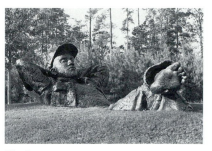

The Dreamer. Photo courtesy The Woodlands Corporation.

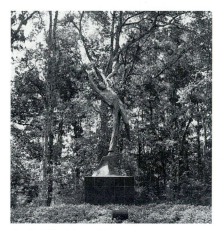

On the Shoulders of Giants.
Photo courtesy The Woodlands Corporation.

ON THE SHOULDERS OF GIANTS,
a 15' bronze figurative piece by
Robert Cook, was installed in 1989
at Research Forest Drive and
Grogan's Mill Road.

SMOKEDANCE, by Dale Garman,
includes six figures ranging in
height from 6' to 13'6". It was
installed in 1989 at the Cynthia
Woods Mitchell Pavilion.

THE DREAMER measures 4' high
and 17' long. Installed in 1989, this
bronze figure by David Phelps
reclines in the median west of East
Panther Creek in Woodlands
Parkway.

THE WATCH OWL, a recent
placement measuring 23' high, is
the work of Houston artist Mark
Bradford. It was installed in 1993
at the Cynthia Woods Mitchell
Pavilion.

MIRAGE II, a 10' welded-steel
abstract by Houston artist Ben
Woitena, is the most recent
placement in The Woodlands.
Placed in 1995, it is located at
Research Forest Drive between
Gosling Road and Shadowbend
Place, near Cochran's Crossing
Shopping Center.

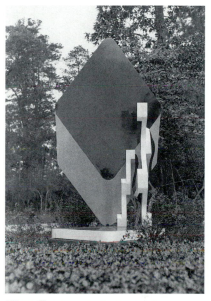

Mirage II. Photo courtesy The Woodlands Corporation.

447

Texas Art Foundries and the Lost-Wax Casting Process

Most art foundries use some variation of the lost-wax process for casting metal objects. Dating back to 4000 B.C., the lost-wax process is among the oldest casting techniques known and is the most popular for capturing in exact detail the original work of the artist. It has changed little since its inception centuries ago, remaining a labor-intensive procedure with many pitfalls. Highly skilled artisans and a long, meticulous process are necessary to transform the sculptor's model into a high-quality bronze sculpture.

The lost-wax process used in most Texas art foundries includes several major elements. The process begins when the artist brings an original model to the foundry. The model may be "to scale," meaning the same size as the finished product, or it may be a maquette that has to be enlarged to the desired size by trained workers using precise mathematical formulas. When it is ready, a flexible rubber compound is sprayed or painted over the full-size model, which is then covered with plaster. The rubber allows accurate reproduction of intricate detail, creating an exact negative of the model, and the plaster reinforces the rubber.

After the rubber and plaster coatings have been individually applied and cured, the rubber and plaster molds are carefully removed and the original work set aside. The rubber and plaster mold segments are pieced back together and secured tightly; then hot wax is poured into the hollow space left by the original model. The mold is carefully rotated so that the hot wax coats its entire inner surface. As the wax cools, the rotation is continued until the wax solidifies to a thickness of approximately one-fourth inch. Excess wax is discarded. The mold is then taken apart and the exact wax positive of the artist's sculpture is removed. The hollow wax replica is touched up, and gates and runners are attached. Gates are channels

449

Houston artist Pat Foley delivers a new work for casting at the Al Shakis Art Foundry. Photo by Robert Little.

Houston artist Trace Guthrie applies rubber to his clay model of Sam Houston. Photo courtesy Trace Guthrie.

When the rubber mold is split open, an exact negative of the original model is revealed. Photo courtesy Trace Guthrie.

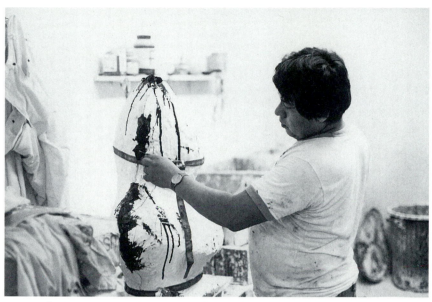

Hermando Garcia secures the ceramic shell with straps.

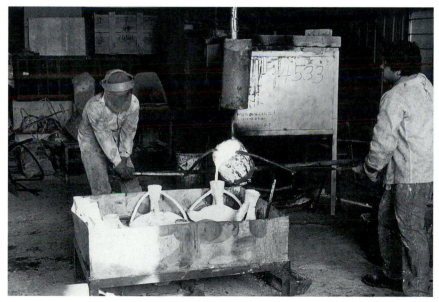

Molten bronze is poured through the gates into the hot ceramic shell.

451

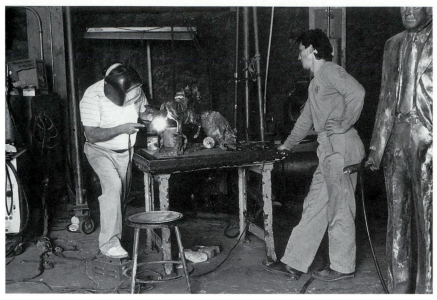

Artist Eric Charles Kaposta and Al Shakis demonstrate the chasing and welding process after the ceramic shell is removed.

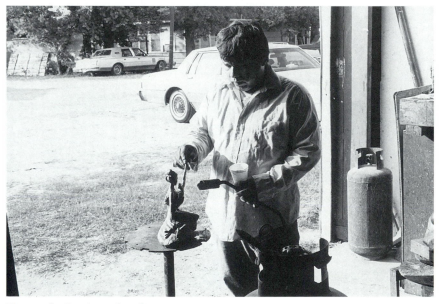

Hermando Garcia applies the patina.

into which molten bronze will be poured, and runners are vents through which air and other gases can escape.

The wax model is carefully coated inside and out with several layers of ceramic slurry, forming a thick wall. The dried ceramic shell on the wax model is fired in a dewaxing oven or burnout furnace where the wax melts away or is "lost." The space between the ceramic walls is then filled with molten bronze. After the bronze has cooled, the ceramic shell is broken away, gates and runners are removed, and imperfections are repaired. If the sculpture has been cast in several sections, the sections are now welded together and hand-finished. Finally, the patina, a chemical coating that protects and enhances the bronze, is applied. The sculpture may be polished with a paste wax for further protection.

For many years, Texas sculptors shipped their original models to art foundries in Chicago, Philadelphia, New York, or Italy. The state's first professional sculptors often complained about the tribulations of shipping fragile models and traveling away from home to oversee the casting process. Today, these Texas art foundries cast large outdoor bronzes for placement in Texas and elsewhere across the nation:

Bob Wilson Art Foundry
(formerly Al Shakis Art Foundry)
Bob Wilson, owner
6107 West 34th Street
Houston, TX 77092
(713) 686-5567

Bryant Art Foundry
Paul E. Bryant, owner
Route 4, Box 165
Azle, TX 76020
(817) 444-4341

Deep in the Heart Foundry
Steve Logan, owner
1008 Alley A
Bastrop, TX 78602
(512) 321-7868

Hoka Hey Fine Arts Foundry
and Gallery
Wade and Richard Cowan,
owners
P.O. Box 88
Highway 377
Dublin, TX 76446
(817) 445-2017

House Bronze, Inc.
Jerry P. House, owner
6830 66th Street
Lubbock, TX 79424
(806) 794-3571

Joe Lewis Art Foundry (formerly
Castleberry Art Foundry)
Joe Lewis, owner
117 Ward Street
Weatherford, TX 76086
(817) 594-0051

Schaefer Art Bronze Casting, Inc.
Joe E. Schaefer, owner
132 South Collins
Arlington, TX 76010
(817) 460-1102

Stevens Art Foundry
Larry Stevens, owner
31806 Bartels Road
Bulverde, TX 78163
(210) 980-2818

Glossary

Abstract: An object or form presented in a nonrealistic manner. Abstraction may retain some of the essential elements of the model, or it may be entirely subjective, expressed in the artist's own visual terms.

Allegorical: A figure that symbolizes a principle or idea such as knowledge, liberty, or justice.

Armature: The skeletal framework upon which the artist molds the figure in clay, wax, or other modeling material. The armature is usually made of wire, wood, or metal beams.

Bas-relief: See *Relief.*

Biomorphic: Similar to forms found in living organisms.

Bronze: An alloy essentially of copper and tin, sometimes including other metals, particularly zinc.

Bust: A sculpture representing the upper part of the human figure, usually including the head and neck, often with the shoulders and chest. Also referred to as a portrait bust.

Carrara marble: A fine white marble with a flat rather than glossy finish. Mined in the mountains near Carrara, Italy.

Carving: The process of taking away; using instruments and tools to cut away material to shape the desired form. The opposite of modeling.

Casting: The process of converting the artist's clay model into a metal sculpture through the use of a mold, or of making copies (casts) of existing sculptures.

Cenotaph: A monument erected to a person or persons whose remains are interred in another location.

Colossal: More than twice life-size.

Cor-ten: An extremely durable type of steel developed in the 1950s; often left unfinished and allowed to rust.

Decorative: Work designed to adorn or fit into some other back-ground; may be referred to as architectural sculpture when applied to a building or structure.

Environmental: Sculpture that incorporates the natural physical environment (earth, water, natural terrain) into the overall design.

Equestrian: A statue of a person on horseback; in this survey, refers to any equine or horse sculpture, with or without a rider.

Figurative: Sculpture that represents the natural appearance of a subject. Also called representational sculpture.

Freestanding: Sculpture that stands free and can be viewed from any side or angle. Also called sculpture in the round.

Frieze: In freestanding sculpture, a band or strip of decoration.

Granite: A hard igneous rock suitable for construction and monu-ments because of its strength and durability; also takes a high polish. In Texas, granite is found in the Llano Uplift of Central Texas and in the Trans-Pecos country of West Texas.

Heroic: Larger than life-size, but smaller than colossal.

High relief: See *Relief.*

Kinetic: Sculpture that involves motion. See *Mobile.*

Limestone: A hard rock composed principally of calcium carbonate. Quarried in more than sixty counties in Texas, making Texas one of the nation's leading producers. Texas Cordova limestone quarried near Austin is unique and beautiful. It has been used in construction throughout the world and is increasingly popular with artists and architects.

Lost-wax process: See the preceding chapter, "Texas Art Foundries and the Lost-Wax Casting Process."

Maquette: A small figure that becomes a working model for a larger work. Based on the artist's drawings, maquettes are sketches in clay through which the sculptor works out the mood and posture of the final sculpture.

Marble: A hard, compact crystalline or granular metamorphic limestone used for construction and ornamental purposes. White Carrara marble from Italy is traditionally the sculptor's favorite stone.

Minimalism: A style of abstract art involving simple, unembellished forms, often geometric in design. Popular during the 1960s.

Mobile: Sculpture that is designed to include a part or parts that move in space, either with the wind's currents or with an electric motor. First popularized by Alexander Calder.

Modeling: The shaping of a pliable material, such as clay, into a form, usually on an armature. In sculpture, modeling is the process of adding to—the opposite of carving.

Mold: The negative form from which a three-dimensional sculpture takes its shape in the casting process.

Monolith: A carved piece made from one block of stone.

Nonobjective: Sculpture that does not portray a natural object. See *Abstract.*

Obelisk: An upright, four-sided pillar that tapers as it rises. Popular as a cemetery monument.

Patina: A coating on bronze and copper sculpture; either a chemical treatment applied by the artist or a natural film formed by exposure to oxygen in the atmosphere.

Pedestal: The base supporting a sculpture.

Plinth: The lowest portion of the base or pedestal.

Pointing: The mechanical measuring of a model in order to duplicate it in another material or size. The pointing machine is a framework of metal arms that can be fitted around a sculpture to measure the relationship between various points on its surface.

Pop Art: A trend that elevated the mundane objects of a consumer society (lipstick, toothpaste, hamburgers) by recreating them, often in colossal sizes and bright colors. Popular during the 1960s.

Portrait bust: See *Bust.*

Relief: Sculpture that is a part of the background surface. Bas-relief (or low-relief) forms are only slightly raised from the background. Alto (or high-relief) forms project well out from the background and can be almost fully rounded.

Representational: See *Figurative.*

Sarcophagus: A stone coffin usually elaborately carved on the exterior.

Sculpture in the round: See *Freestanding.*

Stabile: A stable abstract sculpture, as opposed to a mobile sculpture.

Stele: An upright square columnar piece, traditionally a stone slab with a commemorative inscription and bas-relief.

References and Sources

Amateis, Louis, to Mrs. Cone Johnson. Washington, D.C., January 5, 1907. Archives, Harrison County Historical Museum, Marshall, Tex.

Art on Campus. Houston: University of Houston, University Park Office of Publication, n.d.

Baker, Bryant, to Judge Kemp. New York City, March 11, 1913. Archives, Milam County Historical Museum, Cameron, Tex.

Barac, Jean Williams. "Animating the Stone." *Alcalde* (University of Texas Ex-Students Association), November-December 1987, 6–10.

Barrington, Carol. "Houston Art Trails." *Texas Highways,* April 1989, 3–9.

Beadle, J. H. *Western Wilds and the Men Who Redeem Them.* Memphis: Jones Brothers and Company, 1878.

Beath, Robert B. *History of the Grand Army of the Republic.* New York: Bryan, Taylor and Company, 1888.

Beaumont Art Museum. *David Cargill Sculpture.* Catalogue for exhibition, Beaumont Art Museum, Beaumont, Tex., September 27–October 27, 1974.

Berry, Margaret C., comp. *The University of Texas: A Pictorial Account of Its First Century.* Austin: University of Texas Press, 1976.

Bivins, Mrs. J. K. Scrapbook. Unidentified newspaper article dated September 7, 1936. Local History Archives, Gregg County Historical Museum, Longview, Tex.

Bowie County, Texas, Historical Handbook. Texarkana: Bowie County Historical Commission, 1976.

Brown, J. Carter. "Art Education Flunks Out." *Art News* 87, no. 1 (January 1988), 190.

Brown, Mrs. Sam. "Brief History of Mollie Moore Davis Chapter UDC, 1898–1952." Unpublished paper. Archives, Harrison County Historical Museum, Marshall.

Buenger, Walter L. *Secession and the Union in Texas.* Austin: University of Texas Press, 1984.

Bus, Dan. "How Blind I Was." *Del Rio Guide* 2, no. 5 (August 1982), 2.

Campen, Richard N. *Outdoor Sculpture in Ohio.* Chagrin Falls, Ohio: West Summit Press, 1980.

Carlozzi, Annette. *Fifty Texas Artists.* San Francisco: Chronicle Books, 1986.

Century Development Corporation. "Louise Nevelson Sculpture for Placement at Allen Center." News release, Houston, September 20, 1982.

Child Study Center. *A Song.* Brochure on the sculpture of Evaline Sellors. Fort Worth: Child Study Center, n.d.

Coates, Paul, Jr. "Charles T. Williams." *Texas Architect,* October 1964, 16–17.

Confederate Veteran. Edited by S. A. Cunningham. "History of the Dallas Chapter, United Daughters of the Confederacy, and Its Noble Work." July 1898.

———. "Confederate Monument at San Antonio." September 1899, 399.

———. "To the Heroes of Sabine Pass." November 1905, 497.

———. "Confederate Monument at Rusk, Texas." March 1908, 103.

———. "The Corsicana Monument." May 1908, 211.

———. "Unveiling Ceremonies at Gainesville, Texas." August 1908, 377.

———. "The John H. Reagan Monument." March 1910, 99.

———. "Monument at Victoria, Texas." September 1912, 411.

———. "Monument to Hood's Texas Brigade." December 1912, 592.

Coppini, Pompeo. *From Dawn to Sunset.* San Antonio: Naylor Press, 1949.

Countess, Emily. "History of Bell County Chapter #101 UDC, 1896–1982." Archives, Bell County Library, Belton, Tex.

Craven, Wayne. *Sculpture in America.* Newark: University of Delaware Press, 1984.

Curtis, Gregory. "Heroes in the Shade." *Texas Monthly,* July 1989, 5.

Cutrer, Emily Fourmy. *The Art of the Woman: The Life and Work of Elisabet Ney.* Lincoln: University of Nebraska Press, 1988.

Debo, Darrell. *Burnet County History, 1847–1979.* Austin: Eakin Press and Burnet County Historical Commission, 1979.

Denison City Directory. Sioux City, Iowa: R. L. Polk and Company, 1907.

Denison Historical Society. "General Dwight D. Eisenhower." Program for unveiling of Eisenhower statue, Denison, Tex., July 9, 1973.

Directory of Memorials, Monuments, and Statues for Veterans. Austin: Texas Veterans Commission, 1985.

Directory of the City of Louisville for 1891, vol. 21. Louisville, Ky.: C. K. Caron Publisher, 1891.

Directory of the City of Louisville for 1893, vol. 23. Louisville, Ky.: C. K. Caron Publisher, 1893.

Di Valentin, Maria M., and Louis di Valentin. *The Everyday Pleasures of Sculpture.* New York: James H. Heineman, 1966.

Dobie, J. Frank. "The Monument of the Seven Mustangs." *Cattleman,* September 20, 1953, 46.

Doyle, Catharine B. "From Butter to Bronze." *Texas Parade,* February 1963, 20.

Edmonds, Eleanor. "The Genius of William Mozart McVey." *Houston Chronicle Magazine,* October 19, 1986.

Embry, Susan. "Sculpture Rising to New Heights." *State of Art* (Houston), January 1987, 10–12.

Esterow, Milton. "How Public Art Becomes a Hot Potato." *Artnews* 85, no. 1 (January 1986), 75–79.

Evert, Marilyn. *Discovering Pittsburgh's Sculpture.* Pittsburgh: University of Pittsburgh Press, 1983.

Fielding, Mantle. *Dictionary of American Painters, Sculptors, and Engravers.* Edited by Glenn B. Opitz. Poughkeepsie, N.Y.: Apollo, 1986.

Fisk, Frances Battaile. *A History of Texas Artists and Sculptors.* Abilene: Published by the author, 1928.

Forrester-O'Brien, Esse. *Art and Artists of Texas.* Dallas: Tardy Publishing Company, 1935.

"Fortieth Anniversary XIT Rodeo and Reunion." Souvenir program, August 1976.

Fowler, Bob. "The Business of Commissioning Art for Buildings." *Architectural Record*, May 1975, 65–66.

Friedley-Voshardt Company. Sales catalogue, 1897. Library of Congress.

———. Sales catalogue, 1899. Architectural Drawings Collection, University of Texas at Austin.

General Directory of the City of Houston: 1887–1888. Galveston: Morrison and Fourmy, Publishers, 1888.

Goode, James M. *The Outdoor Sculpture of Washington, D.C.* Washington, D.C.: Smithsonian Institution Press, 1974.

Greenway Plaza Newsletter (Century Development Corporation, Houston), September 2, 1973.

"The Hatchel Site." Historical marker files, Texas Historical Commission, Austin.

Hedgpeth, Don. *From Broncs to Bronzes.* Flagstaff, Ariz.: Northland Press, 1979.

"Helium Centennial Monument." News release, Helium Centennial Committee from Government and Industry, Washington, D.C., December 5, 1967. On file at the Amarillo office of the Department of the Interior Bureau of Mines.

Hendricks, Patricia D., and Becky Duval Reese. *A Century of Sculpture in Texas, 1889–1989.* Austin: Archer M. Huntington Art Gallery, College of Fine Arts, University of Texas, 1989.

Holmes, Ann. "The Work of Dubuffet." Brochure, Interfirst Bank, Houston, n.d.

Hopwood, Daniel R. "American Vignettes: Peter and the Indians." *Vista USA*, Spring 1988, 6.

Hughes, Robert. "The Sentinels of Nurture: Henry Moore (1898–1986)." *Time*, September 15, 1986, 102.

Hutko, Beth Ann, ed. *Art Happenings of Houston* 10, no. 1 (Winter 1986).

Hutson, Alice. *From Chalk to Bronze: A Biography of Waldine Tauch.* Austin: Shoal Creek Publishers, 1978.

Industries of Louisville, Kentucky, and of Albany, Indiana. Louisville: J. M. Elstner and Company, Publishers, 1886.

Interfirst Bank. "The Texas Sculpture Entrance Plaza of the First National Bank." Brochure, Interfirst Bank, Fort Worth, 1961.

Iwo Jima War Memorial. Harlingen: Marine Military Academy News and Publications Office, n.d.

Janes, Kirtland, and Company's Illustrated Catalogue. New York: Janes, Kirtland, and Company, 1870.

Jones, William M. *Texas History Carved in Stone.* Houston: Monument Publishing Company, 1958.

Josset, Raoul Jean. Autobiographical sketch and list of works. Files on artists, Dallas Museum of Art.

Kelton-Mathes Development Corporation. "Jane Mathes Kelton: Visionary in Planned Business Communities." News release, Arlington, Tex., February 5, 1986.

Kingston, Mike, ed. *1986–1987 Texas Almanac.* Dallas: Dallas Morning News, 1985.

Knight, Oliver. *Fort Worth: Outpost on the Trinity.* Fort Worth: Texas Christian University Press, 1990.

Koepf, Hans. *Masterpieces of Sculpture.* Edited by J. E. Schuler. New York: G. P. Putnam's Sons, 1966.

Laguna Gloria Art Museum. "Outdoor Sculpture by Texas Artists." Exhibition brochure, Austin, 1986.

Landrum, Graham. *An Illustrated History of Grayson County, Texas.* Fort Worth: University Supply and Equipment Company, 1960.

LTV Sculpture Collection. Dallas: Trammell Crow Company, n.d.

MacDonald, Richard. "Stephen F. Austin—A Texas Man." *News of East Texas* (Naples, Tex.), September 1986, 34.

"The Magnolia Building." Marker application. Historical marker files, Texas Historical Commission, Austin.

Maguire, Jack. "The Tiny Gun with the Big Roar." *Texas Highways,* October 1985, 44–47.

Major, Nettie Leitch. *C. W. Post: The Hour and the Man.* Washington, D.C.: Press of Judd and Detweiler, 1963.

Malmstrom, Margit. "Charles Umlauf: Sculptor of the Living Form." *American Artist,* September 1970, 53.

Marks, Claude. *World Artists, 1950–1980.* New York: H. W. Wilson Company, 1984.

Martin, Jose. Biographical sketch on the life of Raoul Josset, 1959. Texas and Dallas History Section, Dallas Public Library.

McFarland, J. C. Receipts from Missouri Pacific Railroad Company, January 18, 1888, and from J. N. Gilbert, January 26, 1888. Receipts, Capitol Building Commission (Records Group 016). Archives, Texas State Library, Austin.

McIlvain, Myra Hargrove. *Texas Auto Trails: The Northeast.* Austin: University of Texas Press, 1984.

McKenzie, Robert Tait. Presentation address to the National Council, Boy Scouts of America, Philadelphia, June 12, 1937. Archives, Boy Scouts of America National Office, Irving, Tex.

McKinstry, E. Richard. *Trade Catalogues at Winterthur: A Guide to the Literature of Merchandising, 1750–1980.* New York: Garland Publishing Company, 1984.

McNeil, Barbara, ed. *Gale's Biography and Genealogy Master Index.* Detroit: Gale Research Company, 1987.

Messenger (M. D. Anderson Hospital and Tumor Institute, Houston) 7, no. 4 (June 1978).

Miller, Ray. *Eyes of Texas Travel Guide, San Antonio/Border Edition.* Houston: Cordovan Corporation, 1979.

"Miró in America." News release, Gerald D. Hines Interests, Houston, March 25, 1982.

Moon, Turner. "The Boy Scout: Story of the McKenzie Statue." Archives, Boy Scouts of America National Office, Irving, Tex.

Moore, Gayland A. "A Tale of Two Salados." *Texas Parks and Wildlife,* September 1986, 2–7.

Moore in Dallas. Dallas: City of Dallas, 1978.

Mott, J. L. *Illustrated Catalogue of Statuary Fountains, Vases, Settees, Etc.* New York City: E. D. Slater, 1873. Bronx County Archives, Bronx County Historical Society Research Library, New York.

Mygdal, Eugenie Kamrath. "The Artist's Thoughts on the *Generations* Sculpture." Typescript, November 1989. Private papers of the sculptor, Waco.

North Texas Marble and Granite Works to the United Daughters of the Confederacy Greenville Chapter 1236. "Articles of Agreement," July 6, 1925. Records of the Greenville UDC Chapter, Greenville, Tex.

Oatman, Wilburn. *Llano: Gem of the Hill Country.* Hereford, Tex.: Pioneer Book Publishers, 1970.

Office of the Mayor. "Procedures for Evaluating Proposed Acquisitions of Works of Art." Houston, July 19, 1984.

"Old Maude: A Monument to the Longhorn Cow." Dedication program, March 1983. Nita Stewart Haley Memorial Library, Midland, Tex.

Panhorst, Michael W. *Outdoor Sculpture and Public Monuments in the Eastern United States.* Feasibility study for the National Park Service. 1984.

Pearce, Ann. "The Prized Golden Horses of Venice Have Come Indoors." *Smithsonian,* September 1982, 100–107.

The Pedi Post (Children's Medical Center, Dallas) 11, no. 3 (Fall 1982).

"The Pillot Dogs." *Harris County Heritage Society News* (Houston), Spring-Summer 1976.

Pinckney, Pauline A. *Painting in Texas: The Nineteenth Century.* Austin: University of Texas Press for the Amon Carter Museum of Western Art, 1967.

The Pipeliner (El Paso Natural Gasline Company), December 1966.

Proctor, Alexander Phimister. *Sculptor in Buckskin.* Edited by Hester Elizabeth Proctor. Norman: University of Oklahoma Press, 1971.

Prunty, Dorothy. "Those Startling Statues of Texas." *Dallas Times Herald Sunday Magazine,* November 7, 1971.

"Public Art in Public Spaces." Inventory and prospectus. City Planning Department, Houston, January 1976.

"Public Sculpture in Houston." Dedication program for *The Family of Man,* Urban Investment and Development Company and First City Bancorporation of Texas, Houston, December 6, 1982.

Rackley, Audie, ed. "Dedication of Statue." *Quarter Horse Journal* (Amarillo), November 1961, 28.

Rayner, Edwin. *Famous Statues and Their Stories.* New York: Grosset and Dunlap, 1936.

Reed, J. D. "A Millionaire's Sculptures Bring a Human Touch to Cityscapes." *Time,* June 11, 1984, 77.

Reynolds, John. "Exalted Landscapes: A Charge to the Juries." *Landscape Architecture,* September-October 1985, 63.

"Richard Hunt: Sculpture, Drawings, Prints." Brochure for exhibition, Azalee Marshall Cultural Activities Center, Temple, Tex., December 9–February 12, 1980.

Riddle, Peggy. *A Guide to Fair Park Dallas.* Dallas: Dallas Historical Society, 1983.

Robinette, Margaret. *Object and Environment.* New York: Whitney Library of Design, 1976.

———. "Public Sculpture in Dallas." *International Sculpture,* June-July 1986, 6–7.

Rogers, Richard Harrell. "From Faith to Form." Dedication program for the sanctuary of Parkway Presbyterian Church, Corpus Christi, November 1967.

Ruff, Ann. *Amazing Texas Monuments and Museums.* Houston: Lone Star Books, 1984.

Scent of Danger. Brochure. Kingsville: Texas A&I University Alumni Association, n.d.

Schock, Phillip N., ed. "Wichita Falls' Controversial Sculpture." *Texas Weekly Magazine,* December 29, 1985.

Schoen, Harold, comp. *Monuments Erected by the State of Texas to Commemorate the Centenary of Texas Independence.* Austin: Commission of Control for Texas Centennial Celebrations, 1938.

463

Sculpture Placement, Ltd. *J. Seward Johnson, Jr.* Promotional catalogue. Washington, D.C.: Sculpture Placement, Ltd., n.d.

"*Seaman's Memorial Sundial* Program of Dedication." Port of Port Arthur Port Commission, September 12, 1986. On file at the Port Arthur Public Library.

Searcy, Evelyn W., ed. *The Architectural Heritage of McKinney.* Dallas: Williamson Printing Company for the Owl Club of McKinney, 1974.

Selden, Jack. "Remember Goliad!" *Texas Highways,* October 1984, 24–29.

Sisters of Divine Providence. "Blessing of the Wayside Cross." Program, March 27, 1966, Helotes, Tex.

"Sixth Annual Abilene Outdoor Sculpture Exhibit." Exhibition brochure, Cultural Affairs Council and the Fine Arts Museum, Abilene, Tex., 1987.

Skylines (Trammell Crow Company, Dallas), November-December 1985.

Smith, Mark Lesly. "Selections from an Interview with David Deming." Dedication brochure for the unveiling of *Mystic Raven,* Austin, 1983.

Sonnamaker, Bob. "Deep in the Heart of Big Tex." *Texas Weekly Magazine,* October 13, 1985, 15.

"A Statue—A Tribute." Brochure, Stephen F. Austin State University Sesquicentennial Fund Drive, Office of Development, Nacogdoches, 1986.

The Summer Lass-o (Texas Woman's University, Denton), June 13, 1952.

Syers, William Edward. *Off the Beaten Trail.* Waco: Texian Press, 1971.

Teich, Frank. Contract with Richard B. Levy Chapter UDC, Longview, January 11, 1910. Local History Archives, Gregg County Historical Museum, Longview.

———. *Miscellaneous Memorials We Executed and Erected.* Promotional and sales catalogue of Teich's Studio of Memorial Art, Llano, 1926. Archives, Llano County Historical Museum, Llano, Tex.

Temple, Sarah Blackwell Gober. *A Short History of Cobb County, Georgia.* Atlanta: Cherokee Publishing Company, 1980.

Tennant, Allie V. Autobiographical sketch and list of works. Files on Artists, Dallas Museum of Art.

Tennent, Donna. "James Surls: Nature Dictates Configuration of His Sculptures." *Ultra,* November 1981, 16–17.

The Texas Collection, Baylor University, Waco.

Texas Longhorn Breeders Association of America. "Texas Gold: Bronze Monument Unveiled in Fort Worth Stockyards." News release, Fort Worth, December 8, 1984.

Texas Museum Directory. Austin: Texas Historical Commission, 1980.

"Texas Museums." Computer listing. Texas Historical Commission, Austin, 1991.

Texas Senate. *Journal of the Senate of Texas.* August 30, 1932, 187. Archives, Texas State Library, Austin.

Texas Tech University News and Publications Office. "Governor Preston Smith Statue." News release, Lubbock, August 11, 1985.

Thomas, Joshua. "Bluff Improvements: A Focal Point of Downtown Corpus Christi." *Texas Historian,* September 1986, 10.

Thomas, Samuel W. *Cave Hill Cemetery: A Pictorial Guide and Its History.* Louisville, Ky.: Cave Hill Cemetery Company, 1985.

A Tour Guide of Public Sculpture in the Alamo City. San Antonio: San Antonio Museum Association, 1980.

"The Trans Alaska Pipeline Monument." Program, Alyeska Pipeline Service Company, Prudhoe Bay, Alaska, September 1980. Museum of East Texas, Lufkin.

464

Tremonte, Sister Mary Peter. Letter to author, December 18, 1990.

TSA News (Texas Sculpture Association, Dallas), November-December 1989.

Tyler, Paula Eyrich, and Ron Tyler. *Texas Museums: A Guidebook.* Austin: University of Texas Press, 1983.

Tyler Museum of Art. "John Brough Miller." Brochure for exhibition, Tyler, Tex., May 5–June 24, 1984.

Umlauf, Charles. *Charles Umlauf: Sculptor.* Foreword by Gibson A. Danes. Introduction by Donald B. Goodall. Austin: University Art Museum and University of Texas Press, 1967.

Update (National Institute for the Conservation of Cultural Property, Washington, D.C.), Spring 1990.

Van Zandt, Frances Lipscomb. Autobiographical sketch, written in 1906, recorded in Van Zandt County Commissioners Court Minutes, October 3, 1938. Van Zandt County Courthouse, Canton, Tex.

Walker, Rosie. "Laces and Halo Distinguish 4 Allen Center." *Houston Downtown Magazine,* January 16, 1984.

Walraven, Bill. "John Walker Baylor." *Texas Weekly Magazine,* March 2, 1986.

Warren, David B. "Bayou Bend: The Plan and History of the Gardens." *Bulletin: The Museum of Fine Arts, Houston* 12, no. 2 (Winter-Spring 1989), 67.

Warwick, Grace. *The Randall County Story.* Hereford, Tex.: Pioneer Book Publishing Company, 1969.

Welch, June Rayfield. *Historic Sites of Texas.* Dallas: G.L.A. Press, 1972.

Wesley, T. Perry. "The Viquesney Story." MSS. Spencer, Ind., n.d.

Widener, Ralph. *Confederate Monuments, Enduring Symbols.* Washington, D.C.: Andromeda Associates, 1982.

Williams, Annice Lee. *A History of Wharton County, 1864–1891.* Austin: Von Boeckmann–Jones, 1964.

The Woodlands Corporation. *The Cultural Heritage of a Real Hometown: The Woodlands, Texas.* The Woodlands: The Woodlands Corporation, 1983.

Newspapers

Abilene Reporter-News. Richard Horn, "Artist Calls His Herd of Cows Back Home." July 3, 1986.

Amarillo Globe-News. Dan Warren, "One Thousand People Cheer as Monument Placed in New Home." December 17, 1982.

———. Bill Cox, "Persistence Clears Up Tale of Two Statues." March 15, 1984.

Arlington Citizen-Journal. Brenda Channell, "Kelton-Mathes Stone Commission Decorates Business Development." October 2, 1985.

Arlington Daily News. "Sculptures to Adorn Park." August 28, 1985.

Austin American-Statesman. "On Bringing Life Beautiful to Stone." June 20, 1948.

———. Lorraine Barnes, "Mule Not Mink, Hammer Protests." August 20, 1954.

———. "New Statue of Washington to Be Unveiled." February 13, 1955.

———. "A Mallet, a Chisel, a Block of Stone." March 25, 1955.

———. Dixie Shipp, "In Tribute." October 11, 1970.

———. John C. Henry, "Austin's Best, by Design." October 23, 1989.

Austin Statesman. April 26, 1891.

Battalion (Texas A&M University, College Station). "Sculpture Is Gift of 1966." January 22, 1971.

———. "Class of '80 to Give Twelfth Man Statue." March 27, 1979.

Bay City Daily Tribune. David Wolbrueck, "Prominent County Cattleman Should Be Long Remembered" and "Shanghai Also Built a Monument." March 3, 1986.

Beaumont Enterprise. "Confederate Statue Is Ready." October 14, 1912.

Bonham Daily Favorite. "Confederate Monument Is Dedicated." July 27, 1905.

———. "Unveiling of Col. J. B. Bonham." December 19, 1938.

Cameron Herald. "Statue of Ben Milam." July 17, 1938.

Corpus Christi Caller-Times. "Sculpture Selected for Parkdale Library." February 3, 1962.

———. "Sculpture Society Praised." November 11, 1962.

Corpus Christi Times. Mary Alice Evans, "Sanctuary Fosters Feeling of Oneness." November 17, 1967.

Daily Texan (University of Texas at Austin). Becky Cabaza, "University Statue Suspected Image of Film Star Davis." June 18, 1982.

Dallas Downtown News. Lyn Dunsavage, "Downtown Sculpture." May 19, 1980.

Dallas Morning News. Frank Tolbert, "The Dunes around Muleshoe." April 30, 1967.

———. Frank Tolbert, "Dirty Statue of Grape Nuts Man." June 10, 1975.

———. Frank Tolbert, "Cereal King Almost Caused Cowboy Strike." April 21, 1977.

———. Frank Tolbert, "What Ever Happened to Gorgeous Georgia?" October 21, 1977.

———. Frank Tolbert, "On Eating Jicamas in Popeye City." January 14, 1978.

———. Frank Tolbert, "Graveyard Looks Like a Giant Chess Board." February 25, 1978.

———. Janet Kutner, "Sculpture by Rosati." November 24, 1983.

———. Suzanne Halliburton, "Texas Sculptor's Scientific Mind Produces Works of Art." January 26, 1985.

———. Marty Primeau, "Electra Waggoner Biggs." March 17, 1985.

———. Janet Kutner, "Symposium Examines Trends in Sculpture." March 25, 1985.

———. Steve Blow, "College's Removal of Metal Sculpture Sparks Freedom Debate in Longview." March 8, 1986.

———. Janet Kutner, "New Official to Carve Out Master Plan for City." August 18, 1986.

———. Bill Marvel, "Fair Park: '30s Gem Glistens Again." September 24, 1986.

———. Bill Marvel, "Dallas Shapes a Policy to Give the Public a Voice in Public Art." July 12, 1987.

———. Bill Marvel, "The Public Speaks on Public Art." August 2, 1987.

Denison Sunday Gazetteer. "Unveiling of the Monument." April 25, 1897.

El Paso Herald Post. "Sphinxes in Silent Vigil." September 26, 1966.

———. "UTEP Sculpture Will Be Built of Metal." July 18, 1986.

Fort Worth Star-Telegram. "Statue Lends Beauty to Goldfish Pond." October 6, 1965.

———. "A Monument to Texans." August 21, 1985.

———. Keith Matulich, "Backers Ride Herd on Horse Fountain." March 18, 1986.

Four States Press and Texarkana Courier. "Confederate Monument Will Be Presented." April 20, 1918.

Fredericksburg Standard Radio-Post. "Elisabet Ney Sculpture Featured on Grave." April 3, 1985.

Gainesville Daily Register. "Marking Time." August 11, 1986.

Galveston Daily News. Maury Darst, "Galveston Is Home to Many Historic Monuments and Statues." March 3, 1985.

Galveston News. May 14, 1904.

Gonzales Inquirer. "Gonzales Chapter UDC Lays Cornerstone of the Confederate Monument." July 22, 1909.

Granbury Graphic Democrat. Phyllis DeRoos, "State Orders Statue of General Granbury." May 30, 1913.

Henderson Daily News. "Joe Roughneck Monument at Pioneer Park." October 8, 1963.

———. "Repairs Due on School Monument." October 1, 1979.

Hillsboro Mirror. "Let Contract for Monument." December 31, 1924.

———. July 8, 1925.

———. "Site for United Confederate Veterans Monument Selected." July 29, 1925.

Houston Chronicle. "Unveiling of the Monument to Spirit of the Confederacy." January 20, 1908.

———. Karen Kane, "Playful Palm Bids a Frond Farewell." June 12, 1978.

———. "Religious Sculpture on Show at Texas Medical Center." December 26, 1981.

———. "Mexican Sculptor Raising Art to New Heights in Houston." August 1, 1982.

———. "Water for Man and Beast." April 26, 1989.

Houston Post. December 20, 1907.

———. Charlotte Phelan, "How a Sculpture Grew." April 29, 1973.

———. Mimi Crossley, "Kicking Armadillo Tribute to Texas Spirit." March 5, 1982.

———. Teresa Byrne-Dodge, "Art for the City." November 18, 1983.

Irving Daily News. "Running Free: The Mustangs of Las Colinas." October 16, 1984.

Jefferson Jimplecute. "Stern Fountain Marker Dedication Held." December 8, 1983.

Llano News. "Plant Razed by Fire." September 17, 1936.

Longview Daily News. "Dinosaur Park Dream a Reality for East Texas." April 25, 1985.

Longview Morning Journal. Rita Nute, "Veterans Statue a Memorial to County's Soldiers." November 11, 1983.

Longview News Journal. "Famed Sculptor Dies." September 1, 1986.

Louisville Courier-Journal. "James S. Clark, Pioneer Resident, Head of Monument Company, Dies." October 4, 1919.

Lubbock Avalanche-Journal. William D. Kerns, "City Makes Good on Promise to Holly." September 11, 1983.

———. Gerry Burton, "Bronze Statue at Tech to Honor Ex-Governor." September 1, 1985.

Marble Falls Highlander. Joyce Taylor, "Frank Teich, Sculptor of the Hill." October 11, 1973.

———. Dale Fry, "Fame Granted to Llano Sculptor, County." January 3, 1985.

———. Dale Fry, "Goddess of Mystery." January 24, 1985.

Marshall News Messenger. "Historic Stern Fountain Restored in 1981." April 30, 1986.

McKinney Daily Courier Gazette. "Throckmorton's Memory Revered—Beautiful Statue Dedicated." July 5, 1911.

Odessa American. Monte Whaley, "Odessa's Famed Jackrabbit Hops to New Area." April 28, 1985.

Owen Leader (Spencer, Ind.). "Doughboy—Spencer's Landmark for Fifty Years." June 2, 1976.

Paris Farmer's Advocate. October 29, 1903.

Port Arthur News. "Design of Memorial Won Sculptor Assignment from Royalty." March 11, 1941.

———. Maxwell Cook, "Lad of Bronze Survives Angry Music of the Sea." December 24, 1961.

San Angelo Daily Standard. "Tom McCloskey Friend of the Poor Is No More." December 29, 1914.

San Angelo Standard-Times. Elmer Kelton, "True to Union, Texas Germans Fell on Nueces." August 12, 1962.

San Antonio Evening News. "Coppini Defends Cenotaph Work." July 21, 1939.

San Antonio Express. "Memorial for Coppini." April 12, 1953.

San Antonio Express News. Dan R. Goddard, "UT Exhibition Traces a Century of Change in Texas Sculpture." July 30, 1989.

San Antonio Light. "Coppini Defends Cenotaph Work." November 30, 1939.

———. Lamont Wood, "HemisFair—An Artistic Legacy." August 12, 1979.

Shreveport Times. Goodloe Stuck, "Connell Inspired by Plantation Life." September 29, 1985.

Stephenville Empire-Tribune. Wilma Hall, "Hoka Hey Foundry Completes Life-Size Statues." July 12, 1985.

Temple Daily Telegram. "Papers Deposited Monument Vault." October 20, 1916.

Texarkana Gazette. Frank Conway, "Texas, Arkansas Governors Meet in New Boston." July 20, 1986.

Waco Tribune-Herald. Bob Darden, "Cen-Tex Statues Owe Debt to Texan." June 18, 1979.

Wall Street Journal. David Shribman, "Congress Considers a Statue Statute." July 2, 1986.

Weatherford Weekly Herald. "Confederate Monument Paid for New Year's Day." January 4, 1928.

Wharton Spectator. December 17, 1894.

Williamson County Sun (Georgetown). Steve Garcia, "Soldier Gets Confederate Polish." November 10, 1983.

Wimberley View. Linda Allen, "Internationally Known Sculptor Makes Wimberley Home." October 17, 1985.

Index of Titles

Boldface page numbers indicate illustrations.

General Index

Boldface page numbers indicate illustrations.

HOUSTON PUBLIC LIBRARY

R01082 09899

txr T
 730
 .74764
 L778
Little, Carol Morris
A comprehensive guide to
 outdoor sculpture in T